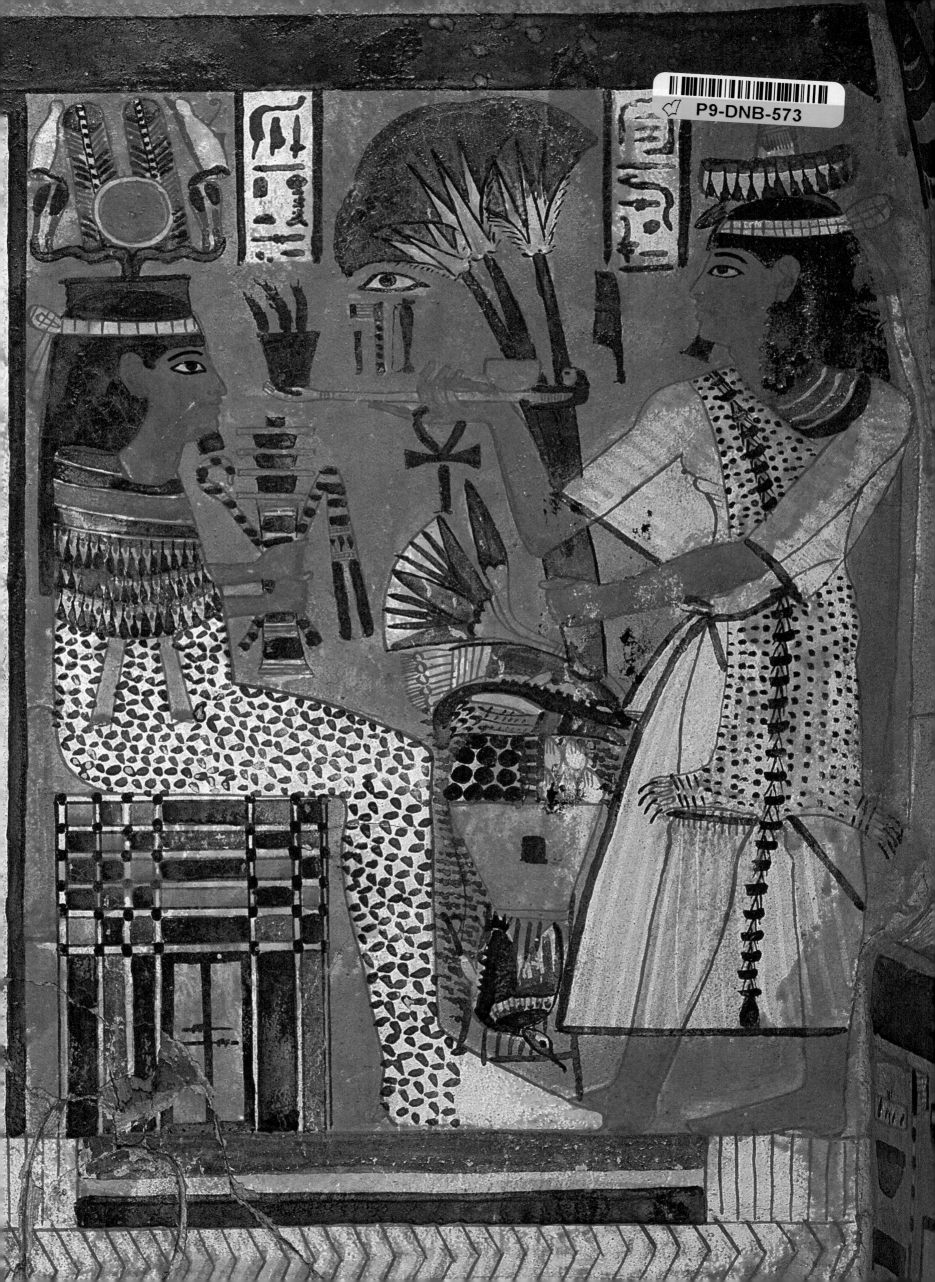

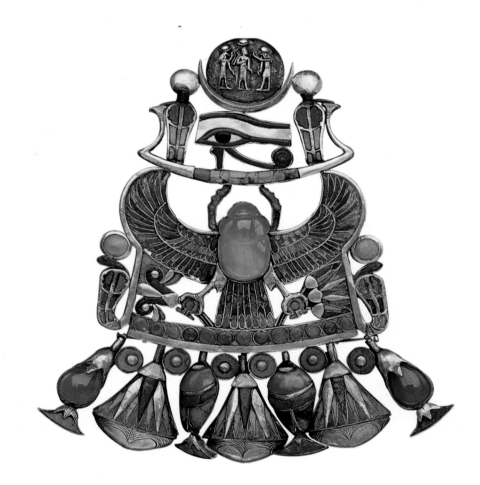

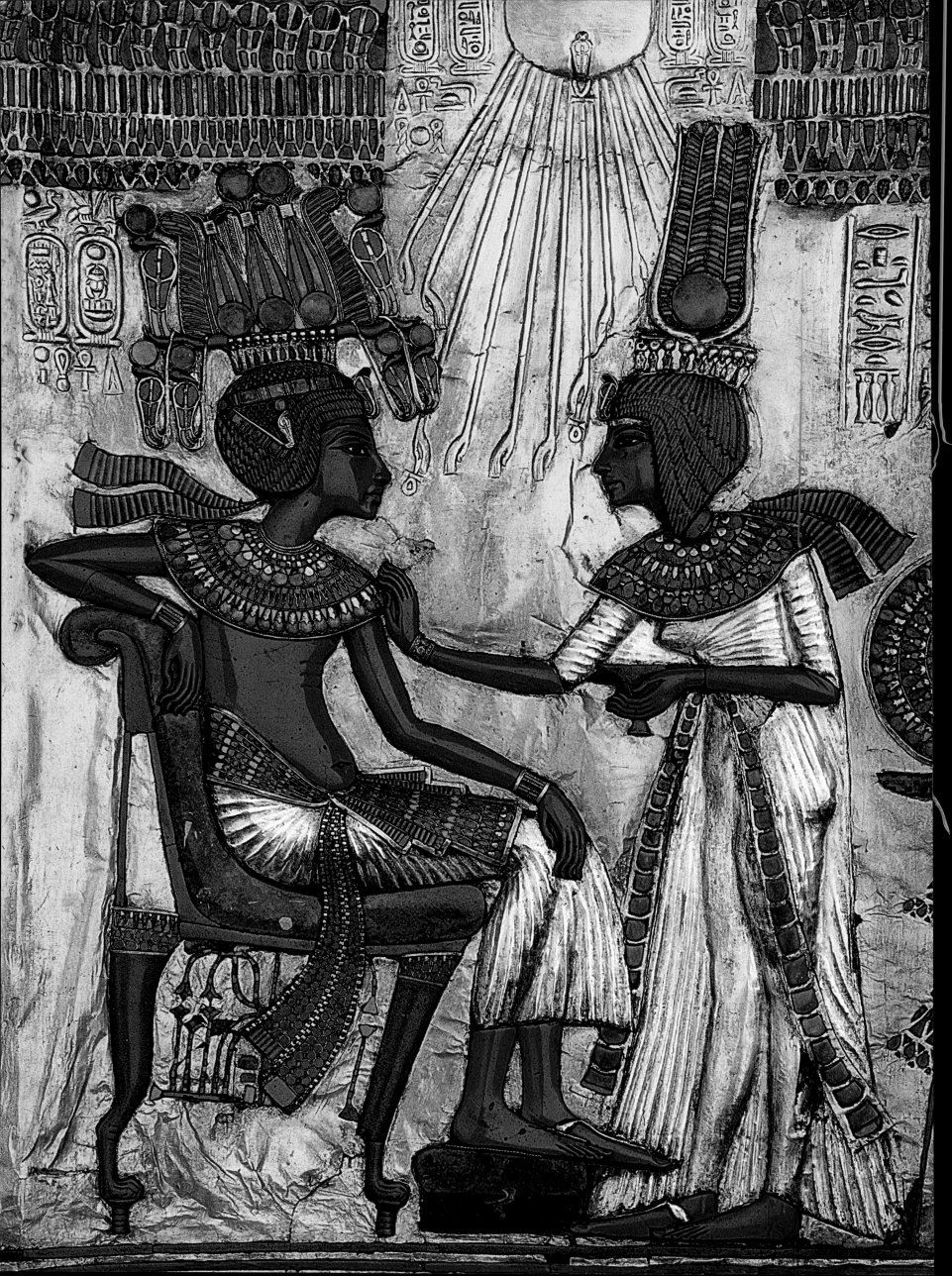

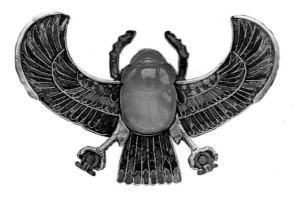

EGYPTIAN TREASURES *from the* EGYPTIAN MUSEUM *in* CAIRO

Edited by

Francesco Tiradritti

Photographs by

Araldo De Luca

Harry N. Abrams, Inc.
Publishers

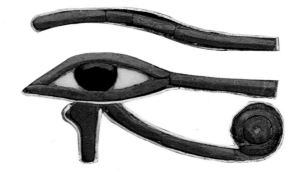

It is now more than 160 years since ancient Egyptian artifacts were first exhibited in Cairo, and almost 100 years since the opening to the public of the present Egyptian Museum on Tahrir Square in the heart of the city. This book is therefore a celebration of the long and distinguished history of the Egyptian Museum in Cairo, and of the scholars who pioneered the science of Egyptology and gave people in modern times the opportunity to wonder at the art and civilization of the ancient Egyptians.

Even more significant, of course, than the achievements of the past two centuries is the art that is contained in the Museum and the history of the people who created it. The Egyptian Museum contains some 150,000 artifacts produced over a period of more than 5,000 years, including great masterpieces such as the objects found in the tomb of Tutankhamun, images of which are now etched into the consciousness of millions of people across the globe.

It is therefore fitting that these two remarkable achievements should be jointly celebrated in the magnificent book you now hold in your hands. Turning through its pages has given me immense pleasure and awakened in me once again a sense of awe and wonder at the glory and the humanity of the people who lived in the land of Egypt all those thousands of years ago. It is my hope and conviction that others will be similarly moved, and will gain from these pages a vivid and inspiring impression of our marvellous history.

The legacy of ancient Egypt is not, however, the possession of modern Egypt alone, but is a gift to the whole world. The civilization that developed on the banks of the Nile has touched every nation on earth in various ways. It is particularly pleasing, therefore, that distinguished Egyptologists have contributed to this book, so that in addition to sections by Egyptian scholars there are chapters from authors in Belgium, France, Germany, Italy, the United Kingdom and the United States of America. This is a reflection not only of the fascination that ancient Egypt continues to exert across the world, but also of the invaluable contribution the international community has made to its rediscovery and to our growing understanding of its civilization. Between them, these renowned scholars have given us within these pages an overview of the entire span of ancient Egyptian history, from Predynastic times through the monumental splendours of the Old Kingdom, the 'golden age' of the Middle Kingdom, the iconoclastic experimentation of the Amarna period, and the imperial militarism of the New Kingdom, to the Late Period and finally the syncretism of the Ptolemaic and Roman eras. In addition, there is also a chapter on the history of the Museum itself, and detailed descriptions of the hundreds of artifacts that are so beautifully illustrated in this book.

The achievements of the ancient Egyptians are an inspiration to us who still live today on the land they first tilled – on the banks of the Nile that gave them life seven millennia ago. As we approach the new millennium, there is much we can still learn from them and much to wonder at. It is my hope that this superb book will inspire all those who read it, and encourage them, if they have not yet done so, to visit the Museum itself and see for themselves the fabulous treasures it contains.

H.E. Mrs. Suzanne Mubarak

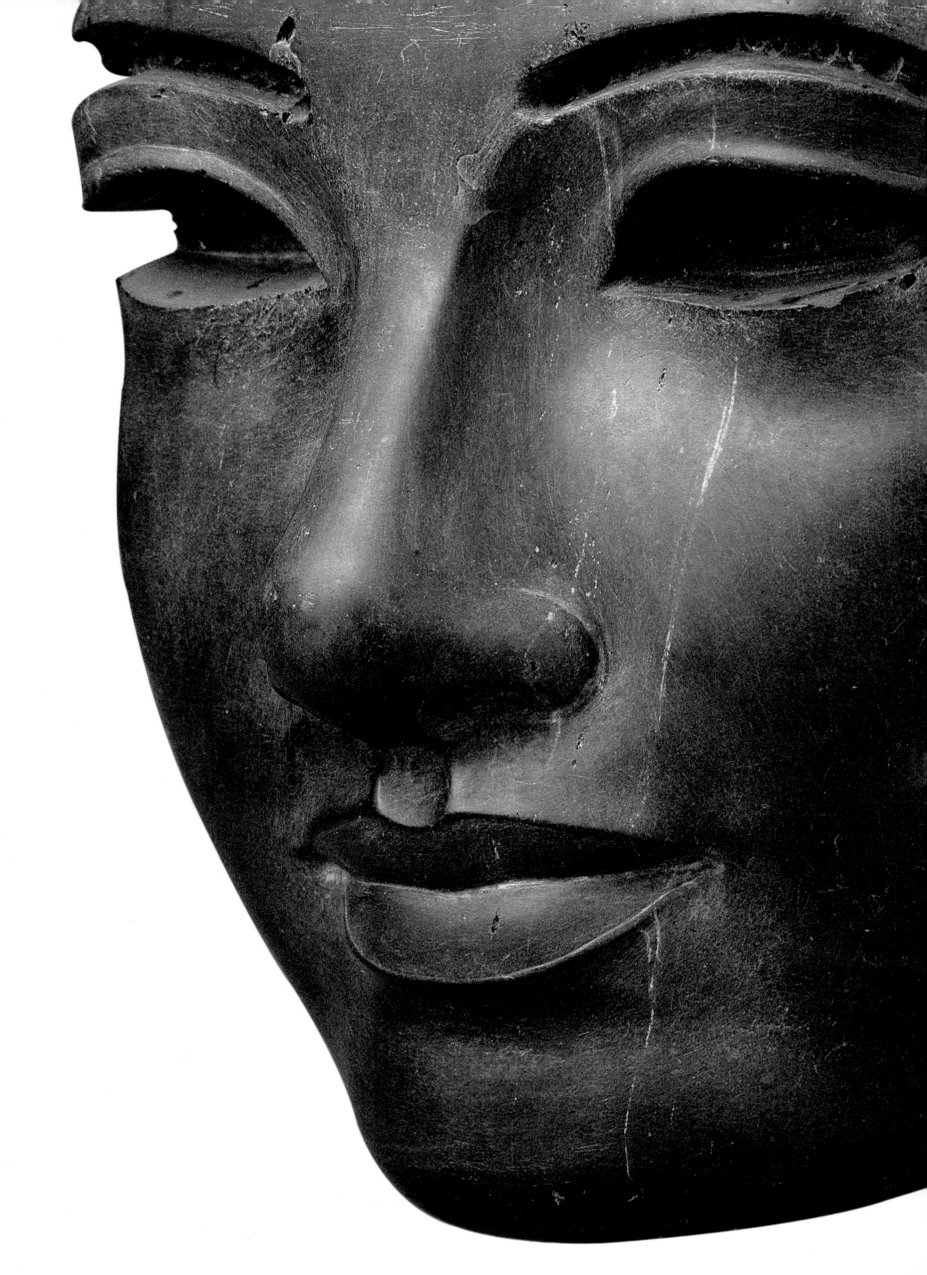

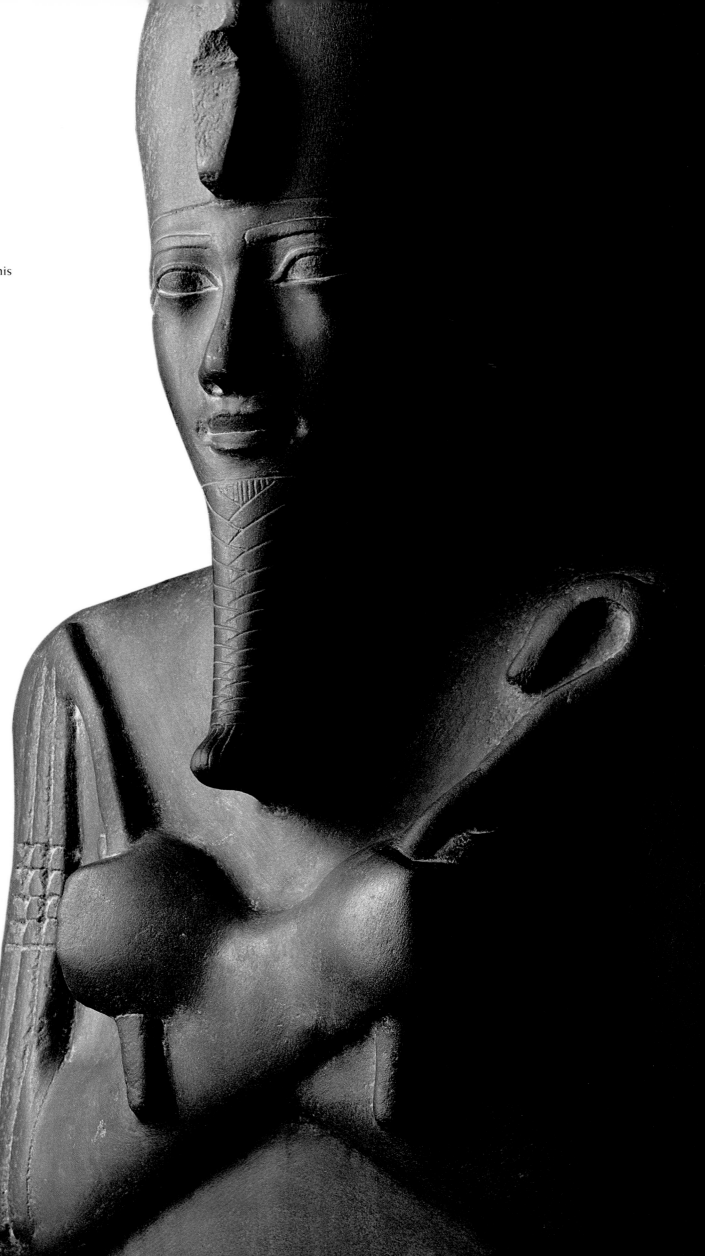

Photographs by
Araldo De Luca

Edited by
Francesco Tiradritti

Editorial production
Valeria Manferto De Fabianis
Laura Accomazzo

Graphic design
Patrizia Balocco Lovisetti
Clara Zanotti

Descriptions
Francesco Tiradritti
Silvia Einaudi
Anna Leone
Rosanna Pirelli
The initials at the end of each description refer to the author.

Translation
Neil Davenport

CONTRIBUTORS

ARALDO DE LUCA
Araldo De Luca is a highly regarded photographer, particularly renowned for his images of statuary and jewelry.

FRANCESCO TIRADRITTI
Consultant Egyptologist at the Civic Archaeological Collection of Milan, Francesco Tiradritti is currently the director of the Italian archaeological mission excavating the tomb of Harwa at Luxor.

MOHAMED SALEH
Director of the Egyptian Museum in Cairo from 1981 to 1998, formerly Inspector of Antiquities at Luxor and the author of numerous specialist works, Mohamed Saleh also lectures in Egyptology at Cairo University.

CHRISTIANE ZIEGLER
Chief Curator of the Department of Egyptian Antiquities at the Musée du Louvre in Paris, Christiane Ziegler has contributed to the catalogues of major exhibitions on Ancient Egypt in France and the United States. In 1997 she led the Louvre archaeological missions to Saqqara, the Ramesseum and the Valley of the Queens.

ZAHI HAWASS
Director General of the Pyramids of Giza and Saqqara, Zahi Hawass co-ordinated excavations that brought to light the tombs of the workers at Giza and oversaw the recently completed Sphinx restoration project. He teaches Archaeology at Cairo University.

DIETER ARNOLD
Curator of the Department of Egyptian Art at the Metropolitan Museum of Art, Dieter Arnold has conducted excavations in Egypt since 1963, in particular at Thebes, Lisht and Dahshur. He holds the Chair of Egyptology at the University of Vienna.

ADELA OPPENHEIM
Research Associate in the Department of Egyptian Art in the Metropolitan Museum of Art, New York, Adela Oppenheim has worked on the excavations at Lisht.

DIETRICH WILDUNG
Chief Curator of the Department of Egyptian Art at the Staatliche Museen of Berlin, Dietrich Wildung is a Professor of Egyptology at the University of Berlin. He was President of the International Association of Egyptologists from 1992 to 1996 and led the East Delta Excavation Project between 1978 and 1989.

ANNA MARIA DONADONI ROVERI
Superintendent of the Egyptian Museum, Turin, Anna Maria Donadoni Roveri specialized in Oriental Archaeology at La Sapienza University, Rome. She has contributed to numerous publications and exhibitions, and has assisted with new excavations at Gebelein.

JEAN YOYOTTE
Honorary Professor of Egyptology at the Collège de France, Paris, and an expert in historical geography, Jean Yoyotte directed the excavations of the French mission at Tanis from 1965 to 1985.

HERMAN DE MEULENAERE
Director of the Fondation Égyptologique Reine Élisabeth in Brussels from 1965, Herman De Meulenaere led the Comité des Fouilles Belges en Egypte from 1966 to 1988. He is an Honorary Professor at the University of Gent.

EDNA R. RUSSMANN
Associate Curator in the Department of Egyptian Art at the Brooklyn Museum of Art in New York, Edna R. Russmann is also the author of numerous publications and lectures in the Egyptian Art at major American universities.

DONALD M. BAILEY
A member of the Department of Greek and Roman Antiquities at the British Museum in London from 1955 to 1996, Donald M. Bailey is an expert in the archaeology of Roman Egypt and has taken part in numerous excavations.

SILVIA EINAUDI
A graduate in Egyptology from the University of Turin, Silvia Einaudi is now at the Egyptian Museum of Turin.

ANNA LEONE
Having specialized in Classical Archaeology at La Sapienza University, Rome, Anna Leone now specializes in studies relating to Roman Africa.

ROSANNA PIRELLI
A lecturer in Ancient Egyptian Language at the Faculty of Letters of the Eastern University Institute of Naples.

The Publisher would particularly like to thank:

H.E. Farouk Hosny – *Minister of Culture, Egypt*
Gaballah Ali Gaballah – *Secretary General of the Supreme Council for Antiquities*
H.E. Francesco Aloisi di Larderel – *Italian Ambassador to Egypt*
Ali Hassan – *Former Secretary General of the Supreme Council for Antiquities*
Mohamed Saleh – *Director of the Egyptian Museum in Cairo*
Carla Maria Burri – *Director of the Italian Cultural Institute in Cairo*
Samir Gharib – *Artistic Counsellor for the Minister of Culture*

Mauro Accornero – *Staff Manager of Ieoc*
Filippo Capurso – *General Manager of Ieoc*
Uldarigo Masoni – *Former General Manager of Ieoc*
Nabil Osman – *Chairman of the Egyptian State Information Service*
Zaki Gazi – *Director of the Cairo Press Centre*
and Gamal Shafik *of the Cairo Press Centre*
for the organization of the photographic assignment
The staff and the curators of the Egyptian Museum in Cairo
Alessandro Cocconi – *photography assistant,*
Ramses *Hilton Hotel in Cairo*
Egyptair.

The Publisher would also like to acknowledge Eni and its Egyptian subsidiary Ieoc, which have supported and promoted the publication of this volume.

CONTENTS

8–9
PECTORAL OF
SHESHONQ II WITH
WINGED SCARAB,
FROM TANIS
JE 72170

Library of Congress Catalog Card Number: 99–72419

ISBN 0–8109–3276–8

Copyright © 1999 White Star S.r.l., Italy
Published in 1999 by Harry N. Abrams, Incorporated,
New York
Published in Great Britain under the title
The Cairo Museum: Masterpieces of Egyptian Art

Printed and bound in Italy

Harry N. Abrams, Inc.
100 Fifth Avenue
New York, N.Y. 10011
www.abramsbooks.com

ABRAMS

The present Egyptian Museum is the fifth home built for the Egyptian antiquities collections in Cairo. The first display of antiquities opened in 1835 at the Azbakiya Gardens in the centre of the city. Subsequently, its contents were relocated to a second exhibition hall, within Saladin's Citadel. In 1855, the viceroy of Egypt, Khedive Said Pasha, presented the contents of the Citadel gallery as a gift to Austrian Archduke Maximilian. French Egyptologist Auguste Mariette exhibited the third collection in a building on the bank of the Nile at Bulaq. This was later transferred to a fourth location in an annex of Khedive Ismail's residence at Giza when the flooding of the Nile endangered the Bulaq building and its artifacts in 1878.

On 15 November 1902, in the reign of Khedive Abbas Helmi, the present museum in Tahrir Square was inaugurated under the directorship of Gaston Maspero. Initially it contained about 50,000 artifacts, but today the museum houses

10 BACKGROUND
PENDANT OF
TUTANKHAMUN IN THE
SHAPE OF A FALCON
(DETAIL)
JE 61893

10 LEFT
LIDS OF CANOPIC VASES
OF TUTANKHAMUN
JE 60687

11
HEAD OF QUEEN
NEFERTITI, FROM TELL
EL-AMARNA
JE 59286

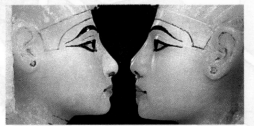

MOHAMED SALEH

PREFACE

more than 150,000. The objects are registered on a database that enables museum curators to keep the records of the pieces up to date, and helps scholars to obtain the information they need for their research. Most artifacts excavated, purchased or confiscated in Egypt eventually found their way to the Egyptian Museum in Cairo, to be either displayed or stored there. Nowadays, new discoveries are kept in the nearest regional museums, of which there are so far twenty-seven, throughout the country.

The Egyptian Museum in Cairo houses the world's most exquisite and extensive collection of ancient Egyptian artifacts. From the Old Kingdom we could mention the statues of Khafre, Menkaure, Rahotep and Nofret, Ka-aper (nicknamed 'Sheikh el-Beled', or the village headman), and the dwarf Seneb and his family. In addition there are the finds from the tomb of Hetepheres, mother of Khufu (including furniture, such as her canopy, bed, stool, sedan chair, as well as her sarcophagus), which are displayed in a special gallery on the ground floor.

From the Middle Kingdom there are the statue of Mentuhotep, the models of army divisions of Mesehti, the models of Meketre, the statues of Senusret III and Amenemhet III, the jewelry of the princesses Khnumet, Sit-Hathor, Sithathoriunet, Mereret, Weret, Ita, Ita-weret and Neferuptah.

From the New Kingdom we can mention the jewelry of Ahhotep, the statues of Hatshepsut, Senenmut, Thutmose III and Amenhotep III, the artifacts of Yuya and Tuyu, the statues of architect Amenhotep, son of Hapu, Akhenaten and Nefertiti, and the sculptures of Ramesses II and Nakhtmin and his wife. The marvellous treasures of Tutankhamun are exhibited on the upper floor in the long eastern gallery, northern wing, and in Hall 3.

From the Late Period, the museum is fortunate to display the treasures discovered in 1939–1940 at Tanis, consisting of more than six hundred items. These treasures, and an important collection of jewelry from various periods, are now well displayed in secure

showcases, and provided with improved lighting and climatic conditions.

With texts by leading Egyptologists and photographs by a distinguished photographer, this book is the first to cover in depth and detail the huge variety of antiquities in the Egyptian Museum. Both the texts and the photographs are well worth the interest of those who appreciate Egyptian art and monuments. We hope the recent modernization of the collection's display, including improvements in lighting and the introduction of automation, will help to highlight further the importance of the artifacts and enhance visitors' appreciation. The new Egyptian Museum at Giza, about to be built, will relieve the current building of some of its burden and create more space for a better display of the Museum's objects. It is also planned to send more objects to regional museums to clear storerooms and use them as display areas and for other services. New displays, exhibitions, recent acquisitions and monthly features also invite visitors to return to the Museum more than once.

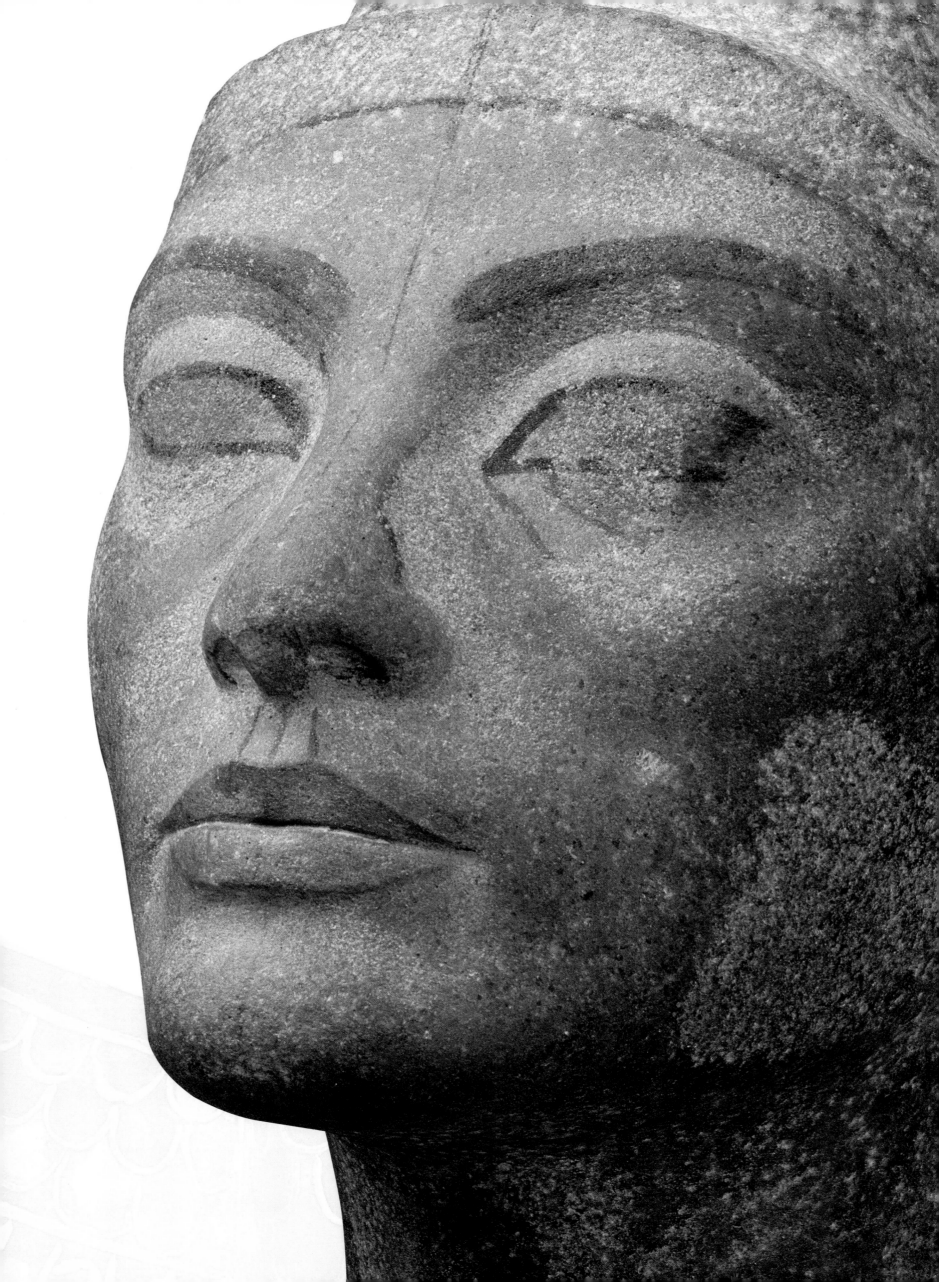

If in military terms Napoleon's expedition to Egypt proved to be a complete fiasco, at least it had the result of bringing the Nile Valley and the civilization of the pharaohs back within the cultural sphere of the Mediterranean. Representatives of the major foreign powers in Alexandria and Cairo were fascinated by Egyptian art and during their terms of office in Egypt, these consuls assembled large collections of antiquities which were then shipped back to the great European cities. Thus a flourishing trade in artifacts began that would feed the European taste for all things Egyptian – the influence of which can clearly be seen in styles of furniture and the decorative arts of the early nineteenth century.

This renewed and popular interest in Egypt and its antiquities encouraged many members of the European aristocracy to visit the banks of the Nile in person. Boats outfitted with every imaginable comfort navigated the river. As well as inspecting and sketching the most important monuments, the tourists of the age never failed to acquire a collection of objects to display to friends and relations at home. These nineteenth-century souvenirs were frequently of considerable size. Coffins were among the most sought-after pieces. Mummies were also in considerable demand, especially if they were still wrapped in their bandages. Once the

F R A N C E S C O T I R A D R I T T I

THE HISTORY OF THE EGYPTIAN MUSEUM

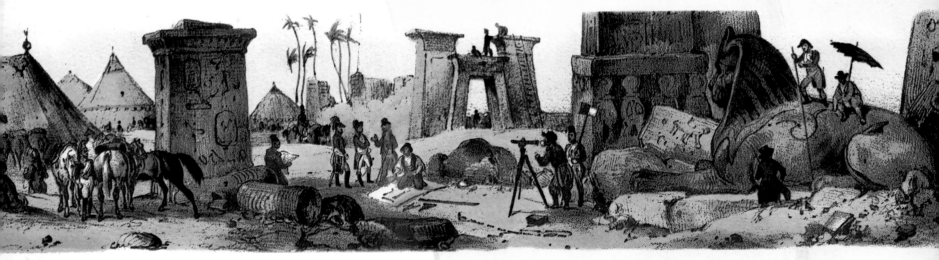

mummies reached Europe, shows were organized at which they were unwrapped and sensitive society ladies duly fainted. Along with mummies and coffins there was also a roaring trade in statues of kings and divinities, stelae, shabti figures, papyri, furnishings, vases, amulets and scarabs. Decorated and inscribed pieces of ruined monuments were carried away wholesale, while intact structures risked being literally dismantled by avid European visitors.

12 BACKGROUND
FUNERARY MASK OF
AMENEMOPE
JE 86059
GOLD LEAF, BRONZE,
COLOURED STONES
HEIGHT 30 CM
TANIS
TOMB OF PSUSENNES I
BURIAL CHAMBER OF
AMENEMOPE
PIERRE MONTET'S
EXCAVATIONS (1940)
TWENTY-FIRST DYNASTY
REIGN OF AMENEMOPE
(993–984 BC)

12 ABOVE
EXPERTS FROM THE
NAPOLEONIC EXPEDITION
TO EGYPT. THE RESULTS OF
THE IMMENSE SURVEY BY
THE 167 MEMBERS OF THE
COMMISSION DES ARTS ET
DES SCIENCES WERE
PUBLISHED IN THE
DESCRIPTION DE L'ÉGYPTE, A
HUGE WORK COMPOSED OF
NINE VOLUMES OF TEXT
AND TEN OF PLATES,
PRINTED IN PARIS BETWEEN
1809 AND 1828.

13 LEFT
STATUE OF ISIS
CG 38884
RIGHT, STATUE OF
HATHOR WITH PSAMMETIK
CG 784
SCHIST
HEIGHT 90 CM; 89.5 CM
SAQQARA
TOMB OF PSAMMETIK
LATE TWENTY-SIXTH
DYNASTY (FIRST HALF OF
THE 6TH CENTURY BC)

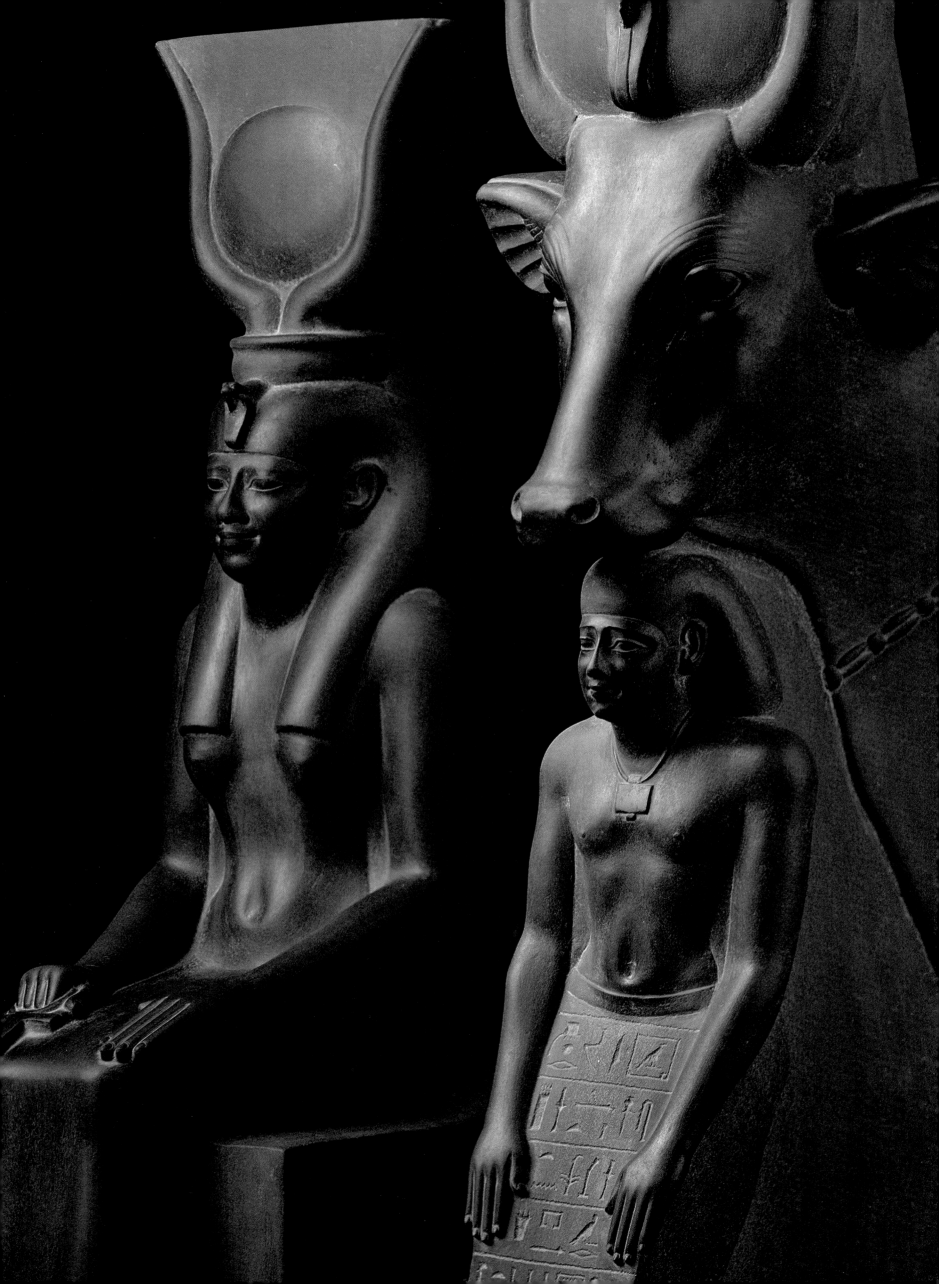

Even Jean-François Champollion (1790–1832), the decipherer of hieroglyphs, was unable to resist the incomparable beauty of the painted reliefs in the tomb of Seti I and decided to remove a door-jamb (today exhibited in the Louvre in Paris). Champollion's Tuscan companion Ippolito Rosellini (1800–1843) followed suit and took the opposite jamb to Florence.

Initially the Egyptians were mystified by the Westerners' interest in what for them were simply stones emerging from the ground. Before long, a rumour began to circulate that these stones concealed untold treasures. The inhabitants of the villages in the vicinity of archaeological sites began to ransack tombs, temples and statues in the vain hope of finding jewels and precious objects. Soon, however, the Egyptians came to realize that the foreigners were interested in the stones themselves rather than anything they might contain. While they could not themselves see the attraction of a lump of carved rock, they quickly became masters in the search for and discovery of antiquities. And a lack of authentic relics proved no problem – the Egyptians had no hesitation in producing fakes that were so well made that they fooled even the Egyptologists of the day. Thirty years after the Napoleonic expedition, Egypt was thronged with people who, for one reason or another, were interested in the trade in and export of antiquities. Local authorities also fostered the continuous flow of antiquities out of Egypt.

At that time Egypt was governed by Muhammad Ali (1769–1849), who had been appointed Viceroy by the Ottoman sultan in Constantinople. In the wake of the Napoleonic expedition, Muhammad Ali launched a wide-ranging political strategy designed to open Egypt to the Western world. Foreigners, especially representatives of the powerful nations, were allowed to satisfy their every whim.

14 LEFT
A *KANJA* SAILING ON THE NILE IN FRONT OF THE TEMPLE OF LUXOR: THE BOAT, THE *PRINCE OF AVON AND CARNARVON*, BELONGED TO ÉMILE PRISSE D'AVENNES. IN 1843 THE FRENCH ARCHITECT AND ARTIST REMOVED THE RELIEFS OF THE 'HALL OF THE ANCESTORS' OF THUTMOSE III IN THE TEMPLE OF AMUN AT KARNAK AND SENT THEM TO FRANCE, WHERE THEY REMAIN TO THIS DAY IN THE LOUVRE IN PARIS.(ÉMILE PRISSE D'AVENNES, *ORIENTAL ALBUM*, LONDON, 1864).

14 CENTRE
THIS IMAGE CAPTURES A MOMENT DURING THE REMOVAL OF A COLOSSAL BUST OF RAMESSES II FROM THE RAMESSEUM. THE OPERATION WAS COMPLETED IN NOVEMBER 1816, THANKS TO THE PRODIGIOUS EFFORTS OF GIOVANNI BATTISTA BELZONI, WHO WAS THEN WORKING FOR THE BRITISH CONSUL HENRY SALT. THE BUST IS TODAY IN THE BRITISH MUSEUM, LONDON.

14 LEFT
GIOVANNI BATTISTA BELZONI, BORN IN PADUA IN 1778, WAS ONE OF THE FIRST EUROPEANS TO SEARCH EGYPT SYSTEMATICALLY FOR ANTIQUITIES. AMONG HIS MANY SPECTACULAR ACHIEVEMENTS WERE THE OPENING OF THE TEMPLE OF RAMESSES II AT ABU SIMBEL, THE DISCOVERY OF THE TOMBS OF RAMESSES I AND SETI I IN THE VALLEY OF THE KINGS, AND THE OPENING OF THE PYRAMID OF KHAFRE AT GIZA.

There was, therefore, nothing easier for them than to obtain the firmans (a Persian word meaning 'orders'), or permits that allowed them to undertake excavations throughout Egypt. The granting of lavish excavation concessions was a mere trifle when seen in the context of the economic and commercial advantages that might result from cordial relations with the European powers.

Thanks to foreign aid, Muhammad Ali successfully initiated a process of modernization, leading to considerable improvements in the standards of living of the Egyptian middle classes, but proving not so beneficial for the less well-off.

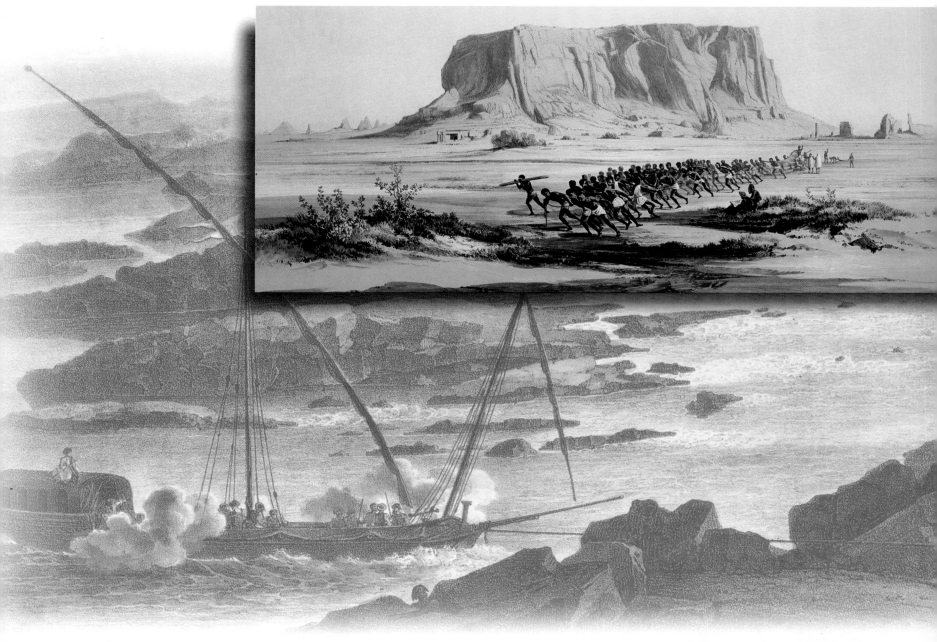

His projects also led to the destruction of innumerable ancient monuments. Many were dismantled and their blocks fed to the limekilns or re-used in the construction of new buildings. A number of factories even had official permits authorizing them to procure mummies, from which they extracted animal black for industrial use. The mummies were burned to obtain a fine carbon which when ground was used in the refining and whitening of sugar. Such products were widely used in Egypt, a major producer of cane sugar, and were also exported in great quantities to the sugar refineries in northern France.

This was the Egypt that Champollion found in 1828, completely focused on its future and apparently uninterested in its glorious past. Using the plates of the *Description de l'Égypte* – the outstanding product of the labours of the savants who accompanied Napoleon's armies – for comparison, the young French academic could not fail to notice just how many monuments had suffered from the ravages of man during the intervening three decades. Whole temple complexes had disappeared without a trace. In the place of the colossi and statues that once had decorated courtyards and processional avenues, Champollion found only enormous holes in the sand dug by those who had taken the objects away.

Champollion was particularly shocked by the fact that private individuals could remove all they desired, with the state showing no real interest in regulating the flow of objects out of Egypt. He was particularly concerned that valuable antiquities might end up in the homes of wealthy Europeans, never to be seen again. Yet he had no objections to the removal of antiquities with official authorization for exhibition in museums or other public sites. Thus he had a rather contradictory attitude to the conservation of Egyptian monuments. On the one hand he criticized the ease with which excavation permits were granted to private individuals, but on the other he had no qualms about searching out exhibits for the Louvre (removing the painted relief from the tomb of Seti I, as noted above). He also proposed the removal of one of the two obelisks standing in front of the pylon of the temple of Luxor, an operation that was duly completed in 1836. One of its most enthusiastic supporters was the French Consul of the period, Jean-François Mimaut (1774–1837). However, Mimaut was also responsible for one of the first official moves designed to bring to the attention of the Egyptian government its own historical and artistic heritage. Passionately interested in antiquities, Mimaut had no hesitation in sending a strongly worded protest directly to Muhammad Ali in opposition to the proposed dismantling of one of the pyramids of Giza in order to use its limestone blocks as building material for a number of dams on the Nile.

It was perhaps Mimaut who also suggested that Muhammad Ali should commission Champollion to prepare a report on the conservation of the Egyptian monuments. Champollion delivered his report towards the end of his stay in Egypt. In it, he emphasized the importance of the monuments from a historical point of view and also noted that their destruction and dispersal was deplored by all the important European figures who visited the Nile Valley. Without proposing any concrete solutions, Champollion called for greater regulation of the excavation and exportation of ancient monuments.

However, when the report reached Muhammad Ali very few people had any interest in following up Champollion's recommendations. The antiquities generated a considerable profit for those who traded in them, and neither the Egyptian sellers nor their wealthy

European clients were truly concerned about safeguarding the ancient monuments.

The time was ripe, however, for a change in the attitude of the Egyptians to their country's ancient heritage. Concrete action to conserve Egypt's cultural inheritance was promoted by Rifa'a al-Tahtawi (1801–1873), a leading scholar of Egyptian culture who had lived and studied in Paris for some time. His philosophical thinking contributed to the development of a nationalist conscience in Egypt during the nineteenth century and a reawakening of interest in the past and all that related to the former glories of the country. Al-Tahtawi succeeded in increasing public awareness of the value of antiquities and secured the issuing of an ordinance on 15 August 1835, whereby the trade in Egyptian antiquities was regulated for the first time. As well as prohibiting the exportation of 'carved stones and objects', a site in Cairo was designated where the ancient objects could be conserved and displayed, as was the case in all the great European cities. The task of collecting the first antiquities and transporting them to the small building in the Azbakiya Gardens was entrusted to Louis Maurice Adolphe

Linant de Bellefonds-Bey (1799–1883), a French engineer and geographer who had long resided in Cairo.

In spite of these initial provisions, the 1835 ordinance was ignored for many years. The trade in Egyptian antiquities and the indiscriminate destruction of monuments proceeded unchecked. Muhammad Ali and his successors continued to regard the newly formed collection of antiquities as a private resource on which they could draw whenever they needed a prestigious gift for an important guest. After a few years this practice had so impoverished the museum that it was moved elsewhere. A single hall in the Ministry of Education within the Citadel was judged sufficiently large to contain the objects that had not yet been given away. The story of the first Cairo museum drew to a definitive close in 1855 when Abbas Pasha offered what remained of the collection to the Archduke of Austria, Maximilian, during an official visit to Egypt.

Auguste Mariette (1821–1881), an assistant curator at the Louvre, had arrived in Cairo five years earlier with the aim of acquiring a collection of Coptic manuscripts with which to enrich the Paris collection. When his mission failed (the

16
MUHAMMAD ALI (1769–1849) IS CONSIDERED THE FOUNDER OF MODERN EGYPT. HIS POLICY OF OPENING UP THE COUNTRY TO THE WEST ALLOWED THE CONSULS OF THE EUROPEAN POWERS IN EGYPT TO AMASS LARGE COLLECTIONS OF ANTIQUITIES. (L.N.P.A. FORBIN, *VOYAGE DANS LE LEVANT*, PARIS, 1819).

16–17 BACKGROUND
THIS ILLUSTRATION, TAKEN FROM THE *DESCRIPTION DE L'ÉGYPTE*, DEPICTS ONE OF THE TWO COLOSSAL STATUES OF RAMESSES II THAT DECORATE THE FIRST PYLON OF THE TEMPLE OF LUXOR. AT THE TIME OF THE NAPOLEONIC EXPEDITION THEY WERE BURIED UP TO THEIR CHESTS IN THE SAND.

17 LEFT
JEAN-FRANÇOIS CHAMPOLLION, IN A PORTRAIT BY LÉON COGNIET OF 1831, LED THE SUCCESSFUL FRANCO-TUSCAN EXPEDITION TO EGYPT. ON MORE THAN ONE OCCASION THE DECIPHERER OF HIEROGLYPHS SHOWED HIS DISAPPROVAL OF THOSE WHO FELT THEY HAD A RIGHT TO STRIP THE COUNTRY OF ITS GLORIOUS ARCHAEOLOGICAL HERITAGE.

17 ABOVE
LINANT DE BELLEFONDS ARRIVED IN EGYPT IN 1818 AND HELD IMPORTANT POSTS IN THE SERVICE OF MUHAMMAD ALI. HE WAS ENTRUSTED WITH COLLECTING A NUCLEUS OF ANTIQUITIES IN A SMALL BUILDING IN THE AZBAKIYA GARDENS.

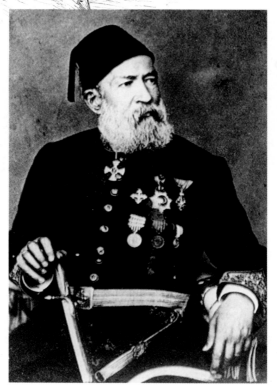

the treasures to Cairo. Mariette managed to intercept the boat transporting the objects and succeeded in recovering the precious cargo, resorting to drastic threats. In 1867, on the occasion of the Exposition Universelle, the treasure of Ahhotep was exhibited in Paris, but even here Mariette was obliged to thwart the Empress Eugénie's designs on the jewels.

In spite of all these problems, and the economic difficulties afflicting the Egyptian state, in 1863 Mariette was able to open the first true Egyptian Museum to the public, utilizing the premises of the Administration du Transit. Until the construction of the Cairo–Alexandria railway, this building had been used for passenger services and for the storage and distribution of goods on the India–England route. The large premises overlooked the Nile in the Bulaq quarter. Subsequently, the museum was expanded on a number of occasions as the collection grew, thanks to the numerous excavations that Mariette and his assistants organized each year. The artifacts in the collection were described in

Coptic patriarch prohibited the sale of any manuscripts kept in the monasteries) he decided to excavate at Saqqara where, after almost a year's labour, he discovered the entrance to the Serapeum. Mariette continued his exploration of the burial place of the Apis bulls for almost three years until he had to return to France. His experiences in the desert sands had, however, left an indelible mark. All the difficulties he had been obliged to tackle in those three years had convinced him that Egypt needed effective legislation to promote the conservation of its monuments. He therefore grasped the opportunity presented by Napoleon II's planned trip to the Nile. With the excuse of finalizing the preparations for the visit, Mariette managed to have himself sent to Egypt once more. On his arrival he undertook a series of excavations and worked to increase the local authorities' awareness of the need to safeguard the ancient monuments.

In 1858 the Viceroy authorized the creation of the Egyptian Antiquities Service, a body whose principal task was to supervise excavations throughout the country. The post of director-general was naturally offered to Mariette. On his

appointment he immediately began an intensive programme of archaeological research. A considerable quantity of objects from the whole of Egypt was soon amassed at Cairo.

In the early years of the Antiquities Service, Mariette was faced with all kinds of problems and had to deal with the greed of both the Egyptians and the Europeans determined to continue their trade in antiquities. A prime example was the discovery of the funerary cache of Ahhotep by Mariette's workmen in the hills of Dra Abu el-Naga in 1859. The coffin of the queen was confiscated by the governor of Qena who, eager to impress the Viceroy, made it his business to send

a guide that was reprinted six times between 1864 and 1876.

The Bulaq premises, however, had the serious disadvantage of being exposed to the annual Nile flood. In 1878 the flooding was so severe that many objects were lost. Mariette, who had always regarded the Bulaq building as a temporary home, seized the opportunity to insist on the provision of a permanent site for the museum that would allow for the continual growth of the collection and would also be beyond the reach of the flooding.

The Egyptian government had previously sanctioned the construction of a monumental museum on the southern tip of the island of Gezira. However, neither the continual requests dispatched by Mariette nor the governmental decree led to a solution, and the museum remained in Bulaq for another ten years.

On Mariette's death, the curatorship of the museum was held for an interim period by Luigi Vassalli (1812–1887), who had worked with Mariette for almost twenty years. He was succeeded by Gaston Maspero (1846–1916), who also did all he could to move the museum out of the Bulaq premises but without success. During the term of his successor, Eugène

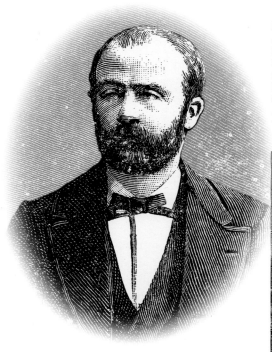

18 TOP
FRENCH EGYPTOLOGIST
AUGUSTE MARIETTE WAS A
KEY FIGURE IN THE
PRESERVATION OF THE
MONUMENTS OF EGYPT.
HE WAS INSTRUMENTAL IN
SETTING UP THE EGYPTIAN
ANTIQUITIES SERVICE AND
THE FOUNDATION OF THE
FIRST EGYPTIAN MUSEUM.

18 BELOW
LUIGI VASALLI, AN ITALIAN
PAINTER AND PATRIOT,
SOUGHT REFUGE IN EGYPT,
WHERE HE BECAME AN
ASSISTANT TO MARIETTE.
ON THE LATTER'S DEATH HE
BECAME TEMPORARY
DIRECTOR OF THE MUSEUM

AT BULAQ. THE TWO
DELICATE WATERCOLOURS
BY HIM REPRODUCED HERE
DEPICT PART OF THE
DECORATION OF THE COFFIN
OF NESIPTAH, THE FATHER
OF MONTUEMHAT, WHICH
HAS UNFORTUNATELY BEEN
LOST.

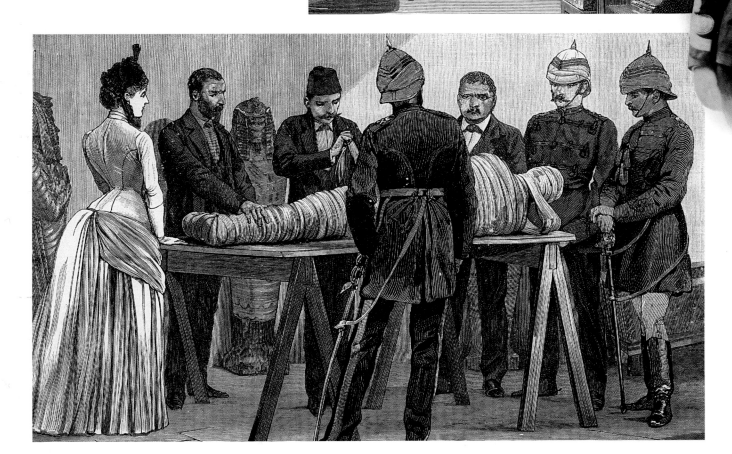

Grébaut (1846–1915), the situation of the objects conserved at Bulaq became critical. In 1889 the building housing the collections reached bursting point: there was no more room in either the exhibition halls or the stores, and artifacts found during that year's excavations had to be left on boats in Upper Egypt for long periods of time.

This catastrophic situation prompted *Khedive* Ismail to hand over one of his own residences at Giza (where the zoo is now located) as the new home for the museum. Between the summer and the end of 1889 all the collections were transferred from

Bulaq to Giza. In January 1890 the new museum was ready to open.

A few years later approval was obtained for the construction of a new building. Seventy-three projects were entered in a competition which was eventually won by the French architect Marcel Dourgnon. The building he designed was highly innovative for its time. Above all, it was the first building in the world to be specially designed and constructed for use as a museum, rather than being converted for this purpose. Second, the building was to be built entirely in reinforced concrete, a relatively new material whose qualities

19 TOP LEFT
GASTON MASPERO WAS
DIRECTOR OF THE
ANTIQUITIES SERVICE IN
TWO DIFFERENT PERIODS.
DURING THE COURSE OF
HIS SECOND TERM OF OFFICE
THE EGYPTIAN MUSEUM
PREMISES AT MIDAN AL-
TAHRIR WERE OPENED.

19 TOP CENTRE
THE FUNERARY HALL OF THE
EGYPTIAN MUSEUM'S FIRST
HOME, OPENED BY AUGUSTE
MARIETTE IN 1863 IN THE
BULAQ QUARTER OF THE
CITY, JUST A FEW METRES
FROM THE NILE.

19 TOP RIGHT
PRINCE ABBAS HILMI, THE
KHEDIVE OF EGYPT, UNDER
WHOSE GOVERNMENT THE
NEW EGYPTIAN MUSEUM
WAS CONSTRUCTED AT
MIDAN AL-TAHRIR.

19 BOTTOM
GASTON MASPERO
UNWRAPPING A MUMMY
FROM THE ROYAL CACHE
OF DEIR EL-BAHRI, IN THE
PRESENCE OF VARIOUS
AUTHORITIES AND
REPRESENTATIVES OF THE
BRITISH ARMY STATIONED
IN CAIRO.

19

20 CENTRE RIGHT
PRELIMINARY EXCAVATIONS
FOR THE UNDERGROUND
STOREROOMS. THE MUSEUM
WAS DESIGNED BY THE
FRENCHMAN DOURGNON
AND BUILT BY THE ITALIAN
FIRM GAROZZO E ZAFFRANI.

were only just beginning to be explored. Many of the designs entered in the competition had drawn inspiration from the architectural models of ancient Egypt while Dourgnon's museum reflected the motifs and forms of Classical antiquity. Only in terms of its plan, and then subtly, did it owe anything to Egyptian temples of the Late Period. For instance, the placing of the Grand Gallery perpendicular to the principal body of the building recalls the pylons of Egyptian temples, and the layout of the rooms around a vast central hall is reminiscent of the external ambulatory of temples such as the one that can still be seen today at Edfu.

Dourgnon conceived of the museum interior as an open space with no strict division between the various areas,

20 TOP AND CENTRE LEFT
TWO MOMENTS DURING
THE CEREMONIAL LAYING
OF THE FOUNDATION STONE
FOR THE EGYPTIAN
MUSEUM AT MIDAN AL-
TAHRIR, HELD IN THE
PRESENCE OF PRINCE ABBAS
HILMI AND GASTON
MASPERO ON 1 APRIL 1897.

20 LEFT AND BELOW
THE CLASSICAL LINES OF THE
GROUND FLOOR AND THE
FAÇADE DESIGNED BY
DOURGNON ARE BEGINNING
TO TAKE SHAPE; THE ARCHES
OF THE ENTRANCE ARE
VISIBLE. BELOW, THE DOME
OVER THE ATRIUM IS SEEN AT
AN ADVANCED STAGE.
DOURGNON MADE
EXTENSIVE USE OF
REINFORCED CONCRETE IN
THE CONSTRUCTION OF THE
BUILDING, A TECHNIQUE
THAT WAS BEGINNING TO
BE USED MORE WIDELY.

allowing visitors to stroll freely amid the imposing remains of ancient Egypt.

The awarding of the commission to Dourgnon, however, aroused considerable controversy, above all among the Italian community in Cairo who had done so much to ensure that approval was given for the funds needed for the construction of the new building. The French victory was regarded as an Italian defeat and the community felt it had been cheated. It was perhaps for this reason that the construction contracts were awarded to the building company run by the Italians Garozzo and Zaffrani. Excavations for the foundations of the new museum began in January 1897, on an open space alongside the barracks of the British contingent stationed in Cairo at Qasr el-Nil.

The ceremony of laying the foundation stone was held on 1 April of that year in the presence of Prince Abbas Hilmi and Maspero, who was once more director of the Antiquities Service and had completed the operation begun by Grébaut.

In November 1901, Alessandro Barsanti (1858–1917), an Italian architect employed by the Antiquities Service, received the keys to the museum and from 9 March 1902 began to transfer the collections from the palace at Giza. During this operation five thousand wooden crates were used. For the large monuments, two trains shuttled back and forth nineteen times between Giza and Qasr el-Nil. The first convoy carried forty-eight stone sarcophagi weighing over one thousand tons in total.

The move was completed hurriedly and in a state of great confusion. Once all the artifacts had reached their new home, for example, officials of the Antiquities Service noticed that the beautiful wooden statue of the pharaoh Hor was missing. The mystery of its disappearance was solved some time later when the precious sculpture was found hidden in a corner of the basement storerooms. During the move it had suffered some damage that the workers had tried to conceal for fear of being punished.

On 13 July 1902, the transfer of the museum's contents was completed with the moving of Mariette's mausoleum to the garden in front of the new building. In his will he had expressed the wish that his body should rest with the antiquities he

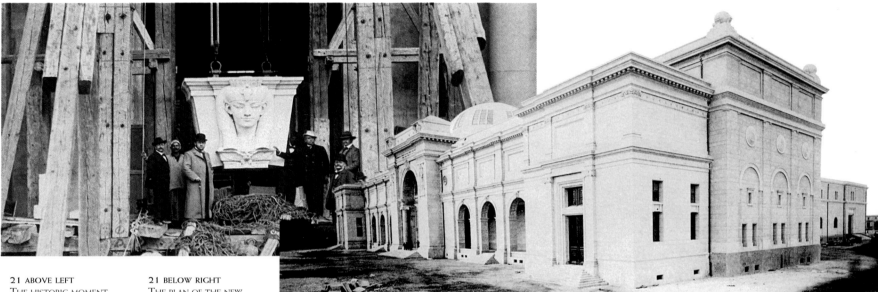

21 ABOVE LEFT
THE HISTORIC MOMENT OF RAISING THE KEYSTONE DECORATED WITH THE HEAD OF ISIS.

21 ABOVE RIGHT
THE MAIN BODY OF THE MUSEUM AT MIDAN AL-TAHRIR ALMOST COMPLETE.

21 BELOW LEFT
THE GRAND GALLERY ON THE GROUND FLOOR, PERPENDICULAR TO THE MAIN BUILDING, RECALLS THE PYLONS OF EGYPTIAN TEMPLES.

21 BELOW CENTRE
A GROUP OF MANAGERS FROM THE CONSTRUCTION COMPANY AND A NUMBER OF MEMBERS OF THE MUSEUM STAFF POSE IN FRONT OF THE MAIN ENTRANCE IN 1901.

21 BELOW RIGHT
THE PLAN OF THE NEW MUSEUM (THE GROUND FLOOR IS SEEN HERE) RECALLS THAT OF LATE PERIOD EGYPTIAN TEMPLES.

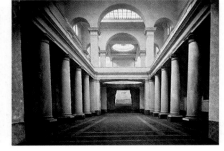

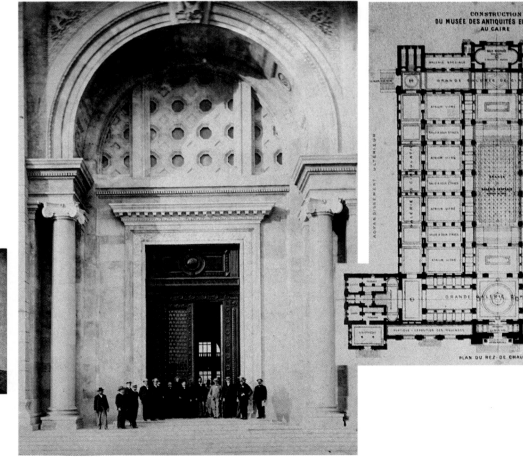

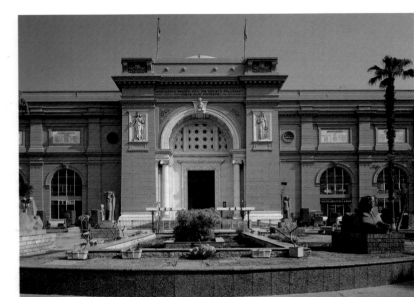

22 RIGHT
THE GARDEN IN FRONT
OF THE MUSEUM ALSO
REFLECTS THE DESIGN
PHILOSOPHY OF
DOURGNON: THE MUSEUM
WAS INTENDED TO BE A
PLACE WHERE THE VISITOR
COULD FREELY WANDER
WHILE SURROUNDED BY THE
REMAINS OF ANCIENT
EGYPT.

22 BELOW
THIS STATUE OF A SEATED
LION (JE 41902) STANDS
IN THE MUSEUM GARDEN.
DISCOVERED AT TELL EL-
MUQDAM (LEONTOPOLIS),
IT DATES FROM THE LATE
PERIOD (664–332 BC).

22 CENTRE
THE CENTRAL HALL OF THE
GROUND FLOOR IS
DOMINATED BY THE
COLOSSAL STATUES OF
AMENHOTEP III AND TIY.

22 BELOW
THE MOVE TO THE NEW
MUSEUM WAS COMPLETED
IN 1902 WITH THE
TRANSFER OF MARIETTE'S
MAUSOLEUM. IN HIS WILL
HE HAD EXPRESSED THE
WISH THAT HE SHOULD
NEVER BE SEPARATED FROM
HIS BELOVED MONUMENTS.

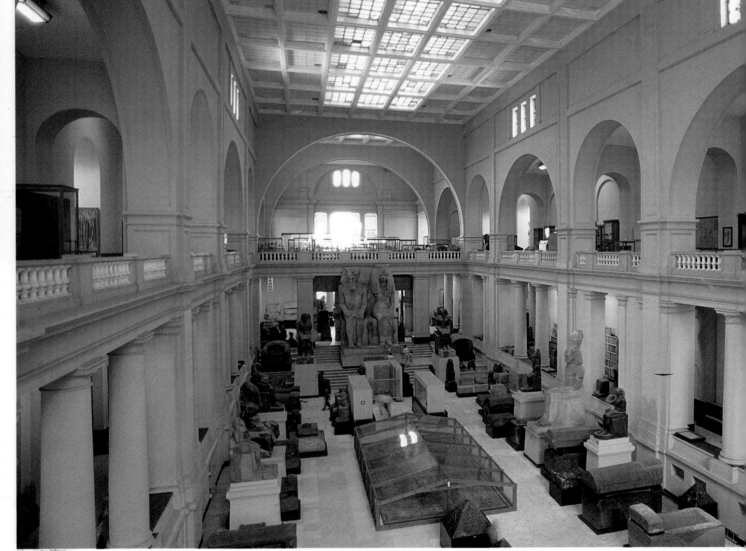

had collected during his lifetime. And on 15 November of that year the Cairo Museum of Egyptian Antiquities was officially inaugurated.

The exhibits were laid out according to the late-nineteenth-century conception of Egyptian culture. Halls were arranged chronologically, based on the knowledge of the time (without taking into account the existence of the Intermediate Periods, then considered to be historically insignificant) and the display of the objects was designed above all on aesthetic criteria. Primarily for structural reasons the largest and heaviest works were installed on the ground floor while the first floor housed funerary assemblages

23 ABOVE
WHILE THE ARCHITECTURAL
STYLE OF THE MUSEUM WAS
CLASSICAL, THE LAYOUT
OF THE INTERIOR, WITH
ITS SYMMETRICAL
ARRANGEMENT OF THE SIDE
ROOMS WITH RESPECT TO
THE VAST CENTRAL HALL,
RESEMBLES THE PLANS OF
EGYPTIAN TEMPLES SUCH AS
THE ONE THAT CAN STILL BE
SEEN TODAY AT EDFU.

23 BELOW
THIS MAGNIFICENT SPHINX
OF THUTMOSE III (JE 15208
= CG 576) STANDS OUTSIDE
THE MUSEUM CARVED IN
PINK GRANITE IT MEASURES
262 CM LONG AND WAS
DISCOVERED BY MARIETTE
IN THE TEMPLE OF AMUN
AT KARNAK. IT DATES TO
THE REIGN OF THUTMOSE
III (1479–1425 BC).

arranged in chronological order. Everyday objects were grouped in a number of rooms according to categories.

In 1908 the skylights above either end of the Grand Gallery had to be rebuilt. The work was entrusted to the French company Daydé, Pillé and Charvaut, which completed the operation in about a year. It was perhaps on this occasion that the balconies around the stairwell leading to the upper floor were constructed, with the aim of housing the innumerable coffins of the Theban priests discovered in the so-called Second Cache of Deir el-Bahri (many were donated to European and American collections). Subsequent remodelling of the building to cope with the huge expansion of the collection led to the closure of a number of rooms on the first floor which were transformed into stores. The portico where plaster casts of monuments had been displayed was also closed early on in order to expand the library and to make way for a number of service rooms.

The unceasing flow of new finds led to continual changes in the arrangement of the collections within the various rooms. Excavations at Tell el-Amarna and the consequent popularity of the art of this period, for example, led to the creation of an area dedicated to artifacts from the site. A suitable home had also to be found for the funerary treasures of Tutankhamun, which began to arrive at the museum in 1923, resulting in a radical reorganization of the exhibits on the first floor. In order to provide room for all the objects found in the tomb of the young pharaoh, the coffins of other kings from the Royal Cache of Deir el-Bahri had to be crammed into other parts of the museum.

Although the exterior of the building has not been modified significantly, the Museum is now situated in a very different setting from the one originally conceived. Where once the barracks of the British contingent in Cairo stood, the imposing Nile Hilton now rises. Behind the Museum stands the towering skyscraper of the Ramses Hilton, while at the front is the

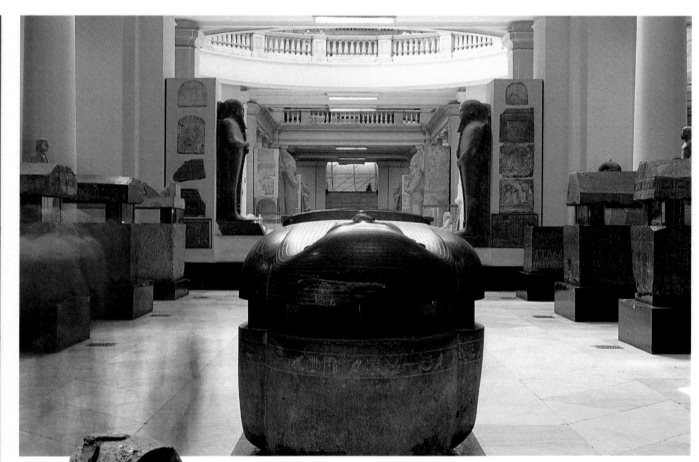

central Midan al-Tahrir, a pulsating square at the heart of the city. The Museum is separated from Tahrir Square by a garden enclosed by a wrought-iron fence. A fountain in the centre of the garden is surrounded by impressive statuary. Mariette's mausoleum, which in the original design was located inside the building (on the ground floor where the objects from the Amarna Period are now displayed), stands in the western corner of the garden. The mortal remains of Auguste Mariette, the man who more than any other devoted himself to the establishment of the Cairo Museum, still rest within a stone sarcophagus resembling those of the Old Kingdom.

23

CHRONOLOGY

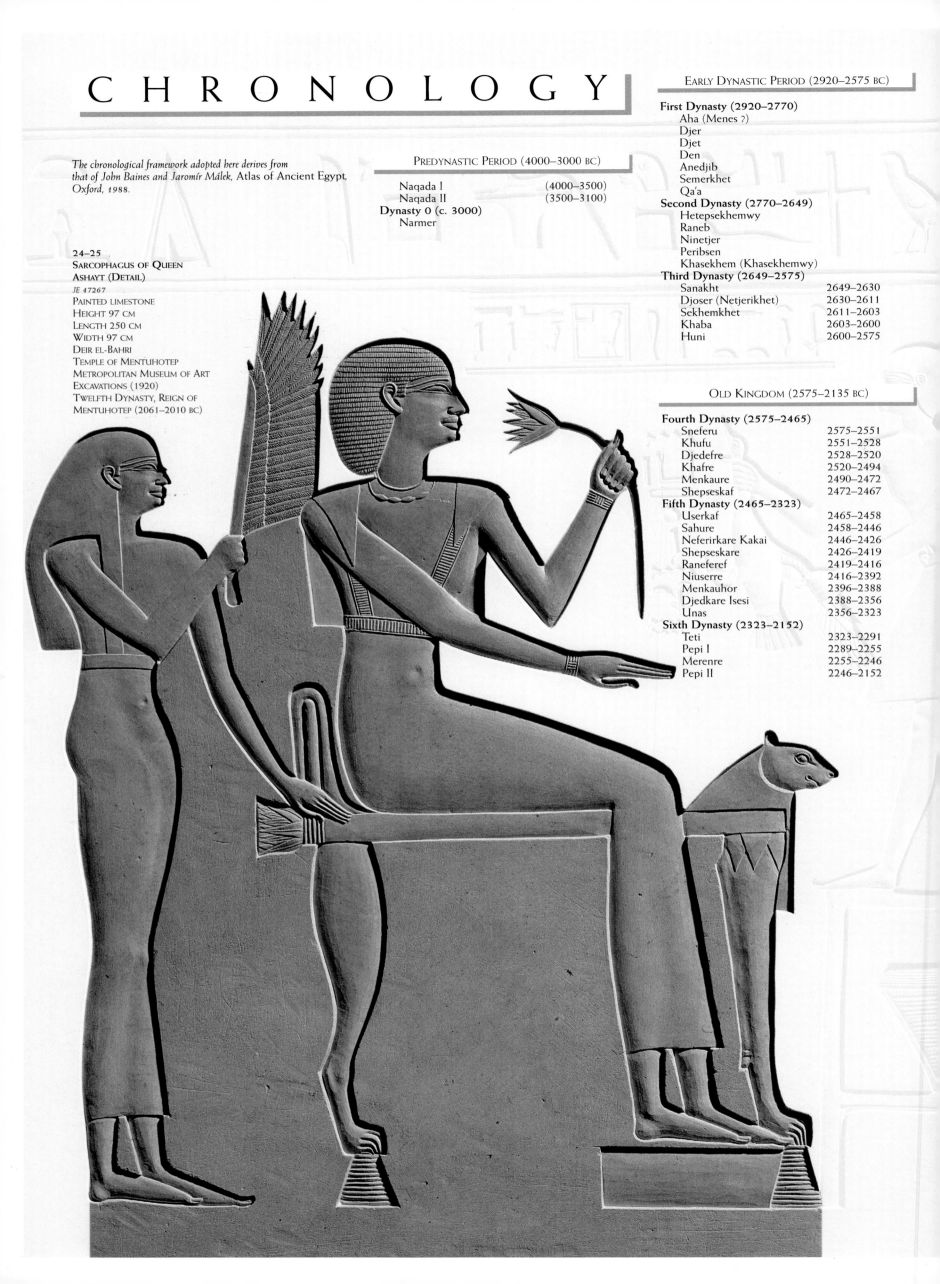

The chronological framework adopted here derives from that of John Baines and Jaromír Málek, Atlas of Ancient Egypt, Oxford, 1988.

24–25
SARCOPHAGUS OF QUEEN ASHAYT (DETAIL)
JE 47267
PAINTED LIMESTONE
HEIGHT 97 CM
LENGTH 250 CM
WIDTH 97 CM
DEIR EL-BAHRI
TEMPLE OF MENTUHOTEP
METROPOLITAN MUSEUM OF ART
EXCAVATIONS (1920)
TWELFTH DYNASTY, REIGN OF
MENTUHOTEP (2061–2010 BC)

PREDYNASTIC PERIOD (4000–3000 BC)

Naqada I	(4000–3500)
Naqada II	(3500–3100)
Dynasty 0 (c. 3000)	
Narmer	

EARLY DYNASTIC PERIOD (2920–2575 BC)

First Dynasty (2920–2770)
Aha (Menes ?)
Djer
Djet
Den
Anedjib
Semerkhet
Qa'a
Second Dynasty (2770–2649)
Hetepsekhemwy
Raneb
Ninetjer
Peribsen
Khasekhem (Khasekhemwy)
Third Dynasty (2649–2575)

Sanakht	2649–2630
Djoser (Netjerikhet)	2630–2611
Sekhemkhet	2611–2603
Khaba	2603–2600
Huni	2600–2575

OLD KINGDOM (2575–2135 BC)

Fourth Dynasty (2575–2465)

Sneferu	2575–2551
Khufu	2551–2528
Djedefre	2528–2520
Khafre	2520–2494
Menkaure	2490–2472
Shepseskaf	2472–2467

Fifth Dynasty (2465–2323)

Userkaf	2465–2458
Sahure	2458–2446
Neferirkare Kakai	2446–2426
Shepseskare	2426–2419
Raneferef	2419–2416
Niuserre	2416–2392
Menkauhor	2396–2388
Djedkare Isesi	2388–2356
Unas	2356–2323

Sixth Dynasty (2323–2152)

Teti	2323–2291
Pepi I	2289–2255
Merenre	2255–2246
Pepi II	2246–2152

First Intermediate Period (2150–2040 bc)

Seventh Dynasty
*A shadowy dynasty. Manetho mentions
'seventy kings of Memphis who ruled
for seventy days' to indicate the
period of confusion through which
Egypt passed*

Eighth Dynasty (2150–2134)
Over twenty ephemeral kings.

Ninth and Tenth Dynasties (2130–2040)
*Dynasties in which the government
of much of Egypt passed into the hands
of the city of Herakleopolis*

Eleventh Dynasty, Theban (2134–2040)

Intef I	2134–2118
Intef II	2118–2069
Intef III	2069–2061
Mentuhotep I Nebhepetre	2061–2010

Middle Kingdom (2040–1640 bc)

Eleventh Dynasty, all Egypt (2040–1991)

Mentuhotep I Nebhepetre	2061–2010
Mentuhotep II	2010–1998
Mentuhotep III	1998–1991

Twelfth Dynasty (1991–1783)

Amenemhet I	1991–1962
Senusret I	1971–1926
Amenemhet II	1929–1892
Senusret II	1897–1878
Senusret III	1878–1841?
Amenemhet III	1844–1797
Amenemhet IV	1799–1787
Queen Sobek Neferu	1787–1783

Thirteenth Dynasty (1783–after 1640)
Around seventy ephemeral Theban rulers

Fourteenth Dynasty
An unknown number of ephemeral rulers

Second Intermediate Period (1640–1532 bc)

Fifteenth Dynasty

Salitis	
Sheshi	
Khian	
Apophis	c. 1585–1542
Khamudi	c. 1542–1532

Sixteenth Dynasty
*Minor Hyksos governors ruling
at the same time as the Fifteenth
Dynasty.*

Seventeenth Dynasty (1640–1550)
*Fifteen Theban kings, among
the most important of whom are:*
Intef V
Sobekemsaef I
Sobekemsaef II
Intef VI
Intef VII
Seqenenre Tao I
Seqenenre Tao II
Kamose

New Kingdom (1550–1075 bc)

Eighteenth Dynasty (1550–1070)

Ahmose	1550–1525
Amenhotep I	1525–1504
Thutmose I	1504–1492
Thutmose II	1492–1479
Hatshepsut	1479–1458
Thutmose III	1479–1425
Hatshepsut	1473–1458
Amenhotep II	1427–1401
Thutmose IV	1401–1391
Amenhotep III	1391–1353
Amenhotep IV/Akhenaten	1353–1335
Smenkhkare	1335–1333
Tutankhamun	1333–1323
Ay	1323–1319
Horemheb	1319–1307

Nineteenth Dynasty (1307–1196)

Ramesses I	1307–1306
Seti I	1306–1290
Ramesses II	1290–1224
Merneptah	1224–1214
Seti II	1214–1204
Amenmesse – usurper during reign of Seti I	
Siptah	1204–1198
Twosre	1198–1196

Twentieth Dynasty (1196–1070)

Sethnakhte	1196–1194
Ramesses III	1194–1163
Ramesses IV	1163–1156
Ramesses V	1156–1151
Ramesses VI	1151–1143
Ramesses VII	1143–1136
Ramesses VIII	1136–1131
Ramesses IX	1131–1112
Ramesses X	1112–1100
Ramesses XI	1100–1070

Third Intermediate Period (1070–712 bc)

Twenty-first Dynasty (1070–945)

Smendes I	1070–1044
Amenemnisu	1044–1040
Psusennes I	1040–992
Amenemope	993–984
Osorkon I	984–978
Siamun	978–959
Psusennes II	959–945

Twenty-second Dynasty (945–712)

Sheshonq I	945–924
Osorkon II	924–909
Takelot I	909–
Sheshonq II	–883
Osorkon III	883–855
Takelot II	860–835
Sheshonq III	835–783
Pami	783–773
Sheshonq V	773–735
Osorkon V	735–712

Twenty-third Dynasty (c. 828–712)
*Various contemporary ruling dynasties, based in
several sites, their precise order still disputed, including*

Pedubaste I	828–803
Sheshonq IV	
Osorkon IV	
Takelot III	

Twenty-fourth Dynasty, Sais (724–712)

Tefnakhte	724–717
Bocchoris	717–712

Twenty-fifth Dynasty, Nubia and Thebes (770–712)

Kashta	770–750
Piankhi	745 -713

Late Period (712–332 bc)

Twenty-fifth Dynasty Nubia and Egypt (712–657)

Shabaka	712–698
Shabatqo	698–690
Taharqa	690–664
Tanutamani	664–657

Twenty-sixth Dynasty (664–525)

Psamtek I	664–610
Necho	610–595
Psamtek II	595–589
Apries	589–570
Amasis	570–526
Psamtek III	526–525

Twenty-seventh Dynasty, Persian (525–404)

Cambyses	525–522
Darius I	521–486
Xerxes I	486–466
Artaxerxes I	465–424
Darius II	424–404

Twenty-eighth Dynasty (404–399)

Amirteus	404–399

Twenty-ninth Dynasty (399–380)

Nepherites I	399–393
Hakoris	393–380

Thirtieth Dynasty (380–343)

Nectanebo I	380–362
Teos	365–360
Nectanebo II	360–343

Thirty-first Dynasty (343–332)

Artaxerxes III	343–338
Arses	338–336
Darius III	335–332

Hellenistic Period (332–30 bc)

The Macedonians (332–304)

Alexander the Great	332–323
Philip Arrhidaeus	323–316
Alexander IV	316–304

Ptolemaic Dynasty (304–30)

Ptolemy I Soter	304–284
Ptolemy II Philadelphus	285–246
Ptolemy III Euergetes	246–221
Ptolemy IV Philopator	221–205
Ptolemy V Epiphanes	205–180
Ptolemy VI Philometor	180–164, 163–145
Ptolemy VII Neos Philopator	145
Ptolemy VIII Euergetes	170–163, 145–116
Ptolemy IX Soter	116–110, 109–107, 88–81
Ptolemy X Alexander	110–109, 107–88
Ptolemy XI Alexander	80
Ptolemy XII Neos Dionysos	80–58, 55–51
Berenice IV	58–55
Cleopatra VII Philopator	51–30
Ptolemy XV Caesarion	44–30

Roman Period (30 bc– ad 311)

*Only the names of the emperors mentioned
in the hieroglyphic and demotic texts
are cited.*

Augustus	30 bc–ad 14
Tiberius	14–37
Caligula	37–41
Claudius	41–54
Nero	54–68
Galba	68–69
Otho	69
Vespasian	69–79
Titus	79–81
Domitian	81–96
Nerva	96–98
Trajan	98–117
Hadrian	117–138
Antoninus Pius	138–161
Marcus Aurelius	161–180
Lucius Verus	161–169
Commodus	180–192
Septimius Severus	193–211
Caracalla	198–217
Geta	209–212
Macrinus	217–218
Didumenianus	218
Severus Alexander	222–235
Gordian III	238–244
Philip	244–249
Decius	249–251
Gallus and Volusianus	251–252
Valerian	253–260
Gallienus	253–268
Macrianus and Quietus	260–261
Aurelian	270–275
Probus	276–282
Diocletian	284–305
Maximian	286–305
Galerius	293–311

E gyptian pharaonic civilization was the heir to cultural elements that gradually evolved throughout the Neolithic era, and then experienced a period of development in the fourth millennium BC. Between 7000 and 5000 BC, the Egyptians began growing crops and breeding animals. From around 4000 BC, a culture known as the Naqada appears, named after the site in Upper Egypt where archaeologists discovered over 2,000 graves with rich funerary assemblages. Similar material also been found in other cemeteries, providing evidence of complex beliefs in the afterlife and high standards of craftsmanship. These graves consist of simple pits in which the deceased were placed together with everyday objects such as jewels, ivory combs and hairpins, palettes for cosmetics, and numerous pottery vessels. Some of these vessels are of an attractive bright

CHRISTIANE ZIEGLER

THE PREDYNASTIC AND EARLY DYNASTIC PERIODS

red, edged with a black burnished finish, while others are richly decorated.

The evolution of the forms of these vessels allows various phases to be distinguished, with a shared repertory of motifs and colours repeated from one site to the next. In the Naqada I period (c. 4000–3500 BC) geometric designs were popular, especially squares and zigzags traced in cream on a brick-red background. In the Naqada II period (c. 3500–3100 BC) vases with rounded bodies appeared, with figurative decoration including humans, animals and boats painted in a dark red colour against a light background. Some vessels were equipped with feet or were made in the shape of animals. Stylized human figures also appear in this period, in the form of

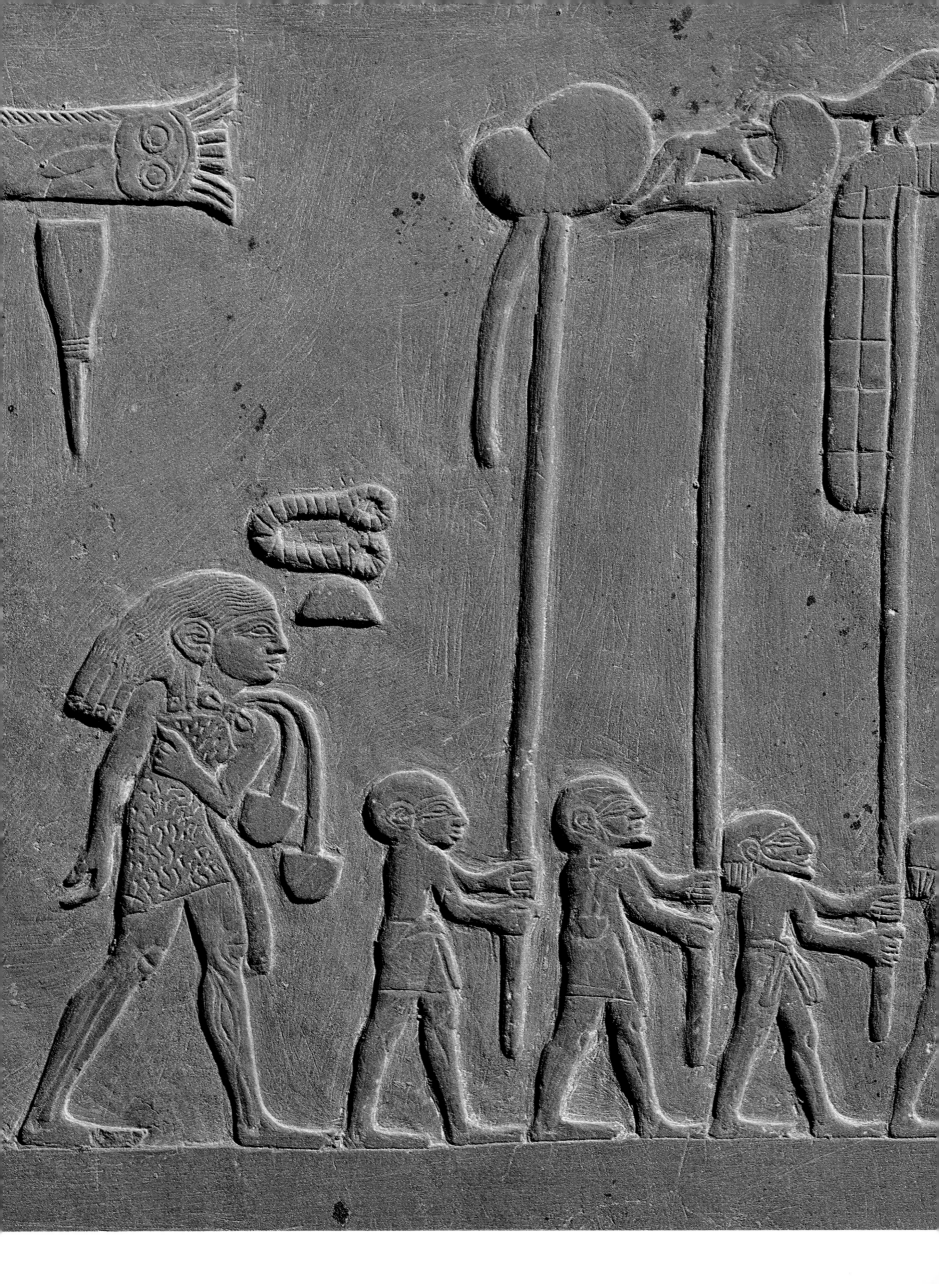

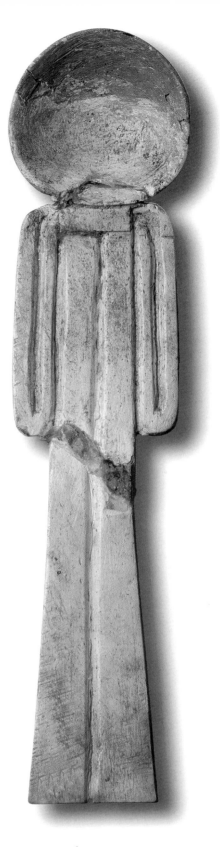

period. We find banners bearing divinity-fetishes– symbols recalling later hieroglyphs – or a bull trampling a fallen enemy.

Among these works, the masterpiece is undoubtedly the celebrated Narmer Palette, commemorating the victories of the ruler traditionally identified with Menes, the unifier of Upper and Lower Egypt. The palette was part of a deposit found in 1897 at Hierakonpolis in a large temple complex built from mud-brick that dated back in its earliest form to the Predynastic. Narmer and Khasekhemwy had both endowed the temple and numerous votive objects bearing the names of the two pharaohs were found in the Main Deposit, a cache that had been deposited at a later date.

The Predynastic Period was followed by the cultural explosion that marked the so-called Pharaonic age. The sedentary cultures of the northern herders and farmers, who had established trade relations with the Near East along routes through Maadi or Buto, were assimilated by the Naqadian culture. In the south, this change was marked the rise of a dominant

class with a new ideology, as well as the emergence of cities. Whether this process of assimilation was peaceful or violent, around 3000 BC it nevertheless gave rise to one of humanity's very first great states.

Society was now based on a monarchy, though it is probable that the essential characteristics had already been established. At the head was the pharaoh, who acted as divine king and guarantor of the harmony of the universe – his power was absolute. The king's tomb was distinguished from those of his subjects by its imposing dimensions and the numerous offerings that were deposited alongside the deceased. The great stone stelae that placed the dead king under the protection of the gods also proclaimed his extraordinary status. We have sporadic evidence of a number of specific rituals in which this status was celebrated, including the coronation and the *sed* festival, during which the king magically renewed his life force and sovereignty. From the evidence of the decoration of the palettes that record the principal events of a king's reign, it seems the stress was always placed on the pharaoh's victories over rebel

stone, ivory and terracotta statuettes. Relatively little is known about daily life in this period. Barley and corn were cultivated and cattle, sheep and goats were raised, while hunting and fishing also provided food. The Naqada Egyptians lived in huts made of mud and reeds, practised the art of weaving, were accomplished copper workers and had mastered the techniques of producing fine ceramics.

By the end of the period sometimes known as Naqada III, the population of Egypt had become concentrated in large agglomerations. Low-relief carving made its first appearance in the form of decoration on ivory dagger handles and large slate palettes. The themes are frequently concerned with war and conflict, commemorating specific events such as hunts and battles with enemy tribes. Such themes presage the historic

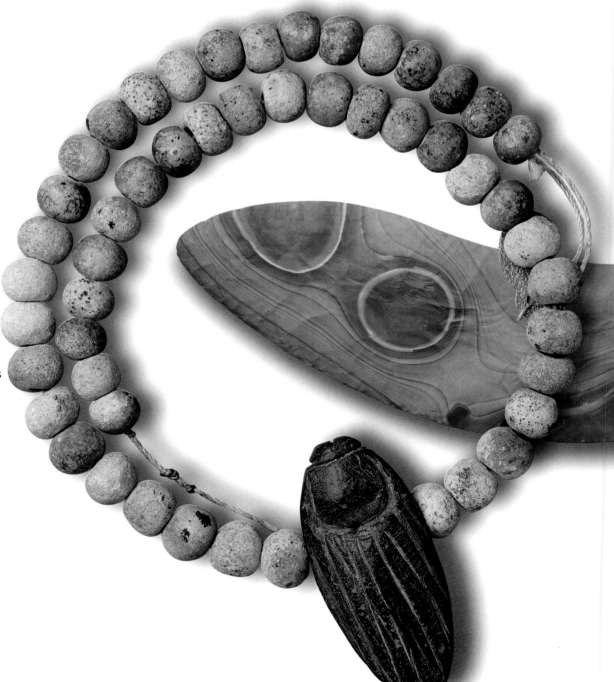

peoples who embodied the forces of disorder. The lands ruled by the pharaoh were distinguished by a rigidly hierarchical administration that made use of a new instrument: writing. Groups of officials and craftsmen were concentrated in the most important cities such as Hierakonpolis and Memphis.

The broad outlines of pharaonic religion also appear to have been already established. Figurative representations were extremely rare, but the principal divinities worshipped in later eras such as Horus, Seth, Hathor, Anubis, Min, Neith and Re, already appeared in a number of inscriptions. The Apis bull, a symbol of fertility, is depicted on a fragment of limestone with characteristics that were to be retained for three millennia. Even though none of the archaic temples has survived intact, a few rare figurative representations and inscriptions, above all those recording foundation rituals, suggest that the core of Egyptian religion was already well consolidated. Cemeteries at Abydos and Saqqara provide much

information about funerary practices. Thousands of votive offerings have been found that are evidence of a belief in a hereafter in which humans had the same needs as they had on earth (food, clothes, weapons and tools). Graves were marked by stelae carved with images and writing to perpetuate the spirit of the dead person.

Despite gaps in our knowledge, the products of this period clearly demonstrate the highly sophisticated skills of the Egyptian craftsmen, which were already being applied within rigorously defined conventions. For example, although of modest dimensions, reliefs from Hierakonpolis and the first royal statues, such as that of Khasekhem, display the monumental character typical of Egyptian art. Unfortunately our knowledge of this period is incomplete, but archaeology provides some idea of works that have been lost. Two plinths and a number of fragments of carved feet testify to the existence of life-size sculptures from the time of the pharaoh Qa'a. And the first royal annals record statues in copper.

Tombs at Abydos, Saqqara and Helwan have furnished us with works of art that

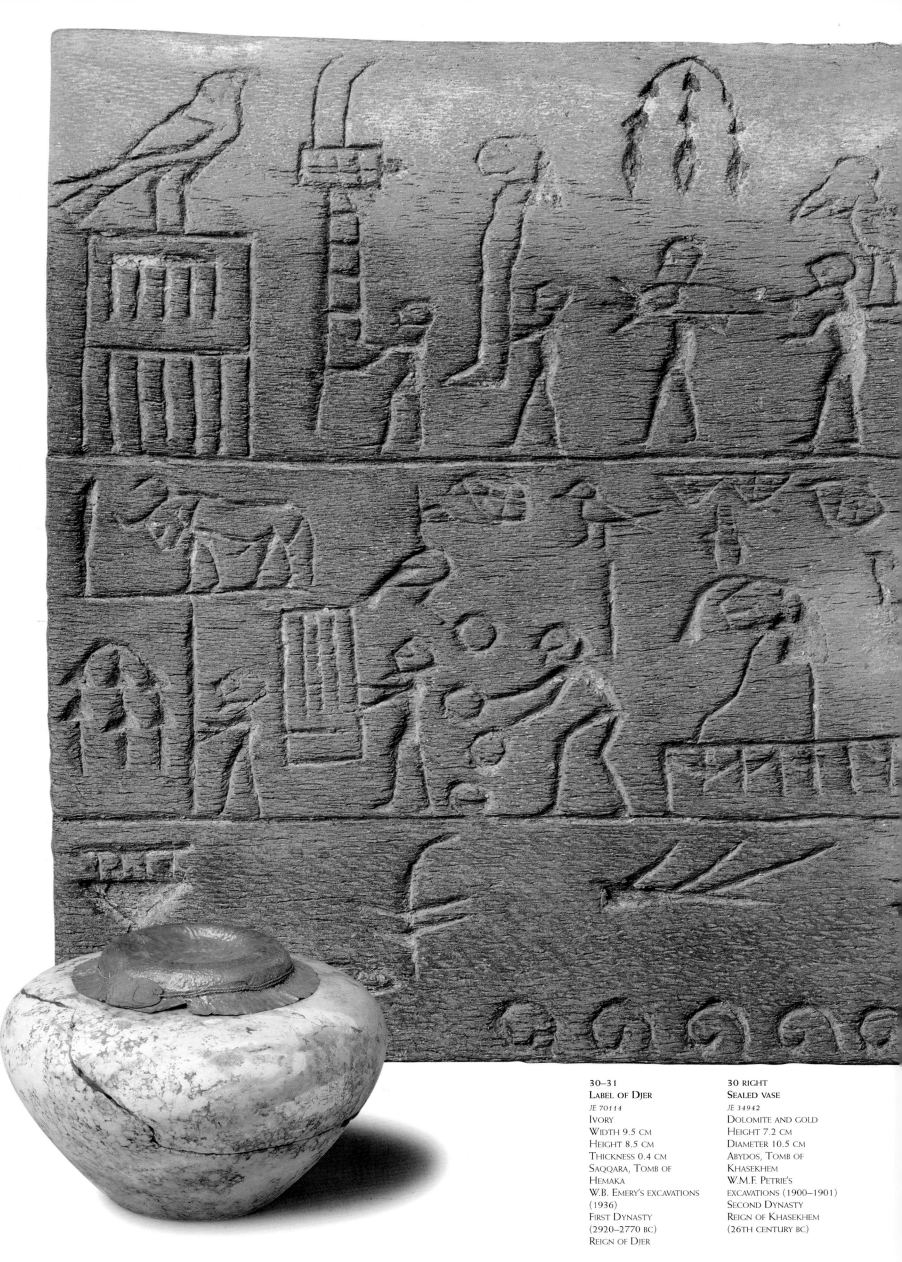

30–31
LABEL OF DJER
JE 70114
IVORY
WIDTH 9.5 CM
HEIGHT 8.5 CM
THICKNESS 0.4 CM
SAQQARA, TOMB OF
HEMAKA
W.B. EMERY'S EXCAVATIONS
(1936)
FIRST DYNASTY
(2920–2770 BC)
REIGN OF DJER

30 RIGHT
SEALED VASE
JE 34942
DOLOMITE AND GOLD
HEIGHT 7.2 CM
DIAMETER 10.5 CM
ABYDOS, TOMB OF
KHASEKHEM
W.M.F. PETRIE'S
EXCAVATIONS (1900–1901)
SECOND DYNASTY
REIGN OF KHASEKHEM
(26TH CENTURY BC)

testify to the skill of goldsmiths, jewelers and sculptors capable of working even the hardest of stones. Of particular note are the fine jewels of king Djer; the enigmatic inlaid discs and wonderfully carved vases from the tomb of the chancellor Hemaka; and the fragile objects in ivory such as spoons decorated with the Knot of Isis, bed legs in the form of bull's hooves, and small columns.

The transition from the Second to the Third Dynasty was apparently smooth, thanks to the mediation of a queen named Nimaathep. Of the five pharaohs whose names we know – Sanakht, Djoser, Sekhemkhet, Khaba and Huni – only two have left monuments worthy of note. All five chose Memphis as the capital of the kingdom, laying the foundations for the classic civilization of the Old Kingdom. Confirmation of their authority is found both at Elephantine, at the First Cataract of the Nile, where a fortress was built, and also in the Sinai desert, where the copper and turquoise deposits were exploited. These Third Dynasty kings successfully organized the development of the state, with a census of wealth and taxes imposed every two years. A new and very powerful position, that of vizier, was created at the head of the administration; Hemaka, whose tomb was found at Abydos, possibly held this post. Prosperity and efficient organization were accompanied by a flourishing of monumental art.

Djoser's reign saw the beginning of the age of monumental stone construction. This was also the first period in which royal tombs took on the pyramidal form that distinguished them from those of ordinary citizens. Each pyramid was completed with a complex of buildings erected to service the cult of the dead king and attend to his needs in the afterlife.

The first pyramid was built on the Saqqara plateau near Memphis, the new capital. The name of the remarkable architect responsible for the invention of dressed stone constructions, Imhotep, has survived, inscribed on the plinth of a statue of Djoser. Over the centuries, Imhotep's teachings were handed down from generation to generation.

31 TOP
VASE WITH HANDLES
COVERED IN GOLD
CG 14341
PORPHYRITE AND GOLD
HEIGHT 14.5 CM
DIAMETER 22 CM
HAMRAH DOM
SECOND DYNASTY
(2770–2649 BC)

31 CENTRE
SMALL SEALED VASE
JE 34941
CARNELIAN AND GOLD
HEIGHT 4.2 CM
DIAMETER 6.5 CM
ABYDOS, TOMB OF
KHASEKHEM
W.M.F. PETRIE'S
EXCAVATION (1900–1901)
SECOND DYNASTY
REIGN OF KHASEKHEM
(26TH CENTURY BC)

31 RIGHT
NECKLACE
JE 87494
FAIENCE AND STONES
LENGTH 82 CM
EZBET EL-WALDA (HELWAN)
PREDYNASTIC PERIOD
(LATE 4TH MILLENNIUM BC)

Early Dynastic architects had already perfected building techniques using wood, reeds, and straw in the form of unfired bricks. But the concept of replacing mud with blocks of stone that were both more attractive and more durable opened up possibilities for new forms of architecture. Initially stone structures imitated models from an architecture using perishable materials, but their translation from one material into another caused technical problems.

Apart from the systematic use of limestone, Djoser's tomb is distinguished by its shape – a step pyramid. Its final appearance, however, was apparently reached in stages. Built of layers of limestone blocks, the pyramid rises at one end of an enclosure covering an area fifteen hectares, surrounded by a boundary wall. Originally the structure took the form of a huge mastaba (from the Arabic for 'bench', due to its shape), but this was then extended to incorporate the tombs of the king's family. Imhotep first added four steps to this base and then another two,

the six levels climbing into the sky to form the first step pyramid. The structure, 60 metres high with its base measuring 109 by 121 metres, was visible from a great distance. A reflection of ancient concepts of the hereafter, it invited the spirit of the deceased king to take its place among the immortal stars. The outline of this monument also recalls the primeval mound out of which the sun emerged. This evoked the version of the creation myth that was associated with Heliopolis, but also alluded to the passage of the sun, which death attempts to merge with.

Below the pyramid is a labyrinth of subterranean chambers, with storerooms containing thousands of stone vases, many of which date from periods earlier than the reign of Djoser. The king had his own funerary apartment beneath the pyramid, with walls covered in marvellous blue faience tiles. Limestone false-door stelae carved in low relief show the king making a ritual run, accompanied by inscriptions consisting of extremely fine hieroglyphs. A number of similar relief scenes were

found in the South Tomb, which forms a replica of the main funerary complex, adjacent to the pyramid. The entire complex was surrounded by a wall ten metres high, built of carefully dressed limestone blocks in the recessed 'palace façade' style. This great wall is interrupted by a single entrance, which leads to a remarkable gallery of fluted columns. This gallery in turn gives access to the large courtyard, delimited to the west by the magnificent Cobra Wall. Storerooms and a series of ritual buildings, some of which are solid 'dummy' structures, extend around the pyramid. The roofs of the shrines are pitched and the pilasters resemble the trunks of trees or bundles of plants, floral ornaments and reeds set in the walls; fake wood knots are carved into the ceiling. There is nothing clumsy or poorly finished. Although the columns that rise from the ground like plants are not yet fully detached from the walls, they already display a great variety: fluted, proto-doric or topped by capitals in the form of papyri. For the first time, elements inherited from an architecture using organic, lighter materials were now carved from the fine Tura limestone.

Djoser communicated with the world of the living by means of his statue placed in a small shrine built at the base of the pyramid, where the statue could receive the reinvigorating breath of the north wind through narrow openings. The magnificent image of Djoser in painted limestone was the first life-size royal effigy. It has a striking appearance due to the dramatic expression of the rough face, with its protruding cheekbones and heavy mouth; the eyes were once inlaid, but the sockets are now empty. Djoser is depicted in the same pose as his predecessor Khasekhemwy, and is wearing the *nemes*, the typical striped headdress, and a long beard, both symbols of kingship.

Contemporary statues are rare but are clearly inspired by the royal model. That of Hetepdief, in granite, is a good example: the priest is represented kneeling in a supplicating pose. His oversized head

32 LEFT
RECEPTACLE IN THE FORM OF A SHELL
JE 92656
GOLD
LENGTH 5.3 CM
SAQQARA, FUNERARY COMPLEX OF SEKHEMKHET
ANTIQUITIES SERVICE EXCAVATIONS (1950)
THIRD DYNASTY
REIGN OF SEKHEMKHET (2611–2603 BC)

32 BELOW
STONE VASE WITH THE NAMES OF PREDYNASTIC KINGS
JE 88345
SCHIST
HEIGHT 12 CM
DIAMETER 23 CM
SAQQARA
THIRD DYNASTY
(2649–2575 BC)

appears to rest directly on his shoulders, the limbs are massive, but the outlines of the costume and the details of the body and hair are carefully rendered.

There are no surviving statues of Sekhemkhet, Djoser's successor. His pyramid, close to Djoser's complex, still provided a number of surprises, however. Along with many stone vessels, the tomb contained numerous pieces of jewelry, armlets composed of strings of beads and a splendid gold shell. Although the alabaster sarcophagus was found in place and apparently still sealed, there was great disappointment when it was opened and found to be empty.

At Saqqara, not far from the earliest pyramids, the most important members of the court were buried in large, mud-brick mastabas, some of which were decorated with stone reliefs depicting scenes of the funeral feast. The deceased were placed in burial chambers below ground, surrounded by furnishings and food that would allow them to continue to exist in the afterlife. On the outside of the tomb was a niche where offerings were left to ensure the survival of the dead person. These offerings were also depicted on stone false-door stelae or on the walls of the funerary chapel.

The mastaba of Hesire, a high-ranking official in the court of Djoser, reveals the progress made by artists in relief sculpture

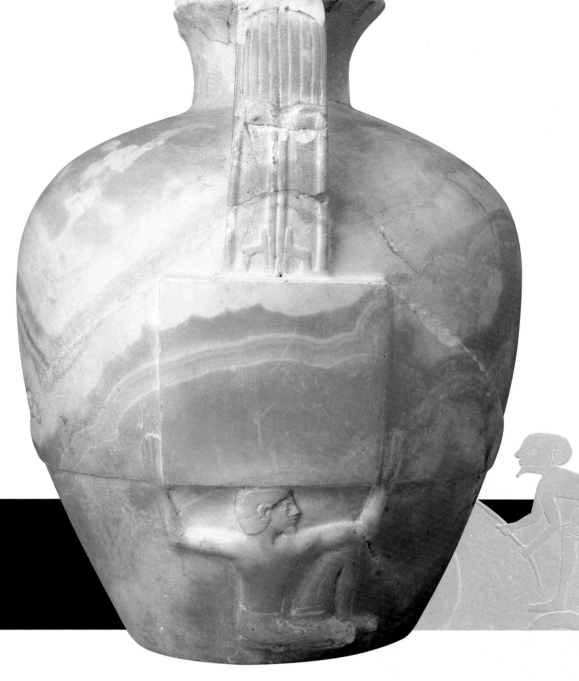

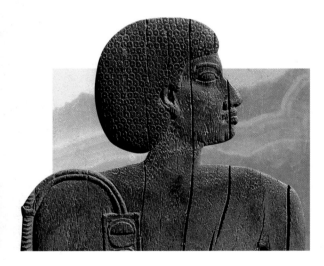

and painting. The eleven niches set within his chapel were decorated with carved wooden panels depicting the deceased. These delicate reliefs represent the figure of the dead man walking or seated comfortably in front of a table laden with food. The severe face, framed by curly hair, is executed in an extremely realistic fashion, as are the details of the clothing, sceptres and the scribe's instruments. The same attention to detail is found in the paintings decorating the corridor of the mastaba. Here the furnishings offered to the deceased are depicted with meticulous accuracy, with even the grain and knots in the wood reproduced.

33 LEFT
PANEL OF HESIRE
CG 1428
WOOD
HEIGHT 111 CM
SAQQARA
MASTABA OF HESIRE (A 3)
AUGUSTE MARIETTE'S
EXCAVATIONS
THIRD DYNASTY
(2649–2575 BC)

33 ABOVE
JUBILEE VASE
JE 64872
ALABASTER
HEIGHT 37 CM
DIAMETER 28 CM
SAQQARA, PYRAMID OF
DJOSER, SUBTERRANEAN
GALLERY
ANTIQUITIES SERVICE
EXCAVATIONS (1932–1933)
SECOND DYNASTY
(2770–2649 BC)

BIOGRAPHY

Christiane Ziegler, *a graduate of the School of Higher Studies at the University of the Sorbonne, is the Chief Curator of the Department of Egyptian Antiquities at the Musée du Louvre, Paris. She has worked with leading publishing companies and the most important specialist periodicals. Among the works she has edited are* Naissance de l'ecriture: cuneiformes et hieroglyphes *(Paris, 1982),* Tanis, trésors des pharaons *(Freiburg, 1987) and* Egypte prédynastique, Thinite et Ancien Empire *(Paris, 1998). She has been responsible for the catalogues of major exhibitions on ancient Egypt in France and the United States and has worked, for example, with the New York Metropolitan Museum of Art, the Musée Canadien des Civilisations at Ottawa, the Royal Ontario Museum of Toronto and the University of Warsaw. She has also overseen the production of sixty episodes of the series* Les secrets du Nil *for French television.*

In 1997 she directed the Louvre archaeological expedition to Saqqara, the Ramesseum and the Valley of the Queens. She is currently preparing the exhibition Les temps des pyramides *at the Grand Palais in Paris and the accompanying documentary.*

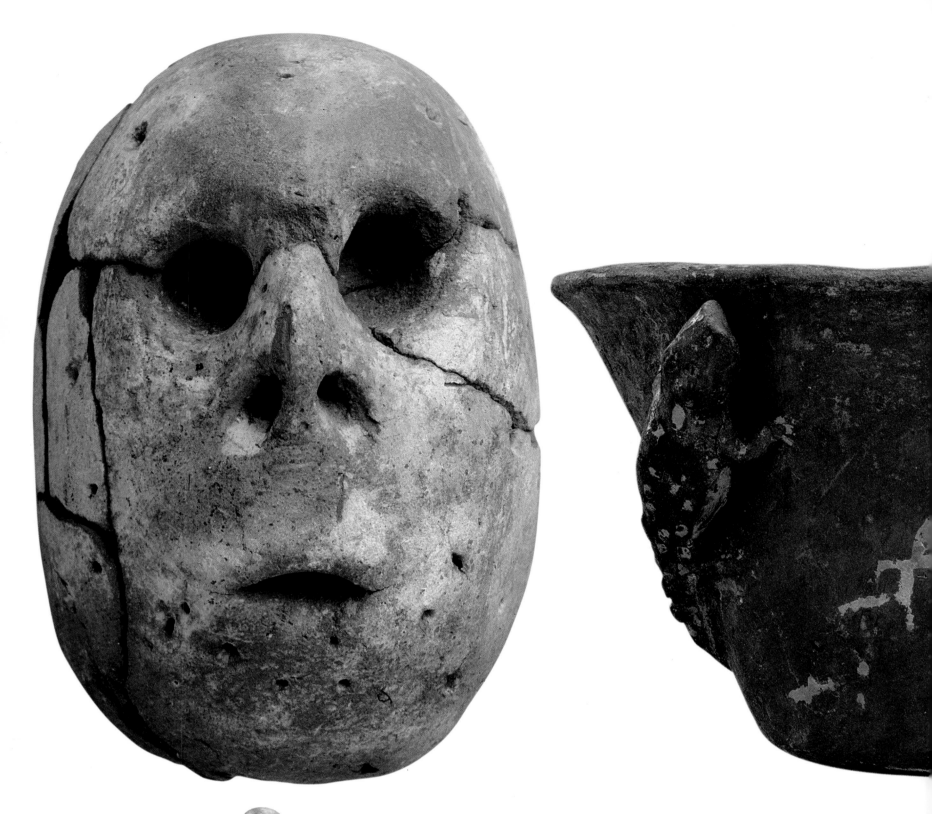

JE 97472

MALE HEAD

TERRACOTTA WITH TRACES OF PAINT
HEIGHT 10.3 CM; WIDTH 6.7 CM
MERIMDA BENI SALAMA; GERMAN ARCHAEOLOGICAL
INSTITUTE IN CAIRO EXCAVATIONS (1982)
NEOLITHIC (LATE 5TH MILLENNIUM BC)

Recent excavations at Merimda Beni Salama, a village in the Western Delta, have brought to light levels dating from between the sixth and fifth millennia BC. This is one of the oldest Neolithic settlements yet discovered in Egypt and provides us with a picture of a society that, while still relying heavily on hunting and gathering, shows the first signs of developing an economy essentially based on cultivation and herding.

The interpretation of what appear to be among the oldest funerary practices of the Nile Valley is still problematical. At an early stage of the excavations, a number of circular graves containing burials were located among the houses.

Only recently, with the application of increasingly precise stratigraphic methods, has it been demonstrated that the houses and the tombs in fact belong to two different periods. It has also been discovered that the cemetery area was superimposed over the inhabited area after the latter had been abandoned. The presence of scant funerary assemblages demonstrates the existence of beliefs associated with the survival of the individual in the spiritual world.

This terracotta head, found in one of the most recent levels of the settlement, is more enigmatic. The perfectly oval face has features in the form of depressions of various shapes and sizes to represent the eyes, nostrils and mouth. Only the nose is in slight relief. It has been suggested that small holes scattered around the head, the chin and the cheeks once held tufts of real hair, which would have given the head a male identity.

Traces of paint remain on the head and there is a deep hole in the neck into which a rod would probably have been fixed. If the head was attached to a rod in this way it is possible that it served as the terminal of a sceptre used in magico-religious ceremonies, thus conferring a kind of life-force.

This interpretation is based exclusively on anthropological parallels with present-day rituals. In fact there is a scarcity of similar objects from such ancient times, and no parallels can be found in prehistoric Egypt.

The dating of its manufacture makes this one of the oldest representations of the human figure ever to have been discovered in Africa. (F.T.)

JE 38284 = CG 18804

BOWL WITH RELIEF DECORATION

......................

CLAY

HEIGHT 11 CM; DIAMETER 19.5 CM
PERHAPS FROM GEBELEIN; ACQUIRED IN 1906
PREDYNASTIC PERIOD, NAQADA I (4000–3500 BC)

This flared bowl with a flattened rim is typical of the pottery production of the early Predynastic Period. Generally characterized by the red colouring of the surfaces, decoration consists of geometric motifs or stylized plants or animals rendered by means of rapid brushstrokes in white paint.

On the outside of this particular vessel, however, there is an unusual applied decorative element, rare for this period. Clay models of four crocodiles have been attached diagonally to the exterior surface of the bowl, with their noses almost touching the rim.

The spines of the animals are shown in relief, and there are spots of white on their backs. Their exposed sides, the edges of their tails and claws are also highlighted in white. The four reptiles are separated from one another by diagonal bands composed of a diamond pattern in the same white paint.

The rim of the bowl is painted with a continuous white herringbone pattern, while the interior is decorated with two triangles of the same diamond motif used on the outside. The two triangles are arranged one above the other and point towards the bottom of the bowl. They are separated by an irregular band of squares that also continues on the base, with the squares diminishing in size.

The bowl is not perfectly preserved. One of the four crocodiles is missing and only one of the other three is complete. The external surface is heavily worn and the paintwork, originally white, has in a number of areas become a yellowish colour or even disappeared altogether. (S.E.)

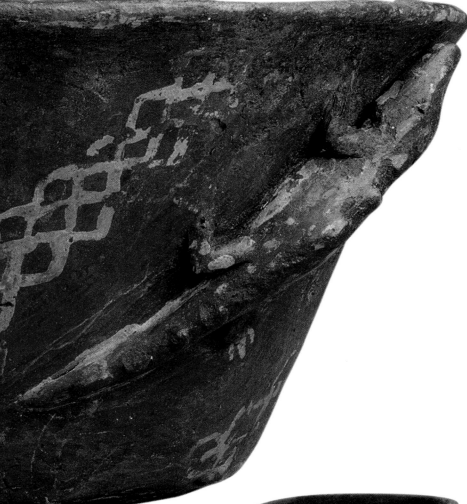

JE 41247 - 41251 - 26530 = CG 20087

'BLACK-MOUTH' POTS

......................

CLAY

DOUBLE VASE (JE 41247): HEIGHT 7.6 CM; WIDTH 6.5 CM
GLOBULAR VASE (JE 41251): HEIGHT 7 CM; DIAMETER 6.6 CM
ABYDOS; E.R. AYRTON'S EXCAVATIONS (1909)
TRIPOD CUP (JE 26530 = CG 20087):
HEIGHT 13.2 CM; DIAMETER 5.7 CM
GEBELEIN, DISCOVERED IN 1885
PREDYNASTIC PERIOD, NAQADA I (4000–3500 BC)

During the Predynastic Period, great quantities of pots in a wide range of shapes were produced in Egypt. Some of these have been found as far south as Nubia. Ewers, bowls, plates and globular cups were created by shaping the local clay by hand and setting it to dry in the sun.

The surfaces of these pots were carefully burnished with stones and were either left in their natural terracotta colour or covered with a thin layer of pigment.

The so-called black-mouth pots were produced during the Naqada I period and are characterized by a dark band around their rim. The remainder of the exterior surface is coloured red with haematite, while the interior is entirely black. This unusual two-tone effect was obtained by up-ending the pot in a layer of slow-burning coals. The lack of oxygen had the effect of carbonizing the surface, thus blackening the clay. The three black-mouth pots seen here show something of the variety of shapes found in the usual repertoire of forms for this type of pot.

The curious double vase has a slightly convex base and two mouths at different heights and of different diameters. The globular vase, with its sophisticated and precise form, has a fine, raised rim. The tall, slender cup rests on three feet. Above the feet runs a white-painted band with a decorative herringbone motif.

These vessels could be used to contain either liquids or solid foods and were placed in tombs as part of simple funerary assemblages. (S.E.)

JAR WITH PAINTED DECORATION

PAINTED CLAY
HEIGHT 22 CM; DIAMETER 15 CM
PROVENANCE UNKNOWN
PREDYNASTIC PERIOD, NAQADA II (3500–3100 BC)

In the Naqada II period, also known as the Gerzean, pottery production developed considerably and there were numerous innovations in form, decoration and technique. The pottery produced during this period is characterized by the use of a pale clay, perhaps pre-worked on a hand wheel. The clay was left in its natural state and decorated with red-painted motifs depicting stylized animals, plants, human figures and boats. These images all evoke the Nile Valley environment, populated by the typical river flora and fauna. The most frequently found type of vase was a closed shape, with handles and well-defined individual elements.

This particular jar has a slightly convex base. Below the mouth, which has a flat, sharply defined rim, there are two lugs, pierced by small tubular holes. The exterior is decorated with red paint. At the widest part of the body, the decoration features an image of a large boat from which forty vertical lines descend. These have been interpreted as oars. There are two cabins on the boat, from the roof of one of which flies a banner. The symbol on the flag recalls the divine emblems used to identify the various nomes (districts) of Egypt. A standard rises from the prow; and an anchor hangs below, ready to be thrown into the water.

Below the boat are four stylized ostriches flanked by two aloe plants that continue on the opposite side of the vessel. A similar scene appears on the other side: a boat, with a stylized branch above. Above this is a line of five ostriches, again flanked by aloe plants. The presence of water, which could hardly be ignored in a river environment, is suggested by undulating lines on the handles and around the base of the vessel. (S.E.)

COSMETIC PALETTE

SCHIST
HEIGHT 15 CM
GERZA, TOMB 59; W.M.F. PETRIE'S EXCAVATIONS (1911)
PREDYNASTIC PERIOD, NAQADA II (3500–3100 BC)

The oldest palettes discovered in Egypt date to 5000–4000 BC, when they were placed in tombs as part of funerary assemblages. Initially they were rectangular in shape and were used to mix mineral pigments – malachite and galena – for eye-paint. During the Naqada I and II periods new types of palettes appeared, carved in the form of animals (turtles, fish and birds), or in the shape of a shield. In the latter case, the surfaces of the palettes were decorated with more or less stylized reliefs with magical-religious meanings. From the late Predynastic Period, the principal use for these palettes was as offerings in temples rather than as grave goods. Examples of large size with extremely complex figurative decoration were deposited by worshippers as votives.

This unusual schist palette was part of a Predynastic funerary assemblage which also contained ordinary vessels. It has an oval shape that widens slightly towards the top and is it pierced so that it could be suspended. The highly stylized relief decoration on one side reproduces the head of a cow with upward curving horns and prominent ears. Five stars are included in the composition: two at the tips of the horns, one on the top of the head, and two on either side of the ears. The image was probably designed to evoke one of the bovine-form deities – the greatest being Hathor – who in this period were identified with the heavens. This palette was actually used to grind cosmetics, as indicated by the traces of malachite still present on the reverse. (S.E.)

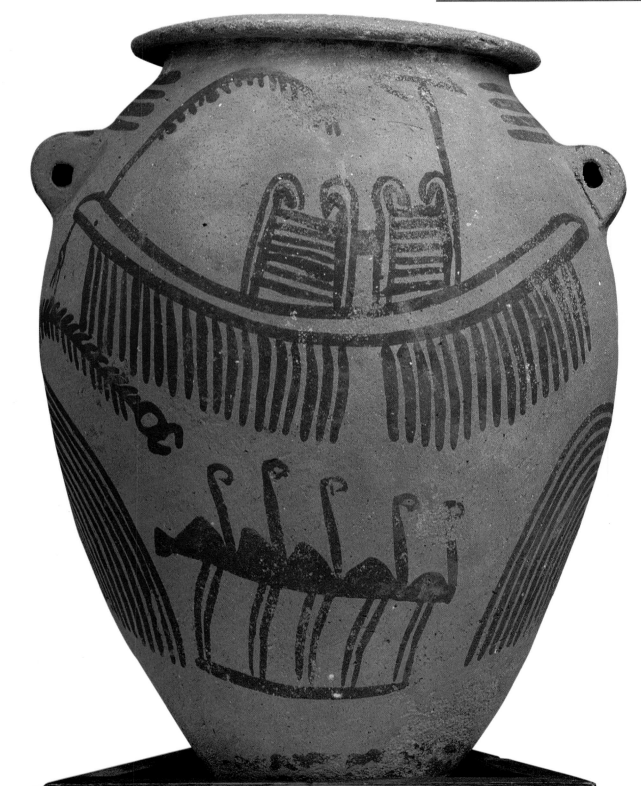

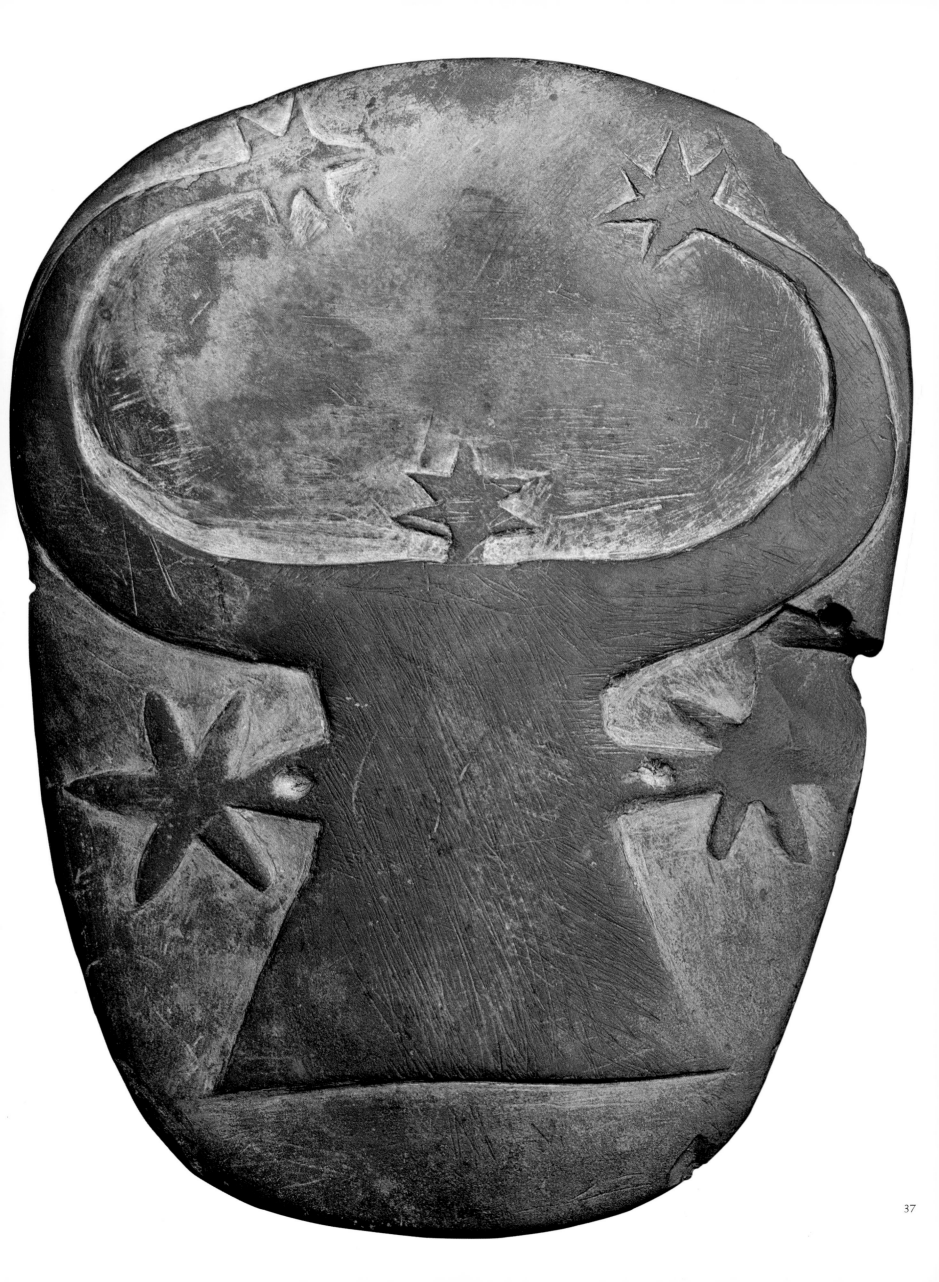

LOWER FRAGMENT OF THE 'LIBYAN PALETTE'

·······························
SCHIST
HEIGHT 19 CM; WIDTH 22 CM
ABYDOS; PREDYNASTIC PERIOD (C. 3000 BC)
·······························

Only the lower section of this palette has survived and it is therefore impossible to determine which was the principal face. This would have had been carved with the shallow depression in which the mineral pigment was ground and its decoration would have commemorated a specific event.

Four registers of decoration survive on one face. In the first partially preserved register a row of bulls can be seen facing right. The first three animals are set well apart from one another while the head of the last, evidently due to lack of space, is superimposed on the hindquarters of the preceding one.

All three surviving bulls are shown with their heads lowered and stretched slightly forwards, as if they are about to charge. The eyes are large and further emphasized by a series of lines. The musculature of the legs is stylized and stresses the power of the bulls, distinguishing them from the animals depicted in the two registers below. The line of donkeys does not display such dramatic tension. The less detailed surfaces of the animals do not contrast so sharply with the empty spaces within which the figures are carved. The last donkey, again due to lack of space, is smaller than the one that precedes it, but the two animals are not superimposed.

In the third register a line of rams is depicted. Here the problem of fitting the available space was solved by depicting the last animal in the line with its head turned backwards; it is also smaller in scale than the others.

At the bottom of the palette, the last register contains eight trees, probably olive trees, arranged in two rows. The name of the palette is based on a reading of the two hieroglyphs at the top right of this scene: a piece of land on which is placed a throwing stick, corresponding to the name *tjenehu*, denoting the Libyan regions.

It is not known for certain if olives were cultivated as early as this.

The decoration on this face of the palette has been interpreted as a celebration of a victory over a group of Libyan peoples. In this interpretation the lines of animals represent the spoils of war.

On the other side of the palette the surviving scene is half-way between pictorial representation and hieroglyphic writing. It is set below the base line of another scene, of which only three feet now survive. A number of animals – a falcon, a lion, a scorpion and two falcons on a banner – all holding a mattock, each sit on the walls of a city. Within the buttressed walls of the seven cities are several squares representing buildings and a hieroglyph.

This scene has been interpreted as depicting the founding of a series of cities by a ruler symbolized by the animals, with the enclosed hieroglyphs identifying the settlements' names. (F.T.)

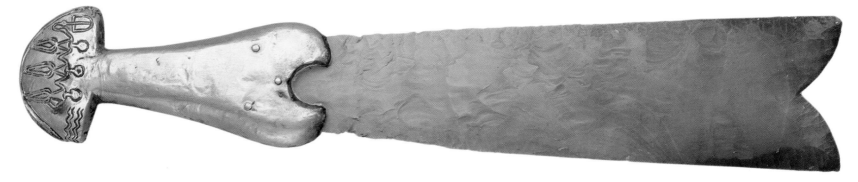

JE 34210 =
CG 64868

GOLD-HANDLED FLINT KNIFE

FLINT AND GOLD LEAF
LENGTH 30.6 CM; WIDTH 6 CM
PERHAPS FROM GEBELEIN; ACQUIRED AT QENA IN 1900
PREDYNASTIC PERIOD, NAQADA II (3500–3100 BC)

This flint knife with a gold handle was not intended for everyday use. Given its fine craftsmanship, it would probably have been used exclusively in religious ceremonies and rituals.

The flint blade, with its carefully polished surface, has a forked tip and tapers slightly towards the handle in which it is inserted. The edges are minutely serrated to facilitate cutting.

The handle is made of two gold plates fixed together by three rivets, with a coating of plaster over the final part of the blade. In the centre of each side of the handle where it joins the blade a small semicircular notch is cut out, while the pommel is in the form of a crescent moon.

On the pommel the gold is incised with stylized motifs drawn from the classic iconography of the Naqada Period, as seen above all on pottery vessels. On one side are three stylized female figures, perhaps dancers, holding hands. The one on the left is holding a kind of fan. Next to the right-hand figure are four incised undulating lines, representing water. On the other side of the pommel a boat is depicted, the hull of which follows the curve of the handle. Two tall central cabins are shown on the boat and a number of banners. Next to the boat is a small, stylized aloe plant filling the available space. Not surprisingly in a country where all life depended on the Nile, boating scenes were frequently used as decorative elements from the Predynastic Period onwards. (S.E.)

THE NARMER PALETTE

GREEN SCHIST; HEIGHT 64 CM; WIDTH 42 CM
HIERAKONPOLIS (KOM AL-AHMAR)
J. QUIBELL'S EXCAVATIONS (1894)
EARLY FIRST DYNASTY, REIGN OF NARMER (C. 3000 BC)

The Narmer Palette was part of a votive deposit found during excavations at the temple of Horus at Hierakonpolis. The deposit contained several palettes as well as numerous other objects. In Egyptian mythology the eye of Horus was regarded as a manifestation of the solar disc and the palettes found in his sanctuary would have been left there as offerings magically to protect the eye of the god from damage. Eye-paint, produced by grinding malachite or galena on a palette, was used as a protection against the strong glare of the sun and was also thought to have the power to preserve sight.

Egyptian kings proudly depicted their deeds on the votive palettes. On this one the name of Narmer is inscribed top-centre, within the *serekh*, flanked by two female heads with the ears and horns of a cow — one of the earliest images of the goddess Hathor.

The principal face of the palette is divided into three registers. In the top one, Narmer, wearing the Red Crown and followed by his sandal bearer, is preceded by a line of five figures, the four smaller ones each carrying a banner which can be interpreted as personifications of regions of Egypt. In front of them lie the headless corpses of ten men with their hands tied behind their backs; above them is a boat. In the central register, two men are straining at the leashes of two felines with extremely long necks. Their entwined necks encircle the shallow depression in which, in a royal palette, the pigments for eye-paint would have been ground. The lower register depicts a bull, undoubtedly a symbolic representation of the king, demolishing the walls of a city with its horns. Under its hooves lies the body of a dead enemy.

The reverse side of the palette shows the tall figure of a king wearing the White Crown and brandishing a mace to threaten a fallen enemy in front of him whom he is holding by the hair. Behind the king, on a smaller scale, is another representation of his sandal bearer.

The scene is described top-right in a composition of hieroglyphs that is at the same time pictorial and textual: a falcon with a human arm grips a cord attached to the nostrils of the head of a man emerging from

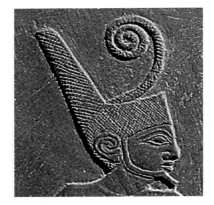

a piece of land with papyrus plants. The composition can be read as: 'the falcon [the king] has captured the man of the papyrus bed [the Delta].' Below this scene is another register featuring two male bodies with outspread limbs.

Narmer has been identified by some with Menes, the ruler whom Manetho placed at the beginning of the First Dynasty and who has therefore been attributed with the founding of Egyptian civilization. In this light, the decoration of the palette has been interpreted as the celebration of the final victory of Upper over Lower Egypt. But recent archaeological discoveries have demonstrated that the unification of Egypt was already well established by the time of Narmer.

This depiction of Narmer wearing the White Crown and carrying a mace is one of the earliest images of the king depicted as the guarantor of order. The defeat of the Delta enemies would have symbolized the destruction of evil. The palette's principal face represents the king's heroism in war: Narmer, wearing the Red Crown, views the decapitated bodies of his enemies. (R.P.)

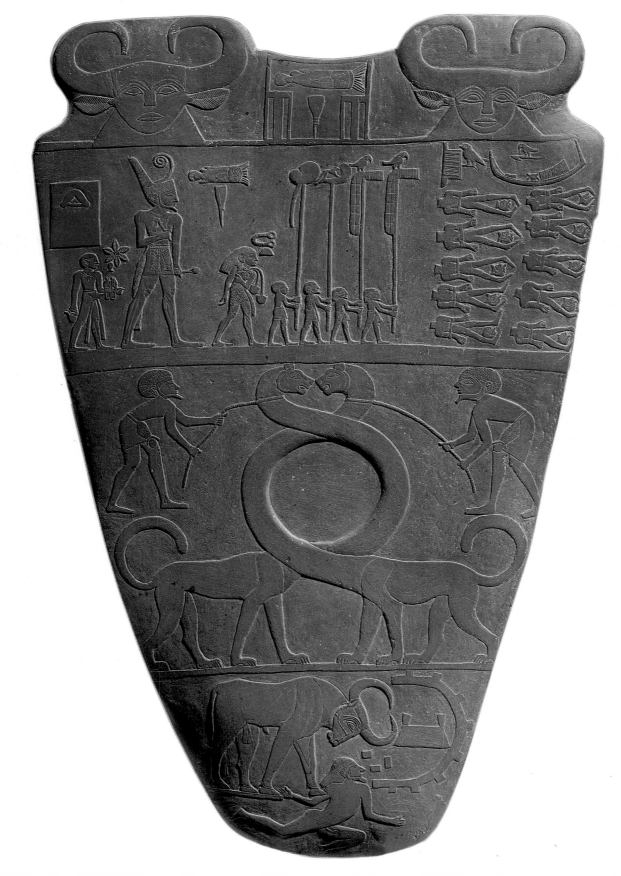

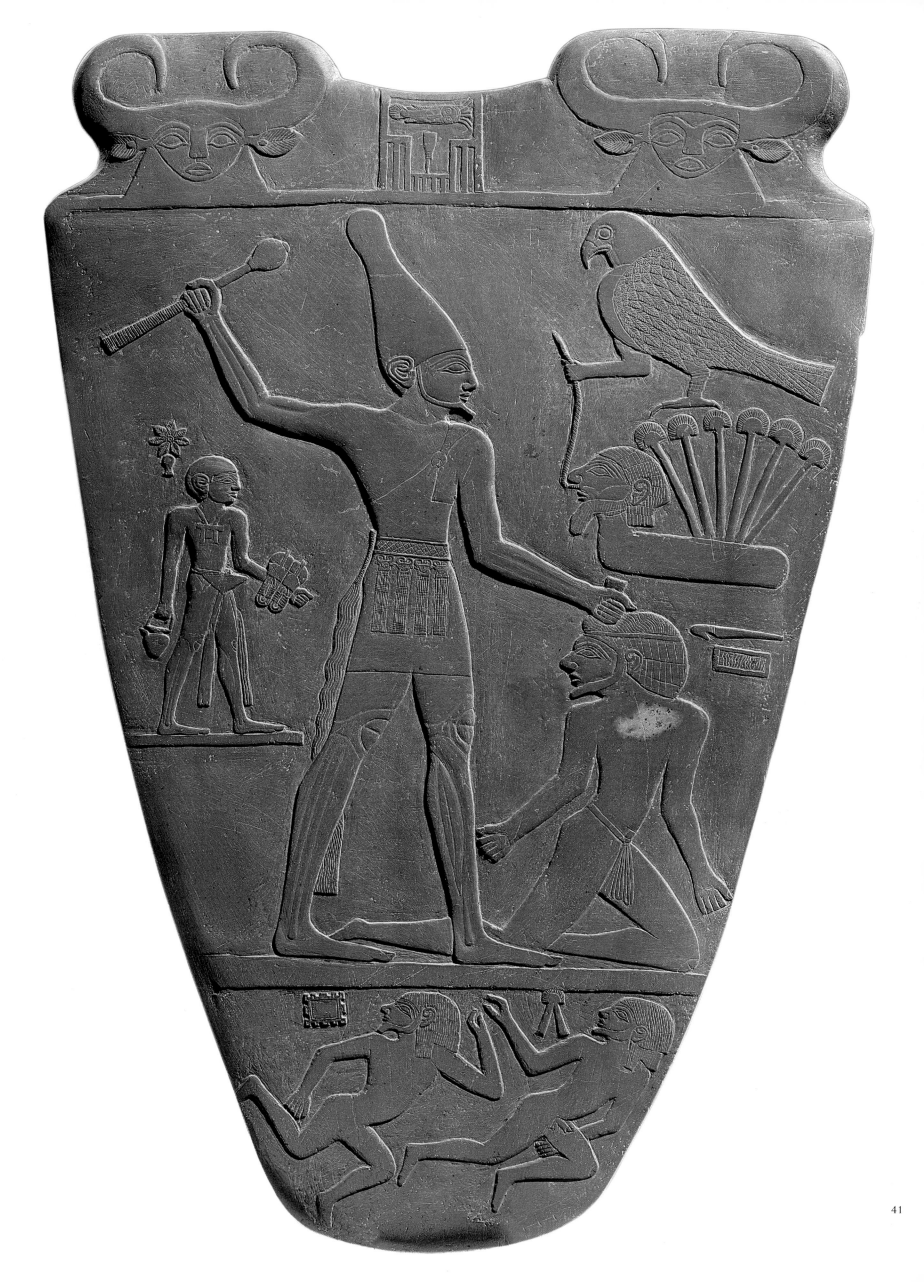

JE 31773 = CG 14142

LABEL OF AHA

IVORY; HEIGHT 4.8 CM; WIDTH 5.6 CM
NAQADA; 1897 EXCAVATIONS, A FRAGMENT WAS DISCOVERED BY J. GARSTANG (1904)
FIRST DYNASTY (2920–2770 BC), REIGN OF AHA

Jars containing oil, a product highly prized by the ancient Egyptians, normally carried ivory labels of various types. Smaller examples featured numbers and written indications as to the contents of the jar and a location (perhaps of production). Larger ones also included information about the type of oil, the names of the relevant king and the date, the latter indicated by an event of particular importance that occurred during the year in question.

The fragments of this tablet with the name of King Aha were found on two separate occasions among the remains in the tomb of one of the king's wives. Two names of the pharaoh are inscribed in the top right corner, alongside the hole for the string by which the label was attached to the jar. Aha's Horus name is inscribed within the *serekh*, or symbolic palace façade. In this instance the feet of the falcon perched on the top extend within the design and are transformed into two arms holding a mace and a shield. This figure forms the hieroglyph that in the can be read as Aha and signified 'the fighter'. To the right, enclosed within a pavilion, is the king's *nebty* name. In Egyptian, *nebty* means 'two ladies', referring to the two deities that together symbolize the union of the country, the vulture goddess Nekhbet of Upper Egypt and the cobra goddess Wadjet of Lower Egypt. The two goddesses are carved above a symbol very similar to the hieroglyph indicating the *senet* boardgame, read as *men*, which also means 'endure' or 'establish'. This possible reading has led to the association of the *nebty* name of Aha with that of Menes, the king whom Manetho lists as the first to reign over a unified Egypt. Menes has also been identified with Narmer, but the association with Aha has found further confirmation in archaeological evidence brought to light in recent years.

To the left of the names of Aha is a depiction of a boat with a richly decorated prow and a central cabin. Above this vessel is a falcon on another boat, which can be read as a caption relating to the identity of the occupant of the cabin – perhaps either the king or a simulacrum of the god Horus. If the second interpretation is correct, it is probably a reference to a festival in which the divine image of the god was taken out of the temple in a solemn procession. On the left-hand edge of the label a number of rather worn hieroglyphs can be traced, which perhaps refers to a battle fought by the king and also to building work he commissioned.

On the right of the scene below is a building, within which three figures are standing. A fourth man holding a staff is depicted outside the building, facing the centre of the composition where there are two men carved on either side of what appears to be a large vessel on a support. To the left are trussed prisoners, a tethered and a decapitated bull, a number of jars, and loaves placed on a straw mat (corresponding to the hieroglyph symbolizing 'offerings').

In the lower register a line of male figures with folded arms advances towards the left, where the name of an oil is written. (F.T.)

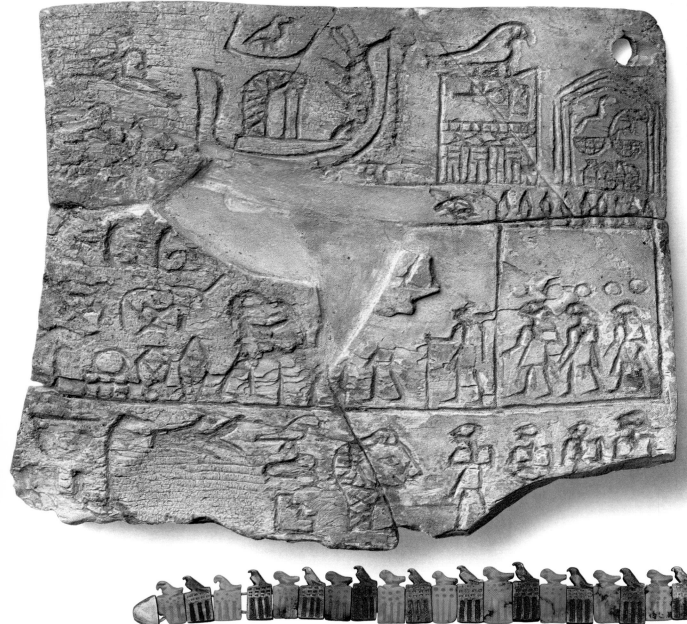

BRACELETS FROM THE TOMB OF DJER

GOLD, LAPIS LAZULI, TURQUOISE, AMETHYST
LENGTH FROM 10.2 TO 15.6 CM; ABYDOS, TOMB OF DJER
W.M.F. PETRIE'S EXCAVATIONS (1901)
FIRST DYNASTY (2920–2770 BC), REIGN OF DJER

These four bracelets were discovered by Petrie in the tomb of Djer, the third pharaoh of the First Dynasty. The tomb was situated in the royal cemetery of Abydos, an important centre for the earliest kings of a unified Egypt. At some time during the Old Kingdom the tomb had been entered and plundered. In the New Kingdom, it was considered to be the mythical burial place of the god Osiris.

These four bracelets were found still in place on an arm (perhaps that of a woman) wrapped in linen bandages and discovered hidden in in the wall of the tomb.

The bracelets are well designed and original in form: beads of harmoniously alternating colours are combined in numerous and varied patterns. They display the great technical mastery of the craftsmen in working the typical materials of Egyptian jewelry at this period.

The first bracelet is made up of twenty-seven small plaques of the falcon, symbol of the god Horus, perching on the *serekh* motif, which represents the plan and façade of a royal palace. Within this *serekh* symbol was inscribed the 'Horus name' of each pharaoh, the first and oldest of the five names constituting the royal nomenclature. The plaques decrease in size from the centre to the two ends and are made alternately of gold and turquoise, creating a sophisticated chromatic contrast. Each plaque is pierced with two transverse holes to allow threads to be inserted which are then fixed to a triangular gold element at each end.

The second bracelet consists of three rows of beads joined at four points, including the two ends, so as to form three identical sections. On either side of the central section are two groups of three beads in gold, turquoise and lapis lazuli, with turquoise discs at either side. The beads of the central section of the bracelet are larger than the others but are arranged in the same rigid sequence. In the centre is a

tapering, ridged bead of lapis lazuli, and at either side are three beads (the central one of gold or lapis lazuli, and the other two of turquoise) separated from another tapering bead which was made by winding a gold wire around a small cylindrical bar. The bracelet is fastened by a small gold button inserted between two rings placed at either end.

The third bracelet has twelve beads of hourglass shape, linked vertically in four groups of three, which in turn are separated by pairs of lozenge-shaped turquoise beads. Each group of hourglass beads consists of a central amethyst bead, though in one case, this is replaced by a brown glass paste substitute, flanked by two gold beads. Strangely, the beads are not pierced but are joined by a wire passing around the central groove and held in position by a slim gold ring. The lozenge-shaped turquoise beads have gold-leaf caps at the ends and are pierced to allow the passage of the wire.

The fourth and final bracelet is the smallest of the group and was placed closest to the mummy's wrist. This bracelet is composed of two parts that, when found, were still joined by a braid of gold threads and hairs, possibly from the tail of a giraffe. The section of the bracelet intended to be visible on the upper part of the wrist is more elaborate: in the centre is a gold rosette flanked on either side by three rows of beads. Each of these rows is composed of turquoise beads of irregular size, separated by small gold rings and spheres. The ends of each of the three rows are joined with a large lapis lazuli bead, followed in one case by a final gold sphere.

The other section of the bracelet, which would have formed the back, has the same rows of beads but lacks the central rosette; the order of the last two lapis lazuli and gold beads is also inverted. (S.E.)

DISC FROM THE TOMB OF HEMAKA

BLACK STEATITE
DIAMETER 8.7 CM; THICKNESS 0.7 CM
SAQQARA, TOMB OF HEMAKA; W.B. EMERY'S EXCAVATIONS (1936)
FIRST DYNASTY (2920–2770 BC), REIGN OF DEN

Hemaka, who lived during the First Dynasty, was one of the first figures to hold the important political position of treasurer and possibly vizier to the king without being a member of the royal family. His tomb at Saqqara contained a rich funerary assemblage that included numerous decorated discs in stone, copper, wood, horn and ivory. These were discovered in 1936 in an open wooden box.

Their function is still unclear, though Emery, who discovered them, suggested that they were used as small spinning tops. They would have been rotated in the box on wooden sticks inserted in the holes through the centre of each disc.

This steatite disc has one flat side and one that is slightly convex. On the convex surface is a marvellous hunting scene in relief, cleverly worked out to achieve a sense of balance and symmetry, with two dogs and two gazelles arranged in a quadrilateral within the circumference of the disc. The figurative decoration is enhanced by

a skilful contrast of colours. One of the dogs and the horns and hooves of the gazelles are carved from the steatite disc itself, while the second dog and the bodies of the two gazelles are inlaid in pink-veined alabaster.

The artist was not attempting to portray two contemporaneous scenes, but rather two successive moments in the hunting of the gazelle by the dog. The dog initially tracks its prey and then attacks head-on, biting at its neck. The figures of the two fighting animals, with the gazelle rolling over with its hooves in the air, serves to offset the rigid symmetry of the composition and to emphasize the movement of the scene. The dogs, with their more agile and sinuous bodies, can be seen as symbols of victory, while the cruder gazelles with arching backs can be interpreted as symbolizing defeat.

The decorated side of the disc is surrounded by a border carved with a pattern of intersecting lines. (S.E.)

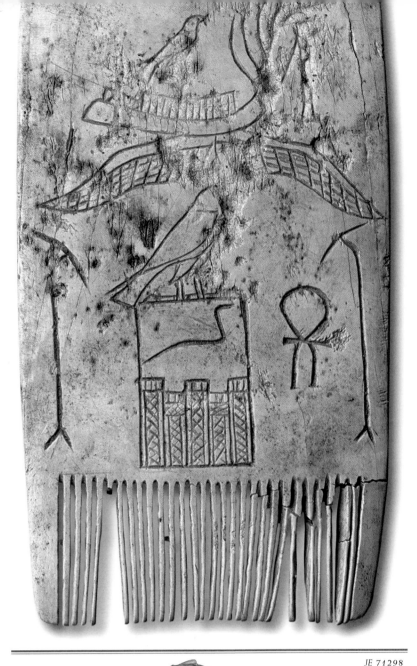

JE 47176

COMB WITH THE NAME OF DJET

IVORY
LENGTH 8 CM; WIDTH 4.5 CM
ABYDOS
FIRST DYNASTY (2920–2770 BC), REIGN OF DJET

In ancient Egypt, any object could be charged with symbolic value, irrespective of its normal function. In all periods of pharaonic history, for instance, there is a predilection for producing artifacts that resemble naturally occurring objects which were thought to possess special protective powers. This was especially true of items for personal grooming as they came into direct contact with the body.

It is no surprise also to find that a simple comb, such as this example from Abydos, is inscribed with the name of a king. Simply the mention of the king's name was thought to confer apotropaic properties on the object. In this case, the comb was perhaps once part of Djet's funerary goods, which would equally justify the presence of his name.

At the centre of the decoration is the *serekh* symbol (a stylized view of a royal palace) surmounted by a falcon, within which is inscribed the name of Djet. The *serekh* is flanked by two *was* sceptres symbolizing power. On the right there is also an *ankh*, the symbol for life.

The upper part of the pictorial area is occupied by a pair of wings. A boat rests on the wings and a falcon perches on the cabin of the boat. This is an allegorical image showing the sky (the wings), traversed by the sun (the boat), thought to navigate the heavens each day from east to west. The boat is very similar to those painted on vases of the Naqada II period, and is also comparable to the actual solar boat of Khufu, discovered in 1954 in a pit at the base of the south side of his pyramid at Giza.

Djet's comb is the oldest known example of this decorative motif. Transformed into the canonical image of the winged solar disc, the same theme was found frequently in succeeding periods, especially on stelae and architraves. (F.T.)

JE 71298

DISH IMITATING BASKETRY

SCHIST
HEIGHT 4.8 CM; LENGTH 22.7 CM; WIDTH 13.8 CM
NORTH OF SAQQARA; W.B. EMERY'S EXCAVATIONS (1937–1938)
SECOND DYNASTY (2770–2649 BC)

The production of stone vessels is one of the most characteristic crafts of pre- and proto-historic Egyptian culture. The artisans of the period achieved high levels of skill and could create the impression of plasticity using even the hardest stones. They were thus able to carve vessels that reproduced objects in other, perishable, materials, which was part of a tendency in archaic Egyptian art to confer eternity on objects by transforming them into stone. This tendency also led to the transformation of proto-historic shrines built of of wood, straw and mud-brick into monumental limestone structures from the reign of Djoser on.

This dish, found in the tomb of an official who lived during the Second Dynasty, accurately reproduces a papyrus original.

The artist did not merely superficially imitate the bundles of papyrus stems, but also closely observed the way they curved and were arranged, rejecting any stylistic short-cuts. The separate, individual stems are rendered by undulating lines that even represent the natural variations in their thickness. The cords that fasten the basket together are depicted with extreme realism and are superimposed one over another.

The hieroglyphic symbol for gold is inscribed at the end of one of the long sides, perhaps referring to the original contents of the papyrus basket. Scenes from later periods (above all from the New Kingdom) do show figures in the act of presenting or carrying objects of

precious metal in baskets or on trays. It is by no means certain, however, that this example from Saqqara was actually filled with gold. What is more probable is that the word 'gold' inscribed on the object ensured the symbolic presence of the precious

metal. The dish can therefore be seen in the same light as a stone vessel, also in the Museum, which is in the form of a storage jar. Its shape alone ensured the barley (for bread and beer) necessary for the eternal survival of the deceased. (F.T.)

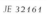

STATUE OF KHASEKHEM

SCHIST
HEIGHT 56 CM
HIERAKONPOLIS (KOM AL-AHMAR); J. QUIBELL'S EXCAVATIONS (1898)
SECOND DYNASTY (2770–2649 BC), REIGN OF KHASEKHEM

This sculpture is one of the oldest examples of royal statuary from pharaonic Egypt. It was found, together with a similar example in limestone now in the Ashmolean Museum in Oxford, at Hierakonpolis, a city that played a fundamental role throughout the Protodynastic Period.

The modelling of the statue breaks away from works of the previous period and anticipates stylistic features of Old Kingdom

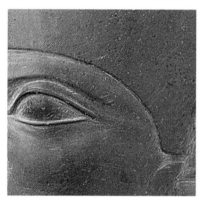

statuary. This can be seen particularly in the enhanced three-dimensionality of the sculpture. The work retains and emphasizes the frontal view of the subject but, compared with earlier sculptures, acquires greater depth and character. The decision to depict the king seated on a chair with a low back and wearing the White Crown on his head confers a verticality and a lightness to the figure as a whole that contrasts with the attempt to keep the composition as close and contained as possible. This second tendency is in keeping with the most typical canons of ancient Egyptian art whereby the block of stone from which the work was carved was kept as compact as possible.

Khasekhem is wearing the typical costume of the Jubilee (the *sed* festival) that was celebrated in the thirtieth year of the king's reign and was designed to reaffirm his power and ability to govern. The costume consisted of a cloak that covered the entire figure to the calves, with the right flap of cloth thrown over the left. The left arm, folded across the waist, seems to be covered by a wide sleeve with a broad band along the edge. The right arm is resting on the thigh.

The hands are closed in fists and both have a hole in which the royal insignia would once have been inserted. In contrast with the hands, which are rendered in a very geometric and stylized manner, the pharaoh's feet are modelled with extreme care and rest on the same base as the low-backed throne.

On the front edge of this base is incised the name of the king and the number of enemies he has defeated (47,209). Images of their dismembered bodies decorate the sides of the base. These depictions of defeated soldiers, hurriedly incised and shown in the disordered poses of death, are a counterpoint to the solemn, dignified and restrained image of the sovereign. The two different representative fashions thus highlight the institutional role of pharaonic monarchy that saw the king engaged in the continual struggle to prevent the intrusion of chaos (the enemies) in the ordered world (Egypt).

A more historical interpretation of the figures decorating the statue base interprets the images of the dead enemies as commemorating Khasekhem's victory over the peoples of the north who rebelled against the central power. Following his success, the pharaoh changed his name to Khasekhemwy ('The two powers arise', suggesting the unification of Egypt). According to other theories, Khasekhem and Khasekhemwy are to be seen as two distinct and successive rulers. (F.T.)

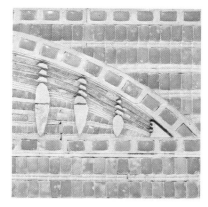

JE 68921

DECORATIVE TILE PANEL

·······································

LIMESTONE AND FAIENCE; HEIGHT 181 CM; WIDTH 203 CM
SAQQARA, FUNERARY COMPLEX OF DJOSER
ANTIQUITIES SERVICE EXCAVATIONS (1928)
THIRD DYNASTY, REIGN OF DJOSER (2630–2611 BC)

This panel, as reconstructed in the Egyptian Museum, is an example of the decoration of the walls of Djoser's underground apartments (also known as 'blue rooms') below his Step Pyramid at Saqqara. Djoser's funerary complex is in many ways a milestone in the development of Egyptian royal architecture: the choice of the pyramid shape and the use of stone for the pharaoh's tomb are the two most important features.

While these two aspects represent major innovations, other features maintain continuity with the traditions of the previous era. Although they were built in stone to preserve and declare throughout eternity the established union between kingship and divinity, all the buildings in Djoser's complex feature traditional decorative motifs previously created in lighter, perishable materials. The enclosure wall is decorated with the 'palace façade' motif, characteristic of the mastabas of the first two dynasties built in unfired brick. The chapels in the courtyards surrounding the pyramid reproduce the wooden architecture of the shrines of the South and the North. The king's funerary chambers also reflect the same concept.

This panel, made of blue faience tiles set into the limestone wall, is a sophisticated, durable version of a woven and painted reed-mat structure. The upper part is further enlivened by the motif of an arch supported by twelve *djed* pillars which decrease in size from the centre towards the edges.

Similar panels also decorated the walls of the South Tomb, a sort of replica of the king's tomb, situated below the opposite side of the courtyard dominated by Djoser's pyramid. (R.P.)

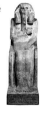

JE 49158

STATUE OF DJOSER

·······································

PAINTED LIMESTONE; HEIGHT 142 CM
SAQQARA, *SERDAB* OF THE FUNERARY COMPLEX OF DJOSER
ANTIQUITIES SERVICE EXCAVATIONS (1924–1925)
THIRD DYNASTY, REIGN OF DJOSER (2630–2611 BC)

King Djoser is represented seated regally on a throne with a high backrest. His right arm is held across his chest with the hand closed, while the left is resting on his left leg with the hand open, palm upwards. He is wearing the cloak of the jubilee festival, which enfolds him, leaving only his hands exposed. His heavy, black, three-part wig falls in two bands on either side of his neck and is partially covered by an archaic version of the *nemes*, the royal headdress that here takes the form of a simple cloth fixed at the front. The exposed ears are set at right angles to the head, a feature frequently encountered in the statuary of later periods, particularly the Middle Kingdom.

The rather stiff pose of the figure is counterbalanced by the plasticity of the face. Deep and closely set eyes are overshadowed by thick eyebrows that would once have been inlaid. High cheekbones, hollow cheeks, a slightly prominent lower jaw and a large mouth are emphasized by the long ritual beard. These features all contribute to an impression of both power and divinity.

On the front of the base are the titles and name of the king Netjerykhet. The name Djoser, by which the pharaoh is usually known today, is not found in contemporary inscriptions but only in documents of later periods.

This sculpture, the first example of life-size Egyptian statuary, was discovered in the *serdab* of the funerary complex of Djoser at Saqqara. Set against the north wall of the Step Pyramid, this small room was equipped with two holes corresponding with the position of the statue's eyes, thus allowing the pharaoh to look out and participate in the rituals and celebrations that took place in the adjacent temple. A plaster cast today replaces the sculpture that is kept in the Egyptian Museum. (R.P.)

47

JE 28504 = CG 1426 – 1427 – 1428

PANELS OF HESIRE

WOOD; HEIGHT C. 114 CM; WIDTH C. 40 CM
SAQQARA, MASTABA OF HESIRE (A 3)
REMOVED BY A. MARIETTE; THIRD DYNASTY (2649–2575 BC)

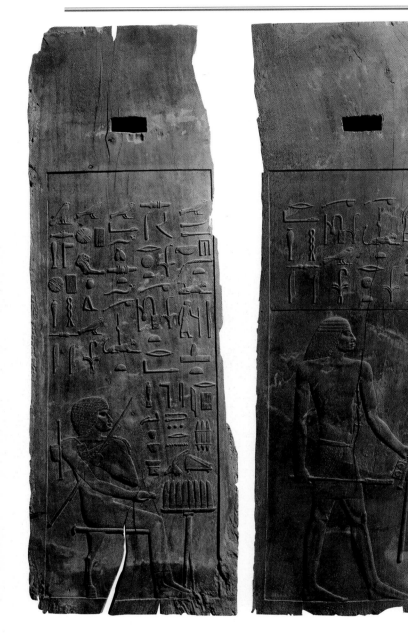

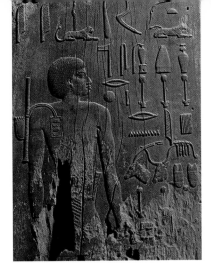

Above the offering table in front of Hesire is a hieroglyphic list of the offerings presented to the deceased: incense, wine, meat and bread. The upper part of the panel is occupied by a list of the titles and the name of Hesire who is defined variously as the chief dentist, royal scribe, chief of Buto and priest of Horus.

In panel CG 1427 Hesire is seen standing with his left leg advanced; in his left hand he is holding the instruments of a scribe and a staff and in his right the *kherep* sceptre, a symbol of power. Here he is wearing a long wig that descends to his shoulders and a short, belted kilt. The tall, slender figure of the official is depicted with great care: the musculature of the arms and legs is emphasized, with chiaroscuro effects achieved through the skilful use of relief. As in the other two panels the face has a stern, serious expression and strong features – arching eyebrows, alert eyes and high, prominent cheekbones, and a narrow mouth with a moustache. The upper part of the panel, separated by a thin incised line, carries a number of Hesire's titles and his name.

Hesire is again portrayed in a standing pose in panel CG 1428, with his arms held along his body and his hands free. On his right shoulder he carries the equipment of a scribe and he is wearing a short kilt. A black curly wig, shorter than the previous examples, frames the face with its soft lines. In front of the official would once have stood an offering table below a list of the offerings made to the deceased, but unfortunately this area of the panel is badly damaged. As in the other cases, the upper part of the panel is occupied by the titles and name of the deceased. (R.P.)

The three panels illustrated here were part of a group of six discovered in the mastaba of Hesire, located to the north of Djoser's Step Pyramid complex at Saqqara. The last resting place of this high-ranking official was divided, as was usual, into an underground part, including the burial chamber where the body of the deceased was placed, and a superstructure. The upper part included the *serdab*, a room in which a statue was placed, and the chapel for funerary offerings. The chapel was a long, narrow room decorated with patterns imitating mats and equipped with niches. The splendid relief panels portraying Hesire in various poses and costumes were from this area. All the panels have a rectangular hole at the top, by which they could be attached to the walls of the niches.

In the first panel (CG 1426), Hesire is seated on a chair with legs ending in lions' paws, facing right. He is wearing a short curly wig and a long cloak that reaches his ankles but leaves his right shoulder and arm exposed. His arm is extended towards the offering table in front of him. His left arm is folded across his chest, and in his left hand he holds a long, thin staff. The tools of the scribe's trade are hanging over his right shoulder. These consist of a palette with discs for the two colours (red and black), which is tied by a ribbon to the water bottle and stylus which rest against his shoulder-blade.

JE 34557 = CG 1

STATUE OF HETEPDIEF

RED GRANITE
HEIGHT 39 CM; MEMPHIS (1888)
THIRD DYNASTY (2649–2575 BC)

This sculpture portrays a kneeling male figure, with his hands held open on his knees, palms downwards. The man is wearing a short, curly wig, rendered by horizontal incisions running round the head, crosscut by vertical lines. The wig frames the man's face with strong features: large, serene eyes, long straight nose, high cheekbones, full cheeks and prominent lips.

In strong contrast with the detailing of the face, the small, stubby body is roughly fashioned and wrapped in a short kilt recognizable only at the rear where the cloth is represented in relief at the waist. Written on the base in low relief is the name of the figure, 'Hetepdief'. He was probably a priest dedicated to the service of the cult of the first three kings of the Second Dynasty, whose names are incised on his right shoulder: Hetepsekhemwy, Raneb and Ninetjer.

The statue should be seen in relation to a group of around twenty so-called archaic sculptures with which it shares certain typological and stylistic features. They are all carved from hard stone and have roughly sketched bodies, short, thick necks, and very detailed heads which are large in comparison with the bodies. None has been discovered *in situ*, and only a few carry brief inscriptions.

It is very likely that the majority of them originally came from the tomb of the person thus portrayed. In the case of the statue of Hetepdief, however, since he is represented in a position of prayer, a location in a shrine dedicated to the three kings named on his shoulder is a possibility.

Clear stylistic parallels and comparisons with other inscriptions allow this sculpture to be dated to the period following the reign of Djoser, which also saw the introduction of the use of statuary in the pyramids. As mentioned, several other archaic statues can be dated with certainty to the same period. (R.P.)

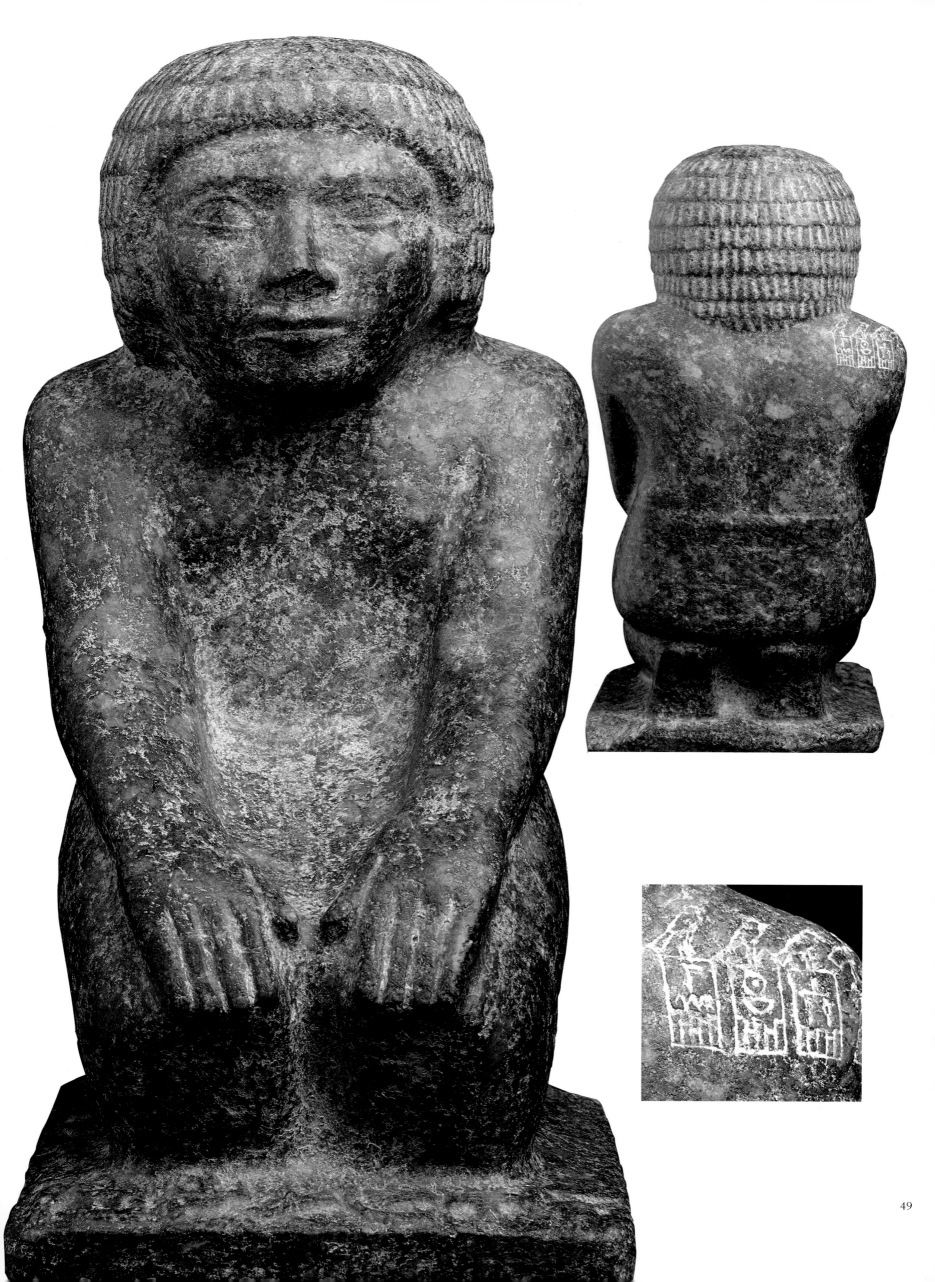

The Old Kingdom, particularly from the Fourth Dynasty to the end of the Sixth Dynasty, represents the high point of ancient Egyptian culture. This period gave birth to the distinctive style and canons of Egyptian art and architecture. It was as if in the Fourth Dynasty some master-plan or programme was devised that defined the specific forms, proportions and orders of art and architecture. Each element of official and funerary practice had its own model, a systematic organization of the relevant elements intended to fulfil a set of specific functions. Each element was also linked inseparably to the others and was part of a basically unified programme. The overall purpose was to confirm the perfect nature of each king's rule and to emphasize his special relationship with the divine world. This canonical system endured until the end of ancient Egyptian history.

Our knowledge of the Old Kingdom comes chiefly from the monuments and objects found in the desert cemeteries of Giza, Abu Roash, Zawiyet el-Aryan, Abusir, Saqqara, Dahshur and Meidum – all sites lying in the vicinity of the ancient capital of Memphis. With the rediscovery of ancient Egypt in the nineteenth century, these sites were ransacked for portable objects, large and small, to grace

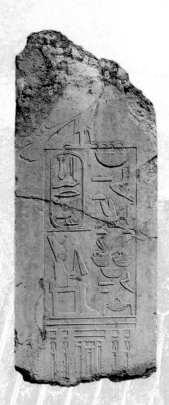

ZAHI HAWASS

THE SPLENDOUR OF THE OLD KINGDOM

FROM THE FOURTH DYNASTY TO THE SIXTH DYNASTY

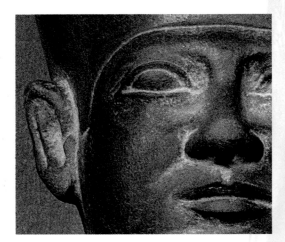

foreign collections. This wholesale looting ceased after the setting up of the Egyptian Antiquities Service in 1858 when Mariette, a young protégé of the Egyptian khedive, employed vast teams of workmen to clear large cemeteries and buried temples. For the first time, major works of art stayed in Egypt. However, Mariette paid his workmen according to the objects found. And it is rumoured that if finds were short, the workmen were quite capable of buying objects on the flourishing antiquities market to present as their own discoveries, or even, when they hit a particularly productive site, to withhold objects 'for a rainy day'!

Later archaeologists working in this area supervised their men more closely, and the provenances of objects found by Herman Junker, George Reisner, Abd al-Munim Abu Bakr, Ahmed Fakhry and

Selim Hassan are well documented and contribute greatly to our knowledge.

The first true pyramids appeared at the very beginning of the Fourth Dynasty, having evolved from the Third Dynasty step pyramids. From the experimental pyramids of Sneferu, the first ruler of the Fourth Dynasty, they quickly evolved within a single generation into the largest stone monuments of the ancient world.

Sneferu built four pyramids: two near the entrance to the Fayum at Meidum and Seila, and two at Dahshur – the Bent Pyramid and the North Pyramid. The Meidum pyramid seems to have been begun as a step pyramid but was completed as a true pyramid after Sneferu's fifteenth year. The Dahshur pyramids, which were completed later in his reign, demonstrate how quickly skills in engineering and stone working were

developing. These pyramids did not stand on their own, but were part of a complex of buildings. A typical pyramid complex contains about fourteen architectural components, each with a specific function and location. The Meidum pyramid is the first example of this type of funerary complex, which continues through the Old Kingdom with little change except for topographic reasons.

The Giza group of pyramids, built by the descendants of Sneferu, follows the same architectural programme. The pyramid, situated on the high desert overlooking the valley, contained the burial of the king and was the focal point of the cult carried out at the lower and upper temples, linked by a causeway. These temples contained all the halls, rooms and corridors necessary for the enactment of the rituals for the king's spirit

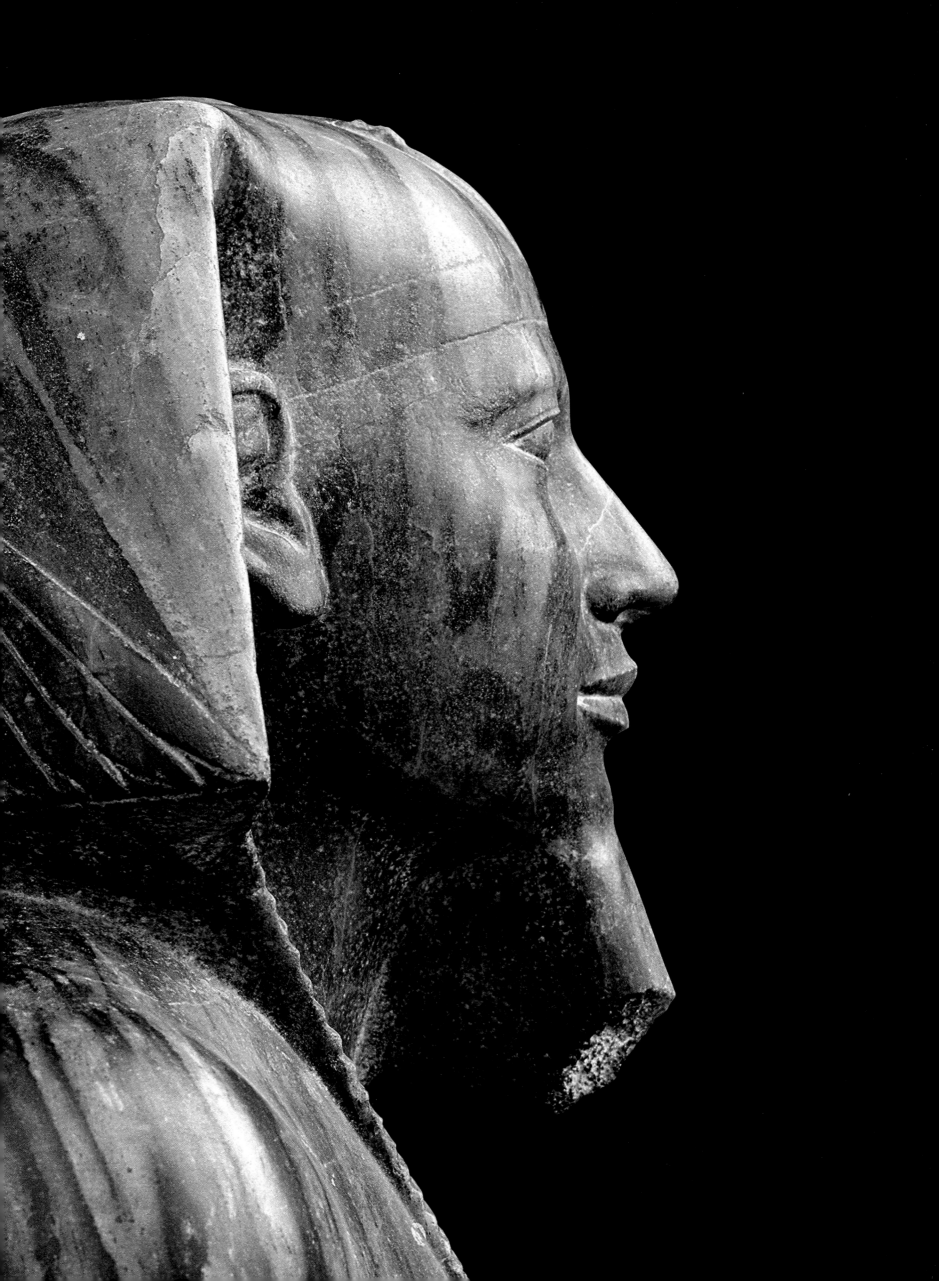

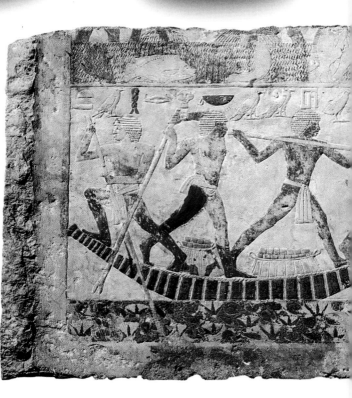

52 ABOVE
BOX FOR COMPONENTS OF
PORTABLE PAVILION
JE 72030
INLAID WOOD
LENGTH 157 CM; WIDTH
22.5 CM; HEIGHT 19 CM
GIZA, TOMB OF HETEPHERES
I (G 7000 X)
G. REISNER'S EXCAVATIONS
(1925); FOURTH DYNASTY,
REIGN OF SNEFERU
(2575–2551 BC)

52 RIGHT
GOLD VESSELS
JE 52404 – 52405
GOLD
CUP WITH SPOUT: HEIGHT

5.2 CM; DIAMETER 8.5 CM
VESSEL: HEIGHT 2.4 CM;
DIAMETER 8.2 CM
GIZA, TOMB OF HETEPHERES
I (G 7000 X)
G. REISNER'S EXCAVATIONS
(1925); FOURTH DYNASTY,
REIGN OF SNEFERU
(2575–2551 BC)

52 BELOW
RESERVE HEAD
JE 46217
LIMESTONE; HEIGHT 26 CM
GIZA, WESTERN CEMETERY
MASTABA NO. G 4340

HARVARD-BOSTON
EXPEDITION (1913);
FOURTH DYNASTY, REIGN
OF KHAFRE (2520–2494 BC)

52–53
RELIEF WITH FISHERMEN
JE 30191 = CG 1535
PAINTED LIMESTONE
WIDTH 145 CM
SAQQARA, UNKNOWN TOMB
FIFTH DYNASTY
(C. 2465–2323 BC)

and for the gods. They also provided the space for the statuary and wall reliefs required to enhance these cults.

Although most of these buildings have suffered over the millennia from the depredations of tomb and stone robbers, exploration and clearing have brought to light some of the finest sculpture produced in Egypt. One of the earliest discoveries was made by Mariette when Khafre's valley temple was cleared in the 1850s and the astonishing diorite statue of Khafre was found concealed in a pit.

Contemporary documents are scarce and are almost all tailored to religious and royal requirements. State records yield only bald factual statements; religious and funerary texts are magical in nature. And officials of the Fourth Dynasty simply recorded their titles. Economic records,

which must have existed, have not been found. The sheer complexity and size of the Fourth Dynasty monuments, however, provide insights into the more prosaic details of governmental organization.

One powerful indication of the king's control over the vast agricultural and mineral wealth of the country, unified under a powerful civil service that revolved around the king's immediate family, is the staggering volume of stone moved, especially during the first three reigns. From the time of Sneferu, pyramid building was the country's foremost national project. The precision of the engineering and orientation of these colossal stone structures of the Fourth Dynasty implies a profound knowledge of astronomy and mathematics for which there is as yet no written evidence. The enormous workforce required must have been drawn from villages throughout the country and organized into teams, probably based on their home district. It is likely that their housing and food supplies were administered through the same

partly carved out of the rock. These were the tombs of the artisans and overseers. In one tomb, a small hole in the mud-brick wall revealed a pair of gleaming eyes. Four and a half thousand years ago, a group of statues had been placed in this niche and bricked up, except for a small hole from which they looked out.

The kings of the Fifth and Sixth Dynasties built their tombs at Saqqara and Abusir. Although their pyramids are not as famous as those of Giza, they incorporate several innovations. The last king of the Fifth Dynasty, Unas, covered the walls of the internal chambers of his pyramid with vertical columns of hieroglyphs. These are the Pyramid Texts: a series of magical spells and utterances based on solar and Osirian religious beliefs which seek to ensure a prosperous afterlife for the king. So powerful was the magic of the written word that its presence alone made the expressed thought a future reality. The discovery of these texts, in the last years of Mariette's life, opened a new chapter in the study of Egyptian religious beliefs.

with his discovery. When he showed them to me, we started excavating and found more blocks with fantastic scenes.

All artistic endeavours in the Old Kingdom developed within the context of the Egyptian concept of kingship and religion. The human body was celebrated as an image of the spirit within. Once a statue was animated by the ritual of 'Opening of the Mouth', it had the potential to house the spirit, which could then exist forever. The beauty that the Egyptian craftsmen strove for provided an attractive dwelling place for the spirit and a focus for veneration and offerings.

Many of the wall reliefs and royal statues now filling the museum once adorned the pyramid complexes. Today it is only possible to reconstruct the original positions of these pieces on paper, to show the complex interaction between art and the architecture for which they were produced.

The timeless and special appeal of Egyptian art was achieved through a combination of pleasing proportions and

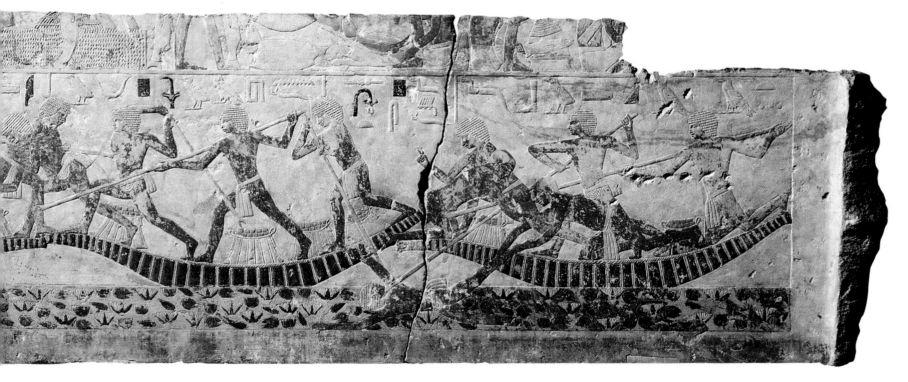

system of teams. The success of these mammoth building projects indicates that the necessary social organization and the administrative skills were in place.

A few years ago, a chance discovery in the low desert margin south of the Great Sphinx was made by a rider whose horse stumbled into a hole, revealing a mud-brick wall. When we investigated, we uncovered a small, densely packed cemetery of mud-brick and stone tombs in various shapes and sizes: tiny, flat-topped rectangular mastabas, conical 'beehives', vaulted corridors, and all sorts of variations, often built with blocks of granite and basalt. Excavation showed that this was the burial ground of workmen and labourers connected with the pyramids.

A narrow flight of steps led from this cemetery up the cliff face to larger tombs,

In addition to the decoration of the internal chambers, the temples outside the pyramids were richly decorated with wall reliefs and adorned with statues of the king and gods. At Abusir, a German team under Ludwig Borchardt cleared pyramids and temples, finding an estimated ten thousand square metres of decorated wall reliefs. It was scarcely credible that more than eighty years later there could be anything left to uncover. However, when the Supreme Council of Antiquities decided to clear away the wind-blown sand with a bulldozer, a driver uncovered decorated blocks from the causeway. Thinking he would not be believed, he photographed the carved scenes of starving people and teams of men dragging the pyramid capstone, and astonished everyone at the inspectorate

superb craftsmanship. All representational forms were drawn in accordance with a strict canon for the human figure, by which the ratio between different parts of the body was always the same, no matter what the size. The basic iconography was established during the Third and Fourth Dynasties, and changed little thereafter.

In paintings and reliefs, the human body was drawn with the head in profile, the shoulders and chest frontally, and the lower torso and legs in profile. Such a figure, although anatomically impossible, is remarkably lifelike. The most important figures are always shown much larger, be it the king or a deity or the owner of the tomb. The same canon applied to figures in the round or in relief, and also to the hieroglyphs that often enhanced and extended pictorial and plastic art.

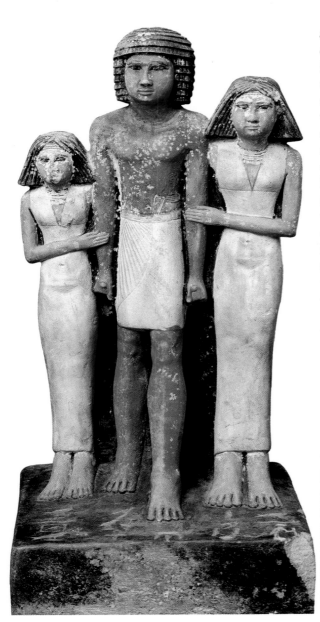

Other traditions were also established at this time. For example, there are subtle differences in the depiction of male and female figures that bring out their different roles in ancient society. Men are shown striding forwards, in contrast with women, who have one foot only slightly advanced or both feet placed sedately together. This distinction between the active, outward-oriented life of men and the quieter, house-oriented existence of women is maintained by the convention of depicting women's skin a pale yellow colour in contrast to the deep red-brown of the men. Eyes were sometimes inlaid, the iris made of gleaming rock crystal with a hole painted black for the pupil. The effect is startling and lifelike, especially when seen in the dim light of a tomb, as was the case when the famous statues of Rahotep and Nofret were discovered.

The craftsmen who made the statues and wall decorations worked in teams, under the direction of a master. Young apprentices were trained in workshops and as their skills increased they were given more complex assignments. When working on a statue, the outline was first painted on to the initial rough stone block. Assistants then removed the excess stone using copper chisels and stone mauls. The outline was repainted and the whole operation repeated until the statue was roughed out. At this stage, trained sculptors finished the body while the master completed the head.

Workshops were maintained by the palace and by some temples. It was probably in the temple workshops that the canons of art were originally formulated, while the stylistic details that changed from time to time may have come from the royal workshops and were certainly most influenced by the idealized official portraits of the king and royal family. Works from provincial workshops can usually be distinguished by their lack of sophistication.

Because they were functional, statues were part of an architectural programme. Their size, type and placement accorded to a formula that integrated them into the building they adorned.

Seated and standing figures of the king are the earliest type of royal statuary. Only one statue survives of Sneferu, the first ruler of the Fourth Dynasty. Found by Fakhry in the valley temple of the Bent Pyramid at Dahshur, it had been broken into three pieces and part of the head was missing. With the help of the German Archaeological Institute, this statue has recently been restored and will now be exhibited in the Egyptian Museum.

We are even less fortunate with likenesses of Khufu, second ruler of the dynasty. Only one tiny statuette survives, found not in the vicinity of his Great Pyramid, but over five hundred kilometres south at Abydos. It was discovered by Flinders Petrie, often called 'the father of Egyptology'. When his workmen brought

him the headless statuette, he noticed the break at the neck was new and ordered his workmen to sift the sand and scour the local antiquities market until the head was found. Two weeks later it was reunited with the body.

The most famous royal statue of this period is undoubtedly the diorite statue of Khafre, originally from his granite valley temple at Giza. This statue is the embodiment of divine kingship. The king, seated on his throne, projects an elegance and majesty on a monumental scale not seen before. The anatomical details of the body enhance the impression of human strength and stability, while the divine falcon hovers behind his head as if to fly with the king to the realm of the gods. This statue also represents the triad of Osiris, Isis and Horus. Horus is the falcon, the throne is the hieroglyphic sign of the goddess Isis, and the king represents Osiris, ruler of the Underworld.

54 ABOVE
STATUE OF MERESANKH WITH HIS TWO DAUGHTERS
JE 66617
PAINTED LIMESTONE
HEIGHT 43.5 CM; WIDTH 21 CM; DEPTH 20.5 CM
GIZA, MASTABA OF MERESANKH
S. HASSAN'S EXCAVATIONS (1929–1930)
LATE FIFTH DYNASTY (SECOND HALF OF THE 24TH CENTURY BC)

54 RIGHT
DOUBLE STATUE OF MERESANKH
JE 66620
PAINTED LIMESTONE
HEIGHT 59.5 CM; WIDTH 21 CM; DEPTH 20.5 CM
GIZA, MASTABA OF MERESANKH
S. HASSAN'S EXCAVATIONS (1929–1930)
LATE FIFTH DYNASTY (SECOND HALF OF THE 24TH CENTURY BC)

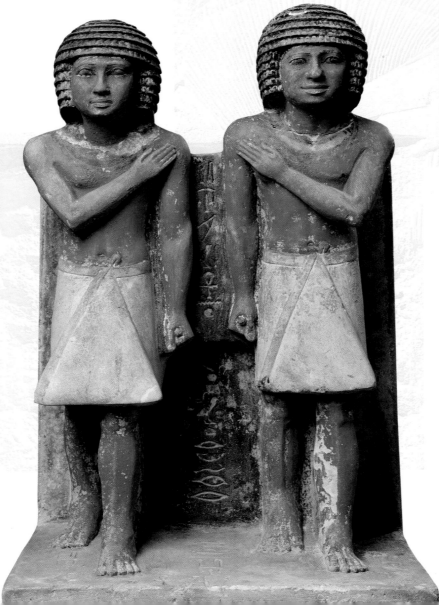

It is estimated that Khafre's pyramid complex at Giza once contained fifty-eight statues. Only a few have survived, and these are damaged. Emplacements for four colossal sphinxes, each more than eight metres long, flank the entrances of the valley temple. Inside the entrance passages are tall niches which once held colossal statues, possibly of baboons. Within the valley temple itself were emplacements for twenty-three almost life-size statues of the king; fragments of several have been found. In the funerary temple there were at least seven large statues of the king in the inner chambers and twelve more colossal ones around the open courtyard. In the Sphinx Temple, next to the valley temple, were ten more huge statues of Khafre. No other Old Kingdom pyramid temple has evidence of so many statues on such a large scale.

Yet the largest statue of this reign is, of course, the Great Sphinx. Carved from an outcrop of rock left in the quarry from which building stones for the pyramids and temples were extracted, the Sphinx lies in an artificial hollow at the foot of the desert hills, next to the causeway and valley temple of Khafre's pyramid complex. Its face, carved in a likeness of Khafre, once had a long, braided 'false' beard, such as gods or deified kings wore. Fragments of this were found by Giovanni Battista Caviglia in 1817 and raise the question of whether the beard was part of the original design or was a New Kingdom addition. The fragments seem to be made from the same limestone as the body, but they are only about thirty centimetres

thick with a roughened back surface, as if to assist bonding to the rock of the body. Only thirteen percent of the beard survives, making it impossible to put it back without extensive restoration. Its replacement would also radically alter one of the best-known faces from the ancient world. The nose seems to have been deliberately chiselled off in the fourteenth century, perhaps as a reaction to a wave of disasters which swept the country at that time – plague, famine, wars – for which pagan images were held responsible.

The Sphinx suffered also in modern times: its surface is crumbling and some of the ancient veneer stones have fallen off, as well as a chunk of bedrock from the shoulder. Recent conservation efforts have succeeded in stabilizing its condition. Its very ruinous state, however, has prompted speculation that it is really much older than the Fourth Dynasty constructions around it, but the arguments for an older

date rest entirely on geological speculation. The archaeology of the site shows clearly that the Sphinx was created at the same time as the lower temple and causeway of Khafre.

Khafre's successor Menkaure also adorned his pyramid complex with statues. When Reisner excavated the temples, he found several intact sculptures and many fragments, including pieces of a larger-than-life alabaster statue that once stood on the central axis of the funerary temple. Some of the best-preserved pieces are the statues from the valley temple showing the king accompanied by the goddess Hathor and a nome-deity. The king is always depicted wearing the White Crown of Upper Egypt and the nome deities are those of Upper Egyptian provinces. They were perhaps originally placed around the central court, where many fragments of others were found. These triads could also be interpreted as representing Horus (the

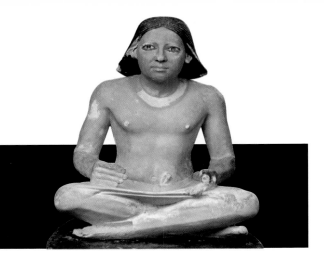

king), Hathor and Re (represented as the sun disc on Hathor's crown). They would then be the focus of the cult of the sun god Re, as creator and sustainer of the world. Re's daughter and wife, Hathor, is depicted with the features of the queen, wife of the living king and mother of the next. These triads suggest that the Old Kingdom pyramid complexes were dedicated to the king and these deities, reinforcing their close relationship.

Few monumental sculptures have survived from the Fifth Dynasty, but those that have show that the skills of the early Old Kingdom had not diminished. The head of Userkaf from his sun temple is of outstanding quality, as is the colossal red granite head of this king from Saqqara.

At Abusir, recent work by the Czech team under Miroslav Verner in the unfinished pyramid of Raneferef has brought to light six small portrait statues of this little-known king, beautifully executed in a variety of different stones. Seventy years earlier, a German team had abandoned work at this pyramid, considering it unprofitable. In the funerary temple the Czech team also discovered statuettes of the traditional enemies of Egypt: Asiatics, Libyans and Nubians.

Two statues in beaten copper from the reign of Pepi I of the Sixth Dynasty have recently been restored. One is life-size while the other is smaller; both portray the king. Although records show that copper statues were made as early as the Second Dynasty, these are the only extant examples from the Old Kingdom.

The use of relief sculpture to decorate temple walls evolved through the Old Kingdom. In the time of Sneferu, reliefs are found only in the valley temple. In Khufu's reign, they appear throughout the pyramid complex, and by the Fifth and Sixth Dynasties, the programme was fully developed.

Wall reliefs were created in a similar way to sculpture in the round. The outline was roughly sketched on the wall in red ink, and

corrected in black ink. Masons would then remove the background, leaving the images standing out for skilled craftsmen to carve the details.

The subject matter of the reliefs can be divided into various categories. First, there are scenes of domination in which the king is seen subduing disorderly elements of the universe, such as wild animals or foreigners, or asserting his sovereignty over his kingdom. These scenes include the hunting of wild animals in the desert, smiting foreigners and receiving offerings from within and outside Egypt. The dedicatory titles of the king reinforce this important aspect of kingship.

In other scenes the king is identified with deities and is depicted as Horus, the falcon god. He is always shown in the company of gods and goddesses, and one of his principal duties is to present offerings to them.

There are also scenes of the king celebrating the jubilee festival (sed festival), showing the king in his palace with his officials and courtiers, seated in the special heb-sed chapel, and performing the ritual run to celebrate his renewed kingship and successful fulfilment of his duties.

Finally there are scenes of the deities confirming the king's power and authority. By offering him the hieroglyphic symbols for power, authority, domination and a long life, they confirm the reality and effectiveness of his kingship. These scenes were designed to confirm the perfect nature of the king's governance forever, culminating in the scene of his own deification.

Once a series of scenes had become part of the repertoire, they were repeated in later temples, not always in the same order, or even as a complete programme, but they were nevertheless effective. For example, a scene from the Fifth Dynasty temple of Sahure depicts the king smiting his Libyan foes. This same scene was copied in all its details, including the names of the enemy, two hundred years later, in the temple of Pepi II. The

historical reality of the event was unimportant but the repetition of the scene ensured the current king's ability to dominate the foes of Egypt.

Objects, both those used in daily life and those intended as funerary objects, also conform to a programme which parallels the dual functions of temple and palace, as attested by wall reliefs and statuary. In Old Kingdom temples, the southern storerooms contained the objects used to maintain the cult, while the northern storerooms held the palace objects that the king would use in the afterlife. Other objects, chosen according to a prescribed programme, were placed in the burial chamber.

Unfortunately, however, no royal burial-place of the Old Kingdom has yet been found intact. Even the subsidiary pyramids of the royal women did not escape later plundering, probably during the breakdown of central power at the end of the Sixth Dynasty. However, in 1925 an unmarked shaft was discovered on the east side of the Great Pyramid. Various inscribed objects from the tomb chamber at the bottom indicate that its owner was Hetepheres, wife of Sneferu and mother of Khufu. Among the objects found were an empty alabaster sarcophagus, a complete set of canopic jars and many items of furniture covered in gold and bearing her names and titles or those of Sneferu. The lack of any superstructure above the shaft and the absence of a body have excited many theories. Reisner, who excavated the tomb, thought that the queen had died early in the reign of Khufu and was buried at Dahshur, near her husband's pyramid. At some point during Khufu's reign, her tomb had been broken into and the body stolen, so her son had the remains brought to Giza, where they were buried hastily near his pyramid.

Another recent theory is that the queen was interred in the Giza shaft as an interim measure during the early years of the construction of the pyramid complex, with the intention of building a small pyramid above the burial. Instead, the small pyramids were built further to the south (to make way for the causeway of the

Great Pyramid) and the queen's body was transferred, leaving her sarcophagus, furniture and canopic jars behind. A third suggestion is that the queen was originally buried in the northern queen's pyramid but this was plundered in the disturbed period at the end of the Old Kingdom. The priests of Khufu's funerary cult removed the funerary furniture and the empty sarcophagus and transferred it to a more secure, unmarked shaft.

As dwelling places were built of mud-brick, the only non-royal architecture to survive is in the form of private tombs. These present less of a uniform and consistent pattern than the royal pyramid complexes, and also show more development in the course of the Old Kingdom. In the early Old Kingdom the king's family and officials were usually buried near his tomb. As the period progressed, these tombs became larger and more elaborately decorated.

Most of what we know about the history and civilization of the pyramid age comes not from the cities of the Old

Kingdom, which were largely destroyed, but from the desert cemeteries that stretch in a great arc from Abu Roash in the north to Meidum in the south. Clustered around the foot of the royal pyramids are the tombs of the citizens of the king, both high court luminaries like Ty and Mereruke at Saqqara, and lesser folk such as Debhen at Giza, and the workmen's tombs. At Giza, the private tombs form a veritable city of the dead laid out on a regular plan of streets and avenues. When Mariette's men first saw these flat-topped, oblong structures with sloping slides, they were reminded of the mud-brick seats outside their own houses and hence called them 'mastaba', the Arabic word for a bench; and so they have been known ever since.

The tomb-chapel, the focal point of the private burial, evolved from the offering stela which identified the owner's name and titles, and the 'false door' that allowed the deceased access to the world of the living. By the Old Kingdom, these two features were placed inside a tomb-

56 OPPOSITE BELOW
STATUE OF A SCRIBE
CG 78
WHITE LIMESTONE
HEIGHT 49 CM
SAQQARA; FIFTH DYNASTY
(2465–2323 BC)

57
STATUE OF PTAHSHEPSES
AS A SCRIBE
CG 83
WHITE LIMESTONE
HEIGHT 42 CM
SAQQARA, MASTABA C 10
FIFTH DYNASTY
(2465–2323 BC)

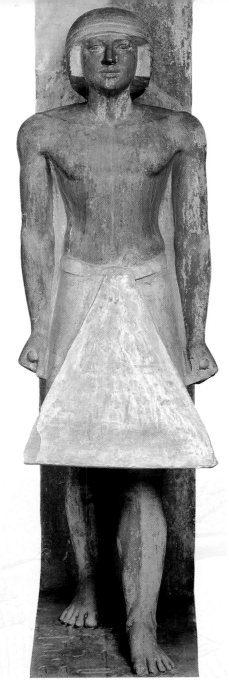

Nile presented different orientations, as the position of the chapel entrance was dictated by the terrain, rather than the architect.

As with royal statues, the statues of private individuals were supposed to function as suitable receptacles for the spirit of the deceased, and served as the focus for rituals and offerings. Most of the private statues were made of limestone and wood, which were easier to fashion than harder stones. A few wooden statues have survived, such as the famous example known as the 'Sheikh el-Beled', a prosperous, middle-aged official in reality called Ka-aper. These softer materials allowed very fine details of the eyes and ears and the strands of hair to be represented. A rare example of a basalt statue of a non-royal individual was recently discovered at Giza, belonging to Per-nyankhu, a dwarf who was depicted carrying the staff and baton of authority. The inscription on his right leg says 'He who pleases his majesty every day'. Recent evidence suggests that he was the father of the dwarf Seneb.

Individual statues, nearly always male, are usually carved as standing figures. Less frequently the figure is seated in a small chair, or on the ground, cross-legged as a scribe. They often hold a staff or some other indication of rank. Although usually depicted in their prime, with lean muscular figures, there was no inhibition about showing the older bureaucrats with a

are nearly always depicted naked, sometimes with a finger to the mouth in a childlike gesture and, although smaller in size, the bodily proportions are the same as those of adults.

Husband and wife are frequently represented close together, for instance side by side in a pair statue, with the wife placing one arm around her husband's waist, and the other arm touching his arm in a conventional gesture of affection and support. This has the effect of thrusting the man forwards, as if to receive the offerings presented, a suggestion reinforced by the convention of showing the wife with both feet together while the husband strides out. This mirrors the real-life situation where the breadwinner supported his wife and children in his lifetime; likewise, the deceased will receive the offerings in the tomb on behalf of his family.

In another common arrangement of such figures the wife is depicted at a much smaller scale, kneeling at her husband's knees and clasping his leg. At this diminutive scale she is often not much bigger than the small children who appear at their parents' sides.

One unusual arrangement of a pair statue is that of the dwarf Seneb and his wife. His short legs are accommodated by seating him cross-legged on a bench so that he is the same height as his wife who is sitting next to him. In the space where the legs would usually be shown in such a

chapel, on the west wall. The gradual expansion of both these essential features and the need for increased wall space was the motivation for the enlargement of private tombs throughout this period. At first, inscriptions gave only names and titles of the occupant. Later, they included details of the family and the biography of the owner. The simple offering stela was elaborated into whole processions of offering-bearers, as well as depictions of official and family life, and scenes of recreation. By the end of the Old Kingdom, the simple, one-roomed chapel had become a labyrinth of decorated chambers and corridors.

Repeated tomb relief themes range from general outdoor motifs, such as water scenes, agriculture and animal husbandry, to more specific scenes of workshops and offices. In the inner chambers the scenes are usually of offering, with processions of offering-bearers, and animals and butchery. The actual list of offerings and the offering table were depicted in the innermost chapel next to the false door.

The shape of the tomb-chapels also changed as they increased in size, but their basic plan was flexible enough to accommodate architectural variations. Rock-cut tombs in the cliffs bordering the

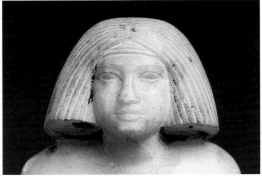

comfortable middle-aged spread. Women, on the other hand, are rarely depicted as anything other than slim and youthful. Even pregnancy is shown only as a discrete rounding of the otherwise flat stomach. There are few statues of women shown singly; the best known is the seated figure of Nofret. However, her statue does form a pair with that of her husband, Rahotep, and should properly be considered as part of a group. The realistic way in which this high-ranking pair are portrayed represents a sudden development in three-dimensional art at the beginning of the Fourth Dynasty.

In the pair statues showing husband and wife together, the woman is usually shorter and slighter than the man, a distinction that reflects a real difference in male and female bone structures. Children

statue are his two diminutive children – an attractive and clever way of drawing attention away from Seneb's short stature, while fulfilling the requirements of depicting this canonical family group.

In addition to statues of private individuals, the Old Kingdom artists also produced another genre, the so-called servant statues. These are small figures of men and women engaged in everyday tasks such as grinding grain, making beer, tending fires and baking bread, or butchering animals. It may be that placing these figures in the tomb magically ensured a food supply for the deceased. Whether they are servants or helpers, or even members of the family, is not clear.

Another category of sculpture is the enigmatic 'reserve heads'. These are realistically sculpted heads that bear no

indication that they had ever been attached to a body. The heads were placed at the entrance of the burial chamber of certain individuals during the Fourth Dynasty. Only thirty-seven examples are known. Some of them are masterpieces of portraiture and may have been made in the royal workshops, in which case they would have been gifts from the king.

Their purpose may have been to act as a substitute if the mummy or statue of the deceased were damaged or removed. A curious, distinctive feature, which has not been explained convincingly, is that in nearly all cases the ears are either deliberately broken or simply missing. This could be due to the rough handling of the heads by tomb robbers, or the result of deliberate mutilation.

The collapse of the Memphite government at the end of the Sixth Dynasty ushered in a century of famine and trouble. Perhaps it was the long reign of Pepi II, which ancient sources claim lasted over ninety years, that weakened the hold of the central government. Or maybe the culprit was a series of low or destructively high Nile floods that brought famine. Large-scale buildings and works of art ceased to be produced. And it is probably during this time that the tombs and pyramids were entered and robbed. It was not until the country was reunited under a new line of rulers from the southern city of Thebes, in the Eleventh Dynasty, that prosperity was restored.

58 OPPOSITE LEFT
STATUE OF TY
JE 10065 = CG 20
PAINTED LIMESTONE
HEIGHT 198 CM
SAQQARA, MASTABA OF TY
(NO. 60)
FIFTH DYNASTY,
REIGN OF NIUSERRE
(2416–2392 BC)

58 OPPOSITE CENTRE
STATUE OF A STANDING
WOMAN
CG 134
ALABASTER
HEIGHT 50 CM
SAQQARA
FIFTH DYNASTY
(2465–2323 BC)

59 RIGHT
FRAGMENT OF A STATUE
OF URKHWY
JE 72221
LIMESTONE WITH TRACES
OF POLYCHROME
DECORATION
HEIGHT 35 CM
UNKNOWN PROVENANCE
SIXTH DYNASTY
(2323–2150 BC)

BIOGRAPHY

Zahi Hawass *is the Director General of the Pyramids of Giza and Saqqara. He discovered the tombs of the workers who laboured on the construction of the pyramids and those of the officers of Khufu west of the Great Pyramid. He was also the first to discover reliable indications as to the methods used in the building of the pyramids.*

Among his most recent archaeological enterprises, of particular importance are the direction of excavations in the area of Menkaure's pyramid and the finding of the double statue of Ramesses II. Having completed the Sphinx restoration project promoted by President Mubarak in May 1998, Zahi Hawass is now devoting himself to the detailed exploration of the entire Giza

plateau. He will soon propose a new approach to one of the most difficult problems in modern Egyptology: how to reconcile mass tourism with archaeology.

In recognition of his work in the field of Egyptology he has received a Fulbright scholarship and a doctorate from the University of Pennsylvania. He has also contributed to a number of prestigious encyclopaedic works relating to Egyptian and Near Eastern archaeology and is the author of publications about the pyramids, the role of women in the royal families of ancient Egypt, and many other similar topics. He teaches archaeology at the University of Cairo, has taught Egyptology courses at UCLA, and has lectured at conferences throughout the world.

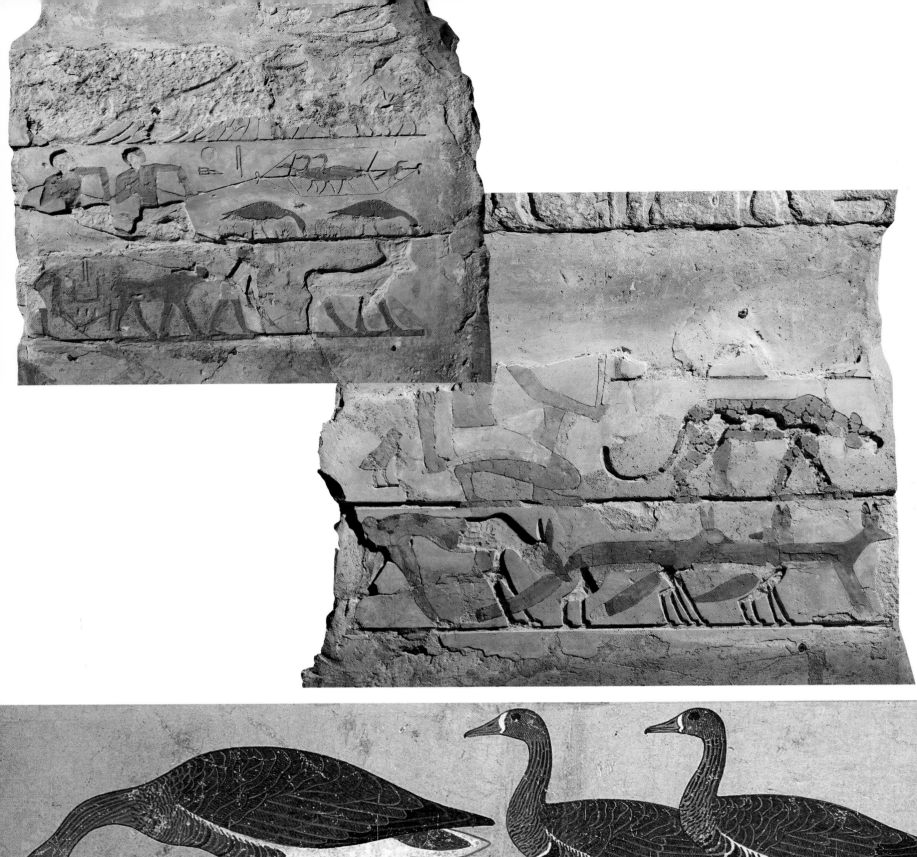

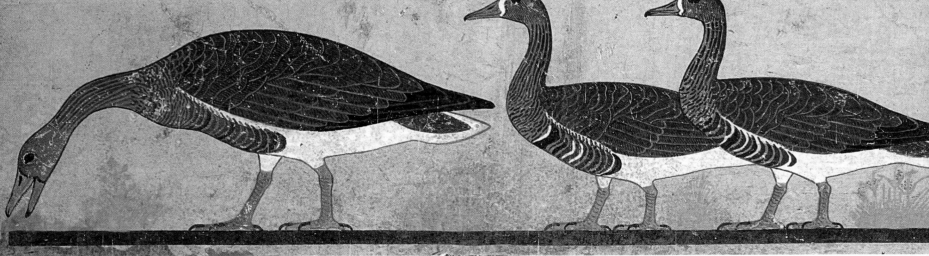

JE 34571 = CG 1742

THE 'MEIDUM GEESE'
...............................
PAINTED PLASTER
HEIGHT 27 CM; WIDTH 172 CM
MEIDUM, MASTABA OF NEFERMAAT; A. MARIETTE'S EXCAVATIONS (1871)
FOURTH DYNASTY, REIGN OF SNEFERU (2575–2551 BC)

This fragment of painted plaster was part of the wall decoration of the mastaba of Nefermaat and Atet at Meidum. More precisely, it decorated the lower section of the wall of the passage leading to the chapel of Atet. Discovered during Mariette's 1871 excavations in the area, the work was immediately recognized as one of the greatest masterpieces of ancient Egyptian painting.

It was painted using a tempera technique, with pigments of mineral origins diluted in water. The precise nature of the binding agent is not known, although it may have been a gum-like substance or egg white.

The scene shows six geese in a field. There are subtle variations that break up the overall symmetry, a practice typical of Egyptian art in the Old Kingdom in particular, and also a feature of the art of later periods. The six geese are arranged in two groups of three, facing in opposite directions. Four have their heads lifted while the two at either

JE 43809

Two Fragments of Wall with Inlaid Decoration

LIMESTONE, COLOURED PASTE
HEIGHT 61.5 CM AND 62 CM; WIDTH 138 CM AND 124 CM
MEIDUM, MASTABA OF NEFERMAAT; W.M.F. PETRIE'S EXCAVATIONS (1892)
FOURTH DYNASTY, REIGN OF SNEFERU (2575–2551 BC)

These two fragments are from the mastaba of Nefermaat, a son of Sneferu. They form part of a group of architectural elements that were removed from the tomb on two separate occasions: during the excavations of Mariette in 1871 and of Petrie in 1892.

The method of decoration is evidence of experimentation with new and highly innovative techniques. However, it seems the Egyptian artists were not satisfied with the results of the experiment, since no further examples of this technique have been discovered.

The shapes of the figures were first incised in the limestone, and these were subsequently filled with coloured paste. As it dried, the paste tended to fall out, and perhaps this was the reason why inlaid wall decoration was eventually abandoned. Some New Kingdom examples do exist, but these use glass paste. The results are extremely effective due to the vividness of the colours and the appearance of depth that the Egyptian artists managed to achieve using this material.

On the right-hand fragment illustrated here, the decoration is arranged in two registers. Both feature hunting scenes: in the lower register three foxes are being followed by a dog that is biting the tail of the rearmost fox. The upper register portrays a man crouching behind a leopard. In his hands he holds two throw-sticks (a type of non-returning boomerang) which he is using to hunt the animal from a distance.

Three registers survive on the second fragment, but the upper one is in a very poor condition. However, it is still possible to distinguish the legs of various animal as well as plants. The middle register features another hunting scene. This time water birds are being trapped in a hexagonal net. Two men kneel on the left of the field, leaning backwards as they pull on the ends of the rope that closes the net containing four geese. Below the net, on the same plane as the men, another two geese are depicted pecking at something in the grass. Between the men and the net, as a caption to the scene, is the hieroglyphic verb *sekh* which means 'close' (the net).

The lower register contains a scene of ploughing. On the right an ox, its coloured paste now missing, is pulling a plough guided by a man. Behind them another ox and another man are represented in the same pose. The word *seka* or 'plough' can be read between the men and the oxen.

These representations are part of the repertoire of scenes of everyday life that decorated the walls of the superstructure of tombs at this period. Such scenes were intended to perpetuate the deceased's relationship with the world of the living.

Alongside these scenes, the deceased is frequently portrayed in the act of receiving funerary offerings. The decorative programme of the tombs of private individuals was designed to ensure that the deceased continued to enjoy the same status that they had held in their earthly life. (R.P.)

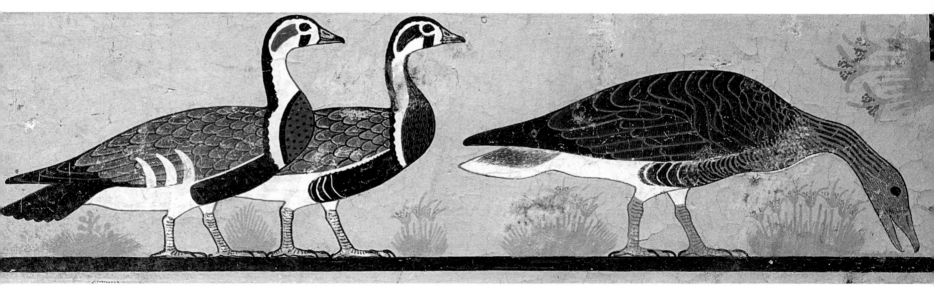

end are bending over pecking at the ground for food. Various details, particularly in the use of colour, enliven the painting, overcoming the lack of movement, and transform a potentially banal composition into a masterpiece.

The right-hand pair of erect geese have different plumage from the other pair and create a marked variation in the repeated sequence of colours, but their tails are arranged more symmetrically. This creates a highly effective disjunction at the focal point of the entire composition.

The two groups form two distinct elements that can each be enclosed within an imaginary semicircle leading from the beak of the goose with the outstretched neck to the tail of the bird at the centre. This grouping of three is not a casual arrangement. A group of three was the method used by artists to express the concept of plurality in the ancient Egyptian language. The three geese on the right and the three on the left therefore represent an unspecified number of birds. In this way the scene goes beyond simple artistic depiction and conventions and can be considered a true example of a pictographic writing system.

The artist has not attempted to represent geese as they exist in nature – the differentiating features of the two types depicted do not allow us to identify actual species. Rather the artist has depicted archetypal geese that, given the high degree of stylization in the rendering of their plumage, more closely resemble hieroglyphs than real birds. The background, a neutral pinkish grey against which the geese stand out sharply, provides further evidence that this work is in effect a text.

The tufts of grass sprouting between the geese provide a deliberate counterpoint to the ordered scene, continuing the play of avoided symmetry that makes the work a timeless masterpiece. (F.T.)

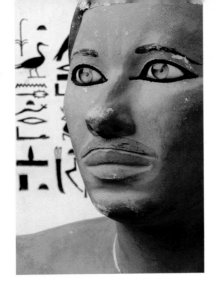

STATUES OF RAHOTEP AND NOFRET

PAINTED LIMESTONE
RAHOTEP (CG 3): HEIGHT 121 CM; *NOFRET* (CG 4): HEIGHT 122 CM
MEIDUM, MASTABA OF RAHOTEP; A. MARIETTE'S EXCAVATIONS (1871)
FOURTH DYNASTY, REIGN OF SNEFERU (2575–2551 BC)

These statues depicting Rahotep and his wife Nofret were found in the Rahotep's mastaba to the north of the pyramid of Sneferu. The two figures are seated on rather solid, square-cut chairs with high, broad backrests that are only slightly lower than their heads. Rahotep's chair is slightly wider than his wife's.

Rahotep is represented with his right arm folded across his chest and his left resting on the left leg. Both his hands are closed. He is wearing a short black wig that leaves his thin face and high forehead completely uncovered. His facial features are carved with great realism. The large eyes are inlaid with quartz and rock crystal and are outlined with heavy black eye-paint and surmounted by painted eyebrows. The nose is well shaped and the rather large mouth is highlighted by a black-painted moustache. Around his neck he is wearing a thin chain and pendant. He is clothed only in a short white kilt. His torso and arms display a well-balanced and powerful musculature, while his legs and feet are rather heavy. On the back of the chair on either side of his head are three columns of painted hieroglyphs listing his titles and name. He is defined as 'son of the king of his body' and among his other titles were 'Priest of Re at Heliopolis, superintendent of works, and superintendent of expeditions'.

Nofret is depicted with her arms folded, swathed in a cloak. The cloak, from which her right hand emerges, wraps around her tight tunic and reveals the forms of her body. Around her neck is a *usekh* necklace with strings of beads of alternating colours: light and dark blue, and red, ending in a row of blue pendants. Her heavy black wig descends to her shoulders and is bound around her forehead by a band decorated with floral motifs. Her face is quite full and has delicate features. The inset eyes are slightly narrower than those of Rahotep. The nose is small with gentle curves, and the mouth is also small with fleshy lips. On the backrest, on either side of her head, an inscription reads 'She who knows the King Nofret'.

The difference in the skin colour of the two figures follows the usual Egyptian practice in depicting males and females. Male figures are always ochre (sometimes almost red) while females are painted a pale yellow.

In spite of the rigidity of the pose and the fixed gaze, these two statues reveal the artist's great skill in giving life to stone images. Even if we did not have the inscriptions to identify the two figures as members of the royal circle, the high quality of the sculptures would be sufficient to reveal them as the work of court artists. (R.P.)

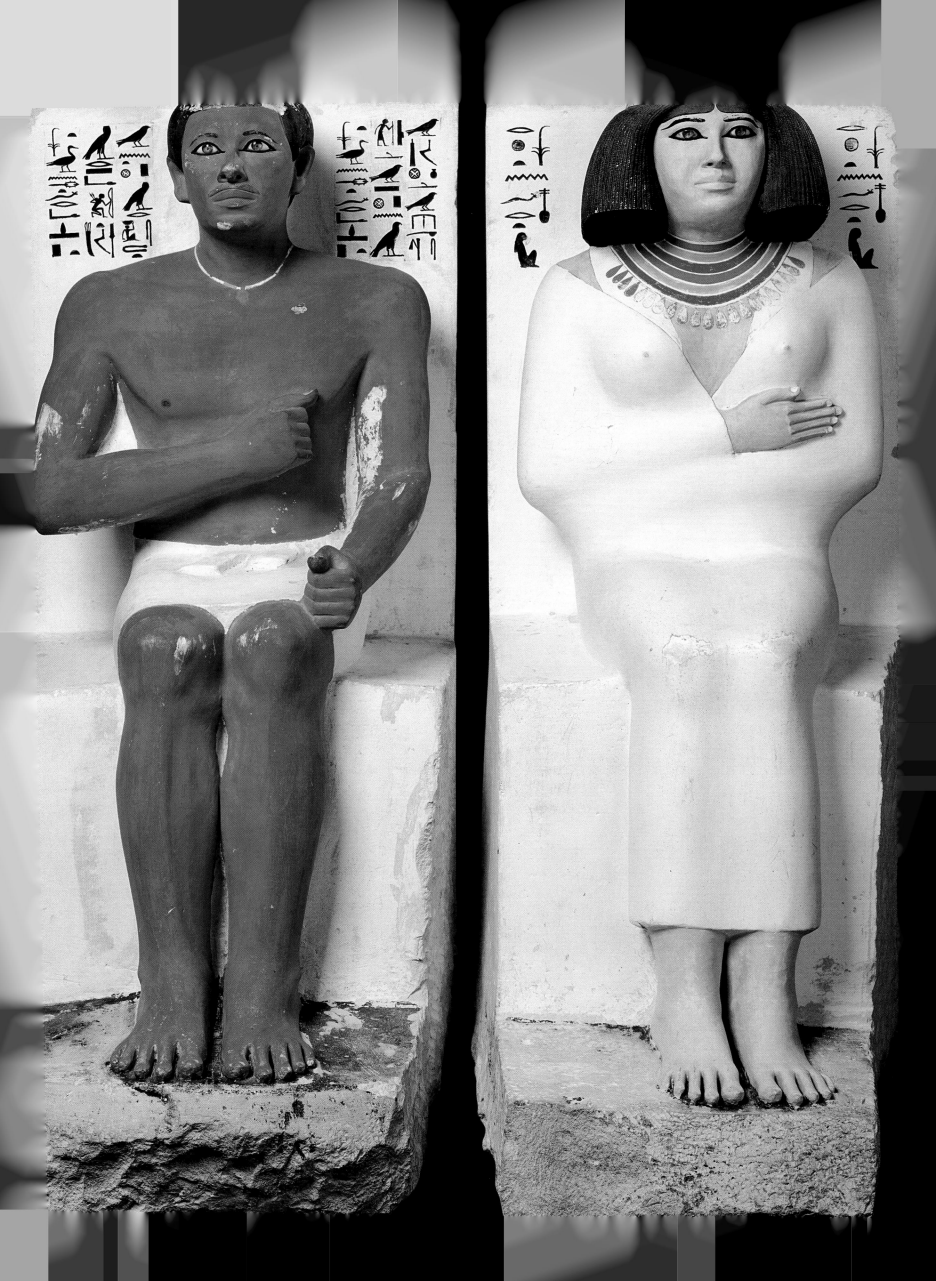

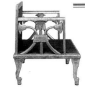

CHAIR OF HETEPHERES
..
WOOD AND GOLD LEAF
HEIGHT 79.5 CM; WIDTH 71 CM
GIZA, TOMB OF HETEPHERES I (G 7000 X); DISCOVERED BY G. REISNER (1925)
FOURTH DYNASTY, REIGN OF SNEFERU (2575–2551 BC)

This chair, together with another similar example and other furniture, was discovered in the tomb of Hetepheres, in a jumbled heap alongside the queen's alabaster sarcophagus. The seat and the backrest in natural wood are surrounded by a simple wooden frame covered with gold leaf, with high arms in gilded wood attached.

The armrests consist of a horizontal bar with a curved upper surface decorated with parallel incisions. The vertical support for the arms is formed of another wooden element, the front of which is decorated with a representation of a woven mat.

The space formed between the arms, the seat and the backrest is occupied by an elegant floral motif which constitutes the dominant decorative element of the armchair.

It is composed of three papyrus flowers, the symbol of Lower Egypt. Their stems are tied by a band imitating a cord. The central flower is straight, while the two blossoms on either side are curved, creating a delicate and elegant fretwork effect.

The backrest of the chair, reinforced at the rear by means of a central support, would originally have been decorated with one of the many inlaid panels found in the funerary assemblage, perhaps the one found below the seat depicting a woman holding a lotus flower to her nose.

The legs are of gilded wood and are modelled in the form of lions' paws on a small cylindrical supports. The front pair is taller than the rear pair, and the deep, wide seat thus slightly inclines towards the rear. (S.E.)

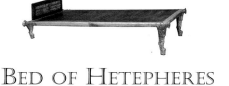

BED OF HETEPHERES
..
WOOD AND GOLD LEAF
LENGTH 178 CM; WIDTH 97 CM; HEIGHT 21.5–35.5 CM
GIZA, TOMB OF HETEPHERES I (G 7000 X)
DISCOVERED BY G. REISNER (1925)
FOURTH DYNASTY, REIGN OF SNEFERU (2575–2551 BC)

The bed of Hetepheres, which was probably designed to be placed below the portable canopy in gilded wood also found in the tomb, was part of the queen's rich funerary assemblage. According to one theory, her burial goods were transferred from her original tomb at Dahshur to another, supposedly more secure tomb at Giza.

The contents of the tomb were discovered in great disarray, the bed was upside down, with its legs pointing towards the ceiling and the headboard towards the entrance to the chamber.

The wooden frame covered with thick gold leaf is made up of two long side bars with terminals in the shape of a stylized papyrus; these sides are linked to one another by two wooden crosspieces. The bed rests on four gilded wooden supports in the form of lion's legs which are attached to the frame with leather straps. The head of the bed is slightly higher than the foot, giving the bed a gentle slope.

The mattress base, supported by two long wooden beams, is fixed to the external frame of the bed. A thin mattress would probably have been laid on top. At the head of the bed would have been placed the gilded and silvered headrest found inside a gold box.

At the foot end of the bed is a wooden panel which is attached to the bottom crosspiece by means of wooden tenons inserted into copper holders. The side facing the bed is decorated with two bands: the upper one contains a continuous feather motif, while the lower one features three rosettes in addition to the feathers. The external surface of the panel was left as plain wood. (S.E.)

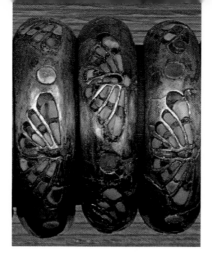

JE 53265 - 53266
- 52281

CASKET WITH BRACELETS

CASKET (JE 53265): GILDED WOOD; LENGTH 41.9 CM
WIDTH 33.7 CM; HEIGHT 21.8 CM
BRACELETS (JE 53266 - 52281): SILVER INLAID WITH CARNELIAN,
LAPIS LAZULI AND TURQUOISE; DIAMETER 9-11 CM
GIZA, TOMB OF HETEPHERES I (G 7000 X); DISCOVERED BY G. REISNER (1925)
FOURTH DYNASTY, REIGN OF SNEFERU (2575–2551 BC)

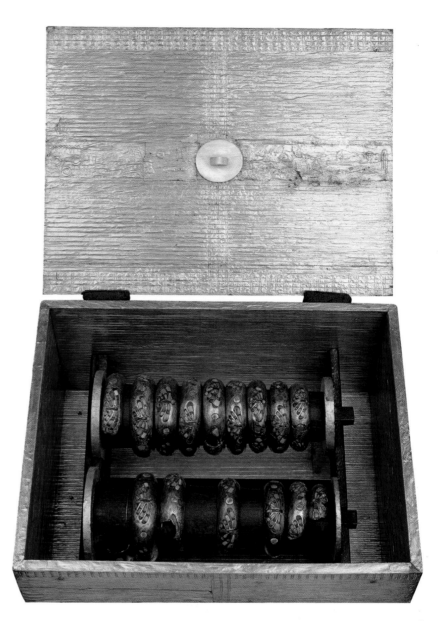

Hetepheres I was the wife of Sneferu, the first ruler of the Fourth Dynasty. She was also the mother of Khufu, who ascended to the throne of Egypt on the death of his father. Her original tomb may have been located at Dahshur, close to the pyramid of her husband, but when it was violated by thieves shortly after the burial, it was decided to transfer the contents to a new, more secure underground tomb close to the pyramid of Khufu.

The queen's funerary assemblage was particularly rich and bears testimony to the exceptional furnishings of the royal tombs of the Old Kingdom. Among the numerous objects haphazardly piled up within the tomb was this casket in gilded wood placed within a chest. The internal and external surfaces of the casket are covered with horizontally incised gold leaf, with borders of a pattern resembling the weave of straw mats.

The lid, fixed to the rear of the casket by means of hinges, is lifted with an ivory knob placed in the centre. On either side of the knob is a horizontal hieroglyphic inscription, reading on the left 'box containing bracelets', and on the right 'Mother of the king of Upper and Lower Egypt Hetepheres'.

Below this second inscription the word 'bracelets' has been added, traced in black ink by a scribe. Perhaps this was done when an inventory of the contents of the tomb was made on the occasion of their transportation to the new tomb at Giza.

The casket was carefully made to contain two rows of ten bracelets. These are threaded on to wooden bars, at the end of which are gold discs. The twenty bracelets, some of which were discovered in a badly damaged state, are made from a curving sheet of silver, open on the interior. The external surface of each bracelet has a number of shallow depressions for the insertion of polychrome inlays, forming a brightly coloured decoration. Four stylized butterflies are separated from one another by a small disc of red carnelian. The bodies of the insects and parts of their wings are inlaid with lapis lazuli. The heads and wings are in turquoise while the tails are in carnelian.

The queen would have worn the bracelets, decreasing in diameter, on her forearms, as seen in numerous relief sculptures in Old Kingdom tombs, and not around her ankles as Reisner, their discoverer, originally thought. (S.E.)

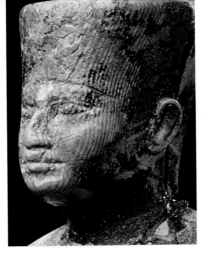

STATUETTE OF KHUFU

IVORY; HEIGHT 7.5 CM
ABYDOS; W.M.F. PETRIE'S EXCAVATIONS (1903)
FOURTH DYNASTY, REIGN OF KHUFU (2551–2528 BC)

This miniature ivory figurine represents Khufu, the builder of the Great Pyramid at Giza, seated on a low-backed throne. The pharaoh's right hand is held to his chest and holds a flail while the left hand rests on his left knee. He is wearing the Red Crown of Lower Egypt and a short *shendyt* kilt decorated with fine pleating rendered by incisions.

In spite of the diminutive size of the piece, the face of the sovereign is carved with great care, depicting in detail the narrow eyes, broad nose, a rather large mouth and a projecting chin. The head is bent slightly forwards and set on broad shoulders, while the rest of the figure is fairly compact.

On the left-hand side of the throne, the royal cartouche is unfortunately illegible. But the *serekh* with the king's Horus name is preserved on the right-hand side. It was only by a fortunate chance, therefore, that this miniature was identified as the only complete image of the builder of the greatest pyramid in Egypt.

When the statuette was discovered during excavations by Petrie at Abydos the head was missing. Petrie immediately realized, however, that the breakage was very recent and aware of the importance of the find, he had all the debris carefully examined until, after three weeks of fruitless labours, his workmen managed to recover the missing head. At that time Petrie was conducting excavations on the site of a ruined temple dedicated to the god of the dead, Osiris. The shrine had been in existence since the Protodynastic Period, although it had originally been dedicated to the god Khentiamentiu (a divinity subsequently assimilated by Osiris). The shrine was continually embellished in later periods with statues and votive stelae, dedicated by kings and private individuals to the great lord of the dead, whom Egyptian mythology also identified as the founder of the pharaonic state and the primordial ancestor of all Egypt's rulers. (R.P.)

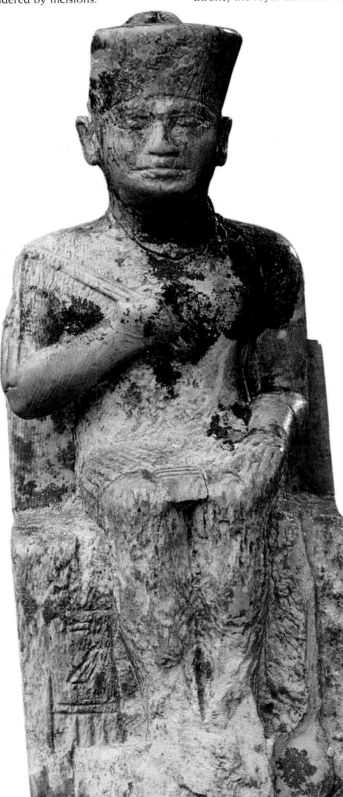

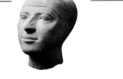

RESERVE HEAD

LIMESTONE
HEIGHT 25.5 CM
GIZA, WESTERN CEMETERY, MASTABA G 4640
FOURTH DYNASTY, REIGN OF KHAFRE (2520–2494 BC)

During the reigns of the three great pharaohs, Khufu, Khafre and Menkaure, the tombs of the most important state figures, many of whom were directly or indirectly related to the pharaohs, were constructed in the cemeteries of Giza alongside the royal pyramids. In the Western Cemetery in particular, among the objects making up the funerary assemblage of the deceased were rather enigmatic sculptures known as 'reserve heads'. Around thirty examples have been found. Deposited close to the coffins, they probably represent the deceased and were substitutes for complete statues that never appear in these tombs, the majority of which date from the reign of Khafre.

Yet these sculptures have a number of features that support a different interpretation. All the known examples lack a wig, one of the elements used to indicate social standing. The ears are also missing or cut off and there are no inscriptions detailing the name or titles of the figure portrayed.

One hypothesis is that these heads should instead be seen as models used to produce the funerary mask that completed the process of mummification which aimed to reconstruct the body of the deceased. Like other elements used in the burial ceremonies, these heads were then placed in the tombs alongside the mummy. This would explain the extreme care taken over the modelling of the face as well as the absence of the ears.

A number of these pieces appear to have been deliberately damaged. On the basis of this observation a recent interpretation suggests that the heads were used in rituals designed to counter potential danger from the spirit of the deceased. While very intriguing, this theory does not appear to be supported by all the evidence.

The attractive sculpture illustrated here has large, almond-shaped eyes, outlined by deeply incised eyelids and surmounted by arching and rather elongated eyebrows in relief. The straight nose has a wide, fleshy base with a sharp incision where it meets the surface of the face. The full mouth is set in a slight smile and the large jaw and broad chin lend the sculpture a sense of great interior strength. (R.P.)

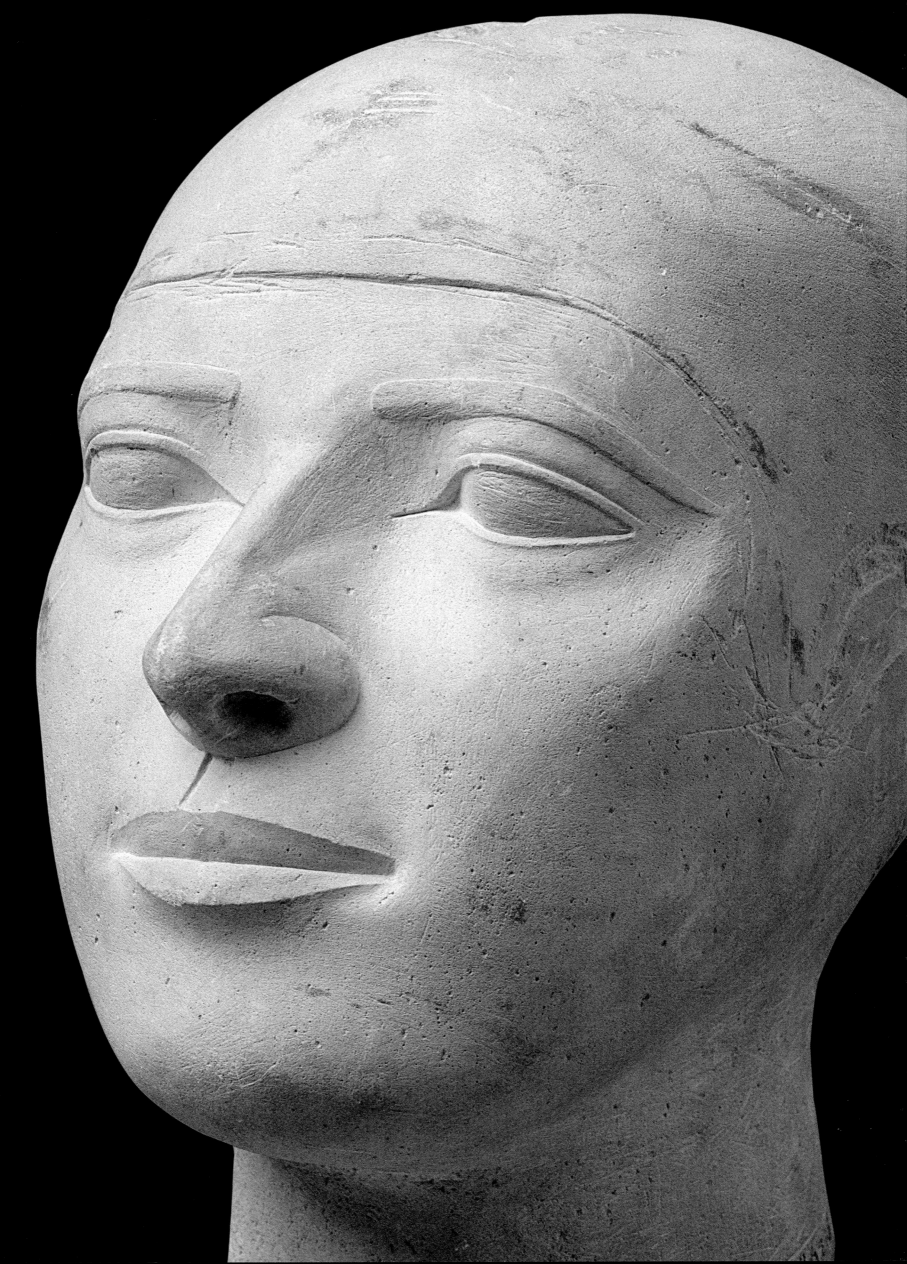

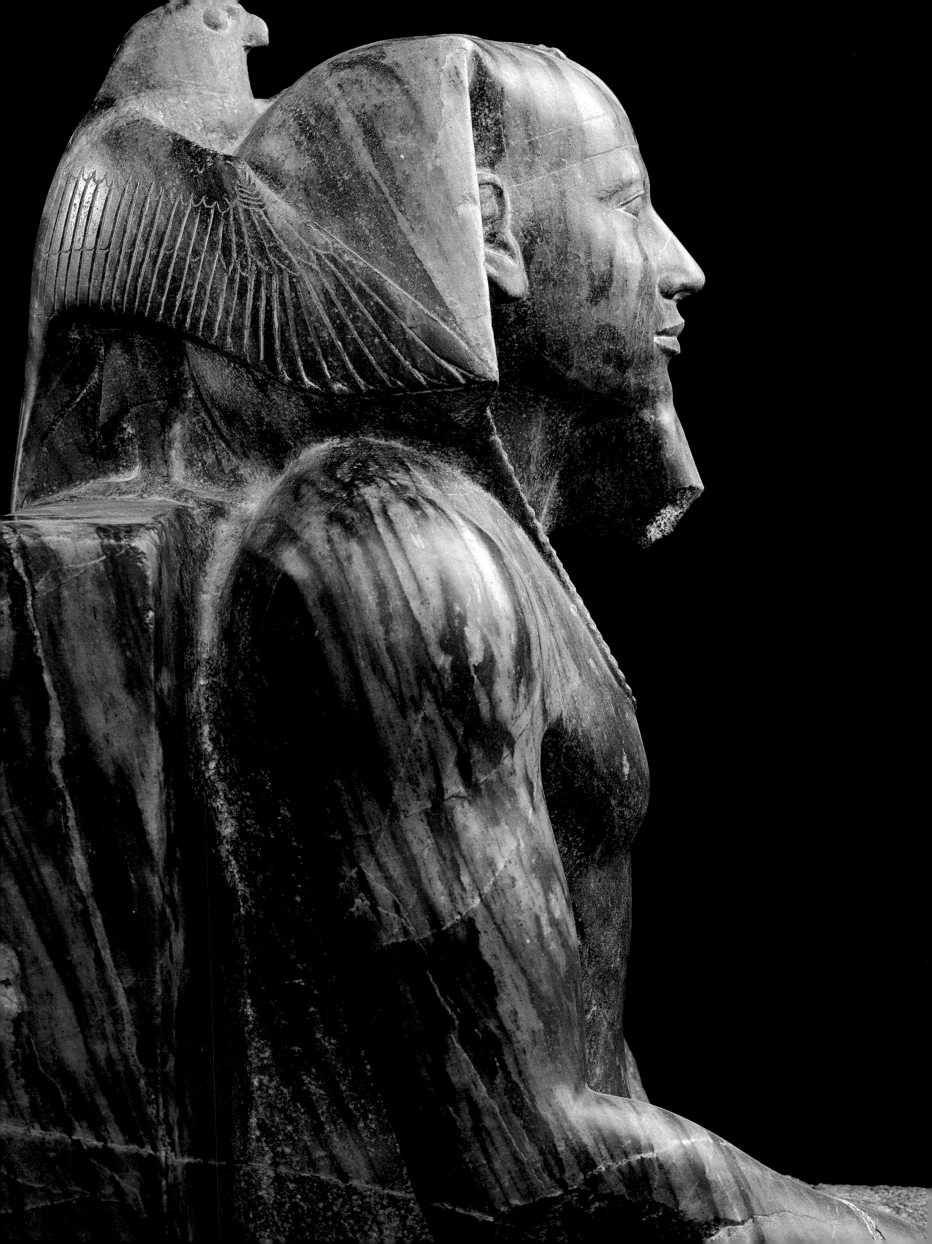

STATUE OF KHAFRE

......................................

DIORITE
HEIGHT 168 CM
GIZA, VALLEY TEMPLE OF KHAFRE; A. MARIETTE'S EXCAVATIONS (1860)
FOURTH DYNASTY, REIGN OF KHAFRE (2520–2494 BC)

One of the great masterpieces of Egyptian art, this majestic statue depicts the pharaoh Khafre seated on a throne that rests on a high base. The backrest reaches the pharaoh's shoulders, above which is a falcon, protectively enfolding the pharaoh's head with its wings. The feet of the throne are carved in the form of the paws of lions, whose heads decorate the front of the seat.

The side panels between the legs of the beasts carry the characteristic *sema-tawy* decorative motif in relief, the symbol of the 'union of the two lands'. The motif is composed of the two heraldic plants of Lower and Upper Egypt, the papyrus and the lotus, whose stems entwine around the hieroglyph for the windpipe and lungs, which can be read as 'unite'.

Khafre wears the *nemes* headdress, adorned with a cobra, and a *shendyt* kilt. In his right hand he holds a piece of cloth while his open left hand rests palm down on the left knee. The regal face is broad and adorned with a false beard. The eyes are small and surmounted by eyebrows in relief, and the nose is broad. The prominent mouth is framed by deep lines. The sense of interior strength and power evoked by the face is echoed by the powerful musculature carved with great skill.

The statue was discovered in a pit in the Valley Temple of the pyramid of Khafre. It was probably originally positioned within this magnificent building, which is still well preserved. Narrow slits in the upper section of the high granite walls allowed light to filter through into the shrine, where it was reflected off the alabaster floor and illuminated the statues of the king. Khafre's temple, an architectural masterpiece, sits well alongside another of the great works of Khafre – the Sphinx, the guardian of the pharaoh's sacred burial place. (R.P.)

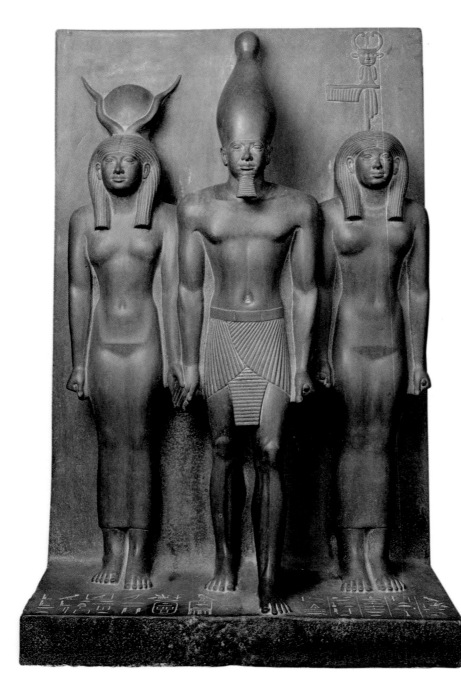

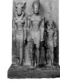

TRIAD OF MENKAURE

GREYWACKE; HEIGHT 93 CM
GIZA, VALLEY TEMPLE OF MENKAURE; G. REISNER'S EXCAVATIONS (1908)
FOURTH DYNASTY, REIGN OF MENKAURE (2490–2472 BC)

In this triad Menkaure is flanked on the right by the goddess Hathor and on the left by a much smaller male figure who wears a three-part crown and a small beard and is shown striding forwards. On his head is the symbol of the nome of Thebes. In contrast with other groups, while the figures are close next to each other there is no actual contact between them. The goddess holds her arms down along her sides, with her hands open against her legs. The hands of the king and the third figure are closed around cylindrical objects.

Another two Menkaure triad groups are conserved in the Museum of Fine Arts in Boston. Unfortunately, one is badly damaged; the other represents the pharaoh on the left of the seated goddess Hathor, with the female personification of the 'Hare' nome on his left.

According to one theory, there would originally have been thirty of these groups, one for each of the Egyptian provinces, but more recently the triads have been interpreted as sculptures dedicated by the pharaoh to the provinces in which the cult of Hathor was strongest. If this theory is correct, there would have been eight statuary groups in total. Although the figures are always the same – the pharaoh, the goddess and a personification of a southern district – the triads display a great variety of details and poses that probably acted as models for the private statuary of the succeeding dynasty. The choice of greywacke was particularly felicitous as, in contrast with the harder diorite used during the reign of Khafre, it allowed the sculptor to model the figures with extreme precision and great expressive strength. (R.P.)

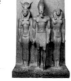

TRIAD OF MENKAURE

GREYWACKE; HEIGHT 95.5 CM
GIZA, VALLEY TEMPLE OF MENKAURE; G. REISNER'S EXCAVATIONS (1908)
FOURTH DYNASTY, REIGN OF MENKAURE (2490–2472 BC)

This triad portrays Menkaure wearing the White Crown of Upper Egypt and a *shendyt* kilt; he is accompanied on his right by the goddess Hathor who is holding his hand. On the pharaoh's left is another female figure, almost the same size as the goddess, on whose head is the symbol of the Diospolis nome, the seventh administrative district of Upper Egypt, whose capital was Hiw (Diospolis Parva).

The base, dorsal slab and the figures were sculpted from a single block of greywacke. Carved alongside the feet of the figures are hieroglyphic texts identifying the goddess, the offerings of the district, and the names of the pharaoh, identified by both his name as the ruler of Upper and Lower Egypt, Menkaure, and by his Horus name 'Kakhui'.

The Menkaure triads were probably part of a group of eight sculptures that would have decorated one of the rooms in the Valley Temple belonging to the king's pyramid complex. They were dedicated by the pharaoh to the goddess Hathor, to whom offerings were made from all the nomes of Upper Egypt, where her cult was particularly popular. (R.P.)

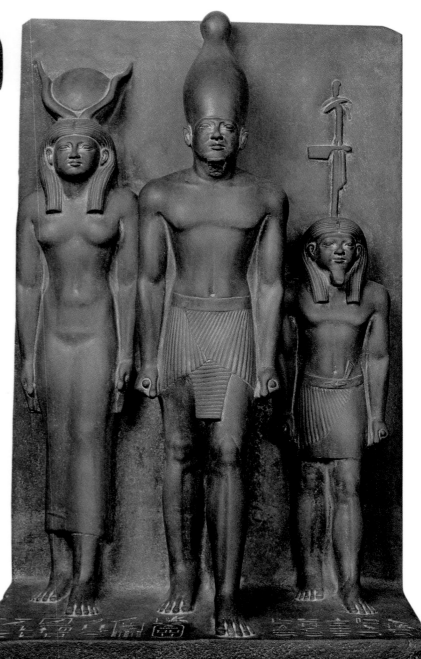

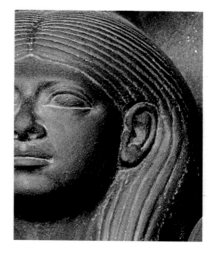

TRIAD OF MENKAURE

GREYWACKE; HEIGHT 92.5 CM; WIDTH 46.5 CM
GIZA, VALLEY TEMPLE OF MENKAURE; G. REISNER'S EXCAVATIONS (1908)
FOURTH DYNASTY, REIGN OF MENKAURE (2490–2472 BC)

This statuary group again depicts three figures standing on a base and set against a broad dorsal slab. In the centre, wearing the White Crown of Upper Egypt, is the pharaoh Menkaure, who is shown as if striding forwards. On his right is the goddess Hathor and on his left a female personification of the seventeenth nome, or administrative district, of Upper Egypt, identified by the symbol above her head.

The pharaoh is wearing a false beard, the symbol of divinity, and a pleated *shendyt* kilt with a smooth, wide belt. His arms are held to his sides and he is gripping two cylinders; these frequently appear in the hands of the king but their precise function is still unknown.

Menkaure's face is rather round. His eyes are drawn with deep incisions and his arching eyebrows continue the line of the nose with its wide, rounded base; the exposed ears are set flat against the head. The pharaoh's body is represented with great care: broad shoulders and chest, and well-modelled leg and arm muscles that express strength, power and security.

Hathor, also depicted in a striding pose, is wearing a three-part wig with deeply incised locks. On her head is her characteristic emblem of the solar disc and cow's horns – a zoomorphic symbol of the goddess. She is wearing a tight tunic that reaches to just above her ankles and highlights the form of her body. Her right arm is held along her side, with the hand gripping the *shen* symbol of eternity. Her left arm passes behind the king and her left hand is visible on his left arm.

The female figure on the other side is slightly shorter than Hathor and, in contrast with the other two, is represented in a stationary pose. She is wearing a wig and tunic like

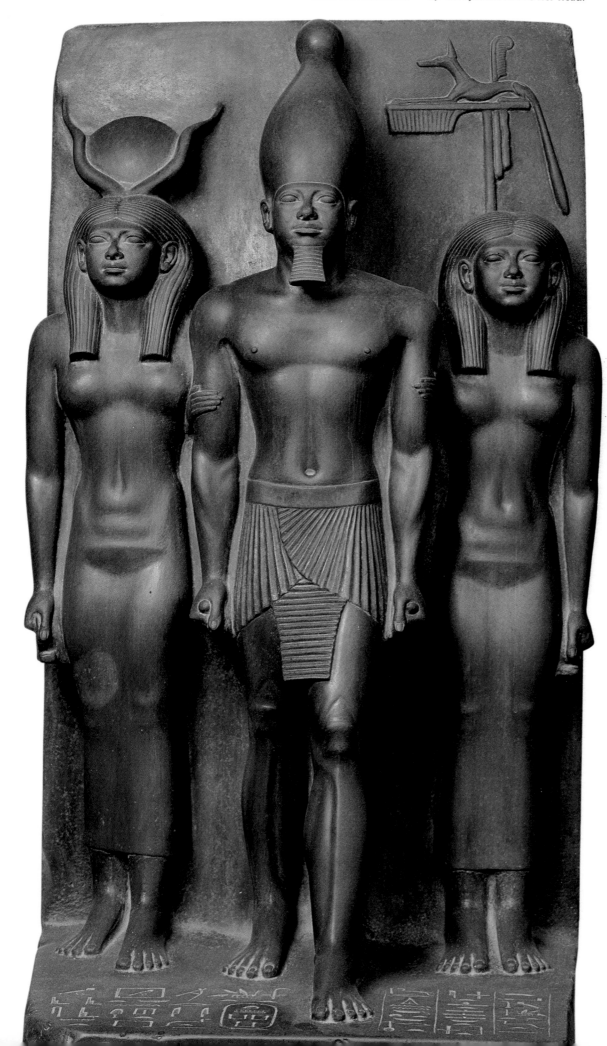

those of Hathor, but on her head she carries a banner with the image of the god Anubis. Her right arm passes behind the shoulders of the pharaoh and her hand grips his right arm. As was customary in statuary of the Old Kingdom, the faces of the two female figures are identical to that of the pharaoh.

Columns of text inscribed in front of the feet of the three figures contain the names and titles of the king and the goddess: 'Ruler of Upper and Lower Egypt, Menkaure, eternally beloved', 'Hathor, mistress of the house of the sycamore in all its homes', and an offering verse in which the personification of the nome promises the king 'all good things … and appearance in glory as the king of Upper and Lower Egypt in eternity'. (R.P.)

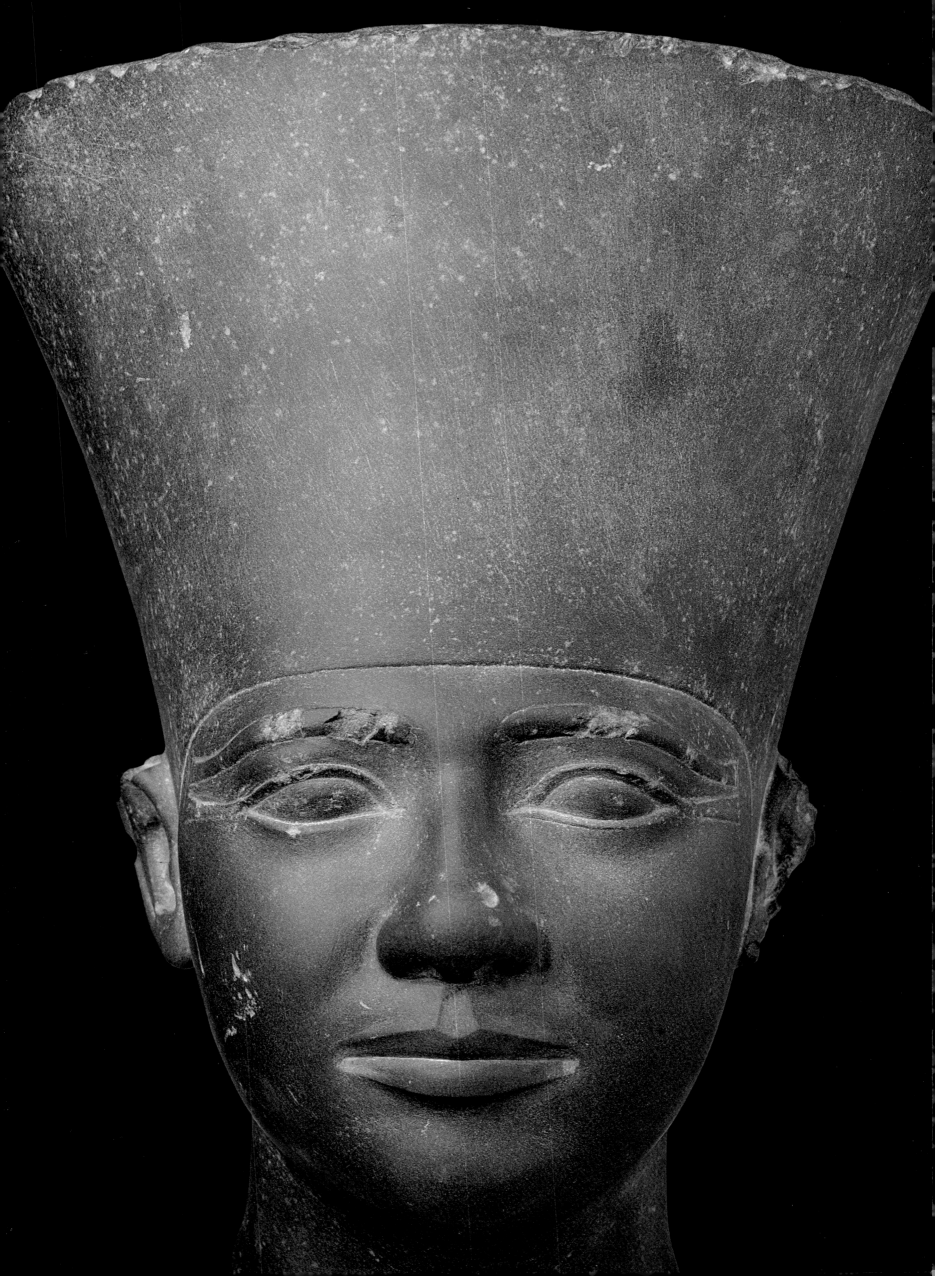

HEAD OF USERKAF

GREYWACKE; HEIGHT 45 CM
ABUSIR, SUN TEMPLE OF USERKAF; JOINT EXCAVATIONS OF THE
GERMAN AND SWISS INSTITUTES OF CAIRO (1957)
FIFTH DYNASTY, REIGN OF USERKAF (2465–2458 BC)

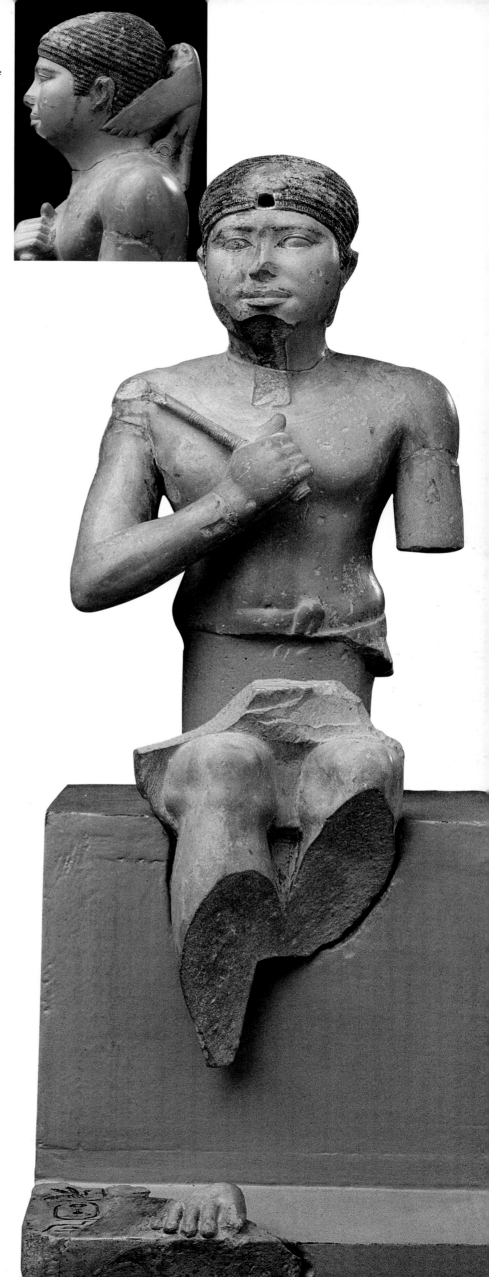

This head of the pharaoh Userkaf comes from the first of the five sun temples which the kings of the Fifth Dynasty dedicated to the god Re at Abu Ghurob. As with the celebrated statues of Menkaure, the choice of greywacke has allowed the sculptor to produce an image of the king that is striking in the soberness of its lines but also in the vividness and subtlety of the face, as if frozen in eternal youth.

The oval of the king's face gracefully extends the tapering line of the Red Crown and terminates with the gentle curve of the chin. The eyebrows in relief are elongated towards the temples, as is the eye-paint that extends the outlines of the expressive eyes. All these features are framed by the incised line marking the base of the crown on the forehead. With its broad, rounded base the nose resembles that of the portraiture of Menkaure, but is set above a slightly wider and more decisively drawn mouth topped by a moustache in very slight relief. The relatively small ears are just visible when the portrait is viewed from the front.

This sensitive portrait has great appeal and is one of the rare examples of sculpture in the round from the Old Kingdom to portray the king wearing the Red Crown of Lower Egypt. It represents a significant moment in the artistic development of Egyptian sculptors at the beginning of the pharaonic period. (R.P.)

STATUETTE OF RANEFEREF

PINK LIMESTONE, PAINTED; HEIGHT 34 CM
ABUSIR, FUNERARY TEMPLE OF RANEFEREF
CZECH ARCHAEOLOGICAL MISSION EXCAVATIONS (1984–1985)
FIFTH DYNASTY, REIGN OF RANEFEREF (2419–2416 BC)

The pharaoh Raneferef is shown seated on a cube-shaped throne with a projecting frontal plinth, on which the only surviving foot rests. The head is turned slightly to the right. Raneferef's right arm is folded to his chest and he is holding a *hedj* sceptre in his right hand. Only the upper part of the left arm is preserved, but it was probably originally resting on the left leg. The king is wearing a black-painted, curly wig. At the centre of the forehead is a hole, probably for the attachment of the royal cobra, the coils of which are just visible on the headdress. Raneferef is dressed in a kilt, a flap of which emerges from the smooth belt.

While little of the body is preserved, the high quality of the sculpture can be seen from degree of care taken over the head. The round face is framed by a wig with side flaps; the eyes, surmounted by eyebrows in relief, are incised on a slightly convex surface. The straight nose is small and set between two deep lines framing the large, smiling mouth, with its thin painted moustache.

A false beard was once attached to the chin but is now missing. As in the case of the sculpture of Khafre, Raneferef is protected by a falcon perched behind him, its wings enfolding the king's head and neck below the ears. The bird, a manifestation of the god Horus holds two *shen* symbols of protection and stability in its talons.

The sculpture was discovered in the Funerary Temple of the pyramid of Raneferef at Abusir during the excavations conducted by the Czech mission of 1984–1985. (R.P.)

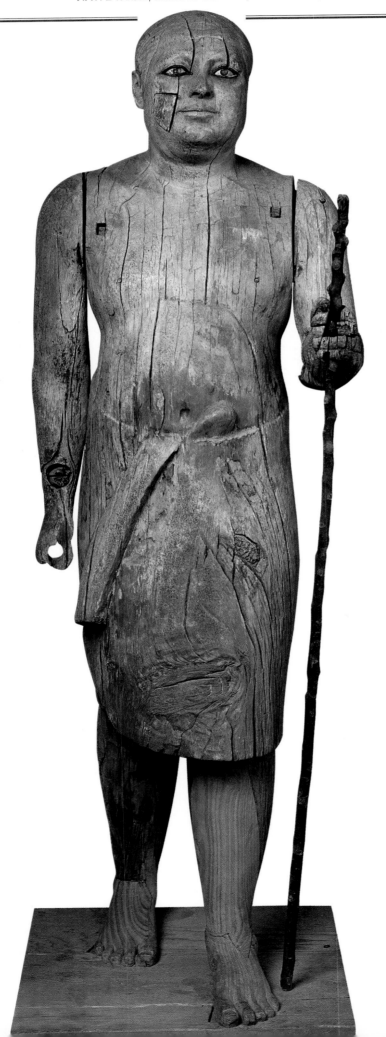

STATUE OF KA-APER

SYCAMORE WOOD; HEIGHT 112 CM
SAQQARA, IN THE VICINITY OF THE PYRAMID OF USERKAF, MASTABA C8
A. MARIETTE'S EXCAVATIONS (1860)
FIFTH DYNASTY, REIGN OF USERKAF (2465–2458 BC)

This sculpture is popularly known as the 'Sheikh el-Beled', a name given to it by Mariette's workers on discovering the statue because of its similarity to the chief of their village (the meaning of the name in Arabic). In reality it portrays the figure of a chief lector priest whose real name was Ka-aper.

The high-ranking official is portrayed in an unusual pose in the context of Egyptian statuary: he is striding with his left leg advanced, but in contrast with conventional sculptures, the weight of the figure rests on the front foot while it is the rear one that is shown in movement. The arms were carved separately and then attached to the body, as was customary with wooden sculptures. The figure's right arm hangs straight along the body, while the left is bent at the elbow and held forwards, the hand gripping a staff (today replaced by a modern reproduction) on which Ka-aper seems to be leaning his weight.

The figure as a whole is bulky, the head rounded, the body fairly plump and the legs robust. Ka-aper has cropped hair, scarcely delineated by an incision around the face and light stippling on the scalp. The high, smooth forehead is interrupted by eyebrows in slight relief that arch over striking eyes. These are outlined in copper to imitate the lines of eye-paint and inlaid with rock crystal. The nose is small and straight, the mouth fairly large, and the wide jaw is softened by plump flesh and a double chin. The rather rounded stomach is wrapped in a kilt reaching the knees, knotted at the waist with a large flap.

Unusual for the extreme realism with which the figure is depicted, this sculpture perfectly embodies the psychological and physiological characteristics of a wealthy man, captured in the slow, dignified movement appropriate to his rank.

A magnificent example of the private sculpture of the Fifth Dynasty, this statue is deservedly one of the most frequently illustrated and most highly regarded works of the Old Kingdom. (R.P.)

STATUARY GROUP OF THE DWARF SENEB AND HIS FAMILY

PAINTED LIMESTONE; HEIGHT 34 CM; WIDTH 22.5 CM
GIZA, TOMB OF SENEB; H. JUNKER'S EXCAVATIONS (1926–1927)
LATE FIFTH–EARLY SIXTH DYNASTY (24TH–23RD CENTURY BC)

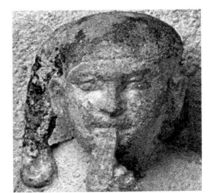

The great sense of harmony and order that permeates all forms of Egyptian art is exemplified by this family group, which includes an unusual figure. The head of the family, Seneb, was supervisor of the pharaoh's wardrobe and served the cults of the Fourth Dynasty pharaohs Khufu and Djedefre.

Seneb's growth has been affected by dwarfism, a condition which is represented realistically: his head is large, his body and limbs short in comparison. None the less, the Egyptian artist has managed to create a framework that inserts his unusual body-type without affecting the balance of the composition.

Seneb is seated next to his wife on a rectangular seat, with his arms folded on his chest and his legs crossed in the position of a scribe. His wife is seated in the traditional pose. In the space below the seat that in other statues would be occupied by Seneb's legs, are the couple's two children.

Seneb has short hair, large, slightly upturned eyes, a pronounced nose and mouth, and small ears. He is wearing a short white kilt. His skin is painted an ochre tone. His wife, Senetites, has very light skin and is wearing a smooth black wig that reaches her shoulders, and a long white tunic. Her arms are affectionately embracing her husband. Her right hand rests on his right shoulder and her left on his left arm.

The children are depicted naked, both with their fingers to their mouths. The boy on the right of the composition is wearing the braid of youth. On the panels of the seat and on the base are incised the names and titles of the four figures.

The sculpture was discovered within the small limestone *naos* of Seneb's tomb at Giza. (R.P.)

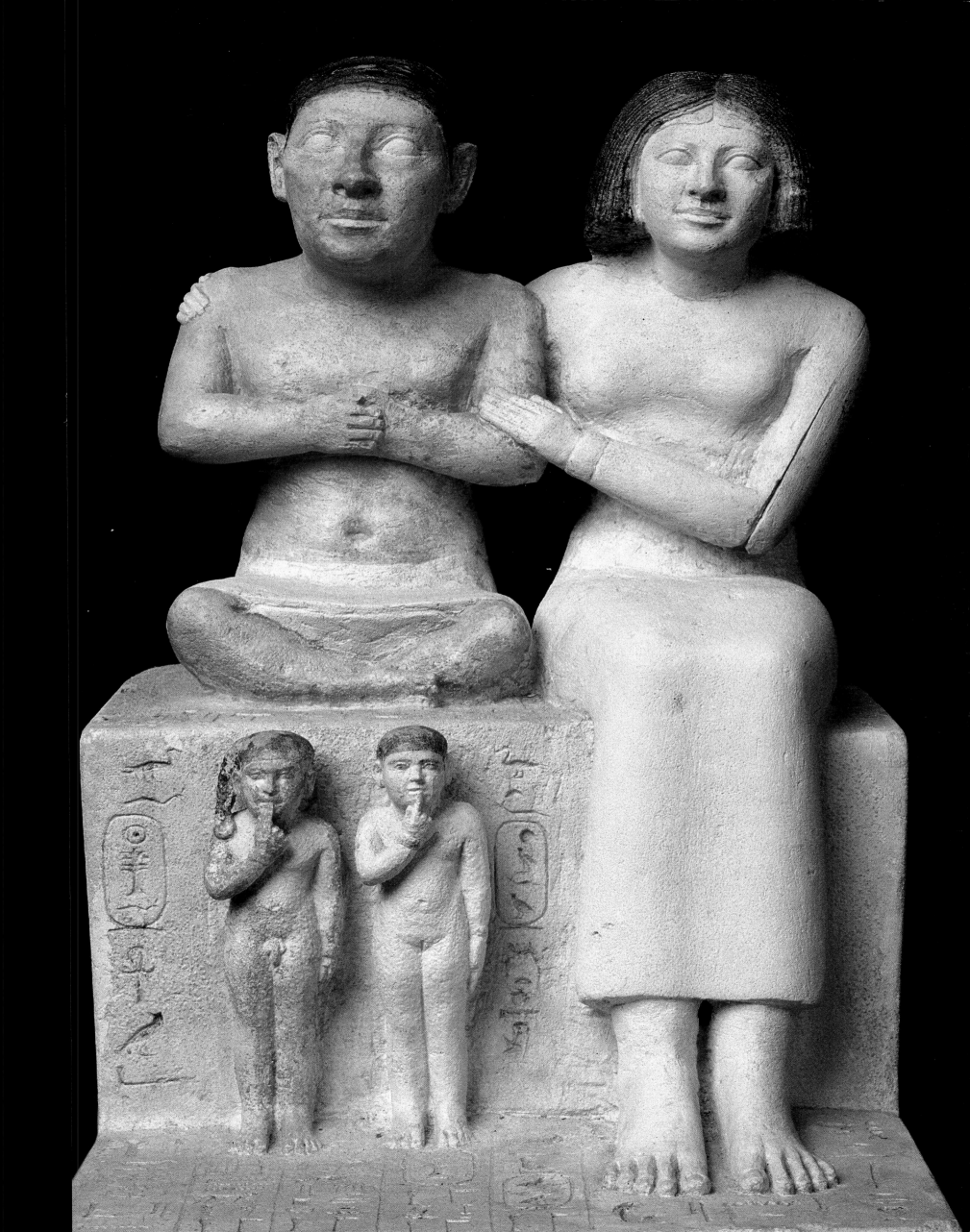

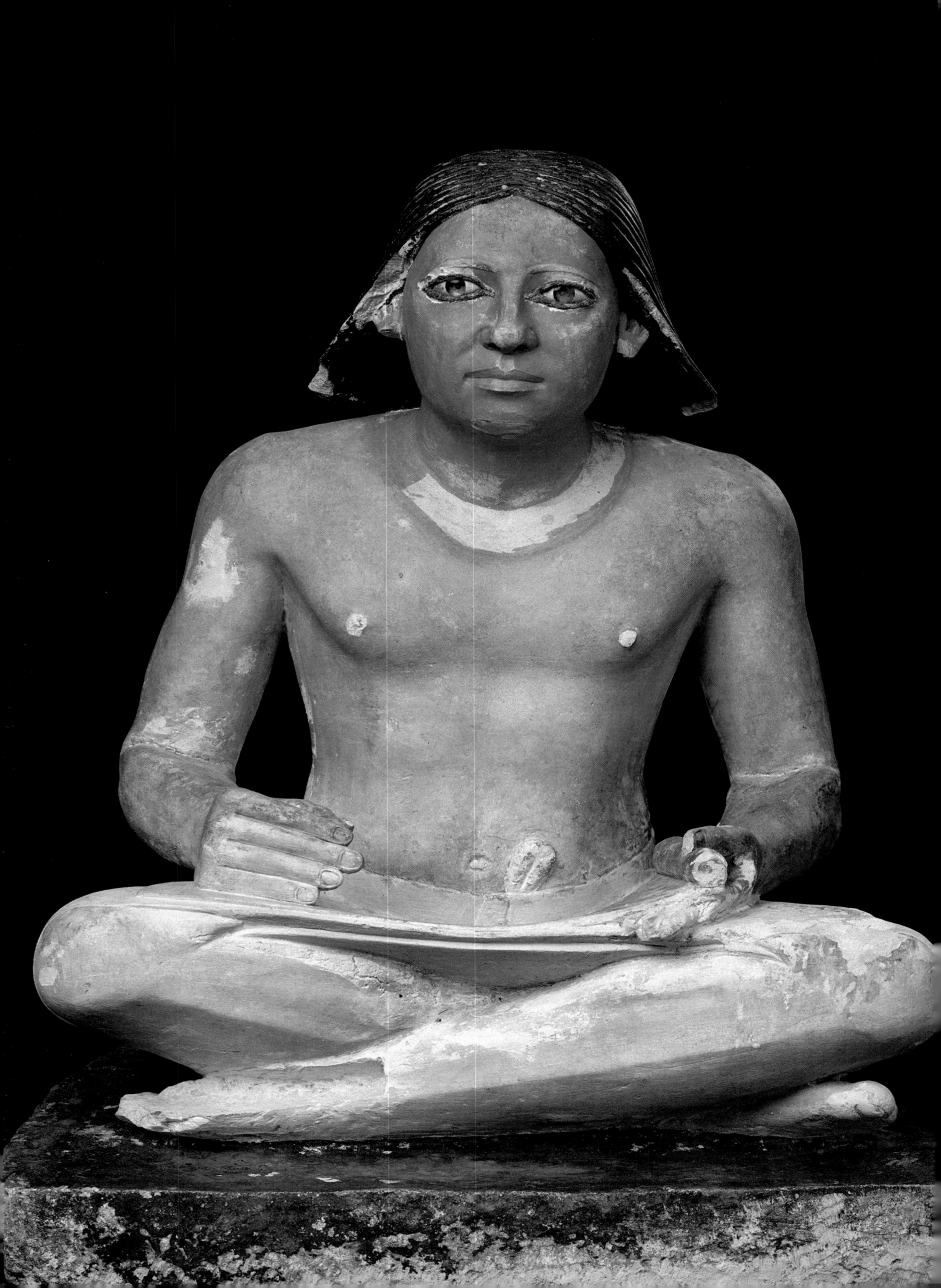

STATUE OF A SCRIBE

..

PAINTED LIMESTONE
HEIGHT 51 CM
CEMETERY OF SAQQARA
EARLY FIFTH DYNASTY (MIDDLE OF THE 25TH CENTURY BC)

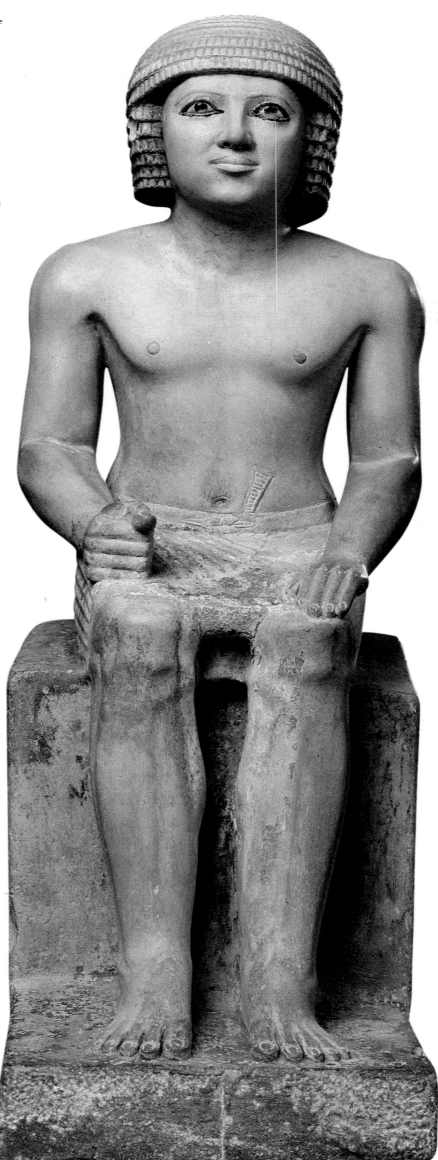

This statue, on a black-painted rectangular base, represents a scribe seated on the ground with his legs crossed. A partially unrolled papyrus scroll, held in his left hand, rests on his crossed legs. The right hand, intended to grip a stylus, is poised over the open papyrus in the act of writing.

The man is wearing a black flaring wig that leaves the lobes of his ears exposed and elegantly frames his strong facial features. His countenance is rather rounded and he has a broad forehead. Two large, inset eyes are outlined by a thick rim of copper representing eye-paint and are surmounted by eyebrows in relief, producing a striking effect. The nose is straight and regular and the lips of the cleanly drawn mouth are full.

With a gaze fixed straight ahead, the scribe seems to be removed from the activity in which he is engaged.

An unpainted band around his neck reveals the presence of a multiple-strand necklace. The skin is an intense orange on the face and neck, but fades below towards yellow. The broad shoulders and chest, with musculature highlighted by the pectorals, are somewhat at odds with the generally relaxed pose of the seated man.

He is wearing a short white kilt, bound with a belt from which a loop emerges next to his navel. The lower part of the body appears less well finished: the legs are rather roughly modelled and are set in a rigid position, in contrast with the fluid lines of the rest of the body.

Figures represented as a scribe, such as this, became very popular in private statuary. They appeared during the course of the Fourth Dynasty, the earliest example being that of Prince Kauab, who lived during the reign of Khufu. (R.P.)

STATUE OF A SEATED MALE FIGURE

..

PAINTED LIMESTONE
HEIGHT 61 CM
SAQQARA; EGYPTIAN ANTIQUITIES SERVICE EXCAVATIONS (1893)
EARLY FIFTH DYNASTY (MIDDLE OF THE 25TH CENTURY BC)

This statue portrays a male figure seated on a cube-shaped throne with a projecting frontal step on which the feet rest. The man is wearing a curly, helmet-like wig that would originally have been painted black, and a short, white, pleated kilt. Both of his hands are resting on his knees, the right is closed in a fist and held vertically, while the left is open and palm down on the leg.

The man's rounded face is tilted slightly upwards and possesses a great and intense luminosity. The large inset eyes are outlined with rims of copper representing the lines of eye-paint and topped by

relief eyebrows. The nose is broad and straight, though quite small, as is the mouth, though the lips are full. The luminosity of the face, the liveliness of the eyes and the shape of the mouth give the face a joyful expression. The body is slightly under-sized in proportion to the head and is less well finished; the arms in particular are rather rigid. The broad shoulders, square-cut torso and the muscular legs are in sharp contrast with the serenity of the face.

The sculpture was discovered at Saqqara, not far from the attractive statue of a scribe (CG 36), discussed above. (R.P.)

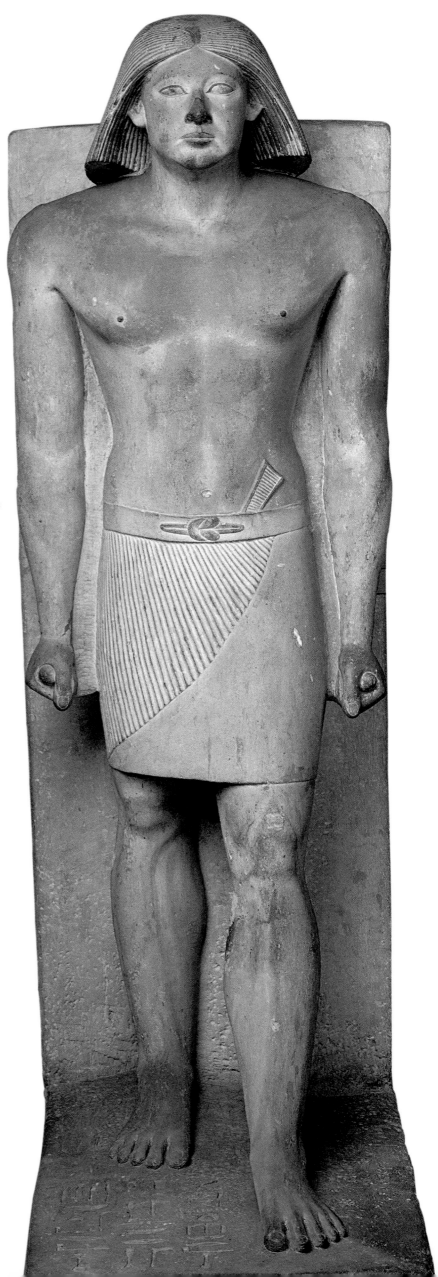

JE 10063 = CG 19

STATUE OF RANEFER WITH WIG

PAINTED LIMESTONE
HEIGHT 178 CM
SAQQARA, MASTABA OF RANEFER (NO. 40)
A. MARIETTE'S EXCAVATIONS (1860)
FIRST HALF OF FIFTH DYNASTY (MIDDLE OF THE 25TH CENTURY BC)

This statue represents the high priest Ranefer and was discovered, together with the one shown opposite, in his tomb at Saqqara. Both provide important evidence of the high artistic standards achieved by Egyptian sculptors of the Old Kingdom.

Ranefer is depicted striding forwards. The plinth rises at a right angle behind him to the level of his head, forming a broad dorsal stela that protects the full height of the figure. He is wearing a flaring wig that leaves the lobes of his ears exposed and forms an elegant frame to the sophisticated features of his face. The eyes are embellished with black outlines that are slightly downturned at the tips and are followed by the line of painted relief eyebrows. The straight nose widens slightly at the base. The mouth is small and delineated with precise outlines. The cheekbones and slightly wide jaw are softened by the rounded lines of the cheeks. The strong neck rests on broad shoulders and over a powerfully muscular torso emphasized by a central line reaching the navel. The pectorals are linked with the arms by tapering curves. As the figure is gripping two cylindrical objects in his hands, the muscles of the arms are emphasized and appear tensed.

Ranefer is wearing a short kilt with a pleated flap fastened by a belt with a central knot. The muscles of the legs are also carefully rendered and, like the rest of the figure, reveal the strength and powerful physique of the healthy young man.

Ranefer's name and titles, including that of priest of Ptah and Sokaris, are carved on the base, alongside the front foot. (R.P.)

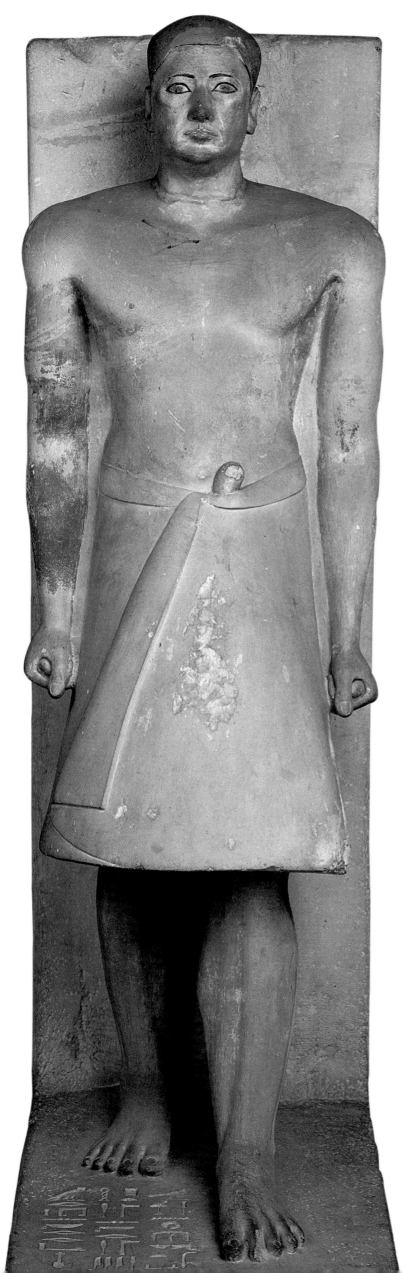

Statue of Ranefer

Painted limestone
Height 186 cm; Saqqara, Mastaba of Ranefer (no. 40)
A. Mariette's excavations (1860)
First half of Fifth Dynasty (middle of the 25th century bc)

In this statue, as in its pair, Ranefer is portrayed upright, standing on a base. The rear of the base rises at a right angle to form a dorsal slab that rises to almost the full height of the figure. The priest is depicted in the same pose as in his other statue, with his arms extended along his body and his hands closed around two objects. However, several elements make this statue of Ranefer quite different from the first, both in terms of dress and physiognomy.

Ranefer is wearing a loose skirt reaching his knees, with a rigid front flap that falls from a belt knotted at the waist. The black-painted hair is very short and clings to the head like a cap. The face has features very similar to the other statue, but the cheeks are hollower and the overall shape is heavier, with a slight double chin.

While the physique is similar, with broad shoulders and powerful limbs, the muscle tone is softer, with gentler, broader curves that conceal the bone structure. The central groove dividing the chest is less noticeable and the stomach is slightly more prominent. All these elements clearly indicate a

desire to present a more mature image of Ranefer as an older man.

The sculptures were discovered in two niches in the back wall of the mastaba chapel of Ranefer in the cemetery at Saqqara, where a seated statue of his wife Hekenu was also placed. The dimensions of the mastaba and the quality of the sculptures are evidence of Ranefer's high social standing, and enable us to identify royal court sculptors as the creators of his splendid portraits. (R.P.)

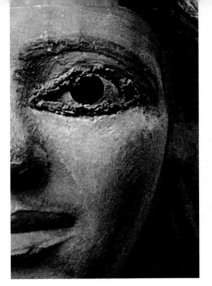

STATUE OF KAEMKED KNEELING

PLASTERED AND PAINTED LIMESTONE
HEIGHT 43 CM
NECROPOLIS OF SAQQARA, TOMB OF THE TREASURER WERIRNI (NO. 62)
A. MARIETTE'S EXCAVATIONS (1860)
SECOND HALF OF FIFTH DYNASTY (EARLY 24TH CENTURY BC)

Kaemked is depicted kneeling on a rectangular base with his hands crossed on his lap. On his head is a medium-length flared wig, with the impression of locks of hair created by regular vertical grooves cut in the stone. Wigs of this type are fairly common in private statuary of this period.

The priest is wearing an elegant short kilt with pleated panels and a knotted belt with four rows of beads attached. His thin face has rather prominent features: inset eyes decorated with eye-paint represented by a thick copper outline, a wide nose, rounded at the base, and a fairly large mouth with

fleshy lips, set in a serene smile. His wide-shouldered torso has pronounced pectoral muscles, with a median groove reaching to the navel clearly visible.

This statue, of good artistic quality, is in strange contrast to that of the tomb's actual owner, the treasurer Werirni (Kaemked was his funerary priest). It was found in the tomb of the official, together with other statuettes of servants.

The kneeling posture was not very common in the Old Kingdom but has a precedent in the archaic statue of Hetepdief, another priest connected with the funerary cult of three Second Dynasty kings. (R.P.)

DOUBLE STATUE OF NIMAATSED

PAINTED LIMESTONE
HEIGHT 57 CM
SAQQARA, MASTABA OF NIMAATSED (D 56)
A. MARIETTE'S EXCAVATIONS (1860)
SECOND HALF OF FIFTH DYNASTY (EARLY 24TH CENTURY BC)

This sculpture represents a double image of the priest and judge Nimaatsed, associated with the cult of Hathor and Re in the solar temple of Neferirkare Kakai. Nimaatsed's titles and name are contained in the brief inscription incised in the black painted base and picked out in white. A dorsal plaque rises from the base and reaches to the height of the shoulders of the two figures.

The only substantial difference between the two figures, apart from a barely visible rotation of the axis of the right-hand statuette, is a slight variation in height, with the left-hand figure being the taller. In both cases Nimaatsed is portrayed in the customary striding pose with his arms held to his sides. He is wearing a flaring black wig, a fairly common feature of private statuary of this period, that leaves the lobes of his ears exposed and frames his oval face with its large painted eyes.

Each has a mouth with fleshy lips and is adorned with a black moustache. Around the neck are matching necklaces with multiple strands, alternating blue and white.

The slim, naked torso has well defined pectoral muscles and tapers to a narrow waist. The skin is painted in a strong ochre tone. A white kilt reaches to just above the knees. A flap, folded over the right-hand side, is pleated and painted yellow. One end of this flap is inserted below the belt and emerges alongside the navel. Although the legs are slim, they have a solid musculature.

Mariette discovered several statues of Nimaatsed in his mastaba at Saqqara. This particular example is undoubtedly a significant and interesting document that combines the customary beauty of the sculpture of this period with unusually well preserved and bright colours. (R.P.)

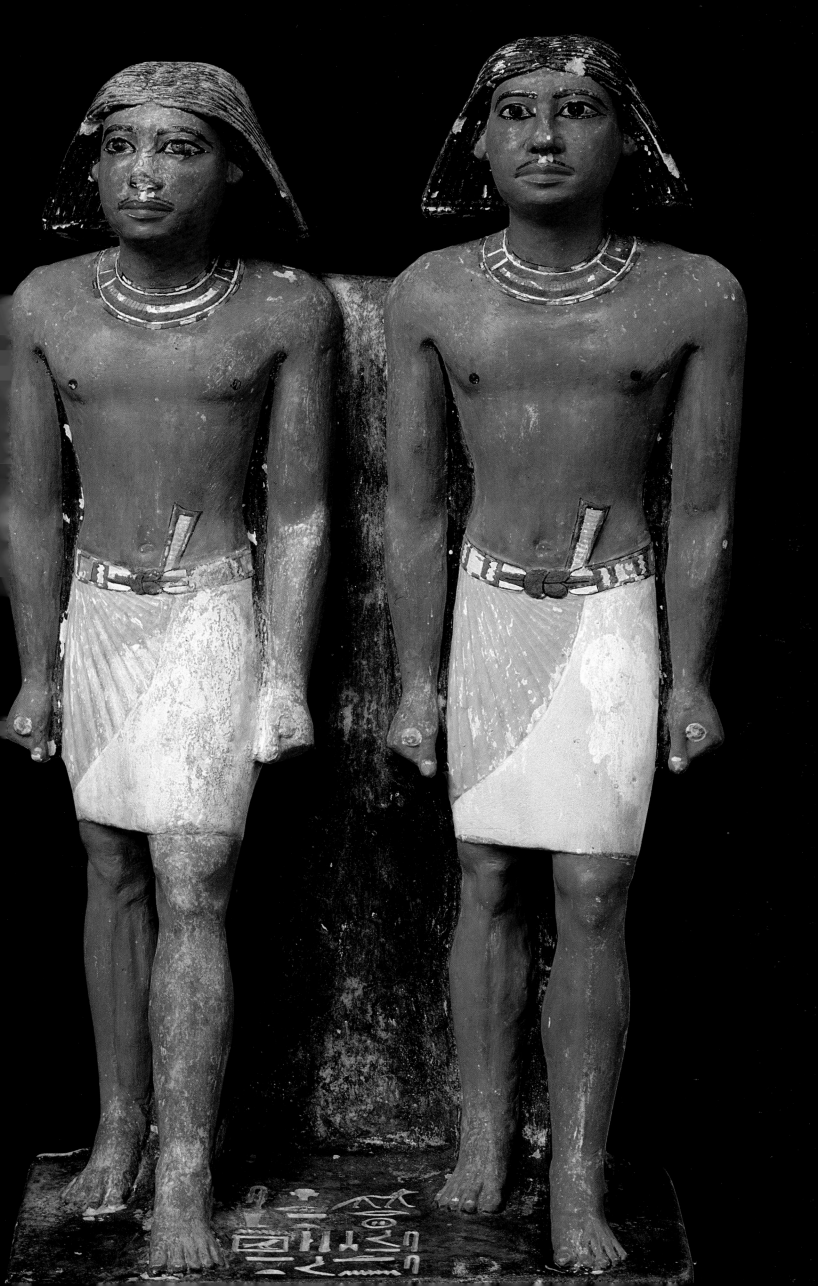

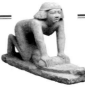

STATUETTE OF A WOMAN GRINDING GRAIN

...

PAINTED LIMESTONE; HEIGHT 32 CM
CEMETERY OF GIZA
FIFTH DYNASTY (2465–2323 BC)

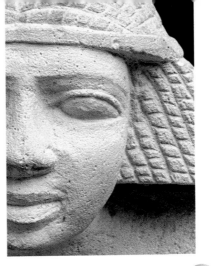

STATUETTE OF A SERVANT PLUCKING A GOOSE

...

PAINTED LIMESTONE; HEIGHT CM 28
SAQQARA; S. HASSAN'S EXCAVATIONS (1935)
FIFTH DYNASTY (2465–2323 BC)

A great many statuettes depicting servants were found in the mastabas of the Old Kingdom. They can be divided into two main groups by date and material. The oldest ones, carved in limestone, date back to the Fourth Dynasty and were produced at least until the Fifth. They are concentrated above all in the Memphis area, although a few also originate from Dara in Middle Egypt. The later ones are made of wood and have been found mostly in provincial cemeteries. Statuettes in wood first appeared in the Fifth Dynasty and continued to be produced until the end of the Middle Kingdom (an outstanding example is the female offering bearer from Meketre's tomb).

In most cases the sculptures portray servants at work, though entire battalions of soldiers, presumably representing men at the service of the tomb's owner, are known from the Middle Kingdom. The Old Kingdom models show the servants at work at a variety of household activities. Most frequently they are represented catching or butchering animals, or preparing different types of bread and cakes. Men clean jars or mould vases; women prepare beer, knead dough, or grind grain, as seen here.

The woman is kneeling and leaning forward, resting on her outstretched arms. In her hands she is grasping the cylindrical stone that serves as a quern. In front of her is an oblong stone with raised ends, along which she rolls the millstone (on some models there are containers at the end to catch the grain). Like the servant preparing beer opposite, she is dressed only in a short skirt, revealing the well-developed muscles of her arms and torso. Her face is carved with great care and is extremely expressive. Her head is raised and she is looking ahead, appearing to be detached from the laborious task she is engaged in.

Her curly hair, carved in detail, spreads out on either side of her face. It is held in place by a ribbon, with ends that fall down to the nape of her neck at the back. Her face is round with long, narrow eyes and eyelids that slant down slightly, like her eyebrows. Her regular-shaped nose is quite small and her fleshy lips are slightly apart. (R.P.)

This statuette of a man plucking a goose belongs to the same series of depictions of servants discovered in Old Kingdom mastabas. Until the beginning of the Sixth Dynasty, these sculptures were arranged in the *serdab*, alongside the statue of the tomb's owner. Later they were also placed in shafts or niches. This example, resting on an irregularly shaped base, portrays a male figure kneeling on the ground, his right leg folded beneath him and his left drawn up to his chest. He has short, faintly traced hair that leaves his ears exposed and he is wearing a white kilt.

His face has marked features, with asymmetrical, long and narrow eyes, a regularly shaped nose, and a wide mouth adorned with thin painted moustaches. The skin, as was customary with male statues, is painted an ochre colour. The arms bent at right-angles are held forwards with the hands resting on a small table on which lies a slaughtered goose with its long neck folded.

From the earliest times, offerings of geese, together with the legs of cows, were the most precious gifts made to both the gods and the dead. In fact the ritual of offering geese had a central role in the decorative schemes of tombs, especially in the Old and Middle Kingdoms, associated with lists of goods for the deceased and scenes of the butchery of cows and the presentation of their meat.

As was often the case in ancient Egypt, rather than being unequivocal, the symbolic value of geese within the context of funerary and divine cults varies and can be read in the light of diverse and at times apparently contradictory keys. While the goose may be associated with the god Amun and seen as a symbol of the life force, it is also identified with the god Seth and, as a consequence, used as a symbol for a defeated and sacrificed enemy. This is also clearly demonstrated by the *senedj* hieroglyph depicting a butchered goose which translates as 'fear' or 'terror'. (R.P.)

STATUETTE OF A WOMAN BREWING BEER

PAINTED LIMESTONE
HEIGHT 28 CM
CEMETERY OF GIZA, MASTABA OF MERESANKH
S. HASSAN'S EXCAVATIONS (1929–1930)
END OF FIFTH DYNASTY (FIRST HALF OF THE 24TH CENTURY BC)

This lively figurine depicts a woman bending over a bowl that rests on a vat or large jar with a spout. She is probably mixing the ingredients of the recipe for beer in ancient Egypt: cakes of barley bread, water and date liquor added for sweetening.

The woman's is wearing only a close-fitting, medium-length white skirt and a necklace, the pale blue shape of which can be clearly seen around her neck. Her head is covered by a medium-length wig with individual locks of hair rendered by separate vertical incisions. Her own natural hair can be glimpsed beneath the wig on her forehead. She has full face, with very striking features: large down-turned eyes emphasized by heavy eyebrows, a flattened, irregularly shaped nose, and a mouth with a hint of a smile. Her torso, full breasts and muscular arms give the impression of vitality and strength; the rest of the body is less carefully modelled. Although rather crude, the figure as a whole has a great sense of realism and movement.

This figurine is part of a series of numerous servant statuettes discovered in Old Kingdom mastabas. As already noted, they were first found in tombs of the Fourth Dynasty and reproduce the day-to-day working activities that in wealthier tombs were depicted in wall reliefs. (R.P.)

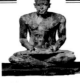

STATUE OF MITRI AS A SCRIBE

STUCCOED AND PAINTED WOOD
HEIGHT 76 CM; WIDTH 50 CM
SAQQARA, MASTABA OF MITRI; ANTIQUITIES SERVICE EXCAVATIONS (1925–1926)
LATE FIFTH DYNASTY, EARLY SIXTH DYNASTY (24TH–23RD CENTURY BC)

Eleven wooden statues depicting Mitri, his wife, or the couple together, were found in the *serdab* of his mastaba, located to the southeast of the boundary wall of the funerary complex of Djoser at Saqqara. Today, five are in the Egyptian Museum, another five are in the Metropolitan Museum of Art, New York, and the eleventh is in Stockholm.

Mitri, who possessed the titles of Administrator of the Nome, Great of the Ten of Upper Egypt and Priest of Maat, is represented here as a scribe, seated on the ground with his legs crossed and holding a partially unrolled papyrus scroll on his knees. The outside edge of the thin rectangular base on which the sculpture rests is inscribed with his name and titles.

The stuccoed and painted wooden sculpture has lost much of its colour and the surface is not well preserved, but the face of the high-ranking functionary, rendered particularly expressive by the brilliant, inset eyes, is striking in its vividness and realism. The head is covered with short hair, leaving the slightly protruding ears exposed and framing the rounded face. The splendid eyes are outlined with thin copper rims; the white is made of limestone while the iris is a dark stone. The cheeks are full, the nose regularly shaped, and the mouth fairly wide, with fleshy lips adorned with a thin, painted moustache. Traces of the red skin tone survive in places. Around Mitri's neck is a broad, multiple-strand necklace, with patches of the original colour surviving (light blue, green and white). He is bare chested and is wearing a short kilt, one end of which is tucked under his belt. In contrast with the face, with its serene, innocent gaze that suggests a very young model, the torso and limbs have powerful musculature but are not as well finished. This contrast between the modelling of the face and of the body is found in both private and royal statuary of various periods – a comparison can be made with the contemporary copper statue of Pepi I. (R.P.)

FALSE-DOOR STELA OF IKA

ACACIA WOOD
HEIGHT 200 CM; WIDTH 150 CM
SAQQARA; ANTIQUITIES SERVICE EXCAVATIONS (1939)
FIFTH DYNASTY (2465–2323 BC)

Funerary offerings of food for the dead person's *ka* were placed in front of the false-door stelae in their tombs. These stelae were typically carved in stone, but this particular one, dedicated to Ika, is one of the few known examples in wood. It accurately reproduces all the elements of a functional doorway: the opening is topped by a cylinder representing the rolled straw mat that could be dropped down to close it. On each side of the door itself are recessed panels topped by a lintel. Above this in turn is by a rectangular space with a decorated panel. A further two supports form the framework on which a second lintel rests.

Ika held the titles of *wab* priest ('pure' priest) and Governor of the Great House. He is portrayed both in the opening of the doorway, with his son Tjenty, and in the left-hand recessed panel with another son, Abedu. Ika's wife, Iymeret, is portrayed in the right-hand panel, together with their daughter Tjentet. The couple are also represented in the panel above the lintel, seated at either end of a table on which loaves of bread are placed. The surrounding space is filled with hieroglyphs recording the offerings to the couple.

In the left-hand recess Ika is shown walking. He is wearing a short kilt with a pleated flap and has a wig reaching his shoulders that resembles the one worn by Hesire, an official who lived over three centuries earlier during the Third Dynasty. In fact, the modelling of the figures, their dress, the emblems with which they are accompanied and the choice of wood as the material for the false-door stela would all seem to emphasize Ika's desire to imitate in his funerary monument the wooden panels of his great predecessor, Hesire. Ika is also holding a sceptre in his right hand and a long staff resting on the ground in his left.

He is depicted in a similar pose within the doorway, this time wearing a short wig. In the right-hand panel, his wife Iymeret, priestess of Hathor, Lady of the Sycamore, is represented standing with her feet together and wearing a long tunic with broad straps that leave her breasts exposed. Her right hand is raised towards the face of Ika and she holds a lotus flower.

The door jambs, lintels and panels bear incised hieroglyphic texts that repeat the traditional offering formulas, followed by the titles and name of Ika. (R.P.)

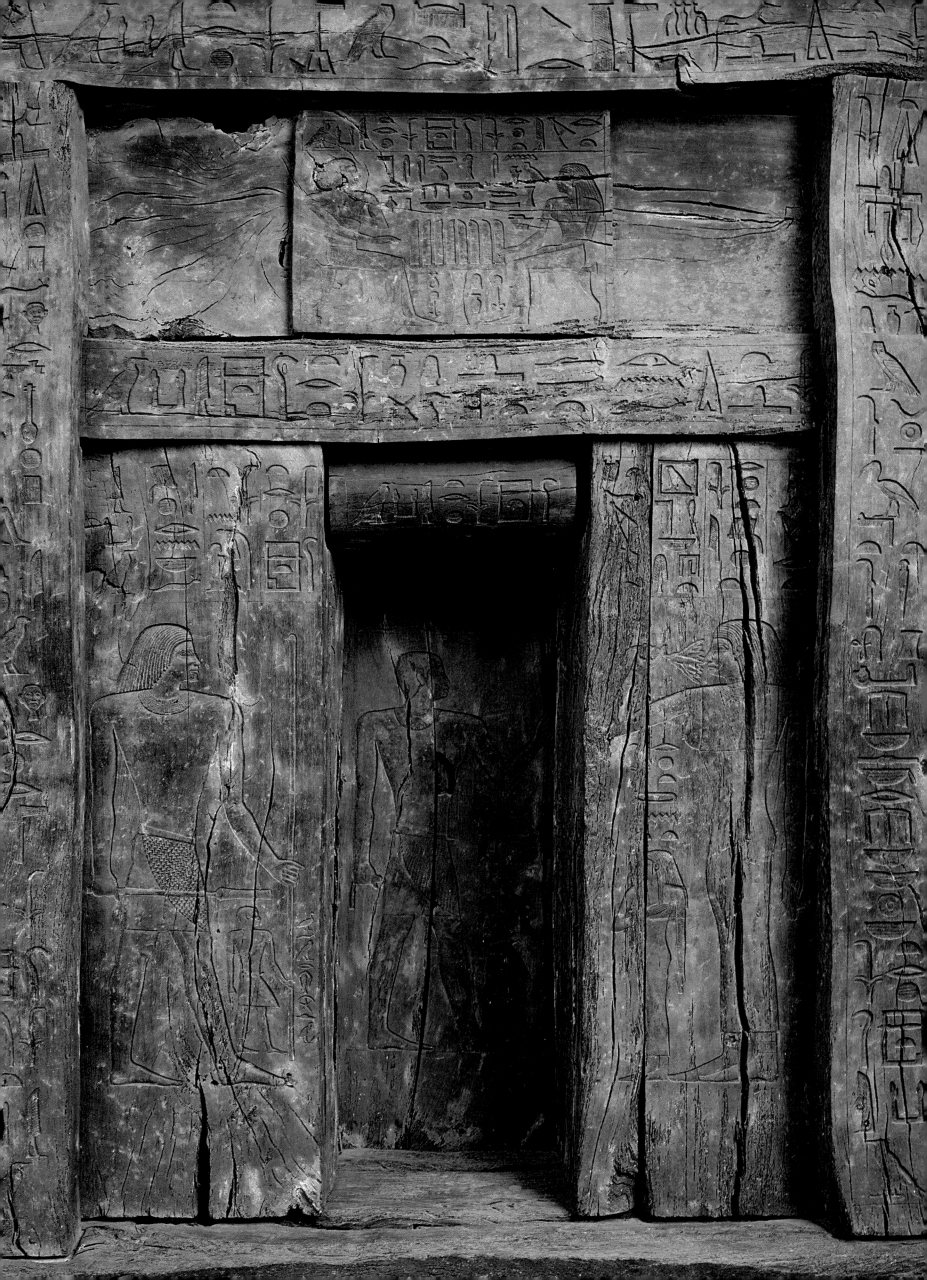

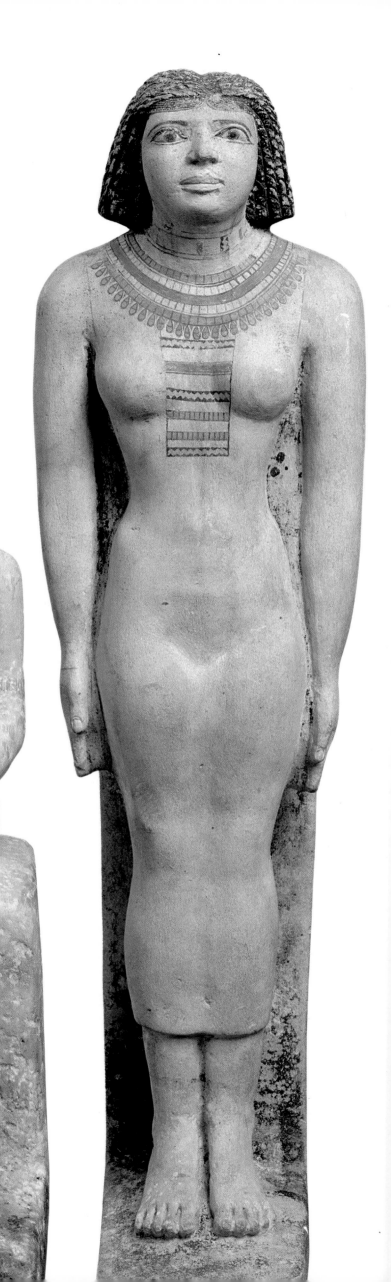

THE FAMILY OF NEFERHERENPTAH

PAINTED LIMESTONE; *MERETITES* (JE 87807): HEIGHT 39 CM
SATMERET (JE 87806): HEIGHT 53 CM; *NEFERHERENPTAH* (JE 87804): HEIGHT 65 CM
ITISEN (JE 87805): HEIGHT 37 CM; CEMETERY OF GIZA, MASTABA OF
NEFERHERENPTAH; S. HASSAN'S EXCAVATIONS (1936)
END FIFTH–EARLY SIXTH DYNASTY (MID-24TH CENTURY BC)

This group of statues portrays the family of Neferherenptah, a *wab* priest who supervised the funerary cult of the two great kings of the Fourth Dynasty, Khufu and Menkaure. The family group was found by Selim Hassan during excavations in 1936 in the priest's mastaba tomb in the Giza cemetery.

Neferherenptah, also known as Fifi, the head of the family and is represented in the characteristic pose for male statuary. His statue rests on a base that rises at the back to form a wide dorsal pillar. Both statue and base are painted black, although areas of this colour are now faded.

Fifi wears a medium-length curly black wig that covers his ears completely. A white-and-blue *usekh* necklace hangs around his neck. He is dressed in a short, white kilt with a belt in relief at the waist. Fifi's plump face has large painted eyes with blue irises, topped by long raised eyebrows that follow the shape of his eyes, slanting gently down at the outer ends. His calm gaze appears to be directed heavenwards. His nose is fairly large and broad, and a narrow moustache above his small, fleshy mouth provides a decorative touch.

Although his body is not as heavily built as those of other statues described here, it is well proportioned, with visible, if not prominent, muscles. Regardless of its relatively small size and a certain rigidity of form, this statuette is an appealing example of the sculpture produced at the end of the Fifth Dynasty. Inside the *serdab* of Fifi's tomb, his statuette was placed in the centre, between his daughter (on the left) and his wife (right), while the couple's son was on the far side of his sister.

The statuette of Satmeret, Fifi's wife, stands on a low base with a dorsal pillar. Her rather stiff pose contrasts with the bright colours that are a striking feature of the statuette. Smaller in size than her husband, Satmeret is portrayed standing with her arms held rigidly against her body, hands on thighs. She is wearing a medium-length black wig, its curls created with tiny grooves. The rigidity of her body is

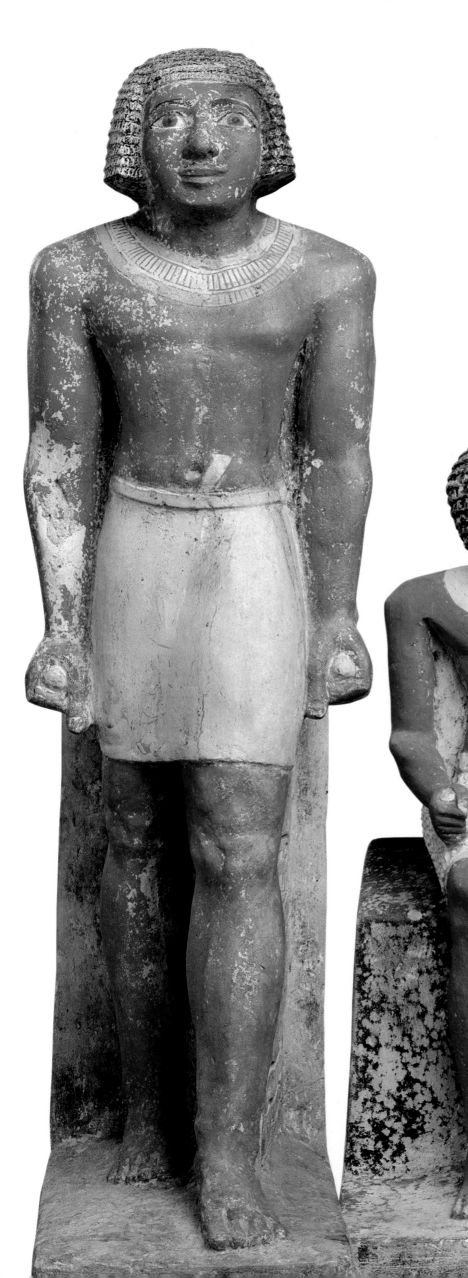

also reflected in her facial features: her wide-open eyes have dilated pupils, painted black. Her nose is short and her mouth appears to be firmly closed. Around her neck she wears a multicoloured collar and a wide *usekh* necklace comprised of rows painted blue, white and red. Hanging from the necklace is another adornment: a wide rectangular band formed of rows of variously coloured beads, adding a colourful note to her white robe. The robe is tight fitting and long, reaching to her calves. The fabric is clearly meant to be flimsy and elegant, revealing the form of her body underneath. Her well-rounded breasts, stomach muscles and shapely legs – barely concealed – offer a striking, perhaps even deliberate contrast with the conventional posture and rigidity of the rest of the sculpture.

Although the statuette of Itisen, the couple's son, is smaller in size, he is depicted as an adult rather than as a child. He is sitting on a cube-shaped seat with a plinth but no back. His clenched right hand is placed vertically on his knee, his left hand is palm down. He is wearing a curly black wig, shorter than his father's, that follows the lines of his face. Around his neck is the white outline (not painted) of a broad necklace. He is clothed in a short white kilt with a pleated border, held up by a belt with a small piece of material projecting from it.

Itisen has a rather round face and large eyes with black-painted pupils, surmounted by painted eyebrows in relief. His nose is neatly shaped, and his slightly protruding mouth is not wide but has fleshy lips. His slender neck is set on broad shoulders that contrast with his lean torso, divided vertically by a median groove that narrows noticeably towards the waist. Although thin, his knees and legs are meticulously carved; their shape makes it possible to visualize the bone structure beneath. His skin is painted dark ochre. Like the statuettes of his parents, Itisen is also characterized by a marked rigidity of form, only partly relieved and brightened by the strong colours.

Of the four statuettes found in the *serdab* of Neferherenptah's mastaba, that of Meretites, sister of Itisen, is the most expressive. Admittedly it lacks much of the colour that in some way gives life and luminosity to the others, but the almost ecstatic look of Meretites' face and the soft lines of her body confer a particular elegance and hieratic grace. Slightly larger than her brother, she is represented in the classic seated pose, with her hands open, palms down on her knees. She is wearing an ankle-length robe and, as a note of adornment, a broad, unpainted necklace. Covering her head is a rather voluminous, medium-length wig, with tiny braids that start from a central parting. On her forehead her real hair can just be seen beneath the edge of the wig. She is leaning her head very slightly backwards with the result that her rather wide face seems to be turned upwards. Her eyes too appear to be raised towards some unknown point, and have an almost inspired look. Her nose is regular and her mouth, carved with soft, precise lines, has pronounced lips. Meretites has a straight back, less prominent breasts than her mother, and more rounded torso and hips. She appears to have been fashioned in keeping with older aesthetic canons, dating back to between the end of the Third and the beginning of the Fourth Dynasties. (R.P.)

JE 32158

FALCON'S HEAD

····················

GOLD AND OBSIDIAN
HEIGHT 37.5 CM
HIERAKONPOLIS, TEMPLE OF THE GOD HORUS OF NEKHEN; J. QUIBELL AND
F.W. GREEN'S EXCAVATIONS (1897–1898); SIXTH DYNASTY (2323–2150 BC)

When the ancient temple of the god Horus at Hierakonpolis was completely rebuilt during the New Kingdom, a number of objects from the temple's equipment were gathered together and carefully buried in a deposit below the new chambers. They were subsequently discovered by James Quibell and F.W. Green during their excavations of 1897 to 1898.

This magnificent embossed gold falcon's head was found below the floor of the principal chamber and represents the god Horus. Although numerous suggestions have been proposed regarding its date of manufacture (the most plausible dates the piece to the Sixth Dynasty), there is as yet no attribution of the work to a specific period. The problem lies in the extremely faithful reproduction of the characteristic features of the bird, directly inspired by the tendency towards naturalism typical of Egyptian art of all ages. Certain details of the modelling are rendered in a more geometric and abstract fashion, however, such as the thin engraved lines representing the areas of differently coloured plumage on the bird's cheeks and the back of its head. The use of a single bar of obsidian for the eyes passing right through the head is particularly effective and results in a piercing, profound gaze very similar to that of the real bird. This feature lends the work an austere air with a hint of latent threat.

The head was originally part of a religious statue made of various materials. The body was of copper and fixed to the head with copper and gold nails. In front of it was set a statue of a king, a later addition that was intended to represent the king's wish to place himself under the protection of the god Horus.

The twin-plumed headdress also, decorated on the front with the royal *uraeus*, was a later addition, probably dating from the New Kingdom shortly before the head was deposited below the temple floor. (F.T.)

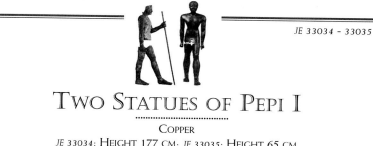

TWO STATUES OF PEPI I

COPPER
JE 33034: HEIGHT 177 CM; JE 33035: HEIGHT 65 CM
HIERAKONPOLIS, TEMPLE OF THE GOD HORUS OF NEKHEN
J. QUIBELL AND F.W. GREEN'S EXCAVATIONS (1897–1898)
SIXTH DYNASTY, REIGN OF PEPI I (2289–2255 BC)

During the excavation of temple of Horus of Nekhen at Hierakonpolis, a pit was discovered, which contained a schist statue of Khasekhem, a pottery lion (today in the Ashmolean Museum, Oxford) and two beaten copper statues. The smaller copper statue had been dismantled into a number of pieces and placed inside the torso of the larger (also dismantled), over which a copper sheet had been laid. This

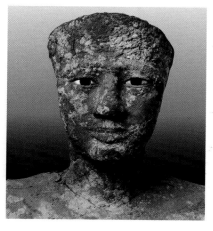

sheet was embossed with a hieroglyphic inscription reading 'Long live Horus, the Beloved of the Two Lands, the King of Upper and Lower Egypt, the Son of Re Pepi blessed with life and power. The first day of the Jubilee….'

Due to the length of time the statues had been subjected to process of oxidation the metal had badly decayed. A programme of restoration began immediately after the discovery and proved to be long and complex. The two statues were reassembled and then exhibited in a single display case as if they were part of a single composition. A further restoration became necessary in recent times, which proved to be equally painstaking and difficult. However, it led to the discovery of new facts that have allowed the two statues, and above all their mutual relationship, to be reassessed.

After their discovery it was possible immediately to identify the larger statue as representing Pepi I, thanks to the inscription on the copper sheet, but the same was not true of the smaller statue, for which a number of identifications were proposed. The most persuasive of these suggested that it was an image

of the pharaoh Merenre, portrayed alongside his father Pepi I with whom he shared the throne in the year of the royal jubilee. An alternative hypothesis was that both statues portrayed Pepi I, the smaller version showing the rejuvenation of the king as a consequence of the jubilee celebrations.

Both hypotheses rely on the assumption that the statues were part of a single group, based on the fact that they were found together. This does not, however, mean that they necessarily shared the same original location. That the smaller statue was found inside the torso of the larger and that the latter was placed under an inscription mentioning Pepi I could only mean that they shared a single identity.

The two statues were made of beaten copper sheets and assembled with nails. The eyes are inlaid with limestone and obsidian. The larger sculpture represents the king striding, his right arm held to his

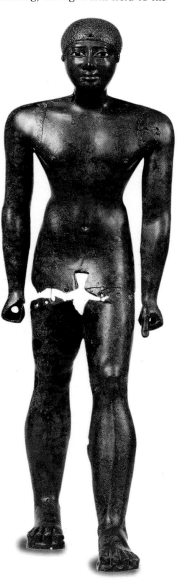

side and his left extended in front of him. He would once have held a sceptre and a staff in his hands. The rear section of the skull is missing as it would originally have been completed by a crown. The whole of the missing pelvis section would have consisted of a kilt made from some different material. The toenails were covered with gold leaf, as shown by the few traces that still remain.

The smaller statue also shows the king in a striding pose but his arms are both held along his sides. The hands held two royal attributes that were made separately, as was the kilt that sheathed the king's flanks. In this case Pepi I is wearing what appears to be a curly wig. The hole in the forehead clearly allowed a uraeus of a different material to be attached. The toenails were again covered in gold leaf. (R.P.)

STATUETTE OF PEPI II

ALABASTER; HEIGHT 16 CM
SAQQARA, SOUTH FUNERARY TEMPLE OF PEPI II
G. JEQUIER'S EXCAVATIONS (1926–1927)
SIXTH DYNASTY, REIGN OF PEPI II (2246–2152 BC)

According to the inscription on its base, this small alabaster sculpture portrays the pharaoh Pepi II. He is represented as a child in a pose that is highly unusual in either private or royal statuary. The king is seated on the ground with his legs folded and slightly apart. His left hand is resting on his knee while the fingers of his right (now missing) were once held to the mouth in the classic Horus-child manner.

Pepi II is completely naked, apart from a kind of smooth cap on his head adorned with a cobra. This type of head covering is an uncommon iconographical element in royal statuary. Among the few comparable examples is a bust of Shepseskaf (the last king of the Fourth Dynasty) with a cap that rather than being smooth has parallel incisions and is also adorned with a cobra. There is also a fragmentary statue of Raneferef (Fifth Dynasty), though rather than a cap it would be more accurate to describe him as wearing a short, curly wig with a cobra at the front.

The rounded face of the king is youthful rather than childish, with rather irregular features. His eyebrows are carved in relief. The nose is wide at the base; the mouth is fairly large and partially covered by the index finger of the right hand. The graceful limbs and a slightly rounded stomach are evidence of the artist's intention to render a boyish figure.

The only other sculpture in the round depicting this king is equally unusual. A sculptural group in the Brooklyn Museum shows Queen Ankhenesmerire, the mother of Pepi II, holding the royal child on her knee. Pepi is portrayed as an adult pharaoh with a nemes headdress and shendyt kilt, his diminutive size indicating his extreme youth. Similar

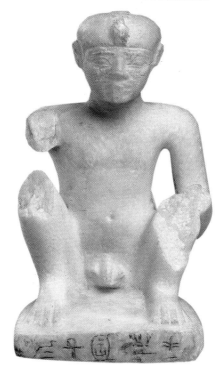

statuary groups are not found until the Amarna Period.

There are two curious facts about the statuary of Pepi II. Although he is known as the most long-lived of Egyptian pharaohs (sources speak of a reign lasting ninety years), these are the only two known statues. Moreover, both of the images portray the pharaoh as a child. If this can be explained by the fact that Pepi II ascended to the throne at just six years of age, it is odd that no other documentation of his long reign has survived. It is likely, however, that both of these sculptures belonged to the early period of his reign, during which his mother Ankhenesmerire acted as regent. These figures were designed to emphasize the important role played by the queen in the government of the country until the young pharaoh reached maturity. (R.P.)

The Middle Kingdom collection of the Egyptian Museum in Cairo surpasses by far, both in number and quality of objects, all other collections in the world, including that of the Metropolitan Museum of Art, New York, or the equally pre-eminent collection in the Louvre. In fact, the collection of Middle Kingdom royal sculpture is the Egyptian Museum's most spectacular section, illustrating developments in Egyptian art from the Eleventh to the Thirteenth Dynasty with outstanding examples. At the same time, the sculpture also displays the varying character of kingship in ancient Egypt, and in particular the ways in which it was represented during the Middle Kingdom. This period differs significantly from preceding ones when the omnipotent and god-like king was the manifestation of the falcon god Horus and the son of Re.

At the end of the Sixth Dynasty, the power of the Memphis-based government declined, with the centralized state apparently fragmenting into smaller units. This political decentralization also liberated the hitherto overlooked arts of the provinces – especially the Upper Egyptian hinterland – from domination by the Memphite model. Dramatic changes from the prevailing tradition in the 160

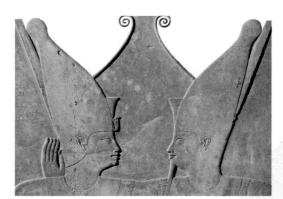

DIETER ARNOLD

THE MIDDLE KINGDOM AND CHANGING NOTIONS OF KINGSHIP

years from the late Sixth Dynasty to the end of the Eleventh Dynasty are apparent in the wall decoration and painted stelae of private tombs in Middle and Upper Egypt, such as at Naga al-Deir, Thebes and Mo'alla. Their elongated, mannerist and disproportionate figures, which often seem to float in space due to the absence of ground lines, are clearly released from the old rigid canon of proportions.

This phase of flowering of provincialism was soon replaced in Upper Egypt by the new political and artistic order of the Theban rulers of the middle Eleventh Dynasty, especially by the most powerful king of the time, Mentuhotep Nebhepetre. Despite attempts by Theban artists to recreate the Memphite style, their works are infused with Upper Egyptian motifs and elements. This blend of styles is well documented by some important objects in the Cairo Museum from the earlier part of the reign of Mentuhotep Nebhepetre, for

instance the limestone sarcophagi of Princess Kawit and Queen Ashayt found in the king's temple at Deir el-Bahri. Their relief decoration displays the workmanship of artists who appear to have been trained in woodcarving. Their expressive provincialism and the novel subjects are independent of Old Kingdom Memphite prototypes and elevate hitherto minor motifs, such as the adorning of the queen by her servants or the milking of a cow, to central themes.

After a lengthy struggle Mentuhotep succeeded the rulers of Herakleopolis in the middle of his reign. A statue chapel of the king from Dendera can be seen as a monument to his victory. Its decoration and inscriptions make it clear that the chapel was built in the sanctuary of the goddess Hathor to commemorate the king's victory and the reunification of the country. A relief on the chapel's end wall depicts the theme of military glory: the

pharaoh is smiting the heraldic plants of the two countries, a unique representation of an Egyptian king fighting against his own countrymen. Other wall reliefs emphasize divine aspects of the ruler, suggesting that the chapel housed a royal statue and was designed to be a cult sanctuary for the king. The themes, forms and execution of the reliefs demonstrate a newly established Upper Egyptian style. It is no coincidence that the royal statue-cult was put under the protection of Hathor at Dendera. The goddess not only played a major part in the religious life of Upper Egypt during the Eleventh Dynasty, but from earliest times was also seen as the mother of kings – giving them life, and also guaranteeing their rebirth after death.

Another small temple was dedicated by Mentuhotep to the god Montu of Tod, who was probably thought to have granted victory to Mentuhotep. Some wall blocks from this temple are good examples of the

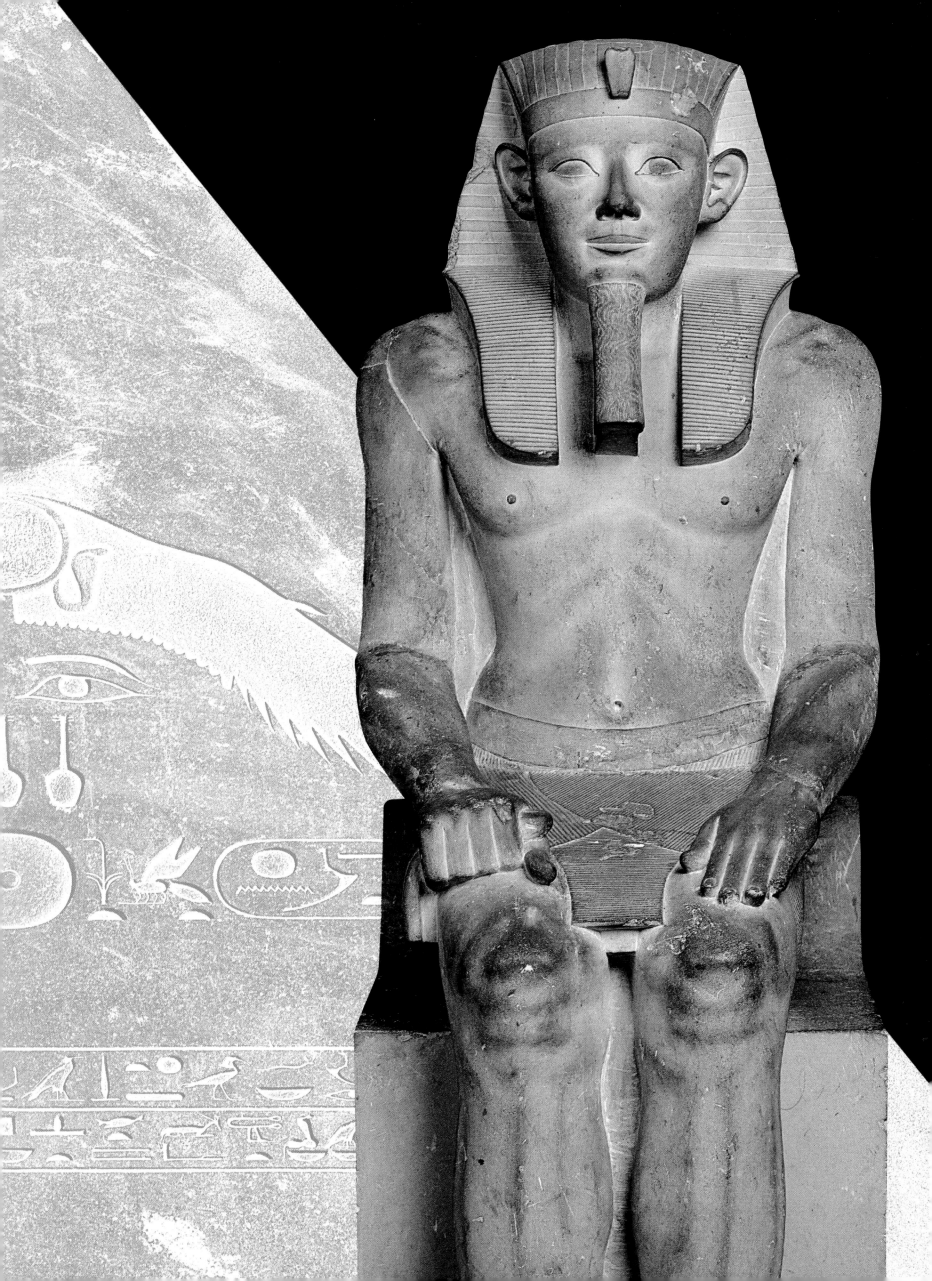

release of new artistic energies in Upper Egypt after turbulent times.

The most significant architectural monument of the period is the temple of Mentuhotep at Deir el-Bahri, Thebes, which was dedicated to Montu, the king and later to Amun-Re. Its terraced structure and open pillared halls surrounding the core of the temple seem to have their source in Upper Egyptian architectural ideas. A life-size seated figure of the king in painted sandstone was buried in its own tomb, 70 metres below the temple. The statue was found in a recumbent position, with the head separated from the body, and this together with its dark colour suggest that it was buried as part of an Osiride ritual. The powerful body, the round face and large eyes demonstrate the awakening of strong rural forces in the Theban province that had hitherto lain dormant. The same features reappear in another, non-royal, statue of Antef.

Mentuhotep Nebhepetre's shadowy successor Seankhkare replaced the chapel of Montu built by his predecessor at Tod with a larger triple shrine. A group of decorated wall blocks survive from this building and are now in the Cairo Museum. It is interesting to see how in the generation following Mentuhotep Nebhepetre, Upper Egyptian provincial art developed a new style, clearly influenced by Memphite prototypes, a reaction also reflected in the private stelae of the period.

The colourful pictorial world depicted on the walls of Old Kingdom mastabas almost ceased with the end of the Sixth Dynasty. From that period on, scenes of daily life retreated underground, appearing in burial chambers as wall paintings and in the form of wooden miniatures (so-called models) depicting tools, weapons and boats, as well as figurines of animals and humans in various occupations. These models were certainly intended as provisions for the deceased's otherworldly household. The Egyptian Museum's collection of such models is unsurpassed. One outstanding group comes from the early Twelfth Dynasty tomb of the chancellor Meketre (TT 280). It includes models representing fishing-boats trailing a draw-net, other boats, a kitchen scene, a garden with a portico, a carpenter's workshop, a spinning and weaving workshop, and, most spectacularly, a large group of figures inspecting cattle.

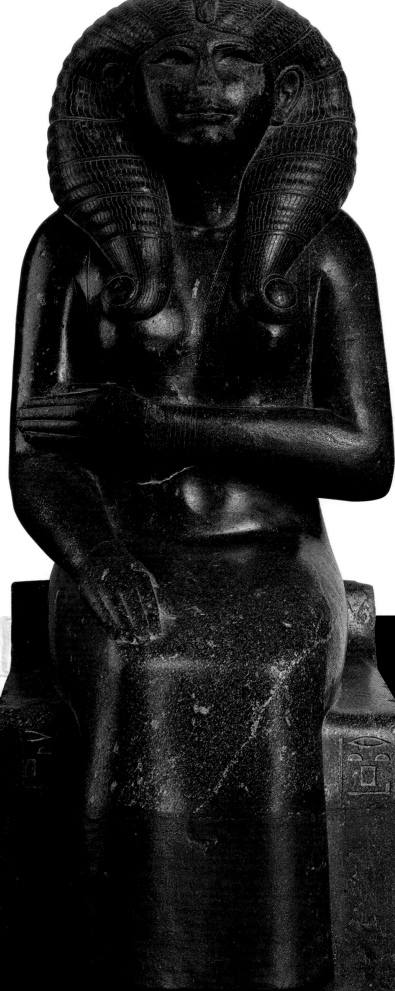

92
STATUE OF QUEEN NOFRET
JE 37487 = CG 381
BLACK GRANITE
HEIGHT 165 CM
WIDTH 51 CM
TANIS; AUGUSTE MARIETTE'S EXCAVATIONS (1860–1861)
TWELFTH DYNASTY
REIGN OF SENUSRET II (1897–1878 BC)

93 OPPOSITE ABOVE
MODEL OF A BOAT WITHOUT SAILS
JE 46716
PAINTED WOOD
HEIGHT 61 CM
LENGTH 139 CM
WIDTH 25 CM
THEBES, TOMB OF MEKETRE (TT 280)
METROPOLITAN MUSEUM OF ART EXCAVATIONS (1919–1920)
ELEVENTH DYNASTY (LATE 21ST CENTURY BC)

93 OPPOSITE BELOW
MODEL OF BOAT WITH SAILS
JE 46720
PAINTED WOOD
LENGTH 124 CM
THEBES, TOMB OF MEKETRE (TT 280)
METROPOLITAN MUSEUM OF ART EXCAVATIONS (1919–1920)
ELEVENTH DYNASTY (LATE 21ST CENTURY BC)

The single figure of a magnificent offering-bearer, 1.23 metres high, surpasses all other figures from the tomb in size and quality. The woman's beautifully modelled figure is one of the most exquisite female images from ancient Egypt. Two other stunning examples of early Middle Kingdom model carving are the brightly painted groups of marching soldiers from the early Middle Kingdom tomb of Mesehti at Asyut. The two groups are differentiated by skin colour, dress and equipment and seem to form a bodyguard for the protection of the deceased.

Theban autonomy and dominance came to an end when, for unknown reasons, Amenemhet I transferred his residence to the region of the Old Kingdom capital Memphis, founding his new residence at Iti-tawi, modern Lisht. After Amenhemet's apparently troubled reign, his son Senusret I succeeded in re-establishing the old splendour of Egypt. This was highlighted not only by the construction of a grand pyramid precinct at Lisht but also by great building activity in all the important sanctuaries of the country.

Architecture, sculpture and reliefs are marked in this period by a return to the traditions of the Old Kingdom, which in many instances included outright copying. This backward-looking, 'archaizing' tendency of the Twelfth Dynasty is the first of several such renaissances or renewals in Egyptian art. The early phase of the development of Twelfth Dynasty

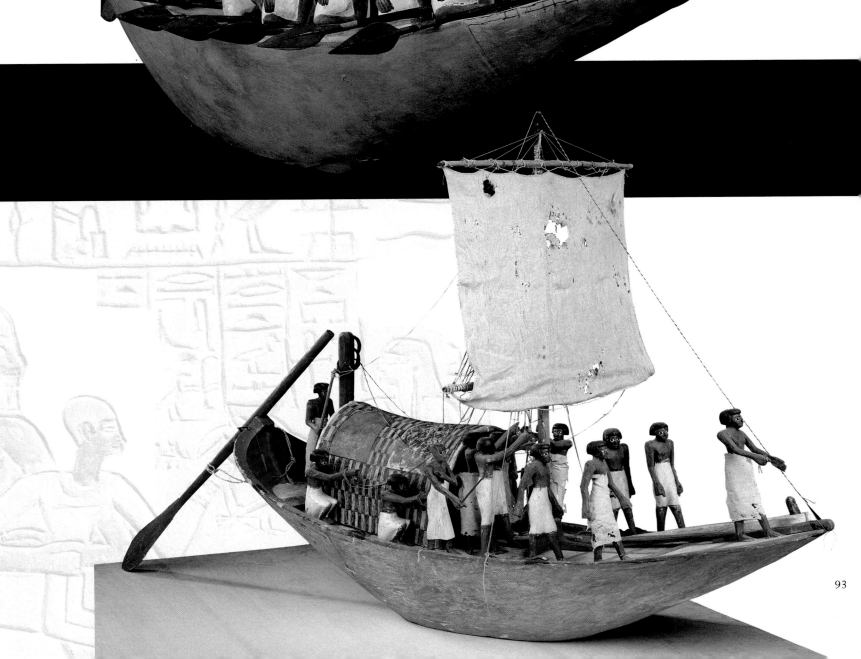

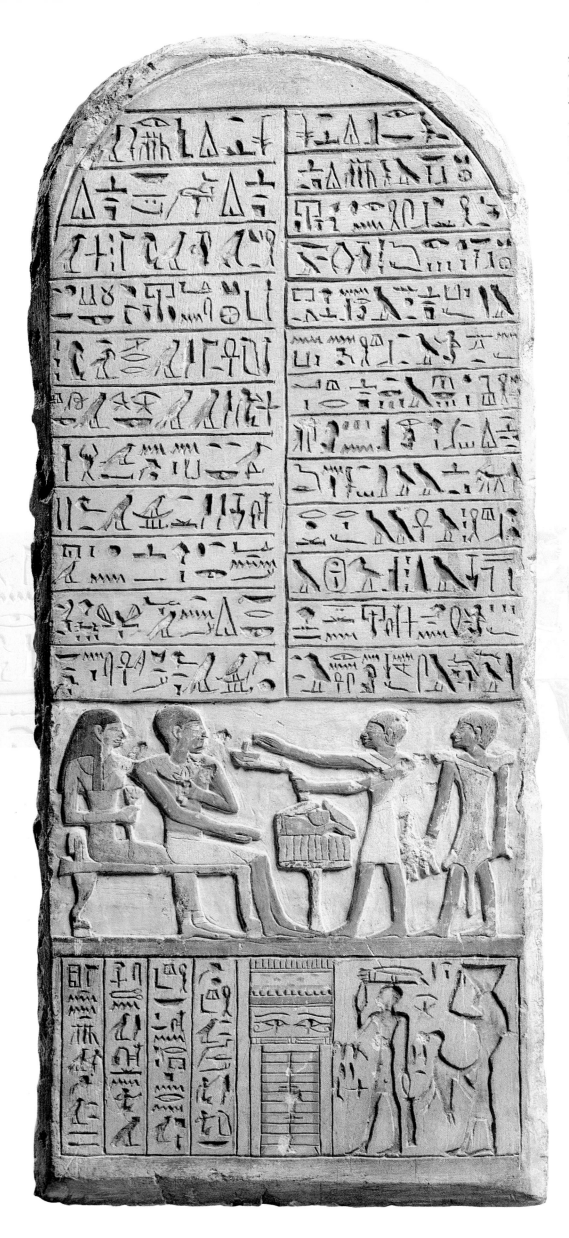

sculpture is represented by a group of ten over-life-size seated figures of Senusret I from the king's pyramid complex at Lisht. The statues of white, unpainted limestone were never set up in the temple, probably because of a change in plan. The relief decoration on the sides of their thrones praises the king as the founding hero who re-established Egypt by the unification of the two countries. The rigid, passionless expression of the king's face, with its frozen smile, links the figures to late Old Kingdom sculpture. Lacking any individual characteristics, the statues are monuments of the period's perception of kingship.

Some of the one hundred panels that once decorated the inner stone enclosure of the pyramid precinct of Senusret I at Lisht are also in the Cairo Museum. The panels were originally positioned at equal intervals, juxtaposed on the exterior and interior of the 5.6-metre-high wall. They show a fecundity figure carrying offerings of reviving water and bread into the temple entrance. Above each fecundity figure is a beautifully carved, intricately

detailed representation of the façade of the king's palace enclosing the king's names. As in ancient times, the royal Horus falcon perches on top of the panel, announcing that the enclosed pyramid precinct is to be understood as the dwelling place of the Horus-king.

The causeway to the pyramid of Senusret I was lined by so-called Osiride statues, featuring the royal head on a mummy-like body standing against a dorsal pillar. The similarity of the body to a mummy has brought about the misleading interpretation that such statues are representations of Osiris. Since statues of this type usually lack individual features they may well represent images of kingship in its most general, un-iconic form.

Senusret I also built sanctuaries at Karnak, connected with the royal renewal festival, the *heb-sed*. The most spectacular was the so-called White Chapel, now rebuilt in the open-air museum of Karnak. Another similar structure contained sturdy limestone pillars whose decoration includes depictions of the god Ptah embracing the

king and hieroglyphs, creating magnificent surface textures of light and shadow.

The block statue, after some modest forerunners from the Sixth Dynasty on, was a newcomer to private funerary sculpture of the Twelfth Dynasty. Early examples are two statues of the chamberlain and royal seal-bearer Hetep from Saqqara. Whereas in most later block statues the squatting body is represented wrapped tightly in a cloak, below which the contracted legs are only faintly visible, these early examples still show the legs and arms fully delineated.

Royal sculpture of the following reigns of Amenemhet II and Senusret II, the 'classical' phase of Twelfth Dynasty art, is encapsulated in two monumental seated figures of Senusret II and two smaller statues of his queen Nofret found at Tanis, in the northeastern Delta. The king's face, surrounded and enhanced by the wide wings of the *nemes* headdress, radiates divine harmony and elation. Nofret wears the royal *uraeus* (cobra crown) and the huge ceremonial wig with curled tips

generally associated with Hathor, thus identifying the queen with her divine counterpart. A small but fine wooden portrait of a queen, princess or noblewoman found at Lisht probably dates from the middle of the Twelfth Dynasty. The head was part of a less than life-size composite statue. The heavy black wig was embellished with gold ornaments. The mild face is beautifully carved and polished but has suffered the loss of the originally inlaid eyes. In 1860 another delightful head of a young woman was found at Saqqara. It probably also dates to the middle of the Twelfth Dynasty but was made in a different wood carver's workshop. Her youthful oval face is surrounded by a mass of wavy black hair.

A painted wooden statuette, originally part of a group of two royal figurines, represents the same phase of sculptural development around the middle of the Twelfth Dynasty. The two images were discovered in a small cache hidden in the brick enclosure wall of the mid-Twelfth Dynasty mastaba of Imhotep at Lisht.

When the finds were divided, the statue wearing the Red Crown was allocated to the Metropolitan Museum of Art, while that with the White Crown went to Cairo. Since the figures lack a royal name and the royal *uraeus* at the front of the crowns, they cannot depict a specific king. Rather they seem to be images of divine kingship, connected with an unknown funerary function. Even without a direct association to a contemporary ruler, the faces of the figures – square, with deeply shadowed eyes – display the unmistakable characteristics of the kings of the middle of the Twelfth Dynasty, most probably of Amenemhet II.

Works from the middle of the Twelfth Dynasty radiate the aura of a secure, harmonious and youthful world ruled by the idea of an everlasting, perfect *maat*, the controlling force of the Egyptian cosmos. This positive world-view became clouded in the following period, the third and final phase of the dynasty, dominated by two outstanding rulers Senusret III and Amenemhet III. Their reigns, evidently

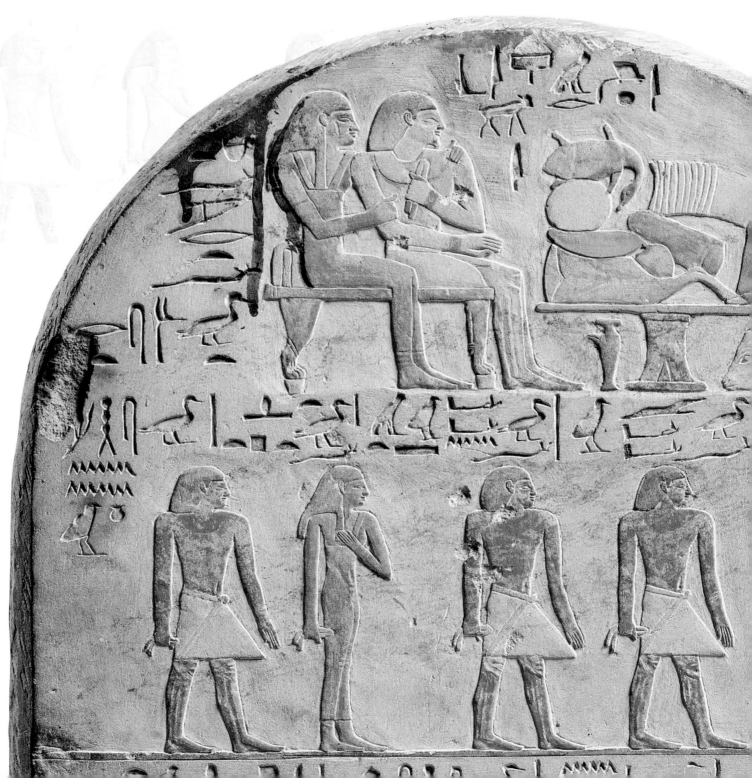

94 LEFT
STELA OF NEMTYEMHAT
CG 20088
PAINTED LIMESTONE
HEIGHT 57 CM
WIDTH 23 CM
ABYDOS
MIDDLE KINGDOM
(2040–1640 BC)

94 RIGHT AND 95
STELA OF IHY
CG 20525
PAINTED LIMESTONE
HEIGHT 49 CM
WIDTH 38 CM
ABYDOS
MIDDLE KINGDOM
(2040–1640 BC)

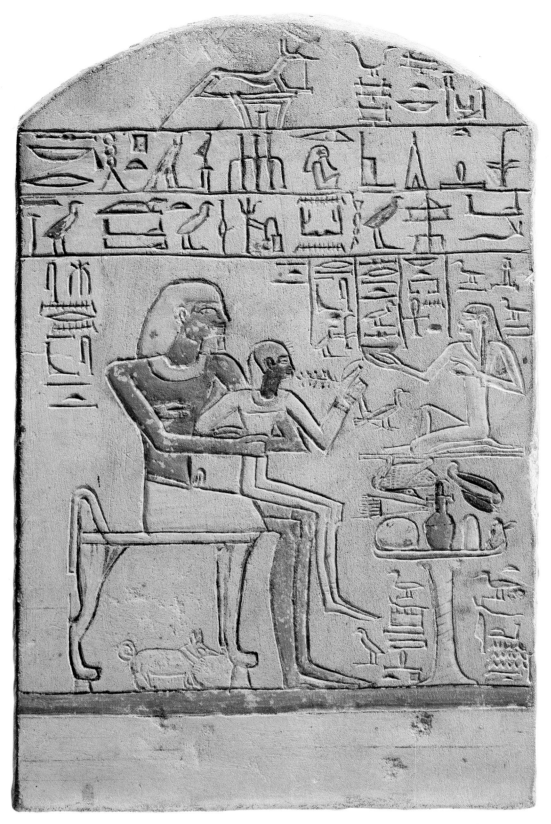

king on the occasion of his *sed* festival, celebrating the jubilee of his reign. These festival reliefs culminate with a scene carved on the lintel: the king is enthroned in his festival costume under the double-throne pavilion. At the climax of the rejuvenating *sed* festival rituals, standards representing Horus and Seth transfer eternal life to the king. The purpose of the scenes is multi-layered, reaching far back into the early periods of Egyptian history. Ultimately, an exchange between the king and the gods is immortalized in stone at the entrance gate into royal cult complexes: the deities bestow on the king renewed power, and the king guarantees them provisions and continuous faith.

A large number of royal statues of Senusret III's son, Amenemhet III, are preserved. Excavations in the temple ruins of Tanis in the northeastern Delta brought to light a group of at least seven granite sphinxes of Amenemhet III. These formidable royal images differ considerably from most other known sphinxes by their dominant, powerful animal nature. While usually the head of a sphinx is entirely human, here the face of the king is framed by a huge lion's mane – a terrifying expression of the superhuman strength of the pharaoh in a lion's body.

An unusual twin image of Amenemhet III in diorite also comes from Tanis. The statue shows the king twice, side by side, with the long, heavy wig and false beard that characterize the primordial creator divinities of the country. Slightly bending under its weight, the king carries a rich

highly affluent, were marked nevertheless by profound political, religious and artistic unease. Not surprisingly, the faces of royal and private sculptures express, for the first time, doubts, frustration and signs of age. How far real, personal portrait-like features crept into official court images remains difficult to decide and is not ultimately of great interest since Egyptian artists strove to create primarily an image of 'the King'. Changes in royal imagery, therefore, have to be interpreted as reflecting changes in the role, not the person, of the ruler.

The Theban area was the site of several monumental granite statues of Senusret III. He dedicated one group of six life-size standing statues to the temple of King Mentuhotep Nebhepetre at Deir el-Bahri. The most stunning piece from this group is displayed in Cairo. Since Senusret III is shown in a gesture of adoration, the statues may have represented the king in his

priestly function, worshipping his respected ancestor. Another magnificent statue of the king comes from the temple of Montu at Medamud near Thebes. It shows a vigorous, more youthful ruler in a majestic posture, suggesting perhaps the king in his role as the young Horus, avenger of his father Osiris.

An important aspect of kingship is represented by a monumental limestone gate of Senusret III, of which numerous decorated blocks were found at Medamud and subsequently reconstructed in the Egyptian Museum. The monument, in form a common architectural type, carries the relief decoration of a *sed* festival gate. The representations on such gates usually included depictions of the major Egyptian divinities standing in front of their chapels. One doorframe shows the Upper and the other the Lower Egyptian divinities. The gods are apparently gathered around the

offering. As suggested by the modest pose, the statues might represent the king in his function as a provider of offerings for the gods, a notion supported by the archaic decoration that recalls both the earliest times and creation and fecundity. Both statue types – lion king and fecundity king – may have been part of the same unusual but significant statue programme that commemorated aspects of kingship and its role in the creation of the universe.

The perception of the human ruler as an incarnation of archaic kingship is also revealed in the majestic granite bust of Amenemhet III found in the crocodile sanctuary of Medinet el-Fayum. In this unusually compelling image, the king wears the costume of a priest and the heavy wig of a primeval divinity, combining the key features of kingship: the divine aspect of the human ruler, who is a god in his own right, and in his office

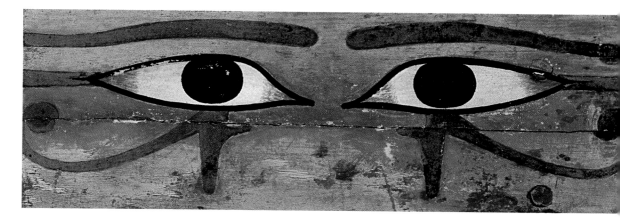

as the foremost priest of the gods. In such a context the aged features of the king serve to underline the connection of kingship with creation and 'the first time' (the idealized past). Recurring allusions to 'the king of the old age', seem to reflect an urgent attempt to replenish the ailing image of kingship – drained of significance since the time of Senusret III – with fresh life. The royal statuary of the late Twelfth and the Thirteenth dynasties does not represent aged individuals but the ancient institution of kingship.

When the first pyramid of Amenemhet III at Dahshur developed structural problems, a second pyramid and temple were built as the king's burial place near Hawara, at the entrance to the Fayum Oasis. Travellers from Greece and Rome associated its huge temple with the legend of the 'labyrinth'. Several important sculptures of Amenemhet III were found there, the best-preserved being a seated, life-sized limestone image. In this statue Amenemhet III appears as a fragile human being. This is fitting because the image was most probably placed in the sanctuary of his mortuary chapel to receive offerings and rituals performed by the royal priests.

Colossal royal statues were rare during the Middle Kingdom. The Egyptian Museum in Cairo houses a 76-centimetre-high granite head of Amenemhet III from Bubastis that belonged to a colossus that may have been 3.5 to 4 metres high. The head's now cavernous eyes were originally inlaid and would have filled the statue with terrifying magic life.

In the Museum there is also a group of five more-or-less complete pyramidions (capstones of pyramids) from the Middle Kingdom. Cut from blackish, hard stone they impressively terminated the four huge white limestone surfaces of a pyramid's casing. Contrary to common ideas about

gilded tops on Old Kingdom pyramids, there is no indication of gilding. The most spectacular example is the pyramidion of the pyramid that Amenemhet III built in his earlier years at Dahshur. In the shape of a miniature pyramid, it is 1.31 metres high, made of exquisitely carved and polished stone. Huge eyes on the east face 'contemplate' the beauty of the sun god Re, as an inscription states, when his rays touch the pyramidion at sunrise.

In the Twelfth Dynasty, a new category of statue appeared: the private temple statue. These sculptures did not attract cults for themselves but were admitted as unassuming guests to the gate or offering hall of a god's temple where the temple priests assured them of continuous audience and maintenance. The temple statues represented their owners according to their functions, and were mostly seated in modest postures on the ground. Their location far from their owner's tomb required lengthy inscriptions identifying the owner and requesting the attention and prayers of the passing priests. Their subordinate position and public visibility seem to have transformed the statues' function gradually from living bodies of the *ka* into memorial monuments.

One of the major achievements of Middle Kingdom architecture was the building of temple-like rock tombs, mostly in Middle and Upper Egypt, in places such as Beni Hasan, Barsha, Asyut, Qaw el-Kabir, Thebes and Aswan. Except for some examples of fine reliefs now in museums, the architecture of these tombs can be experienced only at the site. However, the burial chamber of the Twelfth Dynasty seal-bearer of the king Harhotep (TT 314) from Thebes was reconstructed in the Egyptian Museum. The chamber was not part of the accessible rooms of the tomb where the rituals were performed but is a good example of the often lavish underground burial crypts housing the stone sarcophagus of the deceased. At Thebes and other places, the crumbly rock walls were often cased with fine white limestone slabs decorated with paintings of the funeral furnishings, false doors, offering lists, and coffin texts.

In the Middle Kingdom the minor arts played a great role in the realm of the dead, amply illustrated in the Cairo Museum for instance by an immense collection of royal and private canopic burial jars and chests from Middle Kingdom cemeteries. Canopic burials developed modestly during the Old Kingdom but gained special importance during the Twelfth Dynasty. They grew into a kind of separate, secondary tomb

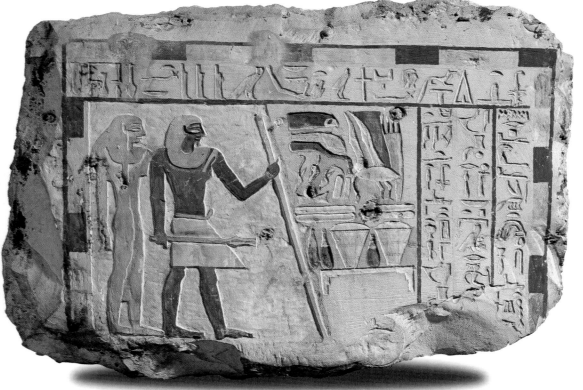

96 OPPOSITE
FUNERARY STELA
OF DEDUSOBEK
CG 20596
PAINTED LIMESTONE
HEIGHT 28.5 CM
WIDTH 18.5 CM
ABYDOS, NORTHERN
NECROPOLIS
MIDDLE KINGDOM
(2040–1640 BC)

97 ABOVE
DETAIL OF THE COFFIN OF
SENBI
JE 42948
PAINTED WOOD
HEIGHT 63 CM
LENGTH 212 CM
A. KAMAL'S EXCAVATIONS
(1910)
TWELFTH DYNASTY
(LATE 20TH CENTURY BC)

97 LEFT
STELA OF A GENERAL
JE 45969
PAINTED LIMESTONE
HEIGHT 80 CM
WIDTH 55 CM
NAGA EL-DEIR
TWELFTH DYNASTY
(LATE 20TH CENTURY BC)

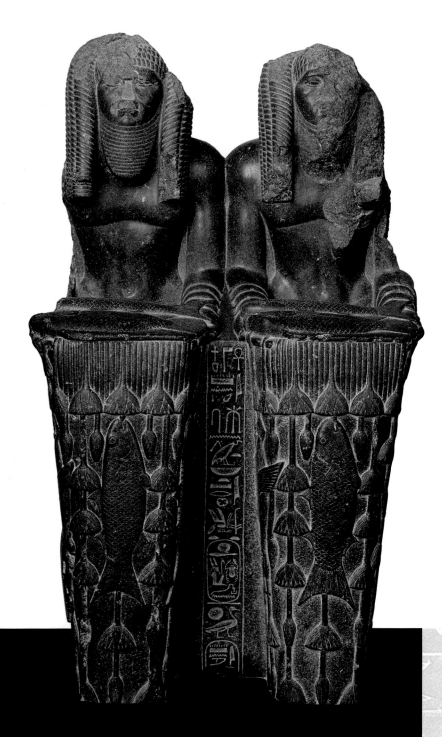

bureaucrats with bald heads sometimes covered by long, heavy wigs. They are wrapped in long kilts, the ends of which are knotted beneath the breast, or they clasp cloaks around their shoulders. The Cairo Museum owns half the known examples of royal statues of this period. With their intense, severe and sombre facial expressions and large ears, these statues clearly continue the royal image of the age of Senusret III and Amenemhet III. The athletic structure of their bodies seems to express the military strength of these rulers, underlined by a noticeable geometrical surface design. The peculiar lifeless expression of the face of such statues may reflect the rather depleted condition of kingship in this period and support the notion that Egypt was no longer ruled by kings but administered by officials.

The earliest example of royal sculpture of the Thirteenth Dynasty, the wooden life-size statue of King Auibre Hor, addresses another important aspect of the king, his endurance in eternity. As shown by the pair of raised arms on the head, the symbol for *ka*, the statue represents the king's mysterious second being. The *ka* was a non-corporeal life-force that separated from the body after death and took up temporary residence in a statue-body.

Besides statuary of the kings Neferhotep I Khasekhemre and Sebekhotep IV Khaneferre from Karnak and Tanis, the Egyptian Museum owns two colossal seated

98–99
PYRAMIDION OF THE
PYRAMID OF AMENEMHET
III AT DAHSHUR
JE 35122
BASALT
HEIGHT 140 CM
WIDTH AT BASE 185 CM
DAHSHUR
TWELFTH DYNASTY
REIGN OF AMENEMHET III
(1844–1797 BC)

99 RIGHT
STATUE OF SAKAHERKA
JE 43928
QUARTZITE
HEIGHT 62 CM
KARNAK, TEMPLE
OF AMUN-RE
LATE TWELFTH-EARLY
THIRTEENTH DYNASTY
(18TH CENTURY BC)

with stone canopic chests in the shape of a square sarcophagus. These chests, made of alabaster, housed four canopic jars for the mummified viscera, fitted with stoppers carved in the shape of human heads.

The extraordinary number of rulers of the Thirteenth Dynasty – approximately seventy – that appeared in subsequent king lists has not been fully explained. It is clear that the pre-eminent role of kingship in the Twelfth Dynasty must for unknown reasons have come to an end, but we have no indications of devolution of control, of power struggles, or political and economic chaos. The central government in the Memphite region seems to have kept control during the following 130 years. Nevertheless, the number and importance of royal and private monuments and statuary decreased considerably, notwithstanding the high quality of some sculptures. The transfer of much of the ruling power from the king to the vizier during the Thirteenth Dynasty is reflected in a decline of royal sculpture in favour of statuary of high officials. These statues of officials represent 'aged' wise

98 ABOVE
DOUBLE STATUE
OF AMENEMHET III
JE 18221 = CG 392
GREY GRANITE
HEIGHT 160 CM
TANIS
TWELFTH DYNASTY
REIGN OF
AMENEMHET
III
(1844–1797 BC)

granite figures of Semenkhkare Mermeshau, the largest statues found at Tanis. They are characterized by an intense, sinister look, a geometric surface structure of the bodies and legs, and a surprisingly narrow waist.

Around 1650 BC the gradual decline of the power of the Thirteenth Dynasty facilitated a gradual foreign infiltration into the Delta from the northeast, later known as the Hyksos invasion. The assumption of power by the Hyksos, and thus the end of the Thirteenth Dynasty, signals a new chapter in Egyptian history, the Second Intermediate Period.

BIOGRAPHY

Dieter Arnold has been curator of the Department of Egyptian Art at the Metropolitan Museum of Art, New York, since 1985. He has conducted excavations in Egypt since 1963, in particular at the archaeological sites of the Middle Kingdom at Thebes, Lisht and Dahshur. He has worked with the German Archaeological Institute in Cairo and has been appointed to the chair of the Egyptology department at the University of Vienna. During his career he has developed specialist knowledge in the fields of pharaonic architecture, building techniques and the art and archaeology of the Middle Kingdom in particular.

STATUETTE OF A BEARER

..................................

PAINTED WOOD; HEIGHT 36.5 CM
MEIR, TOMB OF NIANKHPEPI THE BLACK (A 1)
ANTIQUITIES SERVICE EXCAVATIONS (1894)
SIXTH DYNASTY, REIGN OF PEPI I (2289–2255 BC)

As the inscriptions on the base of his wooden statue record, Niankhpepi the Black was 'supervisor of Upper Egypt, chancellor of the king of Lower Egypt, sole friend, respected by the great god, great and ritual priest of the priests'. Niankhpepi was the governor of the fourteenth province of Upper Egypt and had his tomb cut into the rocks at Meir, the cemetery of the capital of the region of Qus. His composite name, based on that of king Pepi I, demonstrates that he lived at the end of the Sixth Dynasty. This was a crucial period in Egyptian history, a time of disintegration that was to lead to the transformation of some of the largest districts into autonomous states.

The wooden statue carrying the principal titles of Niankhpepi was found in a shaft two metres deep within the tomb. Piled all around it were a number of other statues portraying the deceased's servants. Remarkable for its formal beauty and the brilliance of its colours, this statuette portrays a bearer. He is depicted in a striding pose, wearing a short wig and a simple, white kilt. He is carrying a rucksack on his back, suspended from a white strap around his neck. We do not know what was in the rucksack, but it must have been heavy given that a second supporting band is wrapped around the bearer's left arm, which he is holding bent backward, steadying his load.

On the base of the bag itself are two projections that perhaps were stuck into the ground so that the rucksack would stand upright when put down. The bearer's right arm is folded across his chest, supporting a basket. This basket, woven from plant fibres, has a handle and is decorated with small black, green and red squares forming a geometric lozenge motif. (F.T.)

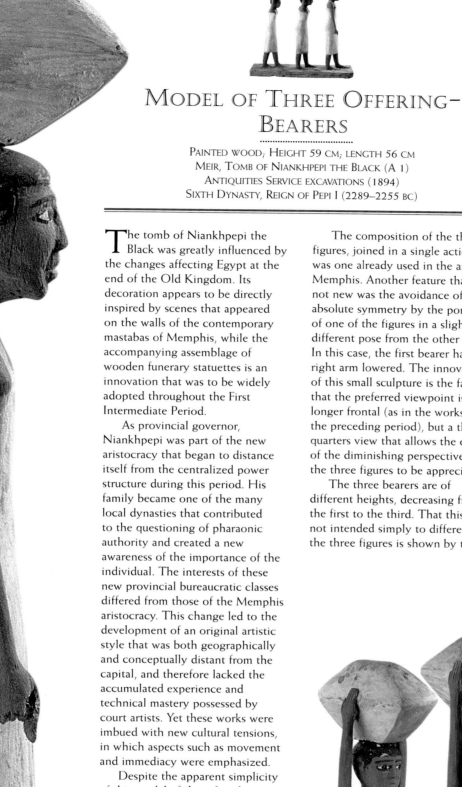

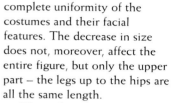
MODEL OF THREE OFFERING-BEARERS

PAINTED WOOD; HEIGHT 59 CM; LENGTH 56 CM
MEIR, TOMB OF NIANKHPEPI THE BLACK (A 1)
ANTIQUITIES SERVICE EXCAVATIONS (1894)
SIXTH DYNASTY, REIGN OF PEPI I (2289–2255 BC)

The tomb of Niankhpepi the Black was greatly influenced by the changes affecting Egypt at the end of the Old Kingdom. Its decoration appears to be directly inspired by scenes that appeared on the walls of the contemporary mastabas of Memphis, while the accompanying assemblage of wooden funerary statuettes is an innovation that was to be widely adopted throughout the First Intermediate Period.

As provincial governor, Niankhpepi was part of the new aristocracy that began to distance itself from the centralized power structure during this period. His family became one of the many local dynasties that contributed to the questioning of pharaonic authority and created a new awareness of the importance of the individual. The interests of these new provincial bureaucratic classes differed from those of the Memphis aristocracy. This change led to the development of an original artistic style that was both geographically and conceptually distant from the capital, and therefore lacked the accumulated experience and technical mastery possessed by court artists. Yet these works were imbued with new cultural tensions, in which aspects such as movement and immediacy were emphasized.

Despite the apparent simplicity of this model of three female offering bearers from the tomb of Niankhpepi, it reveals some of the new artistic trends of the period. In ancient Egypt the number three was used to indicate a plural and consequently a multitude. The three figures therefore represent an unspecified number of bearers. Each of them wears a white linen robe with a single shoulder strap, and has hair cut short and each is carrying a container on her head.

The composition of the three figures, joined in a single action, was one already used in the art of Memphis. Another feature that was not new was the avoidance of absolute symmetry by the portrayal of one of the figures in a slightly different pose from the other two. In this case, the first bearer has her right arm lowered. The innovation of this small sculpture is the fact that the preferred viewpoint is no longer frontal (as in the works of the preceding period), but a three-quarters view that allows the effect of the diminishing perspective of the three figures to be appreciated.

The three bearers are of different heights, decreasing from the first to the third. That this was not intended simply to differentiate the three figures is shown by the complete uniformity of the costumes and their facial features. The decrease in size does not, moreover, affect the entire figure, but only the upper part – the legs up to the hips are all the same length.

These three bearers have therefore been depicted in such a way as to give a realistic impression of a line of advancing figures that become larger as they approach the observer. The composition also can also be seen as an attempt to reproduce the movement of walking and so another interpretation of these three figures could be that they in fact show a single bearer, portrayed at three different points as she walks forwards towards the viewer. (F.T.)

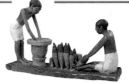

Model Depicting the Preparation of Bread and Beer

Painted wood; Height 35 cm; length 53 cm
Meir, Tomb of Niankhpepi the Black (A 1)
Antiquities Service excavations (1894)
Sixth Dynasty, Reign of Pepi I (2289–2255 BC)

Bread and beer were staple commodities in ancient Egypt. A jar and a loaf of bread are frequently reproduced, together with ritual verses and the names and titles of the deceased, on offering tables found at all sites and in all periods of ancient Egyptian history.

The importance of bread in the Egyptian diet is demonstrated by the fact that the names of over forty varieties are known, differing in form, added ingredients and, above all, the type of flour used. The grain was first ground and the flour was then refined and sifted. Next, the dough was prepared by adding milk and the ingredients to flavour or sweeten the bread. At this point terracotta moulds were warmed over a fire which were then filled with the prepared dough. In the New Kingdom, baking techniques were improved by the use of better ovens.

Beer was the other important part of the diet and was made from barley. Ground and mixed with water, it was poured into receptacles and briefly heated before being left to soak in water sweetened with dates. Once the barley had fermented, the resulting liquid was filtered into another vessel.

This model from the tomb of Niankhpepi shows the final stages in the preparation of bread and beer. The two workers, one in front of the other, both have very short, neat hair and are wearing simple, short white kilts. The standing figure is leaning forwards slightly and has his hands in a vessel placed on a support, in which the beer is fermenting. The seated figure has a terracotta mould between his outstretched legs which he is filling with dough. In front of him is a pile of moulds in which the bread is already cooking. (F.T.)

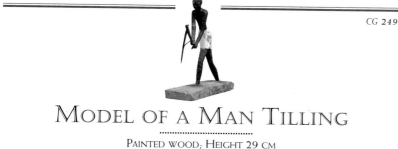

MODEL OF A MAN TILLING

PAINTED WOOD; HEIGHT 29 CM
MEIR, TOMB OF NIANKHPEPI THE BLACK (A 1)
ANTIQUITIES SERVICE EXCAVATIONS (1894)
SIXTH DYNASTY, REIGN OF PEPI I (2289–2255 BC)

Among the many statues of workers discovered in the tomb of Niankhpepi the Black, this figure of a man tilling the land best demonstrates the changing aesthetic climate at the end of the Old Kingdom. It reveals an interest in movement, the careful observation of everyday reality and, at the same time, a certain impressionistic feel, in which the overall vision is more important than the accurate rendering of minute details. These innovative aspects anticipate the cultural outlook of the following period, in which capturing a sense of immediacy became more highly regarded than the attractiveness and balance of the composition.

These new artistic tendencies are evident above all in the extremely elongated forms that consciously violate all the preceding canons. The unnatural proportions, the dissolution of the body and its transformation into a series of curvilinear elements serve to transmit something more than a simple image of a man working in the fields. The significance of the figure does not lie solely in what it outwardly represents, but also in the sense of movement it succeeds in conveying. There is a clear attempt to reproduce in sculptural form the dynamic, perceived reality of a man working in the middle of a field at noon, when the rays of sun beating down and the waves of heat appear to make the figure quiver.

The sculptor describes, rather than simply imitates, the surrounding environment with a careful eye that does not neglect the faithful transposition of each individual detail. This explains the absence of the man's feet, his ankles rising directly from the base. This is a successful device for reproducing the effect of the farmer seen working in fields flooded with water.

This statuette of the farmer cultivating his fields can be seen, therefore, as an innovative work for the age in which it was produced. It anticipates the most characteristic features of works of the First Intermediate Period, frequently and erroneously described as a period of decadence in Egyptian civilization.

We might discover decadence in this piece if we assess the small wooden sculpture by the artistic canons of Memphis, where formal order was paramount; and indeed an echo of the rigidly ordered compositions of the period can still be seen in the figure's long stride, repeated in the opening of the two elements of the hoe. But the absence of a style structured according to an adherence to precise rules is amply compensated for by a degree of freshness and immediacy, rarely found in earlier work. (F.T.)

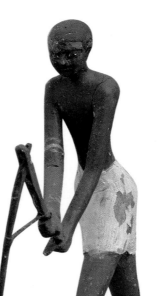

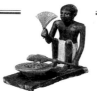

MODEL OF A MAN ROASTING A DUCK

PAINTED WOOD; HEIGHT 24 CM
MEIR, TOMB OF NIANKHPEPI THE BLACK (A 1)
ANTIQUITIES SERVICE EXCAVATIONS (1894)
SIXTH DYNASTY, REIGN OF PEPI I (2289–2255 BC)

Several of the wooden statues found in the tomb of Niankhpepi reproduce scenes of everyday life that in previous periods were depicted in relief on the walls of the mastabas of the highest-ranking dignitaries of the Memphite aristocracy. The most frequently illustrated themes concern the preparation of food.

In this case a man is portrayed squatting in front of a brazier. He has very short hair and is wearing a simple, short white kilt. In his left hand he is holding a stick with a duck skewered on to the end. In his right hand he is holding a fan with which he is kindling the glowing embers in the brazier.

In Egypt, duck and beef served to vary a diet that was essentially based on vegetables. Meat was an expensive food and was widely consumed by the wealthy. Such foods featured very little in the diets of the poor, however, where the need for protein was met above all by fish, available in abundance in the Nile.

Duck hunting was a frequent subject in the scenes decorating the walls of Old Kingdom tombs. Such hunts took place in swamps, using nets hidden in clearings amid the reed beds. The tomb's owner was frequently shown hunting duck with a throwing stick, and among the objects of Old Kingdom funerary assemblages we frequently find miniatures in various kinds of stone depicting roast ducks.

Actual mummified ducks, contained in white-painted wooden sarcophagi in the shape of the roasted bird, were customarily included among the funerary foods placed in the tombs of the New Kingdom rulers. (F.T.)

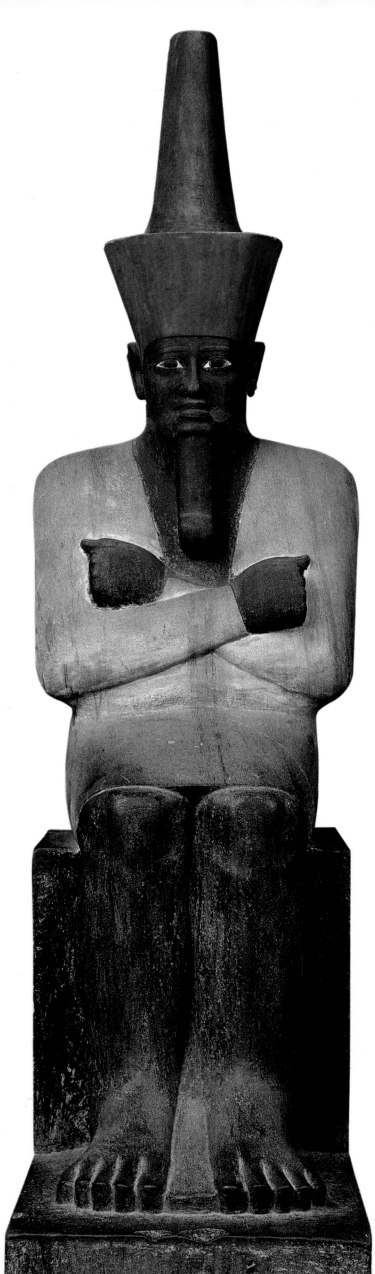

STATUE OF MENTUHOTEP NEBHEPETRE

PAINTED SANDSTONE
HEIGHT 138 CM
DEIR EL-BAHRI, CENOTAPH OF MENTUHOTEP NEBHEPETRE
DISCOVERED BY H. CARTER (1900)
ELEVENTH DYNASTY, REIGN OF MENTUHOTEP NEBHEPETRE (2061–2010 BC)

The king, with his arms crossed over his chest, is seated on an undecorated cube-shaped throne that itself rests on a long rectangular pedestal. He is wearing the Red Crown of Lower Egypt, a long false beard – a symbol of divinity – and a short white ceremonial cloak that reaches to just above his knees. The skin is painted black, in sharp contrast with the white of the cloak, which leaves his hands and part of his chest uncovered.

Although life-size, the statue seems larger and presents an imposing and authoritative image of the king, with no concession to superfluous details. The body appears to be only sketchily carved from the block of sandstone; the legs and feet are disproportionately large and bulky compared with the rest of the figure. Only in the rendering of the face and the head is there any detail. The majestic Red Crown frames the square-cut face, leaving the large ears uncovered. The close-set eyes are painted white with black pupils and have a remarkable luminosity. They are elongated towards the temples by a line of eye-paint and surmounted by heavy eyebrows in relief. The nose is straight and regular while the mouth is not fairly small but has full lips. The result is a strong and solemn image of the second great unifier of the pharaonic state after Menes.

The statue also symbolizes the duality of the sovereign, who in the living world embodies the falcon god Horus, the powerful conqueror, and in death is identified with Osiris, the king of the dead.

The sculpture was discovered, wrapped in many layers of fine linen, in 1900 at the bottom of a shaft in the northeastern part of the courtyard of the funerary temple of Mentuhotep at Deir el-Bahri. The entrance to the corridor that led to this chamber was brought to light only by chance when the horse ridden by the then inspector of the Antiquities Service, Howard Carter, stumbled. The animal's hooves had uncovered the slab of stone covering the subterranean access passage. This strange episode is commemorated in the name given to the hole in the ground where the statue was found buried: Bab al-Hosan, which in Arabic means 'The Horse Gate'.

Numerous hypotheses have been proposed to explain the nature of these underground rooms. It has been suggested that they formed the original tomb of the king, which was abandoned following the completion of the more grandiose architectural project of the temple. Alternatively they may have served as a cenotaph symbolizing the dual burial of the pharaoh (as the ruler of the unified Two Lands). However, one thing does appear certain – that this room had a ritual nature as the place in which Mentuhotep donned the traditional cloak of the royal jubilee, the ceremony in which the power and sacredness of the pharaoh were renewed. (R.P.)

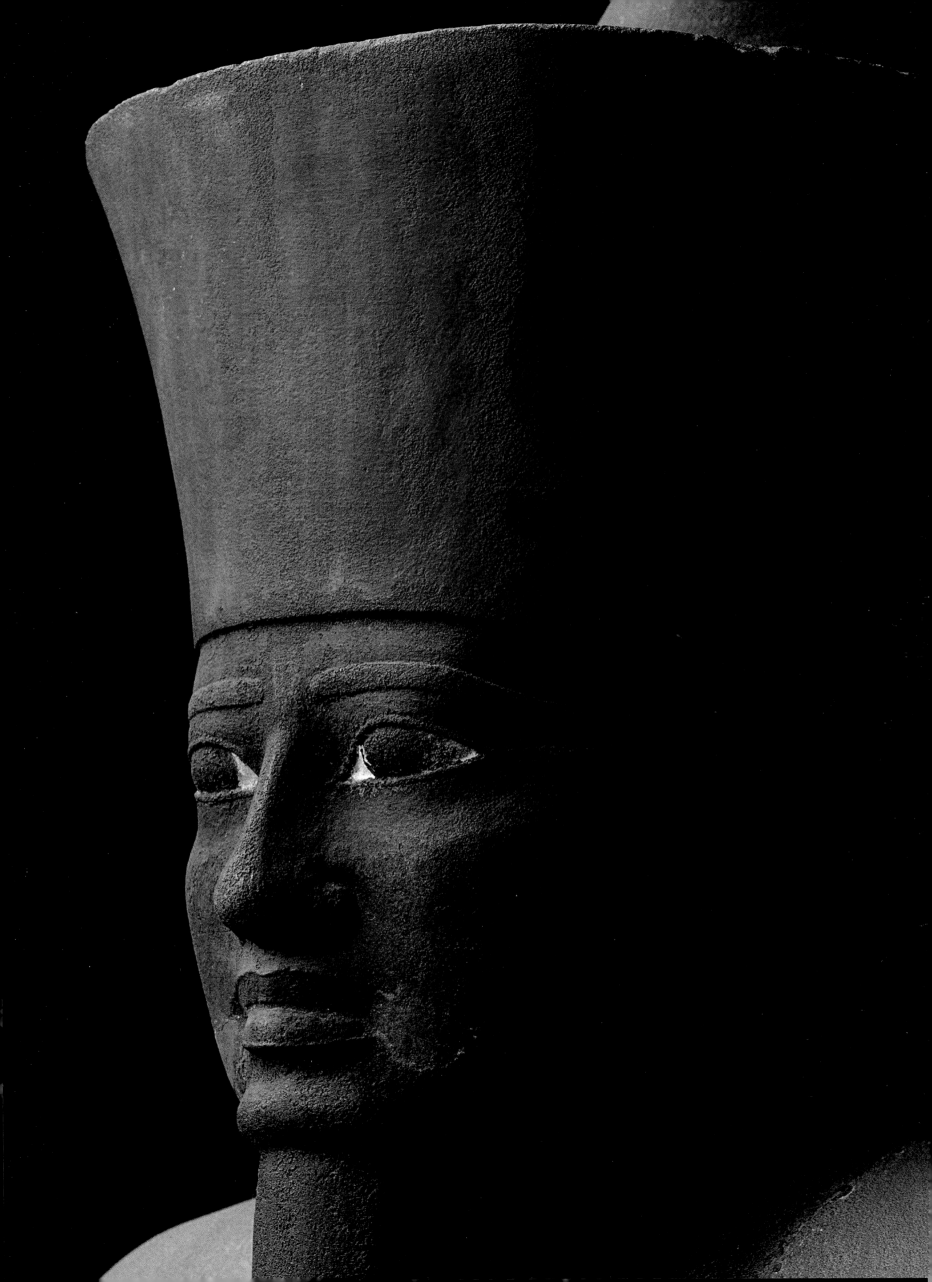

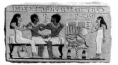

JE 45626

FUNERARY STELA OF AMENEMHET

....................................

PAINTED LIMESTONE; HEIGHT 30 CM; WIDTH 50 CM
ASSASIF (TT R4)
METROPOLITAN MUSEUM OF ART EXCAVATIONS (1915–1916)
ELEVENTH DYNASTY (2134–1991 BC)

This rectangular stela, wider than it is tall, is decorated with a brightly coloured scene of funerary offerings. Across the top is a horizontal inscription of hieroglyphs set between two deeply incised lines.

On the left-hand side, three figures are seated on a black bench with supports in the form of lions legs. Below the bench is a basket, from which the handle of a mirror emerges. Seated at the right-hand end of the bench is the owner of the stela, Amenemhet, with his wife Iji on the left, and the couple's son Antef between them.

The naturalness of the scene is striking, with the three figures depicted in poses of affectionate intimacy. The woman has her arms around her son's shoulder while he, in turn, links his left arm with Amenemhet's right and holds his left hand with his right.

All three figures have broad, green-painted necklaces around their necks. Iji is wearing a long black wig, a tight, white tunic with straps that leave her breasts exposed, and several bracelets and anklets. The male figures are wearing short, white kilts and both have short, black hair. The father also has a beard framing the jaw, terminating in a goatee.

On their right is an offering table, piled up with numerous foodstuffs, while at the other end of the stela is a standing female figure (small in scale in comparison with the other three) dressed like Iji. A line of hieroglyphs identifies her as Hapi.

The inscription includes an offering verse dedicated to Osiris, 'for the venerable Amenemhet and the venerable Iji'. (R.P.)

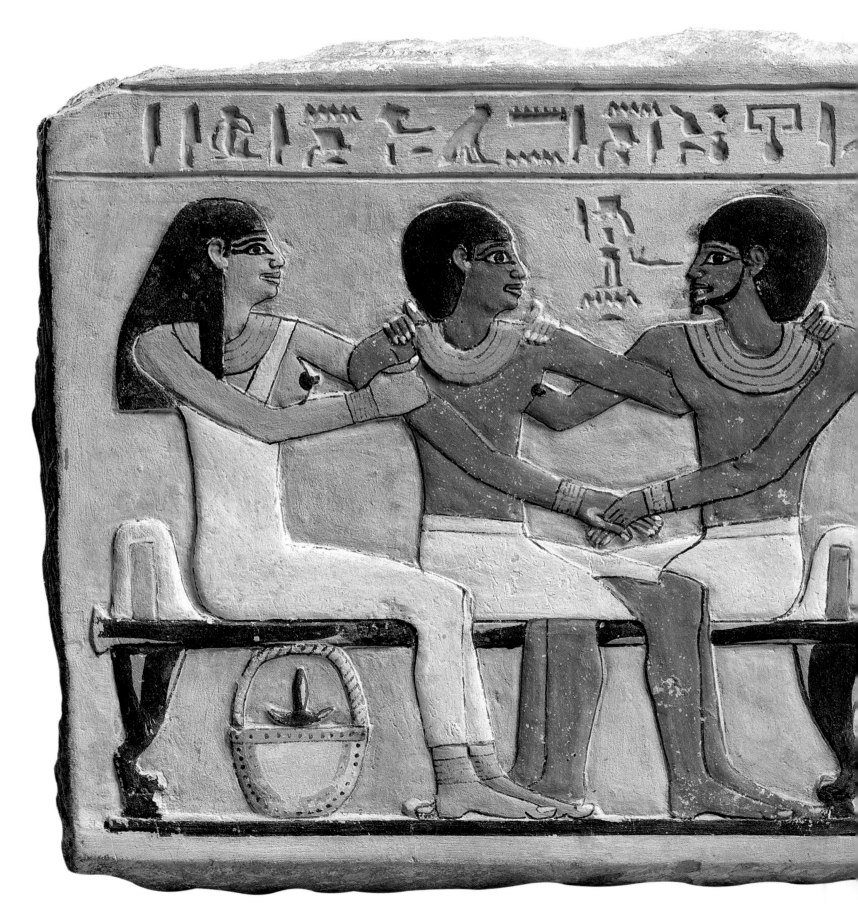

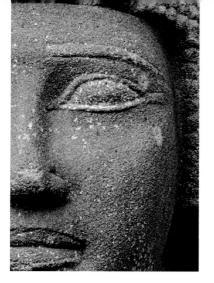

JE 89858 - 91169

STATUE OF GENERAL ANTEF

PAINTED SANDSTONE; HEIGHT 58 CM
ASSASIF, TOMB OF GENERAL ANTEF
EXCAVATIONS OF THE GERMAN ARCHAEOLOGICAL INSTITUTE (1963–1964)
ELEVENTH DYNASTY, REIGN OF MENTUHOTEP NEBHEPETRE
(2061–2010 BC)

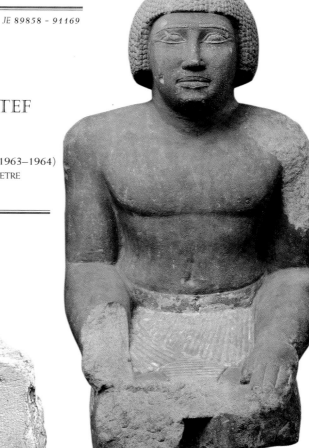

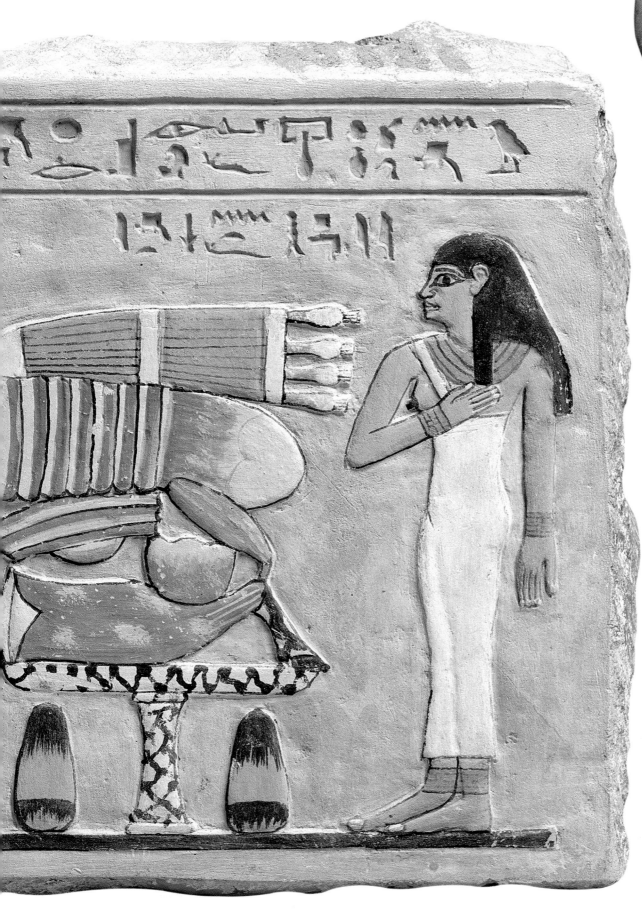

This statue, of which parts are missing, has been restored from two fragments: the head and the torso have separate Egyptian Museum inventory numbers.

The sculpture was discovered in the chapel of the tomb of General Antef, not far from the temple of the pharaoh Mentuhotep at Deir el-Bahri. Antef's tomb had a porticoed façade, a characteristic feature of Theban funerary architecture at this period. Antef was superintendent of the Royal Troops and evidently occupied a position very close to the king, as shown by the location and size of his funerary monument.

The general is portrayed seated, with his hands on his knees. He is wearing a short wig that covers his ears, with tight curls rendered by fine incisions. His round face has very similar features to those of the king he served: the close-set eyes are decorated with the same type of eye-paint and the straight, regular nose is set above a well-defined mouth with strong outlines. The head is set on a thick neck and broad shoulders.

The square torso is visually divided into two by a line passing below the breast. The arms are large rather than muscular and are held tight to the body, while the forearms rest heavily on the thighs. Antef is wearing a short pleated kilt with a belt identical to those worn by the pharaohs. (R.P.)

JE 30986 = CG 258

TROOP OF EGYPTIAN SOLDIERS

PAINTED WOOD
HEIGHT 59 CM; WIDTH 62 CM; LENGTH 169.5 CM
ASYUT, TOMB OF PRINCE MESEHTI
ELEVENTH DYNASTY (2134–1991 BC)

This troop of forty Egyptian soldiers is set on a single base and divided into ten rows of four men. It is possible to identify their ethnic origin by a variety of features. Their skin is light, although of a darker shade of brown than that used to represent dignitaries and pharaohs (a clear sign of a different life style, involving long periods in the open air). Their black hair is of medium length and cut helmet fashion. The soldiers are bare chested and bare footed and all are wearing short white short kilts with longer central flaps. In their right hands they hold lances and in their left, shields. They are depicted marching as a compact group, though several details lend a degree of vivacity to the regularity and uniformity of their movements and clothing. Every shield is different and is painted in imitation of the skins of various animals. The height of the figures also varies and creates a certain disorder. All the faces have individual features, though they share a very lively gaze thanks to their large painted eyes decorated with a thin line of eye-paint.

The presence of such models of armed troops in tombs at this period is undoubtedly a reflection of the new social and political situation. Local princes clearly felt the need to introduce innovative iconographical elements in representing themselves and their status to emphasize their new-found power and autonomy. (R.P.)

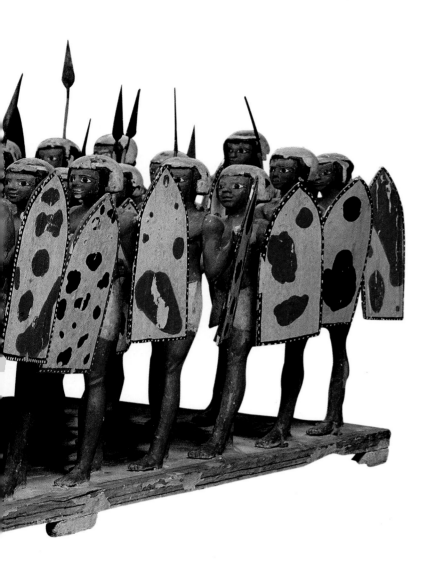

TROOP OF NUBIAN ARCHERS

PAINTED WOOD
HEIGHT 55 CM; WIDTH 72.3 CM, LENGTH 190.2 CM
ASYUT, TOMB OF PRINCE MESEHTI
ELEVENTH DYNASTY (2134–1991 BC)

This group of wooden models represents forty archers set on a single base, arranged in ten rows of four. Their identity as Nubian troops is revealed by both their black-painted skin and their clothing. They all wear a yellow or red loincloth in the form of a broad band wrapped around the waist and thighs, with a flap of cloth in the centre decorated with blue-green geometric motifs on a red ground.

Bare footed and bare chested, they are depicted marching in unison with long strides. They are wearing black curled wigs with a white band around their foreheads. Thin chains hang around their necks and they have anklets on each leg. In their right hands they hold a bow and in their left a number of arrows.

Each face is unique and features large, white-painted eyes that stand out vividly against the dark skin. The strong colours, varied faces and the different heights of the soldiers create a great sense of movement and liveliness in this otherwise uniform group. It was probably part of the army of Prince Mesehti, in whose tomb the model was found.

The practice of including statuettes of servants and workers among funerary goods was already established in the Old Kingdom, when representations of domestic and manufacturing activities predominated. Between the First Intermediate Period and the Middle Kingdom, entire armies were frequently represented, along with wooden models showing activities associated in some way with the life of the deceased. The squadron of Egyptian soldiers shown opposite also comes from Mesehti's tomb. (R.P.)

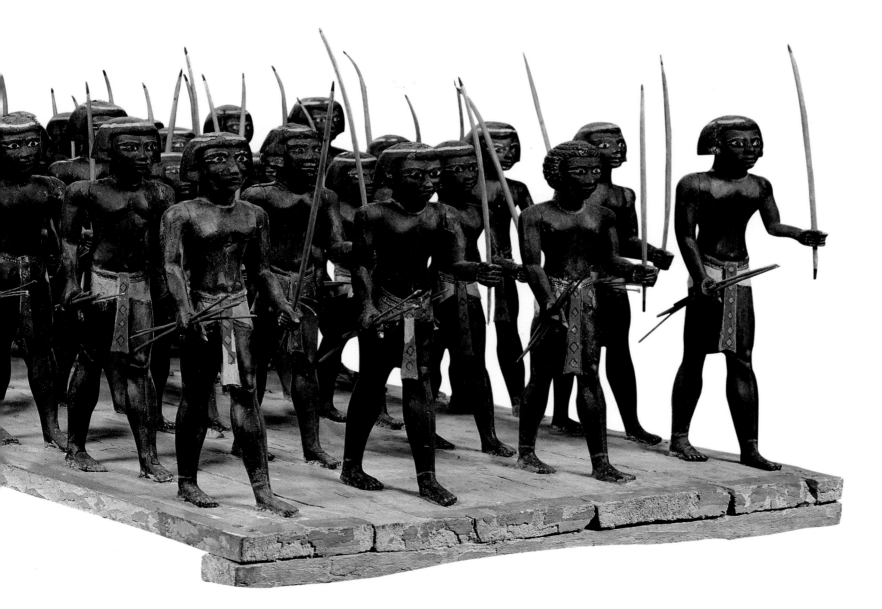

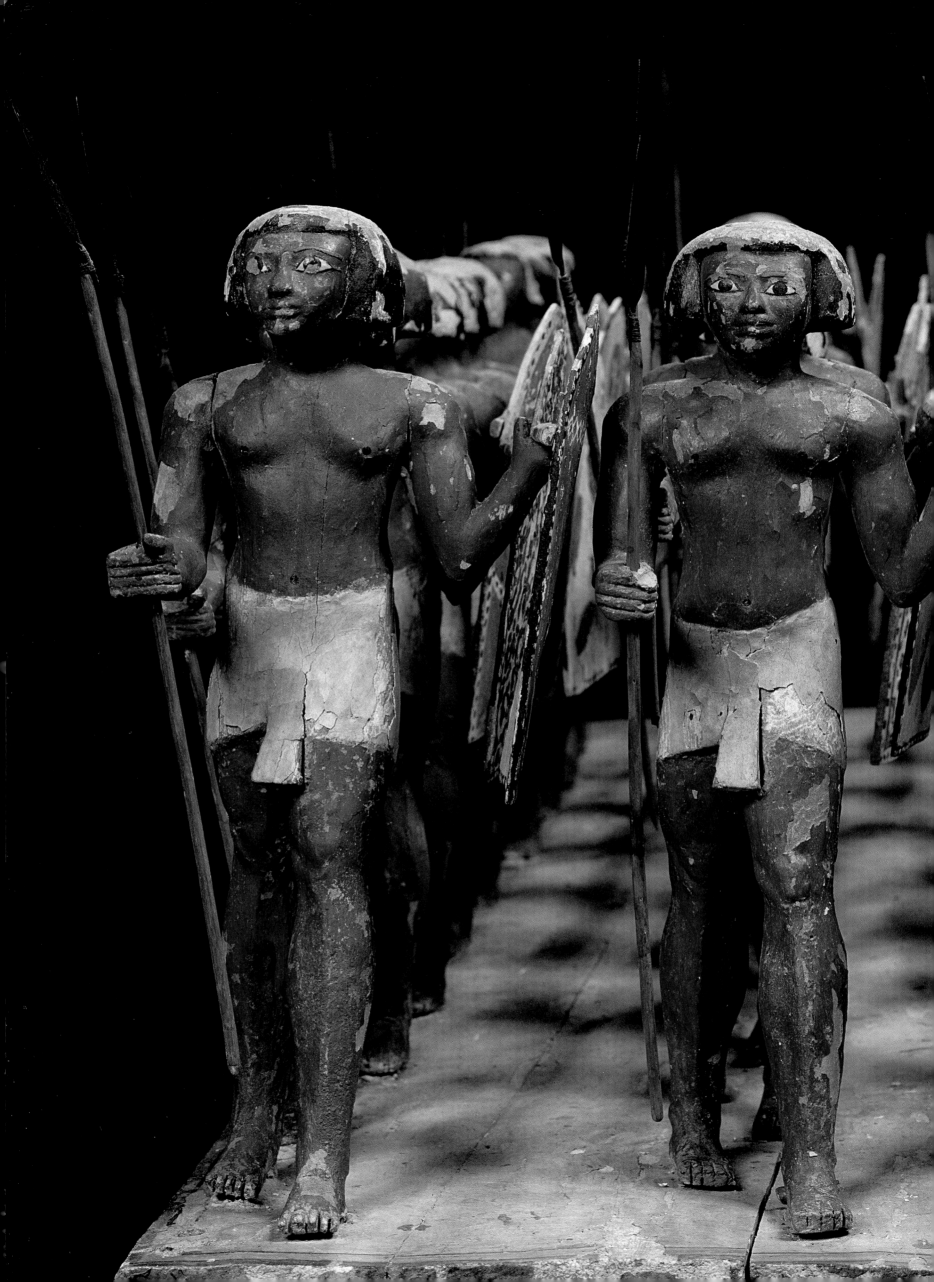

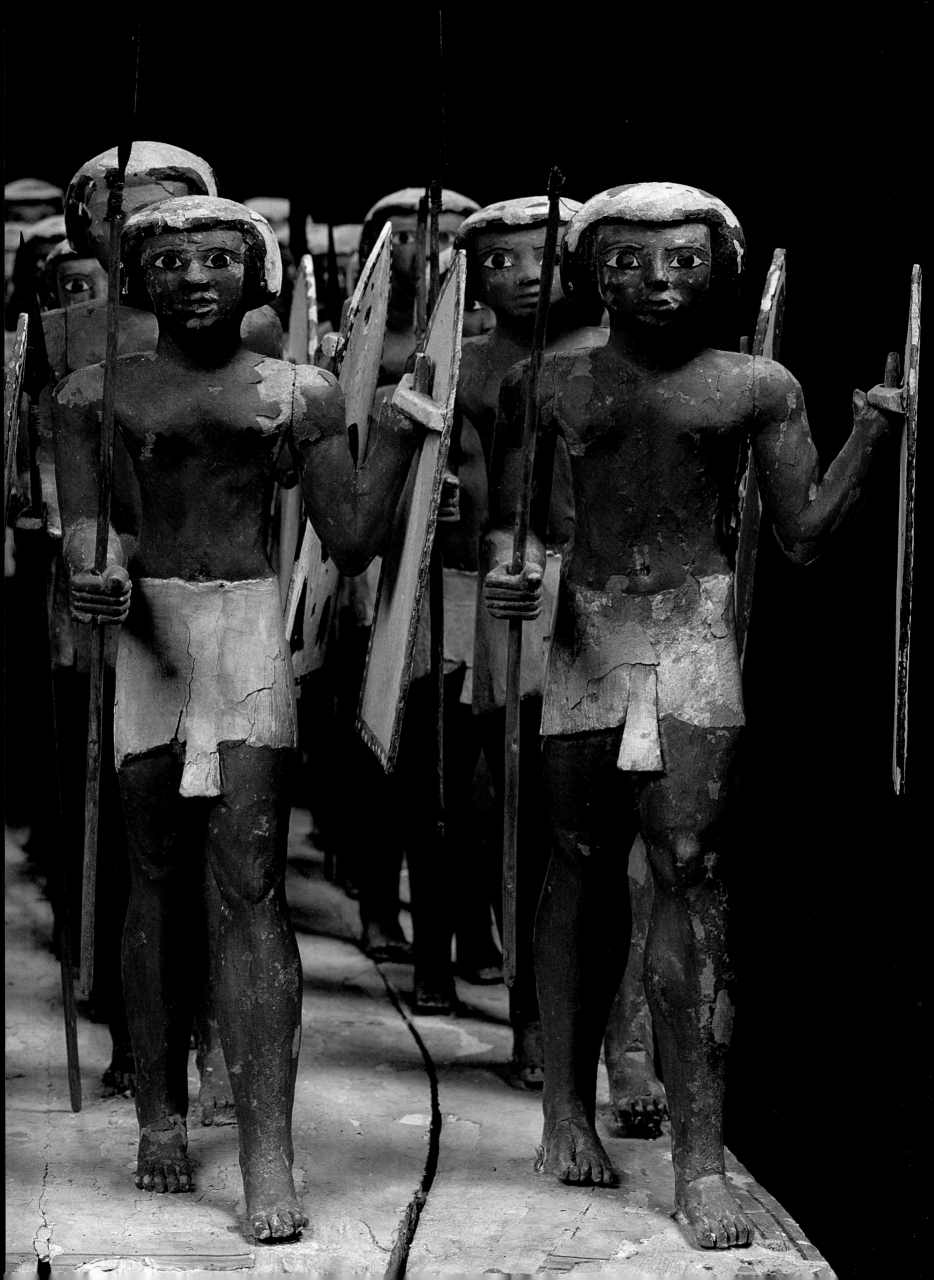

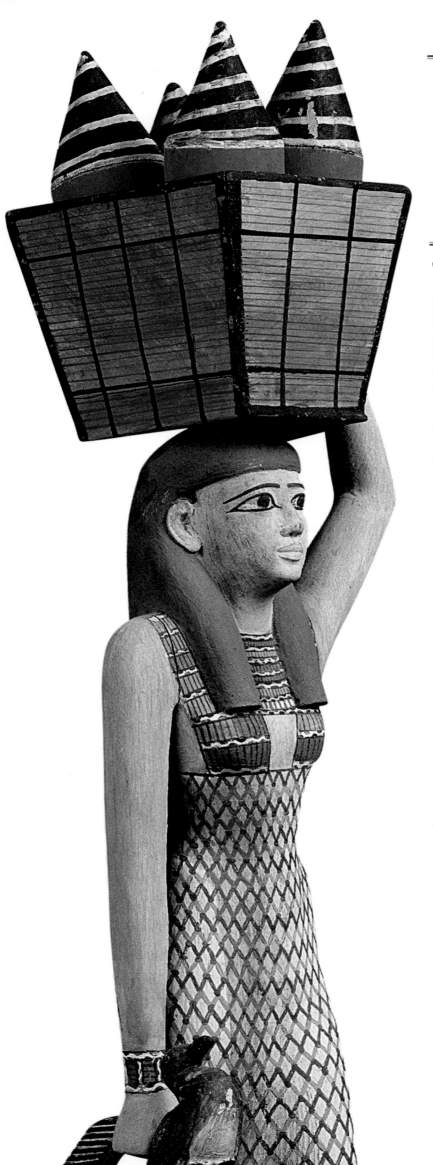

OFFERING–BEARER

PAINTED WOOD; HEIGHT 123 CM
DEIR EL-BAHRI, TOMB OF MEKETRE (TT 280)
METROPOLITAN MUSEUM OF ART EXCAVATIONS (1919–1920)
ELEVENTH DYNASTY (2134–1991 BC)

This wooden sculpture, around two-thirds life-size, was part of a group of twenty-five models found in the tomb of Meketre. It is a sophisticated and remarkable example of a representation of the human figure which combines perfection of form with a search for harmony of colour and detail.

Set on a rectangular base, the woman is depicted walking and carrying a wickerwork basket on her head. This container has reinforced corners and contains four red jars for wine, sealed with conical lids. Her left hand is raised above her head to support the basket while her right arm hangs down by her side and she holds a live goose by its wings. Her jewelry consists of coloured bracelets around both wrists and a multiple-strand necklace of red, green, white and blue around her neck.

She is wearing a black, three-part wig, the front panels of which pass behind her ears and descend either side of her delicate face. Two large, almond-shaped eyes are painted in white with dark pupils and are decorated with dark outlines of eye-paint. Her long black eyebrows follow the line of the eyes. Her nose is straight and her mouth is small and rounded. The tight tunic that reaches to just above the ankles is held up by two broad straps that cover her breasts and echo the colours of the necklace. The decoration of the tunic itself is especially elegant, with a net pattern in which red and green alternate; around the bottom is a double band of diamond motifs. The woman is bare footed, but she wears identical broad anklets. The modelling of her willowy body – with its slim waist, high hips and long legs – revealed rather than concealed by the tunic, is extremely beautiful.

The vivacity of the colours and the perfect state of preservation of this sculpture mean that we can still appreciate to the full this exquisite work of art from four thousand years ago. (R.P.)

JE 46721

MODEL OF A HOUSE AND GARDEN

Painted wood; Height 43 cm; width 40 cm; length 87 cm
Deir el-Bahri, Tomb of Meketre (TT 280)
Metropolitan Museum of Art excavations (1919–1920)
Eleventh Dynasty (2134–1994 BC)

Archaeological remains, the paintings, reliefs and models preserved in tombs, as well as literary texts all provide detailed information about the various types of houses that were found in the Nile Valley. Generally built of unfired brick and covered with roofs of lightweight materials, Egyptian houses naturally varied according to the wealth and social standing of their occupants. They might be one or more storeys high, of restricted size or extremely spacious and luxurious, and above all they might be surrounded by a garden, smallholding or extensive estates of cultivated fields.

A medium-sized house would always have a vegetable patch as well as a pool with an ornamental garden, where families would probably spend much of their time, living and working.

This model from the tomb of Meketre shows the interior courtyard of a house. Between the house and garden is a portico supported by two rows of four fluted columns reproducing bound lotus stems and flowers. The bright colours of the columns are perfectly preserved, with the individual stems alternately painted white, blue and pale yellow, and the capitals green and red. Just as spectacular are the colours of the façade of the house which is decorated with variously coloured mats. In front of the portico is a rectangular basin painted in blue, surrounded on three sides by sycamore trees, the leaves and fruit of which are all minutely represented.

The skilful combination of colours and the precise painting of the architectural elements and the plants document both the taste of wealthy Egyptian householders and the high artistic standards achieved in the creation of these miniatures. (R.P.)

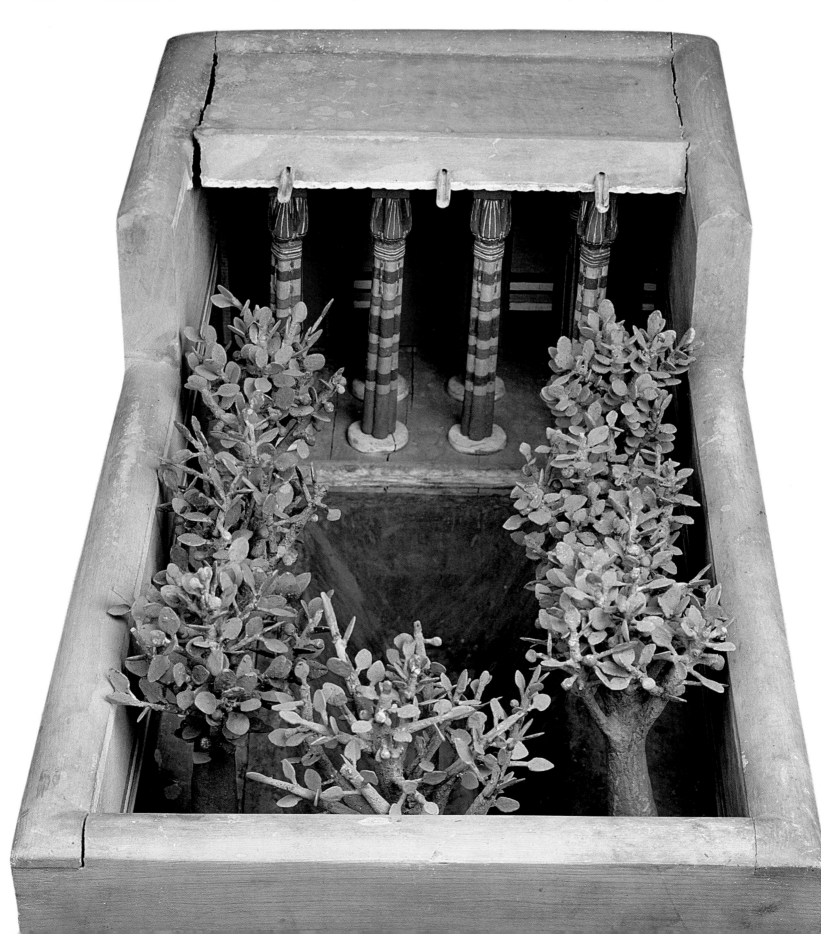

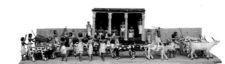

MODEL DEPICTING THE COUNTING OF LIVESTOCK

PAINTED WOOD
HEIGHT 55 CM; WIDTH 72 CM; LENGTH 173 CM
DEIR EL-BAHRI, TOMB OF MEKETRE (TT 280),
METROPOLITAN MUSEUM OF ART EXCAVATIONS (1919–1920)
ELEVENTH DYNASTY (2134–1991 BC)

This model from the tomb of Meketre provides us with a vivid glimpse of one of the activities associated with agricultural life in Egypt. The master of the house is supervising the counting and inspection of his livestock as they are driven in front of him by his workers. Meketre and other functionaries are sitting in a pavilion in the shade as the variously coloured animals pass before them.

The pavilion has a roof supported by four fluted columns painted light blue and white. Meketre is seated on a large chair inside, while a number of scribes and his son are sitting on the floor alongside him. Each of the scribes holds an open papyrus scroll on his lap, and in front of each is a small, low table on which are placed pens and inks. Another two figures are standing close by with staffs in their right hands with which they are ready to punish any irregularities on the part of their subordinates. In fact, outside the pavilion, in front of the master of the house, one of the supervisors is raising his staff to a standing man, probably a negligent herder, who is bending slightly forwards.

Another seventeen men are busy controlling and herding the wayward livestock in the desired direction. Some of them are equipped with staffs while others are holding several animals by ropes tied around their horns. Four of the men are leaning upright against the back wall, probably overseeing the operation. A touch of realism is added to this very evocative scene by the clothing of the men, which is partially made of real cloth.

These models are particularly important to scholars and researchers not only from an artistic point of view but also as vivid documentary evidence. Through these works the ancient Egyptians have provided us with windows into their everyday lives. (R.P.)

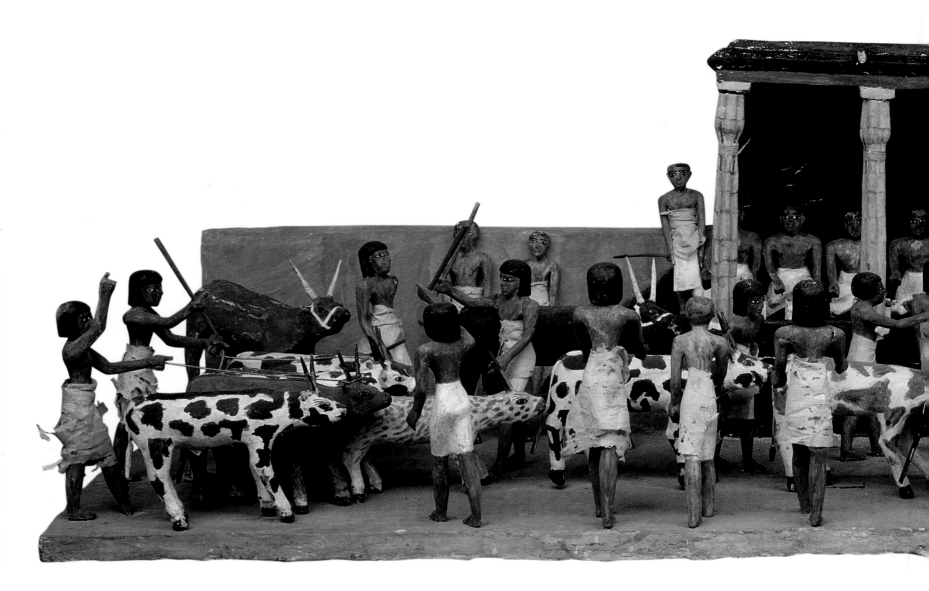

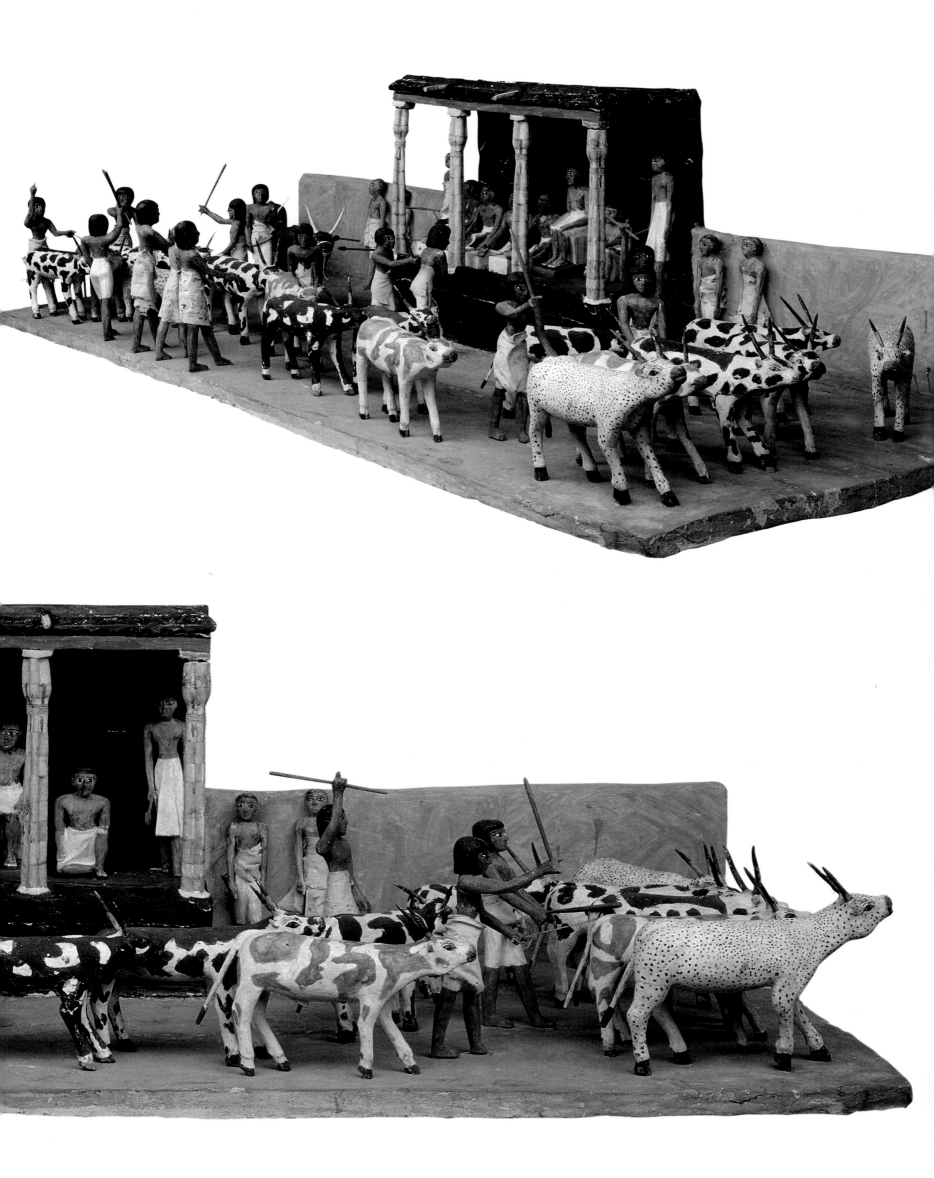

MODEL OF A FISHING SCENE

PAINTED WOOD; HEIGHT 31.5 CM; WIDTH 62 CM; LENGTH 90 CM
DEIR EL-BAHRI, TOMB OF MEKETRE (TT 280)
METROPOLITAN MUSEUM OF ART EXCAVATIONS (1919–1920)
ELEVENTH DYNASTY (2134–1991 BC)

On the walls of Egyptian tombs of the Old Kingdom are painted scenes of what has been described as 'everyday life', among which are representations of hunting and fishing. Fishing was either carried out from land using throwing nets, or from reed boats using dragnets. Among the models found in the tomb of Meketre this one depicting fishing from boats is undoubtedly one of the most lively thanks to the colours used, the realism and the sense of movement and activity that suffuses the scene.

Two boats are sailing parallel to each other, on both of which are five men: one seated in the bow, one at the stern and the other three standing in the middle. The two seated figures have one leg folded on the deck and the other drawn up to their chests. They are rowing with long oars placed on the right-hand side of the boats. All four of them wear loose kilts that reach their knees. The standing men are leaning over towards the net that is strung between the two boats; the two closest to the sides are holding a rope to which the net is attached. They are wearing shorts that reach to their knees and are held up by a single strap crossing diagonally over their chests. All the figures have brown skin and medium-length black wigs that cover their ears.

The light-green coloured boats are striped with bands of yellow running around them in imitation of the cords which fastened the bundles of reeds. At each end the bundles are tied up to form into posts. At the prow the post resembles a lotus flower while the one at the stern is much narrower.

The two boats are attached to a green-painted wooden base on which the net also rests. The circular net is suspended from a rope with floats and contains fish of various species. (R.P.)

117

MODEL OF A WEAVING WORKSHOP

PAINTED WOOD
HEIGHT 25 CM; WIDTH 42 CM; LENGTH 93 CM
DEIR EL-BAHRI, TOMB OF MEKETRE (TT 280)
METROPOLITAN MUSEUM OF ART EXCAVATIONS (1919–1920)
ELEVENTH DYNASTY (2134–1991 BC)

This model depicts a rectangular room, painted sand-yellow, with a door in one corner slightly open. The interior is a hive of activity, with a group of women engaged in various activities connected with weaving. Two kneeling figures are working on two horizontal looms placed almost in front of one another, occupying the centre of the room. A further eight women are standing, and are either spinning thread or winding the thread on to skeins for weaving.

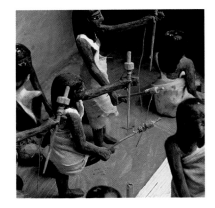

Various tools and baskets are placed close by on the floor. Three other women are crouching on the floor with their backs to the walls.

The workers have brown skin, darker in tone than that used for high-ranking figures, and neat, mid-length hair. Their clothing is made of plain, unpainted cloth, probably originally red, and is extremely simple, consisting of sheets, wrapped around the body and passed over one shoulder to create a strap.

Weaving was one activity in ancient Egypt in which female workers predominated. Women could earn an income through this type of work that was independent their husbands', which allowed them to make various types of transactions on their own behalf. Furthermore, as shown by a papyrus of the reign of Seti I (Nineteenth Dynasty), they were also frequently in charge of important workshops producing fabrics and clothes for the pharaoh and his court. (R.P.)

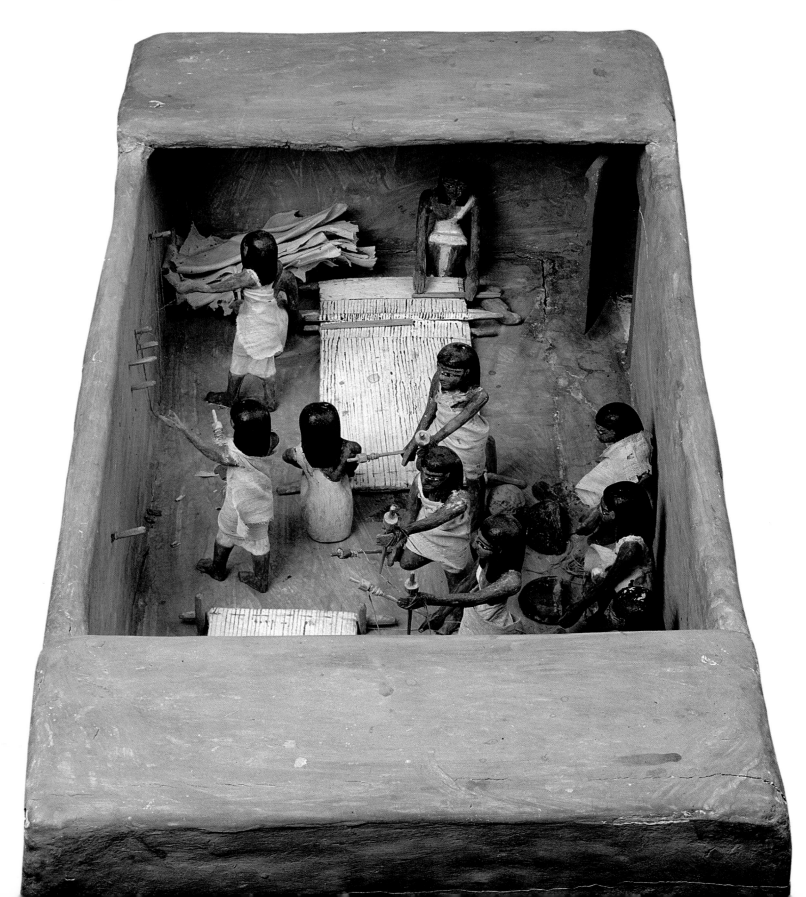

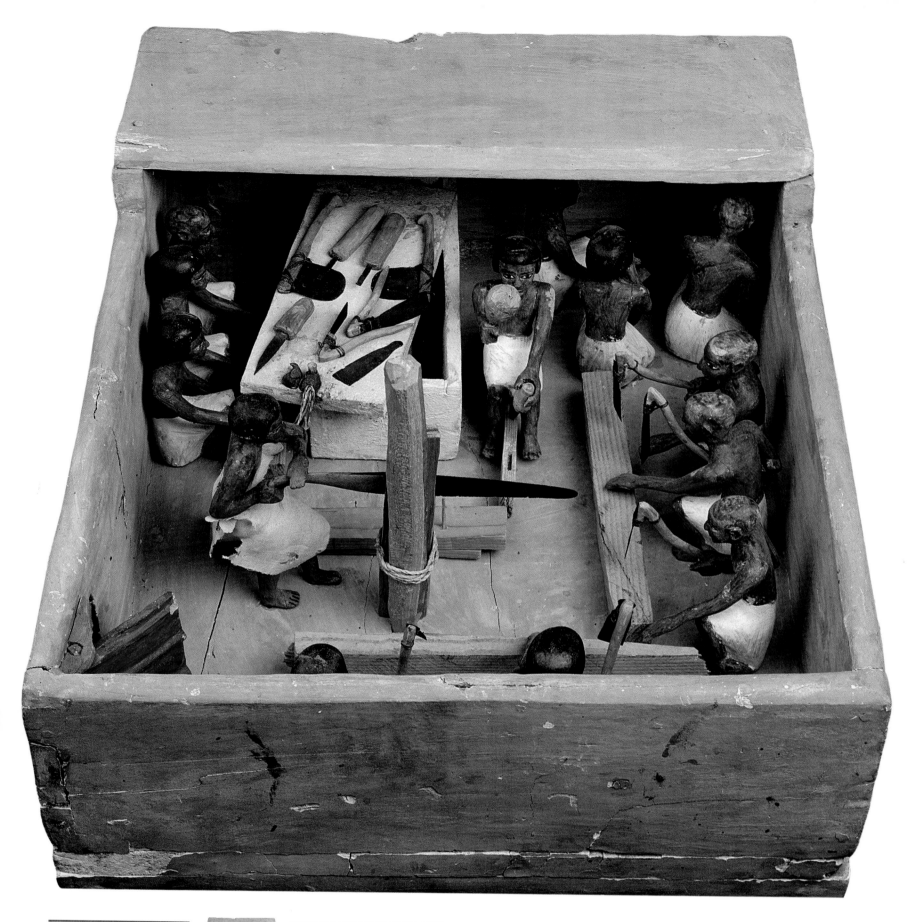

JE 46722

MODEL OF A CARPENTRY WORKSHOP

PAINTED WOOD
HEIGHT 26 CM; WIDTH 52 CM; LENGTH 93 CM
DEIR EL-BAHRI, TOMB OF MEKETRE (TT 280)
METROPOLITAN MUSEUM OF ART EXCAVATIONS (1919–1920)
ELEVENTH DYNASTY (2134–1994 BC)

The scene represented in this model is evidence not only of the activity that might be expected to have taken place in the workshops of an important Egyptian estate, but also the working conditions of skilled labourers. Here a dozen carpenters occupy a fairly small workshop, in one corner of which is a doorway.

A very large white chest with a lid fills one corner of the workshop. It contains a range of tools, some of which are very similar to those still in use today, including chisels, axes and saws and blades of various sizes. The chest was fastened with a cord that still had an intact clay seal.

In the centre of the workshop a standing figure is sawing a large piece of wood fixed to a vertical post. Other men are seated along the sides, finishing planks. Several kneeling workers are tempering their tools in a hearth. All the men in the workshop are bare-chested; some are bald while others have medium-length wigs; they all have brown skin.

While the colours used to paint this model are fairly dull (from pale yellow to ochre, from the black of the wigs to the brown of the skin) the scene is enlivened by the great variety of tasks and activities performed by the men. (R.P.)

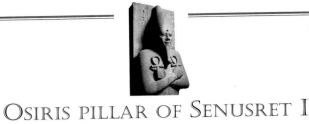

OSIRIS PILLAR OF SENUSRET I

PAINTED LIMESTONE
HEIGHT 470 CM
KARNAK
TWELFTH DYNASTY, REIGN OF SENUSRET I (1971–1926 BC)

Numerous statues of Senusret I portray him as Osiris, standing against a pillar. Most of them come from Lisht where the king and his predecessor Amenemhet I built their pyramids, surrounded by the tombs of their relations and most important dignitaries. Another statue portraying Senusret in the same pose was found at Abydos, although its style links it to the same artistic school as the other examples. Still another example (illustrated here) was found at Karnak. Senusret is portrayed in the traditional mummiform fashion with his arms folded across his chest. In each hand he is holding an *ankh* symbol of life. It is interesting to note, however, that in contrast with other Osiris colossi, here the arms and hands are clearly distinct from the body, almost as if they were free of the shroud covering the rest of the figure. The two *ankh* symbols are carved in high relief.

Senusret is wearing the White Crown of Upper Egypt, with a hole at the front that would once have held the royal *uraeus*. The squarish face, painted light orange, has strong features: the large, almond-shaped eyes with well-defined lids are surmounted by thick eyebrows in low relief; the nose is wide at the base and the rather large mouth has fleshy lips set in a serene smile. The pupils and eyebrows are painted black.

An inscription on the pillar, either side of the king's head reads, on the right, 'Son of Re, Senusret', and on the left, 'Beloved of Amun-Re, lord of the sky'.

This Karnak sculpture, which seems to be more akin to the statuary of the Eleventh rather than the Twelfth Dynasty, is notably different from the other Osiris statues of the pharaoh which lack the interior strength and power expressed by this colossus. (R.P.)

PILLAR OF SENUSRET I

PAINTED LIMESTONE
HEIGHT 434 CM; WIDTH 95 CM; KARNAK, TEMPLE OF AMUN-RE
COURTYARD OF THE CACHETTE; G. LEGRAIN'S EXCAVATIONS (1903–1904)
TWELFTH DYNASTY, REIGN OF SENUSRET I (1971–1926 BC)

This pillar portrays the second pharaoh of the Twelfth Dynasty, accompanied by a different deity on each of the four sides. Although not complete, the work bears eloquent testimony to the stoneworking skills of Egyptian craftsmen in the production not only of large sculptures in the round, but also of reliefs of sophisticated elegance.

Senusret I has left us several monuments and works of art of an extremely high artistic standard, such as the White Chapel, which was completely reconstructed from blocks of stone found in the fill of the third pylon of Amun-Re's temple at Karnak. It is works such as these, like the earlier imposing monuments of the Old Kingdom, that demonstrate the presence in Egypt of incomparable artists who glorified its deities and rulers in periods of great stability and strong centralized power.

The four sides of Senusret's pillar show the king embracing four different deities. On one is the falcon-headed Horus of Edfu (described by the inscription, however, as 'Lord of Heliopolis'). On another the Theban god Amun in human form wears an archaic version of the headdress with double plumes. A hieroglyphic inscription gives Amun the epithet of *Kamutef*, which literally means 'the bull of his mother'. Ptah, the patron god of craftsmen, is depicted within a shrine and wearing the cap of the artisan. Atum is shown wearing the Double Crown, the symbol of royal power over a united Egypt.

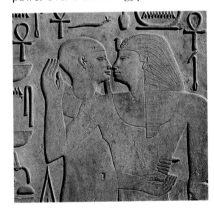

Senusret himself wears the Double Crown when in the presence of Atum and Horus, while he wears the Red Crown of Lower Egypt before Amun *Kamutef*, and the *nemes*, the headcloth decorated on the forehead with the royal *uraeus*, in the presence of Ptah. Above Senusret and the gods, brief columns of hieroglyphic texts identify the characters in the scenes and also contain propitious phrases for the king, which also appear in the remains of the inscriptions on the base of the pillar. (R.P.)

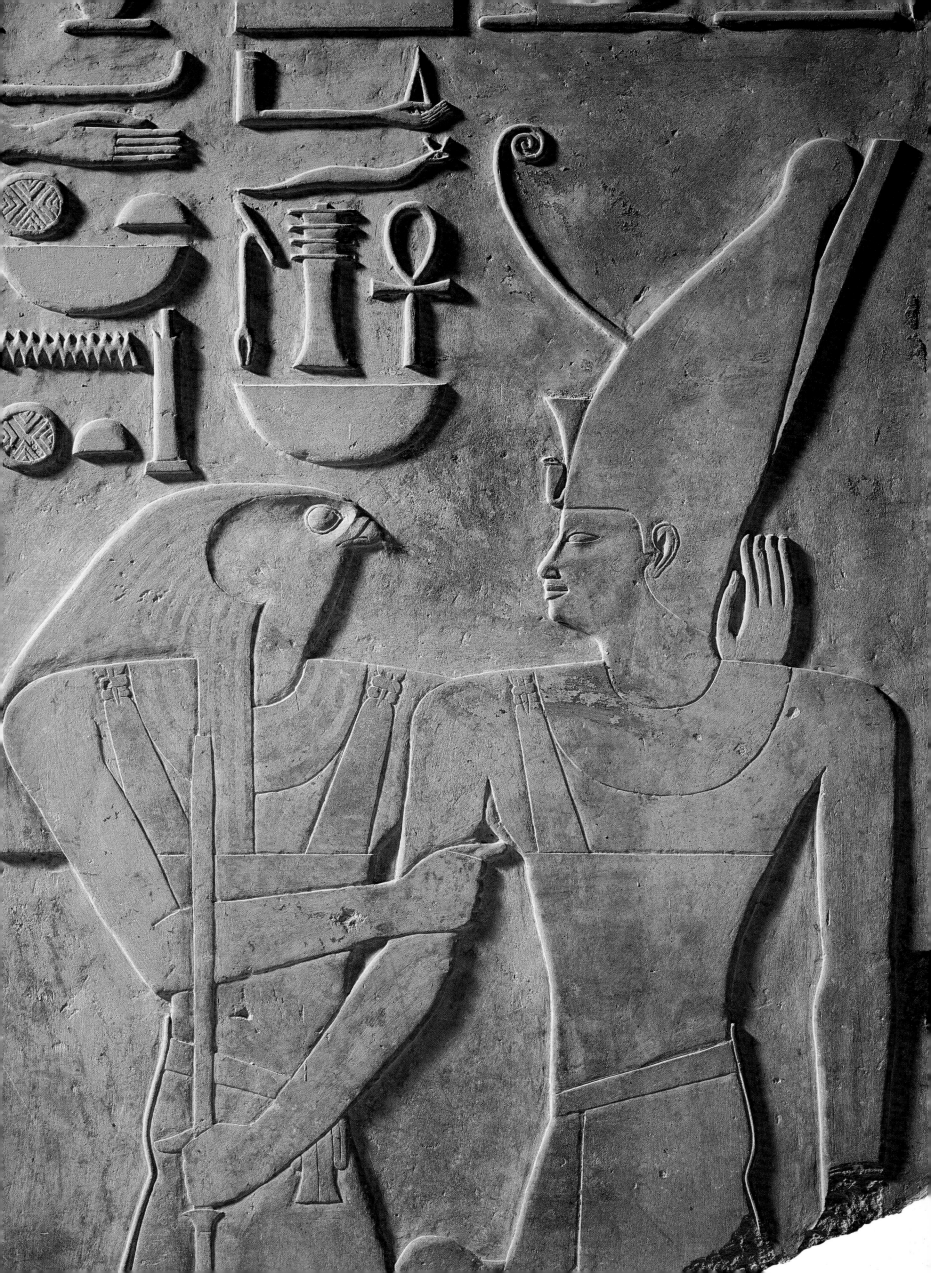

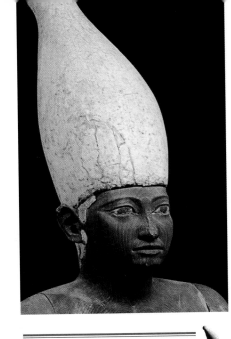

JE 44951

STATUETTE OF A KING

STUCCOED AND PAINTED CEDAR WOOD
HEIGHT 56 CM
LISHT, TOMB OF IMHOTEP, CLOSE TO THE PYRAMID OF SENUSRET I
METROPOLITAN MUSEUM OF ART EXCAVATIONS (1915)
TWELFTH DYNASTY, REIGN OF SENUSRET I OR AMENMEHET II (1971–1892 BC)

This small wooden sculpture placed on a rectangular base portrays a striding pharaoh. While his right arm is held along his body (the hand would once have held a *kherep* sceptre but this is now missing), the left is extended forwards and the hand grips a long staff. The head of this staff is hooked and thus resembles the *heqa* sceptre. As is usually the case with wooden sculptures, the arms and other elements of the figure were carved separately and then fixed to the body with tenons.

The king is wearing the White Crown of Upper Egypt and a short white kilt with two symmetrical and pleated flaps fixed to his belt. The oval face of the statue is skilfully carved, with the details rendered with great precision. The large, deep eyes are emphasized by curving lines stretching towards the temples, and are made particularly vivid by the white of the corneas and the black of the dilated pupils. The gaze is slightly down-turned. The nose is long and thin and the mouth is small but the lips are full. Although the torso is not powerful, the musculature is precisely rendered, dividing the body into three sections delineated by the pectorals and the stomach muscles. The modelling of the legs highlights the bone structure of the knees and the muscles of the calves.

Another wooden statuette similar to this one but wearing the Red Crown of Lower Egypt is now in the Metropolitan Museum of Art, New York. The two statues were discovered in one of the chambers of the private tomb of the chancellor Imhotep who built his funerary monument not far from that of Senusret I. Although the statuette has been identified as an image of Senusret I on the grounds of the proximity of Imhotep's tomb to the king's pyramid, there are no elements that confirm that it is a portrait of that king. Recent stylistic analysis has instead led to the suggestion that the two statuettes are portraits of Amenemhet II. (R.P.)

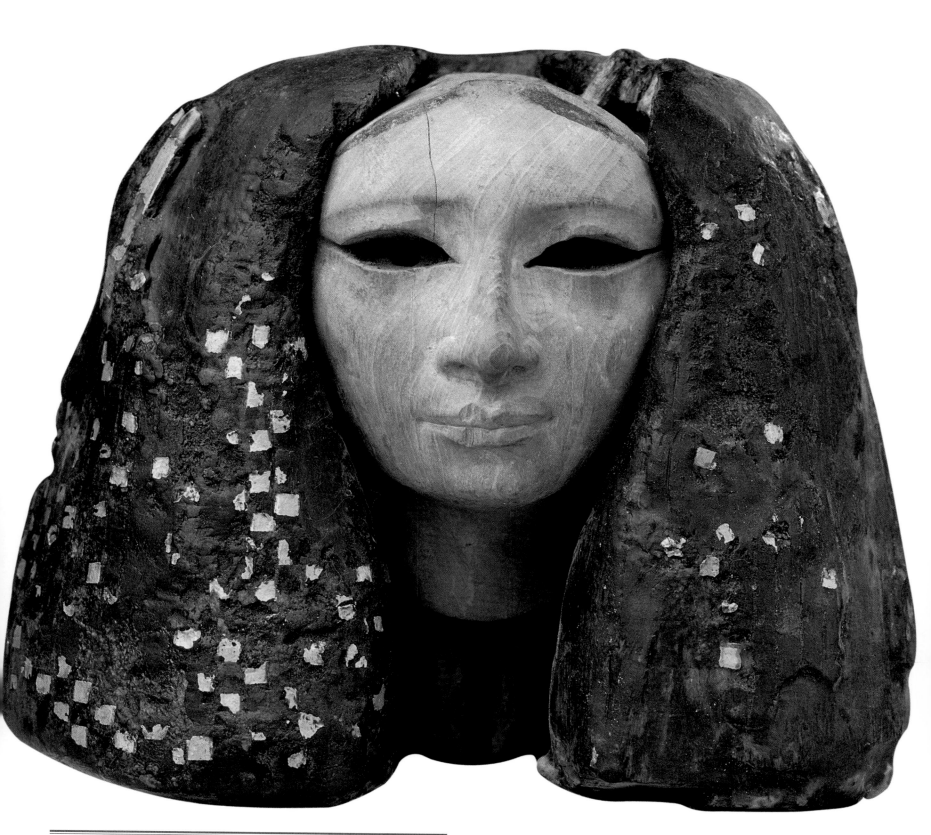

JE 39390

HEAD OF A FEMALE STATUE

PAINTED WOOD WITH GILDING; HEIGHT 10.5 CM
LISHT, AREA OF THE PYRAMID OF AMENEMHET I
METROPOLITAN MUSEUM OF ART EXCAVATIONS (1907)
TWELFTH DYNASTY, REIGN OF AMENEMHET I (1991–1962 BC)

This elegant head, discovered in the area of the pyramid of Amenemhet I, was originally part of a female sculpture, the arms of which were found at a later date. It is not possible to determine whether the sculpture portrays a princess of the royal family or even a queen, but the fine quality of work and the gilded decoration of the wig do suggest that the piece was produced in a royal workshop.

The small head is composed of two separate parts – the face and the wig – joined by means of tenons. The princess' own black hair is visible in slight relief above the forehead and is covered by the large, long wig that creates a perfect and precious frame for the face. Square tesserae of gold (partially preserved) have been inserted into the surface of the wig, apparently originally in a chequer-board pattern. The fact that the wig is much thinner at the top in proportion to the great width of the sides suggests that it would once have been topped by a crown or diadem.

The slim, smooth face has an expression of measured sweetness and is evocative of a young woman on the threshold of maturity. The features are attractive and form a balanced composition, with a high forehead with eyebrows in relief and eyes (once inlaid but now unfortunately missing) with a slim, elongated shape. A groove at the outer corners of the eyes represents the elongated line of eye-paint. The nose is thin and straight and the well proportioned mouth lends a serious expression to the face.

In spite of its small size, this head embodies the same search for perfection that characterizes monumental statuary, a feature that is common to both royal and private statuary in various periods of Egyptian history. (R.P.)

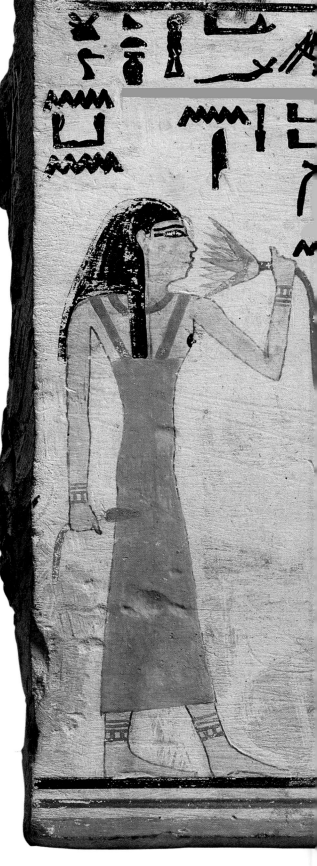

JE 48858

Block Statue of Hotep

GREY GRANITE
HEIGHT 73 CM
CEMETERY OF SAQQARA
EARLY TWELFTH DYNASTY (20TH CENTURY BC)

The block statue, which represents an individual seated on the ground with the legs brought up to the chest and the arms crossed over the knees, appeared in Egypt during the Middle Kingdom. Examples from this early period are not numerous, but the genre developed and became increasingly popular in later periods. The two statues of Hotep in the Egyptian Museum, one in limestone and the other in granite, represent the oldest examples yet discovered.

In both cases Hotep is represented as if seated in a sedan-chair with high arms and a curved back, from which only his head, arms and the front part of his legs and feet emerge. With rare exceptions, the sedan-chair, an indication of the high social standing of the individual thus portrayed, was to disappear from the block statues of the successive ages. In later examples the figure represented in this pose was generally covered with a large cloak that left only the arms and occasionally the feet exposed.

In this example of a block statue made of granite, Hotep is wearing a smooth, flaring wig with a slight central parting that leaves his protruding ears exposed. In contrast with the modelling of the body the face, with its soft, delicate lines, is carefully finished. The eyes, with the typical eye-paint, are large; the nose is regularly shaped and the mouth small with full lips. The chin is thrust slightly forwards and is adorned with a short beard striated with horizontal incised lines. The arms rest flat on the upper surface of the cube while the large legs with thick ankles and broad feet are well defined below. Deep incisions delineate bone structure and musculature.

An offering verse and the name and titles of the figure are incised at either side of and between the legs. (R.P.)

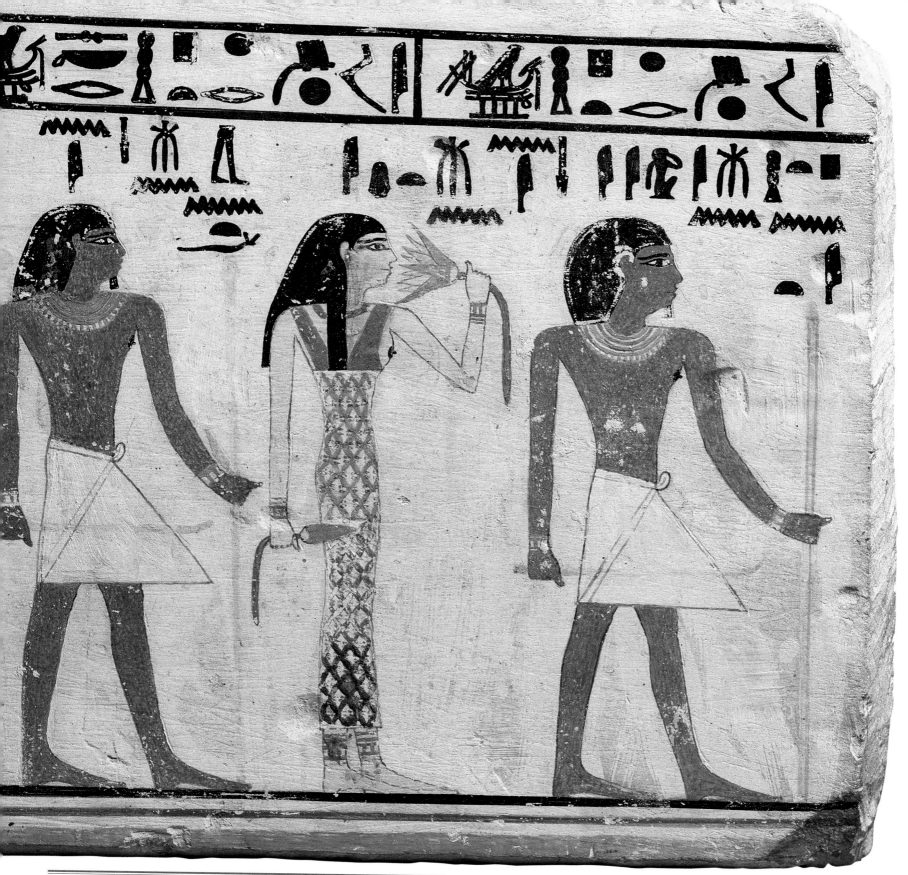

JE 45625

STELA OF NITPTAH

PAINTED LIMESTONE
HEIGHT 23 CM; WIDTH 30 CM
CEMETERY OF ASSASIF (TT R6)
METROPOLITAN MUSEUM OF ART EXCAVATIONS (1915–1916)
END OF MIDDLE KINGDOM (SECOND HALF OF 18TH CENTURY BC)

This rectangular stela features a line of brightly painted figures accompanied by their names. Above them all runs a horizontal line of hieroglyphs forming an inscription which affirms that the deceased and the members of his family enjoy the state of *imakhu* (a term usually translated as 'venerated' or 'revered') in the presence of the god Ptah-Sokaris who is asked to intervene on their behalf to enable their *ka* to make use of 'beer, beef and poultry'.

The deceased, Nitptah son of Ay, is at the right-hand edge of the stela. He is depicted in a walking pose with a staff in his left hand and a kind of whip in his right. He is wearing a medium-length wig, a short white kilt with a rigid triangular panel at the front, a broad necklace and two bracelets around his wrists. His chin is adorned with a short beard. Behind Nitptah is presumably the figure of his wife, whom the hieroglyphic inscription above identifies as 'Seni, daughter of Tai'. The woman holds an open lotus blossom to her face and another flower still in bud in her right hand. She is wearing a long, three-part, black wig, a green necklace formed of a single string and a tunic with straps that leave her breasts exposed. The tunic is covered with a net of variously coloured beads.

Behind their parents are the couple's two children: 'Antef, generated by Seni', represented in the same pose and clothing as his father, and 'Djedu, daughter of Seni'. In contrast with her mother, Djedu is depicted in a walking pose and is wearing an all-green tunic. She too holds one lotus flower to her face and another, still in bud, in her right hand. Both Djedu and her mother Seni wear bracelets and anklets.

All four figures stand on a base composed of three lines painted in black, ochre and green. As was customary in representations of men and women in ancient Egypt, females had lighter coloured skin (pale yellow) than the men who were painted in a brick red.

In spite of the conventionality of the scene and the figures, the brilliant colours lend the scene life and a certain beauty. (R.P.)

125

COFFIN OF KHUI

PAINTED WOOD
LENGTH 189 CM
ASYUT, TOMB 8; FRENCH INSTITUTE OF ARCHAEOLOGY EXCAVATIONS (1910)
MID-TWELFTH DYNASTY (20TH–19TH CENTURY BC)

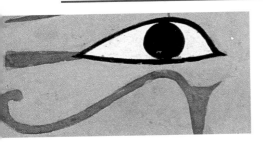

The oldest examples, dating back to the beginning of the Old Kingdom, reproduced the forms and decorative motifs of a palace, demonstrating that rather than the tomb (the physical space in which eternity was still constantly contaminated with the everyday) it was the coffin that was considered to be the deceased's eternal resting place. A door and a pair of eyes painted on the east side of the coffin allowed the deceased contact with the living, whose offerings provided the necessary nourishment for continued spiritual life.

When, at the end of the Old Kingdom, high-ranking officials ceased to be buried in imposing mastabas whose walls were entirely covered with relief decoration, the coffins were embellished with further decorative elements. The interior began to be covered with images and texts which, it was thought, would prove useful to the deceased in the Underworld. A frieze contained representations of the most important offerings and objects in the funerary assemblage and entire surfaces were filled with columns of text containing prayers, myths, spells and prescriptions that were thought to be crucial for eternal life.

Following the appropriation of royal privileges and authority by courtiers and the highest ranking classes, the greater part of the texts inscribed in coffins prove to be identical to, or at least inspired by, the funerary rituals of earlier kings. A whole series of religious texts of diverse origins and nature began to be included in coffins in the Middle Kingdom. As time passed, selections were made and the inscriptions on coffin walls were standardized, culminating in the compilation of a compendium today known as the Coffin Texts.

The coffin of Khui is datable to the Twelfth Dynasty when this process of standardization was apparently complete. Here there is nothing that cannot be found on any other contemporary coffin, with one exception. On the external wall of his coffin, next to the pair of eyes that allowed him to look out upon the outside world, Khui was portrayed with what was probably his favourite dog, Iupu.

It is a very simple scene depicted in the vivid, unsophisticated style of the provincial works of the period. The two figures have no base and appear to be suspended in an empty space. Khui is represented in a striding pose, dressed only in a simple short white kilt. His left arm is folded across his chest and in that hand he is gripping a sceptre that terminates in a human hand. His right arm is next to his side and in that hand he is holding the leash of Iupu, a spotted dog with a tail curling upwards, very similar to the dogs that can be still seen in the Egyptian countryside today.

The touching tenderness of the master towards his faithful canine servant is typical of the spirit of the Middle Kingdom, an age when sentiment frequently prevailed over form, leading to the creation of delightful works of art that are characterized by freshness and immediacy. (F.T.)

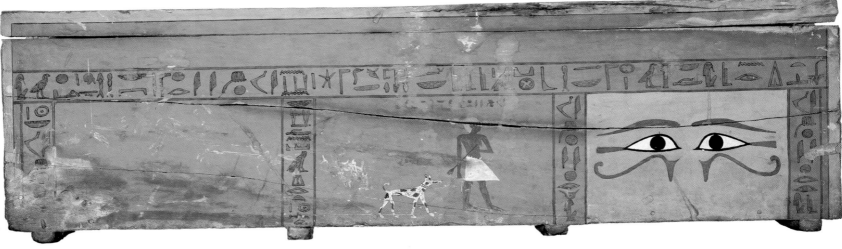

For the ancient Egyptians the coffin was not simply a container for the mortal remains of an individual but was above all the means of preserving the body for eternal life. This concept, deeply rooted in all periods of Egyptian history was well expressed in the terms *neb ankh* 'Master of Life' and *hen en ankh* 'Container of Life' frequently used as definitions of the coffin.

COFFIN OF SEPI

PAINTED WOOD
HEIGHT 70 CM; LENGTH 233 CM; WIDTH 65 CM
DEIR EL-BERSHA, TOMB OF SEPI III
EGYPTIAN ANTIQUITIES SERVICE EXCAVATIONS (1897)
TWELFTH DYNASTY (1991–1783 BC)

Illustrated here is the interior of one of the short sides of the outer coffin of General Sepi, an official of the 15th district of Upper Egypt, the nome of the Hare. It was in this province that his double coffin was found, with an external rectangular casket containing a mummiform coffin also in the Museum in Cairo.

Externally the coffin is decorated with the traditional 'palace façade' motif, surmounted by two *wedjat* eyes. These symbolic eyes were painted on the side of the coffin to which the face of the deceased was turned, covered protectively by the funerary mask. The coffin walls were also painted and incised with protective verses.

The interior of the coffin is decorated with further apotropaic verses and a number of passages from the Coffin Texts that were intended to enable the deceased to undertake the journey to the underworld and ensure his spiritual destiny. These texts draw on and expand the funerary verses of the Old Kingdom, known as the Pyramid Texts because they were originally incised only in the interiors of royal pyramids from the Fifth Dynasty onwards.

This particular panel from Sepi's coffin has a frame painted round three sides consisting of alternating coloured squares. The main decoration in the panel within the frame is divided in two areas of almost equal size, surmounted by a row of stars, symbolizing the night sky. A text composed of large hieroglyphs is painted in the upper part which identifies the figure as 'Venerable in the presence of Nephthys who is below your head [thus indicating that this was the panel that closed the end of the coffin corresponding with the head of the deceased], the Chief of the army, Sepi, right of voice.' Below this inscription is a narrow band of more hieroglyphs that list the offerings placed on two tables: vases for unguents, a linen bag, two head-rests, two pieces of cloth and a lamp with a living flame. The lower section is almost wholly occupied by a funerary text (inscribed in cursive hieroglyphs) from the Book of the Two Roads, together with a representation of the underworld. This consists of a series of concentric oval shapes, at the centre of which the god of the dead, Osiris, is seated on a throne. (R.P.)

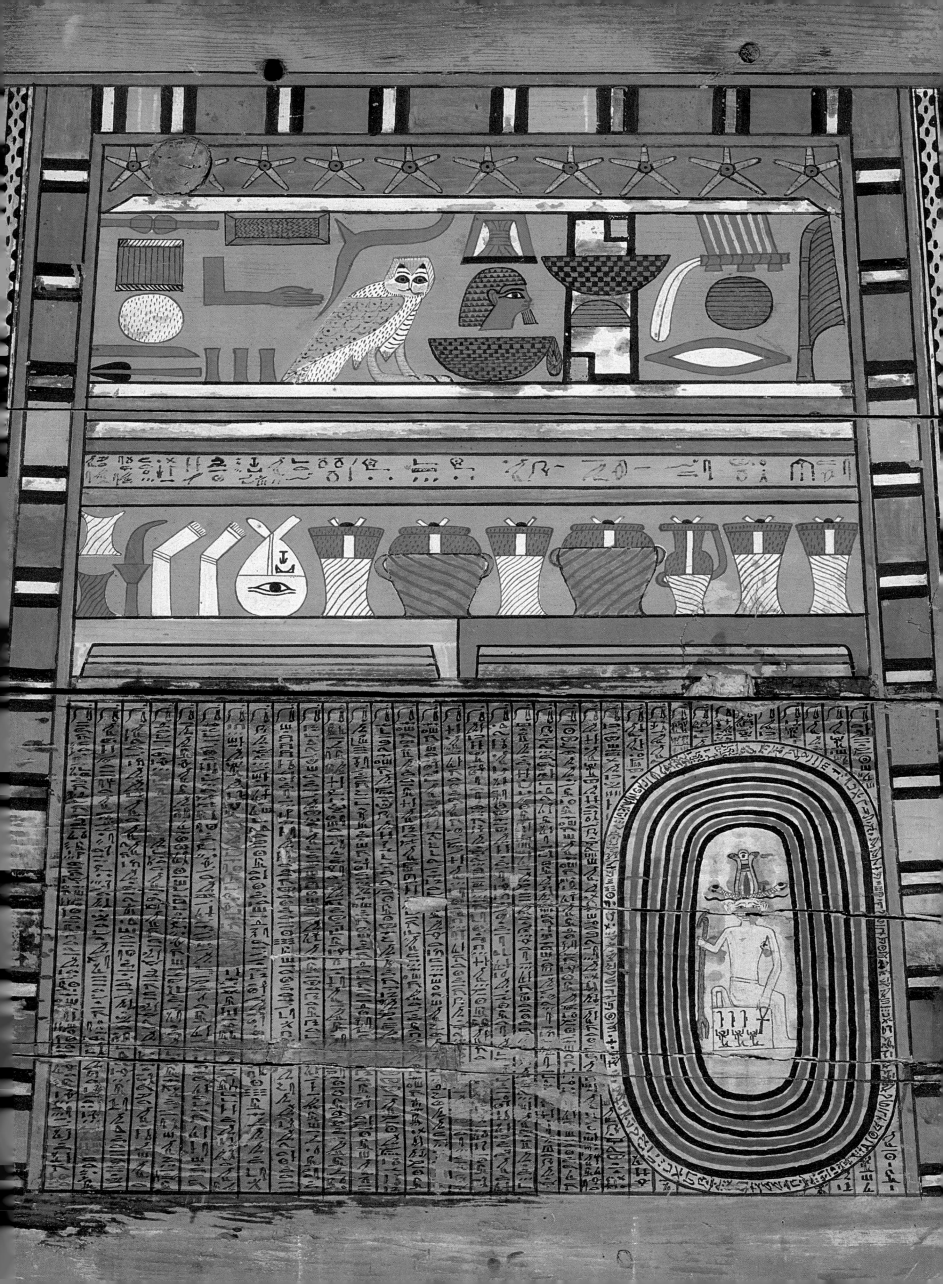

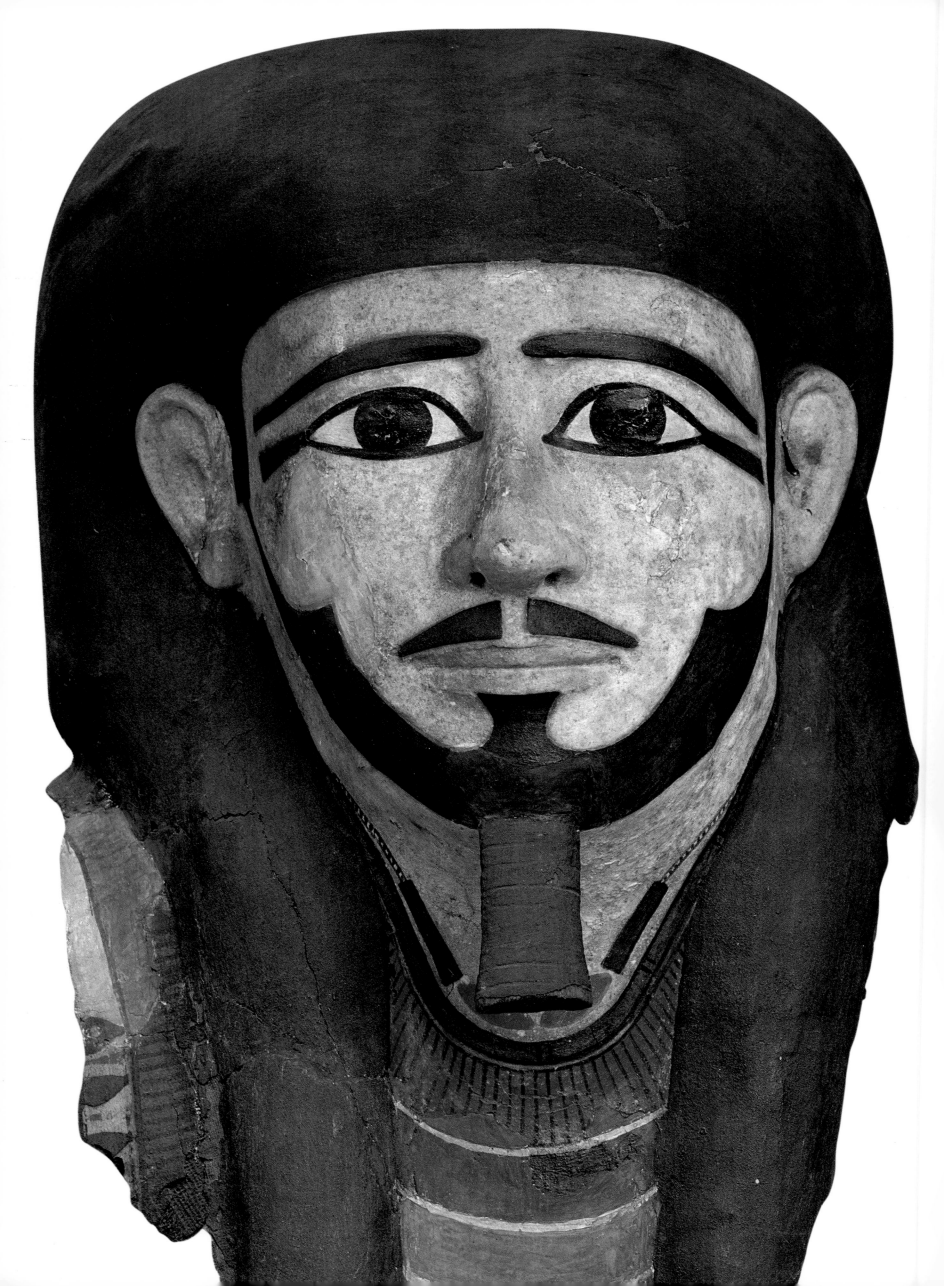

FUNERARY MASK

STUCCOED AND PAINTED LINEN
HEIGHT 50 CM
PROVENANCE UNKNOWN
MIDDLE KINGDOM (2040–1640 BC)

The aim of mummification was to restore to the body of the deceased – emptied of its internal organs and bodily fluids that would have led to putrefaction and decomposition – an appearance as close as possible to that of an intact being ready to live a new life after death. For this reason, in addition to the packing used to fill the cavity left by the removal of the internal organs and the bandages that were a reference to the recomposition of the body of Osiris, from the end of the Old Kingdom, the mummy also was equipped with a funerary mask. These were intended to ensure the complete restitution of the facial features of the deceased and in some cases were extended with a kind of pectoral. They were made of layers of linen covered with stucco which was then painted, a material known as cartonnage.

The example illustrated here portrays a man with an oval face and large eyes outlined with black eye-paint and surmounted by thick, close-set eyebrows. The nose is slim and regularly shaped; the rather wide mouth with well defined lips is framed by centrally divided moustaches and a dark painted beard ending in a square-cut goatee. The relatively compact wig is also painted black and at the front falls in two sections that partially cover a necklace consisting of multiple, variously coloured strands. Above the *usekh* necklace is another, made of long cylindrical beads (two black and two red).

The fragmentary state of the pectoral means that only part of the side decoration of the necklace is preserved, but it is possible to see that it terminates with a string of blue-painted oval beads. Stylistic comparisons with other examples of masks similar to this one allow us to date it to the Middle Kingdom. (R.P.)

JE 46774

SET OF CANOPIC VASES OF INEPUHOTEP

LIMESTONE AND GILDED WOOD; HEIGHT 34 CM; DIAMETER 11 CM
SAQQARA, CEMETERY TO THE NORTH OF THE PYRAMID OF TETI; ANTIQUITIES
SERVICE EXCAVATIONS (1914); EARLY TWELFTH DYNASTY (20TH CENTURY BC)

The tomb of Inepuhotep and Usermut, two individuals who lived during the Twelfth Dynasty, was discovered to the north of the pyramid of Teti at Saqqara. Their funerary assemblage, typical of the period, included wooden coffins, canopic vases, models of boats, wooden statuettes of servants at work, and pottery vessels of various types and shapes.

The four canopic vases for the internal organs of Inepuhotep were placed in no particular order inside a box made of precious imported wood. Each vase carried an inscription, in which the abbreviated name of the deceased (Inepu) is associated with that of a divinity.

The roughly finished vases are atypical in that they are made of limestone and topped by a lid made of painted wood in the form of a human head. The lids depict the four sons of Horus under whose protection the internal organs were placed, after being extracted from the body of the deceased during the embalming process.

The four heads have black wigs that descend to the shoulders; the eyes are painted in black and white. Three of the faces have a dark red skin-tone with black-painted moustaches and straps around the chin to attach the false beard that survives in only two cases.

The fourth lid is instead painted yellow and also differs from the others in that it is the only one not to have a moustache, the strap around the chin and the false beard. This lid represents Imseti, the tutelary god of the liver.

Imseti continued to be represented with human features even when from the start of the New Kingdom the other three sons of Horus were portrayed with animal heads on the lids of canopic vases. Duamutef was represented with the head of a jackal, Qebehsenuef with the head of a falcon, and Hapy with the head of a baboon . (S.E.)

HIPPOPOTAMUS

BLUE FAIENCE
HEIGHT 11.5 CM; LENGTH 21.5 CM
NECROPOLIS OF DRA ABU EL-NAGA
A. MARIETTE'S EXCAVATIONS (1860)
SECOND INTERMEDIATE PERIOD (1640–1532 BC)

JE 21365

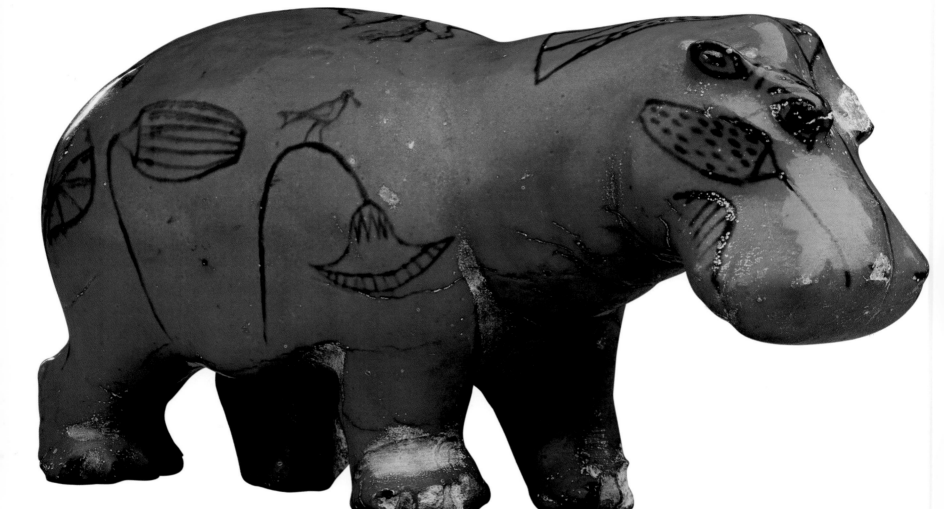

The hippopotamus appears both in Egyptian art and literature. Examples in the form of terracotta figurines have been discovered in tombs and settlements, dating back as far as the Predynastic Period.

Faience figurines of hippopotami are frequently found in tombs dating to the Middle Kingdom and Second Intermediate Period. However, it seems they disappeared abruptly at the end of the Seventeenth Dynasty. These faience figurines are generally associated in the tombs with female statuettes which symbolized fertility, and the two evidently shared a role in the regeneration of the deceased. Both also seem to be linked with fertility and procreation.

Taweret, goddess of female fertility and the protector of childbirth, took the form of a hippopotamus, combined with elements of other animals. On walls of temples she appears in scenes of marriages of the gods and the divine birth of kings.

The figurine illustrated here reproduces not only the actual shape of the animal itself, but in its painted decoration also refers to its natural habitat in the swampy margins of the Nile. Aquatic plants are drawn on its large body – open papyrus flowers and lotus flowers. Its mouth, eyes and ears are picked out in black against the bright blue. (R.P.)

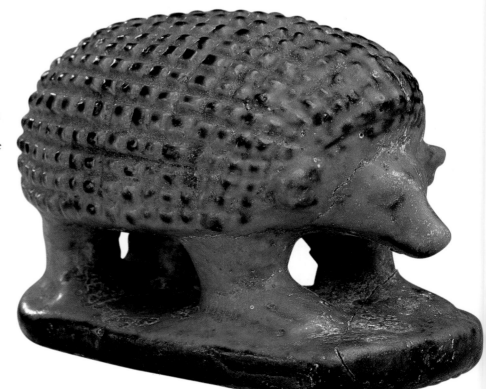

HEDGEHOG

BLUE FAIENCE
HEIGHT 5.3 CM; LENGTH 7 CM
WESTERN THEBES
MIDDLE KINGDOM (2040–1640 BC)

Among the many animals Egyptian artists carved in the round or represented in reliefs and paintings, the hedgehog was a constant presence. In the figurine illustrated here, the artist has on the whole respected the natural form of the animal. It has the characteristic elongated muzzle, small eyes and pointed ears, with the short legs bearing the comparatively large bulk of the body, completely covered with prickles. These are rather stylized and rendered simply by intersecting incisions on the curving back of the animal. The figurine stands on an oval base cast in the same mould.

The ancient Egyptian name for the hedgehog, which tends to be confused with the porcupine in artistic representations, is unknown.

It appears in bas-reliefs in Old Kingdom tombs as the decoration of the prows of ships or in the form of free-standing clay sculptures.

The hedgehog was usually seen as an animal of the desert, both in hunting scenes and as funerary offerings. They were probably deposited in tombs as amulets, perhaps associated with the two deities Mut and Bes, both linked with birth: Mut as the divine mother par excellence; Bes as the protecting god of the mother and child.

The shape of the hedgehog was also used in the production of animal-shaped vases, in particular faience *aryballoi* (a container usually for oil or perfume) of the Greco-Roman period. They are found above all at Naukratis. (R.P.)

'CONCUBINE OF THE DEAD'

BLUE FAIENCE
HEIGHT 13 CM
THEBAN NECROPOLIS, TOMB OF NEFERHOTEP (TT 316);
METROPOLITAN MUSEUM OF ART EXCAVATIONS (1922–1923)
ELEVENTH DYNASTY, REIGN OF MENTUHOTEP (2061–2010 BC)

From as early as the Predynastic Period, female figurines decorated with painted or incised motifs were produced in Egypt and have been interpreted as symbols and amulets associated with fertility.

As with the piece seen here, a number of examples from funerary assemblages of Middle Kingdom tombs are lacking the lower part of their legs, which are only modelled as far as the knees. It is not clear whether there was some magical or apotropaic value associated with this curious feature (for example, to prevent the statuette from leaving the tomb in which it had been placed) or whether the intention was simply to focus attention on the rest of the figure, which was complete to the smallest detail.

This figurine, of an intense blue, is wearing a smooth three-part wig that leaves the ears uncovered. The face is roughly triangular, with large, black-painted eyes (like the wig and the eyebrows), a small mouth and a barely sketched mouth. The breasts are small and the hips rounded. The pubic triangle is emphasized with a dotted motif. On the front of the thighs are diamond shapes, which in real life would have been painted with henna. This corresponds with the practice, still common today, of painting parts of the body with henna on special occasions such as marriages.

Although the female figure is shown naked, she is adorned with a long chain with pendants, bracelets, and two strings of beads that descend from the shoulders to join two others that pass around the waist above the navel. A belt consisting of shells alternating with beads, similar to those actually found in the funerary equipment of princesses of the Twelfth Dynasty, is also draped around the hips of this attractive figure. (R.P.)

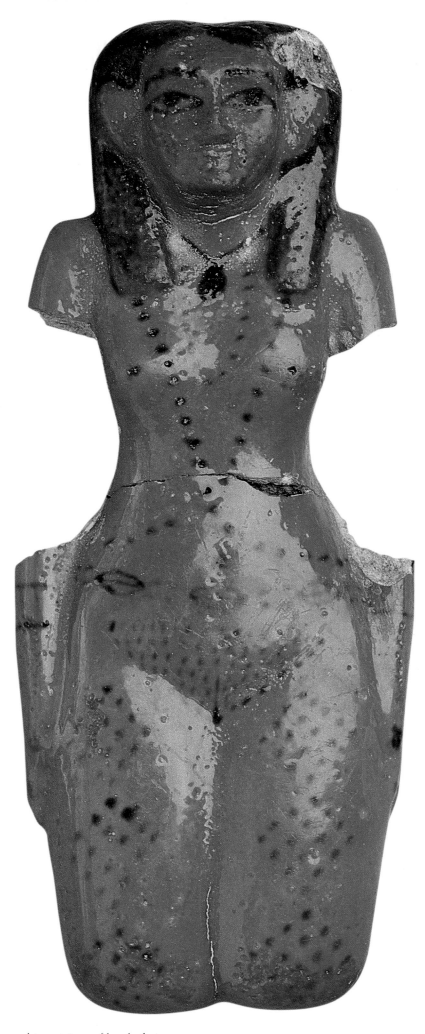

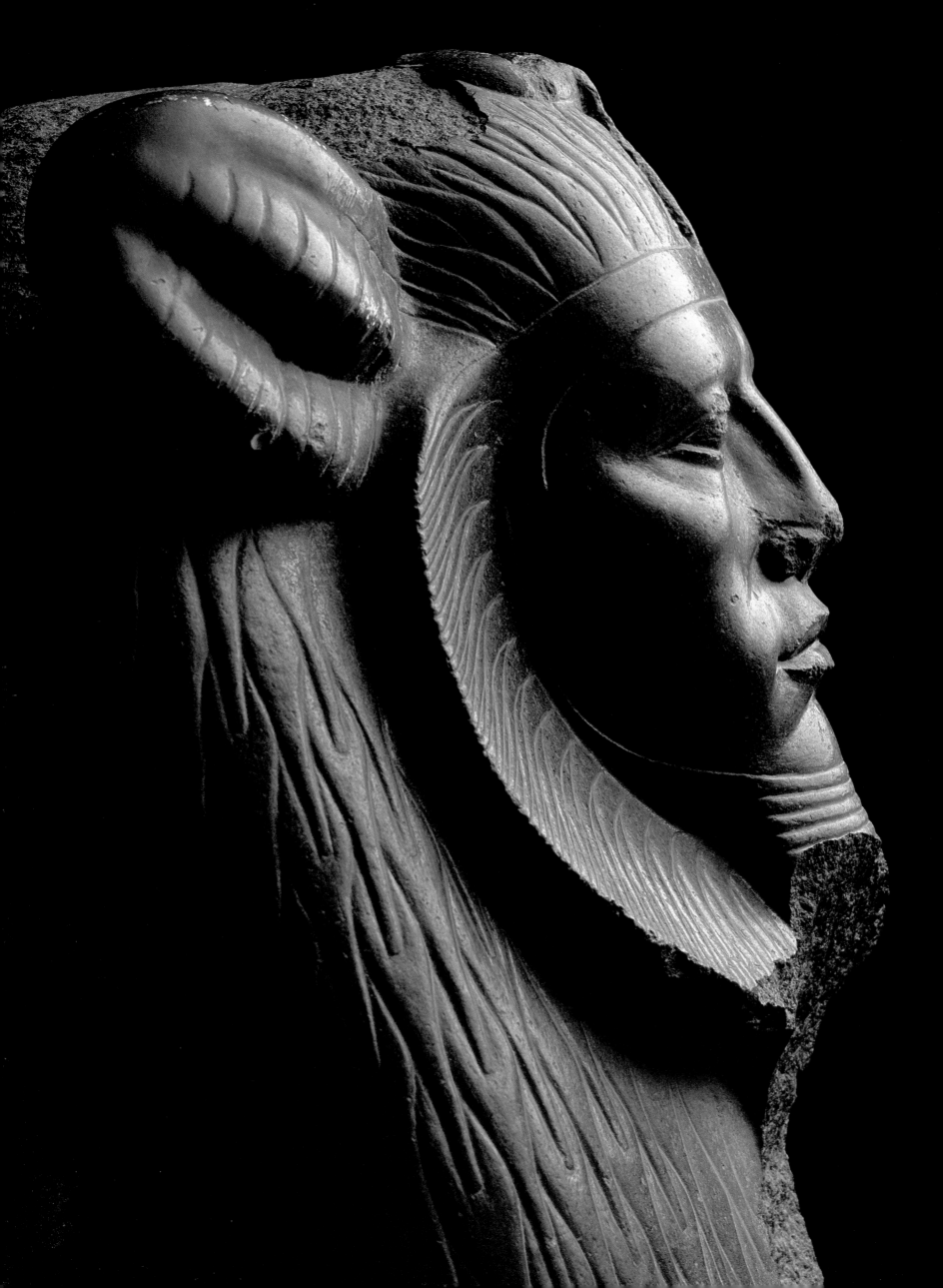

SPHINX OF AMENEMHET III

GREY GRANITE
HEIGHT 150 CM; LENGTH 236 CM
TANIS; A. MARIETTE'S EXCAVATIONS (1863)
TWELFTH DYNASTY, REIGN OF AMENEMHET III (1844–1797 BC)

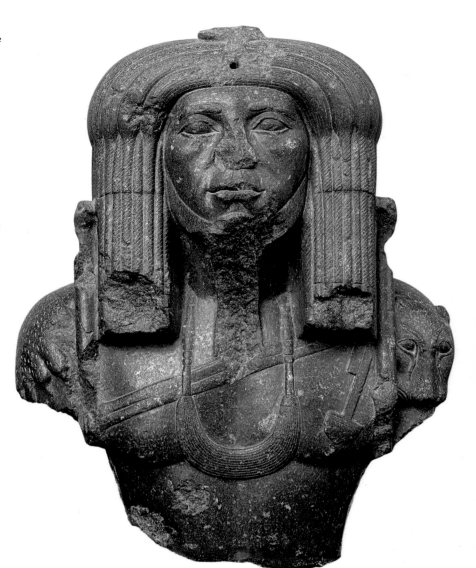

Sphinxes of Amenemhet III were extremely popular with rulers in later periods. They were usurped and re-used in the Hyksos Period by King Nehesi, in the Ramesside Period by Ramesses II and Merneptah, and finally in the Twenty-first Dynasty by Psusennes. The exact site of their original location is still in doubt, but it was probably the temple dedicated to the goddess Bastet at Bubastis. They were actually found at Tanis, where they may well have been taken by Psusennes, together with other monuments from earlier periods selected to embellish the capital of the pharaonic state of the Twenty-first and Twenty-second Dynasties. The prestige that this particular type of sculpture must have enjoyed is also demonstrated by the fact that during the Eighteenth Dynasty, Queen Hatshepsut used it as the model for her own sphinx, which is also in the Museum in Cairo.

The king is depicted in the traditional pose, with the body of a lion and a human head, but in this instance the head is framed not by a *nemes*, the head-dress usually worn by a ruler when depicted as a sphinx, but by a long, thick mane from which leonine ears emerge. A cobra symbolizing kingship is placed on the forehead.

The austere face, characteristic of the royal statuary of the period, has small, concave eyes, and a nose delimited by deep furrows that emphasize the pronounced and determined mouth and the protruding chin.

The titles of the kings who usurped the statue are visible in various places. Around the slightly damaged base, moreover, runs an inscription containing part of the titulary of Ramesses II: 'The Horus, Powerful Bull beloved of Maat, possessor of jubilees like his father Ptah; the King of Upper and Lower Egypt *Usermaatre Setepenre*; the Son of Re Ramesses *Meriamun*.' The same names and titles can also be read on the front of the base. (R.P.)

UPPER PART OF A STATUE OF AMENEMHET III IN PRIESTLY DRESS

BLACK GRANITE; HEIGHT 100 CM
FAYUM, CROCODILOPOLIS (MIT FARES); EXCAVATIONS 1862
TWELFTH DYNASTY, REIGN OF AMENEMHET III (1844–1797 BC)

Only the upper part of this intriguing statue survives, but the imposing dimensions of even this fragment demonstrate that the complete work would have been well over life size.

The king is dressed in a very unusual costume, but is represented in the unmistakable style that characterizes all his portraiture. The highly expressive face is, in fact, very similar to that of the group of sphinxes of Amenemhet III found at Tanis and now in the Museum in Cairo. The eyes have a rather heavy appearance due to the half-closed lids, the cheeks are furrowed by deep lines, the lips are fleshy and follow an undulating line, while the chin is slightly protruding. The long wig is particularly wide around the face and is composed of thick locks of hair forming a broad arc around the forehead before joining in braids falling to the shoulders on either side of the face. At the centre of the forehead is a hole that would once have housed the cobra, of which the undulating coils can still be seen on the top of the head.

Amenemhet III is wearing a leopard skin, of which a paw is visible on the right shoulder and the head on the left. The pelt is held in place by two bands crossing diagonally across the chest. A *menat* necklace hangs around the neck. Traces on the chin and chest are all that remain of a long, broad beard. On either side of the wig are the tips of two standards, topped by a falcon's head, which the king held close to his body. This detail supports the hypothesis that this sculpture is the first example of the standard-bearer statue that was later frequently used in representations of officials and priests in the Ramesside Period.

This sculpture, with its archaic iconography of the pharaoh in his priestly role, was found in Crocodilopolis, the capital of the Fayum, near the area where Amenemhet built his funerary complex later known as the 'labyrinth'. (R.P.)

133

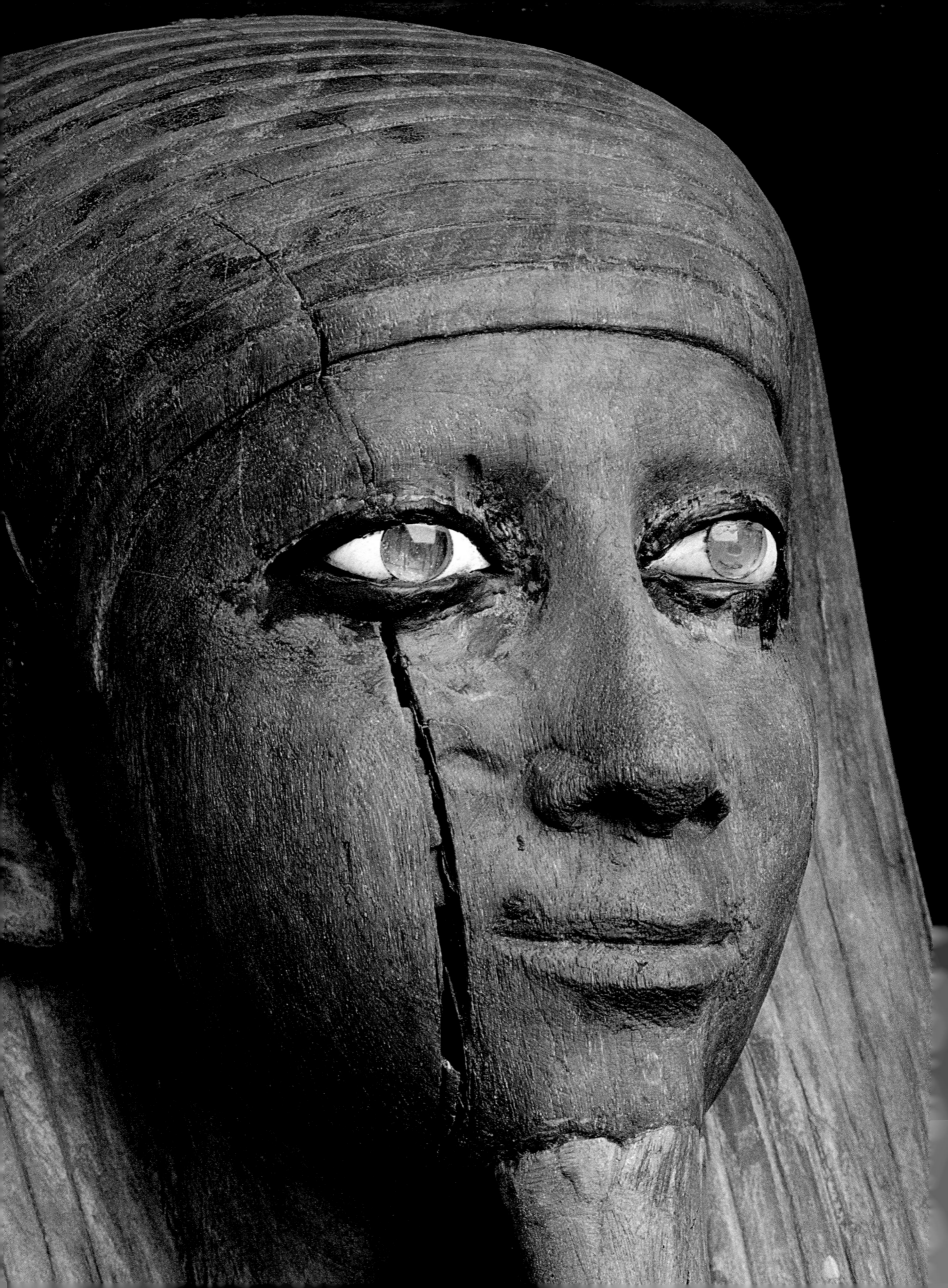

JE 30948 = CG 259

KA-STATUE OF AUIBRE HOR
WITHIN A SHRINE

WOOD, GOLD LEAF
HEIGHT OF THE STATUE 170 CM; HEIGHT OF THE SHRINE 207 CM
DAHSHUR, AREA OF THE PYRAMID OF AMENEMHET III
J. DE MORGAN'S EXCAVATIONS (1894)
THIRTEENTH DYNASTY, REIGN OF AUIBRE HOR
(18TH–FIRST HALF OF THE 17TH CENTURY BC)

This striking statue depicts the *ka* of Auibre Hor, a ruler of the Thirteenth Dynasty. According to the ancient Egyptians, the *ka* was the immaterial double of a person – a sort of divine spirit or life force. The *ka* survived the death of the individual and the offerings placed on altars before the funerary stelae were dedicated to this spirit. It was the *ka* of the god, housed in the statue, that allowed him to manifest himself on the earth.

This immaterial aspect of a person or god is depicted in hieroglyphic form by two arms, bent upwards at the elbows, like those seen here crowning the head-dress of Auibre Hor.

Certain elements of the statue (the arms, the left leg and the toes) were carved separately and assembled by means of tenons, as was usually the case with wooden statuary.

The king is represented in a striding pose on a rectangular base. His right arm is held along his body and in this hand he would once have gripped a *kherep* sceptre; the left arm is extended forwards and this hand would once held a long staff reaching the ground. The figure is wearing a long, three-part wig striated with narrow, parallel incisions, which leaves the ears

exposed and reaches the chest. The figure is otherwise naked, although traces of a belt are visible around the waist and there are a number of holes below the navel that were probably used to fix a separate loincloth or kilt.

The king's oval face is particularly refined, with inlaid eyes outlined with bronze; the nose is straight and the mouth small. A long, slim beard, a symbol of divinity, is attached to the chin. The neck was once adorned with an *usekh* necklace covered with gold leaf. Traces of this precious metal are also visible on the wig.

This sculpture is a fine example of the wooden statuary of the early part of the second millennium BC which in certain respects appears to draw on Old Kingdom traditions.

When the Egyptian Museum's collections were transferred rather hurriedly from Giza to the present building in Tahrir Square, the statue was slightly damaged in a number of places by clumsy workers. In order to escape severe punishment, they then decided to conceal the piece in the museum's underground storerooms. The precious statue was thus thought to have been lost until it was rediscovered a few years later, restored, and put on display once again. (R.P.)

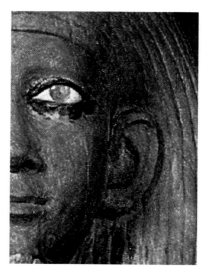

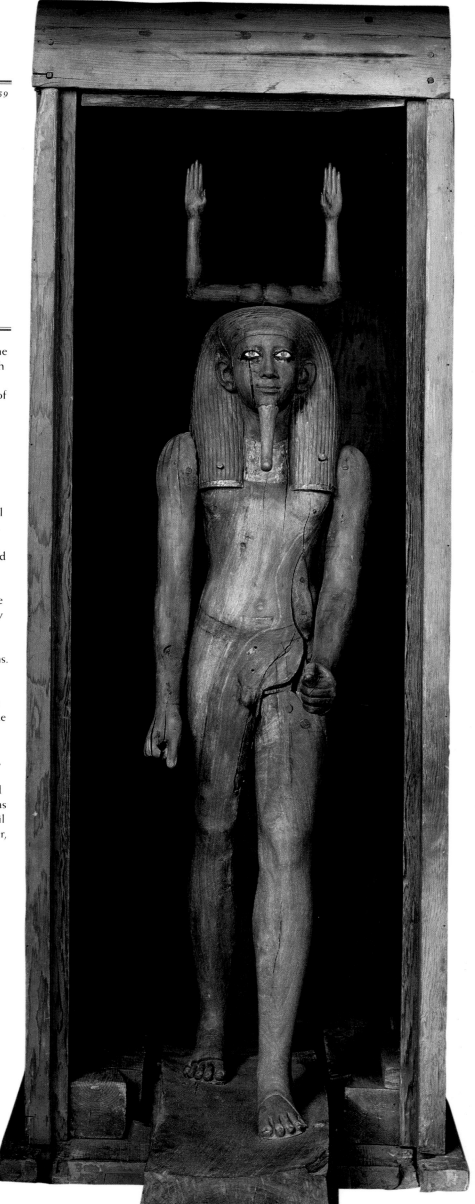

The artistry and skill of Middle Kingdom craftsmen is nowhere more evident than in the jewelry that was created for the queens and princesses of the Twelfth Dynasty. The exquisitely crafted, brightly coloured crowns, necklaces, bracelets, anklets and rings that adorned these women rank among the greatest achievements of the Egyptian jewelry maker. While the larger pieces of the New Kingdom and Third Intermediate Period impress the viewer with their elaborate use of gold and semiprecious stones, Middle Kingdom ornaments are subtle and intimate, rewarding patient viewing of their complex inlaid patterns.

The royal jewelers of the Twelfth Dynasty relied primarily on a few materials to achieve their creations: gold, faience, amethyst, lapis lazuli, carnelian, turquoise, feldspar and occasionally silver. Intricate inlays were created by cutting lapis, carnelian, turquoise and feldspar into tiny, beautifully shaped pieces, which were then inserted into cells formed by gold strips attached to a gold base plate. The resulting works combine lustrous arrangements of

ADELA OPPENHEIM

THE ROYAL TREASURES OF THE TWELFTH DYNASTY

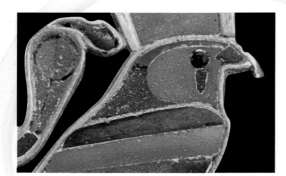

deep, shining colours with superb technical mastery. Individual elements were also created from single materials such as gold and amethyst, usually embellished with chased or incised decoration. These components were then assembled into finished pieces of jewelry, with the addition of a variety of beads, some minute, also made from semiprecious stones. In rare instances, gold objects with granulation have been found, but such pieces are believed to have been imported into Egypt from areas in the northern Mediterranean.

The jewels of Middle Kingdom queens and princesses were decorated with designs and symbols that both protected the wearer and demonstrated his or her status. Some items, such as *uraei* and pectorals incorporating the names and images of the king, defined the wearer as a member of the royal family. Other types of jewelry were commonly worn by upper-class men and women. Jewelry elements often took the form of symbols, which were intended

to protect the wearer against evil forces, and promote positive outcomes such as the birth of healthy children.

Although the caches from which many Twelfth Dynasty royal jewels were recovered remained untouched by tomb robbers, the decay of the threads that bound the jewelry elements together resulted in the loss of their original arrangement. Our understanding of how jewels were composed and worn has been aided by paintings, reliefs and sculptures that depict royal and non-royal women adorned with a variety of ornaments. In addition, jewelry has sometimes been found on the decayed remains of mummies, revealing the area of the body on which a particular item was worn.

Only a few royal Twelfth Dynasty diadems have survived, each with a unique arrangement of floral motifs. Flowers often adorn women's heads in paintings, reliefs and sculpture, and the royal diadems presumably represent a translation into permanent materials of ornaments that

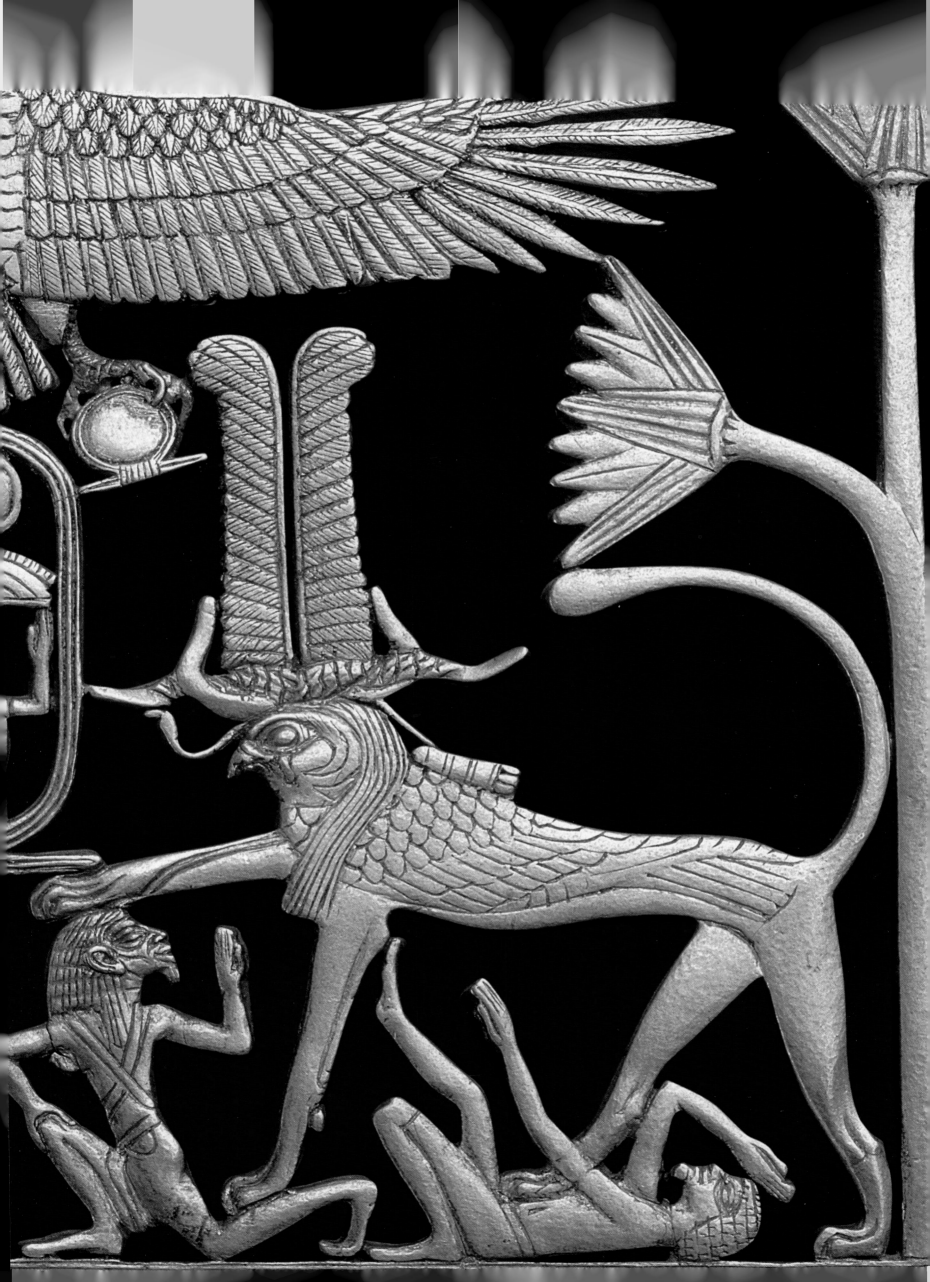

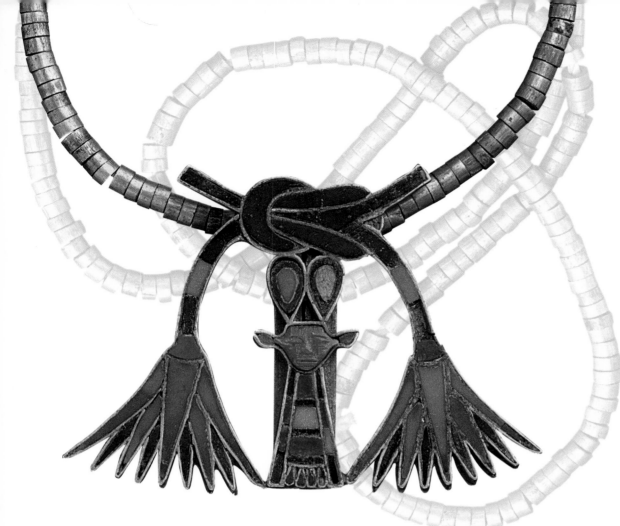

138 LEFT
CLASPS OF NECKLACE
OF SIT-HATHOR
JE 30862
GOLD, CARNELIAN,
LAPIS LAZULI, TURQUOISE
HEIGHT 2.7 CM
DAHSHUR, FUNERARY
COMPLEX OF SENUSRET III
TOMB OF SIT-HATHOR
JACQUES DE MORGAN'S
EXCAVATIONS (1894)
TWELFTH DYNASTY
REIGN OF SENUSRET III
(1878–1841 BC)

138 BELOW
BRACELET OF
QUEEN WERET
JE 98785 A, B - 98788 A, B -
98790 D - 98792 D - 98793 D
GOLD, TURQUOISE,
LAPIS LAZULI, CARNELIAN
HEIGHT 4 CM
LENGTH 15.5 CM
DAHSHUR, FUNERARY
COMPLEX OF SENUSRET III,
PYRAMID OF WERET;
METROPOLITAN MUSEUM
OF ART EXCAVATIONS
(1994)
TWELFTH DYNASTY
PERIOD BETWEEN THE
REIGNS OF AMENEMHET II
AND SENUSRET III (LATE
20TH–EARLY 19TH CENTURY
BC)

139 OPPOSITE ABOVE
PECTORAL OF MERERET
JE 30875 = CG 52002
GOLD, CARNELIAN,
TURQUOISE, LAPIS LAZULI,
AMETHYST
HEIGHT 6.1 CM
WIDTH 8.6 CM
DAHSHUR, FUNERARY
COMPLEX OF SENUSRET III
TOMB OF MERERET
JACQUES DE MORGAN'S
EXCAVATIONS (1894)
TWELFTH DYNASTY
REIGN OF SENUSRET III
(1878–1841 BC)

were commonly made with fresh flowers. Flowers also feature prominently in scenes depicting hunting in the marshes and banquets, where they serve to emphasize the aspects of fertility and rebirth inherent in such scenes. In addition to floral elements, the diadem of Sithathoriunet includes a *uraeus*, while a vulture with outspread wings is found on one of the diadems of Khnumet. These emblems define the wearer as a member of the royal family, and transform the diadem from a piece of jewelry that could be worn by any upper-class woman into regalia meant only for a queen or princess.

Broad-collar necklaces were popular ornaments throughout Egyptian history. Princess Neferuptah owned one of the most beautiful surviving Middle Kingdom examples of this type, which consisted of multiple long strands of beads extending between the shoulders; a counterpoise, formed by horizontal rows of beads, hung down the back between the shoulder blades, and helped to hold the elaborate necklace in position. Neferuptah's necklace was embellished with three Horus heads: one at each end of the broad-collar and a third at the top of the counterpoise. The falcon-headed god Horus was identified with the living king, and the presence of this symbolism on the collar stresses the owner's close association with the reigning monarch.

A rarely preserved necklace type consists of a large, elaborate pendant called a pectoral, which was worn over the breast, suspended from strands of drop and ball beads. The earliest known pectorals date from the mid-Twelfth Dynasty and their designs are based on the names and titles of the king. Examples dating to later in the Twelfth Dynasty display crowded scenes representing the king's domination over foreign enemies. Elaborate chased work on the backs of the pectorals highlights the great skill of the Egyptian artisan; such details were presumably seen only by the royal ladies as they put on their jewels.

A group of inlaid amulets known as motto clasps are probably related to the necklaces. These small clasps are composed of inlaid hieroglyphs that form words or short phrases such as 'joy', 'birth' or 'the hearts of the two gods are content', a phrase that refers to the reconciliation of the rival deities Horus and Seth. Because we have no depictions of motto clasps in Middle Kingdom art and they have not been found on mummies, their precise function remains uncertain. Each piece has a carefully worked sliding clasp with narrow tubes for the insertion of threads, and so these objects may have been used as fasteners for simple strands of beads and pectorals.

The most common type of bracelet worn during this period consists of rows of tiny beads made from semiprecious stones and separated by spacers, which are stiff gold bars made from rows of joined beads. Such bracelets are frequently shown in Egyptian art. Bracelets worn by royal women often had elaborately inlaid clasps decorated with either the name of the king or symbols such as the *djed* pillar, a hieroglyphic sign that denoted stability and endurance. Another type of bracelet was made of larger beads and had amulets in the form of recumbent gold lions, which symbolized the king and royal power. The most skilfully made of these lion amulets are in effect tiny sculptures, with faces that display individualized expressions and finely worked details. Recumbent lion amulets are never

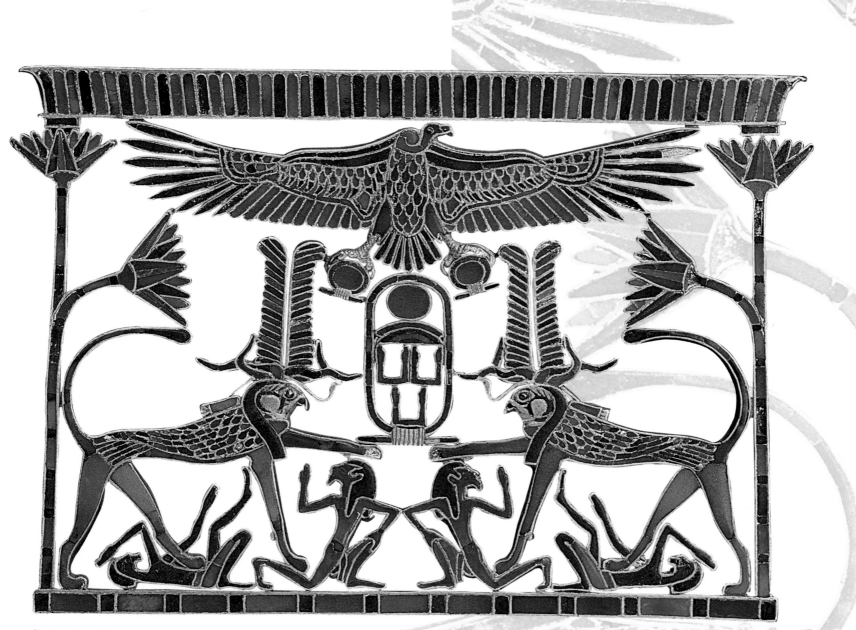

depicted in Egyptian art, but have been found in the wrist area of mummies of the Middle Kingdom, suggesting that they were parts of bracelets.

Anklets made from semiprecious stones and gold spacers, similar in design to the wide bracelets, were common ornaments. Strands of larger beads were also used to create anklets. In some instances, claw-shaped pendants of either solid gold or gold inlaid with semiprecious stones were suspended from anklets. The association of claw pendants and anklets is confirmed by a tomb painting from Qaw el-Kabir in Middle Egypt, which depicts dancers wearing such jewelry.

In the Twelfth Dynasty, scarabs might be worn as finger rings. A narrow hole was drilled through the length of the scarab, and a thin piece of twisted gold wire was inserted to form the ring. Scarab rings have been found in burials with their wires removed, indicating that the objects were transformed from wearable pieces of jewelry into funerary amulets. The bases of the scarabs were decorated with a variety of motifs. Some were inscribed with the names and titles of the royal women who owned them, while others were simply left

139 RIGHT
NECKLACE OF MERERET
JE 30884A - 30923 =
CG 53169 - 53170
GOLD AND AMETHYST
LENGTH 34 CM
DAHSHUR, FUNERARY
COMPLEX OF SENUSRET III
TOMB OF MERERET
JACQUES DE MORGAN'S
EXCAVATIONS (1894)
TWELFTH DYNASTY
REIGNS OF SENUSRET III
AND AMENEMHET III
(1878–1797 BC)

139

blank. Later in the Twelfth Dynasty, scarabs began to be inscribed with the names and titles of pharaohs. The ancient Egyptians believed that a divine scarab beetle pushed the rising sun above the horizon every morning, an idea that had its origins in the beetle's habit of laying its eggs in balls of dung. The dung ball and the young beetles that emerged from it were equated with the sun and became powerful solar symbols of regeneration.

Paintings and statuettes dating to the Middle and New Kingdoms frequently depict young women wearing cowrie-shell girdles, indicating that the type was worn over a long period of time. The images show otherwise naked young women adorned with girdles slung low on their hips. The oval shape and open centre of the cowrie shell are suggestive of female sexual organs and the shells were certainly intended as amuletic aids to reproduction.

Most of our knowledge of Twelfth Dynasty royal jewelry has come from the excavation of nine intact caches discovered within the last hundred years – treasures displayed in the new jewelry exhibition in the Egyptian Museum, Cairo. The collections were found under a variety of circumstances and were excavated with techniques that reflect the development of archaeological practice and theory over the last century. Earlier Egyptologists tended to stress the 'treasure' aspect of the objects, while more recent work has concentrated on the symbolism of the pieces, their place in royal ritual and court ceremony, and their chronological development. The greater care with which the later caches were excavated, combined with the increasing number of carved, relief and painted images of women wearing such items of jewelry that have come to light, have allowed more accurate reconstructions of the objects.

Among the first examples of ancient Egyptian jewelry to be excavated in modern times were the six Middle Kingdom caches discovered by Jacques de Morgan in 1894 and 1895 at Dahshur, a site about forty kilometres south of Cairo. Prominently featured in newspaper and magazine articles, the discoveries were a great sensation at a time of renewed interest in ancient Egypt and its artifacts.

140 LEFT
FLAIL OF NEFERUPTAH
JE 90200
FAIENCE, CARNELIAN, GOLD
LEAF, WOOD (MODERN)
CURRENT LENGTH 36.5 CM
HAWARA, PYRAMID
OF NEFERUPTAH
ANTIQUITIES SERVICE
EXCAVATIONS (1956)
TWELFTH DYNASTY
END OF THE REIGN OF
AMENEMHET III
(C.1800 BC)

140–141
PENDANT OF PRINCESS
MERERET
JE 53070
GOLD, TURQUOISE,
LAPIS LAZULI, CARNELIAN
HEIGHT 4.6 CM
DAHSHUR, FUNERARY
COMPLEX OF SENUSRET III
TOMB OF MERERET
JACQUES DE MORGAN'S
EXCAVATIONS (1894)
TWELFTH DYNASTY
REIGNS OF SENUSRET III
AND AMENEMHET III
(1878–1797 BC)

The first two caches were found in Senusret III's pyramid complex, in a large set of tombs that originally contained the remains of eight royal women. On two consecutive days in 1894, de Morgan discovered the jewels of the Princesses Sit-Hathor and Mereret buried in the floor in front of what are presumed to be their respective sarcophagi. Although the women's tombs had been plundered, the robbers had not found the hiding places of their jewel boxes, which contained magnificent pectorals, bracelets, anklets, girdles, scarabs and cosmetic equipment.

The following year, de Morgan found four more treasures in the pyramid complex of Amenemhet II, the king who is thought to have been the grandfather of Senusret III. Although the tombs were found in a pyramid complex that dates to the mid-Twelfth Dynasty, the burials may actually belong to a later part of the period. Adjoining burials of the Princesses Ita and Khnumet were discovered, untouched since the women were sealed in their tombs. Ita's burial was furnished with relatively simple bracelets, anklets, a broad-collar and a girdle composed of long strands of beads that hung down vertically from the waist. Most spectacular was a bronze dagger with an inlaid hilt. For the most part, Ita's jewelry was found on her mummy, aiding the attempts to reconstruct it. Khnumet's richer collection of jewelry was found both on her body and in the small offering chamber to the side of her sarcophagus. The unusual crowns, necklaces and bracelets placed in the offering chamber were found in a disordered heap under a casket that held ointment jars. Nearby, the unrobbed tombs of Princesses Ita-Weret and Sithathor-Merit contained several bracelets and a broad-collar.

British excavations in early 1914 at the pyramid complex of Senusret II at Illahun in the Fayum uncovered the tomb of

141 BELOW
DIADEM OF
SITHATHORIUNET
JE 44919 = CG 52841
GOLD, LAPIS LAZULI,
CARNELIAN, GREEN FAIENCE
HEIGHT 44 CM
WIDTH 19.2 CM
DAHSHUR, FUNERARY
COMPLEX OF SENUSRET II
TOMB OF PRINCESS
SITHATHORIUNET
TWELFTH DYNASTY
REIGN OF AMENEMHET III
(1844–1797 BC)

Princess Sithathoriunet, which contained an impressive cache of jewelry and cosmetic equipment. The tomb of Sithathoriunet had been robbed in ancient times, but the narrow niche that held her jewelry escaped the attention of the tomb robbers. This rich treasure included a crown, necklaces with pectorals, two types of girdles, bracelets, anklets, motto clasps, a mirror and scarabs. The pieces were found covered with and embedded in mud. All organic matter, such as the wood that formed the jewel boxes and the strings that held the objects together, had completely decayed. Jewelry elements were thus scattered in two areas, with pieces presumably lying near other elements with which they had originally been associated. Guy Brunton painstakingly excavated the jewelry over the course of eight days. In an effort to recover every tiny bead, Brunton worked with a small penknife and even a pin. After removing the objects from the tomb, the mud was dissolved in water to ensure that no tiny piece was overlooked.

Excavations in the pyramid of Senusret II at Illahun in 1920 led to the discovery of a *uraeus* in the king's burial chambers, one of the few pre-New Kingdom examples of a king's personal regalia to have survived. The piece was found in the debris that covered the floor of the so-called offering chamber. Since the only light available to the tomb robbers was the feeble illumination provided by oil lamps, it is easy to imagine how such a relatively small object was overlooked.

In 1955–56 an Egyptian excavation in the Fayum Oasis, led by Nagib Farag and Zaki Iskander, discovered the intact late-Twelfth Dynasty tomb of the Princess Neferuptah. This princess was buried in a small pyramid that lies about two kilometres southeast of Hawara, the site of the pyramid complex of her father Amenemhet III. Although the burial chamber was half filled with water and mud, its contents were untouched, protected from robbers by seven limestone blocks. Neferuptah's funerary jewelry was found intact inside her sarcophagus. But the mummy, its accoutrements and all organic material, including the threads that held the jewelry together and even the remains of the princess's body, had been completely destroyed by the water. However, the gold elements and beads that formed the princess's regalia had survived, and reconstructions were made based on the relative positions in which the pieces were found, as well as comparisons with other Middle Kingdom jewelry. Neferuptah had a basic set of simply composed objects, including a broad-collar, a necklace, plain bracelets and anklets, and a beaded apron.

Because the discovery of intact collections of Middle Kingdom jewelry is an extremely rare event, it was a great surprise when the Metropolitan Museum of Art's excavation at the pyramid complex of Senusret III, Dahshur, directed by Dieter Arnold, found a small cache of jewelry in 1994. The objects found belonged to Queen Weret, the woman who is believed to have been a wife of Senusret III. The queen's jewelry was hidden in a small niche at the bottom of the vertical shaft that leads into the burial apartments. The location is an unusual one for such items, and may explain why the ancient robbers during their brutal destruction of her burial site overlooked the cache. As now reconstructed, the collection contains two broad bracelets with *djed* pillar clasps, two bracelets with lion amulets, a bracelet with faience knot amulets, a necklace with a so-called motto clasp, two anklets with claw pendants, a cowrie-shell girdle, two amethyst scarabs inscribed for Amenemhet II, and a tiny uninscribed turquoise scarab.

Middle Kingdom jewels are among the loveliest examples of ancient Egyptian lapidary work. As most of these creations are displayed together in the Egyptian Museum, a visit to the museum's jewelry gallery provides a unique opportunity to study and enjoy these works of art.

BIOGRAPHY

Adela Oppenheim *is a Research Associate in the Department of Egyptian Art at the Metropolitan Museum of Art, New York. She has participated in ten seasons of excavations at the sites of Lisht and Dahshur, conducting research on Middle Kingdom royal reliefs and the recently discovered jewelry of Queen Weret.*

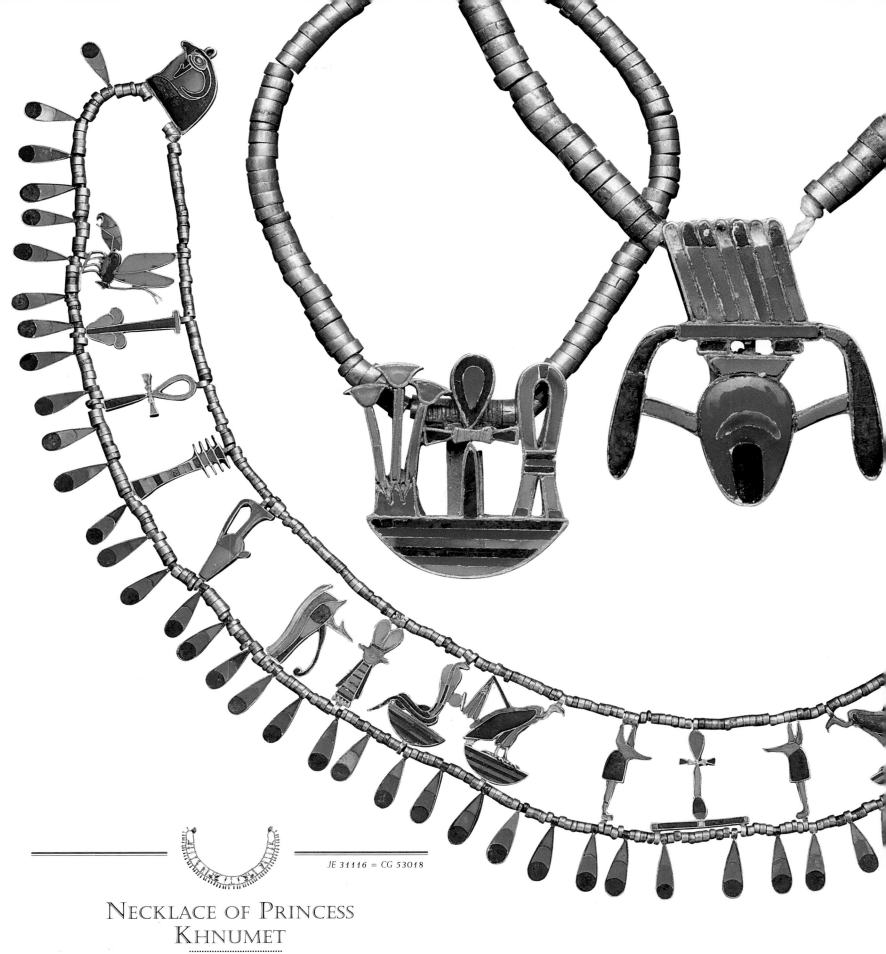

JE 31116 = CG 53018

NECKLACE OF PRINCESS KHNUMET

GOLD, CARNELIAN, TURQUOISE, LAPIS LAZULI
LENGTH 35 CM
DAHSHUR, FUNERARY COMPLEX OF AMENEMHET II
TOMB OF PRINCESS KHNUMET; J. DE MORGAN'S EXCAVATIONS (1895)
TWELFTH DYNASTY, REIGN OF AMENEMHET II (1929–1892 BC)

This fine necklace is one of the numerous jewels discovered in the tomb of Princess Khnumet. The tomb was brought to light in 1895 by Jacques de Morgan in the area to the west of the pyramid of Amenemhet II. When discovered, the various elements of the necklace were scattered in the mummy's bandages and so the piece had to be reconstructed.

The necklace is composed of two strings of gold beads, between which were fixed ten pairs of hieroglyphs running symmetrically in both directions from a central hieroglyphic composition formed of the *ankh* symbol of life on top the *hetep*, which depicts an offering table. From the centre outwards the hieroglyphs consist of an image of the jackal god Anubis, a pair of

female divinities (the vulture goddess Nekhbet and the serpent goddess Wadjet) symbolizing royal dominion of Upper and Lower Egypt, the Hathoric sistrum, the sacred eye of Horus, the *khenem* vase, the *djed* pillar, another *ankh*, the *sema* sign indicating the windpipe and heart, a symbol of unity, and a bee representing Lower Egypt.

A series of multi-coloured drop pendants is attached to the lower row of beads, while the necklace is terminated by two falcon's heads. With the exception of the strings of beads, all the various elements are inlaid with semiprecious stones: turquoise, lapis lazuli and carnelian, which alternate to create a sophisticated and harmonious composition of colours. (R.P.)

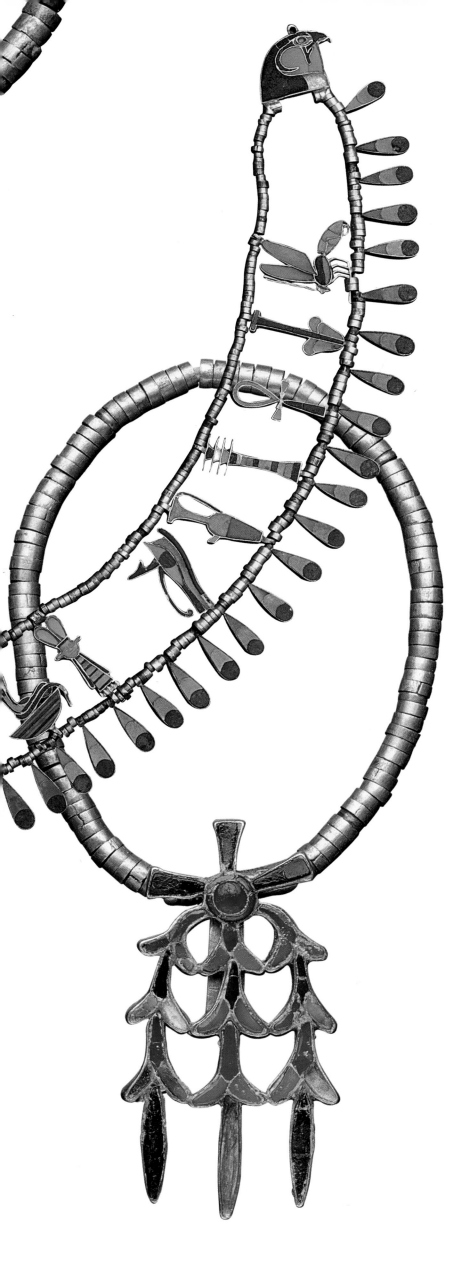

CG 52958
52956 - 52955

ARMLETS OF
PRINCESS KHNUMET

GOLD, CARNELIAN, LAPIS LAZULI, TURQUOISE
HEIGHT OF THE CLASPS 3.3 CM; 1.9 CM; 1.9 CM
DAHSHUR, FUNERARY COMPLEX OF AMENEMHET II, TOMB OF KHNUMET
J. DE MORGAN'S EXCAVATIONS (1895)
TWELFTH DYNASTY, REIGN OF AMENEMHET II (1929–1892 BC)

The intact tomb of Princess Khnumet was discovered to the west of the so-called white pyramid of Amenemhet II at Dahshur. Some items of jewelry were found on the mummy itself, while in an annex off the burial chamber a rich treasure was also discovered. It consisted for the most part of exquisitely crafted pieces that are true masterpieces of the Egyptian goldsmith's art. Bracelets, rings, necklaces and diadems bear witness to the extraordinary skill of the craftsmen of the period and the elegance of the style they developed.

These three armlets are very similar to others belonging to Princess Mereret and are composed of elaborate clasps with augural symbols that embellish simple strings of gilded beads. The pieces may have been worn around the arms. The decoration was created with the cloisonné technique in which semiprecious stones are inserted into small cells of gold.

The first clasp (CG 52958) is composed of four hieroglyphs that form an augural phrase for Khnumet, 'all protection and life are behind (you)', (sa ankh neb ha es). The neb symbol is composed of six parallel, horizontal lines, in which inlays of lapis lazuli, carnelian and turquoise alternate. This symbol constitutes the base on which the symbols of protection (sa) and life (ankh) and a clump of papyri (ha) are fixed, and should be read from right to left. The sa hieroglyph is executed in turquoise with the addition of small polychrome elements: lapis lazuli at the top, a stripe of carnelian between two stripes of lapis lazuli imitating the central band, and two inlays of carnelian at the base.

The symbol of life (ankh), placed in the centre, is made up of a frame of lapis lazuli and a drop-shaped carnelian piece that fills the upper ring. The attachment point of the individual elements is emphasized with a small gold element.

The flowers and stems of the clump of papyrus plants are in turquoise, but their bases are

rendered with small pieces of carnelian. The second clasp (CG 52956) is composed of two joined hieroglyphs that form the word 'joy' (aut-ib). The upper symbol, which perhaps represents a section of the backbone with the ribs, is characterized by a number of oblique lines, the tips of which are of lapis lazuli while the rest is made of turquoise.

Below is a central carnelian element with tips in lapis lazuli curving downwards over two small lapis lazuli rectangles. The second hieroglyph depicts a heart, fixed to the upper symbol by means of a trapezoidal element in turquoise. The heart is in carnelian, inlaid with a crescent of turquoise, below which is a lapis lazuli oval; the two lateral protuberances are also in turquoise.

The third clasp (CG 52955) is composed of the hieroglyph mes, a symbol of birth. From a small carnelian circle bordered with turquoise, three segments of lapis lazuli branch out. Three segments of carnelian, lapis lazuli and turquoise curve downwards. The

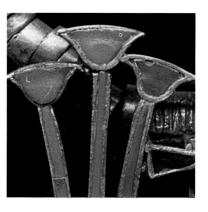

stylized hieroglyph represents three fox skins tied together. The back of each clasp is in chased or smooth gold, and is equipped with two rings into which the ends of the bracelet strings were knotted. One of these rings is fixed, while the other runs along a groove to allow the bracelet to be opened. (S.E.)

JE 31091 =
CG 52044 - 52045

CLASPS OF THE BRACELETS OF PRINCESS KHNUMET

GOLD, TURQUOISE, LAPIS LAZULI, CARNELIAN
HEIGHT 3.9 CM
DAHSHUR, FUNERARY COMPLEX OF AMENEMHET II, TOMB OF KHNUMET
J. DE MORGAN'S EXCAVATIONS (1895)
TWELFTH DYNASTY, REIGN OF AMENEMHET II (1929–1892 BC)

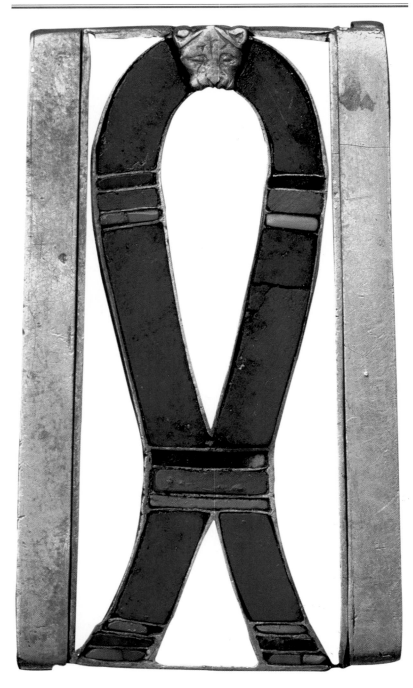

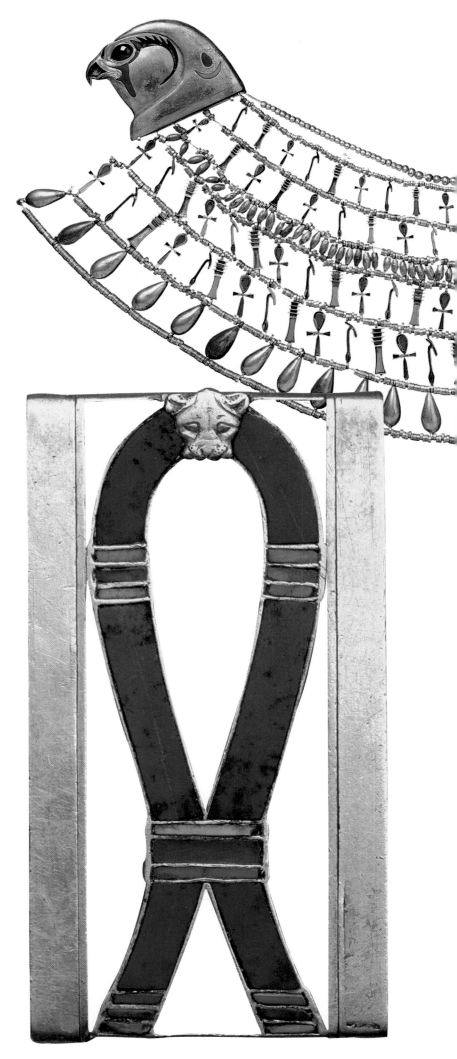

These two clasps were fixed to the ends of two bracelets which once belonged to the Princess Khnumet and were discovered in her funerary cache at Dahshur. They both served to secure bracelets fashioned alternately from gold, carnelian, lapis lazuli and turquoise beads.

Both clasps consist of a slim gold frame. Along the frame's longer sides run flat gold bars. The bars have sixteen holes through which the bracelet strings were threaded. The interior of the frame is dominated by a large *sa* hieroglyph, the symbol of protection. The hieroglyph perhaps represents a folded reed mat, part of the equipment carried by shepherds and used by them to protect themselves from the wind, hence its apotropaic significance. The amulet, bordered in gold, is inlaid with lapis lazuli with the addition of polychrome bands on either side of the ring, at the narrow centre and at the bases. Each clasp is composed of three segments: one in carnelian placed between two in turquoise, delimited by slender gold borders. A small, gold leopard's head, seen from above, is soldered to the top of both the *sa* hieroglyphs, further enhancing the decoration.

The all-gold backs of the two clasps are finely chased and feature *sa* hieroglyphs with representations of bundles of seven branches fastened with triple straps in six places. These correspond with the leopard's heads and the inlaid segments respectively on the front faces. (S.E.)

144

NECKLACE OF PRINCESS KHNUMET

JE 30942

GOLD, LAPIS LAZULI, TURQUOISE, CARNELIAN, GARNET, FELDSPAR
DIMENSIONS OF THE TERMINALS: HEIGHT 3.8 CM; WIDTH 4.3 CM
DAHSHUR, FUNERARY COMPLEX OF AMENEMHET II, TOMB OF KHNUMET
J. DE MORGAN'S EXCAVATIONS (1895)
TWELFTH DYNASTY, REIGN OF AMENEMHET II (1929-1892 BC)

The mummy of Princess Khnumet was wearing this light, sophisticated *usekh* (from the Egyptian for 'broad') necklace round its neck when it was discovered. The jewel appeared in fragments; and its various component parts were reassembled by its discoverer. However, the falcon-headed terminals seem too narrow for this broad necklace, casting doubt on the accuracy of de Morgan's reconstruction.

Topped by a row of gold beads that increase in diameter towards the centre, the collar is composed of six rows of pendants separated by strings of gold beads, creating a delicate lace-like effect. Four rows are formed by a continuous succession of three hieroglyphs, *ankh*, *was* and *djed*, symbolizing respectively 'life', 'power' and 'stability' executed in gold and inlaid with polychrome semiprecious stones. Their dimensions increase progressively from the top to the bottom of the necklace. The first two rows of amulets are separated from the successive rows by a dense series of oval gold beads. The staffs symbolizing power are always set differently in the right and left halves of the piece so as to present

mirror images around the central axis. At the bottom is a series of well-spaced gold droplet pendants enclosed by a string of gold beads.

Two falcon's heads in embossed gold are attached to either end of the necklace and would once have been linked together, probably by a string of beads. The two heads are embellished with inlays of coloured stone that emphasize the details of the falcons' faces. The beaks are in lapis lazuli while the dark garnet eyes are surrounded by lapis lazuli rims that evoke the different colouring of the falcon's plumage. The heads of the two birds are also adorned with drop-shaped pieces of carnelian placed above feldspar crescents. The backs of the heads are in simple smooth gold. The birds' necks are closed by a small plaque perforated with seven holes through which the strings of the necklace were threaded into internal cavities in the two clasps. (S.E.)

CG 52860

DIADEM OF PRINCESS KHNUMET

SILVER, GOLD, CARNELIAN, LAPIS LAZULI, TURQUOISE; CIRCUMFERENCE 64 CM
DAHSHUR, FUNERARY COMPLEX OF AMENEMHET II, TOMB OF KHNUMET
J. DE MORGAN'S EXCAVATIONS (1895)
TWELFTH DYNASTY, REIGN OF AMENEMHET II (1929–1892 BC)

This diadem belonged to Princess Khnumet and is composed of eight horizontal decorative elements and the same number of vertical elements, alternating to create a harmonious play of forms. The cloisonné technique was used to create this piece, with semiprecious stones inlaid in the gold support that constitutes the structure of the diadem.

Each horizontal element is centered around a rosette, the carnelian nucleus of which is surrounded by fourteen turquoise petals that stand out against a background of lapis lazuli. Each of them is flanked by two stylized flowering rush calixes decorated with small inlays of carnelian, lapis lazuli and turquoise in the form of leaves. From the tips of the leaves sprout four stylized flowers, two in carnelian and two in lapis lazuli, that form the connection to the central rosette.

The individual vertical elements of the diadem are composed of a rosette identical to those described above, to which the same rush calix motif is attached and surmounted by two flowers of carnelian and two of lapis lazuli.

The polychrome inlays of the vertical plants are set in a herringbone pattern. The various parts of the diadem are linked by small bands of gold nailed to the rosettes, and soldered to the horizontal plant motifs that flank them. The interior surface of the piece is made of gold and is chased in imitation of the inlays decorating the outside of the diadem.

The diadem was originally fitted with two decorative elements, one at

the front and one at the rear. The first takes the form of a small tapering tube imitating the branch of a tree to which are attached light gold leaves and flowers composed of beads of carnelian, lapis lazuli, turquoise and gold set in silver. This fragile ornament, which was inserted in a receptacle at the back of the diadem, was discovered in a very poor condition, bereft of many its leaves and beads.

The second decorative element represents the vulture goddess Nekhbet, with outspread wings and *shen* hieroglyphs symbolizing eternity gripped in her talons. This element would have guaranteed the goddess's protection when the princess wore the diadem.

The back and the long curving wings of the vulture are formed from a single piece of finely chased gold that imitates plumage, while the head, the body and the legs were crafted separately and then soldered to the main element. The vulture's eyes are inlaid with obsidian and the *shen* hieroglyphs are covered with small pieces of carnelian. (S.E.)

145

JE 98783 - 98790 C - 98791 C - 98792 C - 98793 C

NECKLACE OF QUEEN WERET

GOLD, TURQUOISE, LAPIS LAZULI, CARNELIAN
NECKLACE: LENGTH 62.9 CM; *PENDANT*: HEIGHT 1.7 CM; WIDTH 1.7 CM
DAHSHUR, FUNERARY COMPLEX OF SENUSRET III, PYRAMID OF WERET; METROPOLITAN
MUSEUM OF ART EXCAVATIONS (1994); TWELFTH DYNASTY,
THE REIGNS OF AMENEMHET II AND SENUSRET III (1929–1841 BC)

In 1994, a group of finely crafted ornaments was discovered in a niche at the bottom of the shaft that led to the tomb of Queen Weret at Dahshur. Among the pieces were sixty-eight drop beads that belonged to a necklace, and a small pendant that may have served as its clasp. All Weret's jewels were found loose in the soil of the pit in which they were deposited.

They have been reconstructed on the basis of representations of jewelry found in paintings, wall reliefs and sculpture as well as better-preserved examples of Middle Kingdom ornaments.

The arrangement of the necklace is based on the common use of drop beads in necklaces. The diminutive pendant harmonizes well with the small beads and its back is fitted with a sliding clasp, suggesting that it served as a fastener. Both the beads and the pendant are made from gold, lapis lazuli, carnelian and turquoise, materials that are frequently used for fine pieces of Middle Kingdom jewelry.

The pendant is composed of four intricately rendered, inlaid hieroglyphs. Two *netjer* signs, which mean 'two gods', form the top and sides of the pendant, while the horizontal *hetep* offering tables at the bottom can be translated at 'content'. The centre of the pendant is filled by an *ib*-sign, in the form of a heart. Together the hieroglyphs form the phrase 'the heart(s) of the two gods are content', a reference to the mythological reconciliation of Horus and Seth, following the murder of Horus' father, Osiris, by Seth. (Adela Oppenheim)

JE 98786 A, B - 98781 A, B - 98790 B - 98791 B - 98792 B - 98793 B

BRACELETS OF QUEEN WERET

GOLD, TURQUOISE, LAPIS LAZULI, CARNELIAN
HEIGHT 4.1 CM; LENGTH 15 CM
DAHSHUR, FUNERARY COMPLEX OF SENUSRET III, MASTABA OF WERET
METROPOLITAN MUSEUM OF ART EXCAVATIONS (1994–1995)
TWELFTH DYNASTY, REIGNS OF AMENEMHET II
AND SENUSRET III (1929–1841 BC)

The funerary cache of Queen Weret contained several elements that were combined to create these two bracelets: two gold lion pendants, gold clasps in the shape of reef knots, and small ball beads of gold, lapis lazuli, carnelian and turquoise. Lion pendants have been found at the wrists of mummies, suggesting that they were parts of bracelets. This pair is among the most exquisite preserved examples of this type of amulet, which has been found in the burials of many of the royal women buried at Dahshur and Illahun. The lions are represented in a crouching position, with their front paws extended and the tails curved around the left haunch. The gold knot clasps reproduce in a precious material the cord closures found on bracelets of lesser quality. (Adela Oppenheim)

SCARABS OF AMENEMHET II

AMETHYST, GOLD
JE 98778 A: LENGTH 2.57 CM; WIDTH 1.64 CM; JE 98778 B: LENGTH 2.51 CM;
WIDTH 1.64 CM; DAHSHUR, FUNERARY COMPLEX OF SENUSRET III, PYRAMID OF
WERET; METROPOLITAN MUSEUM OF ART EXCAVATIONS (1994)
TWELFTH DYNASTY, REIGN OF AMENEMHET II (1929–1892 BC)

The *Scarabeus sacer*, identified by the Egyptians with the god Khepri ('he who created himself') was a symbol of rebirth and therefore a potent amulet. The mythology surrounding scarabs arises from the behaviour of female scarab beetles, who push balls of dung containing their eggs along the ground; the young beetles later emerge from these balls. The ball was identified with the rising sun, which, it was believed, was pushed over the horizon each morning by a scarab; the beetles themselves became powerful symbols of solar regeneration.

Scarabs, which first appear in the late Old Kingdom, were produced in various materials including faience and a variety of stones. They also had diverse functions, serving both as magical amulets and utilitarian seals. In later periods, commemorative or celebratory scarabs were produced to mark specific events.

These two nearly identical examples, found in the funerary cache of Queen Weret, one of the wives of Senusret III, are elegantly sculpted, with the various body parts carefully represented. The incised inscriptions on the undersides are framed by the unusual motif of a snake coiled in a spiral pattern. The top of both inscriptions contains the royal epithet 'the good god', followed by the name Amenemhet II, who may have been the father of Queen Weret.

A fine, dark, rich amethyst was chosen for the pieces. When placed against a light, the scarabs have a deep purple glow, while the clarity of the stone allows the hieroglyphic inscriptions to be read through the piece. (Adela Oppenheim)

ANKLETS OF QUEEN WERET

LAPIS LAZULI, TURQUOISE, CARNELIAN, GOLD; HEIGHT 3.8 CM; LENGTH 21.5 CM
PENDANT: HEIGHT 2.1 CM; DAHSHUR, FUNERARY COMPLEX OF SENUSRET III
PYRAMID OF WERET; METROPOLITAN MUSEUM OF ART EXCAVATIONS (1994)
TWELFTH DYNASTY, REIGNS OF AMENEMHET II
AND SENUSRET III (1929–1841 BC)

The rich caches of Middle Kingdom jewelry found at Dahshur have recently been augmented by the discovery of the tomb of Queen Weret, a wife of Senusret III, during a campaign of excavations (1994) organized by the Metropolitan Museum of Art and led by Dieter Arnold.

An entrance shaft was discovered south of the king's pyramid that led to a small shrine dug under the westernmost subsidiary pyramid as well as to the burial chambers, which are actually under the king's pyramid. As was the case with some of the other treasures of Middle Kingdom royal women (Sit-Hathor, Mereret and Sithathoriunet), the jewels of Weret were placed apart from the actual burial, and this is what may have saved them from tomb robbers in antiquity. In Weret's case the jewels were concealed in a small niche at the bottom of a shaft leading to the burial chamber.

Many of the objects found in these caches show evidence of wear, indicating that they were actually used by their owners during their lifetimes. Most of the objects found in these treasures were probably royal gifts made by the pharaohs to the women of their family. It is also possible that their mothers either commissioned jewelry for them or bequeathed them as heirlooms.

The two colourful anklets are composed of twenty rows of minute beads arranged in alternate bands of lapis lazuli, carnelian and turquoise, each separated by bars composed of tiny gold beads that were soldered together. The anklets were closed by long sliding gold clasps. Hanging from each anklet are claw pendants made of gold and inlaid with semiprecious stones. The top of each claw is fitted with a tiny gold bead that was inserted into slots left open on two of the bars.

A Middle Kingdom tomb painting includes a rare depiction of dancers wearing such amulets and provided the basis for the reconstruction of these examples. (Adela Oppenheim)

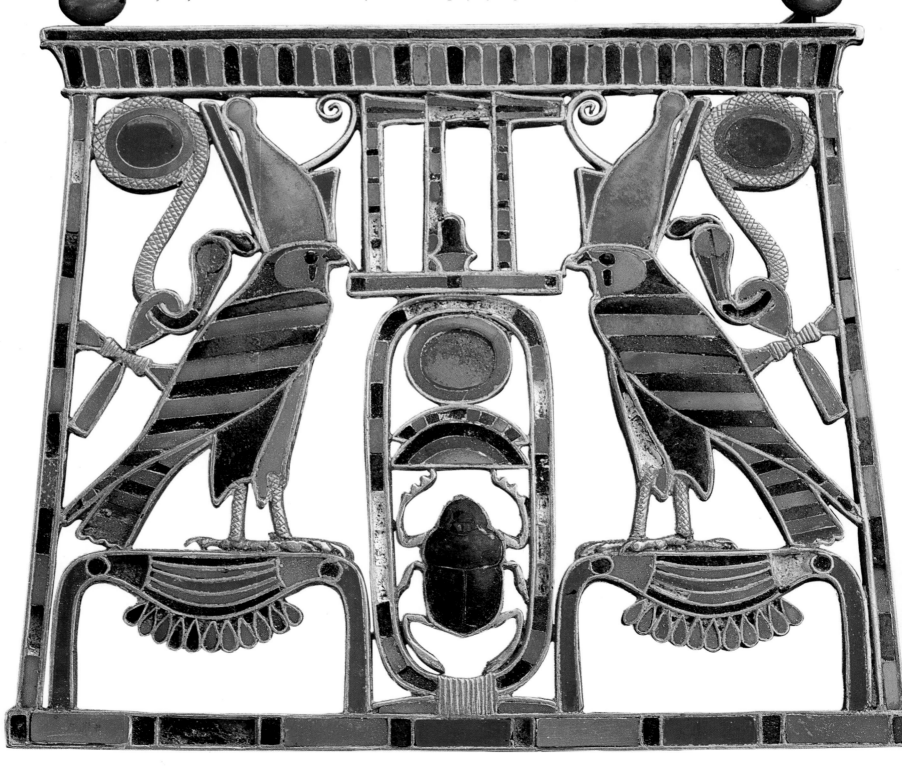

JE 30857 = CG 52001

NECKLACE WITH PECTORAL INSCRIBED TO SENUSRET II

GOLD, LAPIS LAZULI, TURQUOISE, CARNELIAN
HEIGHT OF THE PECTORAL 4.9 CM
DAHSHUR, FUNERARY COMPLEX OF SENUSRET III
TOMB OF PRINCESS SIT-HATHOR; J. DE MORGAN'S EXCAVATIONS (1894)
TWELFTH DYNASTY, REIGN OF SENUSRET II (1897–1878 BC)

Princess Sit-Hathor, who may have been one of the daughters of Senusret II, was buried north of the pyramid of Senusret III. In her tomb, as in the tombs of other princesses from the same period, numerous precious objects were found: scarabs, beads, small images of lions, and pectorals, from which experts have been able to put together magnificent pieces of jewelry.

Among them is this beautiful necklace with pectoral, which is very similar to one found in the tomb of Princess Sithathoriunet, who was also possibly a daughter of Senusret II.

The piece is composed of a string of drop beads in gold, turquoise, lapis lazuli and carnelian, which are separated by gold ball beads. The magnificent rectangular pectoral with slightly tapering sides is designed to imitate a shrine surmounted by an Egyptian cavetto cornice. Two falcons are depicted inside, face to face, wearing the double crown on their heads and standing on a *nub* hieroglyph (representing a necklace and read as 'gold'). This is the graphic representation of the 'Horus of Gold' name, one of the five that were assigned to the pharaoh when he ascended to the throne.

The 'Horus of Gold' name of Senusret II (*Hotep-netjeru*, 'the gods are content') is placed in the centre, between the two falcons and above the royal cartouche, filled with the king's prenomen, *Khakheperre*. At the two upper corners of the scene, behind the falcons, there are solar discs from which hang cobras with *ankh* hieroglyphs around their necks. The composition as a whole is a balanced, complex arrangement of part of the titles of the pharaoh. The necklace may have been a gift from Senusret II to his daughter. (R.P.)

JE 30858 =
CG 53123 - 53136

GIRDLE OF SIT-HATHOR

GOLD, LAPIS LAZULI, FELDSPAR, CARNELIAN
LENGTH 70 CM
DAHSHUR, FUNERARY COMPLEX OF SENUSRET III, TOMB OF SIT-HATHOR
J. DE MORGAN'S EXCAVATIONS (1894)
TWELFTH DYNASTY, REIGN OF SENUSRET III (1878–1841 BC)

Princess Sit-Hathor's tomb contained numerous jewels that have been carefully restored, based on surviving similar pieces from the same period which were found during excavations at Illahun.

This girdle, of eight gold cowrie shells separated by double rows of polychrome beads, was once thought to be a necklace. It is incomplete, as a number of components have been lost. The beads, of carnelian, lapis lazuli and feldspar, are in the form of acacia seeds, and are perforated to allow them to be threaded on to a string.

One shell slides apart, revealing the tongue and groove that form the girdle's clasp. The interiors of other shells contained small pellets that would have made a tinkling sound as the wearer walked.

This girdle belonged to Sit-Hathor and is a typical and well-documented product of the sophisticated goldsmith's art of the middle of the dynasty. Princess Sithathoriunet, buried within the funerary complex of Senusret II at Illahun, had one very similar. (R.P.)

149

GIRDLE OF MERERET

GOLD, AMETHYST; LENGTH 60 CM
DAHSHUR, FUNERARY COMPLEX OF SENUSRET III
TOMB OF PRINCESS MERERET; J. DE MORGAN'S EXCAVATIONS (1894)
TWELFTH DYNASTY, REIGNS OF SENUSRET III AND AMENEMHET III
(1878–1797 BC)

NECKLACE WITH PECTORAL INSCRIBED TO AMENEMHET III

GOLD, CARNELIAN, FAIENCE, LAPIS LAZULI
HEIGHT 7.9 CM; LENGTH 10.5 CM
DAHSHUR, FUNERARY COMPLEX OF SENUSRET III
TOMB OF PRINCESS MERERET; J. DE MORGAN'S EXCAVATIONS (1894)
TWELFTH DYNASTY, REIGN OF AMENEMHET III (1844–1797 BC)

This girdle, part of the funerary assemblage of Princess Mereret, combines the sheen of gold with the strong, dark colour of amethyst in a wonderful play of contrasts. Two amethyst bead strands alternate with superbly crafted gold amulets representing two-faced leopards' heads.

The animal element is clearly used for its magical-protective associations. Leopards' heads are, in fact, quite frequently found in the decoration of both male and female clothing: they were often used as ornaments on royal skirts.

Leopard skins, symbolizing the night sky, were moreover integral parts of the traditional costumes of the funerary priests. They were seen as symbols of fertility and rebirth.

In addition to this belt, among the jewels of Mereret there was an anklet that also combines gold and amethysts. (R.P.)

This pectoral is in the form of a shrine with an Egyptian cavetto cornice, within which is reproduced the classic scene of the pharaoh smiting his enemies. The pectoral is suspended from a necklace composed of beads of carnelian, gold and lapis lazuli.

The whole scene is placed under the protection of the vulture goddess Nekhbet, who is portrayed at the top with outspread wings. The goddess grips the *ankh* hieroglyph (symbolizing 'life') and the *djed* pillar (signifying 'stability') in her talons and extends these symbols towards the king who is depicted below.

One of the most typical of the divine epithets, 'Lady of the Sky', is inscribed on either side of the vulture's head, while at the tips of the wings the phrase 'Mistress of the Two Lands' is inscribed.

Mirror images of Amenemhet III appear in the scene below. The king is portrayed in the act of raising a club to strike a kneeling enemy whom he holds by the hair. The king wears a *khat* headdress and a *usekh* necklace as well as a short tunic fastened by a strap across one breast, and a short kilt with a multicoloured flap.

The enemy figure kneels in front of him and holds out his weapons as a sign of surrender. He is identified by the hieroglyphs as a representative of the *Mentiu Setjet* (Asian Bedouins). At the centre of the heraldic scenes are the epithets and name of the ruler: 'The good god, the Lord of the Two Lands and All the Foreign Countries, *Nimaatre*'.

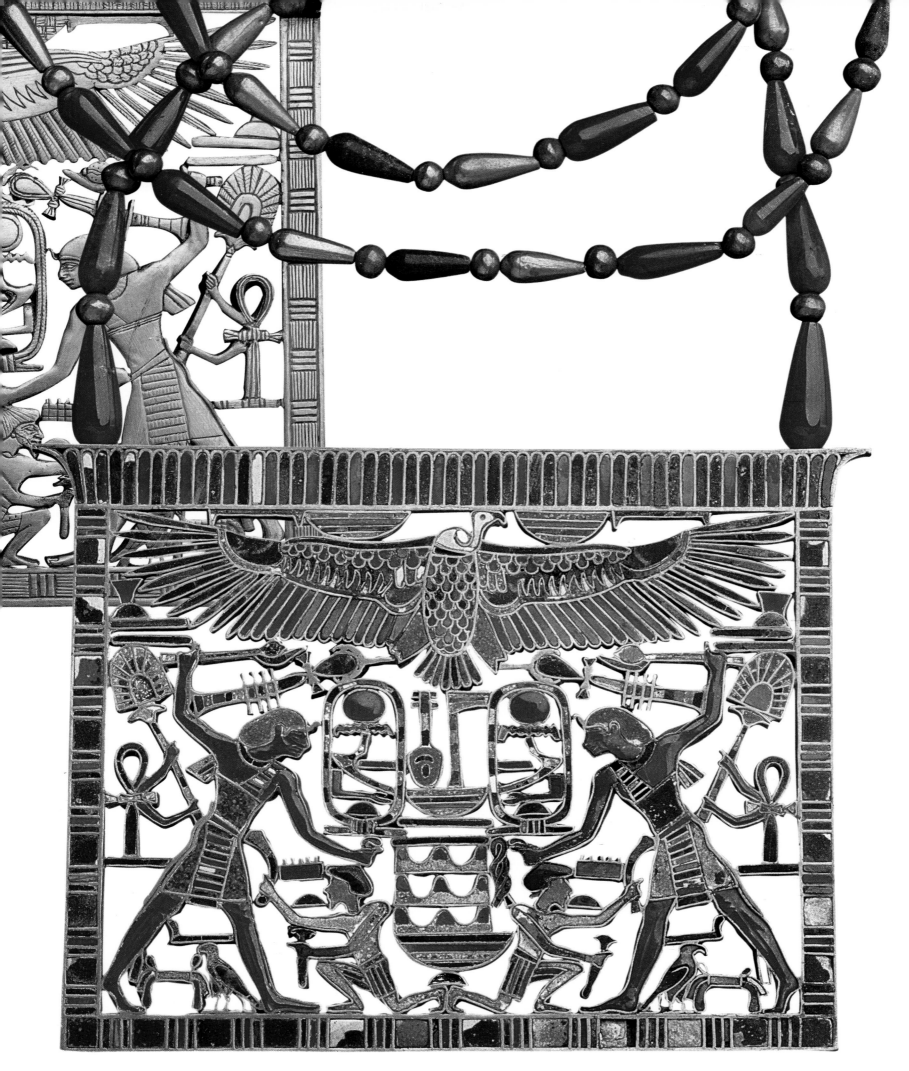

Behind Amenemhet III, an *ankh* hieroglyph carries a large fan that protects the king.

The fact that the figures and hieroglyphic writing are complementary allows the whole scene to be read as if it were a continuous text: 'Nekhbet, Lady of the Sky and Mistress of the Two Lands, gives life and stability to the good god, the Lord of the Two Lands and All Foreign Countries, *Nimaatre*, he who defeats the Asian Bedouins'.

This magnificent pectoral in solid gold is further embellished with inlays in various semiprecious stones that allow each of the figures to be characterized with great precision. Special care was taken in choosing colours for the royal costume.

The light-blue and gold used in the cartouche (symbols of divinity), and the red of the solar disc forming part of the name of the pharaoh, are also worthy of note. The colour red was associated from earliest times with the solar cult, as demonstrated by the use of pink granite or red quartzite for the construction of obelisks. (R.P.)

NECKLACE OF NEFERUPTAH

GOLD, CARNELIAN, FELDSPAR, GLASS PASTE
LENGTH 36.5 CM; HEIGHT 10 CM
HAWARA, PYRAMID OF NEFERUPTAH
ANTIQUITIES SERVICE EXCAVATIONS (1956)
TWELFTH DYNASTY, REIGN OF AMENEMHET III (1844–1797 BC)

The intact tomb of Princess Neferuptah, the daughter of Amenemhet III, was discovered below a ruined brick pyramid located to the southeast of her father's pyramid.

A wooden coffin, decomposed by the time of its discovery, had been placed inside a granite outer sarcophagus and contained the mummy of the deceased. The body was covered with jewelry that has now been returned to its former glory following a long and painstaking period of restoration. The rich collection comprised a bead girdle, necklaces, rings and bracelets executed in gold and semiprecious stones, in the best tradition of the Twelfth Dynasty. The goldsmiths of this period were responsible for producing jewels for many princesses.

This *usekh* necklace decorated the breast of the mummy of Neferuptah and represented a type of ornament that was very common in ancient Egypt. Wall paintings and statues frequently depict deities, pharaohs, queens and ordinary citizens, who wear them both in their lifetimes and after death. The necklace was not purely decorative, but was thought to have an apotropaic value.

The necklace is composed of six alternate strings of feldspar and carnelian tubular beads, separated by gold beads. The lower edge has drop beads inlaid with feldspar, carnelian and blue glass paste, with two horizontal strings of gold beads at the top and bottom.

The ends of the necklace have falcon's head clasps in embossed gold. Two strings of carnelian and feldspar beads emerge from the top of the falcon's head. These strands join a third, smaller falcon's head which forms the top of the *menekhet* counterweight that would have hung behind the neck.

The counterweight's elements echo the motifs of the front part of the necklace and are composed of alternating strings of carnelian and feldspar beads increasing in length from top to bottom and separated by rigid gold bars. The lower edge of the counterweight terminates with ten carnelian drop beads.

The three falcons' heads still have traces of silver inside, which is evidence of an original core to which the numerous strings of beads composing the necklace would have been attached. (S.E.)

JE 44920 = CG 52663

Mirror of Sithathoriunet

Silver, gold, obsidian, faience, electrum, semiprecious stones
Height 28 cm; Illahun, Complex of Senusret II
Tomb of Princess Sithathoriunet
W.M.F. Petrie's excavations (1914)
Twelfth Dynasty, Reign of Amenemhet III (1844–1797 BC)

Rather than a utilitarian piece of equipment, this mirror should be included among the items of jewelry belonging to Sithathoriunet. In addition to the preciousness of the materials, the combination of colours and the fine craftsmanship make it a true work of art.

The reflecting surface is a silver disc inserted in an electrum-covered, obsidian support in the form of an open papyrus flower, with edges in gold. The curving lines of the handle narrow to form the face of the goddess Hathor. As was frequently the case with Hathoric capitals, the goddess's gold head has a double human face with bovine ears. The inset eyes are outlined with lapis lazuli borders which trace the traditional lines of eye-paint; eyebrows in the same stone extend to the temples.

The head is set in a handle composed of an obsidian element in the form of a papyrus stem. The link between the stem and the flower is emphasized by four gold rings in which inlays of carnelian, turquoise and faience are set, while the stem is divided into four sections by lines of gold and decorated at the base with inlays of semiprecious stones.

The mirror was found together with the unguent vases of Princess Sithathoriunet, a daughter of Senusret II. (R.P.)

While there is no doubt that New Kingdom artists made a substantial contribution to the development of ancient Egyptian art, the foundations – the models for statue types, the system of canonical proportions, the artistic conventions for relief sculpture and painting – were laid during the Old Kingdom.

In some respects Egyptian artists reached the peak of their skills during the Middle Kingdom – creating statues, both royal and private, that were portraits with individual features. They also achieved a high level of perfection in temple reliefs, tomb paintings and inscriptions. None the less, compared with the New Kingdom, these two periods, spanning a millennium from 2575 to 1640 BC, have left us with

DIETRICH WILDUNG

THE EIGHTEENTH DYNASTY

very few monuments. When the Roman emperors conquered the Nile Valley around one thousand five hundred years later, they ransacked much of the country's heritage. Scarcely a temple from the Old and Middle Kingdoms survives intact and the number of statues dating from these periods is not large.

The situation is very different when we look at the archaeological remains of the New Kingdom. In the area of Thebes (present-day Luxor) in Upper Egypt, temples and the tombs of the Eighteenth to the Twentieth Dynasties are crowded together in a truly remarkable complex. As the religious centre of the country, the temple of Karnak received lavish gifts from rulers. It was here that religious obligations had to be honoured and forms and symbols of royal power were created. Giving one's own name to a statue at this site was a matter of pride for the leading figures in the country. More than once in the history of the temple of Karnak, its halls and corridors were so full of votive

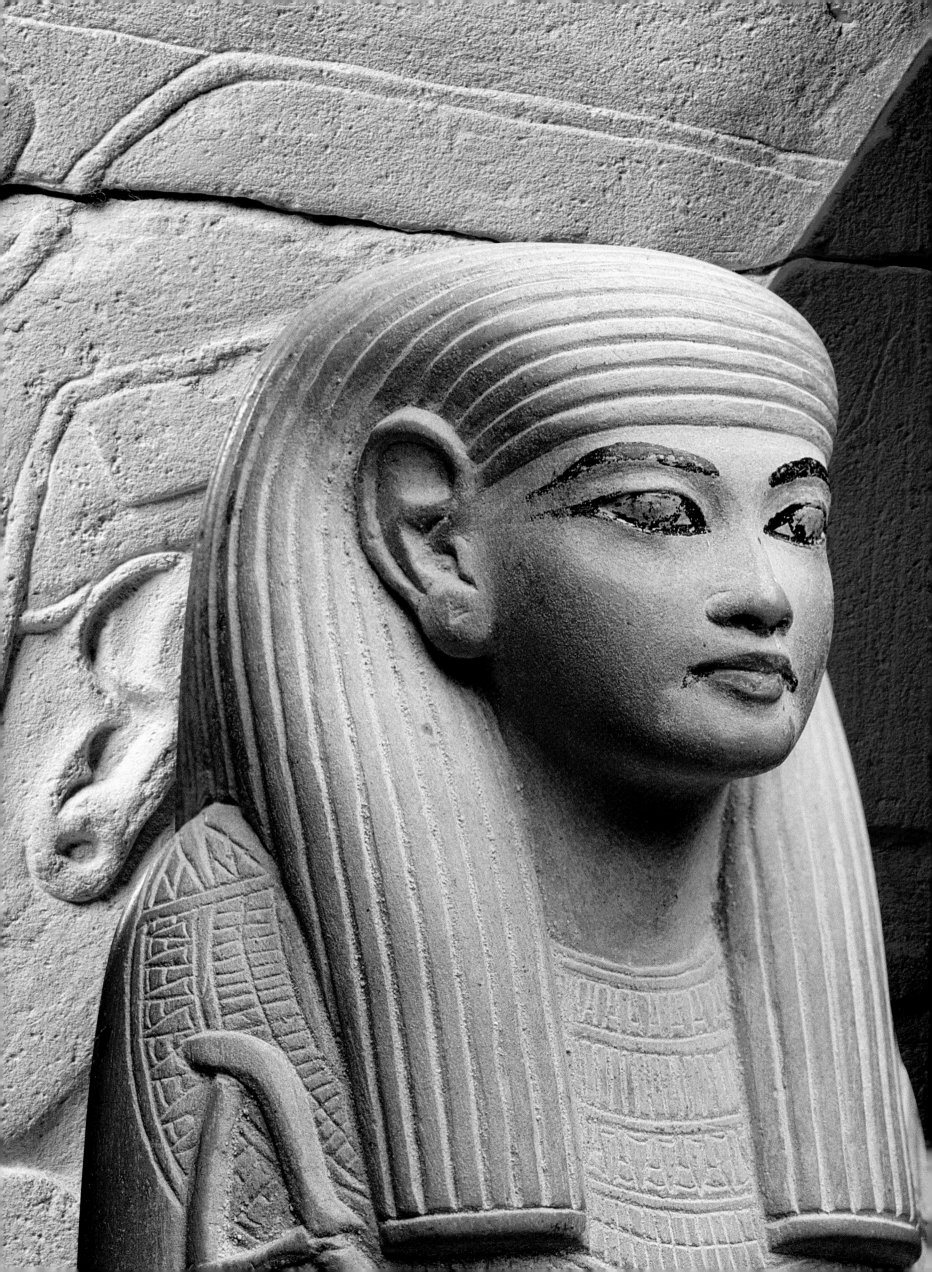

offerings that statues had to be removed and deposited in pits in order to make room for new pieces. At the beginning of the twentieth century archaeologists unearthed 17,000 statues from one of these deposits – known as the Karnak Cachette.

Important cemeteries were established across the Nile from Karnak on the West Bank. New Kingdom pharaohs were buried in the Valley of the Kings in tombs excavated deep in the rock. They built their great funerary temples on the edges of the desert towards the Nile. Wives of kings and members of royal families were buried in the Valley of the Queens. Members of the middle and upper classes were laid to rest in the hundreds of rock tombs that extended for kilometres along the slopes of the Theban cliffs. And the artists and craftsmen who built the tombs and temples had their own cemetery in the next valley at Deir el-Medina.

There is a strong political element in the importance of Thebes in the history of Egyptian art. Twice Thebes was the birthplace of a ruling dynasty. It was from Thebes that, around 2040 BC, Mentuhotep I restored the empire of the pharaohs after the First Intermediate Period. From then onwards, Thebes was the Rome of ancient Egypt. And at the end of the Middle Kingdom, when Egypt was again experiencing a period of crisis and the foreign Hyksos kings of the Middle East reigned in the Nile Valley, it was from Thebes once more that a new Egyptian ruling line emerged. Kamose, a descendant of a family of Theban princes, defeated the Hyksos and defended Egypt from the threat of the Nubian empire of Kerma. His successors Ahmose and Amenhotep I were the founding fathers of the Eighteenth Dynasty, and were still venerated generations later as national heroes.

During the period of Hyksos domination – the Second Intermediate Period – Egyptian art experienced a decline. Then, at the dawn of the Eighteenth Dynasty, artists consciously turned to the great models of the past.

Several statues of Amenhotep I from the area to the west of Thebes are almost identical to representations of Mentuhotep I from five hundred years earlier. The function of Eighteenth Dynasty royal art is clearly associated with the nation's heritage. Images of the pharaoh were not intended to represent an individual figure, but rather the institution of kingship. It is not always easy to attribute royal statues of the first half of the Eighteenth Dynasty to a specific pharaoh. As representations of sovereignty they are idealized works that go beyond individual identity. And as the individuality of the king disappeared from these works, so too did the personality of the various artists.

Around 1479 BC, an unusual dynastic situation proved to be a turning point. On the death of the pharaoh Thutmose II, his son Thutmose III was still a child and his stepmother, Hatshepsut, took over the administration of the government. Assuming her place on the throne reserved for male pharaohs (she was not the first woman to do so, however), Hatshepsut had herself portrayed in a number of her statues with female features but wearing male pharaonic regalia, including a false beard. During Hatshepsut's reign artistic styles broke free from convention, and the themes of relief sculptures were also innovative, as seen especially in the magnificent terraced temple built by Hatshepsut at Deir el-Bahri. Reliefs on the temple's walls depict an expedition to Punt, the land of incense, which may have been located on the Yemen coast or the Eritrean

156 ABOVE
BOX FOR THE GAME
OF SENET
JE 21462
EBONY, BONE, FAIENCE
LENGTH 26.5 CM
WIDTH 7.8 CM
DRA ABU EL-NAGA
TOMB OF HORAKHT
LUIGI VASSALLI'S
EXCAVATIONS (1862–1863)
LATE SEVENTEENTH
DYNASTY
(C. 1600–1550 BC)

156 LEFT
STELA FOR TETISHERI
JE 36335
LIMESTONE
HEIGHT 225 CM
WIDTH 106.5 CM
ABYDOS; EGYPT
EXPLORATION SOCIETY
EXCAVATIONS (1903)
EIGHTEENTH DYNASTY
REIGN OF AHMOSE
(1550–1525 BC)

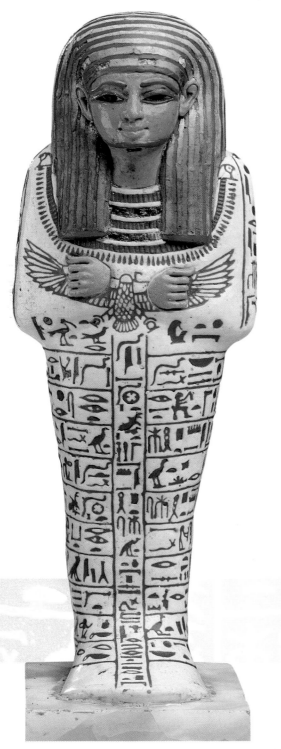

157 LEFT
SHABTI FIGURE
OF PTAHMOSE
CG 48406
POLYCHROME FAIENCE
HEIGHT 20 CM
ABYDOS
AUGUSTE MARIETTE'S
EXCAVATIONS (1881)
EIGHTEENTH DYNASTY
REIGN OF AMENHOTEP III
(1391–1353 BC)

157 RIGHT
PART OF A STATUETTE OF
AMENHOTEP III
JE 37534 = CG 42083
STEATITE
HEIGHT 28 CM
KARNAK, TEMPLE OF
AMUN-RE
COURTYARD
OF THE CACHETTE,
GEORGES LEGRAIN'S
EXCAVATIONS (1905)
EIGHTEENTH DYNASTY
REIGN OF AMENHOTEP III
(1391–1353 BC)

coast of the Red Sea. Plants, animals, marshes and the corpulent queen of Punt were all portrayed with almost scientific precision.

Just as remarkable as the styles and themes that emerged during Hatshepsut's reign was the development of distinct artistic personalities. The chief steward, Senenmut, tutor of Neferure, the daughter of Hatshepsut, was depicted in several places in the funerary temple of Deir el-Bahri in his role as architect. The creation of a new type of statue was also associated with him. A number of block statues, compact seated and kneeling figures, show him holding the princess Neferure. In other statues he is depicted as a sistrum player – kneeling and holding the musical instrument in front of him. Around twenty-five statues of Senenmut survive, a fact that surely indicates the exceptional nature of this unusual figure.

The styles and forms that appeared under Hatshepsut, in both royal and private art, flourished in the next period. Amenhotep II appears in his statues and

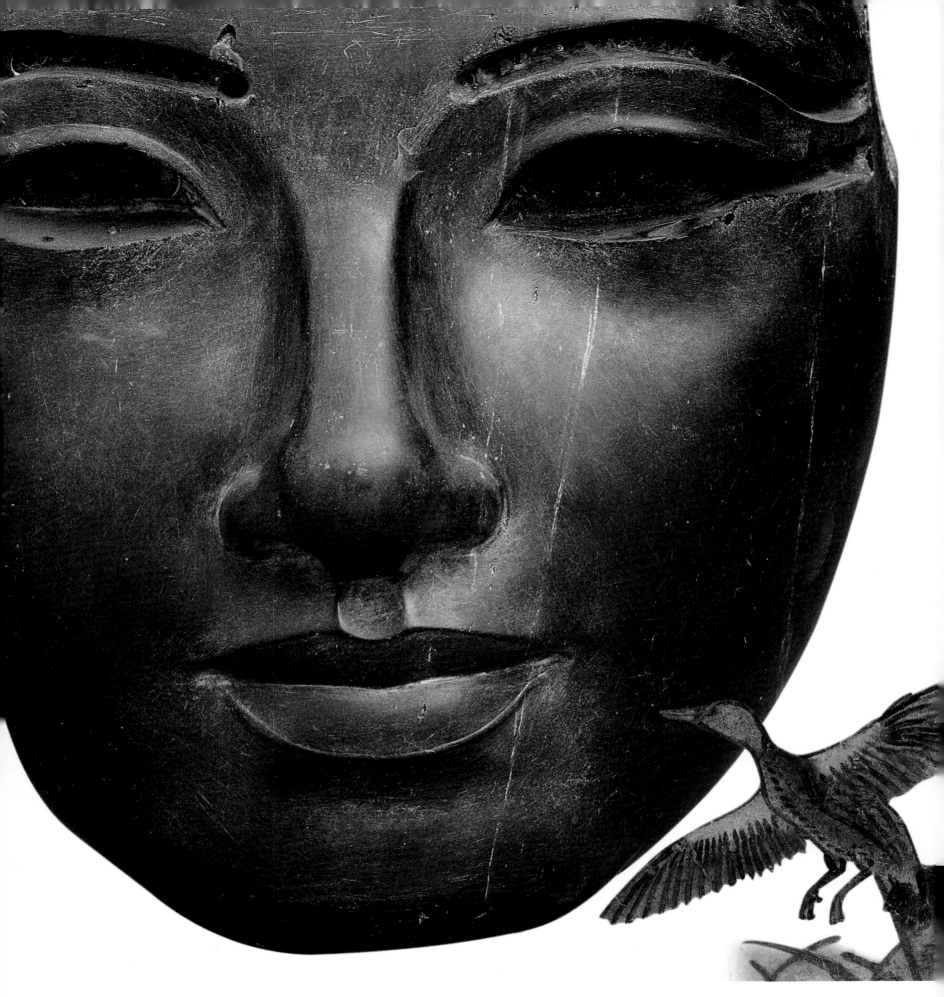

relief sculptures as a heroic young king, while Thutmose IV, who died young, has an almost infant-like appearance in his portraits. Towards the end of the reign of Amenhotep III the idealizing tendency of the art of the early Eighteenth Dynasty was finally halted. In the statues of the king, from small wooden statuettes to the monumental Colossi of Memnon, he was portrayed with rather soft features and a massive physique. The portrayal of the personal characteristics of the king reflects the individualist nature of this particular

ruler. He married Tiye, a woman of low birth and endowed her with the title of 'Great Royal Bride'. A portrait of her with clearly realistic and identifiable features is one of the masterpieces of the period.

Exceptional talents were rewarded with a rise to the highest positions in the state. The most interesting example of such a career is that of the scribe Amenhotep, the son of Hapu. In many statues he is depicted as a scribe, and he was venerated centuries after his death as the epitome of Egyptian erudition.

The political power of Egypt was at its height during the reign of Amenhotep III. Under Thutmose III, the pharaonic empire had become one of the great powers of the Near East and North Africa. Through its economic strength, military presence and diplomatic relations – which also brought female courtiers from foreign kingdoms to join Amenhotep III's harem – Egypt found itself in an unassailable political position.

The lifestyle of the period reflects these international links. Furniture, fabrics and jewelry feature decorative motifs that had

their origins in the Aegean region and the Middle East. Egyptian forays towards Sudan in the south brought Nubian gold, ebony and ostrich plumes to Egypt. In the artistic field too, the opening of Egypt to the outside world offered new possibilities.

It was probably the loosening of the strict rules governing artistic production under Amenhotep III that made possible a profound break in the history of Egyptian art, which has rightly been described as a revolution. Amenhotep IV ascended to the throne by chance, when his elder brother and heir to the throne, Thutmose, died at a young age. Amenhotep IV decreed that Aten, the sun god whom he venerated, was the one true god, thus creating the first form of monotheism. This complete rejection of a pantheon of deities led to changes that touched all aspects of life and took Egyptian art in a new direction.

Instead of representing unchanging ideals that were repeated cyclically and endlessly, the 'snap-shot' appeared, translating a moment into aesthetic terms. Human existence no longer continued in an eternal hereafter, but took place in a brief space of time between birth and death, created and supported by Aten, who was manifest in the king and his family.

The physical model for representing Amenhotep IV became the touchstone, affecting the whole of Egyptian art. The colossal statues that Amenhotep had erected in his temple of Aten at Karnak, set around the open courtyard dedicated to the sun, established a new ideal that might strike the modern observer as one of ugliness. The heavy flanks and thighs recall the iconographical model of the Nile divinity guaranteeing fertility. The unusual facial features are in effect a grotesquely

caricatured portrait of the king. In the portraits of the queen Nefertiti and the couple's children these features recur in only slightly modified form.

It was not simply the style of royal portraiture that saw significant changes, but also the subjects treated in temple reliefs. Immediately behind the imperial temple of Amun-Re at Karnak, Amenhotep IV built a great temple dedicated to the sun god Aten. Wall reliefs show the king and his queen participating in religious ceremonies in the presence of Aten, no longer in the splendours of a space isolated from the rest of the world, but in the midst of temple activities. God was part of the world and part of his creatures.

This new religion inevitably led to a break with tradition. Amenhotep IV, his wife Nefertiti and the court abandoned the ancient residences of Memphis and

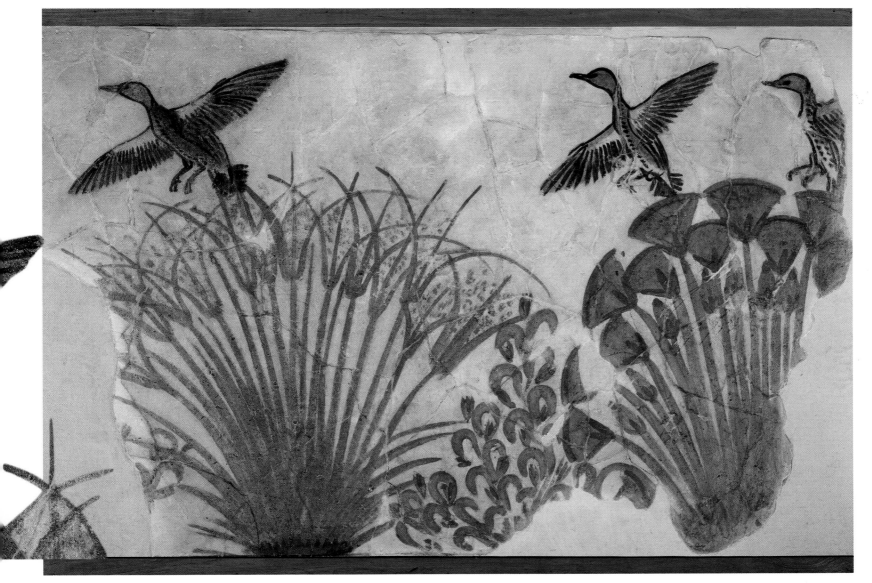

158 OPPOSITE
HEAD OF STATUE
JE 38248 = CG 42101
OBSIDIAN
HEIGHT 20 CM
WIDTH 15 CM
KARNAK, TEMPLE OF
AMUN-RE COURTYARD
OF THE CACHETTE
GEORGES LEGRAIN'S
EXCAVATIONS (1905)
SECOND HALF OF THE
EIGHTEENTH DYNASTY
(14TH CENTURY BC)

159
FRAGMENT OF WALL
PAINTING
JE 33030 - 33031
PAINTED PLASTER
HEIGHT 101 CM
WIDTH 160 CM
TELL EL-AMARNA,
SOUTHERN PALACE
(MERUATEN)
ALESSANDRO BARSANTI'S
EXCAVATIONS (1896)
EIGHTEENTH DYNASTY
REIGN OF AKHENATEN
(1353–1335 BC)

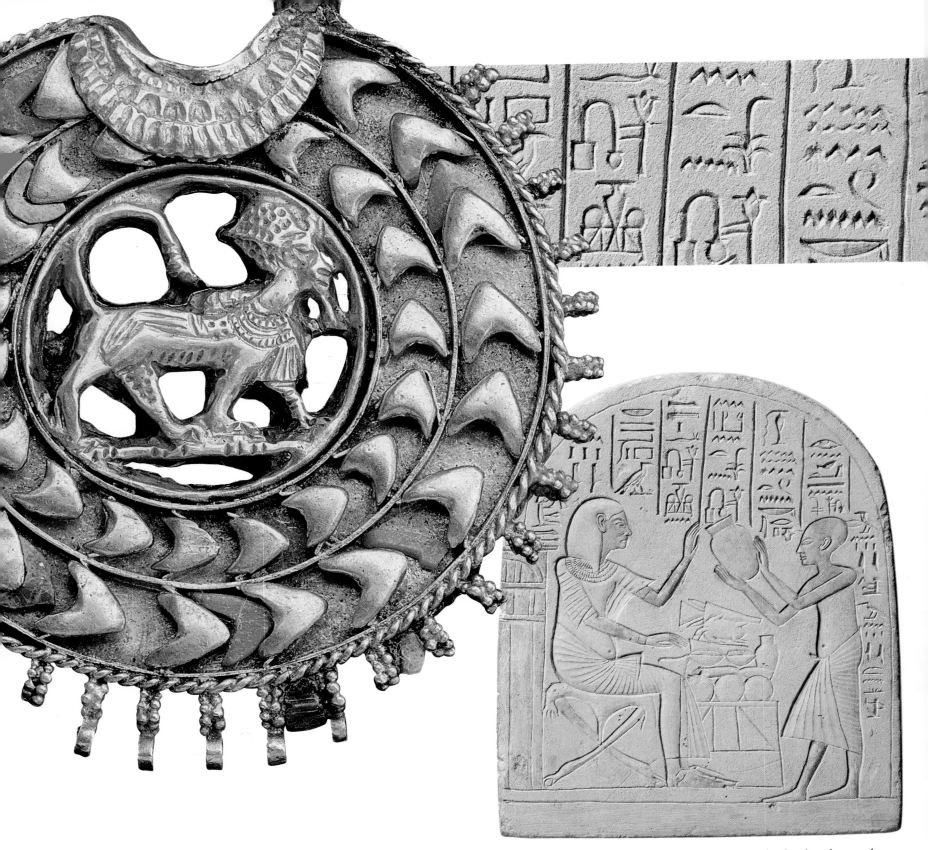

160 ABOVE LEFT
PENDANT WITH
AKHENATEN AS A SPHINX
JE 97864
GOLD AND GLASS PASTE
DIAMETER 4.5 CM
SAQQARA
TOMB OF HOREMHEB
BRITISH–DUTCH
EXCAVATIONS DIRECTED BY
GEOFFREY MARTIN (1977)
EIGHTEENTH DYNASTY
REIGN OF AKHENATEN
(1353–1335 BC)

160 ABOVE RIGHT
STELA OF ANI
CG 34178
PAINTED LIMESTONE
HEIGHT 27 CM
TELL EL-AMARNA
TOMB OF ANI
ALESSANDRO BARSANTI'S
EXCAVATIONS (1891)
EIGHTEENTH DYNASTY
REIGN OF AKHENATEN
(1353–1335 BC)

161 OPPOSITE LEFT
SARCOPHAGUS OF
AKHENATEN
JE 54934
GRANITE
LENGTH 285–288 CM
WIDTH 121–125.5 CM
TELL EL-AMARNA
TOMB OF AMENHOTEP IV /
AKHENATEN (TA 26)
ALESSANDRO BARSANTI'S
EXCAVATIONS (1891)
EIGHTEENTH DYNASTY
REIGN OF AKHENATEN
(1353–1335 BC)

161 OPPOSITE RIGHT
FRAGMENT OF SHABTI
OF AKHENATEN
JE 96830
RED QUARTZITE
HEIGHT 10.5 CM
TELL EL-AMARNA
EIGHTEENTH DYNASTY
REIGN OF AKHENATEN
(1353–1335 BC)

Thebes. The king changed his name from Amenhotep, meaning 'Amun is content', to Akhenaten, translated as 'Glory of the sun disc', and founded his new capital Akhetaten (Amarna) in Middle Egypt.

Amarna was abandoned immediately after the death of Akhenaten and sank into oblivion, but many of its masterpieces have survived. Excavations of the city were conducted by a German expedition under Ludwig Borchardt between 1911 and 1914, and after the First World War by an English expedition. These excavations uncovered many important remains of temples, palaces and homes, as well as the studios of Amarna sculptors. A series of sketches on fragments of limestone, a number of sculptural models and many unfinished statues of the king and his family came to light. These works provide us with a unique overview of the process of artistic creation that made this brief period one of the richest phases in the history of Egyptian art. It is nearly impossible to identify or detect the hands of individual artists in most ancient Egyptian art, but the names and styles of many Amarna artists are known. Many of the unfinished statues of the royal family found at Amarna by Borchardt come from the studio of the chief architect Djehutymes. The chief architect Bek notes in an inscription that he was commissioned by the king in person and the architect Iuty is represented in his own relief sculpture.

The wall paintings and floors of the palaces of Amarna, with their lively plant motifs, bring to mind the French Impressionists, while the softness of the unfinished statues and the busts of Nefertiti evoke Auguste Rodin's work. The statues and relief sculptures are striking for

the repeated presence of the king and queen together as a couple. Akhenaten holds his wife on his lap and kisses her; he attends the sacrificial ceremony under the rays of Aten, accompanied by his wife and daughters. These idyllic images also function as a didactic programme. The love between god and man is reflected in the love between the royal couple. The king kissing his wife incarnates Aten, the sun god, entering into a kind of holy matrimony with the terrestrial queen.

Due to its modern forms, the art of Amarna has aroused particular interest. There can be no doubt, however, that this episode in the history of Egyptian art is not representative of the art of the whole of Egypt. It should instead be seen as a brief hiatus that, due to its position in time forms an interesting watershed by which the fifteen hundred years of Egyptian art that preceded it and the following fifteen hundred can be judged and understood.

By the time Tutankhamun acceded to the throne, Egyptian art had been restored to the traditional course it had abandoned twenty years earlier. The historiography makes little mention of the years of the so-called 'Heretic King'. However, the artistic liberties taken during his rule were to have an influence on the following period. The Ramesside classicism of the second half of the New Kingdom was unable to erase completely the heritage of the art of Amarna – a source of impulses that fluctuated between tradition and innovation, giving 'the new' a strange appeal.

The interlude created by the art of Amarna and the religious revolution responsible for it would appear to be a historical phenomenon that resists easy interpretation. At the height of a culture based on extraordinary continuity and an innate awareness of tradition, and under the influence of a single ruling figure, an evolutionary leap took place that anticipated world religious concepts that only developed centuries later with Judaism and Christianity.

BIOGRAPHY

Dietrich Wildung, born in Bavaria in 1941, completed his studies in Egyptology and archaeology at the University of Munich and the École des Hautes Études in Paris. Chief Curator at the Egyptian Museum of Munich from 1977 to 1988 and Chief Curator of Egyptian Art at the Staatliche Museen, Berlin from 1989 to the present, Vice-President (1976–1989), then President (1992–1996) of the International Association of Egyptologists, he is currently professor of Egyptology at the University of Berlin. He led archaeological expeditions of the East Delta Excavation Project between 1978 and 1989. In 1985 the great value of his work was recognized in his homeland with the award of the Cross of the Order of Merit. Since 1995 he has led the Naga Excavation Project in the Sudan, a country that in 1998 honoured him with the prestigious Order of the Two Niles.

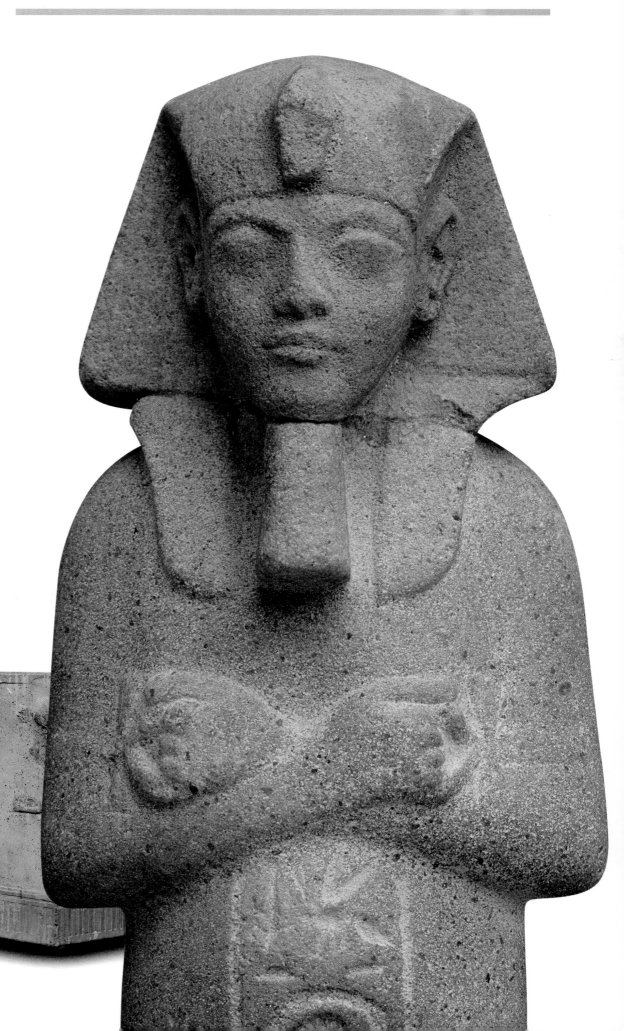

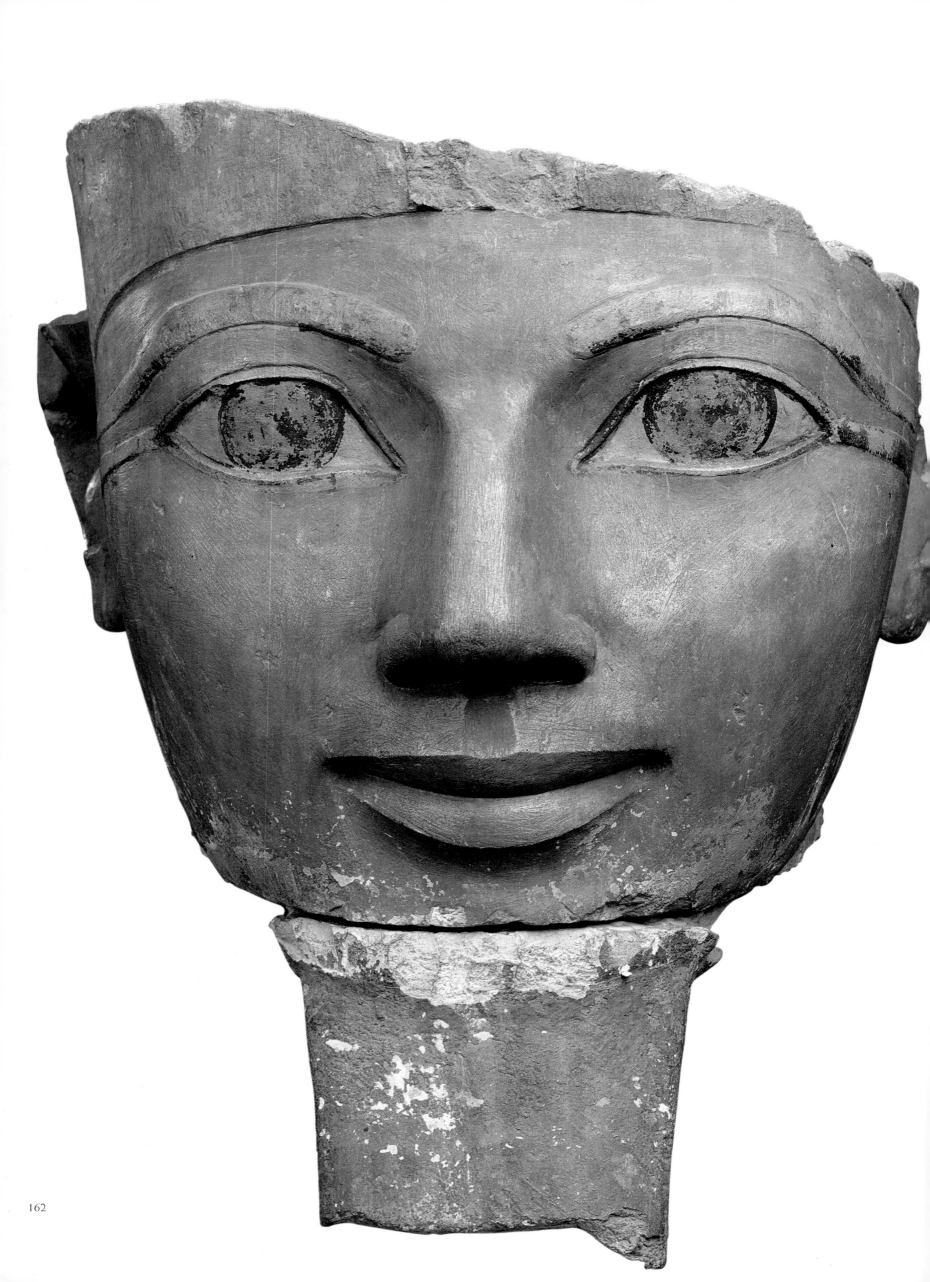

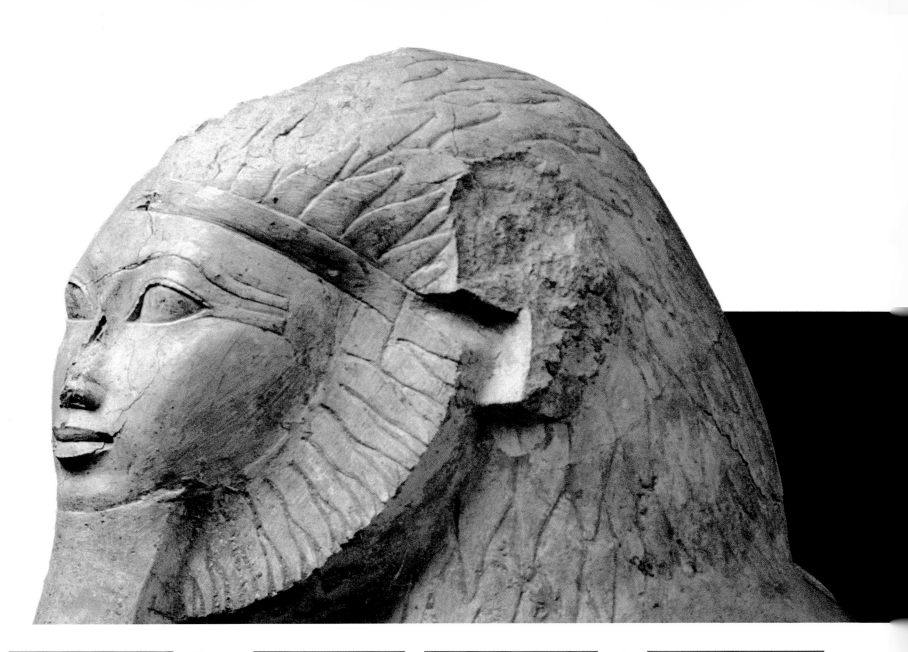

JE 56259 A - 56262

HEAD OF A STATUE OF QUEEN HATSHEPSUT

PAINTED LIMESTONE; HEIGHT 61 CM
DEIR EL-BAHRI; FUNERARY TEMPLE OF HATSHEPSUT
METROPOLITAN MUSEUM OF ART EXCAVATIONS (1926)
EIGHTEENTH DYNASTY, REIGN OF QUEEN HATSHEPSUT (1473–1458 BC)

This head of a colossal statue of Hatshepsut would once have crowned one of the Osirian pillars that decorated the portico of the third terrace of the queen's temple at Deir el-Bahri. It was discovered there in 1926 by the mission of the New York Metropolitan Museum of Art, directed by Herbert Winlock.

The portico was divided into two by a granite portal which preceded the 'Festival Hall', on to which opened the more intimate rooms of the temple and the sanctuary of Amun.

Some of the characteristic stylistic features of the statuary of Hatshepsut are present in this head. The face is triangular and the features are very delicate. The striking almond-shaped eyes, decorated with a line of kohl extending to the temples, have large

dilated pupils, imparting a sense of innocence and purity. The slightly arched nose is long and slim. The small mouth is set in a faint smile. The same face is found not only on many other statues of the queen but also on those representing private individuals of the same period.

One unusual element is the dark red colour of the skin; usually a feature of male images, it is justified in this case by the fact that the queen is represented here as a pharaoh in Osirian form. The false beard painted blue emphasizes the divine nature of the 'king'. The blue colour of lapis lazuli, together with gold, signified divinity.

From what remains of the queen's headdress, it can be deduced that she wore the Double Crown symbolizing the union between Upper and Lower Egypt. (R.P.)

JE 53113

SPHINX OF HATSHEPSUT

PAINTED LIMESTONE
HEIGHT 59.5 CM; LENGTH 105 CM
DEIR EL-BAHRI
FUNERARY TEMPLE OF HATSHEPSUT
EIGHTEENTH DYNASTY, REIGN OF QUEEN HATSHEPSUT (1473–1458 BC)

The leonine body of this sculpture is carved in a fairly classical pose, with the front legs extending forwards and the tail curling around the right rear leg. However, the head, which in such images is usually covered with a nemes headdress, here has a large, thick mane with stylized curls that ends in a short plait on the back. The ears are broken off.

The queen's face is encircled by a fringe of hair and she wears a long false beard. Due to the thick mane, the face of Hatshepsut appears small and refined. The delicately female appearance of the features is somewhat offset by the choice of colours, which conform to the convention of representing the divine nature of all pharaohs by using yellow for gold and blue for lapis lazuli.

A vertical inscription begins below the beard on the chest, protected by the symbol of the sky, and is completed on the base between the front paws. It reads 'Maatkare [the coronation name of Hatshepsut], beloved of Amun, blessed with eternal life'.

Numerous stone sphinxes of Hatshepsut, varying in size, have survived. Many come from her temple of Deir el-Bahri known to the ancient Egyptians as Djer Djeseru, 'The Sublime of the Sublime'. Rows of large sphinxes flanked the ramp leading from the second terrace to the entrance of the temple proper. The example illustrated here was part of a group of smaller sphinxes that lined the processional routes within the temple itself and decorated a number of niches on the upper terrace. (R.P.)

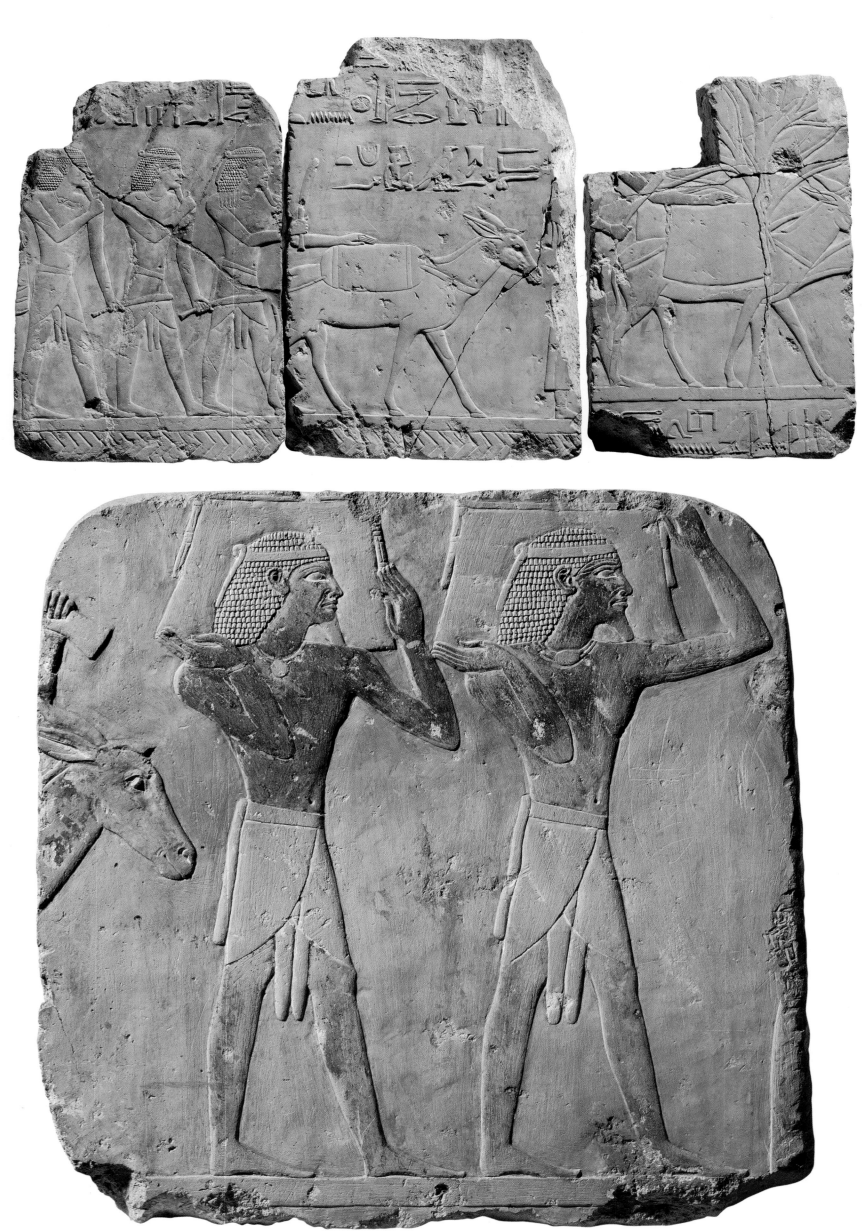

JE 14276 - 89661

FRAGMENTS OF RELIEFS OF THE EXPEDITION TO PUNT

PAINTED LIMESTONE; MAXIMUM HEIGHT 49 CM; MAXIMUM WIDTH 45 CM
DEIR EL-BAHRI, FUNERARY TEMPLE OF HATSHEPSUT
EIGHTEENTH DYNASTY, REIGN OF QUEEN HATSHEPSUT (1473–1458 BC)

These blocks come from the southern portico of the second terrace of Hatshepsut's temple. The reliefs depict scenes of the famous expedition to the land of Punt, dispatched by the queen in the ninth year of her reign. The purpose of the expedition was to obtain exotic and precious products, especially incense, to offer to the god Amun-Re. The five fragments seen here are from the south wall: two from the first register and the other three from the second. The reliefs are very finely carved and in this section depict a very distinctive landscape with a village on the shores of an expanse of water, very probably the Red Sea, where pile-dwellings alternate with palm trees. The lower part of the scene shows the encounter between the natives, who carry a variety of products, and the Egyptian delegation.

On the two blocks from the lower register are three figures pushing a donkey with a kind of saddle. Above it a horizontal inscription describes it as 'the donkey that carries his wife'. This is clearly a reference to the Queen of Punt, portrayed further along the same register. The men walking behind the donkey have curly hair, held in place by a band on their forehead, and short beards. They are wearing kilts with a belt tied behind their backs, and each has a stick in his hand.

One of the three blocks from the upper register also shows a donkey, this time with a pack on its back, pushed by another figure. One of the precious *antyu* trees can be seen in the background. The figures represented on the two remaining blocks are the ruler of Punt, whose name was Parehu, and his wife Ati, followed by three of Punt's inhabitants. The prince, with short hair and a long beard, wears a necklace with three pendants. He is dressed in a kilt with a dagger tucked in the belt and carries a stick in his left hand. The portrayal of the queen is very distinctive, particularly in the light of Egyptian representative canons, since it is a precise portrayal of the condition of steatopygy. The queen's spine is bent forwards and her legs are disproportionately large and short. Deep folds of skin mark the rest of her body. The queen's long hair is tied at the back and she is wears a knee-length belted robe. She has a necklace like her husband's, but with larger beads, and bracelets around her wrists.

A native of Punt, partially preserved, follows the royal couple. He too has curly hair, held down by a band on his forehead, and a short beard; he is wearing the same kind of kilt as the prince. Two other natives follow, carrying the boxes for the Egyptian delegation on their shoulders. All these figures have negroid features.

These reliefs were once stolen from Hatshepsut's temple. When the thieves were captured and the blocks recovered, the originals were taken to the Egyptian Museum and cast impressions now replace them in the wall of the temple. (R.P.)

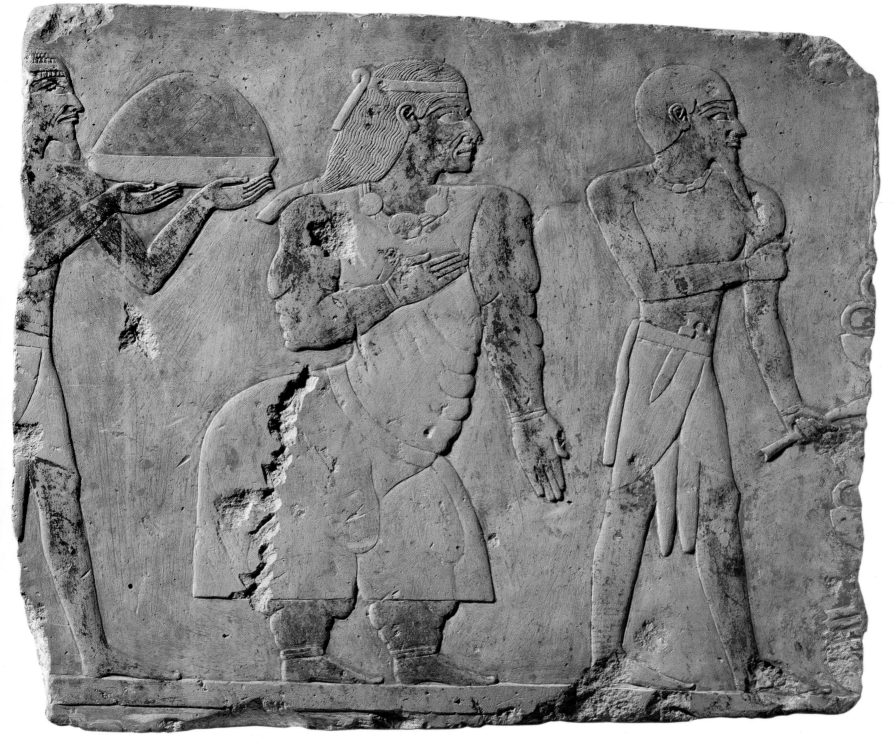

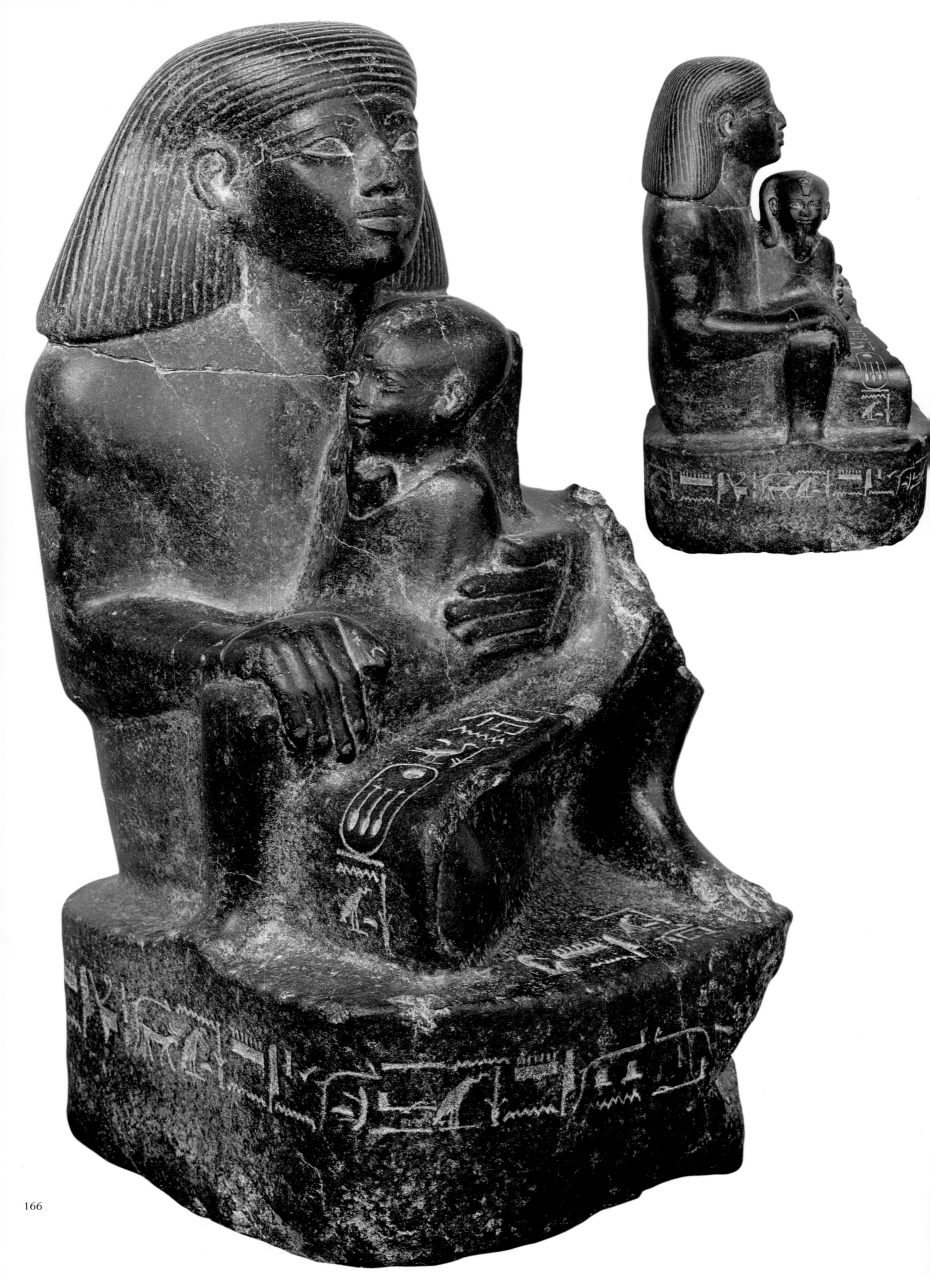

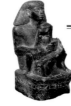

JE 36923 = CG 42116

STATUE OF SENENMUT WITH NEFERURE

BLACK GRANITE
HEIGHT 60 CM
KARNAK, TEMPLE OF AMUN-RE, COURTYARD OF THE CACHETTE
G. LEGRAIN'S EXCAVATION (1904)
EIGHTEENTH DYNASTY, REIGN OF QUEEN HATSHEPSUT (1473–1458 BC)

Senenmut is seated on a high, four-sided base with rounded corners. His right leg is on the ground, folded below the left, which is brought up to his chest. This pose creates a convenient support for the architect to hold the infant Neferure with both hands seated across the axis of his body. He wears a broad wig that leaves his ears exposed and reaches his shoulders. It is divided into narrow locks rendered with incised lines. His face is gazing slightly upwards.

His short kilt is a type of garment that became rarer from the end of the New Kingdom, but is still frequently found in this type of sculpture both early in the Eighteenth Dynasty and during the Amarna Period. His arms encircle the body of the child, protecting

her with his large hands. His right hand is on her knees, the left around her shoulders. Neferure's head is shaven, apart from the braid of infancy on her right temple, and she is completely wrapped in a shawl. A column of hieroglyphs is inscribed alongside her, on the hem of Senenmut's skirt: 'Chief Steward of the Princess Neferure, Senenmut'. Two texts are also inscribed symmetrically around the base, starting from the centre of the front. They record a number of the titles of Senenmut: 'Superintendent of the grain stores, of the lands, of the livestock of the Dominion of Amun'. Another brief caption in front of the feet of the statue of Senenmut repeats his name and the title associated with the possessions of the god. (R.P.)

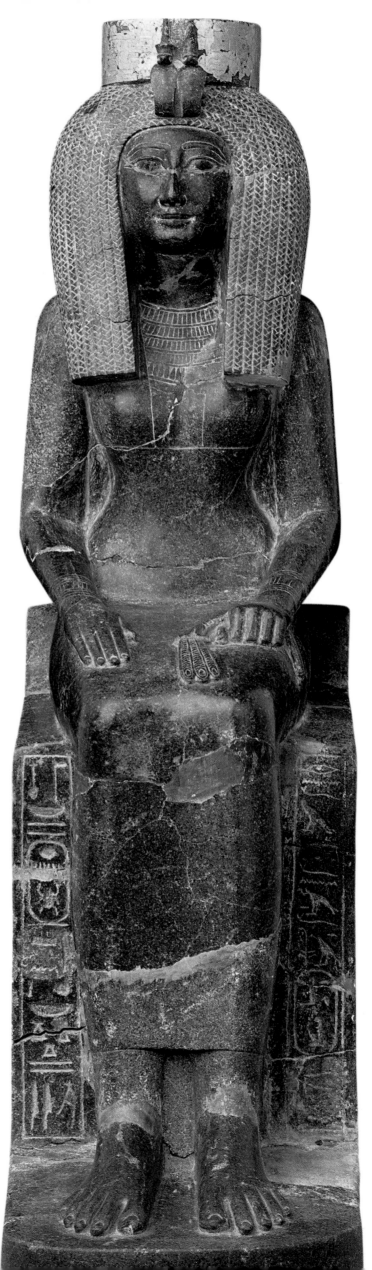

JE 37417 = CG 42072

SEATED STATUE OF ISIS, MOTHER OF THUTMOSE III

BLACK GRANITE, GOLD LEAF
HEIGHT 98.5 CM; KARNAK, TEMPLE OF AMUN-RE
COURTYARD OF THE CACHETTE; G. LEGRAIN'S EXCAVATION (1904)
EIGHTEENTH DYNASTY, REIGN OF THUTMOSE III (1479–1425 BC)

Queen Isis, the mother of the pharaoh Thutmose III, is seated on a throne formed of a single block with the base. She rests her hands on her knees and is holding a lotus flower sceptre in her left hand. Her feet are parallel and slightly apart. The queen's hands and feet have long, slim fingers and toes, and the nails are minutely represented. She wears a heavy three-part wig with braids rendered in the form of fine incisions and a close-fitting tunic with broad straps that cover her breasts.

On her head is a cylindrical diadem covered with gold leaf. Two elements that would have completed the headdress are missing. On the front are two cobras, one with the Red Crown of Lower Egypt, the other with the White Crown of Upper Egypt. Around her neck is a *usekh* necklace.

Isis' oval face has close-set eyes surmounted by broad eyebrows. She has a long, slender and slightly hooked nose, and a small mouth.

The mother of Thutmose III, Isis was not a member of the royal family but was one of the secondary wives of the pharaoh Thutmose II. In the brief dedicatory address inscribed on either side of the legs there is in fact no mention of the titles reserved for the royal wives of the New Kingdom such as 'Great Royal Wife', 'Divine Bride' or 'Daughter of the King'. It reads 'The perfect god, the Lord of the Two Lands, *Menkheperre* beloved of Amun, Lord of the Throne of the Two Lands, has made this as his monument for his mother, Isis'. It should be noted that the name of the god Amun was reinscribed after it had been erased during the Amarna Period. (R.P.)

167

STATUE OF THUTMOSE III, KNEELING

CALCITE
HEIGHT 26 CM
DEIR EL-MEDINA; E. BARAIZE'S EXCAVATIONS (1912)
EIGHTEENTH DYNASTY, REIGN OF THUTMOSE III (1479–1425 BC)

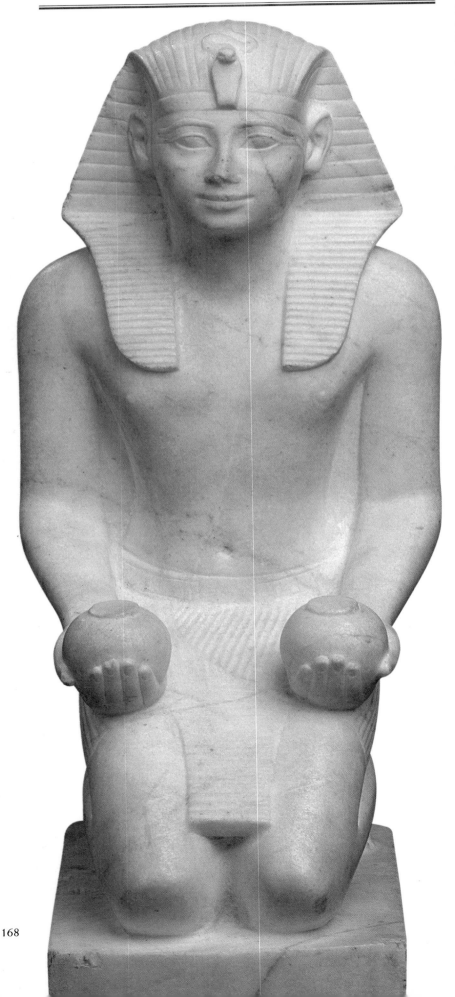

This finely carved statuette shows the pharaoh kneeling on a rectangular base. In his hands, resting on his thighs, he holds two *nu* vases. Thutmose III is wearing the *nemes* headdress with a *uraeus* on the forehead and a *shendyt* kilt with narrow pleats rendered by incisions.

The face has delicate features: small eyes with the typical eye-paint tracing elongated lines around the eyelids, which are echoed by the fairly thick eyebrows. The nose is thin and straight, the mouth is set in a slight smile, and the ears emerge from the *nemes* but are set flat against the head.

Overall, this portrait of Thutmose III unequivocally recalls the style of the statuary of Hatshepsut and probably dates from a fairly early period of his reign. Although the shoulders are broad and the neck is powerful, it is clear that the accent here is not on the athletic appearance and powerful physique of Thutmose III as emphasized elsewhere, but rather on the sacredness of his image as a priest. This pose is serene and hieratic.

Although the statuette was found in the vicinity of the western section of the boundary wall of Hathor's temple at Deir el-Medina, it was probably originally located in one of the temples of Amun, to whom the pharaoh dedicated the vertical inscription incised on the dorsal pilaster. (R.P.)

HATHOR CHAPEL

PAINTED LIMESTONE
HEIGHT 225 CM; WIDTH 157 CM; DEPTH 404 CM
DEIR EL-BAHRI
EIGHTEENTH DYNASTY, REIGN OF THUTMOSE III (1479–1425 BC)

This small Hathoric chapel was constructed by Thutmose III at Deir el-Bahri, between the temple of Mentuhotep II and that of Hatshepsut. It may have been intended as a replacement for the sanctuary dedicated to the same goddess located in the complex of the queen or, more simply, as a further station on the procession route followed by the divine barques visiting the Theban West Bank during the 'Beautiful Festival of the Valley'.

Thutmose III's chapel reproduces, on a considerably smaller scale, the same type of figurative composition that is found in the comparable shrine of Hatshepsut: scenes of offerings to the god Amun, the goddess Hathor (represented as a young cow) and the nursing by Hathor of the king, who is depicted as a young boy.

The chapel is rectangular and has a vaulted ceiling decorated with a starry sky. The back wall is occupied by a scene in which Thutmose III is offering libations and burning incense to the god Amun-Re who is seated on a throne. The texts on the left-hand side contain two of the king's names and comments on his actions. The texts on the right-hand half of the wall present the god 'Amun-Re, Lord of the Thrones of the Two Lands, Lord of Heaven' who turns to the pharaoh with the following words: 'I give you all life, power, stability and joy on my behalf as Re in eternity.' Two scenes featuring Hathor are depicted on the chapel's two long walls. From the back wall, the goddess is shown first in a standing pose, with the solar disc between two cow's horns on her head, in the act of receiving offerings from Thutmose III. Then, in the form of a cow, she is depicted in the act of nursing the young pharaoh kneeling under her; he is also represented as an adult making offerings before the goddess.

On the left-hand wall, Thutmose III is accompanied by his wife Meritre and on the right-hand side by two princesses. The nursing of the king by the cow goddess is also depicted in a sculpture of Thutmose III's successor, Amenhotep II, which was found in this small chapel during Naville's 1906 excavations. (R.P.)

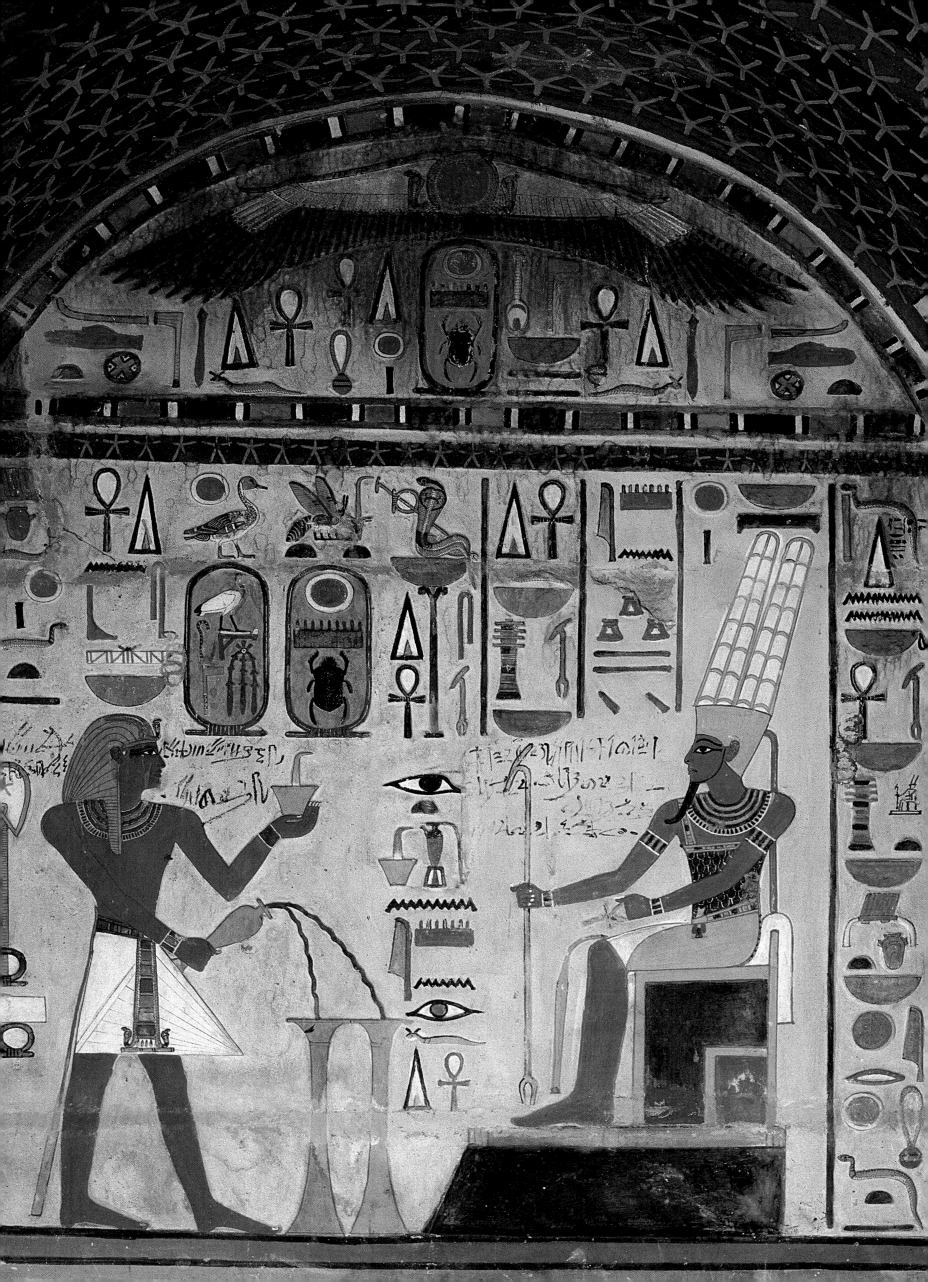

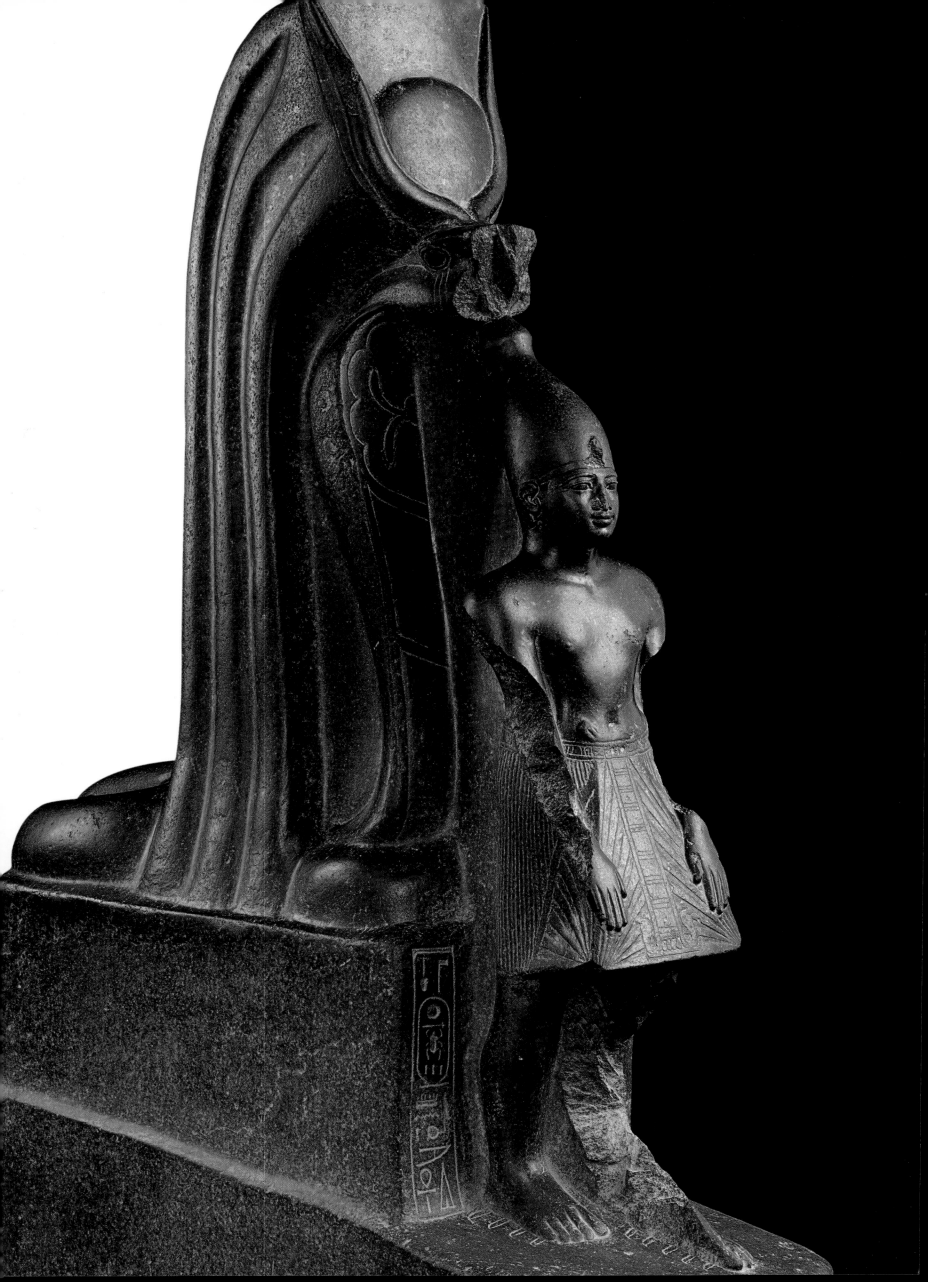

STATUE OF AMENHOTEP II WITH MERETSEGER

GRANITE
HEIGHT 125 CM
KARNAK
EIGHTEENTH DYNASTY, REIGN OF AMENHOTEP II (1427–1401 BC)

This sculpture shows the striding king trampling on the Nine Bows, traditionally representing the enemies of Egypt. His arms are extended along the front of his body with his hands resting on the rigid panel of his kilt. The king wears the White Crown, with the *uraeus*. His oval face has large, well-defined eyes, a long straight nose and a small, rather full mouth. The kilt is decorated with a central stripe running from the belt to the hem, terminating with two cobras.

The large trapezoidal pedestal on which the pharaoh stands is topped by a second element, visible behind the king's shoulders, on which the goddess Meretseger is resting. The goddess is depicted as a cobra with a solar disc and horns on her head. The cobra protects Amenhotep II's head and shoulders with its broad, open hood.

At the rear, the body of the goddess is depicted with the usual coils, but she is also is partially covered by long, thick papyrus stems. Two columns of text reading 'The Ruler of Upper and Lower Egypt *Aakheperure*, beloved of Amun-Re, blessed with life' and 'The Son of Re, Amenhotep, beloved of Amun-Re, blessed with life' are inscribed either side of the pharaoh's legs.

According to one theory this sculpture belonged to the first group of portraits of the pharaoh. It certainly recalls another image of Amenhotep II discovered in the Hathoric chapel of his father Thutmose III at Deir el-Bahri in which the king is shown in the same posture, this time protected by the goddess Hathor in the form of a young cow standing at his shoulder. In this statue the goddess also emerges from a large clump of papyrus stems that surround her head. Statuary groups composed of a human figure and a divinity in animal form were also produced as private sculptures in later eras. (R.P.)

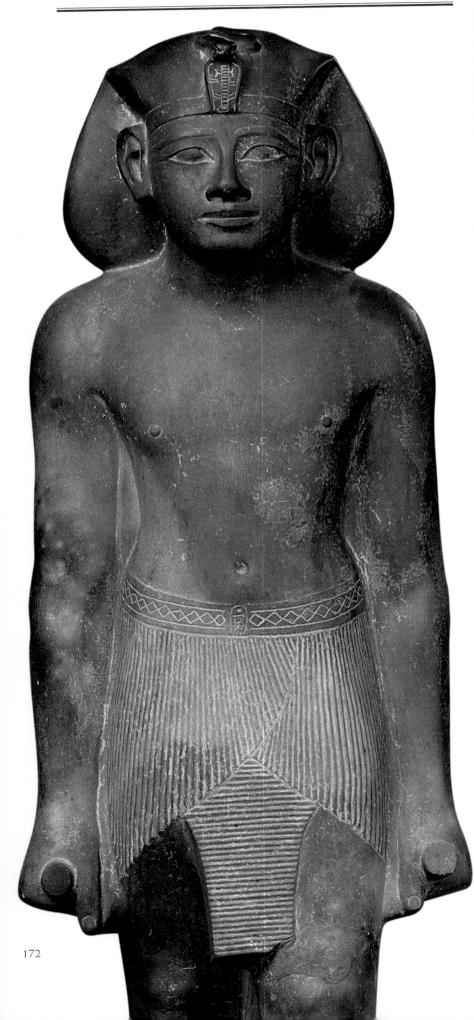

STATUE OF AMENHOTEP II

GREYWACKE
HEIGHT 68 CM; KARNAK, TEMPLE OF AMUN-RE
COURTYARD OF THE CACHETTE; G. LEGRAIN'S EXCAVATION (1904)
EIGHTEENTH DYNASTY, REIGN OF AMENHOTEP II (1427–1401 BC)

In this statue of Amenhotep II, the king is represented striding forwards, with both arms held by his sides. He is wearing the *afnet* headdress, fastened across the forehead by a band to which the royal uraeus is attached. His finely pleated *shendyt* kilt is held in by a belt, the buckle of which carries an inscribed cartouche with the coronation name of the pharaoh, *Aakheperure*.

The pharaoh's slim oval face is perfectly polished, though with fairly pronounced features. His closely set eyes are elongated towards the temples. The eyelids are emphasized by well-defined and prominent eyebrows and framed by rather large ears. The long nose has a fairly wide base, and the mouth is carefully drawn and tightly closed. The face thus has strong, dignified features and a distant gaze that is evocative of the young king's determination to carry forwards the policy of expansion in the Near Eastern regions initiated by his father Thutmose III.

The precision of the pleating on the kilt and the accomplishment of the modelling of the facial features are in clear contrast with the somewhat less careful rendering of other parts of the body: the shoulders are slightly sloping, the musculature is barely sketched, and the legs are rather thickset. It is clear that the artist was most concerned with the pharaoh's face, on which the entire work seems to focus. In spite of the disparity between its various parts, the piece remains a fine example of New Kingdom statuary and is in fact one of the most beautiful representations of Amenhotep II to have been discovered. (R.P.)

STATUE OF THUTMOSE IV WITH HIS MOTHER TIA

GREY GRANITE
HEIGHT 111.5 CM; WIDTH OF THE BACKREST 69 CM
KARNAK, TEMPLE OF AMUN-RE
EIGHTEENTH DYNASTY, REIGN OF THUTMOSE IV (1397–1387 BC)

The two royal figures are sitting on an uninscribed throne with a large backrest and an arched top. Thutmose IV, who is slightly the taller of the two, has his left arm behind the back of Tia, whose right arm reaches behind the king. Their arms cross over one another in the middle of the composition, and their hands are held round each other's shoulders. Both their free hands rest on their thighs: Thutmose's grips an *ankh*, symbol of life, and Tia's is open, palm downwards on her knee.

Unusually, the king wears a wig rather than a crown; it is a fairly elaborate, curled example echoing those found on private statues and covers almost the entire forehead and the ears. At the front of the wig is a cobra that coils twice at the top, raising its head up above the king's forehead. Thutmose wears a *shendyt* kilt with a belt decorated with concentric diamond motifs and fastened by a buckle incised with his name. A bull's tail is visible between his slightly parted legs. His feet rest on the Nine Bows which represent the enemies of Egypt.

The queen wears a long three-part wig with incised braids covered at the top by the plumage of a vulture (an attribute of the queen-mother of the heir to the throne) and decorated at the front with the royal cobra. Her long, close-fitting tunic has two rosettes over her breasts, and her jewelry consists of a *usekh* necklace and wide bracelets. The faces of the two figures are almost identical, except for the royal eye-paint, elongated towards the temples, that heavily outlines the eyes of the king. His oval face has full cheeks, high cheekbones, a straight nose, narrow eyes with eyebrows in relief, and a narrow, closed mouth.

On the front of the throne, outside the legs of the figures, are two columns of hieroglyphs with the names and titles of the couple. By the side of Thutmose IV is written: 'The perfect god, *Menkheperure*, beloved of Amun-Re Lord of the Thrones of the Two Lands, blessed with life'. Beside the queen the column reads: 'The Great Queen, beloved by him, the mother of the king, Tia, right of voice'. This last epithet is normally the prerogative of the deceased and suggests that Tia was already dead when the statue was made. (R.P.)

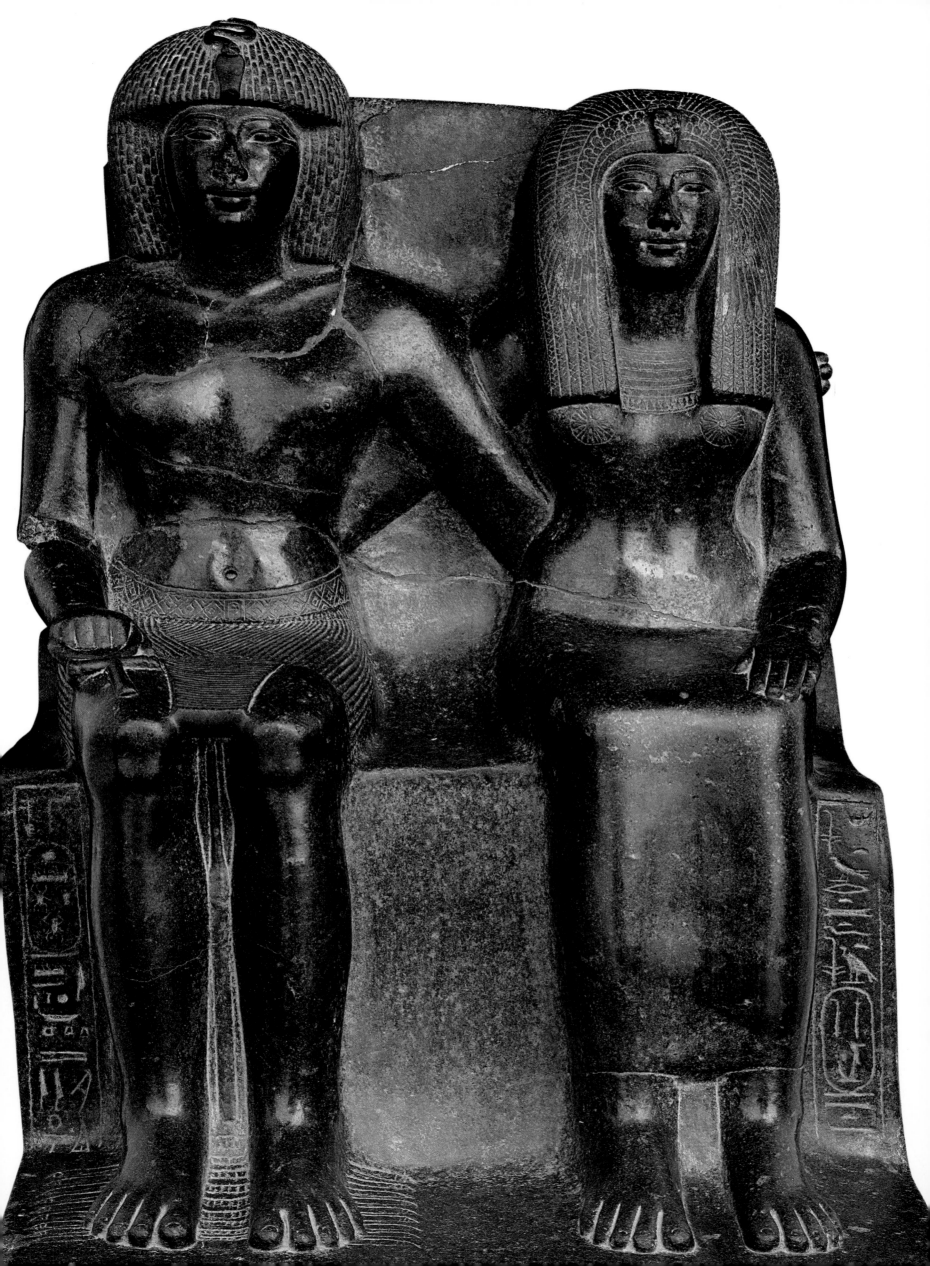

STATUETTE OF IBENTINA

PAINTED SYCAMORE WOOD
NAOS: HEIGHT 62 CM; *STATUETTE:* HEIGHT 38 CM
DEIR EL-MEDINA, TOMB OF SATNEM (NO. 1379)
EXCAVATIONS BY THE INSTITUT FRANÇAIS D'ARCHÉOLOGIE ORIENTALE (1933–1934)
EIGHTEENTH DYNASTY (C. 1490–1450 BC)

This slender, elegant figure carved from sycamore wood represents the lady Ibentina, wife of Satnem, whose tomb it was found in. The tomb's grave goods also included a statuette of Satnem, which formed a pair with this one of his wife. The two small, fine sycamore sculptures were both covered with linen.

Ibentina is depicted standing with her right arm held down beside her body. A string of tiny faience beads is tied around the left arm, which is bent at her waist. She is wearing a wig divided into three sections, with braids held by bands, and a long, close-fitting robe.

Her jewelry consist of bracelets around her wrists. She has a small face with wide, almond-shaped eyes, a slender nose, and a finely shaped mouth. The statuette is fitted into a rectangular base, also made of wood. Around this base is painted a formula for offerings dedicated to the god of the deceased, Osiris, here greeted as lord of Busiris and Abydos.

The statuette is contained in a wooden *naos* complete with a sliding lid. The woman's face and the artistic quality of the sculpture mean that it is possible to date the statuette to the period of Hatshepsut or Thutmose III. (R.P.)

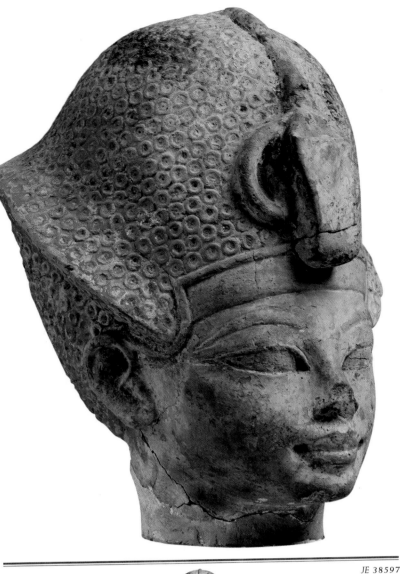

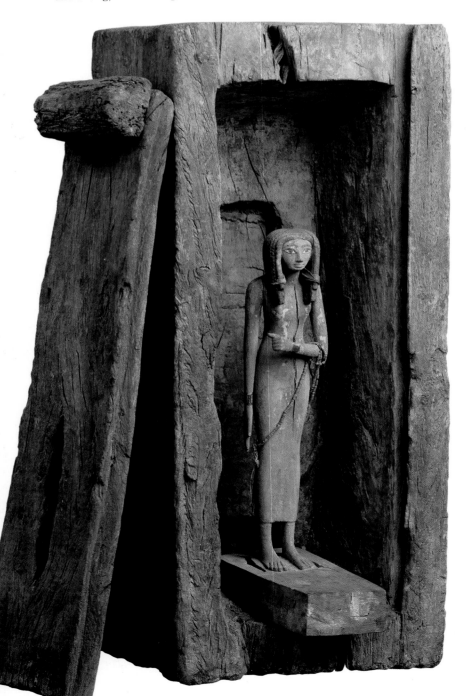

HEAD OF A STATUE OF AMENHOTEP III

STUCCOED AND PAINTED CLAY
HEIGHT 38 CM; KARNAK, TEMPLE OF AMUN-RE
COURTYARD OF THE CACHETTE; G. LEGRAIN'S EXCAVATION (1906)
EIGHTEENTH DYNASTY, REIGN OF AMENHOTEP III (1391–1353 BC)

More statues of Amenhotep III are known – over two-hundred-and-fifty – than of any other ancient Egyptian pharaoh. The availability of such a large number of representations has allowed scholars to trace the development of the portraiture of this king. His portraits move from a stylization aimed at achieving an increasingly refined aesthetic balance, to a radical change in representational style and the adoption of a definitive iconography in the last years of the reign. The king is then shown with smooth, youthful features.

This clay head from Karnak can be dated on stylistic grounds to the final part of the king's reign. It anticipates a number of features that were to characterize the art of the succeeding Amarna Period, with the reign of Amenhotep III's son, Amenhotep IV or Akhenaten.

Amenhotep III is depicted wearing the Blue Crown, the headdress normally found in representations of the king in a military context. It was favoured in this period because with its sharp lines and highly decorated surface consisting of repeated concentric circles it provided a sophisticated contrast with the smoothness and polish of the face.

On the front of the crown rises the cobra, the symbol of kingship. The coils of the snake form a circle above the king's forehead and then extend over the top of the headdress.

The king's large, slanting and almond-shaped eyes are extremely elongated. The eyebrows are also arched and follow the line of the eyes, lending greater emphasis to their upper curves. The nose, with its slightly chipped tip, is small with a flat base. The mouth has fleshy lips with the profile in slight relief; it terminates with two lateral dimples that enliven the full cheeks. (F.T.)

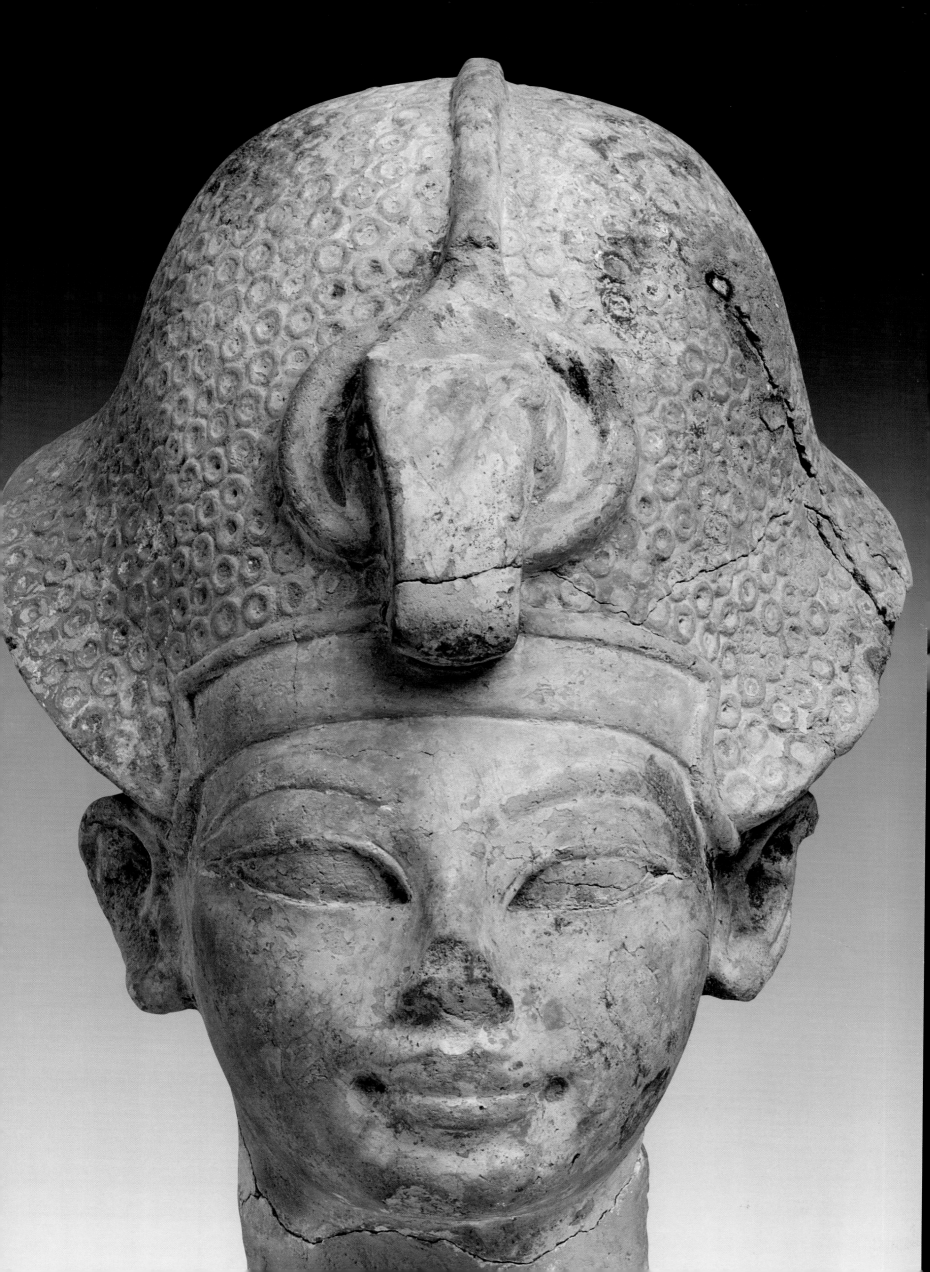

ANTHROPOID COFFIN OF YUYA

WOOD, GOLD- AND SILVER-LEAF, GLASS PASTE, ALABASTER, CARNELIAN
HEIGHT 204 CM
VALLEY OF THE KINGS, TOMB OF YUYA AND TUYU (KV 46)
ANTIQUITIES SERVICE EXCAVATIONS ON BEHALF OF THEODORE DAVIS (1905)
EIGHTEENTH DYNASTY, REIGN OF AMENHOTEP III (1391–1353 BC)

Yuya's mummy was enclosed within four containers. Inside the external sarcophagus were three nested anthropoid coffins of decreasing size. When ancient treasure hunters succeeded in penetrating the tomb, they opened the four cases in order to rob the mummy.

Of the three anthropoid coffins, the innermost is without doubt the one finished with the greatest care and attention to detail. The dead man's face is framed by a heavy three-part wig that leaves the ears exposed. The eyebrows and the outlines of the eyes are inlaid with blue glass paste, the whites of the eyes are in alabaster and the pupils are black glass paste. A trace of red pigment in the inside corners of the eyes lends a degree of naturalness to the gaze.

The nose is slim and straight and the mouth small. A broad-collar adorns his chest. This large jewel features rows of drop beads in the form of floral motifs and is fixed with falcon-headed clasps at each end. Below the necklace a vulture created from inlays of coloured glass paste and carnelian spreads its wings across his chest. In its talons it is holding the *shen* hieroglyph, the circle of cord symbolizing all that the sun surrounds and illuminates and therefore infinity and eternity. Below the vulture is an embossed image of the goddess of the sky, Nut. The goddess has her arms upraised and is standing on the hieroglyph symbolizing gold; she is wearing a tight robe decorated with a net motif.

On either side of the figure of Nut run columns of inlaid hieroglyphs in coloured glass paste. The column on the left contains a request for offerings for the deceased, while on the right is an invocation to the goddess Nut, pronounced by Yuya, defined as the 'father of the god [a priestly title] and favourite of the perfect god [the king]'. A hieroglyphic inscription runs along the lower external edge of the cover. Below the feet there is an image of the goddess Isis kneeling on the hieroglyph for gold and apparently rolling before her the *shen* symbol.

The interior of the lid is covered with a sheet of silver on which a second image of the goddess Nut is incised, again represented standing over the hieroglyph for gold.

The lower casket of the coffin is decorated externally with images of the tutelary deities of the deceased (Thoth, Anubis and the Four Sons of Horus), separated by columns of hieroglyphic texts that define the identity and the function of each. On the left hand side, in a position corresponding with the shoulders, a pair of eyes is depicted (through which the deceased could see) above a shrine.

The interior of the lower casket is also covered with a sheet of silver on which a third figure of the goddess Nut is inscribed. The exposed parts of her body and the band holding her wig are in gold. Above the head of the goddess is inscribed a variation of Chapter 166 of the Book of the Dead, the function of which was to protect the head of the deceased. The internal sides of the casket feature decoration very similar to the outside, with tutelary deities and related columns of hieroglyphic text. (F.T.)

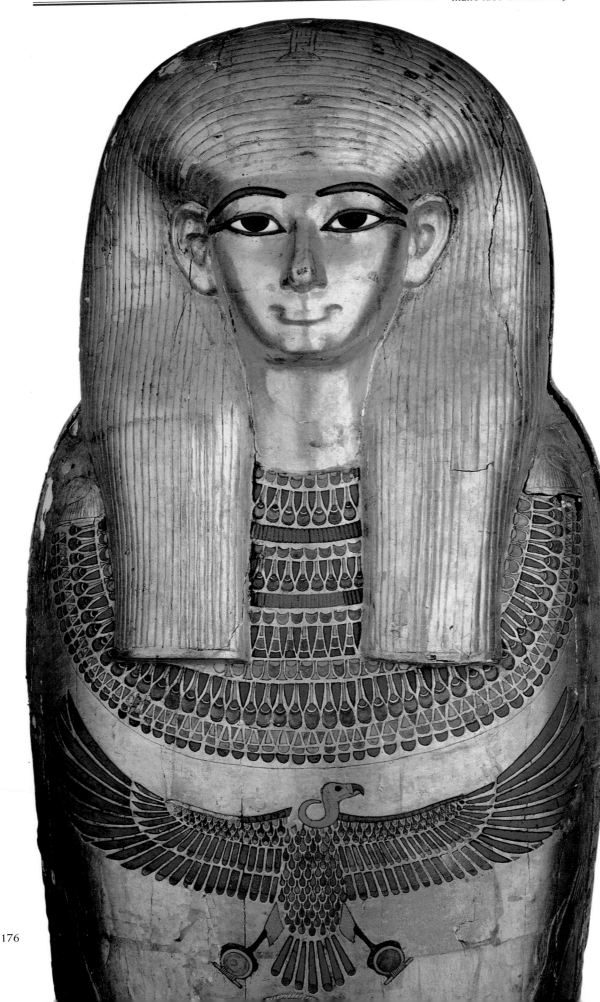

CHAIR OF SITAMUN

STUCCOED WOOD, GOLD LEAF, PLANT FIBRES
HEIGHT 77 CM; HEIGHT OF SEAT 34 CM
VALLEY OF THE KINGS, TOMB OF YUYA AND TUYU (KV 46)
ANTIQUITIES SERVICE EXCAVATIONS ON BEHALF OF THEODORE DAVIS (1905)
EIGHTEENTH DYNASTY, REIGN OF AMENHOTEP III (1391–1353 BC)

This chair, which is large enough to have been used by an adult, has legs joined in pairs (front and rear) by a horizontal bar with tips covered in gold-leaf. The legs are carved to imitate those of a lion, with the musculature and tendons represented in a highly stylized manner. Two female heads are set in front of the arms: the faces, necklaces and crowns are covered in gold leaf, the short wigs, fastened with a band, are left in plain wood.

The seat is made of woven plant fibres. The backrest is reinforced at the rear with three vertical wooden bars. The structure of the chair is held together with mortise and tenon joints. At the rear the join between the legs and the seat is further reinforced by a pair of bronze nails.

Decorating the inside of the chair is a single repeated scene, progressing from the centre outwards, in gold leaf over stuccoed wood. It extends from the backrest to the inside of the arms, giving a figurative unity to the composition as a whole. On the backrest itself the scene is surmounted by a winged solar disc, defined in two hieroglyphic inscriptions as 'He who is in Edfu', a clear reference to the god Horus who was worshipped there. Below, within a pavilion from the ceiling of which hang lotus

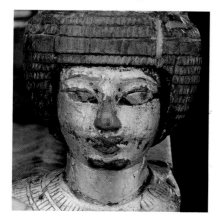

flowers alternately open and in bud, the scene is divided into two parts, which are almost mirror images, except for a few variations. Seated on a chair is a female figure identified in the hieroglyphic inscriptions as 'the daughter of the king, the great, his beloved Sitamun'. The princess has a short wig from which a long and

elaborate braid descends; it is held in place by a band terminating on the forehead with a gazelle's head. Above her head is the hieroglyph of the papyrus plant, the symbol of fecundity and rebirth. With the exception of a long transparent skirt with a wavy decoration, the princess is naked. In one hand she holds a sistrum and in the other a *menat* necklace, shaken by women as musical instruments during the processions in which the image of the goddess Hathor was carried from the temple. The sound produced was so loud and harsh that it was thought to drive away evil spirits.

The princess's jewelry consists of earrings, a broad necklace and bracelets around her wrists. Standing in front of her is a young girl holding out a tray on which is a necklace. The young girl's costume is composed of a short wig held in

place by a band, earrings, a broad necklace, bracelets and a skirt that reaches her ankles. On her head is a rectangular object which might be a perfume block – similar objects are shown on the heads of dancers in walls paintings in contemporary tombs, though these are usually conical. The hieroglyphic inscription above the girl describes her as 'bringing the gold of the foreign countries of the south'.

The scene continues on the inside surface of the arms of the chair, where four girls, dressed in a similar fashion to the first, carry trays of gold rings. Like Sitamun, they have the papyrus plant hieroglyph on their heads.

The external decoration of the arms of the chair features two scenes, also created in gold leaf applied to the stuccoed wood and set in a frame that resembles the rolled mat motif. On the right-hand

arm is an image of the god Bes playing a drum, the goddess Taweret and a second image of Bes dancing with knives, while on the left-hand arm are three images of Bes – two are playing drums and the third is dancing with knives.

Sitamun would have been the first-born daughter of Amenhotep III and Tiye and, consequently, the granddaughter of Tuyu and Yuya. It is possible that the chair was placed in the tomb of her grandparents by Sitamun herself as one of the many offerings that were made on the occasion of the funeral.

The decoration, in particular the figures of Bes and Taweret, are a clear reference to the Egyptian female universe in which these divinities played a fundamental role, above all in connection with fertility, pregnancy and childbirth. The offering of gold to Sitamun is also to be read in this sense. (F.T.)

Jewel Chest of Tuyu

Wood, gold leaf, faience, ebony, painted ivory;
Height 41 cm; length 38.5 cm; width 26.8 cm;
Valley of the Kings, Tomb of Yuya and Tuyu (KV 46); Antiquities Service
excavations on behalf of Theodore Davis (1905); Eighteenth Dynasty,
Reign of Amenhotep III (1387–1350 bc)

Thieves had managed to enter the tomb of Yuya and Tuyu at least once and the funerary assemblage had certainly been plundered before its discovery by archaeologists in 1905. The magnificent chest that had contained the jewels of Tuyu had been opened and emptied. It was found underneath a bed; the lid lay close by, to the left of the entrance to the funerary chamber, alongside Tuyu's wig and an alabaster vase.

The decoration of the chest is elegant and pleasing. The four legs were inlaid with rectangular tesserae of faience and pink painted ivory, separated by bars of ebony and ivory. The same type of decoration framed the sides of the box and the lid, in both cases dividing the main decorative area into two panels.

The lid is rounded and the two ends consist of faience lunettes. Two plaques of the same material cover the upper surface and are decorated with hieroglyphic inscriptions and relief figures in gilded wood. The names of Amenhotep III can be read within a cartouche and are surmounted by a double plume and solar disc.

Below them is Heh, the god of the Millions of Years, seated on the hieroglyph for gold and holding the palm frond symbolizing the year in his hand. The composition as a whole is therefore designed to be read as auguring a long reign for the king – an extremely long one given the mention of an infinite period of time.

A knob on the top of the lid corresponds with another on one of the short sides of the chest. These would have been tied together with a cord and served to seal the treasure chest.

The upper part of the box is fashioned in imitation of a shrine, with a cavetto cornice running around the entire outside top edge. Below this, on each side, is a faience plaque carrying a number of hieroglyphic inscriptions with the individual symbols made from gilded wood. They contain the names of Amenhotep III and his wife Tiye, who was the daughter of Tuyu. Below the faience plaques is a frieze in pierced and gilded wood in which the group of hieroglyphs *ankh, was* and *neb* are repeated several times. The composition had an apotropaic value and served to confer on the owner of the chest 'all life and power'. At the same time, the group recalled the form of the hieroglyph *heb-sed*, the royal jubilee that also had an auspicious meaning.

The fine craftsmanship of the chest, the absence of any specific mention of Tuyu and the inscriptions relating to Amenhotep III and his wife Tiye suggest that the chest was produced in the royal workshops for the queen herself. Subsequently, perhaps on the occasion of the funeral, Tiye would have presented it to her mother as a final gesture of filial devotion. (F.T.)

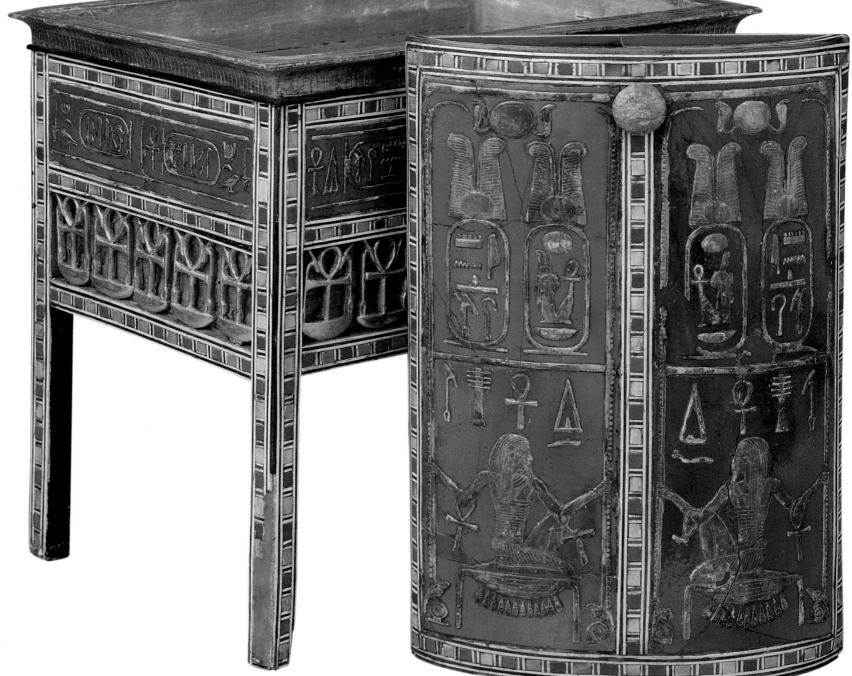

FUNERARY MASK OF TUYU

CARTONNAGE, GOLD LEAF, GLASS PASTE, ALABASTER
HEIGHT 40 CM; VALLEY OF THE KINGS, TOMB OF YUYA
AND TUYU (KV 46); ANTIQUITIES SERVICE EXCAVATIONS ON
BEHALF OF THEODORE DAVIS (1905); EIGHTEENTH
DYNASTY, REIGN OF AMENHOTEP III (1391–1353 BC)

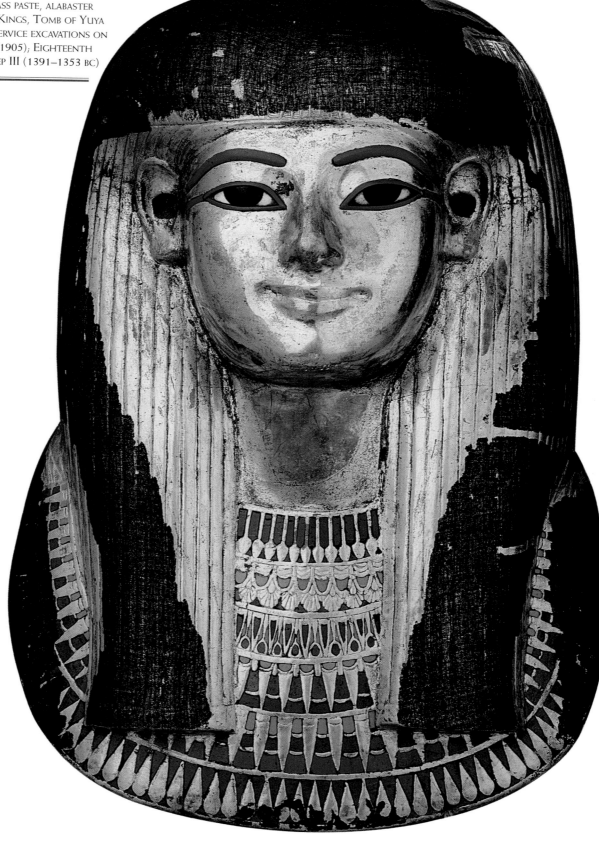

The funerary mask of Tuyu is made of cartonnage, covered with a thin layer of gold foil. When found it was completely covered with the remains of its linen shroud but this was removed in 1982 by the restorer who repaired the mask which had broken into two pieces. A few fragments of the shroud, now blackened with age, still adhere to the wig and part of the pectoral.

The mummy of Tuyu, the wife of Yuya and mother of Tiye, wife of Amenhotep III, was enclosed within a series of containers: two internal

anthropoid coffins and an external sarcophagus.

As explained in Chapter 151b of the Book of the Dead, the funerary mask was the last layer of protection for the face of the mummy. Tuyu is depicted with idealized features; her face is a squarish oval in shape and is framed by a three-part wig that leaves the ears exposed. The headdress is held in place by a diadem that can be seen below the shroud, decorated with floral motifs; a lotus flower is placed above the forehead. The eyes are elongated with the outlines and the eyebrows inlaid in blue glass paste in imitation of lapis lazuli. The whites of the eyes are made from alabaster and the pupils from black glass paste. A dot of red paint in the inside corners lends a degree of naturalness and vivacity to the gaze. The nose is small and straight and the corners of the mouth are set in a slight smile.

Around Tuyu's neck is a broad-collar necklace, its vivid colours realized in glass paste; it is fastened on the shoulders with two lotus flower clasps. The innermost string of beads is composed of the *nefer* hieroglyphic symbols while the one below features a palmette motif.

The others rows have beads in the form of more stylized floral motifs. As was traditionally the case, the outermost string is made up of drop beads.

A remarkable example of the craft production of the latter part of the reign of Amenhotep III, the mask is characterized by a spareness of form that none the less retains a degree of sophistication and elegance. (F.T.)

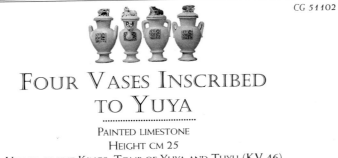

FOUR VASES INSCRIBED TO YUYA

PAINTED LIMESTONE
HEIGHT CM 25
VALLEY OF THE KINGS, TOMB OF YUYA AND TUYU (KV 46)
ANTIQUITIES SERVICE EXCAVATIONS ON BEHALF OF THEODORE DAVIS (1905)
EIGHTEENTH DYNASTY, REIGN OF AMENHOTEP III (1391–1353 BC)

CG 51102

These four vases were discovered in the northeast corner of the burial chamber, at the foot of the great sarcophagus of Yuya. They were all found attached to a single base of painted wood and their interiors are hollow to a depth of only four centimetres. Three have twin loop handles, while the fourth has a false spout in the form of an ibex head.

The lids are carved in the shape of animals. The first on the left reproduces the head of a calf with black markings; the second repeats the ibex motif found on the spout, but this time the animal is portrayed in a reclining pose; the third has a frog; and the fourth again features the head of a calf, this time with red markings.

Each vase has an inscription addressed to Yuya painted on the body in two columns of cursive hieroglyphs. In two cases (on the third and fourth vases), in addition to the usual appellation of 'Osiris' applied to all the deceased, there also appears the epithet 'the perfect god', which was normally only used in connection with the king. This is a fairly unusual formula with few parallels elsewhere and probably should be read as an extension of the appellation of 'Osiris'.

These four vases, like many others in the tomb of Yuya and Tuyu, were imitations of vessels made from more precious materials.

That they were not actually intended to be used is demonstrated by the internal cavities, just four centimetres deep, which were therefore too shallow to be able to contain anything. Their white colouring is undoubtedly a reference to alabaster, while the lids with their animal forms resemble containers found in the funerary treasure of Tutankhamun.

Yuya's four vases should therefore be seen as imitations of vessels that contained unguents and perfumed oils. The fact that they were false did not prevent them from being considered as effective equivalents of the models that inspired them. Their presence was sufficient to ensure that the contents of the vessels reproduced were symbolically part of the funerary equipment. (F.T.)

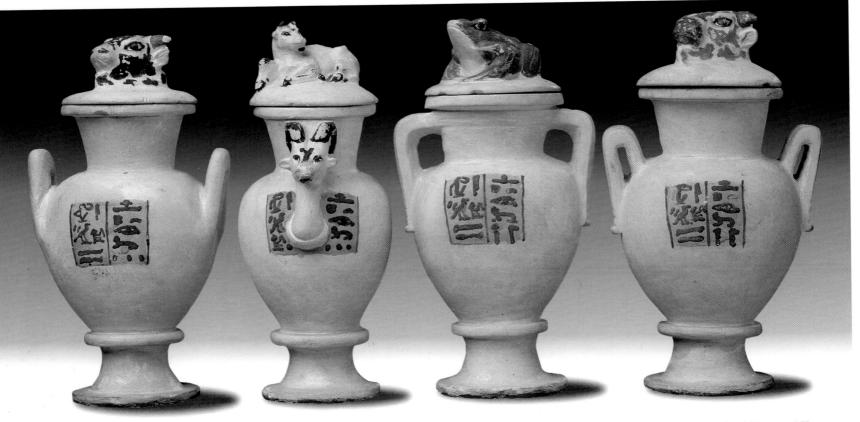

JE 38257

HEAD OF A STATUETTE OF TIYE

GREEN STEATITE
HEIGHT 7.2 CM
SERABIT EL-KHADIM (SINAI), TEMPLE OF HATHOR
W.M.F. PETRIE'S EXCAVATIONS (1905)
EIGHTEENTH DYNASTY, REIGN OF AMENHOTEP III (1391–1353 BC)

The temple at Serabit el-Khadim was dedicated to Hathor, the goddess of turquoise. From the Old Kingdom onwards the Egyptians had ventured into the Sinai in search of this precious mineral which was used extensively for jewelry.

This small head portraying Tiye, the wife of Amenhotep III and mother of Akhenaten, was found in the ruins of Hathor's temple at this site, far from the Nile Valley. It would have been part of a statuette dedicated to the goddess, who, among her many roles was the protective deity of women.

The queen wears a wig of tight curls that leaves her ears uncovered. On her forehead is the double *uraeus* (each of the two cobras wears the double crown). A circular crown rests on the wig and originally would have carried the characteristic twin-plumed headdress. It is inscribed with the cartouche containing the name of Tiye between two winged cobras whose coils extend to the sides of the diadem.

The queen's features follow the stylistic canons of the reign of Amenhotep III, above all in the almond-shaped eyes, the arching eyebrows and the thin nose. The down-turned mouth with fleshy lips is instead a typical feature of the portraiture of Tiye, making her image unique and unmistakable. This particular feature lends the figure as a whole a sense of gravity that is frequently interpreted, with little supporting evidence, as a reference to the hard, decisive character of Tiye. Tiye's strong facial features have also led to suggestions of foreign origins, although again there is no other evidence for this.

The tomb of Yuya and Tuyu, Tiye's parents, was discovered in the Valley of the Kings and still contained their mummies. The couple were originally from Akhmim, a town in central Egypt, and were members of the wealthy provincial middle class. The attention and privileges accorded to Tiye by Amenhotep III throughout his reign (Tiye survived her husband) should perhaps be seen in the light of the king's need to justify his decision to share his throne with a woman who was not of noble birth.

What is certain, however, is that in some of the portraits of Tiye, and this head from Serabit el-Khadim is one of the most important examples, particular features — such as the elongated oval of the face — can be identified that anticipate the style of portraiture of the high Amarna Period. (F.T.)

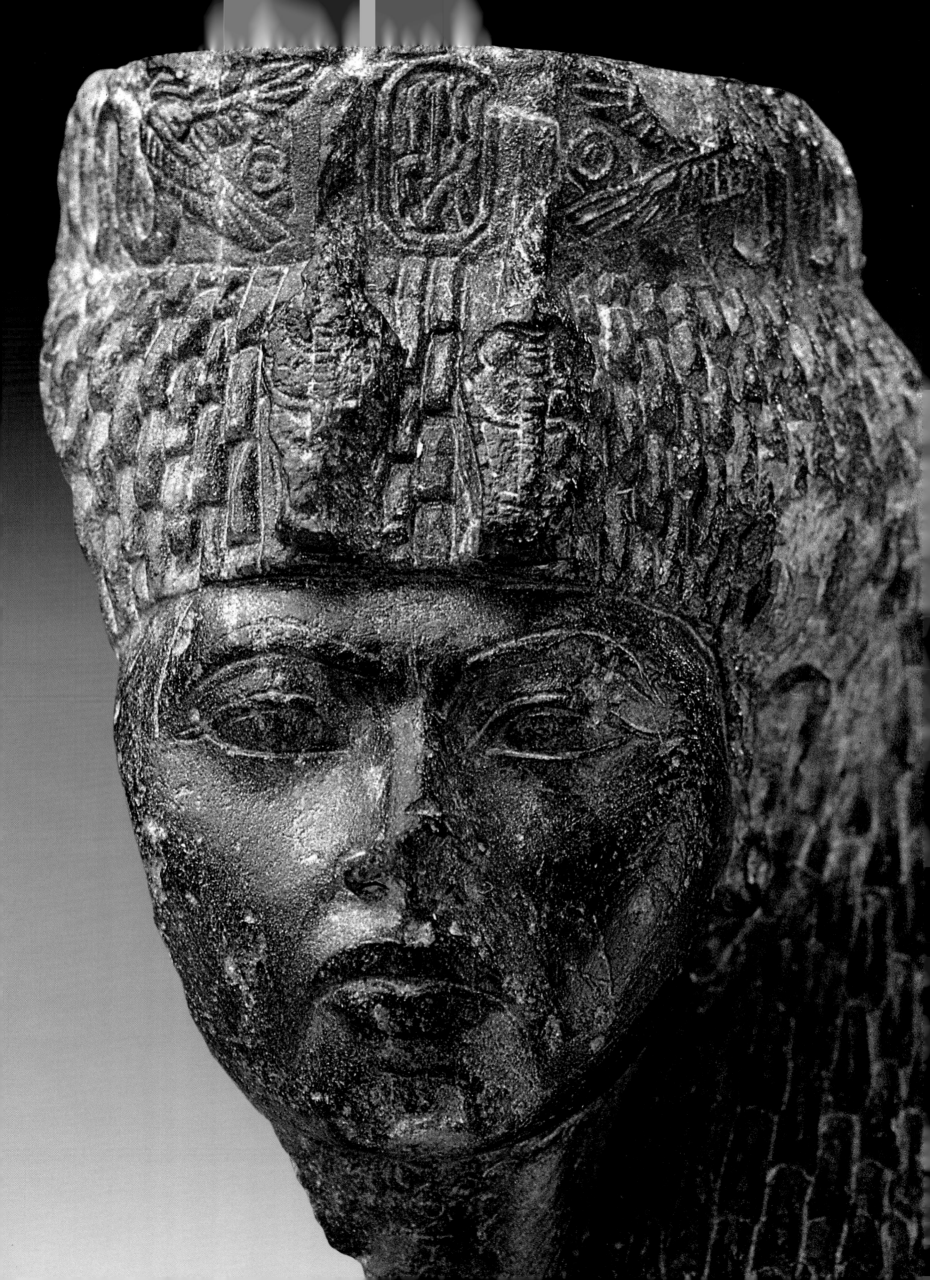

STATUE OF AMENHOTEP, SON OF HAPU, SEATED

GREY GRANITE
HEIGHT 117 CM
KARNAK, TEMPLE OF AMUN-RE, SEVENTH PYLON
G. LEGRAIN'S EXCAVATIONS (1901)
EIGHTEENTH DYNASTY, REIGN OF AMENHOTEP III (1391–1353 BC)

STATUE OF AMENHOTEP, SON OF HAPU, AS A SCRIBE

GREY GRANITE; HEIGHT 128 CM
KARNAK, TEMPLE OF AMUN-RE, TENTH PYLON
G. LEGRAIN'S EXCAVATIONS (1913)
EIGHTEENTH DYNASTY, REIGN OF AMENHOTEP III (1387–1350 BC)

Like many other wise men of ancient Egypt, Amenhotep son of Hapu was the object of posthumous glorification and veneration. Legendary healing powers were attributed to him and he was deified during the Ptolemaic period when a chapel was dedicated to him at the rear of the third terrace of the temple of Hatshepsut at Deir el-Bahri.

During his lifetime Amenhotep was one of the leading officials at the court of Amenhotep III. He was responsible for the sculpting of various statues of the king, on whose he behalf he also supervised the construction of several buildings in the Theban region. Among these were the palace-citadel of Malqata and the funerary temple the king ordered to be built on the Theban West Bank.

The great reputation that Amenhotep son of Hapu earned and the honours he received during his lifetime are reflected in the privilege he was granted by the king in being allowed to build his own funerary temple on the Theban west bank. This was a prerogative usually reserved for the pharaohs alone. In fact his was the only private monument that was allowed to be built among the royal temples.

Another privilege granted to Amenhotep was that he was permitted to place statues of himself within the greatest Theban sanctuary, the temple dedicated to Amun-Re at Karnak. Inscriptions state that the statues were intended to serve as intermediaries between the god and the faithful visiting the temple. For this reason, they were placed close to the temple's entrances.

There are two different types of statue of Amenhotep, both inspired by Middle Kingdom models. This deliberate reference to the past, specifically the age that the Egyptians of the New Kingdom themselves regarded as a classical period, is a clear sign of the prestige and culture of the figure portrayed. The fact that Amenhotep chose to be depicted in the classic pose of the scribe in two of his statues, one of which is seen here, is further evidence of his desire to emphasize his wisdom and knowledge.

The iconography is that of the scribe engaged in his profession. Amenhotep is depicted seated with his legs crossed and his head tilted slightly forwards to look at the open papyrus scroll in his lap. The rolls of fat around his abdomen are symbols of his privileged lifestyle. The hieroglyphs incised on the scroll are almost completely illegible, worn away by the hands of the faithful who for centuries touched the statue in the hope of obtaining favours.

Although these sculptures have all the characteristics of the artistic style typical of the reign of Amenhotep III, they are clearly also inspired by the statues of Mentuhotep, vizier and architect of Senusret I, of whom at least ten statues exist (three in the pose of a scribe) in the temple of Amun-Re.

In the other statue illustrated here Amenhotep is portrayed in a kneeling pose with his hands resting on his thighs. His kilt knotted below his breast and his wig with its ends cut on a diagonal echo models typical of the Middle Kingdom. The particular expression of the facial features also reflects artistic trends of the reigns of Senusret I and Amenemhet III: the eyes framed by heavy eyelids and the wrinkles furrowing the face present an image of a tired man, pervaded by an ineffable unease. What the artist was concerned with portraying was an Egyptian high official preoccupied with the cares of his position.

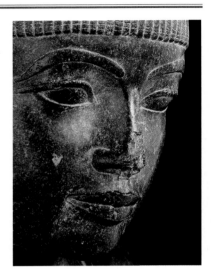

Although the artistic inspiration for this statue is clearly to be found in Middle Kingdom models, it also has other stylistic elements that allow it to be firmly placed within the artistic production of the reign of Amenhotep III, although in a less immediately recognizable manner compared with other examples. It is above all the geometric treatment of certain facial details, such as the eyebrows and the outline of the mouth, that reveals that predilection for perfection of form that is one of the most notable features of the art of this period.

The variation between the statues of Amenhotep has been explained by interpreting the statues as portraits carved at different points in the life of the dignitary both in his youth and maturity. On the other hand, the references to Middle Kingdom models can be seen as learned allusions to an art that, by the era of Amenhotep III, had already taken on the aura of classicism.

By having himself portrayed in this fashion, Amenhotep son of Hapu would have demonstrated his profound knowledge of the past, anticipating by almost seven hundred years that taste for an archaizing style that was to characterize the Twenty-fifth and Twenty-sixth Dynasties and that was to be seen at its height in the statues of Montuemhat. (F.T.)

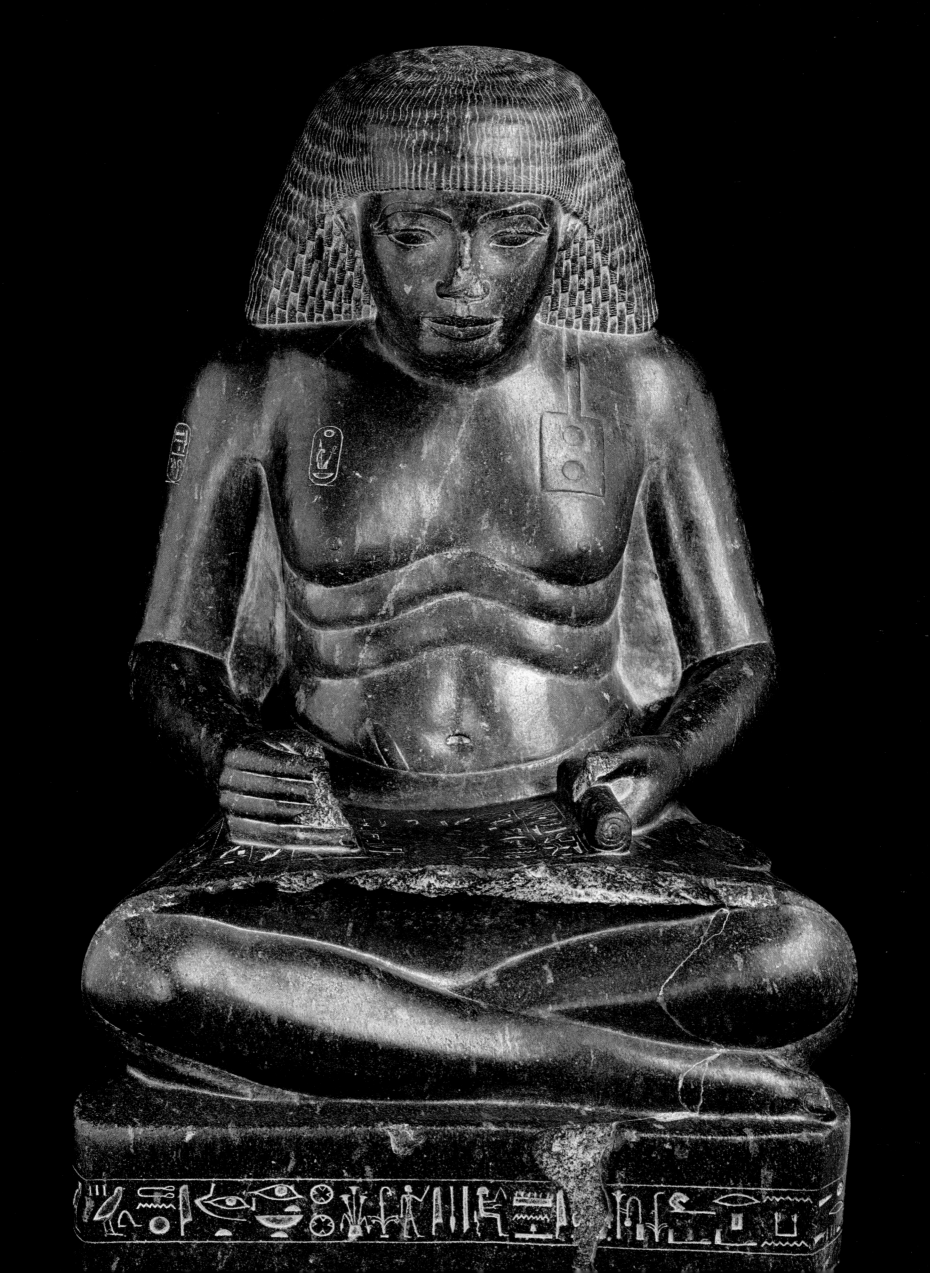

STATUES OF KHAEMWASET AND MANANA

..

STEATITE AND LIMESTONE (BASE)
HEIGHT 27.3 CM
ZAGAZIG (1946)
EIGHTEENTH DYNASTY, REIGN OF AMENHOTEP III (1391–1353 BC)

Although from an archaeological point of the view the Delta region is relatively poorly explored, it has yielded a number of sporadic and chance finds of considerable historical and artistic value. One example is this this statue pair portraying the married couple Khaemwaset and Manana. It was found during the excavations for the foundations of a hospital in the city of Zagazig.

Khaemwaset and Manana are represented in a walking pose. The man's name reveals a Theban origin (Khaemwaset derives from the royal nomenclature and means 'He who appears in glory at Thebes'). His face has been entirely lost, and only the back of the double wig, typical of the period, remains. He is wearing a short-sleeved tunic tied at the neck. On the smooth surfaces of the garment are incised the names of Amenhotep III. A pleated sash with a tasselled edge in front is tied around his waist and hold up the long kilt with broad pleats.

Khaemwaset hold his arms down by his sides. His left hand grips a cylinder (variously interpreted as an artistic convention for the representation of the empty space inside the closed fist or a sceptre), while his right hand is open and, unusually for Egyptian statuary, set at a right-angle to the body rather than being held flat against the thigh.

Manana stands to the left of her husband. She has an oval face with large almond-shaped eyes. Her nose is thin, and her mouth is small with full lips. She wears a broad, heavy wig adorned with a garland of lotus flowers alternately open and in bud. The braids of the wig are held by two bands. She is wearing a tight robe that reaches to her feet. Her breasts are emphasized by rosette decoration. One arm is bare while the left is covered by a finely pleated sleeve. Her jewelry consists a broad necklace and three bracelets. In her left hand she holds a *menat* necklace, an ornament that Egyptian women wore during processions in honour of the goddess Hathor. The necklaces were shaken and the harsh sound produced by the rows of beads striking the heavy metal counterweight (usually in bronze) was thought to drive away evil. (F.T.)

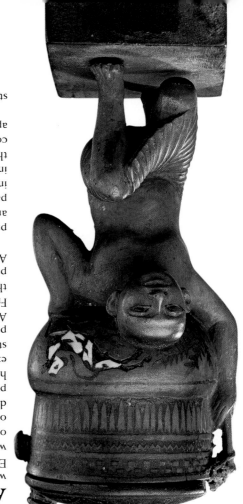

STATUETTE OF HENUTNAKHTU

WOOD PREPARED FOR GILDING
HEIGHT 22.5 CM, SAQQARA
A. MARIETTE'S EXCAVATIONS (1859)
LATE EIGHTEENTH DYNASTY (LATE 14TH CENTURY BC)

JE 6056 = CG 804

A large number of extraordinarily graceful statues of men of women are known from the Eighteenth Dynasty. This small wooden figurine of Henutnakhtu is one example – arguably the finest – of such statues that were produced during possibly the most fertile period in the whole of Egyptian art history. The face recalls the expressionistic and dramatic strength of certain portraits produced between the reigns of Amenhotep III and Akhenaten. From some points of view, indeed, the work could be dated to a phase prior to the artistic revolution of the Amarna period.

The face is slightly large in proportion to the rest of the figure and is surmounted by a heavy three-part wig that accentuates the impression of disproportion. This impression fades, however, once the grace and lightness of the composition as a whole is appreciated.

Henutnakhtu is portrayed in a striding pose, but in contrast with other sculptures of this type, her right foot is set back slightly and at an angle. This pose confers a measured and well-balanced grace to the stride. The slight movement is further emphasized by the pleats of the robe sheathing her hips, which closely follow the line of the right leg.

Henutnakhtu's robe has just one sleeve. The left arm, held at her side, is bare. The right hand, bent below her breast, is holding a floral bouquet and at the same time lifts a flap of the robe which is decorated with a fringe. Henutnakhtu was also holding a second object, of which only a fragment remains in the hollow of her left hand. A perfume cone would have been placed on the top of the wig but this is also now missing.

A broad necklace further embellishes the graceful figure of the woman whose name can be read on the base in an inscription which asks for offerings for the ka of the deceased. The statuette would have served as part of Henutnakhtu's funerary assemblage. (F.T.)

UNGUENT CONTAINER OF SIAMUN

IVORY AND PAINTED WOOD
HEIGHT 14 CM
SHEIKH ABD EL-QURNA, TOMB OF HATIAY
C. DARESSY'S EXCAVATIONS (1896), EIGHTEENTH DYNASTY
EARLY IN THE REIGN OF AMENHOTEP IV–AKHENATEN (1353–1335 BC)

JE 31382

The small tomb of Hatiay, a scribe and superintendent of the grain store of the temple of Aten, consisted of a single underground chamber lacking any decoration in which four coffins and a number of other objects were found. It was the burial place of members of a single family, including three women. Hatiay was the head of the family. The mistress of the house, Siamun, was the owner of this unusual unguent container found in her coffin together with other personal toilet objects.

Fixed to a simple rectangular base, the actual container is supported on the shoulders of a servant, who is bent under the weight of his burden. The man, with his shaved head thrust forwards, has a broad face with long almond-shaped eyes incised above a snub nose. His arms are held in different positions with great realism: the left is bent to support the base of the vase, while the right is extended so that the hand can grip the handle of the receptacle. The servant is wearing the typical kilt with fan-like pleats opening at the front to reveal the knee of the left leg, bent at a right angle with the foot flat on the ground. The other leg rests with the knee on the ground and the foot raised on the tips of the toes, accurately reproducing the pose of a body supporting the vase's weight.

The vase itself is a replica in miniature of one of the Syrian amphorae that were imported to Egypt at that period. The tall, wide neck is set on a slightly swelling body. A long handle is attached from the mouth to the body of the vessel. The lid is a convex disc decorated externally with the image of a calf inlaid in ivory, and is attached to the handle by a cord sealed with clay. The vase was securely sealed by a second cord wrapped around two black buttons, one on the lid and the other attached to the neck of the container.

The exterior of this small unguent container is richly decorated in black on a red background. Around the neck of the container the decoration consists of a continuous band of geometric and stylized flower motifs. On the body a broad frieze is dominated by the images of three calves in ivory. They are depicted playing among trees in a scene of sophisticated naturalism. The artist has succeeded in combining great realism and elegance in the creation of this small object, serving as an example of the high quality of the minor arts produced in the New Kingdom. (S.E.)

UPPER PART OF A COLOSSAL STATUE OF AMENHOTEP IV

SANDSTONE

HEIGHT 185 CM

KARNAK, SHRINE DEDICATED TO ATEN (GEMPAATEN)

H. CHEVRIER'S EXCAVATIONS (1926), EIGHTEENTH DYNASTY, BEGINNING OF THE REIGN OF AMENHOTEP IV–AKHENATEN (1353–1335 BC)

Prior to founding his new capital at Tell el-Amarna, Amenhotep IV (who changed his name to Akhenaten between the fifth and sixth year of his reign) inaugurated a vast building programme at Thebes, close to the temple of Karnak. The young king's intention was to provide an alternative to the cult of Amun by the construction of four sacred buildings dedicated to Aten in the proximity of the stronghold of the Theban clergy (who openly opposed the religious reforms).

To the east of the temple of Karnak rose the *Gempaaten* (which translates as 'The solar disc has been found'). This was the first shrine constructed by Amenhotep IV and consisted of a large porticoed courtyard covering an area roughly 130 by 200 metres, oriented on an east–west axis. Placed against each of the pillars in the courtyard was a colossal statue of Amenhotep IV, over five metres high and painted in bright colours. The king is represented upright and dressed in a short, pleated skirt that completely sheathes his thighs. His arms are folded and his hands hold the insignia of pharaonic power, the *heqa* sceptre and the flail.

Around his wrists and on his arms, as if they were incised on bracelets, are cartouches with the complicated name given to the deified solar disc, 'Re-Horakhty who rejoices in his horizon in his name that is "Shu [or "The Light] that resides in the solar disc."'

STATUETTE OF AKHENATEN WITH A FEMALE FIGURE

LIMESTONE, HEIGHT 39.5 CM

TELL EL-AMARNA, SCULPTOR'S WORKSHOP

L. BORCHARDT'S EXCAVATIONS (1912)

EIGHTEENTH DYNASTY, REIGN OF AKHENATEN (1353–1335 BC)

Numerous unfinished statues, sketches and roughly carved reliefs have been found in Egypt that provide both detailed documentation of the activities of painters and sculptors and also useful information about the way they tackled the production of a work of art. Such documentation has been found dating from various periods in pharaonic history and from various sites in the Nile Valley. Tell el-Amarna, the capital founded by Akhenaten, has proved particularly rich in such finds, including the superlative painted limestone head of Nefertiti, today in the Museum in Berlin. Among the most unusual of these unfinished works is this statuette portraying Akhenaten (identifiable because he is wearing the Blue Crown with a *uraeus*) holding a young female figure on his knees. The surface of the small sculpture is only roughly finished and makes precise interpretation of the work difficult.

The king is seated on a throne with rear legs in the form of animals' legs. On the seat there is a cushion. As well as the large Blue Crown Akhenaten is wearing a robe with short, tapering sleeves. The female figure is sitting across the knees of the sovereign and seems to be naked, with the exception of a short wig. It is not clear whether the cube-shaped block below her feet would have been removed by the artist as he completed the work.

The scene portrayed is particularly unusual and strays from the classic repertory of Egyptian art. The two figures are, in fact, represented in the act of kissing, a degree of intimacy that has few parallels in the art of the Nile Valley. There are a number of erotic aspects to the work, including the fact that the female figure grips the right elbow of Akhenaten in her left hand. This gesture was considered to be very sensual in ancient Egypt and also appears in the decoration of the upper chambers of the monumental gateway of Medinet Habu where Rameses III is intimately portrayed with his bride. The fact that the female figure is wearing a wig in spite of her nudity is further support for the erotic interpretation of this unfinished statuette from Amarna. Precise parallels for this can be found in certain Egyptian erotic poems in which the beloved, before revealing herself to her lover, puts on a wig. The same literary motif is also found in the seduction scene of the *Tale of the Two Brothers* and is also true of the satirical-erotic papyrus conserved in Turin in which the female figure always wears a wig and a few jewels.

The female figure here should perhaps therefore be identified as a wife (possibly Kiya who was frequently portrayed in a short wig), rather than one of the daughters of Akhenaten. This second interpretation, the most commonly accepted, is based above all on the diminutive proportions of the female figure. The disproportion between the size of Akhenaten and that of his queen is, however, a constant feature of official representations, as seen in the reliefs and stelae which portray the entire royal family. (FT.)

Akhenaten's slender and extremely elongated face has features that clearly reflect the climate of innovation in which the sculpture was created. The eyes are reduced to two narrow slits and are overshadowed by heavy relief eyebrows. The nose is straight and very long and is set with geometric precision above a mouth with full lips; two deep lines are incised from the nostrils to the outer edges of the mouth.

The chin is disproportionately long and is extended by a false beard that is itself even more elongated. The pharaoh's ears are also represented in this exaggerated style and are extremely long and have pierced lobes.

The colossi decorating the pillars of the *Gempaaten* were provided alternately with two different headdresses. Both featured the *nemes*, the classic headcloth worn by the pharaohs, with a cobra on the forehead. Above this were either the double crown or the two plumes characteristic of the iconography of the god Shu ('The Air'), but also the incarnation of the light of the solar disc in the Amarna interpretation. The remains of the latter type of headdress survive on the head of this particular statue. (F.T.)

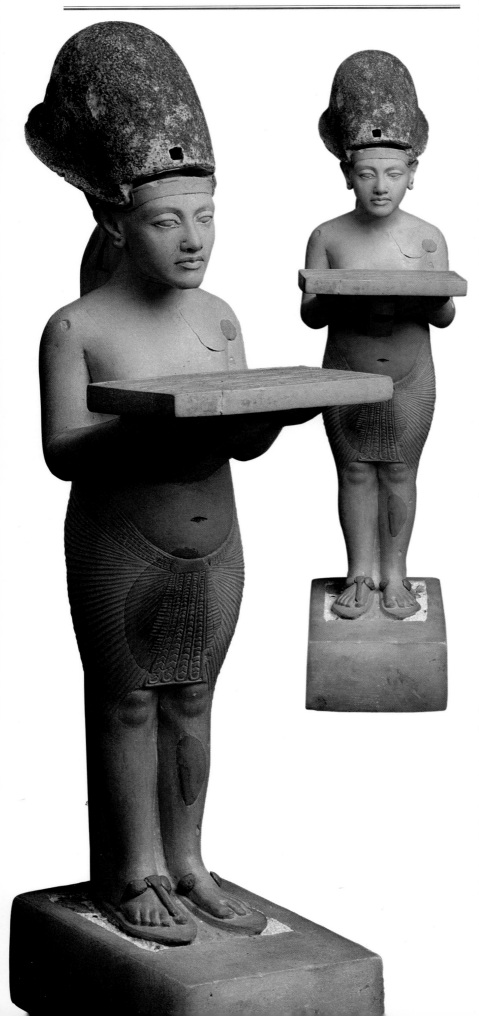

STATUETTE OF AKHENATEN MAKING AN OFFERING

...

PAINTED LIMESTONE; HEIGHT 35 CM
TELL EL-AMARNA; L. BORCHARDT'S EXCAVATIONS (1911)
EIGHTEENTH DYNASTY, REIGN OF AKHENATEN (1353–1335 BC)

This exquisite sculpture comes from the luxurious home of one of the nobles who adopted the religious reforms of Akhenaten and decided to follow the pharaoh to the city of Akhetaten, the capital founded in Middle Egypt.

The small statue would originally have been located on the altar that was usually found in gardens and where the daily rituals in honour of Aten were performed. The Aten was the deified solar disc at the centre of the religious upheaval in Egypt during this period. The presence of an effigy of the king guaranteed the validity of the ceremony, given that only Akhenaten had the prerogative of making offerings to the god.

Akhenaten is shown in the act of making an offering. His hands are holding a slab on which a number of foods and lotus flowers are depicted. Although this type of statuary is known from as early as the Middle Kingdom, the pose in which Akhenaten is portrayed is very unusual. The fact that his legs are together contrasts with the most elementary rules of Egyptian sculpture, which always features male figures in striding poses (with the left leg advanced). And in the art of the Amarna Period, in which movement and light played essential roles in figurative depictions, the immobility of the composition is all the more surprising and suggests that it was the result of a deliberate decision.

By portraying the king in this way the statue highlights the significance of the act. The very immobility of the piece in fact refers to the meditation of the pharaoh before the god. The presence of the deity is reflected in the stone, the yellow colour of which is a reference to the light shed by the solar disc. The statue can therefore be read as a portrayal of the sovereign at the moment in which the Aten in all his splendour makes himself manifest.

The solemnity of the moment is further enhanced by the serious expression on the king's face, free of the nervous impressionism that characterizes his other portraits.

On his head he wears the Blue Crown (carved separately), which by Amenhotep III's reign had evolved from a headdress used mainly in military images to become part of the classic iconography associated with the monarch. The choice of this crown was dictated above all by the artists' preference for its ovoid form which allowed them to exaggerate the curvature of the cranium. A hole at the front would once have held a *uraeus* made from a different material.

Akhenaten's body is also reproduced with the fullness of form typical of the portraits of this ruler, although perhaps not quite to the same degree as in other sculptural or relief portraits. The solemnity of the moment is also underlined by the fact that the pharaoh is wearing sandals on his feet: the Egyptians only wore this kind of footwear on special occasions or for religious ceremonies. (F.T.)

PANEL WITH A SCENE OF THE ADORATION OF ATEN

...

PAINTED LIMESTONE
HEIGHT 53 CM; WIDTH 48 CM; DEPTH 8 CM
TELL EL-AMARNA, THE ROYAL TOMB
ANTIQUITIES SERVICE EXCAVATIONS (1891)
EIGHTEENTH DYNASTY, REIGN OF AKHENATEN (1353–1335 BC)

This panel was found in the rubble blocking the royal tomb of Akhenaten. It is difficult to say what role it played within the funerary monument. Traces of the squaring used by the artist to compose the scene remain on the surface between the figures, and this has led to an interpretation of the work as a model to be used in the execution of the decoration of the tomb.

This scene recurs with some frequency in the Amarna Period and shows the royal family worshipping Aten. The solar disc is placed in the top right corner of the composition and sheds its light on the rest of the scene. All the rays terminate in small hands, some of which are holding *was* (power) and *ankh* (life) hieroglyphs; the hands that come into direct contact with Akhenaten or the offering table placed in front of him below the image of Aten are empty.

This alternation of empty and full is not casual and corresponds to

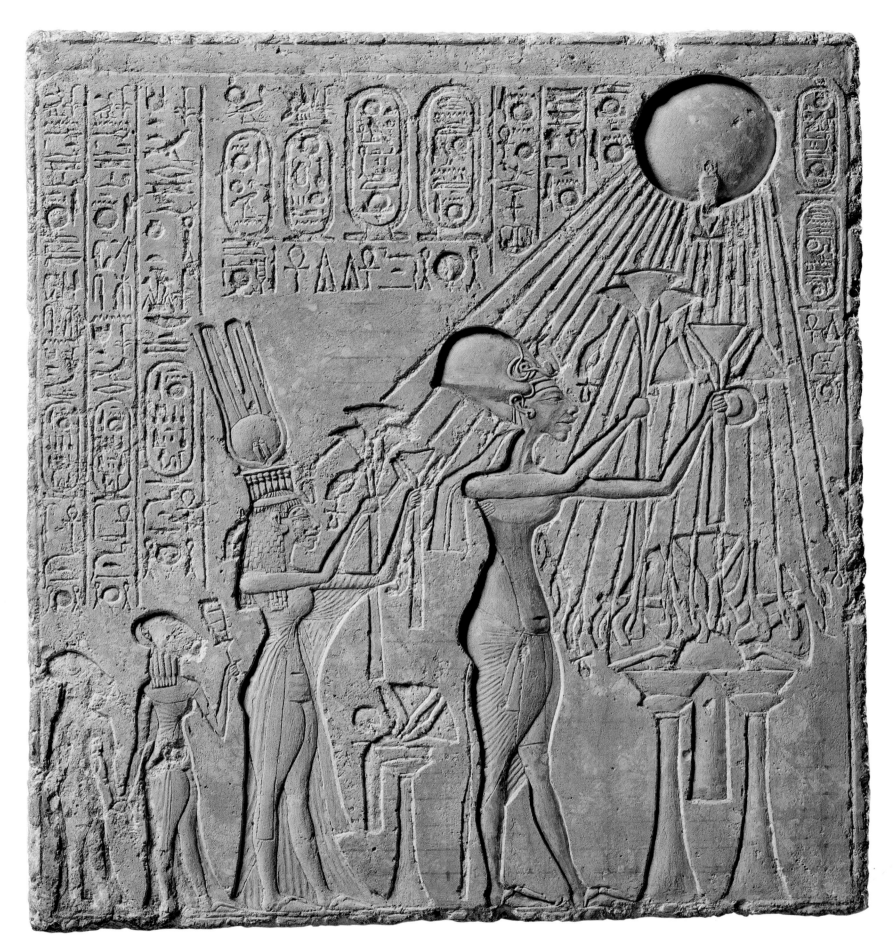

the method of transcribing in hieroglyphs the actions of giving (full hand) and receiving (empty hand).

In this way, the reciprocal relationship between the king and Aten is depicted in pictorial form. The scene thus provides us with an iconographical representation of the classic form of the Egyptian prayer in which the king receives 'life, prosperity and power' from the god, in exchange for charitable acts (in this case the offerings).

The rays of Aten, moreover, serve to set all the elements on three different planes. They pass behind the members of the royal family and in front of the offering table, attributing a different value to each. Akhenaten, Nefertiti and their two daughters Meritaten and Meketaten (the relative importance of whom is indicated by decreasing dimensions) are placed in the foreground, while Aten is set behind them but in front of the offering table in the background.

The contents of the table are almost completed obscured by the rays of the solar disc.

The bodies and facial features of the royal family are depicted in accordance with the distinctive canons of the artistic style of the early part of the reign of Akhenaten. Much has been written about this in an attempt to explain the apparent excessive femininity of the body and features of Akhenaten, and it has frequently been suggested that he was afflicted by some

medical condition or illness. However, it is very probable that the clear deformation of the figures, which is also seen in their attributes such as the crowns, can be ascribed to purely stylistic factors that characterized the beginning of Akhenaten's reign. At this time, the radical religious reformation led to a reassessment of the entire cultural inheritance of the period in an attempt to create a new paradigm that represented a clear break with the past. (F.T.)

JE 59294

SCULPTOR'S TRIAL WITH TWO ROYAL PORTRAITS

.....................................

Limestone; Height 23 cm; Width 31 cm
Tell el-Amarna; J.D.S. Pendlebury's excavations (1932–1933)
Eighteenth Dynasty, Reign of Akhenaten (1353–1335 bc)

Like many of the remains found at Tell el-Amarna, this limestone slab is the subject of much discussion concerning above all the identities of the two faces incised in the stone. They have been identified as two portraits of Akhenaten, or one of Akhenaten next to one of his successor Smenkhkare.

Following an artistic practice maintained in Egypt right up to the Ptolemaic Period, the slab was used by a sculptor to work out his composition on. It should therefore be seen not as a finished piece, but rather as an experiment designed to resolve a specific problem.

Only the upper part of one side of the slab has been incised. The right-hand profile, which was probably executed first given that writing ran from right to left, is of a male figure wearing a headcloth with a cobra on the forehead. The artist has failed to take into account

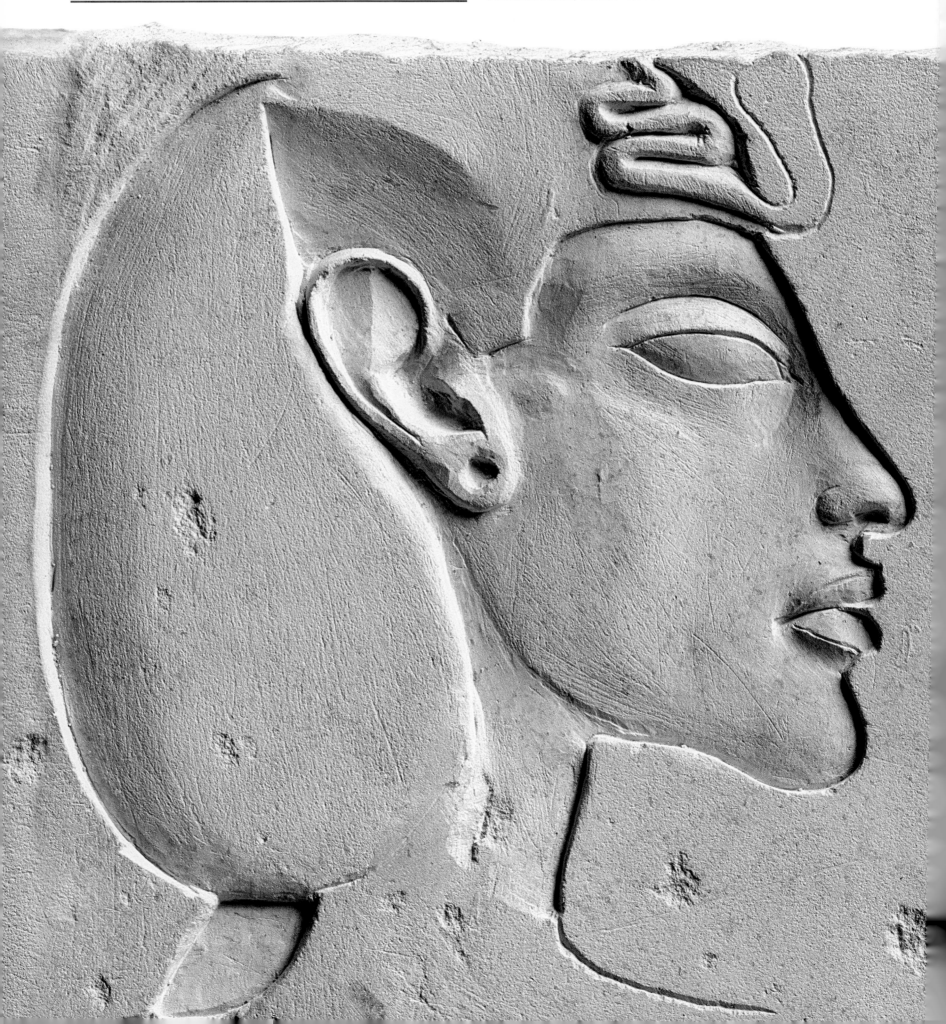

the proximity of upper edge of the slab and the cobra's head is missing. The face has deeply carved features: the eyes are almond-shaped, narrow and enclosed by heavy lids. The nose is long, the mouth fleshy and down-turned, and the chin is prominent. The ears have pierced lobes and the neck is long and slim.

The same facial features recur in the left-hand profile. The nose and chin are long and produce a vertical development of the face that is especially evident in the headcloth, the back of which is flattened as it was too close to the slab's edge.

The great similarity between the two faces leaves no doubt that they are portraits of a single figure, almost certainly to be identified as Akhenaten. The fact that the king is represented twice on the same slab may be explained as the artist's attempt to master a form of portraiture with which he was not familiar. The problem the artist was working on in this sculptural trial may well be that of moving from a portrait of the king that was very realistic (the right-hand face) to one closer to the canons of an art based on the exaggeration of the lines of the human figure. This limestone slab would therefore have been carved in the early part of the reign of Akhenaten, when the stylistic canons deriving from the king's religious and cultural reformation were still being defined. (F.T.)

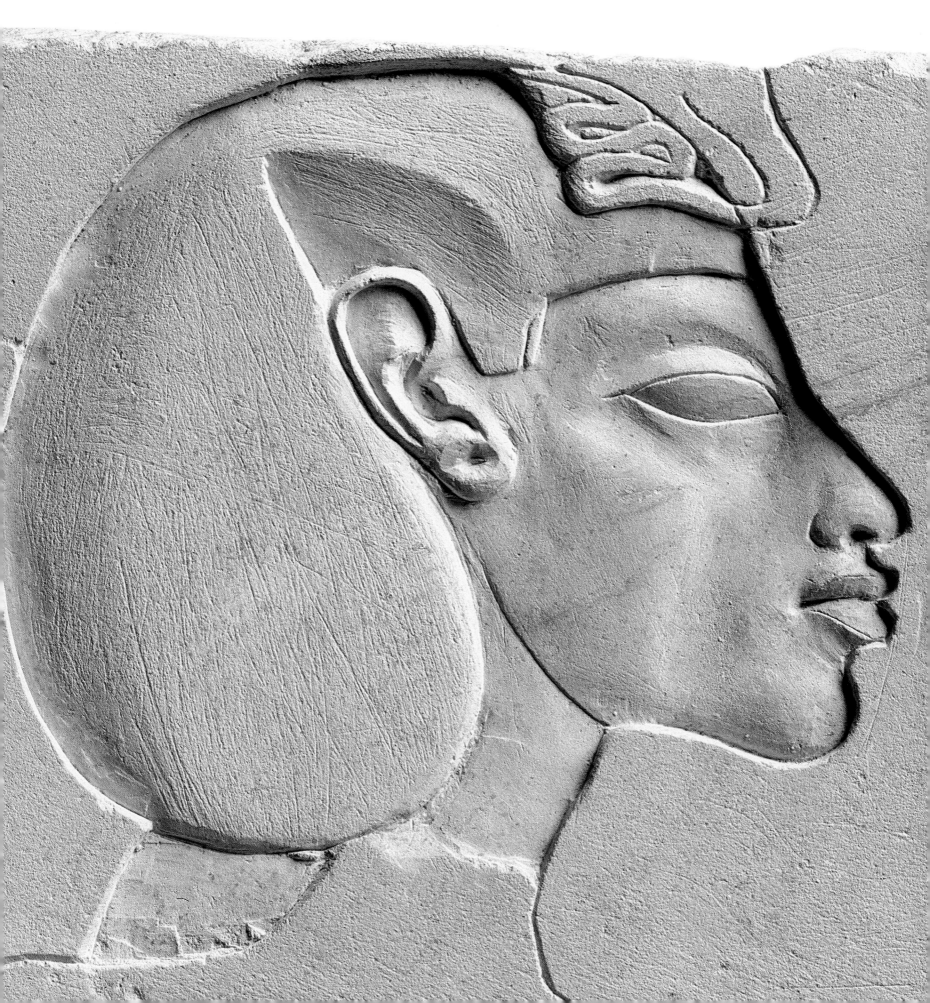

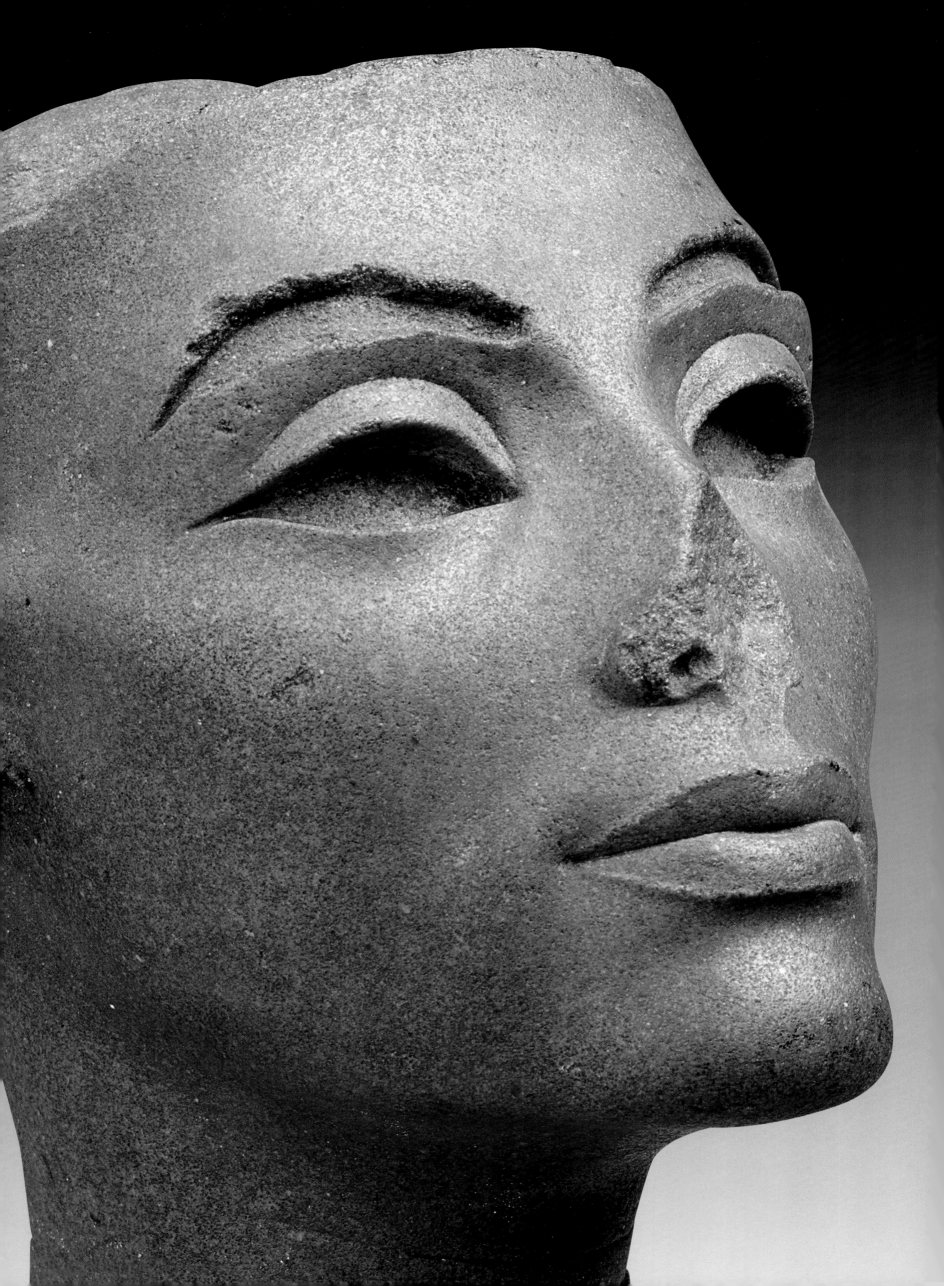

HEAD OF A QUEEN

JE 45547

BROWNISH YELLOW QUARTZITE
HEIGHT 18 CM
MEMPHIS, PALACE OF MERNEPTAH
UNIVERSITY OF PENNSYLVANIA EXPEDITION (1915)
EIGHTEENTH DYNASTY, REIGN OF AKHENATEN (1353–1335 BC)

This head was found below the foundations of the palace of Merneptah and undoubtedly represents Nefertiti. The queen's features are modelled far more realistically in this hard stone than in the celebrated Berlin bust.

The head must originally have been part of a composite statue made from various coloured stones, a practice typical of the Amarna Period. Originally the eyes and the eyebrows would have been set into the stone, probably in opaque glass. A short, broad tenon above the forehead would have been used to attach what was probably a cap-like crown. A line on the forehead indicates that a frontal band in a different material was applied and descended to frame the front part of the ears.

The piece is broken off at the neck and the nose and the tips of the ears are also damaged. The eyes and the eyebrows end in sharp points. The upper edges of the brow are delineated with a deep incision that creates a rounded outline, accentuated by a second line along the lower edge. The lower border of the ocular muscles is softer and less distinct than in the heads of the princesses, and the two lines from the nostrils to the upper lip are also smoother. The mouth is traced by a line that ends in rounded tips at each corner. The cheek muscles are well defined, but are again more delicate than in the figures of the Amarna princesses. The fleshy upper lip features a double arch and is well proportioned with respect to the lower lip.

The style and execution of this piece are both typical of the workshop of Djehutymes at Tell el-Amarna and it is certainly possible that the artist was responsible for this masterpiece. (F.T.)

HEAD OF A PRINCESS

JE 44870

BROWNISH YELLOW QUARTZITE
HEIGHT 19 CM; TELL EL-AMARNA, WORKSHOP OF THE SCULPTOR DJEHUTYMES
L. BORCHARDT'S EXCAVATIONS (1912)
EIGHTEENTH DYNASTY, REIGN OF AKHENATEN (1353–1335 BC)

This head was among the large number of pieces discovered in the workshop of the chief sculptor Djehutymes at Tell el-Amarna. This particular piece was found in the rooms used as stores.

In the first phase of the Amarna Period (years 14–17) the princesses were represented with unnaturally long skulls and slim necks. A number of suggestions attempting to explain this feature identified it as a deliberate or pathological deformity, but such interpretations have long been abandoned. It is far more likely that this was a case of deliberate mannerism in the new artistic style of the period, influenced by religious concepts that emphasized hereditary traits.

The egg-shaped head should be seen in relation to the notion of the princesses as the incarnation of divine creation, following the model provided by depictions of Akhenaten, their father. Youth is emphasized by the roundness of the puppy fat below the chin, even though this is a portrait of a young woman rather than a child. The eyes are large and have dark kohl outlines, the ears are square and shell-like. The protuberance of the lobes of the skull above the ears denote a young person. These large lobes blend harmoniously into the elongated head. The mouth is sensual and is a symbol of femininity. The long chin is balanced by the solidity of the forehead, in contrast with the portraits of Akhenaten, which had a greater stylistic influence than the portraits of Nefertiti. The tenon at the base of the neck indicates that this head was part of a composite statue. (F.T.)

The drama and mystery surrounding the brief reign of King Tutankhamun and the discovery of his tomb by Howard Carter are almost as fantastic and intriguing as the treasures themselves. The history of Tutankhamun's reign must begin with that of the heretic king, Akhenaten. Akhenaten was probably married to a second wife called Kiya, who bore him a daughter and a son. When the king died, Ay, a member of Queen Tiye's family who had been a high-ranking court official and advisor to Akhenaten and Smenkhkare, was faced with the necessity of placing a member of the royal family on the country's throne.

The young prince Tutankhaten – his name was soon to be changed to Tutankhamun – was the only royal son available. His personal name Tutankhamun may mean 'Living image of Amun', and his throne name, *Nebkheperure*, means 'Re appears in many forms'. The boy-monarch was probably born in Akhetaten (the site of today's Tell el-Amarna). According to some Egyptologists, Tutankhamun's father may have been Akhenaten himself, given the great resemblance of his physiognomy to that of the 'heretic king'. However, a text on a lion's statue found at Soleb (in Sudan) and now in the British Museum claims Amenhotep III as the father of the

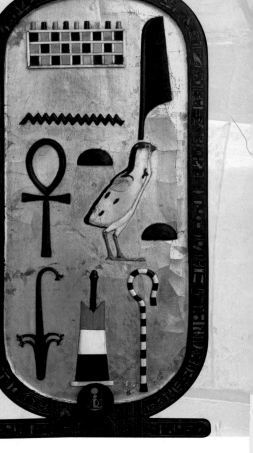

young king. It should be borne in mind, however, that grandchildren, receiving much love and special treatment from their grandparents, might well call them 'father and mother'.

On an Amarna relief from Hermopolis, Tutankhamun mentioned that he was 'the son of the King from his body', but the name of that king is not specified. As these reliefs belonged to Akhenaten's sacred buildings, this strengthened the assumption that Akhenaten was Tutankhamun's father. His mother might have been Princess Kiya, perhaps a secondary wife of Akhenaten who received the epithet 'Greatly Beloved Wife'. Since a lock of Queen Tiye's hair was found encased in three miniature coffins, placed one within another, among the equipment of Tutankhamun's tomb, she might have been his grandmother.

Tutankhamun was only ten years old when he was married to the third daughter of Akhenaten called Ankhesenpaaten (later Ankhesenamun), probably also a half-sister of his. Her name means, 'She lives for the

M O H A M E D S A L E H

TUTANKHAMUN, HIS LIFE AND TREASURES

194 BELOW RIGHT
CASKET IN THE FORM OF A CARTOUCHE
JE 61490
PROBABLY CONIFER WITH EBONY VENEER AND IVORY
HEIGHT 32.1 CM
WIDTH 30.2 CM
LENGTH 63.5 CM
VALLEY OF THE KINGS
TOMB OF TUTANKHAMUN (KV 62); DISCOVERED BY HOWARD CARTER (1922)
EIGHTEENTH DYNASTY
REIGN OF TUTANKHAMUN (1333–1323 BC)

195
MASK OF TUTANKHAMUN
JE 60672
GOLD, LAPIS LAZULI, CARNELIAN, QUARTZ, OBSIDIAN, TURQUOISE, COLOURED GLASS
HEIGHT 54 CM
WIDTH 39.3 CM
WEIGHT 11 KG
VALLEY OF THE KINGS, TOMB OF TUTANKHAMUN (KV 62); DISCOVERED BY HOWARD CARTER (1922)
EIGHTEENTH DYNASTY
REIGN OF TUTANKHAMUN (1333–1323 BC)

194 LEFT
DETAIL OF PECTORAL WITH ISIS AND NEPHTHYS
JE 61945
GOLD, QUARTZ, GLASS PASTE
HEIGHT 12 CM
WIDTH 16.3 CM
VALLEY OF THE KINGS
TOMB OF TUTANKHAMUN (KV 62); DISCOVERED BY HOWARD CARTER (1922)
EIGHTEENTH DYNASTY
REIGN OF TUTANKHAMUN (1333–1323 BC)

194 BACKGROUND
THIRD COFFIN OF TUTANKHAMUN
JE 60671
GOLD, SEMIPRECIOUS STONES, GLASS PASTE
LENGTH 187 CM
HEIGHT 51 CM
WIDTH 51.3 CM
WEIGHT 110.4 KG
VALLEY OF THE KINGS
TOMB OF TUTANKHAMUN (KV 62); DISCOVERED BY HOWARD CARTER (1922)
EIGHTEENTH DYNASTY
REIGN OF TUTANKHAMUN (1333–1323 BC)

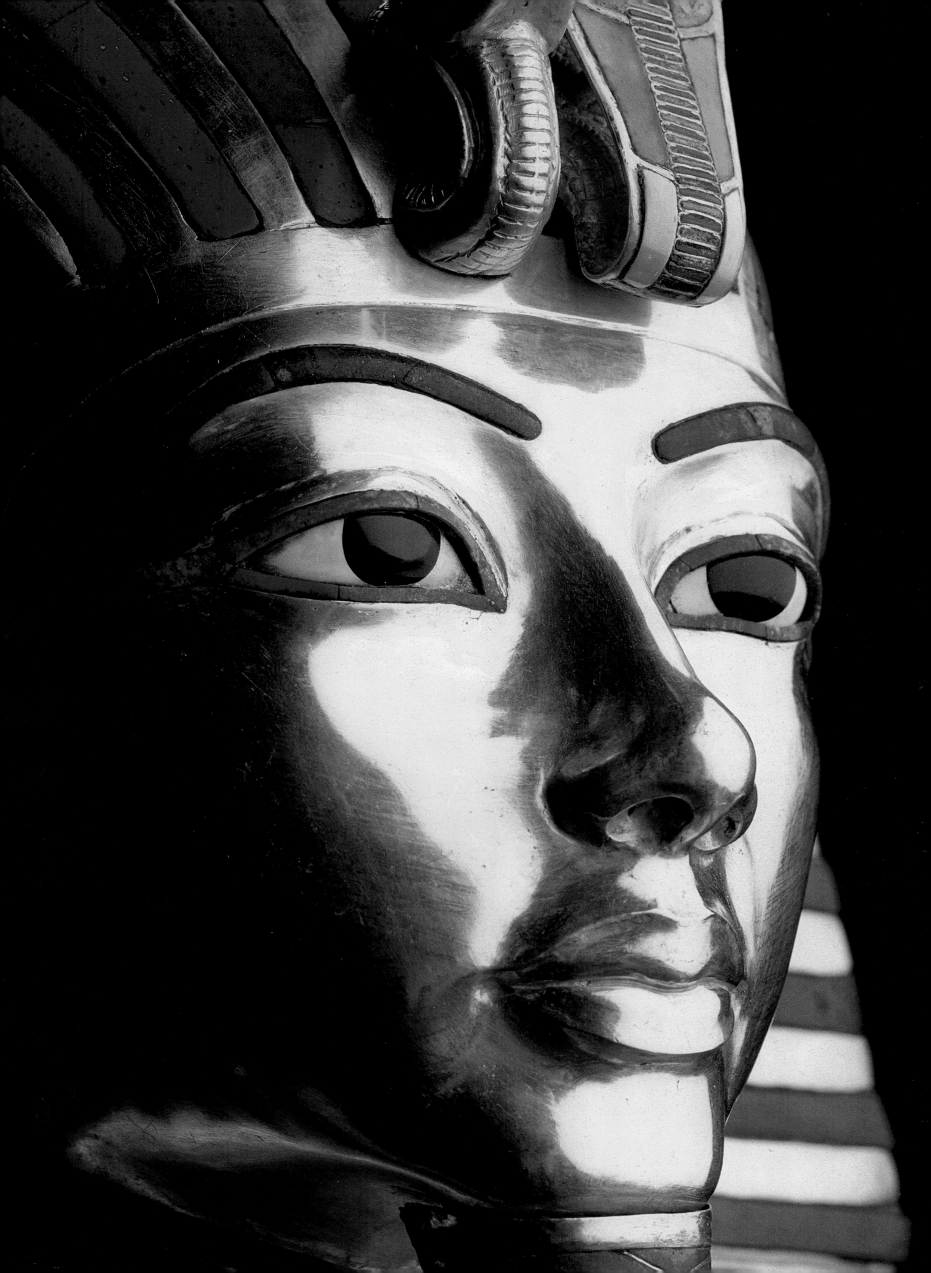

benefit of Amun'. Being the eldest surviving daughter of Akhenaten and his 'Great Royal Wife' Nefertiti, she was the most legitimate royal heiress, and by marrying her, Tutankhamun further strengthened his own legitimacy to the throne. The country he ruled was actually run, however, by the vizier Ay, head of the civil administration, and the army commander Horemheb. The king spent about four years in Tell el-Amarna before abandoning Akhenaten's new city and moving to Memphis, centre of the country's civil and military administration.

Tutankhamun was not very strong physically. His relaxed seated figure shown on the back of his throne as he is being anointed by his queen suggests his weakness. On the sides of the small *naos* covered with gold foil and decorated with embossed relief, the king's figure, shown together with that of his wife, clearly indicates his weak health. Here he is represented shooting arrows at ducks while sitting on a chair, not standing as would be appropriate for such an activity. And on the lid of one of his chests covered with carved and painted ivory, the king is shown standing in a relaxed posture, leaning on his staff. When his body was examined and X-rayed by pathologists after the excavation of his tomb (1923–24), it was suggested that he had suffered from a brain tumour, as the skull cavity within the skull was larger than normal, and that he might have had chest diseases, causing his early death at about twenty. Archaeological evidence from the dated wine jars found in his tomb and the re-examination of the elbow-joints and the wear of his teeth have further strengthened suppositions about the length of his reign and his untimely death.

During the last examination of the body in 1968, a mark of injury on the king's skull was observed. It has been suggested that this injury might have resulted from the impact of an assassin's weapon and would thus supply the cause of the monarch's early death. It is difficult, however, to believe that Tutankhamun was assassinated, and did not die a natural death. This is based upon the following considerations: (1) The king had been chosen by Ay and Horemheb to occupy the throne, and was beloved, protected and supported by them. (2) He had restored the cult of Amun-Re and reopened his temples and those of the other deities banned under Akhenaten. (3) He was the one who 'suppressed wrongdoing throughout the entire land so that Justice remained.... His majesty made monuments for all the gods, fashioning their statues of genuine *electrum*, restoring their sanctuaries as monuments enduring forever, providing them with perpetual endowments, investing them with divine offerings for the daily service, and supplying their provisions on earth.' In the meantime, the name and figures of Amun-Re, which had been erased from temples' walls, were re-cut and the temples' properties that had been confiscated under Akhenaten, were given back. (4) The priests of Amun-Re were very grateful to Tutankhamun, and when he died, they provided him with elegant funerary equipment and produced great memorial ceremonies for him. One of these was the famous festival of Amun-Re, revived in the presence of the king and depicted on the walls of the colonnade in the Luxor temple.

(5) The young king was buried in the tomb originally prepared for Ay in the Valley of the Kings. The latter was in charge of the funerary ceremonies for Tutankhamun. Ay himself was later buried in another tomb in the western Valley of the Kings, not far from that of Amenhotep III. (6) Tutankhamun was buried with all

196 LEFT
STATUETTE OF PTAH
JE 60739
GILDED WOOD, FAIENCE, BRONZE, GLASS
HEIGHT 52.8 CM
VALLEY OF THE KINGS, TOMB OF TUTANKHAMUN (KV 62); DISCOVERED BY HOWARD CARTER (1922)
EIGHTEENTH DYNASTY
REIGN OF TUTANKHAMUN (1333–1323 BC)

197 OPPOSITE LEFT
SHABTI FIGURE OF TUTANKHAMUN WITH RED CROWN
JE 60823
WOOD, GOLD LEAF, BRONZE
HEIGHT 63 CM
VALLEY OF THE KINGS, TOMB OF TUTANKHAMUN (KV 62); DISCOVERED BY HOWARD CARTER (1922)
EIGHTEENTH DYNASTY
REIGN OF TUTANKHAMUN (1333–1323 BC)

the equipment belonging to him and other objects usurped from Smenkhkare's burial, such as the golden miniature coffins that contained Tutankhamun's embalmed viscera, some gold bands on his mummy and one of the enormous gilt shrines. Other things were offered to him by high officials, such as a *shabti* presented to him by general Minnakht and a whip that was given to him by the 'son of the king, captain of troops, Thutmose'.

(7) His tomb was rescued twice from being completely ransacked, whereas his belongings would hardly have been left in the tomb during the reigns of Ay and Horemheb if he had been murdered. (8) If Tutankhamun's name is never mentioned with the other legitimate rulers of Egypt in the king lists compiled in the time of Seti I and Ramesses II, this is due to the fact that he belonged to the heretic family. (9) In the case of murder, Tutankhamun's widow Ankhesenamun would hardly have been able to consider marrying a foreign Hittite prince, and the matter would have been quickly resolved by whoever instigated the murder. In such a case Ay could have

occupied the throne immediately without
giving the young widow a chance to search
for a foreign husband and king.

The queen, who was less than twenty-
five years of age when she found herself a
widow, might have been obliged to marry
the old man Ay, who was called 'god's
father' and who occupied the throne for
nearly four years after Tutankhamun. In the
meantime, the queen tried to find a
husband of her own choice and have a role
in ruling the country, even if she could not
become pharaoh as Hatshepsut and other
women had before and did after her time.
It seems that neither Ay, in his role as new
king, nor the general Horemheb would
allow Ankhesenamun to occupy the throne
as a female pharaoh. The queen was about
to violate all laws and traditions by
contesting the circumstances that had
forced her first to marry her father
Akhenaten, then her half-brother
Tutankhamun, and probably the old man
Ay as well. In any case, she addressed a
message to the Hittite king Suppiluliumas,
asking him to send one of his sons whom

197 RIGHT
STATUE OF THE GOD
KHONSU WITH THE FACE
OF TUTANKHAMUN
CG 38488
GRANITE; HEIGHT 252 CM
KARNAK; GEORGES
LEGRAIN'S EXCAVATIONS
(1904)
EIGHTEENTH DYNASTY
REIGN OF TUTANKHAMUN
(1333–1323 BC)

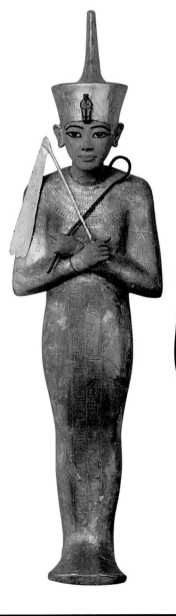

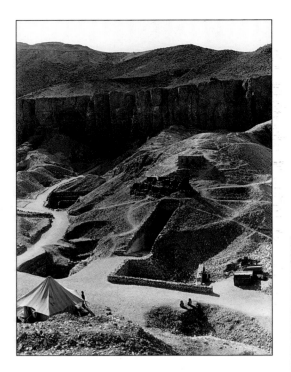

198 ABOVE
A VIEW OF THE VALLEY OF
THE KINGS AS IT APPEARED
DURING THE RECOVERY OF
THE TREASURE OF
TUTANKHAMUN. THE
KING'S TOMB IS LOCATED
BELOW THAT OF RAMESSES
VI AND ITS ENTRANCE IS
PROTECTED BY A LOW WALL
(IN THE CENTRE).

198 ABOVE RIGHT
DETAIL OF THE CLOSURE OF
ONE OF THE GILDED
SANCTUARIES. NOTE THE
CLAY SEAL OF THE THEBAN
NECROPOLIS: A JACKAL
ABOVE THE NINE BOWS,
THE DEFEATED ENEMIES OF
EGYPT.

198 RIGHT
ONE OF THE MOST
EXCITING MOMENTS DURING
THE EXPLORATION OF THE
TOMB OF TUTANKHAMUN:
HOWARD CARTER, WITH
ARTHUR CALLENDER AND
AN EGYPTIAN FOREMAN AT
HIS SHOULDER, ARE
OPENING THE DOOR OF THE
INNERMOST GILDED WOOD
SHRINE IN WHICH THE
SARCOPHAGUS, COFFINS
AND MUMMY OF THE KING
WERE PLACED.

198–199 CENTRE
HOWARD CARTER, WITH
THE HELP OF ARTHUR
CALLENDER AND AN
EGYPTIAN WORKER, PACK
ONE OF TUTANKHAMUN'S
KA STATUES READY FOR
SHIPMENT.

she might marry and with whom she could rule the country. The letter speaks about the death of her husband and the fact that she had no sons: 'They say you have many sons and if you send me one of yours, he shall be my husband.... I shall never take a servant of mine to make him my husband'.

The Hittite king did not take the queen's request seriously. He commented, 'such a thing has never happened to me in my whole life'. Over half a year later, he sent an envoy to investigate the matter, whereupon the queen got upset and sent another letter to the Hittite king. She told him, 'Do you think I would humiliate my country and write to another if I had a son. … I wrote to you only because they say you have many sons. If you give me one of them, he shall be my husband and he shall be the king of Egypt.' This persuaded Suppiluliumas that the queen's intentions were serious, and he sent his son Zannanza to Egypt, accompanied by an escort of guards and courtiers and loaded with gifts. The Egyptians, probably guided by general Horemheb, became aware of the queen's

plans and correspondence with the Hittite court and had the foreign prince murdered before he could reach his destination. At about the same time, Ankhesenamun disappears from the scene. The angry Hittite king, outraged by the assassination of his son, wanted to set forth with his army and attack Egypt, but never carried out his plans. Evidently Horemheb had prepared a strong army and defences to protect the northeastern border against any possible invasion.

Ay died two years after this incident, and, with Horemheb occupying the Egyptian throne as pharaoh, a new era of stability and order began for the country, while the restoration of the cult of Amun-Re and the temples of the gods was pursued energetically. From now on, and for the next century and a half, Egypt regained its position as a world power.

Whenever the name of Tutankhamun is mentioned, the name of the excavator of his tomb, Howard Carter, is bound to come up as well. The sensational finding of his tomb in 1922 is considered one of the

greatest – if not the greatest – of all archaeological discoveries.

In the nineteenth century, a decree from the *Khedive* had permitted consuls of foreign countries to conduct 'legal' excavations anywhere in Egypt and even to keep what they found. Later, excavators were granted about half of the finds. Illegal excavations had deprived tombs and temples of their original treasures, even those objects that had been overlooked or left behind by robbers in antiquity.

Throughout antiquity, tomb robbers had plundered burial sites of both royal and private persons. An ancient Egyptian document written in the time of Ramesses IX (1131–1112 BC) describes an inspection of the royal tombs, believed to have been plundered by a gang of officials and workers of the Theban necropolis. The papyrus also records the thieves' trial and the verdict. The tomb of Tutankhamun, however, is not mentioned in the protocols of these papyri, which means that it was already hidden and had been forgotten by thieves.

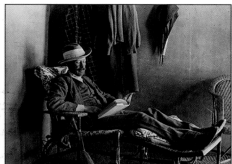

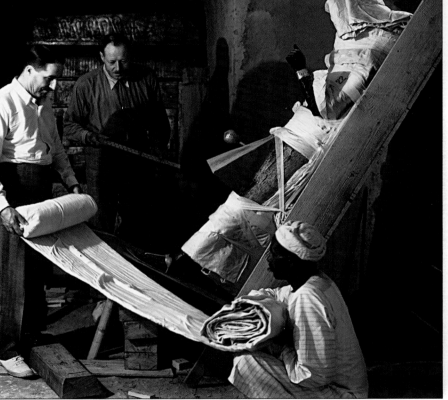

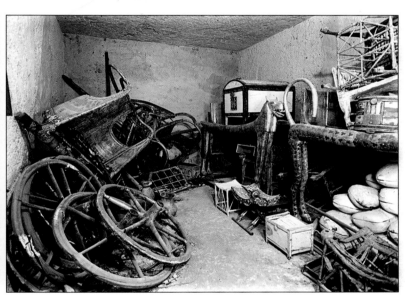

In 1892, Howard Carter, an Englishman who had begun his career in archaeology as a draughtsman with the Egypt Exploration Fund at Beni Hassan and el-Bersha in Middle Egypt, entered the 'Service des Antiquités de l'Égypte'. He was inspector of antiquities of Lower and Middle Egypt but in 1903 he had to quit his job when he refused to apologize to some French tourists whom he had ordered to leave the site after a quarrel at Saqqara.

In 1908, Lord Carnarvon, who had obtained a concession to dig at Thebes, asked Carter to conduct the excavations. Some important discoveries were made, such as the tombs of Thutmose IV and Hatshepsut. The work was interrupted when the First World War broke out in 1914, but resumed in 1917, without any remarkable finds being made for the next five years. On 1 November 1922, Carter resumed his excavations for Carnarvon in the Valley of the Kings, just a few metres east of the entrance to the tomb of Ramesses VI. After four days, the workers came upon a trench filled with a layer of flint chips that led to a staircase cut in the bedrock. At the bottom of the steps was a blocked doorway covered with plaster and bearing the seal of the royal necropolis: the jackal Anubis above the figures of the Nine Bows, or defeated enemies, of Egypt. Carter was convinced that he had come upon a cache that might still preserve objects from the royal tombs. But he hardly imagined he was about to discover the most important royal treasure found for three thousand years. He stopped work and sent a cable to his patron Carnarvon in England: 'At last have made wonderful discovery in valley; a magnificent tomb with seals intact.... Congratulations.'

When Carnarvon arrived, the sixteen steps of the stairway had been cleared; a corridor then went down for about nine metres, ending at a second blocked doorway. In both doorways, holes were evident, and a tunnel had been cut through the rubble that filled the corridor. Although the holes had been repaired and resealed in ancient times, this meant that the tomb had been 'visited' twice by robbers after the king's burial more than 3300 years before. On the first occasion, some golden objects and semiprecious stones had been stolen from the antechamber, and on the second, unguents and precious oils had been poured from their vases into light skin bags.

On 26 November 1922, Carter and his companions opened a hole in the doorway and saw 'wonderful things' glitter and shine in the antechamber. He later wrote that it 'was the day of days, the most wonderful that I have ever lived through'. The royal name written on some of the pieces made it clear that the tomb belonged to King Tutankhamun, few of whose objects had been found previously, and whose name appeared only on some monuments. The tomb had remained untouched for more than 3300 years, since the names of the heretic family to which Tutankhamun belonged had been systematically obliterated and replaced by those of other kings, under Horemheb or later.

The treasures of Tutankhamun's tomb are the only surviving royal funerary

assemblage (consisting of more than 3,500 objects) dating from one of the most prosperous periods of ancient Egypt. They document the flourishing art and crafts of the time and are an invaluable illustration of the daily life of a king in the Eighteenth Dynasty. Here we find his scribal outfit containing palettes of different materials (wood, ivory, faience and stone), some of which may have been used by the king, since the pigments for drawing and writing are worn. Among the pharaoh's writing implements are an exquisite tubular case for brushes and pens in the form of a palm-tree column, made of wood covered with gold foil and inlaid with semiprecious stones and glass. Another item of interest is an ivory burnisher for smoothing the surface of papyrus, made in the form of a brush, the handle of which represents a stylized lily with its stem.

An elaborate alabaster unguent vase was made of different pieces joined together. The vase itself is bound by two heraldic plants, the lily and papyrus, wrapped around it, forming the *sema-tawi* symbol of unification. It is held by two figures personifying the Nile god of Upper and Lower Egypt, which were to provide the royal couple with perfume and guarantee the unification of the country.

We also learn about the king's entertainment: a game box on an ebony stand in the form of a bed and sled is another important item from the treasure of Tutankhamun. The thirty squares of the upper board are for the game of *senet* (or 'passing'), and the twenty squares of the lower are for the *tjau* (or 'robbers') game, all of them inlaid with ivory. Some of the squares of the *senet* game are inscribed with hieroglyphic signs meaning 'beauty', 'spirits', 'water' or 'hazard' (or 'fallen in the water'). Unfortunately, little is known about the rules and how the game was played. However, it is assumed that the winner had to reach the square inscribed 'beauty' or 'happiness'. The knucklebones or casting sticks, preserved in a drawer of the box, would be thrown and the player would move his pieces accordingly. The game is also described in the Book of the Dead (Chapter 17) as one of the prime occupations of the deceased in the netherworld.

A unique object from the tomb is a lifesize wooden portrait bust of the young king. It has been suggested that this was a mannequin of the king used by the tailor making his shirts – they would be tried on the bust before they were worn by the king. The ears of this bust are pierced, so that earrings could be applied.

Many exquisite pieces of jewelry – 143 – were found in the tomb, including gold buckles of openwork, one showing the king in his chariot pursuing enemies and another depicting the intimate life of the king and his queen. There are also necklaces and pectorals of magnificent workmanship and forms. The colours of different semiprecious stones play a great role in enhancing the beauty of the objects, but they also guaranteed eternal life for the king through the amuletic or religious motifs and representations of scarabs and solar-boats, symbols of long life and prosperity. The artists mastered various techniques in manufacturing the jewels, such as cloisonné, filigree, granulation and bead work.

The furniture (for example beds, thrones, boxes and shrines) reveals the technical quality of furniture making, especially in design, draughtsmanship, relief and gilding. The chairs found in the tomb are each of a different shape, their designs showing great originality. Some are ornate stools (folding and rigid) decorated with the hieroglyphic signs for unification. Small folding stools have inflexible seats and feet in the form of ducks' heads biting the crossbar supporting the legs.

The Golden Throne of the king is a masterpiece. Made of precious wood and covered with gold sheet, it features different designs and figures. On the inner panel of the chair the Aten sun-disc sends its rays to shine on the king and queen. This symbol harks back to the era of the monotheistic 'heresy', when Aten was supreme. The intimate scene of the royal couple, with the queen anointing the relaxed king with perfume, is so romantic that it captures our attention completely. Both of them wear elegant costumes and royal accessories, including ceremonial crowns, beautiful wigs of blue glass, broad collars, decorated garments and ornate sandals. Their bodies are inlaid with coloured glass and semiprecious stones, while their clothes are made of silver. Symbols of protection appear on the panels of the throne's armrests: two winged cobras wearing the double crown and two lion heads that might represent the eastern and western horizons.

Another important chair was designed for ceremonial use (probably for a coronation). It features a back panel decorated with fine relief and openwork showing Heh, the god of eternity, holding two year-signs mounted on signs of infinity, crowned by the sun-disc and kneeling on the gold sign. Here he protects the names of Tutankhamun and

grants him long life. The golden winged sun-disc appears above.

The accessories (garments, gloves, sandals, sceptres) and sacred emblems represent a complete set of personal belongings for a king, to be used during his lifetime and on his afterlife journey. The six horse-drawn chariots found dismantled in the tomb are of different designs, some of them showing signs of actual use by the king. One of the chariots is lavishly decorated with gilt reliefs representing African and Asiatic foes, each with their respective ethnic features, being trampled by the king. Fifty articles of warfare, including swords, daggers, shields and bows and arrows were also found among the objects in the tomb. One of the trumpets, made of bronze with gold overlay, has an incised figure of the king being protected and blessed by Amun-Re, Ptah and Re-Horakhty. The trumpet has no valves, but is accompanied by a wooden stopper which might have been used for changing the tones and, when covered with a piece of cloth, as a cleaner. The stopper might also have been used as a core to prevent the bell of the trumpet from being crushed or damaged.

The objects found in the tomb also provide evidence of beliefs in the hereafter and relationships with the different deities of the netherworld. Gilded statues of the king show him realistically in various attitudes and activities. Two of them are of the king on a canoe, harpooning the symbol of evil, the hippopotamus, enemy of the sun-god. He is equated with Horus, in pursuit of the task of avenging his father Osiris. Another pair of statues represents the king on a leopard, wearing the crown of Upper Egypt and holding a flail in one hand and a long staff in the other. These statues might have been put in the tomb to protect the king and enable him to triumph over the hazards of the afterlife.

Finally, there are objects connected with the funeral ceremonies and the burial of a king, including everything to help preserve his body and soul. Mysterious symbols offer him the protection of spirits and assist in his resurrection. Here are food and drink, statues and sarcophagi, gold masks and shrines, as well as miniature golden canopic coffins for the internal organs, and as the canopic box and shrine. Sacred model boats mean the king could travel wherever he wanted to in the underworld.

The wall paintings in Tutankhamun's tomb (KV 62) include funeral processions

200 OPPOSITE LEFT
CASE FOR A MIRROR
JE 62349
WOOD, GOLD- AND SILVER-LEAF, SEMIPRECIOUS STONES, GLASS
HEIGHT 27 CM
VALLEY OF THE KINGS, TOMB OF TUTANKHAMUN (KV 62); DISCOVERED BY HOWARD CARTER (1922)
EIGHTEENTH DYNASTY
REIGN OF TUTANKHAMUN (1333–1323 BC)

200 OPPOSITE CENTRE
STATUE OF THE GOD IHY
JE 60731
RESINED WOOD
HEIGHT 63.5 CM
VALLEY OF THE KINGS, TOMB OF TUTANKHAMUN (KV 62); DISCOVERED BY HOWARD CARTER (1922)
EIGHTEENTH DYNASTY
REIGN OF TUTANKHAMUN (1333–1323 BC)

200 OPPOSITE RIGHT
FALCON
JE 60712
WOOD, GOLD LEAF, BRONZE
HEIGHT 69.2 CM
VALLEY OF THE KINGS, TOMB OF TUTANKHAMUN (KV 62); DISCOVERED BY HOWARD CARTER (1922)
EIGHTEENTH DYNASTY
REIGN OF TUTANKHAMUN (1333–1323 BC)

201 BELOW LEFT
FUNERARY BED
JE 62014
EBONY, GOLD LEAF, PAINT
LENGTH 185 CM
WIDTH 90 CM
MAXIMUM HEIGHT 76 CM
VALLEY OF THE KINGS, TOMB OF TUTANKHAMUN (KV 62); DISCOVERED BY HOWARD CARTER (1922)
EIGHTEENTH DYNASTY
REIGN OF TUTANKHAMUN (1333–1323 BC)

201 BELOW
FUNERARY BED WITH THE COW GODDESS MEHET-WERET
JE 62013
STUCCOED WOOD, GILDED AND PAINTED
HEIGHT 188 CM
WIDTH 128 CM
LENGTH 208 CM
VALLEY OF THE KINGS, TOMB OF TUTANKHAMUN (KV 62); DISCOVERED BY HOWARD CARTER (1922)
EIGHTEENTH DYNASTY
REIGN OF TUTANKHAMUN (1333–1323 BC)

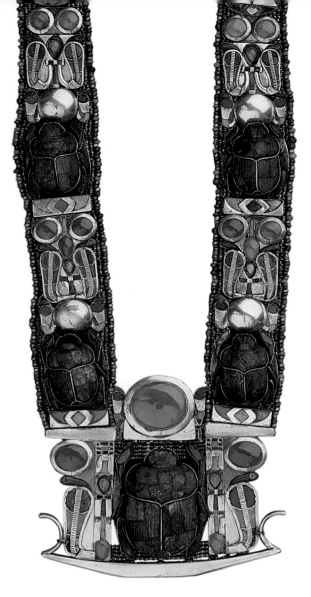

and scenes and texts relating to the rites performed for the king after his death. These were undertaken by his successor, Ay, and not by the eldest son as was the usual custom. It is likely that the wife of Tutankhamun had two miscarriages, as two foetuses, probably female, were buried with the king. So, in the place of a son, Ay performs the 'opening of the mouth' ritual. There are also scenes that identify the king with Osiris or depict his welcome in the underworld by the goddess Nut.

The presence of all these objects in the tomb of Tutankhamun might mean that every royal tomb at Thebes was as richly furnished, or even more so. On the other hand, it could also attest to how much the contemporary priests and courtiers loved the king and were grateful to him,

presenting him with all these beautiful things in appreciation of his restoration of the cult of Amun and the other deities. This would explain why the treasure of Tutankhamun was exceptionally rich, since the king represented a concept rather than an individual person.

Most of the objects from the tomb of Tutankhamun were taken to the Egyptian Museum in Cairo and are on view there. Some were left in a storeroom at Thebes, and a few were recently sent to be exhibited at the Luxor Museum. The mummy of Tutankhamun remains in his tomb, inside the first, outermost coffin of gilded wood, which still lies in the quartzite sarcophagus. It is, however, badly preserved, and its elements are out of joint and damaged. When Howard Carter and

202 LEFT
NECKLACE WITH SCARABS
JE 61896
GOLD, LAPIS LAZULI, CARNELIAN, GREEN FELDSPAR, TURQUOISE
LENGTH 50 CM

VALLEY OF THE KINGS, TOMB OF TUTANKHAMUN (KV 62); DISCOVERED BY HOWARD CARTER (1922); EIGHTEENTH DYNASTY, REIGN OF TUTANKHAMUN (1333–1323 BC)

202–203
CORSLET
JE 62627
GOLD, GLASS PASTE, IVORY, CARNELIAN
HEIGHT 40 CM
LENGTH 85 CM

VALLEY OF THE KINGS, TOMB OF TUTANKHAMUN (KV 62); DISCOVERED BY HOWARD CARTER (1922); EIGHTEENTH DYNASTY, REIGN OF TUTANKHAMUN (1333–1323 BC)

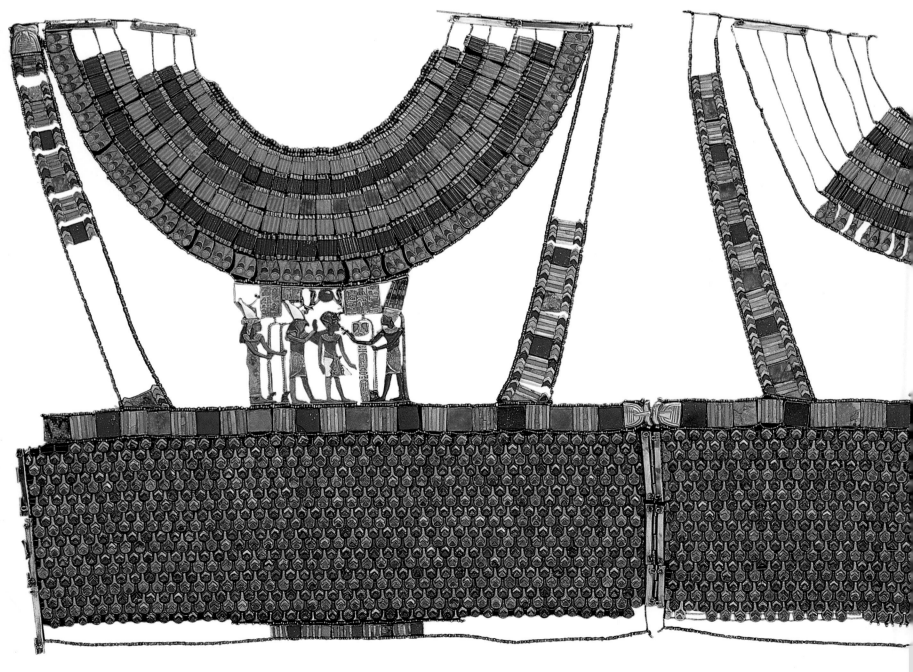

his workers removed the objects from the tomb, they first photographed the items in groups before moving them from their original position, and each piece was numbered. Then, some emergency restoration and preservation operations were conducted and the objects were transferred to the tomb of Seti II, where a laboratory for conservation and packing had been set up. Afterwards, the treasures were transported to Cairo and, on their arrival at the Museum, they were made ready for exhibition. As it was, the museum galleries were not really prepared to receive the important new finds, which exceeded 3,500 pieces. Objects previously on the upper floor were moved to other galleries to make room for the treasures of Tutankhamun.

In April 1923, shortly after the discovery of the tomb, Lord Carnarvon died at a hospital in Cairo from blood poisoning which he had picked up in Luxor and which quickly spread to his glands, with pneumonia supervening. This led to the spread of a superstition that attributed Carnarvon's death to the 'Vengeance of the *Ka*', or, in the modern term, to the 'Curse of the Pharaohs'.

We do not believe, however, that Carnarvon's death was caused by the 'Curse of the Pharaohs', but was mere coincidence. The person deserving the punishment – if any was due – would have been Howard Carter himself, who as it was died seventeen years later, having enjoyed tremendous fame.

203 CENTRE
RING WITH SOLAR BARQUE
JE 62450
GOLD, FAIENCE
LENGTH 2.8 CM
VALLEY OF THE KINGS,
TOMB OF TUTANKHAMUN
(KV 62); DISCOVERED BY
HOWARD CARTER (1922)
EIGHTEENTH DYNASTY
REIGN OF TUTANKHAMUN
(1333–1323 BC)

203 BELOW
PECTORAL WITH
ISIS AND NEPHTHYS
JE 61945
GOLD, QUARTZ, GLASS
PASTE
HEIGHT 12 CM
WIDTH 16.3 CM
VALLEY OF THE KINGS,
TOMB OF TUTANKHAMUN
(KV 62); DISCOVERED BY
HOWARD CARTER (1922)
EIGHTEENTH DYNASTY,
REIGN OF TUTANKHAMUN
(1333–1323 BC)

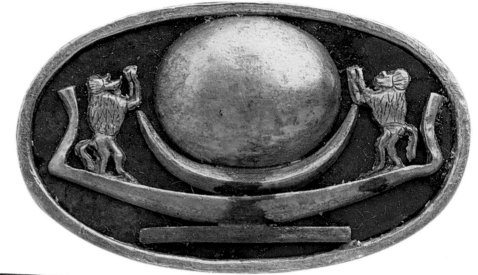

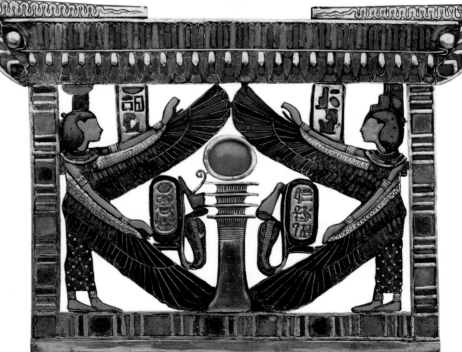

BIOGRAPHY

Mohamed Saleh, *born in Cairo in 1939, qualified in Egyptology in the Egyptian capital and completed his specialist studies at the University of Heidelberg in Germany. He initially worked as Inspector of Antiquities at Luxor and then as curator and Vice-Director of the Egyptian Museum of Cairo, before being appointed Director in 1981. He has contributed to a number of important specialist periodicals and* *written numerous books dealing with Egyptology as well as producing a number of television programmes on the Egyptian Museum and the city of Cairo. In 1984 the French government awarded him the Legion of Honour for the Order of Arts and Letters in recognition of his important work in the cultural field. He currently lectures in Egyptology at the University of Cairo.*

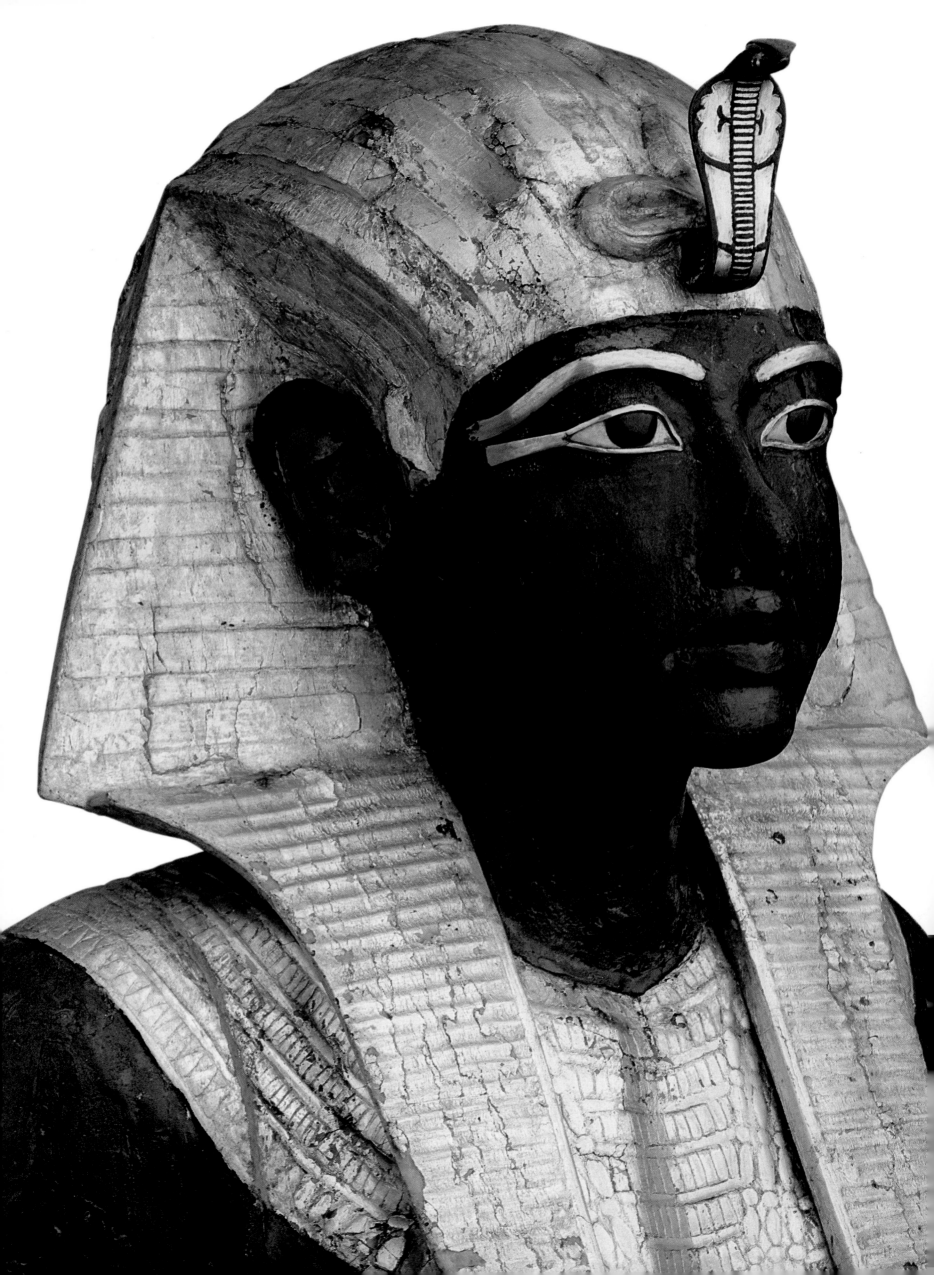

KA STATUES
OF TUTANKHAMUN

WOOD, WITH POLISHED BLACK RESIN AND GILDING
HEIGHT 192 CM; WIDTH 53.3 CM; LENGTH 98 CM; VALLEY OF THE KINGS
TUTANKHAMUN'S TOMB (KV 62); DISCOVERED BY H. CARTER (1922)
EIGHTEENTH DYNASTY, REIGN OF TUTANKHAMUN (1333–1323 BC)

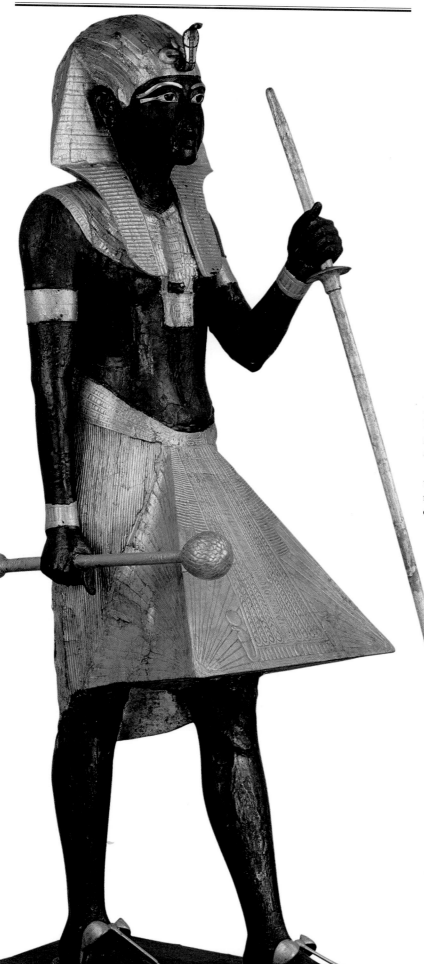

These two statues were discovered in the Antechamber of the royal tomb, facing each other on either side of the sealed entrance to the Burial Chamber. At the time of their discovery, traces of the linen shawls in which they had been draped were found, along with two garlands of olive and persea branches placed as offerings, one on the floor, the other still propped against the wall.

The statues, striking in both their lifesize dimensions and the black finish of the surface, are testimony to the skill of the ancient artist who made them. He succeeded in investing them with a sense of the almost supernatural power they wielded as guardians of the burial chamber. Rather than being intended to frighten any intruders, however, the black skin tone was a reference to the earth and thus, since these are *ka* images of the king, emphasizes the indestructibility of the king, evoking aspects of rebirth and the cyclical resurrection of Osiris.

There are only slight differences between the two statues, first in the type of head covering they are wearing (one has a *khat* headcloth, the other a *nemes*) and also in the inscriptions on their kilts. The king is portrayed in a striding pose, a mace gripped in his right hand and a long staff with a papyrus stem in his left. A gilded bronze *uraeus* adorns his forehead and the eyes are inlaid and outlined with gilded bronze, as are the eyebrows. A gilded *usekh* necklace and a pectoral are depicted on the chest.

The pleated kilt is fastened on the hips with a belt inscribed at the rear and on the buckle with the coronation name of the king

Nebkheperure. The projecting triangular frontal panel of the kilt of the statue with the *khat* headcloth carries the vertical inscription 'The perfect god, rich in glory, a king to be proud of, the royal *ka* of Horakhty, the Osiris, and Lord of the Two Lands, *Nebkheperure*, made just'. The inscription on the other statue records the birth name of the pharaoh, 'Tutankhamun, living forever as Re each day'. Both statues are wearing anklets and bracelets of gilded bronze.

Although made some years after the end of the Amarna Period, these sculptures clearly show the influence of the art that time, with their prominent bellies, slim legs and pierced ears. (R.P.)

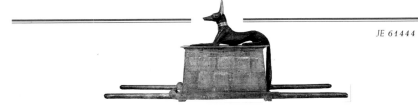

PORTABLE ANUBIS SHRINE
··········
Wood, gessoed and resined, gold leaf, silver, gold, quartz, obsidian
Total height 118 cm; total length 270 cm; width 52 cm
Valley of the Kings, Tutankhamun's Tomb (KV 62)
Discovered by H. Carter (1922)
Eighteenth Dynasty, Reign of Tutankhamun (1333–1323 bc)

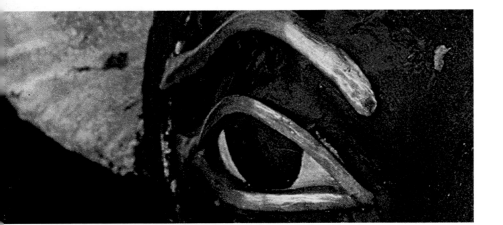

This image of Anubis was placed at the entrance to the Treasury, with its muzzle turned towards the Burial Chamber. When Carter discovered it, the statue of the jackal was still covered with a linen cloth on which the date of the seventh year of the reign of Akhenaten was inscribed. A piece of finer cloth had been draped around the neck and below this a scarf had been tied over a garland of flowers. An artist's ivory palette with the names of the princess Meritaten, the daughter of Queen Nefertiti, lay between the front paws of the animal.

As was customary, Anubis is depicted as a jackal and is lying on top of a shrine. This iconography has very ancient origins and is also found in texts, where it is used to indicate the title of 'Supervisor of the Secrets'.

The animal's body was very carefully rendered. The pelt is taut and reveals the bone structure and tendons beneath the skin. The extended muzzle and the upright ears confer an air of alert vigilance on the sculpture. Not even the long tail, dangling against the rear wall of the shrine, negates the tension pervading the body of Anubis.

The sculpture was carved from wood which was plastered and painted with black resin. Only the

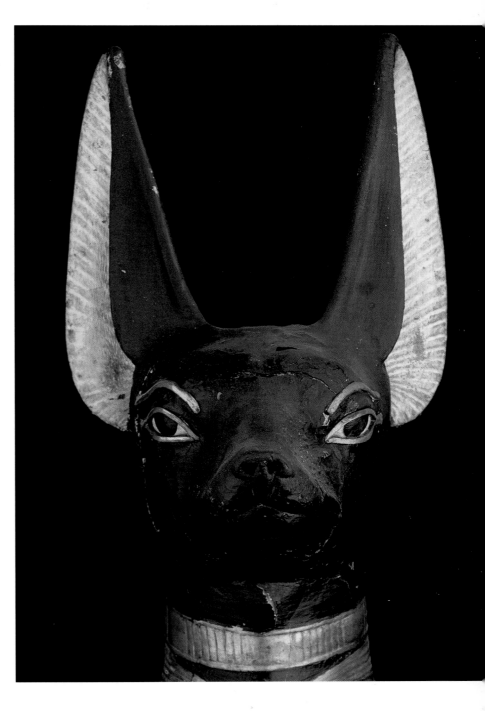

inside of the ears and the collar tied around the neck are covered in gold leaf. The eyes are made of calcite with obsidian pupils, and are outlined with gold; the eyebrows are also gold. The claws are instead made of silver.

The shrine beneath Anubis is made of wood covered with gesso and gold leaf. It features a cavetto cornice and slightly tapering sides. On its long sides the decoration includes a double band of pairs of *djed* pillars alternating with pairs of Isis-knots. Hieroglyphic inscriptions frame each panel and the lower register carries a 'palace façade' motif. The shrine was designed to be transported on a sled. Two long bars project from the short sides and were used to carry the image of the god in processions.

The roof of the shrine can be opened. Placed inside were numerous faience amulets, eight pectorals and two calcite vases, one of which contained a bituminous substance. Originally the objects were packed in pieces of cloth and placed within the shrine in an ordered fashion. When Carter discovered them, however, they were in complete disarray. Thieves had already rummaged through the contents of the shrine in the hope of finding more precious jewels. (F.T.)

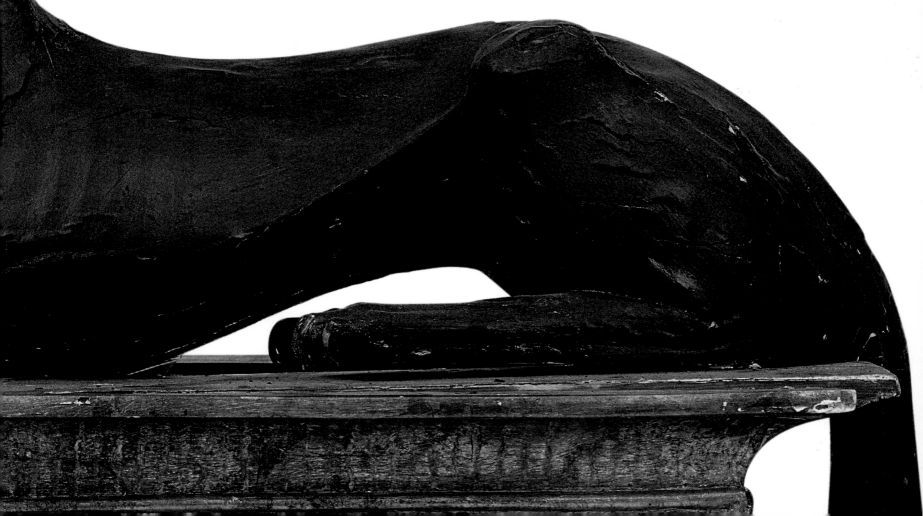

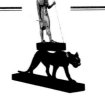

TUTANKHAMUN ON THE BACK OF A LEOPARD

WOOD, GILDED AND PAINTED; HEIGHT 85.6 CM; VALLEY OF THE KINGS
TUTANKHAMUN'S TOMB (KV 62); DISCOVERED H. CARTER (1922)
EIGHTEENTH DYNASTY, REIGN OF TUTANKHAMUN (1333–1323 BC)

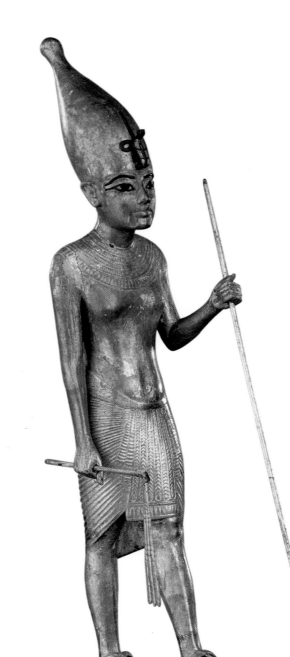

A total of thirty-four wooden statues were found in the tomb of Tutankhamun, seven portraying the pharaoh and the other twenty-seven depicting various divinities from the Egyptian pantheon. The majority of the statues had been placed in the Treasury, inside black wooden shrines mounted on sleds and set along the south wall. A pair of these statues, placed together in the same cabinet and almost identical, depict the pharaoh standing on the back of a leopard.

The image of the king is carved very skilfully in a very hard wood. It was then gessoed and entirely covered with a thin layer of gold leaf. Tutankhamun grips a long staff in one hand and the flail symbolizing his power in the other. He is wearing the crown of Upper Egypt, adorned with the royal cobra on the forehead. The body of the snake is painted black.

The modelling of the head and body shows the influence of the art of the Amarna Period. There is an emphasis on and exaggeration of certain physical details, such as the long, forward-tilted neck, the swelling breasts, the rounded belly and the low waist. It is therefore legitimate to suggest that the statue may have been made for Akhenaten, a hypothesis supported by the fact that when it was discovered it was wrapped in linen cloths that carried inscriptions datable to the third year of that pharaoh's reign.

The face, with its serene, youthful expression, has eyes inlaid with obsidian, bronze and glass. The king is bare chested but wears a large collar that covers his breast and shoulders and terminates with a row of drop beads. The pharaoh's clothing consists of a long, tightly fitting loincloth, knotted at the front and incised with fine lines imitating the pleats in the cloth; he wears sandals on his feet.

The statue of the king stands on a black-painted, rectangular pedestal which is fixed to the arching back of a leopard, also black. The animal is portrayed with great realism, pacing slowly and stealthily. Its body has a sinuous, elegant profile and the head, with gilded ears and muzzle, is held slightly down. A second black-painted pedestal forms the base for the entire sculptural group.

The composition is not intended as a hunting scene, since the king is not bearing weapons, but rather it has a symbolic value. The leopard might represent an allegorical image of the sky, which in the Predynastic period was depicted as a feline that swallowed the sun in the evening before regenerating it in rejuvenated form the following morning. With his gilded body the king could represent the sun god.

According to another interpretation, which is supported by a scene in the tomb of Seti I, the king, whose gilding identifies him as the sun god, is in the underworld and the leopard is painted black, like all the denizens of the underworld. (S.E.)

JE 60709

TUTANKHAMUN ON A PAPYRUS RAFT

WOOD, GESSOED AND GILDED, BRONZE; HEIGHT 69.5 CM; WIDTH 18.5 CM
LENGTH 70.5 CM; VALLEY OF THE KINGS, TUTANKHAMUN'S TOMB (KV 62)
DISCOVERED BY H. CARTER (1922)
EIGHTEENTH DYNASTY, REIGN OF TUTANKHAMUN (1333–1323 BC)

The Treasury in the tomb of Tutankhamun contained twenty-two black-painted wooden caskets or shrines, each of which contained one or more wooden statues portraying either the pharaoh or a number of deities from the Egyptian pantheon.

All the figures contained in these black shrines are fixed to a rectangular base and when discovered were wrapped in a linen cloth datable to the third year of the reign of Akhenaten.

Twin statues made of gilded wood depicted Tutankhamun standing upright on a papyrus raft and engaged in a mythical hunt for a hippopotamus, a symbol of evil. The pharaoh is represented as the incarnation of Horus, the god who, according to myth, sought to avenge the murder of his father by fighting against the evil Seth. Seth was transformed into a hippopotamus and finally defeated.

Tutankhamun, like the victorious god, has the task of fighting against evil and preserving the universal order of which he is the sole guarantor. The king is depicted in the act of hurling his long spear against his enemy. He is taking a long, purposeful step forwards, and concentrates intently on the act he is engaged in.

Tutankhamun is wearing the crown of Lower Egypt, decorated at the front with the royal cobra, which rises above his youthful, fine facial features. His eyes are inlaid and outlined in a dark colour. A *usekh* necklace is depicted around his neck, with imitations of the rows of beads incised into the wood. The soft modelling of the naked torso the slightly swelling pectoral muscles, the rounded belly and the low hips, are clear indications of the influence of the art of the Amarna Period, whose influence was still felt at this time.

The arms were made separately from the body and emphasize the dynamism of the hunting pharaoh: in his right hand he grips the long spear while in his left he holds a coil of rope made from rolled bronze which he will use to capture the defeated animal.

Tutankhamun is wearing a pleated kilt, knotted at the front. The cloth realistically falls from his body in various levels and opens in a fan-like fashion. The striding pose of the statue means that the narrow pleats of the cloth cling tightly to the thighs, allowing the underlying musculature to show. The pharaoh wears thong sandals that were part of his official costume.

The front foot is flat on the papyrus raft while the rear is poised on the tips of the toes, in a realistic portrayal of the pose of someone taking aim and preparing to throw a spear.

The narrow vessel on which the king is sailing is typical of the simple rafts made of papyrus used by the ancient Egyptians. It is painted green, with both prow and stern in the form of papyrus flowers with gilded petals. The raft is attached to a rectangular pedestal painted black that supports the entire sculptural composition. (S.E.)

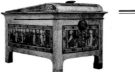

GILDED WOODEN BOX

WOOD, PAINTED AND INLAID, FAIENCE
HEIGHT 39 CM; LENGTH 49.5 CM; VALLEY OF THE KINGS, TUTANKHAMUN'S TOMB
(KV 62); DISCOVERED BY H. CARTER (1922)
EIGHTEENTH DYNASTY, REIGN OF TUTANKHAMUN (1333–1323 BC)

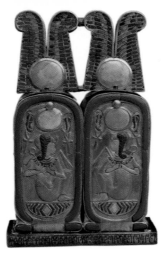

Numerous boxes, caskets and chairs were found piled haphazardly in the western corner of the Antechamber, just as they had been left after the tomb had been ransacked by robbers in antiquity. The containers were almost all rectangular in shape, with lids that were either flat or vaulted, or had triangular pediments.

With the exception of examples in calcite and reed, the majority were made of wood, inlaid with

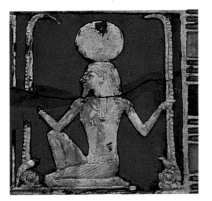

ivory, gold leaf, turquoise or glass paste. In many cases a hieratic or hieroglyphic inscription indicated function and contents, followed by the name of the king and the ritual verse which wished for 'life, strength and health' for the king.

This box takes the form of a rectangular chest supported on simple square feet and closed with a vaulted lid in imitation of the earliest shrines of Upper Egypt. Two large button-like knobs in blue faience, one on the curved part of the lid and the other in the centre of the upper part of the front, were used to fasten the casket by means of a cord tied round them.

The decoration is rich and elegant, with two colours dominating the overall effect. A chequered frame runs around the main figurative panels and creates an attractive contrast with the bright blue faience inlays on the gilded surfaces.

The decoration in the long side panels consists of a series of five royal cartouches set between *uraei* surmounted by the solar disc. In the cartouches the king's birth name, Tuthankhamun, alternates with his coronation name *Nebkheperure*. These same two cartouches are also found in the panels of the front and rear short sides. Here they are placed centrally and flanked by the protective figures of Heh, holding symbols denoting millions of years, arranged symmetrically either side. (R.P.)

OINTMENT CONTAINER

GOLD, SILVER, SEMIPRECIOUS STONES, GLASS PASTE
HEIGHT 16 CM; WIDTH 8.8 CM; DEPTH 4.3 CM
VALLEY OF THE KINGS, TUTANKHAMUN'S TOMB (KV 62)
DISCOVERED BY H. CARTER (1922)
EIGHTEENTH DYNASTY, REIGN OF TUTANKHAMUN (1333–1323 BC)

This unusual ointment container in the form of a double cartouche was used to hold unguent, traces of which were found still inside it. The base is made of a rectangular plate of silver with the edges decorated with a frieze of *ankh* hieroglyphs flanked by two *was* sceptres, the symbol of power. The external surfaces of the receptacle are inlaid with glass paste and semiprecious stones.

The twin containers fixed to the base are made of gold and each take the form of the royal cartouche. Both are surmounted by tall plumes decorated with inlays of red and blue glass paste. In the centre of each pair of plumes is a solar disc. The pairs of plumes are linked by

two gold elements and act as the handle of the lid that closes the container.

Rather than the hieroglyphs composing the name of the pharaoh, the two cartouches contain images of the king sitting on the *heb* hieroglyph. He is dressed in a long robe, wears a broad-collar necklace and holds the royal insignia in his hands – the sceptre and the flail. On his forehead is the cobra, the symbol of pharaonic power. Above the king's head is a solar disc from which two royal cobras emerge, with *ankh* hieroglyphs around their necks. The exposed parts of the king's body are yellow, inlaid with the same material as the solar discs.

The two sides of the cartouches differ in small details. On one side the pharaoh is depicted with the long black braid traditionally worn by young boys, and with his arms folded on his chest. On the other side, he is wearing the Blue Crown and rests both hands on his knees. In one case the crown and the face of the pharaoh have taken on a strange black colouring.

The side walls of the container have the same embossed scene: the god of eternity Heh is kneeling on a *heb* hieroglyph and is holding two palm-tree branches, symbols of millions of years, while from one of his elbows hangs the *ankh* hieroglyph. At the shoulders are two cartouches surmounted by a solar disc that contain the names of Tutankhamun. A winged scarab is depicted above the head of the god Heh. The scarab grips a solar disc between its front legs and the *neb* hieroglyph between its back legs. This symbol is one of the three elements that form the hieroglyphic representation of the coronation name of the king, *Nebkheperure*. The symbolism in the decoration of this container formed a wish for long life and eternal rule for the king. (S.E.)

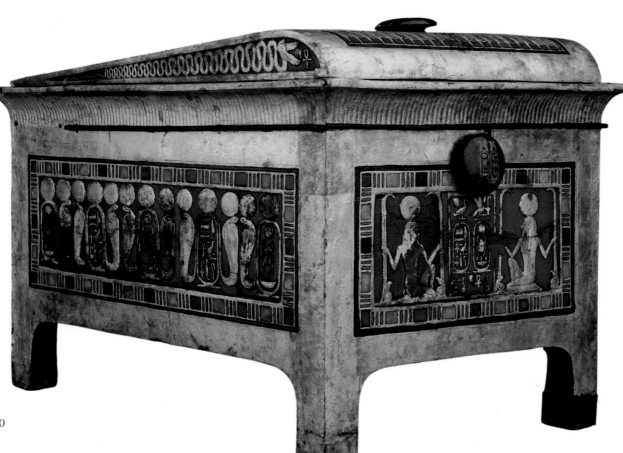

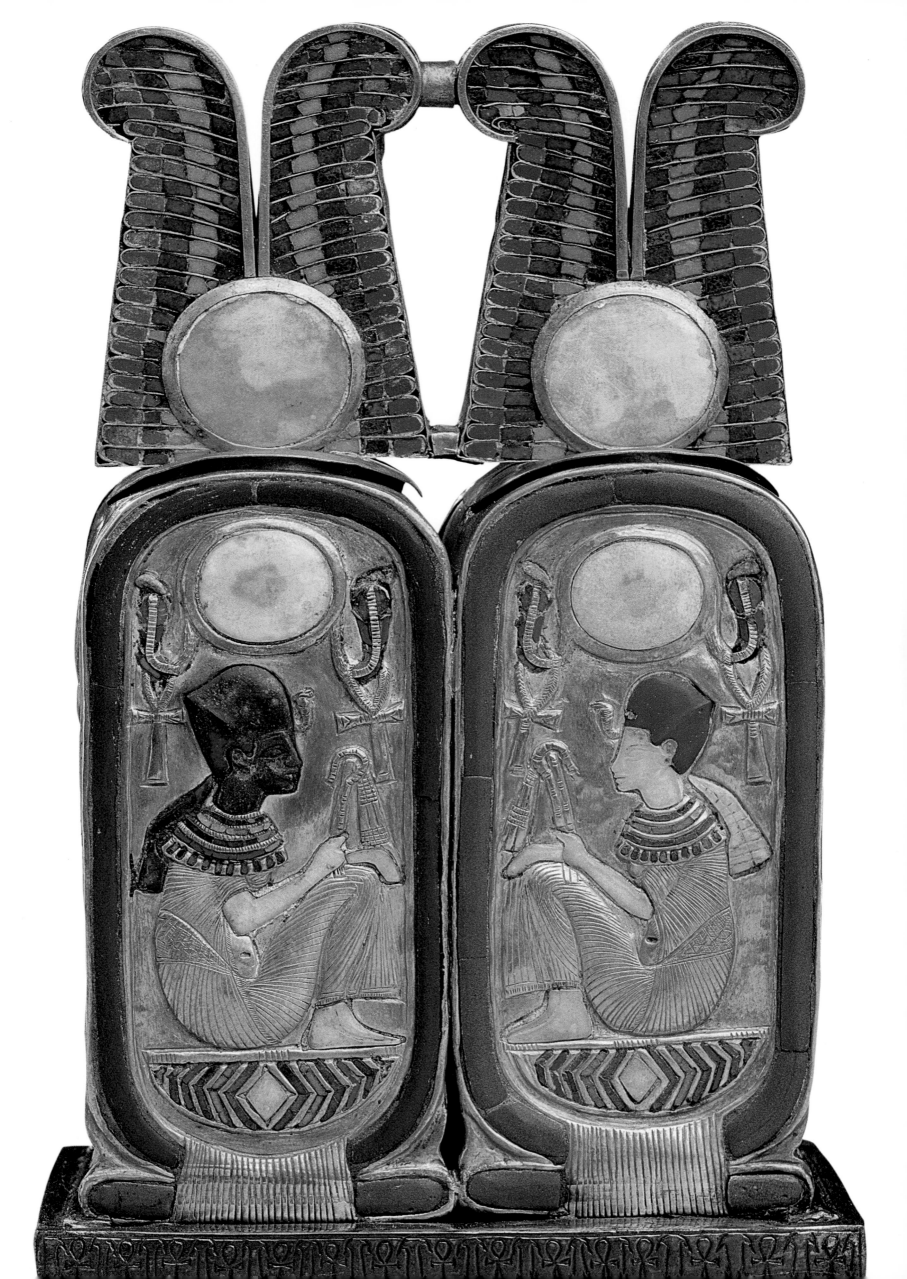

GAME-BOX

EBONY AND IVORY
GAME TABLE: HEIGHT 8.1 CM; WIDTH 16 CM; LENGTH 46 CM
SUPPORT: HEIGHT 20.2 CM; LENGTH 55 CM; VALLEY OF THE KINGS
TUTANKHAMUN'S TOMB (KV 62); DISCOVERED BY H. CARTER (1922)
EIGHTEENTH DYNASTY, REIGN OF TUTANKHAMUN (1333–1323 BC)

This elegant game-box made up of separate pieces is the largest of the four discovered in the Annexe of Tutankhamun's tomb. It takes the form of a box resting on a base supported by four leonine legs, partially covered with gold leaf and fixed to a sled.

The upper surface of the board was laid out for the game of *senet* with an ivory surface subdivided by means of strips of wood into thirty squares, five of which carry inscriptions. There are the same number of squares in ivory on the lower surface of the box, three of which are inscribed. This side was used for the game *tjau*.

On one of the short sides is an opening for the drawer, discovered empty and separate from the box. This would once have contained the pieces used for the games, which were probably removed by thieves as they would have been made of precious materials.

The four sides of the box feature yellow hieroglyphic inscriptions with phrases hoping for the well-being of Tutankhamun, to whom the board belonged. The pharaoh's names and complete titles are recorded.

The rules of the two games played on this board are unknown, but it is probable that the two competing players had to move their pieces around the board after throwing a stick or a form of dice.

Senet was very popular in Egypt from the most ancient times. Boards were frequently placed in tombs to allow the deceased to continue playing after their deaths. The game also had a magical-religious significance and in tomb paintings and in the Book of the Dead the deceased appears seated alone, intent on playing an invisible adversary in a scene symbolizing his successful passage to the spiritual world. (S.E.)

THE 'PAINTED BOX'

WOOD, GESSOED AND PAINTED
HEIGHT 44 CM; LENGTH 61 CM; WIDTH 43 CM
VALLEY OF THE KINGS, TUTANKHAMUN'S TOMB (KV 62)
DISCOVERED BY H. CARTER (1922)
EIGHTEENTH DYNASTY, REIGN OF TUTANKHAMUN (1333–1323 BC)

The high level of artistic skill achieved by craftsmen in general in the New Kingdom, and carpenters in particular, finds magnificent testimony in this sandal casket discovered on the floor of the Antechamber of the tomb of Tutankhamun, not far from one of the two *ka* statues. The decoration, in six symmetrical scenes, anticipates one of the fundamental themes in figurative art in the temples of the Nineteenth Dynasty – the pharaoh in battle defeating his enemies.

In each of the two principal scenes, on the long sides of the casket and enclosed in a frame of a chequer-pattern and a floral frieze, the dominant figure is that of Tutankhamun in his chariot. He drives the chariot with the reins tied around his waist, leaving his hands free to shoots arrows into the confused mass of his enemies. The pharaoh, followed by the ordered ranks of his army, represents the guarantor of order, while the enemy hordes (Nubians on one side, Asiatics on the other) personify chaos. The figure of the king, surmounted by a narrow strip of sky

and protected by a solar disc and two vulture symbols of the goddess Nekhbet, is wearing the Blue Crown (*khepresh*), a bodice-like garment of crossed straps decorated with an *usekh* necklace, a short kilt with a broad belt around the waist, and a quiver slung over his shoulders. The magnificent pair of galloping horses have plumes on their heads and decorated covers on their backs.

Two pairs of decorative scenes, similar in significance, occupy the remaining surfaces: on the short sides the king is represented in the aspect of a sphinx, trampling the northern and southern enemies, while on the lid, divided into two registers, the motif of the long sides is repeated. The pharaoh is again triumphant and shooting arrows at his enemies from his moving chariot. This time the enemy figures are symbolized by the wild animals typically hunted in the desert: lions, antelopes, gazelles, hyaenas, wild monkeys and ostriches.

The casket was closed by means of ties that were attached to the knobs that can be seen on the lid and the short sides. (R.P.)

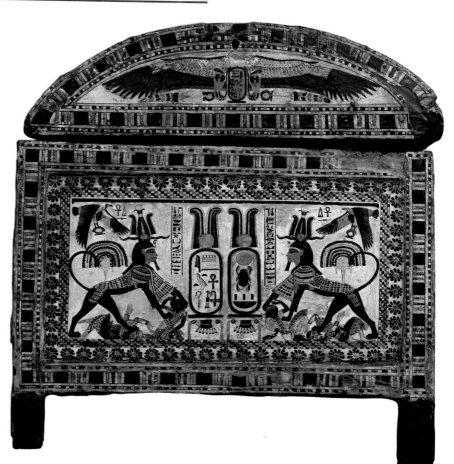

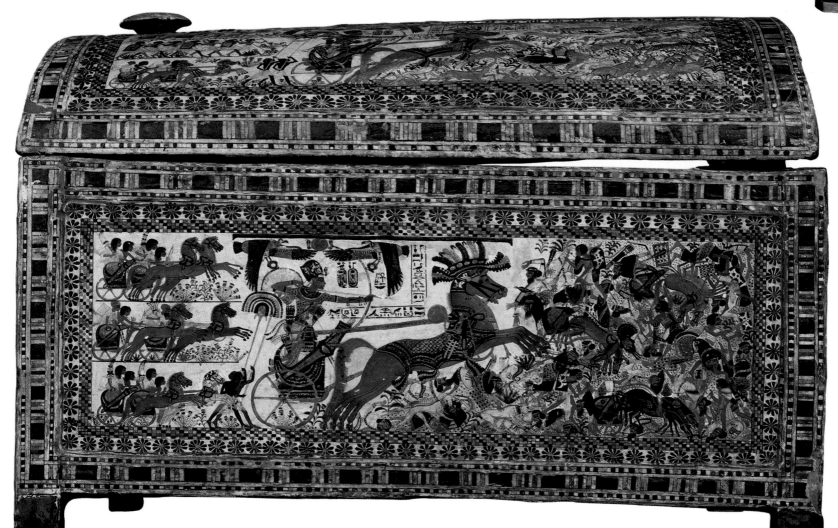

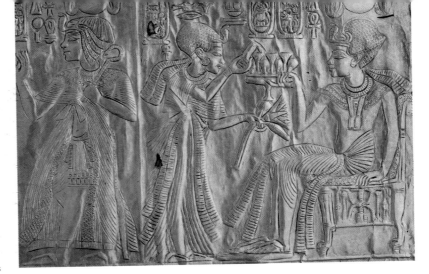

JE 61481

SMALL GILDED SHRINE

GILDED WOOD (SHRINE) AND SILVER (SLED)
HEIGHT 50.5 CM; WIDTH 30.7 CM; DEPTH 48 CM
VALLEY OF THE KINGS, TUTANKHAMUN'S TOMB (KV 62); DISCOVERED BY H. CARTER
(1922); EIGHTEENTH DYNASTY, REIGN OF TUTANKHAMUN (1333–1323 BC)

Discovered still standing on a silver-covered sled in the Antechamber of the tomb of Tutankhamun, this wooden shrine is covered in gold foil applied to a layer of gesso. Its shape, with the roof sloping down from front to rear and the projecting cornice at the top of the walls, recalls the ancient shrine of Upper Egypt.

A double door opens on one of the short sides, fastened with two ebony latches running through gold rings. A cord would once have passed through two loops and been sealed with clay.

Inside the shrine is a gilded wooden support for a statuette, which was probably made of solid gold and removed by grave robbers. The base still carries the marks of the feet, while the name of Tutankhamun is inscribed on the back pillar. On the floor lay the remains of a corslet, fragments of which were found scattered elsewhere in the tomb. Alongside, wrapped in a piece of cloth, there was also a necklace consisting of large beads of gold, carnelian, green feldspar and blue glass, with a gold pendant depicting the human-headed serpent goddess Werethekau ('The Great Enchantress') suckling the young king.

On the roof of the shrine the decoration consists of a winged solar disc at the front and two rows of images of the vulture goddess Nekhbet, with her outspread wings protecting the cartouches of the king and his wife. Two winged serpents with long, sinuous bodies are depicted on the sides of the roof and hold in front of them the *shen* hieroglyph, symbolizing eternity. The lintel above the door also features a winged solar disc, while the cornice above is incised with a continuous series of vertical lines.

The external walls and the doors are subdivided into eighteen panels framed by hieroglyphic inscriptions, with scenes of Tutankhamun and his wife in various aspects of their married life, a theme that recalls the

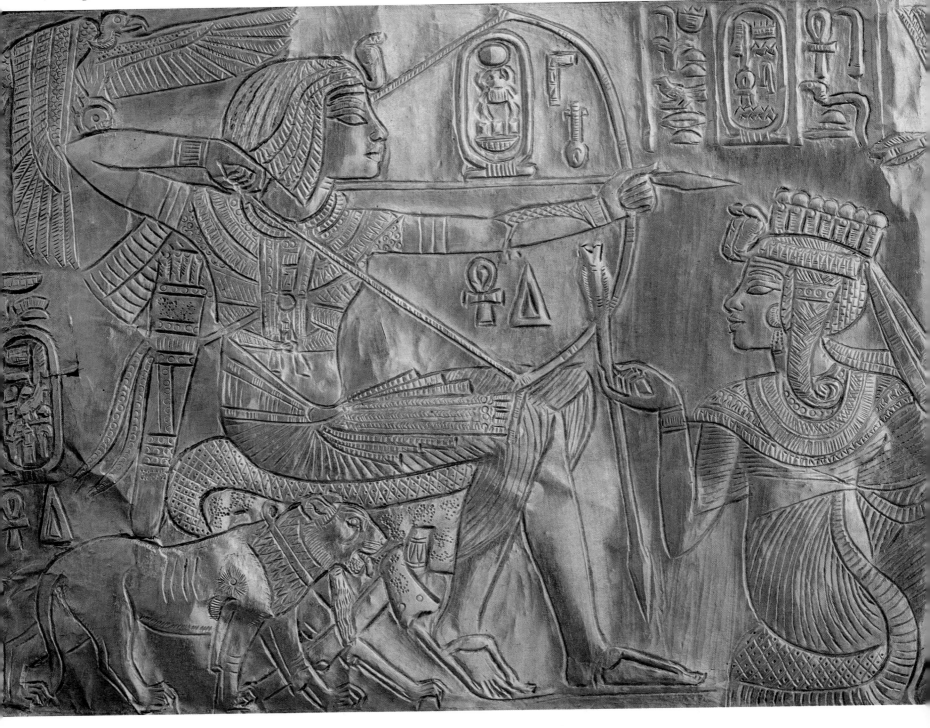

scenes of the Amarna Period. However, it is not only the contents of the various scenes that recall the art of Akhenaten, but also their style, which is characterized by the fineness, grace and sophistication of the modelling. The couple, adorned with jewels and dressed in finely pleated, close-fitting clothing, appear in various situations that reveal their affection for each other, all pervaded by a sense of absolute peace and serenity.

The left wall is divided into four panels. In the bottom left Ankhesenamun crouches before the seated Tutankhamun and is receiving a liquid poured by her husband into her hands from a small vessel. In the other scenes Tutankhamun, always seated on his throne, is portrayed receiving various objects from his wife.

On the right-hand wall, divided into two registers, Tutankhamun is seen hunting birds in a swamp, again in the company of the queen. The rear wall and the doors, both

inside and out, are decorated with scenes in which Ankhesenamun is making offerings in the presence of her husband.

The entire decorative scheme of the shrine has strong symbolic connotations associated with both the religious and political spheres. The intimate ties between the pharaoh and his bride represent the serene relationship between god and man. For this reason it is almost always the queen who is the active figure – she embodies the concept of humanity paying homage to the celestial being personified by Tutankhamun. The hunting scene can be interpreted as a symbolic episode referring to the pharaoh's role in the maintenance of the cosmic order and his constant fight against chaos (symbolized by the birds in the swamp).

Because of the images of the king identified as a god, this statue shrine thus also becomes a reproduction of a shrine dedicated to the cult of a divinity. (S.E.)

215

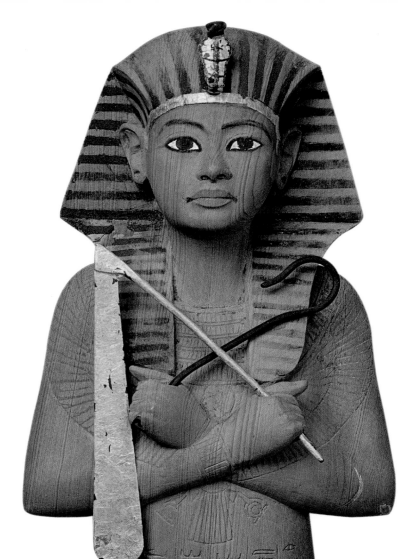

SHABTI OF TUTANKHAMUN
WOOD, GOLD, BRONZE; HEIGHT 48 CM
VALLEY OF THE KINGS, TUTANKHAMUN'S TOMB (KV 62)
DISCOVERED BY H. CARTER (1922)
EIGHTEENTH DYNASTY, REIGN OF TUTANKHAMUN (1333–1323 BC)

The term *shabti* derives from the ancient Egyptian meaning 'answerer', and refers to the moment when the deceased is called upon to perform hard labour in the fields of the underworld. Tutankhamun's tomb contained 413 *shabti* figures; only relatively few of which where inscribed. Of the total number, 236 were found in the Annexe, 176 in the Treasury and just one in the Antechamber. They had originally been kept in wooden caskets with inlays of beaten gold or bronze. The *shabtis* were made from a variety of materials, including wood that was gessoed and painted, and stone.

The larger *shabti* figures varied in form, size and attributes. They were differentiated above all by their headdresses (the Red Crown of the North, the White Crown of the South, the *nemes*, the *afnet* headcloth and a type of cylindrical helmet) and inscriptions. The statuettes portray a figure with youthful features.

The *shabti* seen here shows the king wearing a blue and gold striped *nemes*, with two flaps at the front and a uraeus. Tutankhamun holds a *heqa* sceptre and a flail. His thin face has slightly raised black eyebrows, almond-shaped eyes painted black and white, a small nose, and a wide mouth with full lips. A *usekh* collar hangs around his neck. Six columns of hieroglyphs with Chapter 6 of the Book of the Dead cover the lower part of the statuette.

These statuettes were considered to be substitutes for the deceased and were called upon to perform the gruelling tasks of the afterlife in his place. (R.P.)

SHABTI FIGURE WITH BLUE CROWN
GILDED CEDAR-WOOD; HEIGHT 48 CM
VALLEY OF THE KINGS, TUTANKHAMUN'S TOMB (KV 62)
DISCOVERED BY H. CARTER (1922)
EIGHTEENTH DYNASTY, REIGN OF TUTANKHAMUN (1333–1323 BC)

The number of *shabti* figures present in each tomb varied considerably through time and in relation to the social standing of the owner. Among the *shabti* figures of Tutankhamun are a number that carry the names of officials of his court. These would have been donated by the people concerned, who, in this way, expressed their desire to continue to serve the king even after his death.

Of the 413 *shabti* figures in Tutankhamun's tomb, 365 are labourers, 36 foremen and 12 overseers. The labourers (one for each day of the year) were sub-divided into teams of 10 individuals, each led by a foreman. The work was overseen by a supervisor, the 12 statues corresponding to the months of the year.

This *shabti*, larger than average, is a fine example of small-scale wooden sculpture. The figure is standing in the traditional Osirian pose with the arms crossed over the chest and the hands gripping the symbols of power, the sceptre and flail, the latter made of gold. The face is clearly that of Tutankhamun and is surmounted by a massive black crown from which the large ears emerge. A broad gilded band crosses the forehead, with a gilded cobra set above it. A necklace in gold leaf is shown on the chest and also covers the back of the shoulders.

The body of the figure appears to be bound like a mummy. A double column of hieroglyphs contains an abbreviated version of Chapter 6 of the Book of the Dead. Another inscription incised below the feet of the statue indicates that this *shabti* figure was a gift from the general of the army Minnakht on the occasion of the funeral of Tutankhamun, whose cartouche with his coronation name *Nebkheperure* also appears. (S.E.)

THE GOLDEN THRONE

WOOD, GOLD LEAF, SILVER, GLASS PASTE, SEMIPRECIOUS STONES
HEIGHT 102 CM; WIDTH 54 CM; DEPTH 60 CM; VALLEY OF THE KINGS
TUTANKHAMUN'S TOMB (KV 62); DISCOVERED BY H. CARTER (1922)
EIGHTEENTH DYNASTY, REIGN OF TUTANKHAMUN (1333–1323 BC)

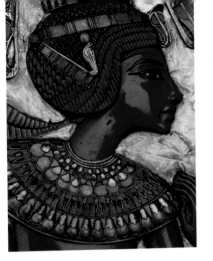

This throne was probably produced in the early years of the reign of Tutankhamun, prior to the religious counter-reformation that marked the definitive end of the Amarna Period.

The fabulous scene decorating the backrest is dominated by Aten, the solar disc, whose cult had spread rapidly during the reign of Akhenaten. Its rays end in tiny hands and dispense life to the young royal couple.

The inscriptions contain the name of the married couple in the Amarna form, with Tutankhamun written as Tutankhaten ('The Living Image of Aten') while the king's wife is given the name Ankhesenpaaten ('Her Life is Aten'). The style of the throne is also typical of the Amarna Period. The gracefulness of the forms combines well with the rich decoration and the luminosity of the colours, resulting in a composition of exquisite craftsmanship.

The scene on the backrest depicts the king relaxing on his throne with his feet resting on a low stool with cushions. He is wearing a short wig surmounted by a composite crown and the typical pleated robe of the time, which left his prominent stomach uncovered, another feature typical of the Amarna period.

Ankhesenamun stands in front of the king, rubbing ointment on the left shoulder of her young consort. The queen is leaning slightly forwards and in her left hand she holds the cup containing the unguent. She is wearing a wig cut diagonally at the back and surmounted by a crown featuring the emblem of the goddess Hathor (a diadem of *uraei* on which a solar disc rests, enclosed within a pair of horns, and from which two tall plumes project). The queen's pleated robe in silver features a subtle play of transparencies around her legs.

Behind the queen is a small table with long legs on which a necklace has been placed. The entire scene is enclosed within an elaborate frame of floral motifs, open in the upper centre section where the Aten solar disc is situated.

The arms of the throne are in the form of two winged and crowned serpents holding the cartouche of Tutankhamun in front of them. The legs, which were linked at the front and rear with a heraldic motif symbolizing the union of Upper and Lower Egypt, terminate in leonine paws. Two lions' heads also emerge from the front section of the throne. The rear of the backrest is decorated with a frieze of *uraei*. (F.T.)

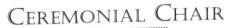

CEREMONIAL CHAIR

EBONY, IVORY, GOLD LEAF, STONE, FAIENCE
HEIGHT 102 CM; WIDTH 70 CM; DEPTH 44 CM; VALLEY OF THE KINGS
TUTANKHAMUN'S TOMB (KV 62); DISCOVERED BY H. CARTER (1922)
EIGHTEENTH DYNASTY, REIGN OF TUTANKHAMUN (1333–1323 BC)

This chair was found in the Annexe, together with a mass of other furnishings. Its form is fairly unusual in that it is actually a stool to which a back has been added. The sides of the curved seat extend beyond the edges of the sloping backrest which descends vertically to the ground.

The surface is entirely decorated with inlays. Along the top of the backrest runs a frieze of *uraei*, at the centre of which is a cartouche with the name of the god Aten surmounted by a solar disc. Below this, a vulture goddess spreads her wings and grips a *shen* hieroglyph and two fans in her talons. The vulture is set between two pairs of cartouches in which Tutankhamun is named as *Nebkheperure* Tutankhaten. The lower part of the backrest features a series of columns of text alternately in ebony and ivory, with the titles of the king. Here his name appears in the later form of Tutankhamun in the horizontal bands of ebony framing the panel.

The appearance of the king's name in its earlier Aten form and the depiction of the deity on the backrest would seem to date the creation of the chair to the early years of the reign of Tutankhamun, before the religious counter-reformation had taken place. However, the fact that the later name of the king also appears conflicts with this interpretation. An explanation for the presence of both forms of the name of the pharaoh may be that the two bands of ebony were applied at a later date, after the chair had been damaged.

The seat, on which a cushion would have been placed, also features inlaid decoration imitating the skin of a spotted animal, probably a leopard. It is supported on slim, elegant legs terminating in ducks' heads, also made of ebony and ivory. The space between the legs and the lower part of the backrest below the seat features the heraldic motif representing the union of Upper and Lower Egypt.

The upper side of the associated footstool is decorated with images of the Nine Bows, figures of foreigners with their hands tied behind their backs, representing the enemies of Egypt. (F.T.)

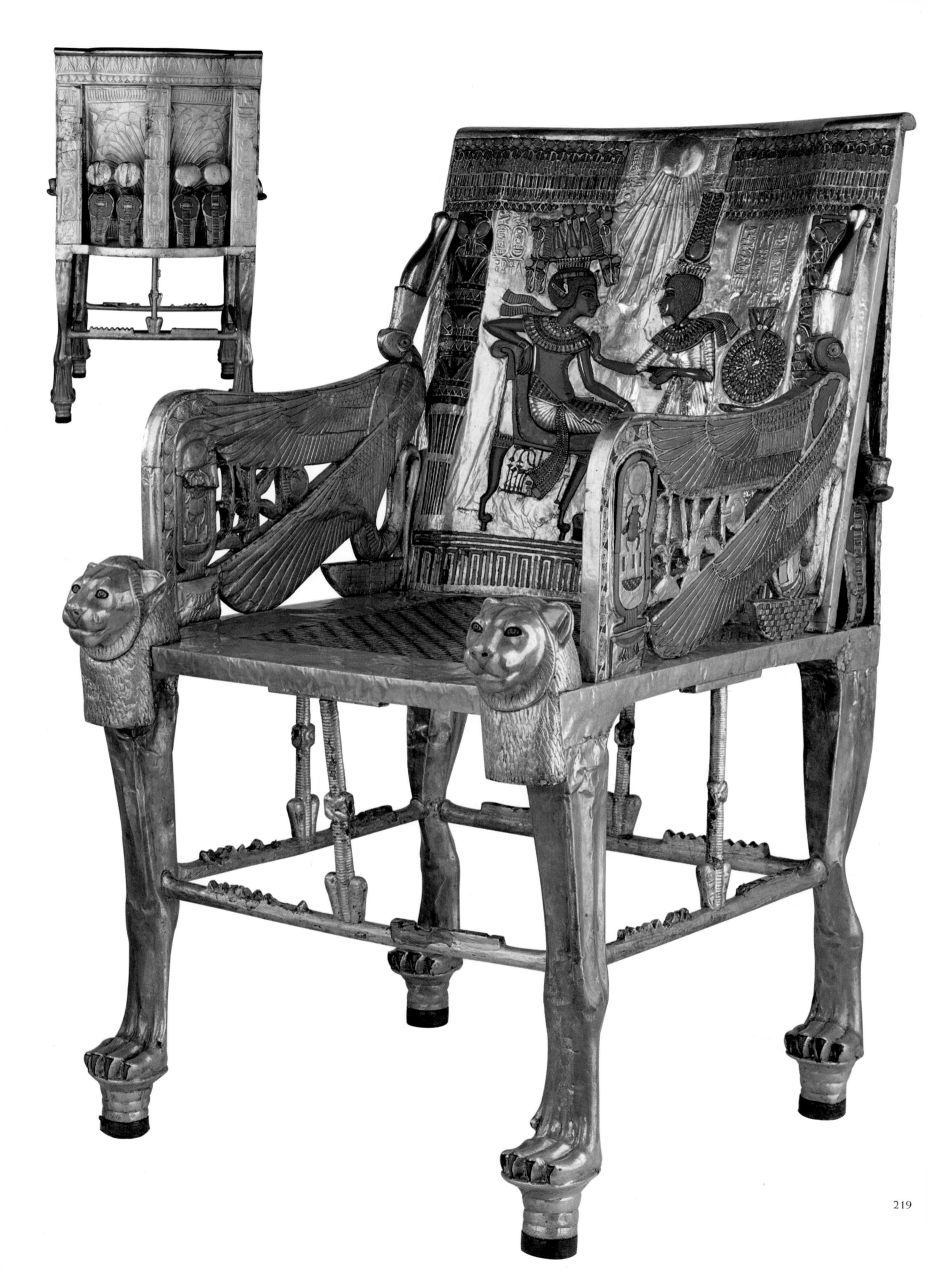

JE 62120

BASIN WITH A BOAT
...
CALCITE, GOLD, SEMIPRECIOUS STONES, IVORY AND GREEN, RED AND BLUE GLASS PASTE
LENGTH 58.3 CM; HEIGHT 37 CM; VALLEY OF THE KINGS, TUTANKHAMUN'S TOMB
(KV 62); DISCOVERED BY H. CARTER (1922)
EIGHTEENTH DYNASTY, REIGN OF TUTANKHAMUN (1333–1323 BC)

Carter found this object made from delicate, transparent calcite in the Annexe of the tomb. Its function is unknown, but a number of suggestions have been put forward. It might have been a perfume holder or unguent vase, or, according to Carter himself, a centrepiece for celebratory ceremonies and banquets since when it was discovered it was decorated with garlands of flowers and fruit.

The elaborate piece is composed of a boat mounted on a pedestal which is decorated with papyrus stems, buds and flowers and set within a rectangular basin. The basin takes the form of the top of a building with a projecting cornice and rests on four short cylindrical feet. The exterior and upper rim of the basin are decorated with chequered and garland motifs in gold and multicoloured glass paste. The side corresponding to the prow of the boat also carries three cartouches containing, respectively, the birth name (Tutankhamun) and the coronation name (*Nebkheperure*) of the king, and the name of his wife Ankhesenamun. Each cartouche rests on the hieroglyph for gold and is surmounted by two tall feathers, which, in the two cartouches of the king, have a solar disc at the centre. At either side of the three names are two small cobras, each with a crown on its head (of Upper and Lower Egypt), supported by the symbolic plants of a unified Egypt, the papyrus and the lotus flower.

The boat has graceful lines: the prow and stern terminate in ibex heads, both facing in the same direction, the one at the stern shown as if twisted through 180°. The horns of the two animals are real, their facial features are painted a dark tone, and the necks are attached to the boat with gold collars inlaid with multicoloured glass paste.

At the centre of the boat rises a small kiosk with a roof similar to that of a shrine and supported by four columns with double capitals composed of a papyrus set in a lotus flower. The four sides of the kiosk are closed with walls that reach up to the stems of the columns and are embellished with plant and geometric motifs.

A naked young girl is seated at the prow of the boat, clasping an ivory lotus flower to her breast in her left hand. Her short curly wig is carved from a hard grey stone. She is wearing a pair of gold earrings, two bracelets of inlaid gold around her wrists, and two armlets above her elbows. At the stern is the unusual figure of a naked dwarf who, when the piece was discovered, was gripping a pole: this is the helmsman of the boat. His hair is identical to that of the young woman seated at the prow and he is similarly wearing two bracelets at his wrists and two armlets above his elbows.

The artisan responsible for this piece was clearly an attentive observer of the physical features of the two figures and created an elegant, harmonious object that is well suited to the undoubtedly ornamental function for which it was intended. (S.E.)

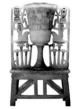

JE 62111

CHALICE-SHAPED LAMP

CALCITE; HEIGHT 51.4 CM
VALLEY OF THE KINGS, TUTANKHAMUN'S TOMB (KV 62)
DISCOVERED BY H. CARTER (1922)
EIGHTEENTH DYNASTY, REIGN OF TUTANKHAMUN (1333–1323 BC)

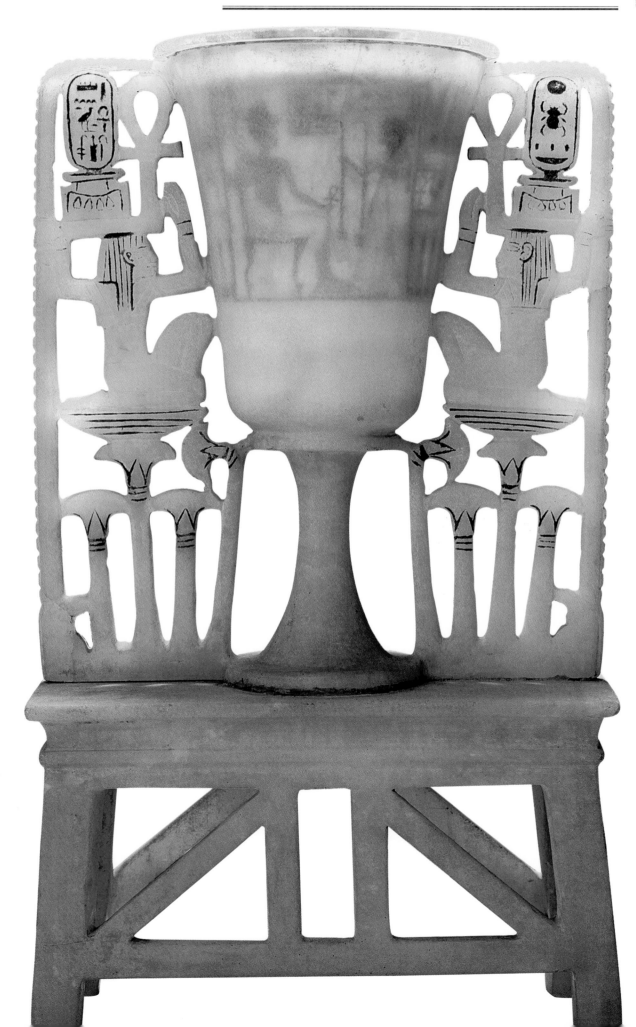

Among the many and varied objects in the funerary assemblage of Tutankhamun arranged around his great shrine in the Burial Chamber, Carter discovered this unique and beautiful lamp. It was made in the form of an elaborate chalice and was composed of a number of elements carved from translucent calcite.

The cup takes the form of an open lotus flower and is flanked on both sides by rich, openwork decoration in which the god Heh is depicted kneeling on a number of papyrus plants with his arms raised. With one hand he is holding a palm branch (the hieroglyphic symbol for 'a year') that forms one edge of the scene, while the other touches an *ankh* symbol placed alongside the king's cartouche. The two cartouches, set above the hieroglyph signifying gold, contain the birth name of the king, Tutankhamun, and his coronation name *Nebkheperure*. The elaborate decoration contains the wish for unity and a long reign for the king.

The cup was intended to be filled with oil (perhaps sesame oil) in which a wick floated. It is only when the lamp is lit that sophisticated painted scenes are visible. On one side Tutankhamun, seated on his throne, receives from Ankhesenamun two long palm branches symbolizing 'millions of years'. On the other side appear cartouches with two of the names of the king set between horizontal bands of plant motifs.

This surprising effect is achieved by means of a smaller version of the cup set within the external shell. The decoration was painted on its outer surface and is only visible thanks to the light shed by the burning wick.

The lamp rests on a simple support made from a single block of calcite sculpted in the form of a small, low table. (S.E.)

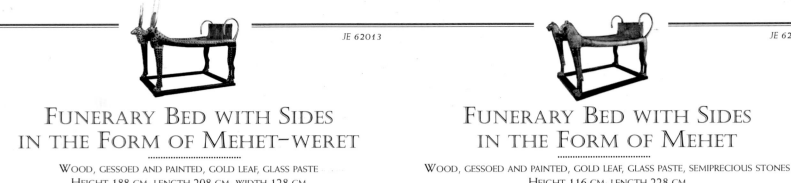

FUNERARY BED WITH SIDES IN THE FORM OF MEHET-WERET

WOOD, GESSOED AND PAINTED, GOLD LEAF, GLASS PASTE
HEIGHT 188 CM; LENGTH 208 CM; WIDTH 128 CM
VALLEY OF THE KINGS, TUTANKHAMUN'S TOMB (KV 62)
DISCOVERED BY H. CARTER (1922)
EIGHTEENTH DYNASTY, REIGN OF TUTANKHAMUN (1333–1323 BC)

FUNERARY BED WITH SIDES IN THE FORM OF MEHET

WOOD, GESSOED AND PAINTED, GOLD LEAF, GLASS PASTE, SEMIPRECIOUS STONES
HEIGHT 116 CM; LENGTH 228 CM
VALLEY OF THE KINGS, TUTANKHAMUN'S TOMB (KV 62)
DISCOVERED BY H. CARTER (1922)
EIGHTEENTH DYNASTY, REIGN OF TUTANKHAMUN (1333–1323 BC)

The tomb of Tutankhamun contained seven beds – four were practical and functional and may have been used by the king, while the other three were ritual couches. They are much taller than the others and had been specially made for the burial ceremonies. Three identical beds are also depicted on the walls of the tomb of Seti II. This demonstrates that the role of such couches was considered to be of such importance that it remained part of funerary rites that were practised over a hundred years apart.

The three funerary beds were found in the Antechamber of Tutankhamun's tomb, placed lengthwise along the wall in front of the entrance and facing the Burial Chamber. The photographs taken at the time of the discovery show them laden with offerings and other objects.

All three beds were made in a similar fashion. The sides were modelled in the form of the elongated bodies of three different animal deities. The first is in the form of a lioness and represents Mehet, a divinity embodying the destructive power of Isis and Hathor and whose anger had to be appeased each year in order to ensure the regular arrival of the Nile flood.

The second bed depicted an animal composed of the head of a hippopotamus covered with a wig, the body of a leopard, and the tail and crest of a crocodile. This monstrous combination represented the dreaded Ammut, the 'Devourer' of corpses who, in the Book of the Dead, is ready to swallow the deceased who fail to be 'justified' before the judgment of Osiris. Ammut also possessed a positive value: in the form of a pig he could personify Nut, the sky, and swallow the deceased so as to give birth to them once more and thus grant them eternal reincarnation.

The third bed has side pieces in the form of a young cow, representing Mehet-weret, 'The Great Flood', the goddess who was the first to emerge from Nun, the primordial ocean.

During the funeral ceremonies, the body was laid out on the three beds. In this way the deceased was brought into contact with the three deities and thus guaranteed the opportunity for rebirth each could offer. Ammut promised the eternal rebirth of the sun (swallowed at dusk by the night sky, which gave birth to it again the following dawn); Mehet the seasonal return of the Nile flood; and Mehet-weret the birth from the primordial ocean, thus combining the concepts expressed by the other two deities, given that the sun and the flood both originated with Nut.

The two heads of the cows representing Mehet-weret are surmounted by horns with solar discs at the centre. The eyes are those of the falcon-god Horus (*wedjat* eyes). The celestial aspect of this divinity is further emphasized by the black spots dotting the bodies, which can be seen in relation to the leopard skin frequently used as an image indicating the night sky.

The legs of the cows act as the legs of the bed itself and rest on a rectangular wooden framework that lends the piece great stability. The flat surface of the bed is composed of wood, gessoed and painted in imitation of woven vegetable fibres. A board, divided into three panels and covered with gold, is set between the elegant curving tails of the animals – this was at the foot end of the bed. The two side panels of this board are decorated front and rear with two *djed* symbols in relief (symbols of stability) while the central panels carry two Isis knots (connected with life).

The bed with effigies of Mehet recurs frequently in funerary iconography and is similar to the one over which Anubis bends during the mummification ceremony. The mane of the lioness is indicated by a short ruff which, like the whiskers, is incised in the gold. The nose and the streaks below the eyes are inlaid with blue glass, while the eyelids are in black glass. The eyes themselves are made from crystal, with the iris painted yellow. The black of the pupils comes from the background which was painted before the application of the crystal. (F.T.)

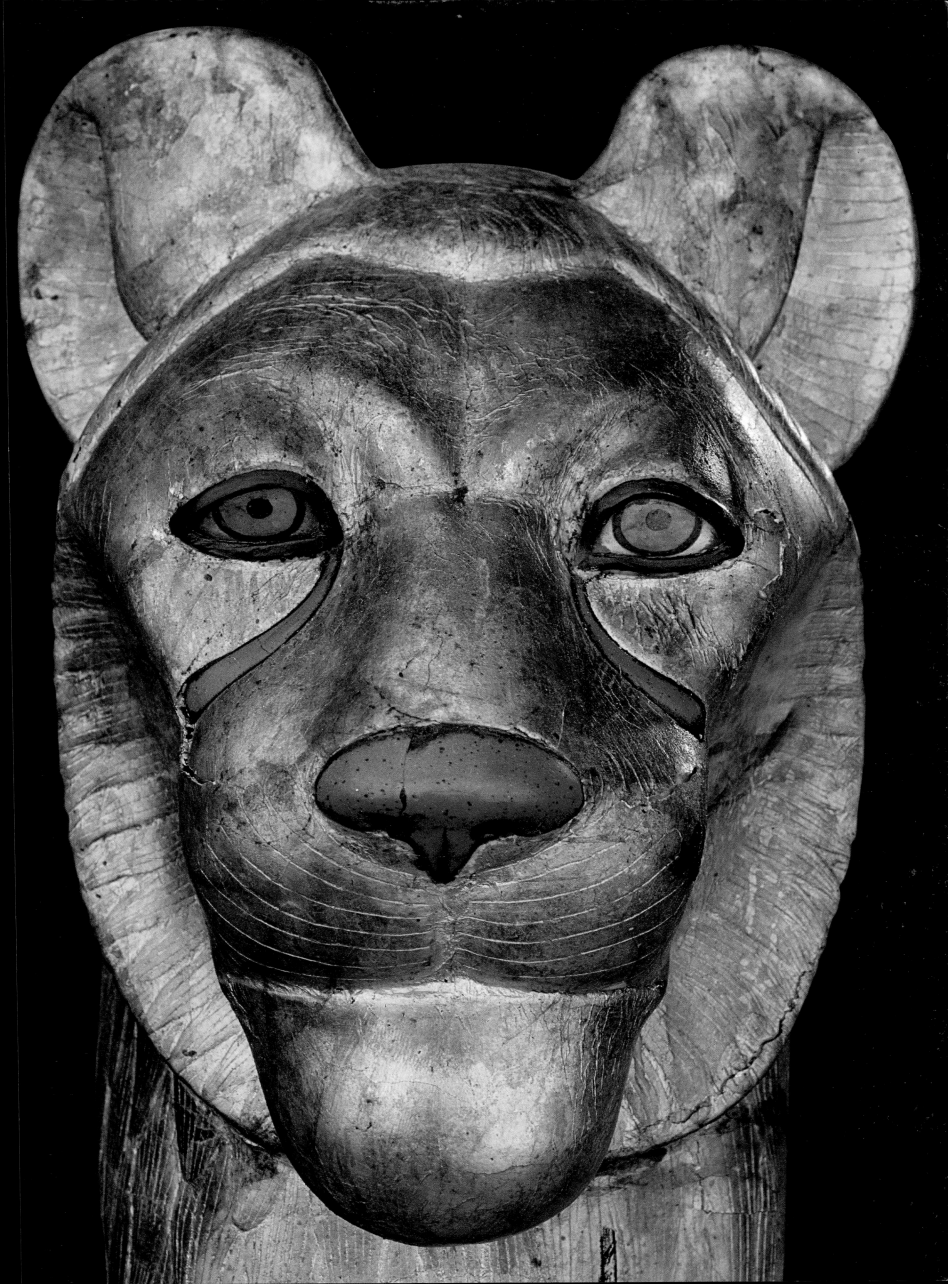

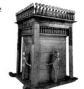

CANOPIC SHRINE

···································

WOOD, GESSOED AND GILDED, WITH INLAYS OF GLASS PASTE AND FAIENCE
HEIGHT 198 CM; LENGTH 153 CM; WIDTH 122 CM
VALLEY OF THE KINGS, TUTANKHAMUN'S TOMB (KV 62)
DISCOVERED BY H. CARTER (1922)
EIGHTEENTH DYNASTY, REIGN OF TUTANKHAMUN (1333–1323 BC)

An imposing and elaborate apparatus for housing the king's canopic vessels was placed against the east wall of the Treasury, facing the door to the Burial Chamber. It consists of a canopy protecting a shrine, the whole arrangement standing on a sled.

Inside the shrine was a chest of veined and translucent calcite; four heads also carved from calcite formed the lids for the four internal compartments. These in turn each contained a small gold mummiform coffin. Each coffin was the receptacle for the embalmed internal organs of the pharaoh.

The outer canopy of gilded wood is fixed to a sled that would have facilitated its movement and is composed of four corner pillars supporting a roof with a projecting cavetto cornice. The two outer sides of each pillar are decorated with hieroglyphic inscriptions carrying the names, titles and epithets of the pharaoh. The roof, which almost reached the ceiling of the Treasury, is surrounded by a parapet of *uraei* with solar discs on their heads.

Between one canopy pillar and the next is a standing goddess in gilded wood, facing inwards with arms outstretched in a gesture of protection. These statues depict the tutelary divinities of the deceased, Isis, Nephthys, Neith and Selkis, identifiable by the hieroglyphic symbols on their heads.

The four elegant and graceful statues are wearing caps from which long hair emerges to drape down their backs. The eyebrows, the outlines of the eyes and the pupils are painted in black, while the eyeballs are white. The heads of the statues are turned slightly to the left or right, breaking with the tradition of rigid frontal views typical of Egyptian art. This innovative style was the result of the Amarna influence, also seen in the long, slim, and slightly forward-tilting necks of the four figures and in the naturalistic modelling of their bodies, revealed rather than covered by the clinging and elaborately pleated robes they are wearing. The robes are fastened at the waist by bands knotted at the front and falling almost as far as the feet. Only one of the short, flared sleeves is visible; the other is hidden by an ample shawl knotted beneath the right breast, covering the left shoulder and arm. A broad necklace of multiple rows of beads is depicted around the neck of each goddess.

The canopy stands over the shrine of gilded wood, the cavetto cornice of which is surmounted by a second frieze of *uraei* with solar discs on their heads. Each wall is decorated with a large scene in shallow relief in which one of the four goddesses faces one of the Four sons of Horus and holds his hand. The space around the figures is occupied by hieroglyphic inscriptions expressing the hope for the protection of the pharaoh's organs. (S.E.)

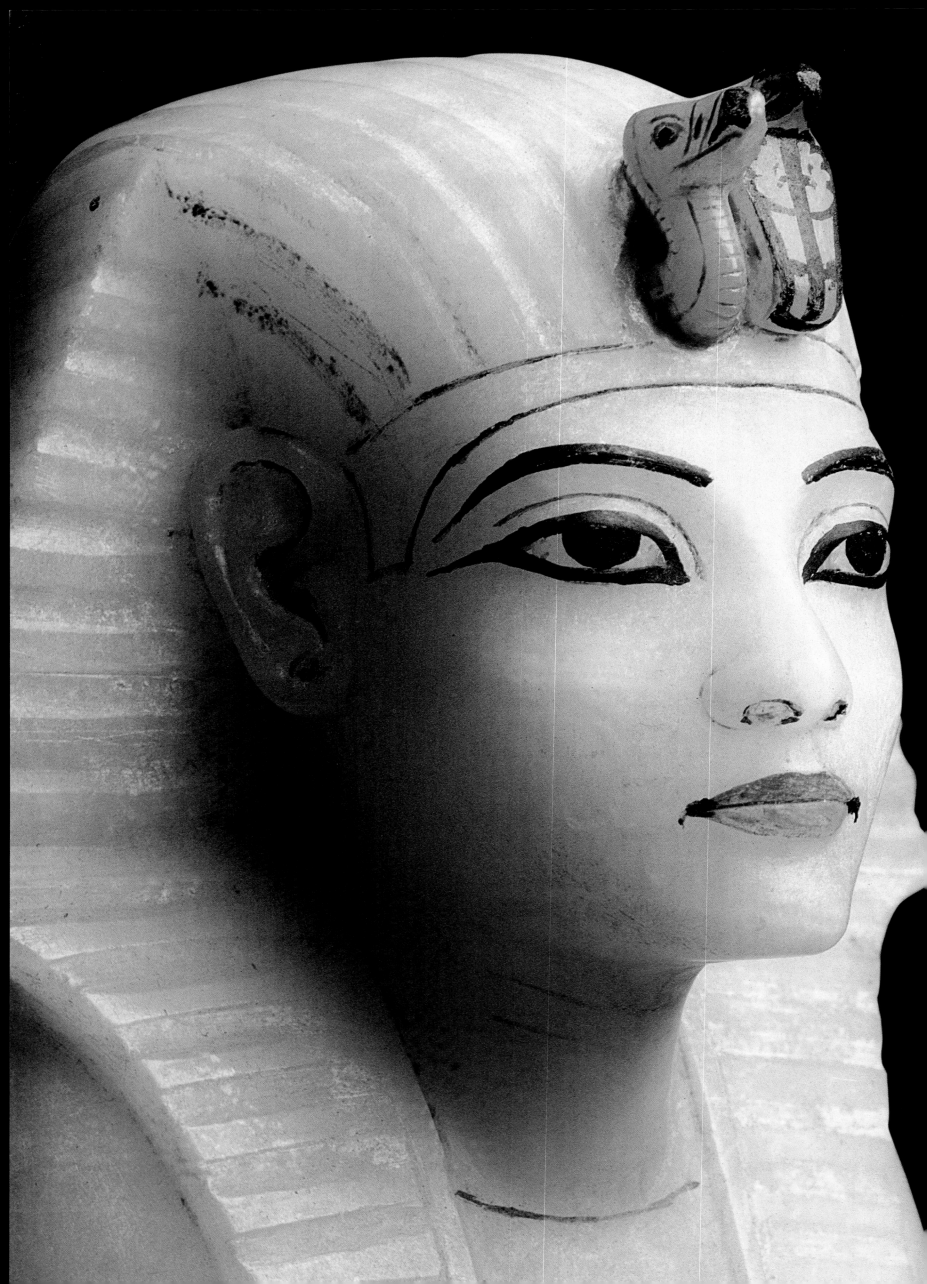

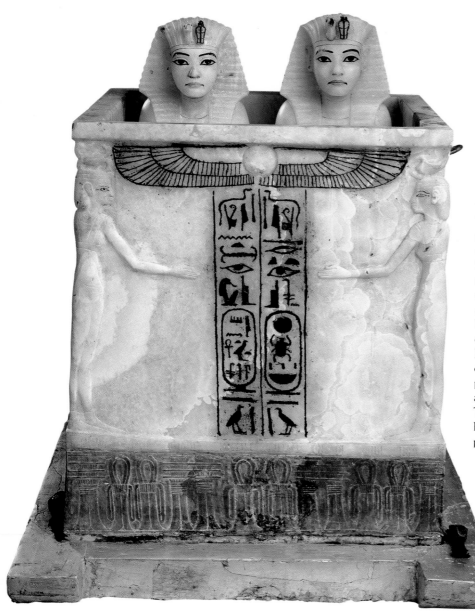

seal of the royal necropolis. This portrays the jackal-god Anubis crouched on top of nine chained prisoners who symbolize the enemies of Egypt.

The walls of the chest itself have a small projecting rim at the top and widen slightly towards the base. At the corners, carved in high relief, are the tutelary deities of the deceased: Isis, Nephthys, Neith and Selkis. These four slender goddesses appear to emerge from the veined calcite; their eyes are painted black and their arms are outstretched to hold the internal organs of the deceased in a protective embrace. Incised on the walls are columns of blue-painted hieroglyphs with prayers offered by the goddesses and sons of Horus on behalf of Tutankhamun, here represented by his cartouches. Surmounting the panel of inscriptions on the front wall is a large winged solar disc.

Around the base of the vessel runs a continuous frieze, covered with fine gold leaf, consisting of double *djed* and *tyt* symbols, emblems of

Osiris and Isis, the tutelary deities of the deceased pharaoh. The calcite canopic chest is fixed on to a gilded wooden sled, similar to the ones that would have been used to pull the heavier objects into the tomb.

The interior of the vessel, only thirteen centimetres deep, is divided into four compartments, each covered by an elegant lid, also carved from calcite, in the form of a delicately carved bust of a king, possibly Tutankhamun. His face is framed by the *nemes* headcloth on which the cobra and vulture – the sacred deities representing a united Lower and Upper Egypt – rear up impressively. The young king's almond-shaped eyes and his eyebrows are painted black; the bright red colour of his lips gives his pale face a striking impression of vitality.

The four internal compartments designed to hold the small gold coffins with the pharaoh's internal organs are an unusual departure from the traditional canopic apparatus found in tombs. (S.E.)

JE 60687

CANOPIC CHEST

CALCITE; TOTAL HEIGHT 85.5 CM; WIDTH OF EACH SIDE OF THE BASE 54 CM
VALLEY OF THE KINGS, TUTANKHAMUN'S TOMB (KV 62)
DISCOVERED BY H. CARTER (1922)
EIGHTEENTH DYNASTY, REIGN OF TUTANKHAMUN (1333–1323 BC)

The elaborate structure housing the canopic vessels in which Tutankhamun's internal organs were preserved was found in the Treasury of his tomb. Considered in its entirety, it is one of the finest masterpieces among the many sumptuous objects that were buried with the king. Inside the gilded wood shrine, surmounted by a canopy also made of gilded wood, was a translucent calcite chest. Inside this vessel were the four small, gold, mummy-shaped coffins that held the king's embalmed internal organs.

The calcite chest was carved in the form of a model of the ancient temple of Hierakonpolis, emblem of Upper Egypt. The roof of the shrine is the lid of the chest and is a single inclined surface, sloping from the façade to the rear. Decorating

the front of the lid is a kneeling goddess with outstretched wings; above her is a central column of hieroglyphs incised in the stone and filled with dark blue pigment. The projecting cornice is engraved with continuous vertical lines. Beneath the architrave on all four sides are uninterrupted hieroglyphic inscriptions, painted blue. The lid was fixed to the vessel with cords knotted to gold rings and sealed with the official

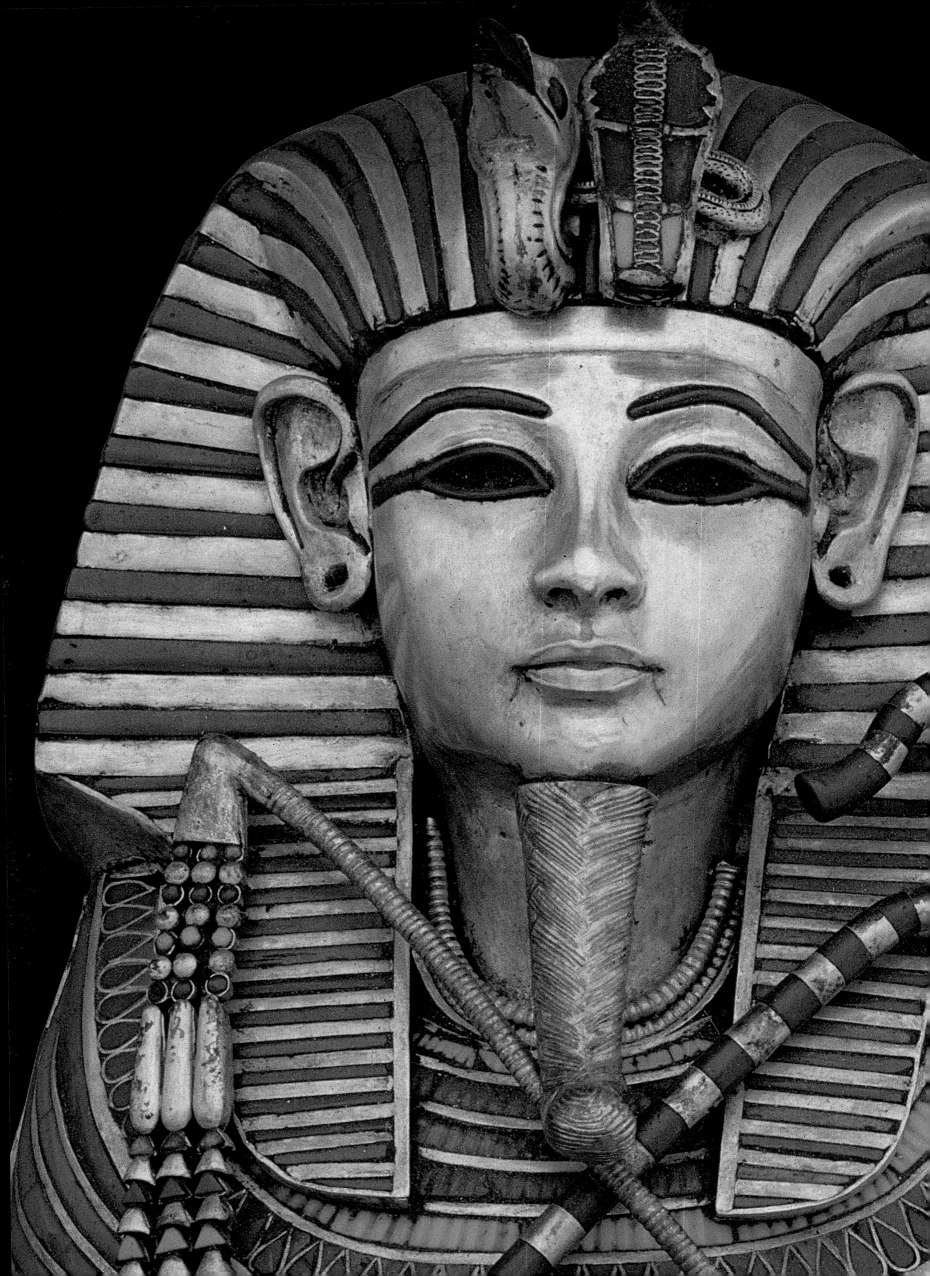

COFFINS FOR INTERNAL ORGANS

GOLD, CARNELIAN, GLASS PASTE
HEIGHT 39 CM; WIDTH 11 CM; DEPTH 12 CM; VALLEY OF THE KINGS
TUTANKHAMUN'S TOMB (KV 62); DISCOVERED BY H. CARTER (1922)
EIGHTEENTH DYNASTY, REIGN OF TUTANKHAMUN (1333–1323 BC)

Tutankhamun's internal organs, embalmed and wrapped in linen, were placed inside four small mummy-shaped gold coffins. These were then placed in compartments in the refined calcite receptacle found in the Treasury of the tomb.

The coffins are exact replicas in miniature of the second coffin in which the young pharaoh was buried. They are outstanding masterpieces of gold craftsmanship. The cases and lids, made from skilfully fashioned thick gold sheet, are entirely covered with inlays of stones and coloured glass paste.

The king is depicted with his arms crossed on his chest – the typical position of the dead – and he is wearing all the attributes of his royal status. His face, with a serene expression, is framed by the *nemes* headcloth, with its distinctive stripes of gold and blue glass paste. These gather at the nape of the neck to form a short plait. Rearing up from his forehead in a threatening pose (their role was, after all, to protect the pharaoh) are representations of the cobra and vulture goddesses of united Egypt.

The eyebrows and outline of the pharaoh's eyes are inlaid with blue glass paste (the stones that once filled the eye sockets and pupils have in one case not survived). His ears, emerging from the headdress, have lobes pierced for earrings, as was then the fashion. Hanging from his chin is a gold plaited beard that ends in a curl on the breast, which is covered by a wide *usekh* necklace formed of rows of polychrome beads ending in a row of drop-shaped pendants. Around his wrists the pharaoh has two wide bracelets, and in his hands, created from embossed gold, he holds the symbols of power, the sceptre and flail, inlaid with glass paste.

His torso is enfolded in two protective vulture's wings, divided into numerous rows of long feathers. The birds' talons, depicted on the back of the case, are grasping *shen* rings, symbols of eternity, rendered in carnelian. The pharaoh's body, from abdomen to feet, front and back, is completely covered with the so-called *rishi* pattern. This pattern imitates plumage, created with droplet and herringbone motifs in multicoloured glass paste. In the centre of this lid is a column of hieroglyphs inlaid into the gold: this contains the prayer of Neith, the goddess associated with Duamutef, the son of Horus who was guardian of the stomach of the deceased.

The interiors of the four coffins are also richly decorated, with the gold surfaces of both lids and cases engraved with finest detailing by a master goldsmith.

The underside of each lid is dominated by the large figure of a goddess, in one case Neith, standing on the symbol for gold, her arms and wings outspread as a sign of protection for the internal organs of the dead king. The deity, depicted beneath her name, is wearing a long, tight-fitting dress, held up by narrow shoulder-straps, and a necklace; her hair is held in place by a headband. Around her person are columns of hieroglyphs with cartouches containing the birth name and coronation name of Tutankhamun.

The pharaoh's cartouches on the four small coffins show traces of alterations, which suggests that they replaced the names of another pharaoh, the original owner of the coffins from whom they were usurped.

The entire interior of each case is divided into horizontal lines of hieroglyphs incised in the gold, expressing wishes for the well-being of, and invoking protection for, Tutankhamun. (S.E.)

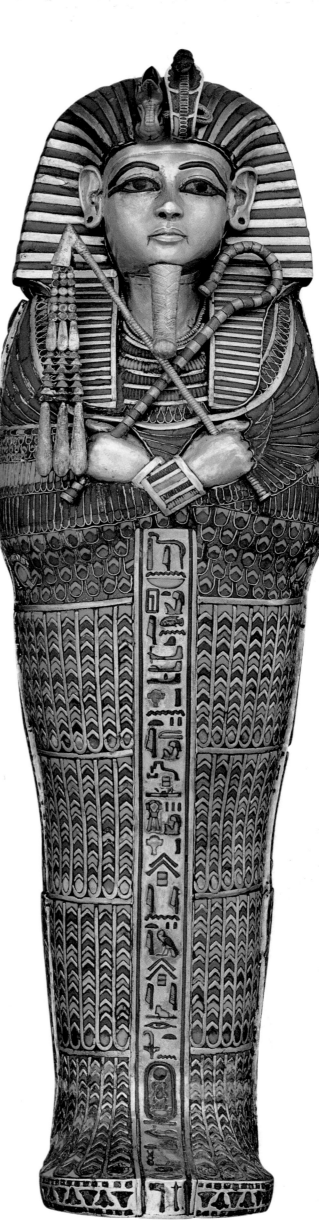

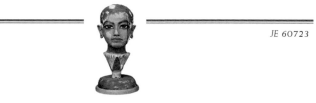

HEAD OF TUTANKHAMUN
EMERGING FROM A LOTUS FLOWER

WOOD, GESSOED AND PAINTED; HEIGHT 30 CM
VALLEY OF THE KINGS, TUTANKHAMUN'S TOMB (KV 62)
DISCOVERED BY H. CARTER (1922)
EIGHTEENTH DYNASTY, REIGN OF TUTANKHAMUN (1333–1323 BC)

This painted sculpture, heavily influenced by the Amarna style, represents the young Tutankhamun and is one of the best portraits of the period.

The support, painted blue, represents the water, from which a lotus flower emerges with its blue petals open. The lotus, of which there are two varieties – with blue or white flowers – was a very common motif in Egyptian art and had strong symbolic values. During the evening its petals close and the flower dips below the surface of the water before emerging the following morning and opening once more. The lotus was therefore considered the daily bearer of the sun god, who rose each morning after having spent the night in the underworld.

The sun god is here identified with Tutankhamun, whose head emerges from the petals. The pharaoh, portrayed as a young boy, has a shaved and particularly elongated skull, a typical feature of the Amarna style; the skin tone of his face is a brick red, the colour traditionally used for males. The large, almond-shaped eyes are delineated with thick black lines that extend to the temples, and the

black pupils stand out against the whites of the eyes. The eyebrows are long and strongly marked. The ears are pierced to allow earrings to be inserted. The straight nose and full, curved lips are facial features typically found in the portraits of Tutankhamun. The neck inserted into the lotus flower is incised with a number of parallel lines that emphasize the fleshiness of the young pharaoh.

The sculpture symbolically confirms that, like the sun god, the king will be reborn in perpetuity in the manner of the lotus flower which blooms again each morning. (S.E.)

MANNEQUIN OF TUTANKHAMUN

WOOD, GESSOED AND PAINTED; HEIGHT 76.5 CM
VALLEY OF THE KINGS, TUTANKHAMUN'S TOMB (KV 62)
DISCOVERED BY H. CARTER (1922)
EIGHTEENTH DYNASTY, REIGN OF TUTANKHAMUN (1333–1323 BC)

This unusual statue in gessoed and painted wood, found in the tomb of Tutankhamun, was identified by Carter as a lifesize mannequin of the king used for fitting his clothes and jewelry. It is an intriguing and slightly mysterious object: the body is cut off below the waist and has no legs while the arms are cut off just below the shoulders.

The king is depicted with youthful features and is wearing a short yellow headdress with a flat top that recalls the taller one worn by Queen Nefertiti in the beautiful bust now in the Berlin Museum. A cobra symbolizing royal power rises above the forehead. The body of the snake is covered with gold leaf and is painted in red and black. The sinuous tail is simply drawn with a thin black line on the headdress.

Tutankhamun's skin is painted dark red, the colour traditionally used by the ancient Egyptians for

male figures. The eyebrows, the outlines of the eyes and the irises are black, with the addition of a touch of red paint in the corners of the eyes. The eyeballs are white. The large ears have pierced lobes in which earrings would have been inserted.

The fleshy lips are emphasized by curving lines. The straight nose and the rounded and slightly projecting chin recall artistic motifs typical of the Amarna Period, found on the bust of Nefertiti and many other works by the court sculptor Djehutymes. This has led some scholars to view this sculpture as in fact a portrait of Tutankhamun's wife Ankhesenamun, daughter of Akhenaten, rather than of the pharaoh himself.

The torso, marred by cracks in the wood, has no detailing to indicate the musculature and is completely painted white as if covered with a linen tunic. (S.E.)

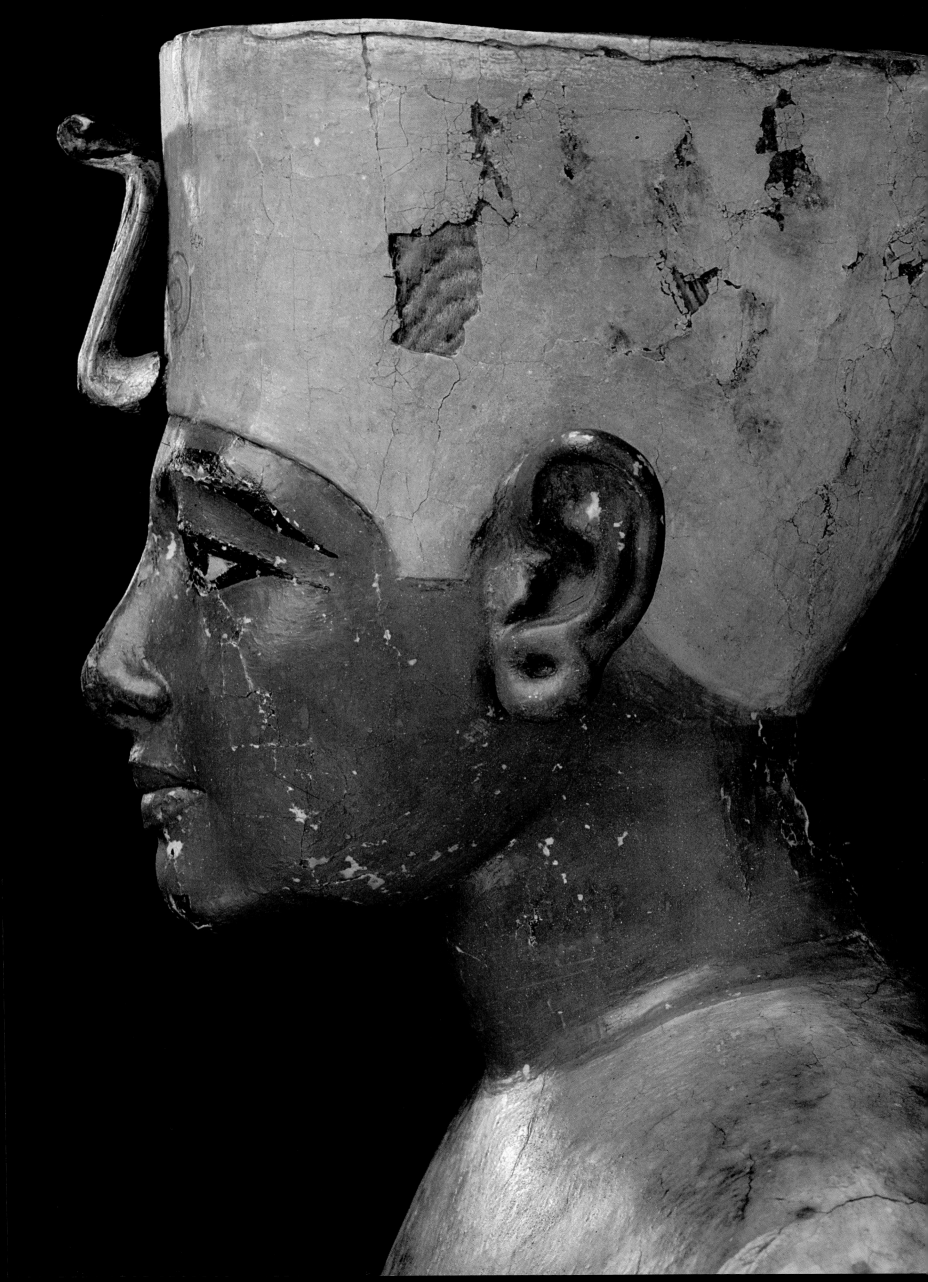

JE 60671

INNERMOST COFFIN

GOLD, SEMIPRECIOUS STONES, GLASS PASTE
LENGTH 187 CM; HEIGHT 51 CM; WIDTH 51.3 CM; WEIGHT 110.4 KG
VALLEY OF THE KINGS, TUTANKHAMUN'S TOMB (KV 62)
DISCOVERED BY H. CARTER (1922)
EIGHTEENTH DYNASTY, REIGN OF TUTANKHAMUN (1333–1323 BC)

The mummified body of Tutankhamun was laid in a splendid and exquisitely made solid gold coffin; this was placed inside two further mummiform coffins in gilded wood that were in turn enclosed in a rectangular quartzite sarcophagus with a red granite lid. Erected around this sarcophagus, one inside the other, were four elegant gilded wood shrines that practically filled the whole Burial Chamber.

The innermost coffin is the most precious of all since it is made entirely from thin gold sheet. It is decorated with finely executed chasing and further embellished with inlays of multicoloured glass paste. The lid and casket take the form of the image of the mummified pharaoh, identified with the god Osiris and adorned with the attributes of sovereignty. Covering the head is the *nemes* headcloth, with stripes incised in the metal; on the forehead are the cobra and vulture, protectors of royal power.

The majestic face of Tutankhamun recalls the young pharaoh as he appears on the other mummiform coffins, on the magnificent mask that covered the face of the mummy, and on several portraits found in the tomb. His eyebrows and eyelids are inlaid with black glass paste, while the outlines of the eye, extending to the

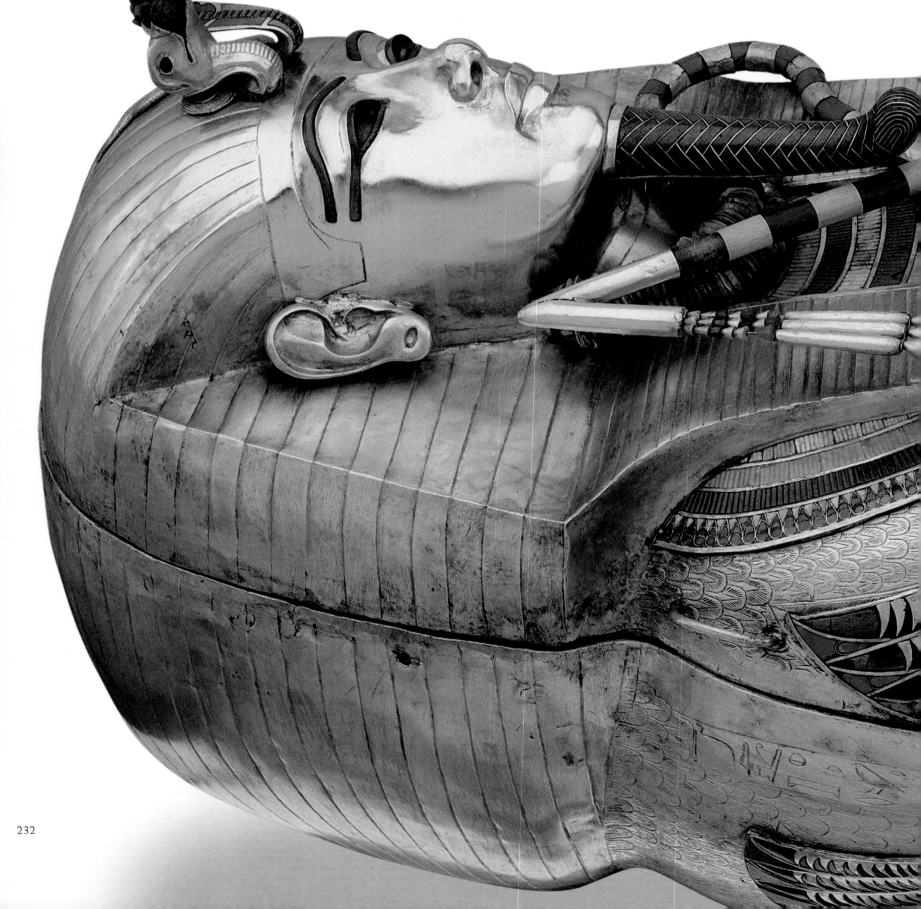

temples, are blue. Inlays for the pupil and eye socket have not survived. Clearly evident in the thick curving lips and large ears, pierced to take earrings, is the influence – albeit now rather attenuated – of the artistic canons of the Amarna Period.

A divine beard hangs from the pharaoh's chin. It is made of gold with inlays in blue glass paste that reproduce a plait with a rounded end. He is wearing an unusual necklace made of a double row of small gold and faience discs, fixed beneath the ears with clasps of floral design. It is a copy of the necklace given by pharaohs to high-ranking officials and army generals as a reward for special favours and services.

His breast is also covered by a wide *usekh* necklace formed of bands of multicoloured inlays and edged with a droplet motif. In his clenched fists he holds the symbols of sovereignty: the sceptre and the flail, worked in gold with inlays in faience, carnelian and glass paste. Adorning his wrists are wide, polychrome bracelets.

The pharaoh's torso is encircled by the outspread wings of Nekhbet and Wadjet, the tutelary deities of Upper and Lower Egypt, modelled as birds with vulture and cobra heads. Their bodies and wings are meticulously decorated with small inlays of polychrome glass paste and stones to imitate plumage; in their gold talons are *shen* signs, symbolizing eternity.

The rest of the lid, from abdomen to feet, has no inlaid work but its entire surface is covered with elaborate chased patterns. Prominent among the long feather motifs incised into the metal are two large figures – the goddesses Isis and Nephthys – dressed in long, close-fitting robes and wearing *usekh* necklaces on their breasts. They are depicted standing with their arms and wings outspread, to indicate their protection of the deceased. The prayers they recite are chased in a double column of hieroglyphs in the centre of the lid, between the bodies of the two goddesses.

Beneath the king's feet, on the end of the coffin lid, is another likeness of the goddess Isis, this time kneeling with outstretched wings.

Minutely incised plumage also decorates the outer surface of the coffin casket, except at the head end where the stripes of the *nemes* headcloth continue from the lid. The inlaid wings of the two birds on the pharaoh's breast extend along both side walls of the coffin, interrupting a long series of hieroglyphs, incised on the edges, in which the cartouches of Tutankhamun are inscribed. (S.E.)

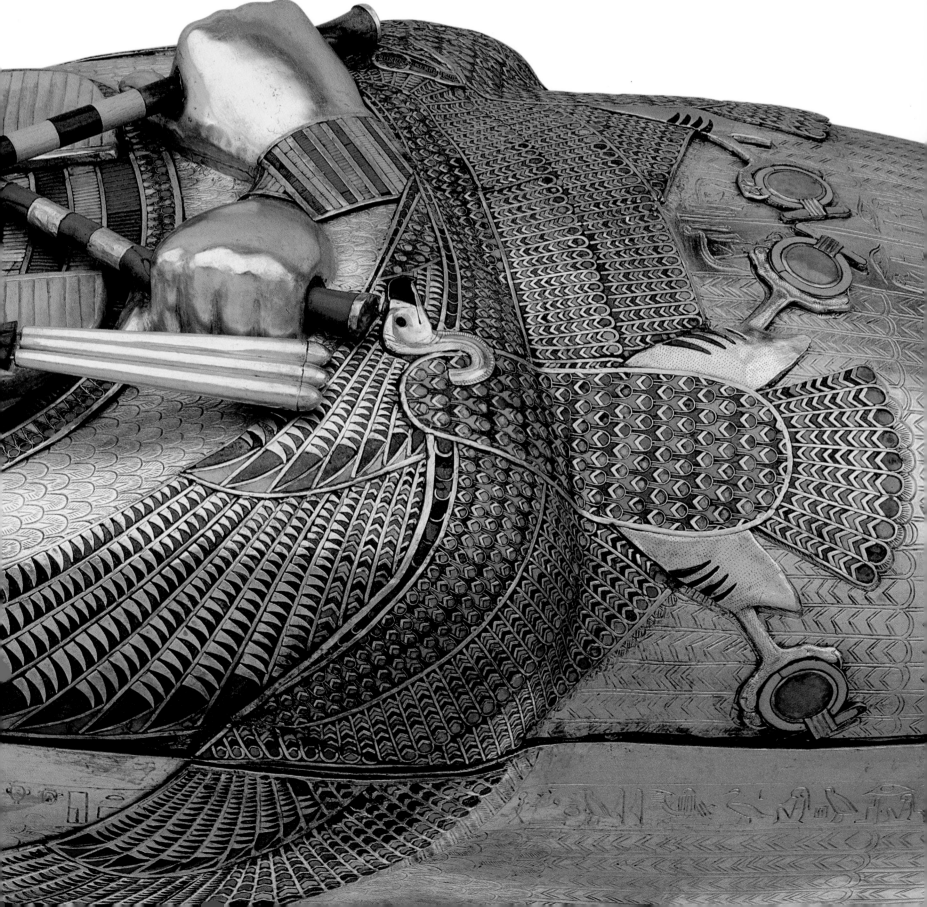

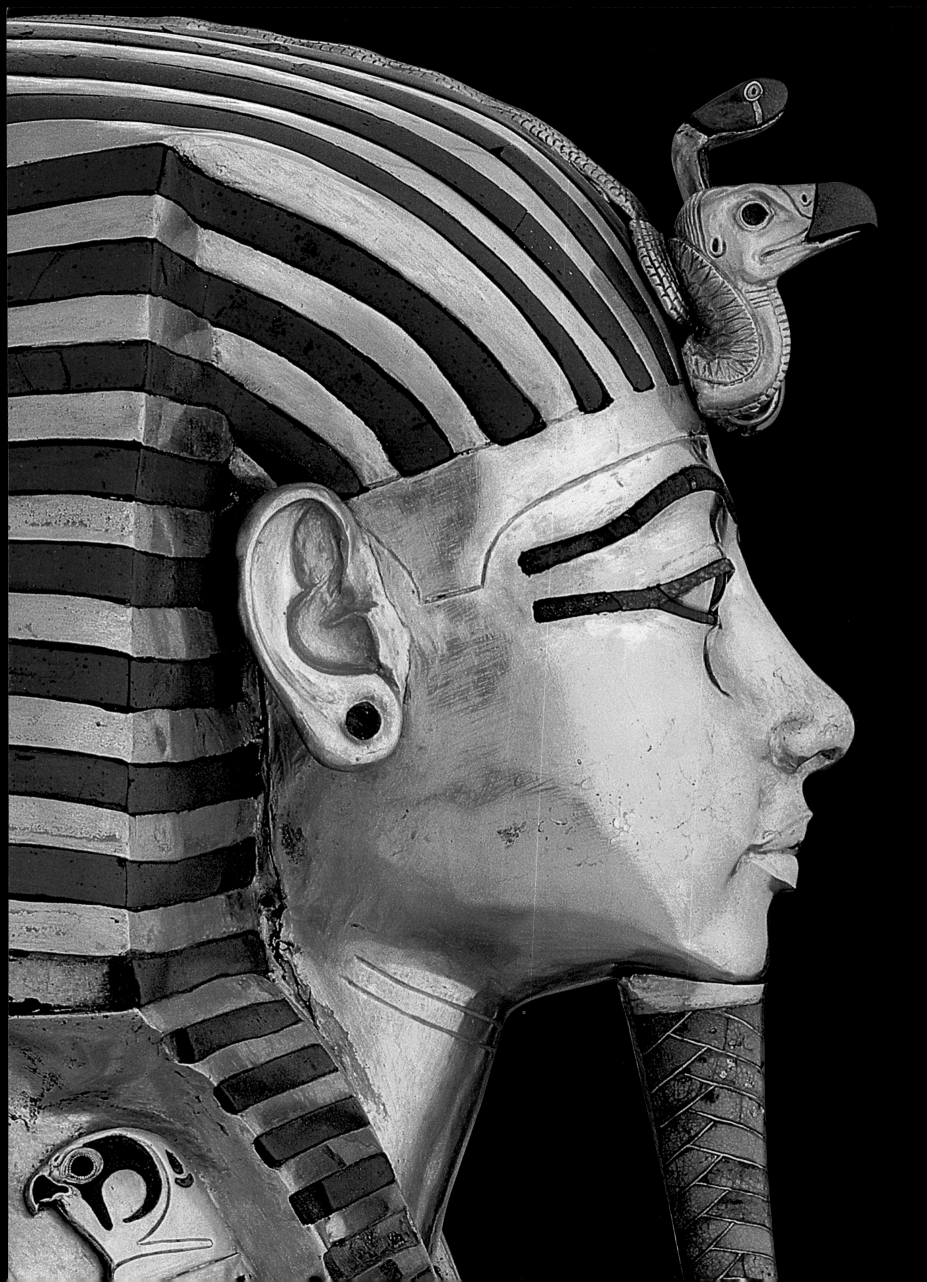

FUNERARY MASK OF TUTANKHAMUN

GOLD, SEMIPRECIOUS STONES, QUARTZ, GLASS PASTE
HEIGHT 54 CM; WEIGHT 11 KG
VALLEY OF THE KINGS, TUTANKHAMUN'S TOMB (KV 62)
DISCOVERED BY H. CARTER (1922)
EIGHTEENTH DYNASTY, REIGN OF TUTANKHAMUN (1333–1323 BC)

Tutankhamun's breathtaking funerary mask is made of solid gold with decorations in carnelian, lapis lazuli, turquoise and glass paste. It reproduces the idealized features of the young sovereign in a style that corresponds with the age following the Amarna Period. The composition of the piece as a whole is based on classical canons, while the slightly elongated oval of the face, the almond-shaped eyes set beneath arched brows, the slim, graceful nose, and the mouth with its full, soft lips reveal the influence of innovations that fleetingly appeared in Egyptian art during the reign of Akhenaten. The result is a well-balanced composition in which the softness and lucidity of the face set off the geometrical precision and opulence of the attributes, almost as if the latter were no more than a simple yet precious frame for an idealized portrait of the king.

Particular attention was paid to the eyes, with the whites inlaid with quartz and the pupils with obsidian. A touch of red pigment in the corners lends a degree of realism. The ears have pierced lobes and are set asymmetrically: the left ear is

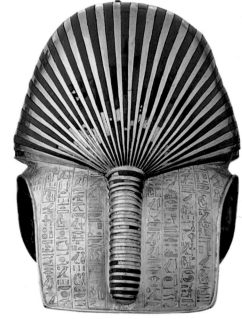

further from the face than the right. The false beard with the upwards curving tip has a framework in gold with inlays of blue glass paste.

The pharaoh is wearing a *nemes* headdress gathered in a braid on the shoulders, the horizontal stripes of which are inlaid with lapis lazuli. On the forehead, the royal cobra sits next to the vulture, the symbols of the goddesses Nekhbet (the vulture) and the Wadjyt (the cobra), tutelary deities of Upper and Lower Egypt respectively, and of the sovereignty of a united Egypt. The chest is covered by a broad collar with twelve rows of inlaid lapis lazuli, turquoise, quartz and coloured glass paste tesserae, the bottom row consisting of drop-shaped motifs. The collar is fastened to the shoulders with two clasps in the form of falcons' heads.

The mask protected the head of the young pharaoh's mummy, with a hieroglyphic text inscribed at the rear reinforcing this property. The individual limbs of the deceased are named and identified with those of various deities. The invocation places the parts in question under the protection of the respective god. During the New Kingdom this religious formula began to be included in the Book of the Dead and, in the numbering given by Lepsius to this funerary compilation, it is today identified as Chapter 151b. (F.T.)

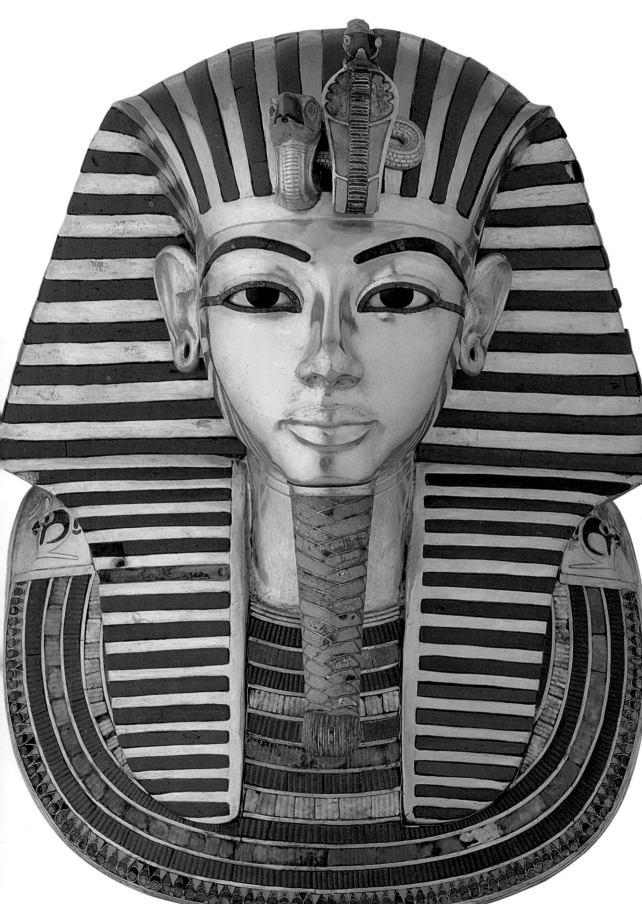

235

PECTORAL WITH WINGED SCARAB

Gold, silver, semiprecious stones, glass paste
Height 14.9 cm; width 14.5 cm
Valley of the Kings, Tutankhamun's Tomb (KV 62)
Discovered by H. Carter (1922)
Eighteenth Dynasty, Reign of Tutankhamun (1333–1323 bc)

This pectoral was one of the many pieces of jewelry found in the tomb of Tutankhamun, placed within the mummy's bindings or conserved in chests in the Treasury and scattered elsewhere. It is an exceptional piece of gold-working in a rather elaborate style, rich in symbolism and featuring a well balanced choice of colours.

The cloisonné technique was used to produce the jewel, with coloured stones and glass paste contained within gold cells forming the structure of the pectoral.

The central element of the composition is a scarab in translucent green chalcedony, to which were attached the open wings and fan-shaped tail of a vulture inlaid with coloured glass. The rear legs in gold are those of the bird of prey and are gripping the *shen* hieroglyph, the symbol of eternity, in their talons. The right foot is also holding a bunch of lotus flowers and the left a lily, symbols of Upper Egypt. This unusual composite creature, symbolizing the sun, is flanked by two cobras seen in profile, inlaid with coloured glass paste and bearing yellow solar discs on their heads.

Set below the tail of the vulture is an ornamental frieze composed of alternating blue and red discs, from which a luxurious floral garland hangs. The garland consists of lotus and papyrus flowers and buds, emblems of Upper and Lower Egypt, separated by small blue discs with gold centres.

A slim boat with upturned ends rests on the front feet of the scarab and the arching wing-tips of the vulture. On the boat is a *wedjat* eye, the left eye of the god Horus representing the moon, flanked by two cobras seen from the front, also with solar discs on their heads. The boat represents the journey taken by the moon, which, according to Egyptian tradition, sails across the sky each night.

The *wedjat* eye is surmounted by a silver lunar disc within a gold crescent. Three figures are depicted in gold relief in the disc: the protagonists in a celestial coronation scene. At the centre is the pharaoh wearing a crown surmounted by the image of the moon and flanked by two divinities making protective gestures towards him: on the left is the ibis-headed moon god Thoth, on the right is the falcon-headed god Re-Horakhty.

The pectoral therefore combines in a single composition replete with religious symbolism, various themes associated with the cycles of the sun and the moon – the two heavenly bodies associated with the power of the Egyptian ruler. (S.E.)

Assorted amulets, characterized by original design and very talented workmanship, combined a religious, symbolic and apotropaic function with an aesthetic and ornamental role; they are a fine testimony to the amazing inventive skills of the artisans who made them.

This pendant depicts a falcon with its large wings outspread, curving upwards as if to protect the dead pharaoh. The body, tail and wings of the bird are decorated using the typically Egyptian cloisonné technique – created by inserting polychrome glass paste and semiprecious stones into cloisons or compartments formed by a network of gold walls.

The falcon's head, seen in profile, has several details inlaid with glass paste, such as its beak, eye and the decorative patches representing the different coloured plumage beneath the bird's eye and on the back of its neck.

On top of the bird's head is a large solar disc in carnelian, surrounded by a gold ring; this attribute shows that the falcon represents the composite solar deity, Re-Horakhty. In its gold talons it grasps *shen* rings (eternity) and the *ankh* (life) with which the god promises the deceased king an eternal afterlife.

The back of the pendant, also of solid gold, is decorated with finely detailed patterns, chased in the metal, that reproduce the decoration on the front of the amulet. The pendant was intended to hang round the neck on a cord, with tiny tassels at its ends, threaded through four eyelets on the back. (S.E.)

JE 61893

FALCON PENDANT

GOLD, LAPIS LAZULI, CARNELIAN, TURQUOISE, GLASS PASTE
WIDTH 12.6 CM
VALLEY OF THE KINGS, TUTANKHAMUN'S TOMB (KV 62)
DISCOVERED BY H. CARTER (1922)
EIGHTEENTH DYNASTY, REIGN OF TUTANKHAMUN (1333–1323 BC)

On the lid of a wooden casket found in the Treasury of Tutankhamun's tomb was a hieratic inscription indicating its precious contents. And piled inside it were numerous pieces of jewelry, left there by the officials of the necropolis assigned with the task of putting the king's tomb in order after thieves had broken in not long after the burial. Some of these pieces had been worn by the pharaoh during his short lifetime, but the majority were made purely for the purposes of his burial.

237

JE 61885

NECKLACE WITH PECTORAL IN THE FORM A SOLAR BOAT

···

GOLD, SILVER, SEMIPRECIOUS STONES AND GLASS PASTE; HEIGHT 44 CM
VALLEY OF THE KINGS, TUTANKHAMUN'S TOMB (KV 62)
DISCOVERED BY H. CARTER (1922)
EIGHTEENTH DYNASTY, REIGN OF TUTANKHAMUN (1333–1323 BC)

This marvellous openwork pectoral, suspended from an elaborate necklace, was among the jewelry of Tutankhamun found heaped inside a box inlaid with ebony and ivory discovered in the Treasury. The hieratic inscription on the lid of the casket reads: 'gold jewelry for the funerary procession from the bedchamber of *Nebkheperure* [the coronation name of Tutankhamun].'

The figurative ornamentation of the pendant centres on a scarab in lapis lazuli, which holds a solar disc of carnelian with a gold rim in its front legs and the *shen* hieroglyphic symbol in its back legs. The beetle's body is reproduced with great accuracy. The scarab symbolizes Khepri, the sun god who appears on the horizon with each new day, bringing a promise of eternal rebirth for the deceased pharaoh. The figures sit on a narrow boat, with its hull decorated with inlays and its ends curving up, that recalls the morning solar barque on which the god appears each day to mankind.

Two baboons, seen in profile, crouch on the roofs of two small gold shrines that emerge from the

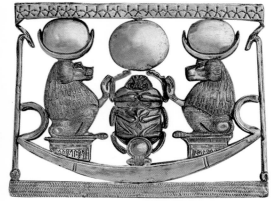

boat. The walls of the shrines, surmounted by a projecting cornice, are engraved with a repeated motif in which the *ankh* symbol of life is flanked by two *was* sceptres.

The shoulders of the two baboons are covered with an imitation of their fur created with shapes framed by gold. The patterns stop at their bulging bellies, and their front limbs stretch forwards to touch the scarab's front legs.

On top of the baboons' heads is a gold lunar disc resting on a silver crescent moon, a double celestial symbol referring to the moon god Thoth, with whom these animals are sometimes identified.

Their presence at the sides of the solar scarab is probably connected with the ancient Egyptian belief that the rising sun was greeted each morning by pairs of baboons. It was thought that they helped it re-emerge from the darkness of night. In fact, these creatures do emit high-pitched screeches at dawn that the Egyptians must have interpreted as their daily tribute to the rising god.

The scene sits inside a narrow frame: its top edge consists of a bar in the shape of the hieroglyphic symbol for 'heaven', inlaid with lapis lazuli and embellished with a row of gold stars; the bottom edge is a rectangular bar inlaid with blue glass paste, with gold wires forming a zig-zag pattern in imitation of the surface of the water over which the boat is moving. Two tall gold *was* sceptres, symbols of royal power, link the sky and the water, and provide vertical borders that enclose the whole scene.

The pectoral is suspended from an elaborate necklace fixed to the top edge of the frame with a hinge. The necklace consists of two parallel rows of alternating polychrome beads with elaborate amuletic and apotropaic figurative elements which are placed symmetrically at the two sides.

At the bottom the god Heh kneels and holds two long palm trunks in his hands. Above the deity is the double pavilion *sed* symbol, containing two thrones, placed on the *heb* festival symbol. Next come the hieroglyphs *djed* (symbol of stability), *ankh* (symbol of life) and *sa* (symbol of protection); each of them, repeated three times, is placed over the *heb* sign and flanked by more *was* sceptres.

On the clasp of the necklace the god Heh appears again, with the *shen* symbol on his head. At his sides are two *uraei*: one wears the crown of Upper Egypt, the other that of Lower Egypt. (S.E.)

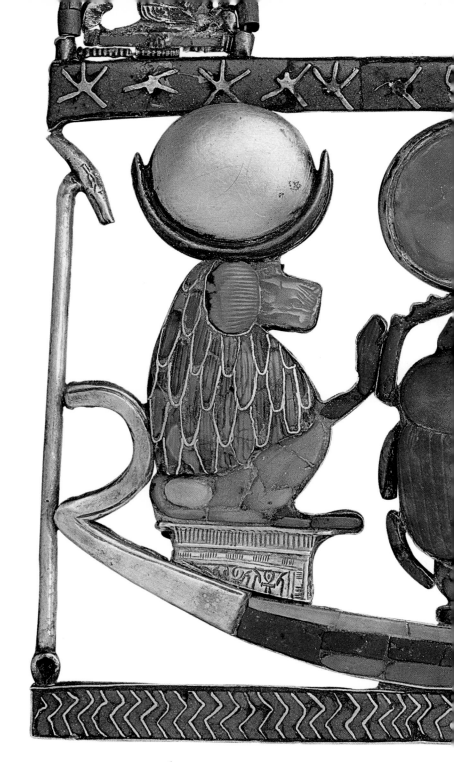

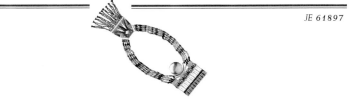

JE 61897

NECKLACE WITH PECTORAL IN THE FORM OF A LUNAR BOAT

···

GOLD, ELECTRUM, SEMIPRECIOUS STONES, FAIENCE
NECKLACE: LENGTH 23.5 CM; *PECTORAL:* WIDTH 10.8 CM; VALLEY OF THE KINGS
TUTANKHAMUN'S TOMB (KV 62); DISCOVERED BY H. CARTER (1922)
EIGHTEENTH DYNASTY, REIGN OF TUTANKHAMUN (1333–1323 BC)

This necklace is a jewel of extraordinary elegance and purity of form, with a well-balanced fusion of variously coloured geometrical elements. Its apparent simplicity contrasts with the complex and sometimes elaborate aspect of many of the other jewels that formed part of Tutankhamun's funerary assemblage.

The principal element of the pendant is a slender lunar boat in

gold which carries a lunar disc in electrum resting on a gold crescent. On either side of the boat are two small gold plaques, each of which carries a cartouche with the name of Tutankhamun flanked by two cobras with wings outspread in a sign of protection. These attach the pendant to a necklace of four strings of cylindrical and oval beads of gold, blue lapis lazuli, red carnelian, green feldspar and dark resin.

Below the boat is a light, pierced plate decorated with four long-stemmed blue lotus flowers, alternating with five buds and eight small seedlings of the same plant. The flowers rise from a thin bar inlaid with lapis lazuli. The shape of the bar takes the form of a hieroglyph used to indicate the sky, from which fall alternating light and dark blue droplets which perhaps represent rain.

The composition is an allegorical representation of the journey completed each night by the lunar boat over the expanse of celestial waters that span the terrestrial world.

The jewel is also equipped with a counterweight of considerable size consisting of a large lotus flower flanked by two lotus flower buds, their petals inlaid with light and dark blue and red glass paste.

Nineteen strings of gold and faience beads each ending with a small pendant in the form of a bell are suspended from the counterweight. (S.E.)

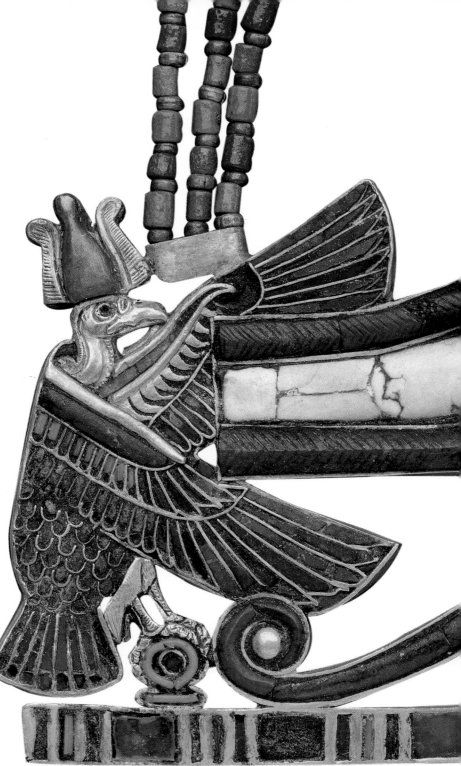

NECKLACE WITH PECTORAL IN THE FORM OF A *WEDJAT* EYE

GOLD, LAPIS LAZULI, TURQUOISE, FAIENCE, GLASS PASTE
HEIGHT OF THE PENDANT 5.7 CM; VALLEY OF THE KINGS, TUTANKHAMUN'S
TOMB (KV 62); DISCOVERED BY H. CARTER (1922)
EIGHTEENTH DYNASTY, REIGN OF TUTANKHAMUN (1333–1323 BC)

This necklace was found among the bandages wrapping the mummy of Tutankhamun and, according to Carter, was a piece of jewelry that the young sovereign would actually have worn during his life. Its decoration has a primarily protective function, with the *wedjat* eye at the centre considered to be an amulet of great efficacy. Legend had it that the falcon god Horus lost the eye during his struggle with the evil Seth. Thoth then found it and returned it to the god. The characteristic mark that appears on the cheeks of the falcon is traditionally associated with Horus' wound – it is identified with the tear of pain welling from the eye when it was torn from its socket. The term *wedjat* means 'healthy' or 'whole' and refers to the fact that the eye was treated and replaced after the battle.

The pectoral is suspended from a necklace made of two triple strings of gold beads alternating with others in red, green and blue faience. At the centre, the *wedjat* eye is created from lapis lazuli (the pupil, the outline of the eye and the eyebrow) and turquoise (the eyeball and the space below the eyebrow), all set in gold. On either side are the two tutelary goddesses of Egypt. On the right rises the serpent goddess Wadjyt, the mistress of Lower Egypt, wearing the Red Crown; on the left, with her wings outstretched towards the *wedjat* eye is the vulture goddess Nekhbet. As guardian goddess of Upper Egypt she wears the White Crown with two feathers at the sides. In her talons she grips the *shen* symbol. At the bottom, the pendant is closed by a horizontal bar decorated with a vertical striped motif.

The heavy necklace is balanced by a counterweight in the form of a knot of Isis set between two *djed* pillars. One of the two amulets also acts as a clasp. (F.T.)

PECTORAL WITH TUTANKHAMUN BETWEEN PTAH AND SEKHMET

GOLD, SILVER, QUARTZ, CALCITE, ELECTRUM, GLASS PASTE
PECTORAL: HEIGHT 11.5 CM, WIDTH 14.1 CM; *COUNTERWEIGHT*: HEIGHT 8.4 CM,
WIDTH 7.8 CM; VALLEY OF THE KINGS, TUTANKHAMUN'S TOMB (KV 62)
DISCOVERED BY H. CARTER (1922)
EIGHTEENTH DYNASTY, REIGN OF TUTANKHAMUN (1333–1323 BC)

This sumptuous and elaborate necklace was contained in a wooden casket inlaid with ebony and ivory found on the floor of the Treasury in Tutankhamun's tomb. The piece consists of an openwork pectoral hanging from a wide necklace with a highly ornamental counterweight.

The magnificent decoration created with multicoloured inlays does not have a funerary theme but instead depicts the coronation of the pharaoh, as he receives his power from the gods. The necklace was therefore not made specifically as part of the pharoah's funerary goods, but on the occasion of his ascent to the throne.

The outline of the pectoral reproduces the form of a temple pylon: its tapering walls rest on a plinth decorated with eight gold solar discs flanked by signs expressing the concept of eternity. Below the cornice of the pylon is a narrow band of blue dotted with gold stars, topped by a polychrome architrave with a projecting cavetto cornice. The scene depicted inside the frame shows the pharaoh standing in the centre, with the two enthroned Memphite deities – Ptah and Sekhmet – at each side.

The king wears a feather robe and a short cloak over his shoulders. He is adorned with several of the attributes of royalty: the three-part blue crown, the *usekh* necklace, and the sceptre and flail. He looks towards the god Ptah, who is wrapped in a tight robe from which his hands emerge; in them he holds the *was* sceptre, symbol of power, and the *ankh* emblem of life. The raised throne on which the deity is seated is decorated with a droplet motif.

To Tutankhamun's left is the goddess Sekhmet with the head of a lioness surmounted by a solar disc. She is also seated on a throne, clothed in an elegant openwork robe; in her right hand she clutches a palm branch, symbolizing thousands of years; her left arm is instead stretched out towards the king, in a gesture denoting affectionate protection. In front of both deities is a small rectangular panel of gold with an engraved inscription, stating the promise each of them made to the deceased: Ptah assures the pharaoh life, power and health; Sekhmet eternity.

Behind Ptah is a tiny image of the god Heh, kneeling on the *heb* festival symbol; clutching bent palm branches, he is surmounted by a

cobra crowned with a solar disc. Behind Sekhmet is the *ka* of the king, with, above, the *serekh* – the stylized drawing of the plan and façade of the royal palace – on which a crowned falcon perches.

The necklace from which the pectoral hangs is formed of fifteen plates edged with a double row of polychrome beads. Decorative motifs of protective and apotropaic significance alternate with panels containing the two cartouches of Tutankhamun, separated by a plant motif.

The counterweight is also pylon-shaped, with two papyrus columns supporting an architrave decorated with striped panels; above the architrave is a projecting moulding with polychrome inlays.

The scene here depicts the pharaoh seated on the throne, facing a winged goddess. He is wearing the Blue Crown, a *usekh* necklace and a long loincloth. In one hand he holds the sceptre, in the other the *ankh* symbol of life, offered to him by the goddess Maat, who is standing in front of him. The deity, whose body is inlaid with blue glass paste, is spreading her wings as a sign of her protection of Tutankhamun.

From a gold bar fixed at the base of the counterweight pylon hang fourteen rows of beads. At the end of each of the eight central strands is a gold fish pendant; the other six have tiny bells that have the appearance of flowers upside down. (S.E.)

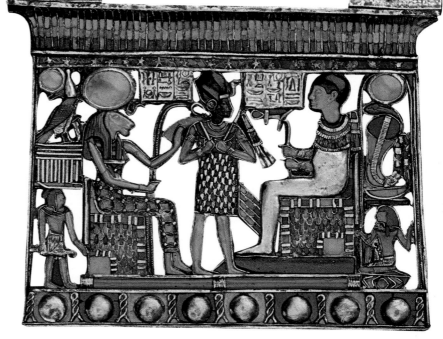

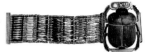

BRACELET WITH SCARAB

JE 62374

GOLD, LAPIS LAZULI, CARNELIAN, GREEN AND BLUE GLASS PASTE,
CALCITE, ELECTRUM; *BRACELET:* LENGTH 10.7 CM; WIDTH 3.5 CM
SCARAB: HEIGHT 6.6 CM; WIDTH 5.1 CM
VALLEY OF THE KINGS, TUTANKHAMUN'S TOMB (KV 62)
DISCOVERED BY H. CARTER (1922)
EIGHTEENTH DYNASTY, REIGN OF TUTANKHAMUN (1333–1323 BC)

A casket in the form of a cartouche was discovered in the Treasury of the tomb of Tutankhamun. Inside were three bracelets with a scarab in the centre. A further twenty-four bracelets of various types were discovered among the mummy's bandages, around the wrists or arms or scattered casually among the layers. This type of jewel had a primarily funeral and religious function, as the scarab was identified by the Egyptians with the morning sun (Khepri) and was therefore a symbol of eternal rebirth for the deceased pharaoh.

The main element of this bracelet is the large lapis lazuli scarab set in gold. The gold cells delimit the various parts of the insect's body and the segments of the pairs of legs. The whole insect is rendered very naturalistically.

The cartouche with the coronation name of the pharaoh (*Nebkheperure*) created in gold hieroglyphs on a lapis lazuli ground is held between the beetle's front legs. Between the hind legs, instead, is a *neb* symbol in light blue glass paste.

The bracelet is attached to the scarab by a gold bar and is divided into seven sections. These consist of rows of cylindrical beads in gold, blue glass paste, lapis lazuli, calcite and electrum threaded between circular beads of gold (smooth or granulated), carnelian, and light and dark blue glass paste. This multiplicity of colours is skilfully balanced and gives the piece a sense of great vitality.

The various parts of the bracelet are divided by eight rigid spacer bars and are edged at top and bottom by a row of gold beads. The clasp takes the form of a gold bar inserted into the right side of the scarab. (S.E.)

PECTORAL IN THE FORM OF A WINGED SCARAB

JE 61886

GOLD, CARNELIAN, TURQUOISE, GREEN FELDSPAR, LAPIS LAZULI, CALCITE
HEIGHT 9 CM; WIDTH 10.5 CM VALLEY OF THE KINGS, TUTANKHAMUN'S TOMB
(KV 62); DISCOVERED BY H. CARTER (1922)
EIGHTEENTH DYNASTY, REIGN OF TUTANKHAMUN (1333–1323 BC)

This pectoral, which would once have adorned the chest of the young pharaoh, was discovered along with many other pieces of jewelry in a box inlaid with ebony and ivory found in the tomb's Treasury. The numerous jewels were piled inside the casket in no particular order by the necropolis officials who had the task of rearranging the king's funerary equipment following the raid by unidentified thieves shortly after the burial and sealing of the tomb.

In the usual style of the jewels belonging to Tutankhamun, this pectoral features a series of iconographical elements of great symbolic value.

At the centre of the composition is the scarab in lapis lazuli, with two outspread falcon's wings decorated using the cloisonné technique to imitate the bird's plumage. The inlays are of carefully selected light-coloured stone.

The scarab beetle was considered by the ancient Egyptians as a symbol of the god of the rising sun, Khepri, who each day pushed the solar disc into the sky. This was due to the beetle's characteristic habit of rolling a ball of dung below the ground to lay its eggs in. Here the solar disc is represented by a disc of carnelian surrounded by gold and placed between the insect's front legs.

As well as having a magical-religious significance, the pectoral was also intended to provide a graphic representation of the king's name. The body of the scarab rests on three vertical bars of carnelian which are in turn attached to the *neb* hieroglyph, so that the succession of the various symbols in the jewel can be read from bottom to top as the name *Nebkheperure*, assumed by Tutankhamun when he ascended to the throne.

The back of the jewel is in plain gold with the inlaid decoration of the front repeated in engraved form.

A small horizontal tube fixed behind the disc of carnelian indicates that the pectoral would have been suspended from a metal or cord necklace and worn around the neck. (S.E.)

Bracelet with Scarab

GOLD, LAPIS LAZULI, CARNELIAN, TURQUOISE, QUARTZ
DIAMETER 5.4 CM
VALLEY OF THE KINGS, TUTANKHAMUN'S TOMB (KV 62)
DISCOVERED BY CARNARVON AND CARTER (1922)
EIGHTEENTH DYNASTY, REIGN OF TUTANKHAMUN (1333–1323 BC)

JE 62360

This heavy, rigid bracelet was found with other pieces of jewelry in a wooden box shaped like a cartouche, found in the Treasury of Tutankhamun's tomb.

The decoration has clear symbolic significance but is also an example of outstanding workmanship combined with a carefully balanced design that is testimony to inexhaustible ability of Theban goldsmiths to come up with new artistic devices.

The bracelet is small in diameter and clearly intended for a thin arm; it shows signs of wear, confirming that it was worn by the pharaoh during his short reign. It is composed of two semicircles joined by a hinge and a clasp which allows it to be opened. On the top part, where the surface widens out, is a large scarab; its body, reproduced in the finest detail, is created from lapis lazuli inlays in gold cloisons. The creature's underside is made entirely of gold. Its gold legs are fashioned with great precision and realism: the front ones have five pointed talons, the back ones end with a hook.

Around the edges of the flat surface that the insect is attached to is a line of tiny gold beads, and a row of pieces of lapis lazuli, gold, turquoise and carnelian. The two small spaces immediately above the bracelet's hinge and clasp on each side are filled with a fine inlaid floral composition. A yellow quartzite flower is flanked by two carnelian buds; separating their stems are two small gold rosettes.

The bottom part of the bracelet is worked externally with chasing and has four parallel rows of tiny gold balls framing lines of polychrome inlays. (S.E.)

243

The exaggerated forms characteristic of the early years of the Amarna Period had already been modified by the second half of the reign of Akhenaten. The artists working at Amarna passed from an initial period of experimentation designed to develop an idiom in complete opposition to what had gone before, through to the creation of a paradigm free of such exaggeration but reflecting the changing conditions of the new social climate. This artistic equilibrium, achieved by the time the Atenian religious experience was about to draw to a close, was maintained during the years following the death of Akhenaten and was reflected in the delicate features of the portraits of Tutankhamun. The brief reign of the young king was followed by those of the priest Ay and the general Horemheb, who encouraged the persecution of the Atenian cult and the effacement of the very memory of Akhenaten himself.

In spite of the complete dismantling of shrines dedicated to Aten and the rejection of the tenets of the religion practised in them, a number of Amarna traits persisted. Consequently, images of Amun-Re, whose cult returned to its position of primary importance throughout Egypt, were

244 CENTRE
HATHOR HEAD PENDANT
(DETAIL)
JE 86780
GOLD AND LAPIS LAZULI
HEIGHT 5.5 CM
WIDTH 5.3 CM
MIT RAHINA (MEMPHIS),
TOMB OF PRINCE
SHESHONQ
ALEXANDER BADAWY'S
EXCAVATIONS (1942)
TWENTY-SECOND DYNASTY
REIGN OF OSORKON II
(883–855 BC)

244 BELOW AND 245
FRAGMENT OF RELIEF
JE 69306
SANDSTONE
HEIGHT 70 CM
WIDTH 75 CM
PROVENANCE UNKNOWN
NINETEENTH DYNASTY
(1307–1196 BC)

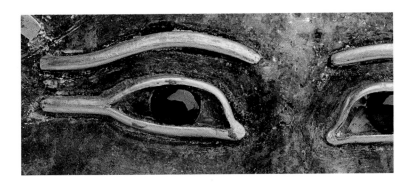

FRANCESCO TIRADRITTI

THE END OF THE NEW KINGDOM AND THE THIRD INTERMEDIATE PERIOD

frequently influenced by the artistic trends of the second half of the reign of Akhenaten. The survival of certain characteristics of this art can also be seen in private sculpture. For example, the mutilated statues of Nakhtmin and his wife have thin faces, with vivid, delicate features. Their almond-shaped eyes, enclosed within heavy lids, clearly derive from Amarna art and contrast with other elements inspired by the formal sophistication of Amenhotep III's era.

A decisive shift in the culture of the period came with the accession to the throne of a new dynasty originating in the Delta region. The patriarch, who had been a companion in arms and vizier of Horemheb, came to the throne of Egypt with the name of Ramesses. On his death, power passed to his son Seti, who conducted an energetic campaign of expansion eastwards.

Seti I also undertook an impressive building programme at Abydos, aimed above all at exalting the glory of the kings who had preceded him on the throne of Egypt. A temple that also contained a chapel for the cult of the living pharaoh

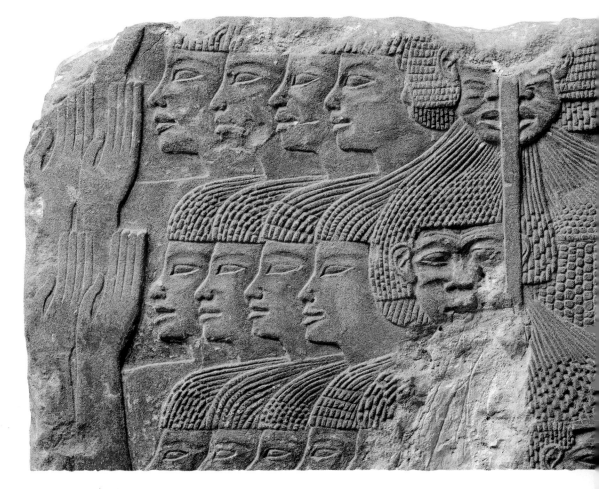

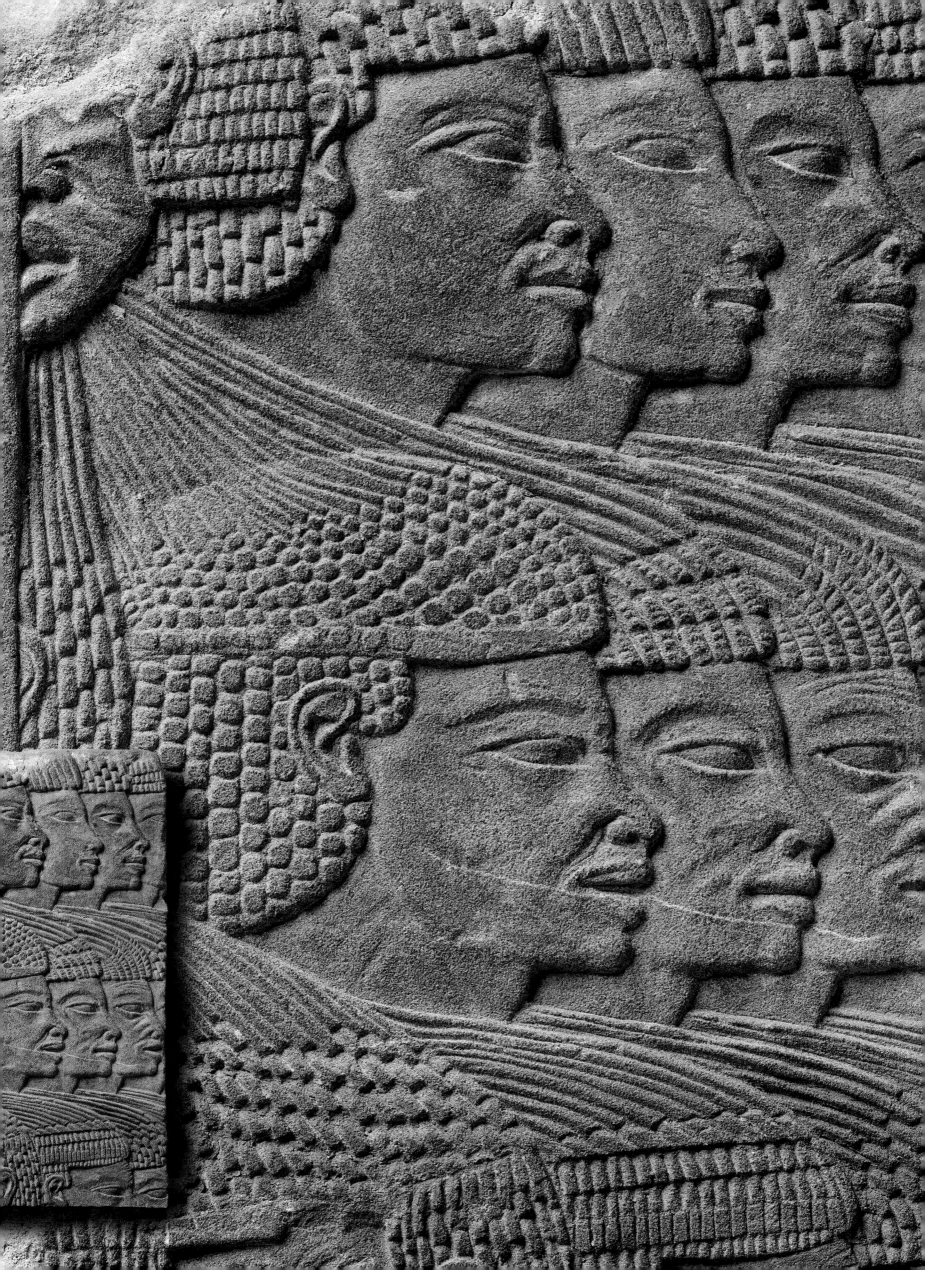

was dedicated to Osiris. Seti I thus initiated a process of veneration of the monarchy that would reach its height during the reign of his son Ramesses II. Seti I had himself portrayed in the company of his young son and heir in the act of offering incense before the cartouches of all his predecessors, thus confirming the legitimacy of his own claim to the throne through the association of his origins with those of the greatest rulers of the past.

Of all his predecessors, Seti I made the most particular reference to Thutmose III, whose great enterprises could hardly fail to appeal to a descendant of a military family. The art of his reign also tended to imitate the solemnity, sobriety and refinement of the early Eighteenth Dynasty. This is clearly demonstrated in the painted reliefs decorating the walls of

the temple of Abydos and Seti's marvellous tomb in the Valley of the Kings. Comparisons with the art of Thutmose are also particularly evident in the sculpture of the period, of which the standard-bearer statue of Seti I from Abydos is a very good example. The facial features recall those of the kings of the early Eighteenth Dynasty, although the clothing in particular – the robe with its elaborate pleating – harks back to the experimentation of the Amarna Period.

A diametrically opposed outlook can be seen in the composite alabaster statue found in the Karnak Cachette. The preciousness of the material and the idealized features of the face are in accordance with the traditions of the late Eighteenth Dynasty. It has been suggested that this statue was actually made in a period prior to the reign of Seti I and that

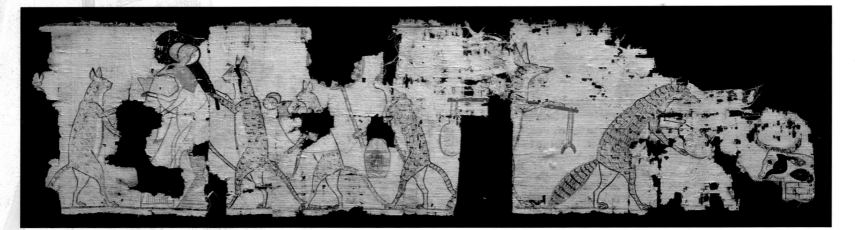

246 ABOVE
PAPYRUS
JE 31199
PAPYRUS
LENGTH 55 CM
WIDTH 13 CM
TUNA EL-GEBEL
NINETEENTH–TWENTIETH
DYNASTY (1307–1070 BC)

246–247 RIGHT
SHRINE OF RAMESSES II
JE 37475 = CG 70003
RED QUARTZITE
HEIGHT 156 CM
LENGTH 271 CM
WIDTH 190 CM
TANIS, TEMPLE OF AMUN-
RE
WILLIAM MATTHEW
FLINDERS PETRIE'S
EXCAVATIONS (1904)
NINETEENTH DYNASTY
REIGN OF RAMESSES II
(1279–1212 BC)

247 OPPOSITE
DETAIL OF RELIEF WITH
RAMESSES II GRASPING
HIS ENEMIES
JE 46189
PAINTED LIMESTONE
HEIGHT 99.5 CM
WIDTH 89 CM
MIT RAHINA (MEMPHIS)
ACQUIRED IN 1917
NINETEENTH DYNASTY
REIGN OF RAMESSES II
(1290–1224 BC)

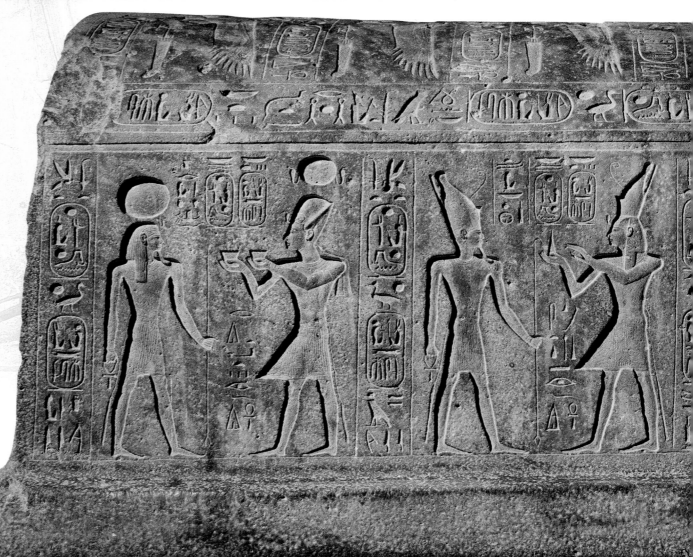

he appropriated it and had hieroglyphic inscriptions with his own name added.

By the time Ramesses II came to the throne, Egypt had already regained the security and cultural homogeneity it had lost during the preceding period. All that was left for Seti's son to do was to keep things on course, and bring to fruition the political initiatives of his father. At home, Ramesses II oversaw an unprecedented building programme designed above all to exalt the figure of the king and the status of royalty. Abroad, he initiated a campaign designed to reassert Egyptian dominion over the Syrian-Palestinian lands. The wars in the territories to the northeast of Egypt's borders concluded with the battle of Kadesh fought against the Hittite troops of Muwatallis. This conflict was brought to an end by a peace treaty that ratified a balance of power between Egypt and the Hittite state. Ramesside propaganda could hardly present the Syrian enterprise as a partial failure, however, so the reports of the battle of Kadesh were transformed into the stuff of legend. The story is narrated on the walls of various temples in relief sculptures that exalt above all the valour of the king.

In this age, the telling of stories through images reached full maturity, as it took advantage of the Amarna experience that focused interest on movement, exploring many of the narrative possibilities of flat figuration.

The same narrative strength is also found in some of the figurative decoration in private tombs of the Nineteenth Dynasty. While these may lack a sense of adventure and a taste for the unusual that can be seen in earlier works, they retain a ability to infuse a scene with an impression of movement. In a relief depicting a procession from Saqqara, a sense of activity and excitement of the moment are found running throughout the decoration.

The art of the reign of Ramesses II, however, is composed above all of grandiose monuments and colossal statues. Everything had to be enormous and spectacular. Everything had to amaze, to be replete with ornament and meaning. This philosophy of construction and monumental artistic canon, even if on a smaller scale, characterized the whole of the succeeding period and this era has frequently been defined as the 'Ramesside Baroque'.

Temples commissioned by Ramesses II introduced novel visual effects and perspectives. Visitors to the Hypostyle Hall in the temple of Amun-Re at Karnak experience the sensation of being an insect

as the name of Ramesses II, to whom the shrine was thus implicitly also dedicated.

This cryptographic device is also found in the magnificent colossus group of the god Horun protecting the young Ramesses II found at Tanis. In this case too, the work has a secondary meaning. The image of the crouching child with his fingers to his lips is fashioned in such a way as to represent the name of Ramesses.

Innumerable statues were produced during the sixty-seven year reign of Ramesses II. Some of them perpetuated the tradition begun by Seti I and were thus inspired by the works of the Thutmosian era. These are above all works in which the king is shown with characteristic, albeit idealized, features: a young man with an almost aquiline nose, his eyes enclosed within heavy lids (an Amarna trait), and his mouth set in a slight smile. Other statues of the king have no distinctive features and in some cases it is difficult to establish whether they were actually produced in the Ramesside workshops or made during an earlier period and usurped by Ramesses, who then had his own name applied.

in the midst of a stone forest. The Ramesseum is striking for the continuous variation of the structures in an architectural game whose only rule is to avoid repetition and symmetry.

The monument most characteristic of the age and one that can be interpreted as a paradigm of the reign of Ramesses II must, however, be his Great Temple at Abu Simbel. Its most exceptional feature is not one immediately visible to the viewer. The temple is based on a typical 'telescopic' plan, with a series of halls of decreasing size like many open-air temples. Yet this sanctuary actually develops within the mountainside. This form of interiorization almost conceals the message transmitted by the structure as a whole. It was, in fact, on this remote site, far from Egypt's cities, that Ramesses II's policy of magnifying the figure of the sovereign reached its crowning glory. Here the pharaoh is venerated as a living god. The deification is not openly proclaimed, but is revealed by numerous architectural details. Among these is the figurative decoration above the principal entrance in which the almost three-dimensional figure of Re-Horakhty, the divinity to whom the temple was dedicated, can be cryptographically read

It was Ramesses II's thirteenth son, Merneptah, who succeeded him, and his statues are very similar to those of his father. The Nineteenth Dynasty then proceeded with a series of kings whose brief reigns are fairly obscure and were marked by internal strife.

A return to a degree of stability came with the Twentieth Dynasty, the kings of which all paid explicit tribute to Ramesses II by choosing names that in one way or another were all based on that of their celebrated predecessor. Thus Ramesses III, as well as having himself portrayed in statues imitating the style of those of the early Nineteenth Dynasty, built a temple on the Theban West Bank at Medinet Habu that was inspired by the Ramesseum. The use of elaborate architectural games to produce a sense of wonder was abandoned, however, and visitors were instead impressed by an overloaded, archaic and lifeless grandiosity.

The art left by the workers who prepared the tombs in the Valley of the Kings is fresher and more spontaneous. The workers lived in the village of Deir el-Medina. Their community was composed mainly of scribes and tomb decorators who, when taking notes or sketching, used fragments of limestone or pottery usually

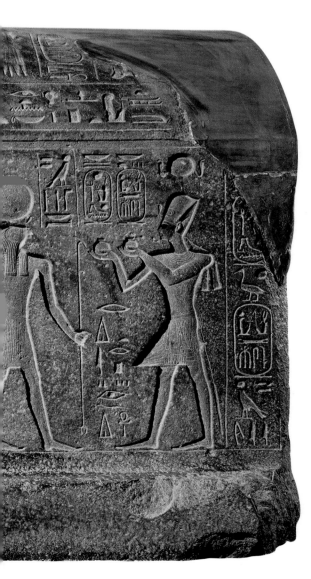

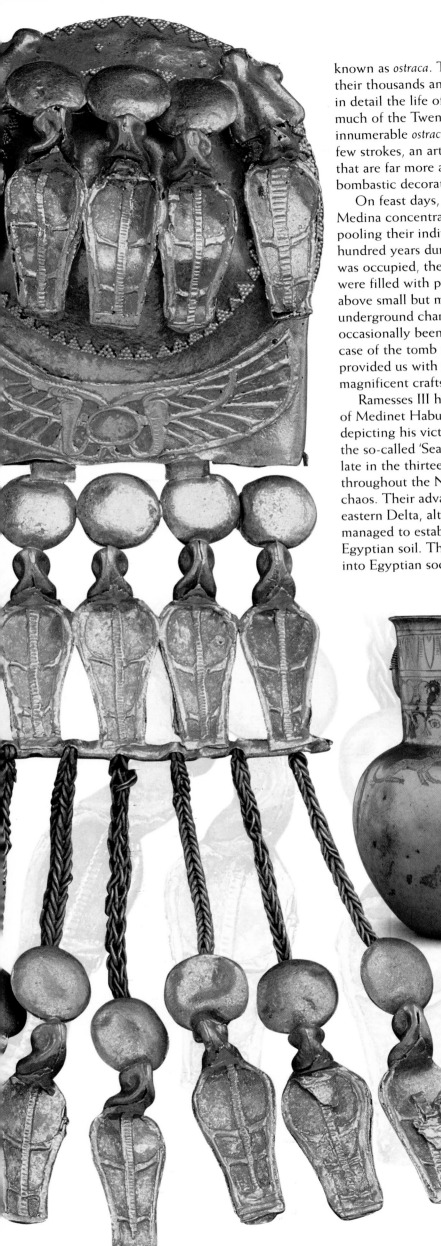

known as *ostraca*. These have survived in their thousands and allow us to reconstruct in detail the life of the working class of much of the Twentieth Dynasty. There are innumerable *ostraca* on which, with just a few strokes, an artist has created works that are far more appealing than the bombastic decorations of the royal tombs.

On feast days, the workers of Deir el-Medina concentrated on their own tombs, pooling their individual talents. In the five hundred years during which the village was occupied, the surrounding hillsides were filled with pyramidal chapels set above small but magnificently frescoed underground chambers. These tombs have occasionally been found intact (as in the case of the tomb of Sennedjem) and have provided us with funerary trappings of magnificent craftsmanship.

Ramesses III had the walls of his temple of Medinet Habu decorated with scenes depicting his victory over the Libyans and the so-called 'Sea Peoples', nomads who, late in the thirteenth century BC, migrated throughout the Near East, causing great chaos. Their advance was halted in the eastern Delta, although small groups managed to establish themselves on Egyptian soil. The infiltration of foreigners into Egyptian society was an urgent issue

throughout the Ramesside period, with a fine line existing between a multiethnic society and racism. The contrasts were strident. The king continued to walk on faience tiles with images of individuals from the ethnic groups who were by then integral parts of Egyptian society, as shown by the many state functionaries with names of Asiatic or Libyan origin.

The crisis faced by Egypt at the end of the Twentieth Dynasty led to a division of political power. The north, where Ramesses II had moved the administrative and political centre of the state, remained under the control of the pharaohs of the Twenty-first Dynasty. But the south effectively declared its independence and passed into the hands of the Theban priests of Amun-Re, who nominally recognized the authority of the north.

The northern kingdom seems to have lived on the memories of the glories of the past. This is demonstrated by the planning of Tanis, the new capital founded in the eastern Delta, which broadly imitated the urban fabric of Thebes. The rulers of the Twenty-first Dynasty transferred the royal cemetery also, and had themselves interred in brick tombs within the principal temple of Tanis dedicated, like that of Thebes, to Amun-Re. The decoration of the royal tombs perpetuated the tradition of royal tombs of the period prior to the adoption of the Valley of the Kings.

The strong attachment to the pomp of the recent past is also demonstrated by a number of furnishings that were found in the royal funerary caches of Tanis but which previously belonged to kings such as Ramesses II or Merneptah (in whose granite sarcophagus Psusennes I was buried). A large quantity of monuments of considerable size were also transported to Tanis from many of the cities of Lower Egypt. Obelisks, colossal statues and columns were selected to embellish the new capital because they were considered to be links with the kings of the Nineteenth and Twentieth Dynasties. This is shown by the fact that, alongside the works that were produced during this period, sphinxes and statues of Amenmhet III bearing the names of Ramesses II and Merneptah also appeared in Tanis.

The pharaohs of the Twenty-second Dynasty were of Libyan origin and revived a policy of eastwards expansion. Sheshonq I (945–924 BC), the founder of the new dynasty, succeeded first in uniting control

248 FAR LEFT
EARRING OF RAMESSES IX
JE 6086 = CG 52323
GOLD
HEIGHT 16 CM
ABYDOS
AUGUSTE MARIETTE'S
EXCAVATIONS (1859)
TWENTIETH DYNASTY
REIGN OF RAMESSES IX
(1131–1112 BC)

248 LEFT
VASE
JE 39871 = CG 53259
GOLD; HEIGHT 7.6 CM
DIAMETER OF THE NECK
3.6 CM
TELL BASTA (BUBASTIS)
DISCOVERED 1906
LATE NINETEENTH
DYNASTY
(LATE 13TH CENTURY BC)

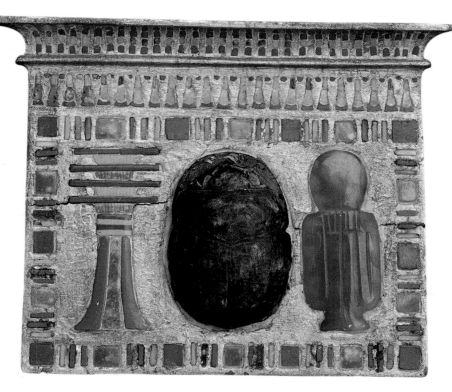

of secular and religious power over the whole of Egypt. With internal stability secured, a military campaign in the territories to the northeast could be undertaken. The Egyptians eventually reached the city of Megiddo after defeating the peoples of Israel. Sheshonq had a stela erected at the site where Thutmose III had celebrated his victory over the allied Syrian-Palestinian peoples. On his return to his homeland he had the account of his feats incised on the walls of the temple of Karnak.

During the reigns of Sheshonq I and his successors, art was still dominated by the past. In contrast with the Twenty-first Dynasty, the point of reference was the Egypt of Thutmose and the sober style of the reign of Hatshepsut. Sheshonq I made explicit references to Thutmose III.

249 ABOVE
PECTORAL
JE 31379
GILDED WOOD, CARNELIAN, GLASS PASTE
HEIGHT 11 CM
WIDTH 14 CM
WESTERN THEBES
TOMB OF HATAWY
ANTIQUITIES SERVICE EXCAVATIONS (1896)
NINETEENTH DYNASTY
(1307–1196 BC)

249 BELOW
HATHOR HEAD PENDANT
JE 86780
GOLD AND LAPIS LAZULI
HEIGHT 5.5 CM
WIDTH 5.3 CM
MIT RAHINA (MEMPHIS),
TOMB OF PRINCE SHESHONQ
ALEXANDER BADAWY'S EXCAVATIONS (1942)
TWENTY-SECOND DYNASTY
REIGN OF OSORKON II
(883–855 BC)

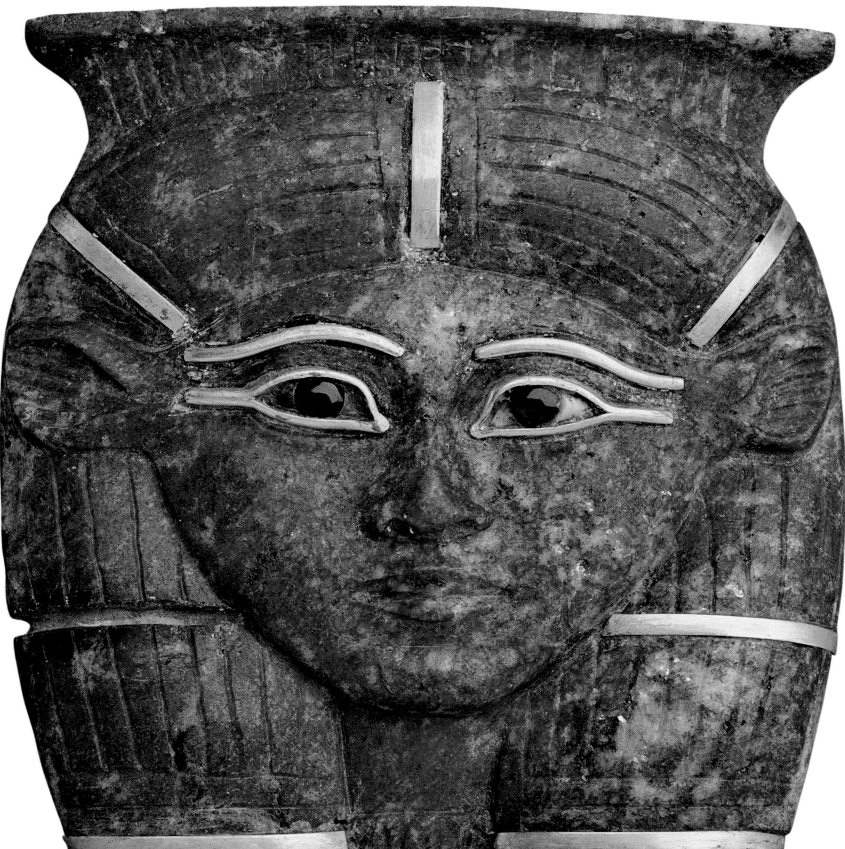

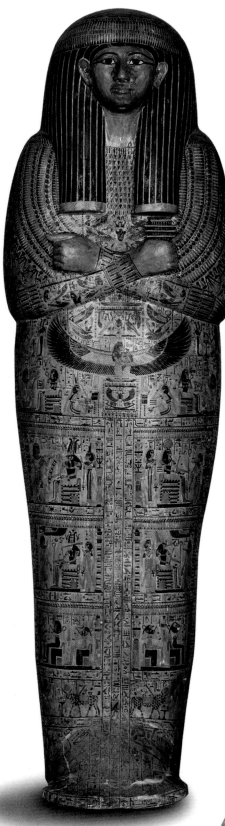

The period between the end of the Twenty-first and the beginning of the Twenty-second dynasties was characterized by a number of changes in funerary customs. Due to incessant tomb-robbing, the practice of preparing sumptuous decorated tombs had long been abandoned at Thebes. The coffin was now painted with texts and images that had previously decorated the walls of tombs. In the same period the Book of the Dead became standardized and was an indispensable part of the funerary furnishings. As in earlier periods, certain beliefs associated with the survival of the dead king were adopted as part of the collective image of the hereafter and were transcribed on papyri in a compendium known as the Book of the Amduat (literally 'What is in the Underworld') and also placed in the coffin.

Late in the last century, besides the famous Cache of Deir el-Bahri which contained the mummies of the kings of the New Kingdom, another multiple tomb was discovered in which the bodies of Theban priests of Amun had been interred. Many of the brightly coloured coffins found on that occasion entered the collection of the Egyptian Museum in Cairo. Lack of space led to others being donated to foreign collections and museums.

For the kings of the Libyan dynasties, references to the past were a means of associating themselves with the glories of earlier periods. But different motives prompted the kings of the Twenty-fifth Dynasty to revive the artistic trends of classic ages – the Old and Middle Kingdoms. The new masters of Egypt originated from the kingdom of Kush (Nubians from northern Sudan). They felt a need to be accepted by the local peoples as the true successors of the pharaonic

tradition. King Piankhi, the first Kushite ruler to succeed in extending his influence over much of Egypt, celebrated his victorious march as far as Memphis with a stela inscribed in solemn language that clearly imitates Middle Kingdom models.

During the course of the Twenty-fifth Dynasty, after a three-hundred year gap, the most important state officials once more began to prepare decorated tombs of large size. Harwa, the holder of one of the highest positions within the Theban clergy, initiated this tradition. His tomb, excavated in the courtyard in front of the temple of Queen Hatshepsut at Deir el-Bahri, was taken as a model by his successors. Like all the officials of the period, Harwa had himself portrayed in a series of statues that he placed within the temples. Some of them show him seated with one knee held to his chest in a pose that, while rare, had been used since the Old Kingdom. The search for something that recalled the past, but at the same time seemed unusual, was the essence of the taste for the antique that characterized the art of the Twenty-fifth Dynasty and was carried through to the following era. Harwa is portrayed with a full and sagging form, and with the face of an old man exhausted by age. This almost portrait-like statue reveals the novelty of the art and thought of the Kushite period. This period also heralded some of the radical changes which Egyptian society was about to experience as it became increasingly open to the cultural stimulus of the Mediterranean world.

The lesson of Harwa was perpetuated, in even more monumental form, by another two Theban officials, Montuemhet and Petamenhotep. With them, Egypt entered the Twenty-sixth Dynasty.

250 ABOVE AND CENTRE
COFFIN OF PAKHAR
CG 6122 - 6121
PAINTED WOOD
HEIGHT 189 CM
WIDTH 59 CM
DEIR AL-BAHRI, CACHETTE
OF BAB EL-GASUS
DISCOVERED BY EUGENE
GRÉBAUT (1891)
MID-TWENTY-FIRST
DYNASTY (LATE 11TH
CENTURY BC)

250 RIGHT
UPPER PART OF A STATUE
OF MONTUEMHET
CG 647
GRANITE
HEIGHT 50 CM
KARNAK, TEMPLE OF MUT
LATE TWENTY-FIFTH–EARLY
TWENTY-SIXTH DYNASTY
(MID-7TH CENTURY BC)

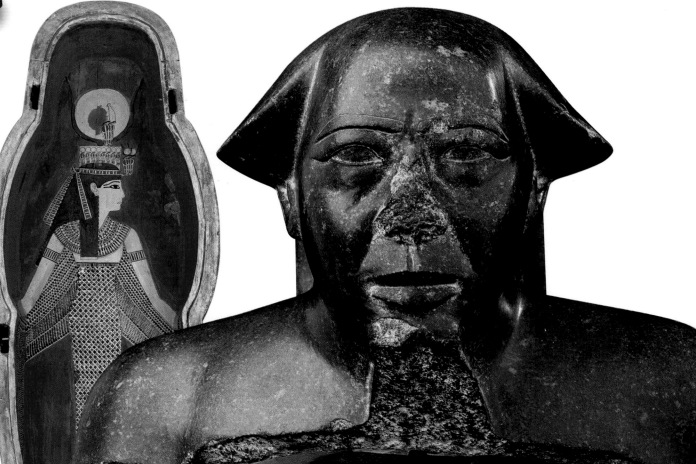

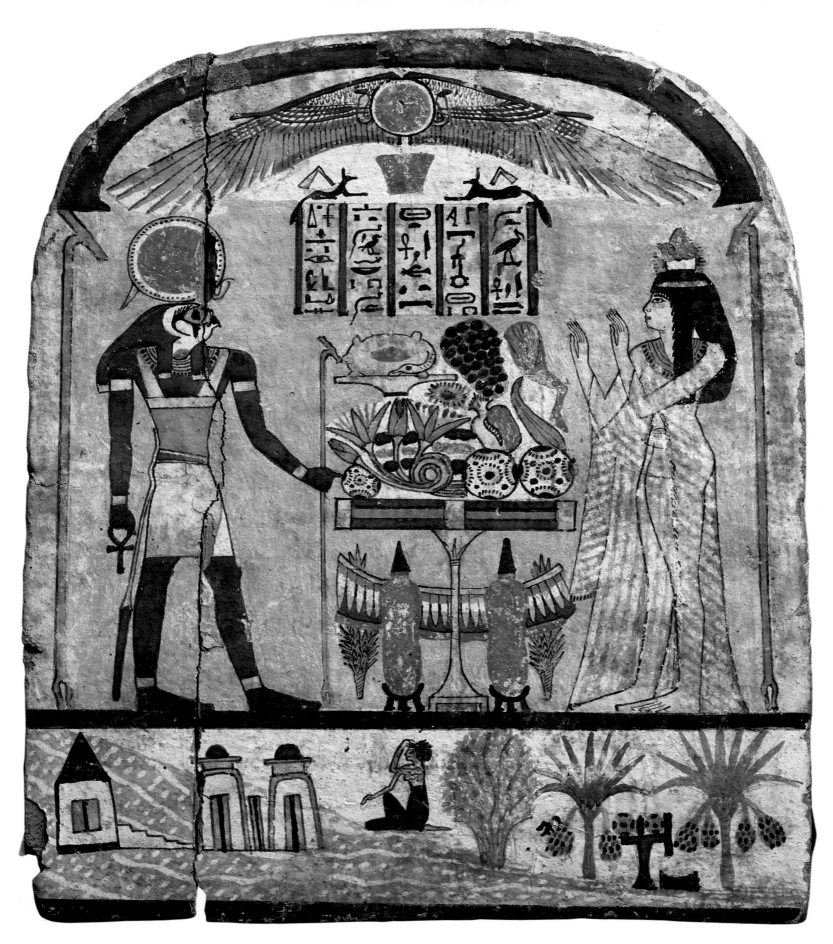

BIOGRAPHY

Francesco Tiradritti was born at Montepulciano in 1961. He graduated with a Bachelor of Arts degree from La Sapienza University in Rome and has a doctorate in Egyptology as well as a Diploma of Advanced Studies from the Sorbonne university in Paris. He is the consultant Egyptologist to the Civic Archaeological Collections of Milan.

He serves on the editorial boards of specialist journals and was responsible for the compilation of the majority of entries dealing with Egypt in the Second Supplement of the Treccani Encyclopedia of Ancient Arts.

He has participated in various excavations in Italy, Egypt and Sudan. He has also curated Egyptological exhibitions including L'Egitto a Milano (Milan, 1991), L'egittologo Luigi Vassalli-bey (Milan and Cairo, 1994–1995), Iside (Milan, 1997), La tierra del toro Apis (Pamplona and Murcia, 1997), and Kemet, alle sorgenti del tempo (Ravenna, 1998).

He is a member of the Italian mission in Cairo for the construction of the new Egyptian Museum at Giza and is director of the Italian archaeological mission at the Tomb of Harwa (Luxor).

251
STELA OF
DJEDAMUNIUNIANKH
TR 25.12.24.20
WOOD, GESSOED AND
PAINTED
HEIGHT 28 CM
WESTERN THEBES
(DEIR EL-BAHRI OR QURNA)
TWENTY-SECOND DYNASTY
(945–712 BC)

UPPER SECTION OF A STATUE OF NAKHTMIN

......................................
LIMESTONE; HEIGHT 34 CM
PROVENANCE UNKNOWN; ACQUIRED IN 1897
LATE EIGHTEENTH DYNASTY
(SECOND HALF OF 14TH CENTURY BC)

This fragment was part of a statuary group portraying Nakhtmin and his wife. The two figures were carved from a single block of stone and were originally joined by a dorsal slab with a curved top.

A wig frames the face of Nakhtmin, its undulating braids represented by very fine incisions that give the head a dynamic look. The face is slightly trapezoidal in form. The eyes are almond-shaped with painted pupils and outlines. They are framed by bold eyebrows, painted black.

Unfortunately the nose, mouth and chin are missing. The lobes of the ears are pierced. Two lines representing wrinkles are incised on the neck. Along the right-hand side of the wig can be seen the remains of a fan. The fan is made of an ostrich plume set in a handle that ends in a papyrus flower. The plume is set in a curve that gently embraces the wig while contrasting with and cutting across the edge of the hair. This geometrical counterpoint can also be seen in the shape of the face which mirrors the trapezoid of the framing wig.

The careful composition of lines, the softness of the features, the attention paid to the representation of the tresses of the wig, and the meticulous detailing of the ostrich plume reveal a search for formal perfection. These elements allow us to date the work to the last reigns of the Eighteenth Dynasty.

In fact the artist of this statue has made a clear attempt to revive the artistic traditions that were interrupted during the reign of Akhenaten. It thus echoes the features typical of the sophisticated style current during the reign of Amenhotep III. However, not all the elements derived from the cultural experience of the Amarna Period have been eliminated, and a number of stylistic features entered the aesthetic vocabulary of all Egyptian artists.

The hieroglyphic inscription that can still be read on the remains of the dorsal slab behind the statue of Nakhtmin's wife attributes the titles of nobleman, royal scribe and supreme general to Nakhtmin. A person with similar titles is known to have dedicated five *shabti* figures in the tomb of Tutankhamun and can probably be identified with the figure depicted in this work.

From other sources we learn that Nakhtmin was the son of a singer of Isis. The connection with this goddess, together with the mention of the god Min in the name Nakhtmin means that it is highly probable that this official came from the city of Coptos or Akhmin. The latter location was also the home of Tiye, the wife of Amenhotep III.

It is therefore very possible that Nakhtmin had been appointed to high-ranking positions within the state through his links with the local aristocracy in that city. During the period, the local elites of this region played a leading role in the political affairs of the entire country. (F.T.)

UPPER SECTION OF A STATUE OF THE WIFE OF NAKHTMIN

......................................
LIMESTONE; HEIGHT 85 CM
PROVENANCE UNKNOWN; ACQUIRED IN 1897
LATE EIGHTEENTH DYNASTY
(SECOND HALF OF 14TH CENTURY BC)

This superb female figure was once part of a single sculptural group together with the statue of her husband Nakhtmin, also shown here. The latter was portrayed in a seated position, while his wife stood to his left with her right arm reaching out around his shoulders, a typical gesture of conjugal love uniting the couple. Her left arm is folded across her breast and she is holding a precious necklace with a *menat*, an ornament in the form of a heavy counterweight. During religious ceremonies, the counterweight was swung when in the presence of the statue of a deity, producing a noise similar to clapping.

A heavy wig, highly fashionable in this period, frames the woman's face. Two masses of extremely fine braids fall at each side, held by a band at the level of the cheeks. Across her forehead is a large diadem, finely decorated with floral motifs. In the centre are three lotus flowers.

The face has very delicate features and is permeated by that subtle expressiveness typical of the statues of the Amarna Period. The oblique lines of the strong eyebrows which disappear under the wig emphasize the almond-shaped eyes. These are also typical features of this artistic period. The outline of the eyes, the pupils and the eyebrows are painted in black. Traces of red pigment can be seen on the slightly down-turned lips. The neck is long and is furrowed by two incised lines.

The woman is wearing a broad-collar necklace consisting of multiple strands of beads, but these were not emphasized. This creates an area that appears almost completely smooth that extends the nudity of the neck to just above the breasts. This is a very effective feature that contrasts with the richness of the almost transparent clothing that drapes the full, rounded contours of her body. The folds of the robe serve to emphasize the swelling of the hips, and to confer an undulating and transversal movement to the sculpture, running from the left arm through to the right, which is extended towards the figure of her husband.

Both this statue and that of Nakhtmin show signs of intentional damage. The fact that the eyes, nose, mouth and hands have been chiselled off suggests the acting out of superstitious beliefs that, as late as the early centuries of the Christian era, attributed life to statues. Damaging the sculpture in this way was thought to prevent it from breathing and from casting spells. (F.T.)

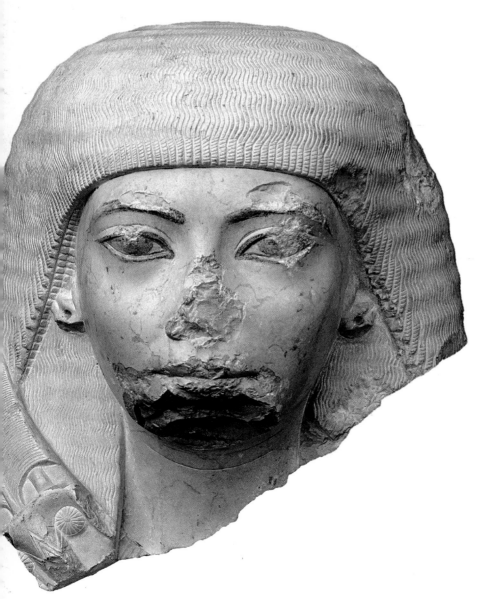

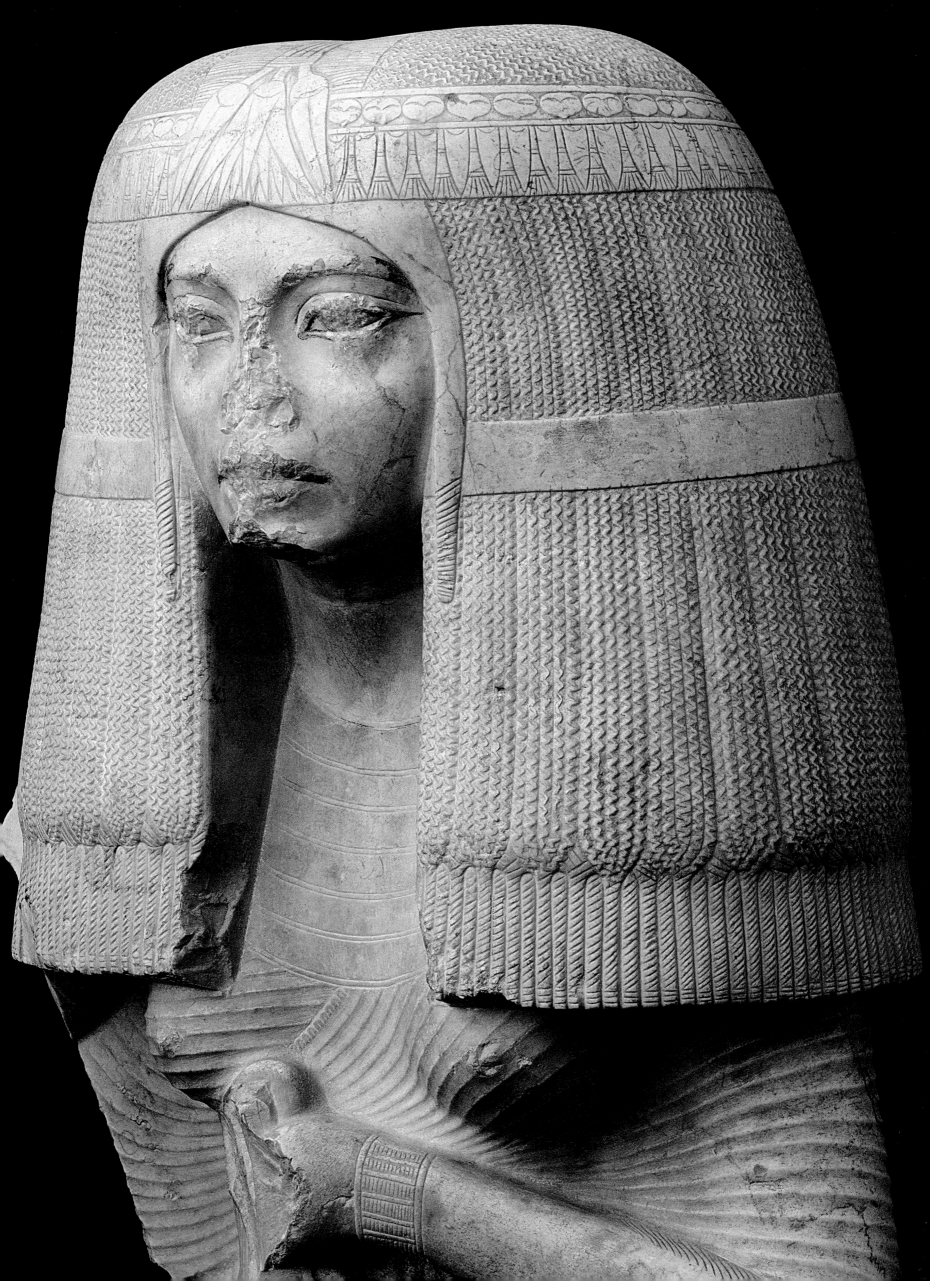

TR 5.7.24.18 - 14.6.24.2

FRAGMENTS OF RELIEF SCULPTURE FROM THE TOMB OF PTAHMAY

····························

LIMESTONE WITH TRACES OF PAINT
HEIGHT 110 CM; TOTAL LENGTH 133.5 CM
GIZA, TOMB OF PTAHMAY; UNAUTHORIZED EXCAVATIONS (1883)
EIGHTEENTH DYNASTY
REIGN OF AKHENATEN (1353–1335 BC)

Ptahmay was the master goldsmith of the temple of Aten at Memphis. He lived during the period of religious reformations promoted by Akhenaten. The decoration of his tomb at Giza, ransacked by inhabitants of the nearby village of Kom el-Batran late in the nineteenth century, clearly shows evidence of the cultural upheavals of a period in which art was subjected to a radical change of manners and styles of such importance that its effects were felt long into subsequent eras.

The two fragments of relief sculpture are divided into a number of registers. The uppermost one is in very poor condition. A number of male figures can be distinguished performing tasks that are almost certainly associated with the working of gold. Ptahmay, of whom only the legs and part of his kilt

remain, is seated on a cube-shaped seat on the right-hand edge of the scene and is checking that all is proceeding satisfactorily. In front of him is a chest and a pair of scales, the central support of which and a dish with a weight in the form of a reclining cow, survive.

Close by, a man seated on a three-legged stool is brandishing a kind of mallet with which he is beating an object above a bench in front of him. The object is probably a gold ingot that is being hammered into gold leaf. Another craftsman, only partially preserved, is standing at his side. A man depicted to a smaller scale and again seated on a three-legged stool, has his back to the other two and appears to be concentrating on counting small objects. Directly above his head is a chest. In front of him is yet another figure, this time busy at a brazier.

The decoration of the middle register depicts a form of musical entertainment. On the right, Ptahmay and his wife Tiy are seated on two chairs, below which are two of their children. Tiy has one arm around her husband's shoulders and the other is resting on his elbow. Ptahmay has his left hand on his wife's knee. His right arm is extended to receive the cup offered to him by a young woman standing before the couple. In her left hand the girl holds a small jar and a cloth. On top of her wig is a perfume cone. Similar cones are worn on the heads of two of the three musicians behind her.

Beyond the musical trio the register divides into two. Here a naked young woman raises her arms to bring her hands towards her face as if entranced by the music or singing. With his back to this scene, and ignoring what is going on behind him, a man draws water from a number of jars set on pedestals. Above him are depicted Kaka, Hori and Ptahmes, three sons of Ptahmay. Each of them is sitting on a stool and holding a lotus flower to his nose. Behind them is a table crowded with food and vessels.

The scene depicted in the lower register takes place in the open air, as demonstrated by the branches shown as if sprouting from above the heads of the figures. Ptahmay stands in the centre, leaning on a tall staff and wearing a long fringed

cape over a kilt. He is checking that a craftsman, with unmistakably African facial features, is doing his job well. The craftsman is brandishing a mallet and is about to strike what appears to be a chisel resting on the upper part of a shrine. Between him and Ptahmay is a worker, depicted on a smaller scale, who carries a heavy basket on his shoulders. Behind Ptahmay is his wife, facing in the opposite direction and extending her right arm towards a water bearer, almost

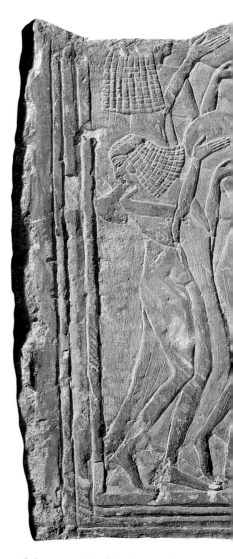

as if she was giving him instructions. Behind the latter figure a young girl draws water from a number of jars set on stands.

All the scenes are permeated by a desire to depict movement that is typical of Amarna art. The alternation of figures of different dimensions sets them on planes at various distances from the observer and gives life to a simplistic yet effective play of perspective. The bodies reflect the predilection for full forms typical of the period. (F.T.)

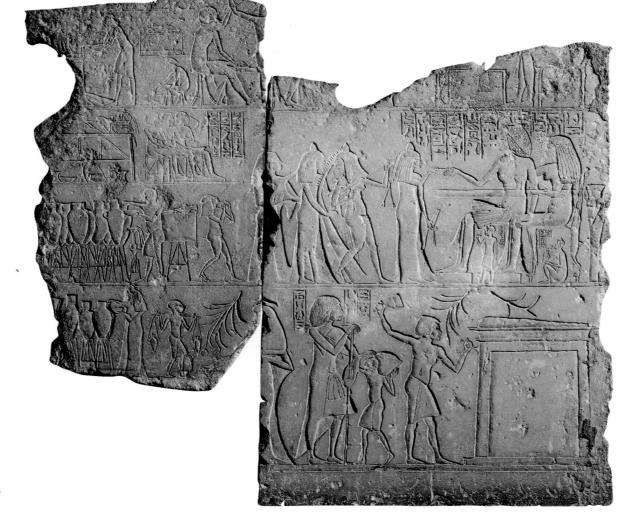

FRAGMENT OF A RELIEF WITH A PROCESSION

LIMESTONE
HEIGHT 51 CM; LENGTH 105 CM
SAQQARA, FOUND AS RE-USED MATERIAL IN THE SERAPEUM
A. MARIETTE'S EXCAVATIONS (1859)
NINETEENTH DYNASTY (1307–1196 BC)

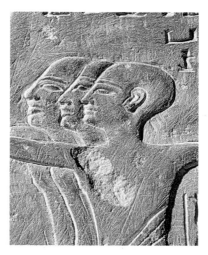

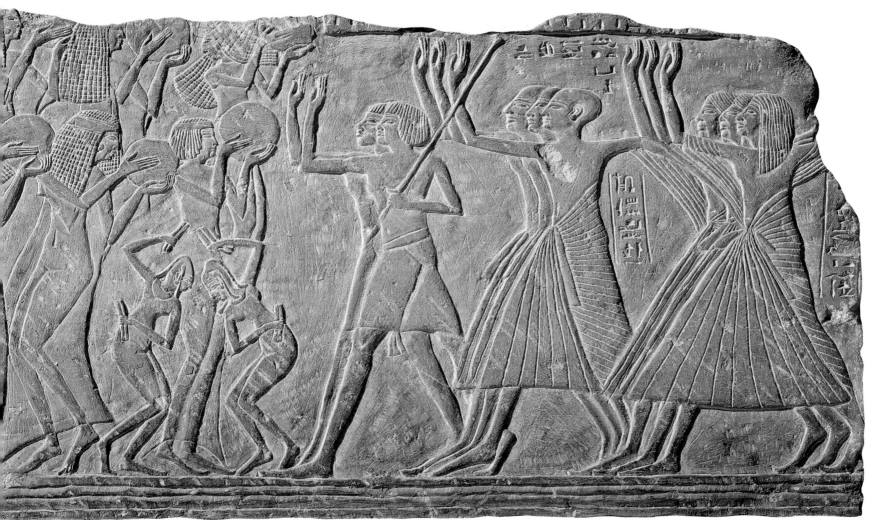

Although found during Mariette's excavations at the Serapeum, this fragment of relief sculpture originally belonged to the tomb of a high-ranking official who had chosen to be buried in the sands of Saqqara, not far from Memphis. From the end of the Eighteenth Dynasty, Memphis was chosen to replace Thebes as the capital of the pharaonic state. This scene would have once occupied the bottom left corner of a wall.

The style and method of arranging the figures in space is very reminiscent of the art of the age following the Amarna Period. But, in the contrast between the formality of the male and the freedom of the female figures, it also reflects the decorative styles of

the reign of Amenhotep III, for instance as found in the funerary scenes in the tombs of Ramose and Userhat at Thebes.

On the left of the scene a group of women is arranged in two rows; each figure is holding a tambourine up in the air. The beating of their hands on the instruments and the rhythmic swaying of their bodies provide a sense of movement that runs throughout the scene.

The tambourines, each set at a different height, lend both rows an undulating motif that picks up on the motion of the figures and underlines its repetition. It is as if a single woman is portrayed from left to right at different and successive moments in the dance. This technique of representing

movement on a flat surface has very deep roots in the art of ancient Egypt and it can be compared with that effect obtained by looking at a series of individual frames of a film. The identity of each female figure is maintained by the variety of items of clothing and ornaments.

In the bottom centre, two young girls are shown playing sticks. This detail, breaking up the solidity of the female group, provides additional animation. A similar effect is provided by the twisting of the heads of two musicians, the first left of the first row and the first right of the second, a movement emphasized by the resulting swinging motion of their wigs.

The procession of men, of which only three rows arranged in

succession remain, is more restrained but still endowed with a degree of dynamism. The male figures are depicted as they stride from the right towards the centre of the scene. The different lengths of the pace of each row, decreasing from right to left, create the impression that the men are about to halt. Their arms are raised to the skies in the gesture that in hieroglyphic writing symbolizes an expression of jubilation.

The variety of their clothing shows that each row was composed of figures with various functions and roles. The names of two of them are recorded in the hieroglyphs that accompany the scene, the *sedjemash* Aanakht and the scribe Amunkhai. (F.T.)

UPPER PART OF A STATUE OF SETI I AS A STANDARD-BEARER

SCHIST; HEIGHT 22 CM
ABYDOS
NINETEENTH DYNASTY, REIGN OF SETI I (1306–1290 BC)

The process of counter-reformation that formed a reaction to the radical break of the Amarna Period was completed by the accession to the throne of Seti I. In a cultural climate based on a return to the past, statuary in particular and art in general drew inspiration from prototypes of the period of Thutmose III, thus openly rejecting the trends that had helped to make the period between the reigns of Amenhotep III and the immediate successors of Akhenaten so fertile and innovative. Some of the artistic developments of the

Amarna Period did take root, however, and were retained in spite of the determined effort of the authorities (state and clergy) to pretend that nothing had happened in the twenty years leading up to the reign of Tutankhamun.

The vibrancy of certain Amarna works, for example, is also found in the depiction of elaborate costumes in the early Ramesside Period, with sophisticated pleating capable of creating a dramatic effect of alternating light and shadow. This is certainly the case with this statue of Seti I, in which the complicated

knotting of the robe beneath the right breast forms the focus of pleats radiating outwards with a centrifugal motion that is the equal of anything produced in the Amarna Period, although the rendering of the musculature is more sober here.

The stunning visual effect of the robe is counterbalanced by the wig, the tightly curled tresses of which fall in descending waves of chiaroscuro. The costume and wig create a dazzling frame for the face, the features reproducing an idealized likeness of Seti I. While the slightly hooked nose and the shape of the mouth may recall Thutmosian statuary, the eyes are

enclosed between heavy lids that are also reminiscent of the post-Amarna tradition.

This sculpture comes from Abydos, the site where Seti I's construction programme was most intense. It was at this site that the king constructed a temple and a cenotaph dedicated to Osiris, in order to legitimize the claim of his house to the throne of Egypt.

Originally the statue would have represented the king in a striding pose, with his arms held to his sides. The left arm held a standard, the upper part of which is unfortunately now lost, thus preventing us from identifying the deity portrayed on it. (F.T.)

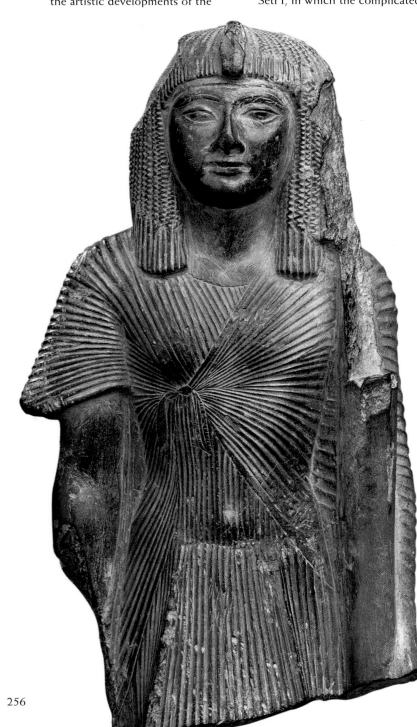

COLOSSAL STATUE

CALCITE; HEIGHT 238 CM
KARNAK, TEMPLE OF AMUN-RE, COURTYARD OF THE CACHETTE
G. LEGRAIN'S EXCAVATIONS (1903–1904)
NINETEENTH DYNASTY, REIGN OF SETI I (1306–1290 BC)

The statue was discovered in the Karnak Cachette where it had been deposited after being disassembled. It is in effect a composite statue – a type frequently found in Egyptian art. Such statues are typically created using different materials. The main parts were made separately, after carefully selecting the best quality stone so that the veining reflected anatomical features. The head and torso were carved from a very dense type of calcite, whereas the legs and hands were sculpted from stone with more veining. Missing elements, such as the garments, attributes and individual facial features must have been made from other, probably precious, materials, which were removed before the statue was buried.

The statue could be dated, mainly on stylistic grounds, to the end of the Eighteenth Dynasty. Several artistic features – such as the full, sensual form of the mouth, the sockets into which the very long, almond-shaped eyes were set, and the narrow and slightly arched eyebrows – suggest it was created towards the end of the Amarna Period or in the age immediately following. Judging from the rather approximate way in which the hieroglyphs were inscribed, it is possible that the name of Seti I, carved on the dorsal pillar and base, was added later, when the pharaoh

presumably decided to take possession of the statue of an immediate predecessor. However, the piece could also have come from the workshop of a sculptor whose style was slightly archaic in the context of the period when it was made, in which case it can be attributed to the reign of Seti I himself.

The king was probably depicted wearing the *khepresh* headdress, the so-called Blue Crown frequently seen in statues and relief carvings produced between the end of the Eighteenth and beginning of the Nineteenth dynasties. The eyes and eyebrows were inlaid. A deep hole beneath the chin suggests the statue had a false beard, while a broad-collar necklace covered the point where neck and torso joined. The holes for the attachment of the hands to the arms must have been concealed by two bracelets. The king was holding something in each hand – either a sceptre or cylinder filled his now-empty fists. His kilt would have been made of gold leaf with fine pleating, with perhaps a lion head occupying the hole on the front panel below his navel.

The king would have been wearing sandals and was depicted trampling on the Nine Bows, the traditional enemies of Egypt. Two of these figures can still be seen on the top of the base, together with Seti I's name. (F.T.)

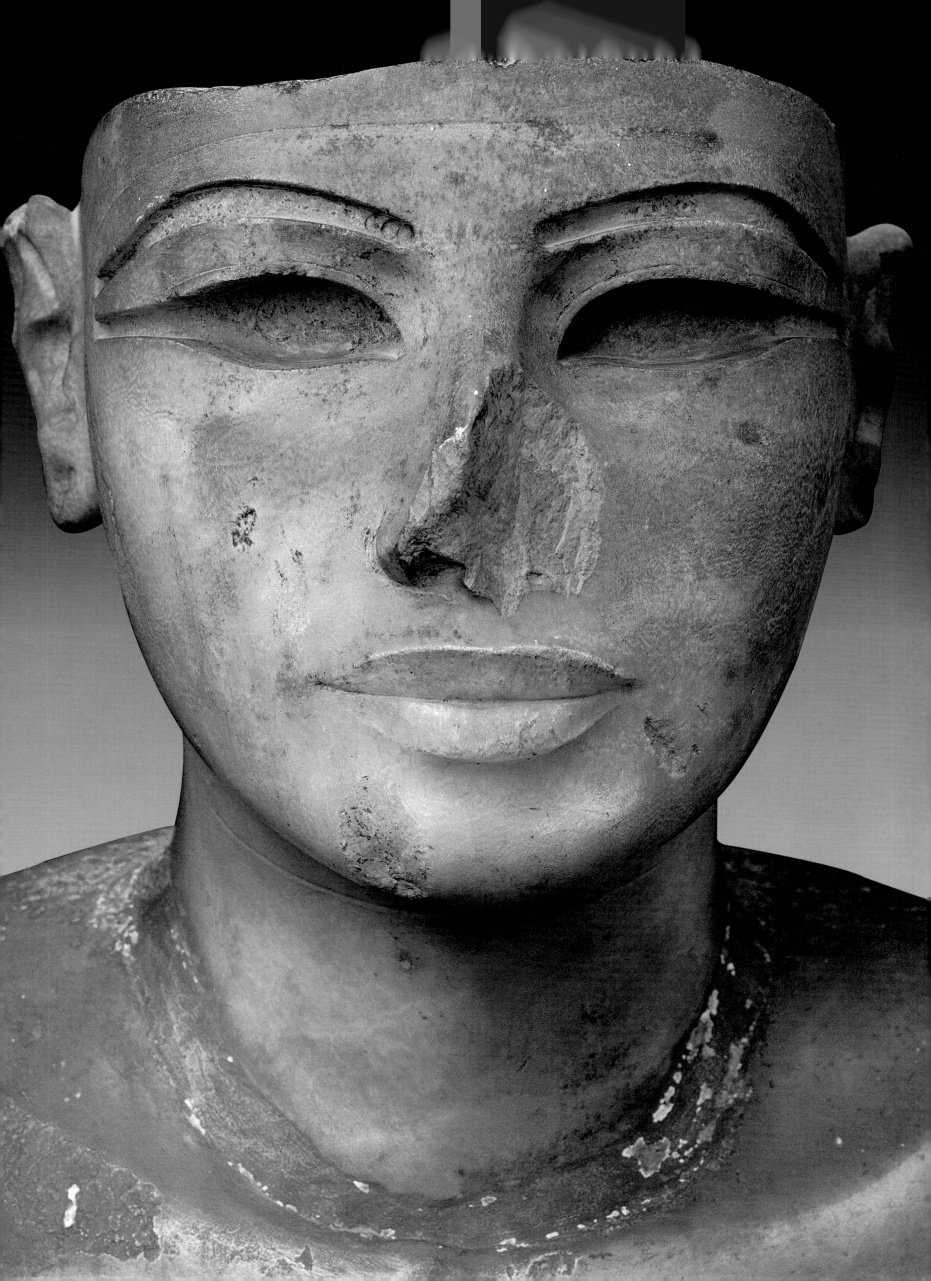

UPPER PART OF A STATUE OF RAMESSES II

DIORITE; HEIGHT 80 CM
TANIS; NINETEENTH DYNASTY, REIGN OF RAMESSES II (1279–1212 BC)

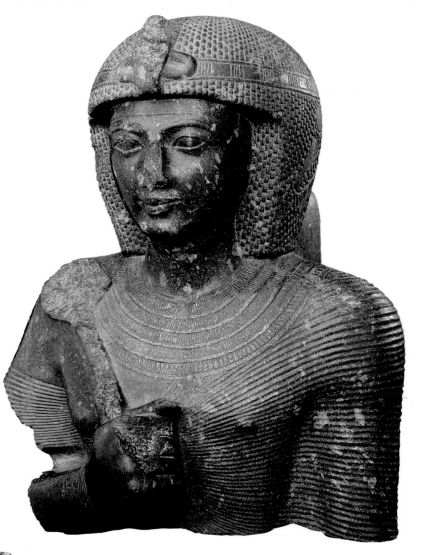

The upper part of this statue of Ramesses II is very similar to the celebrated statue of this pharaoh in the Egyptian Museum of Turin. The most significant difference between the two sculptures lies in the fact that in the Turin example the king is wearing the Blue Crown, while here he is wearing a short wig fastened with a headband on which is the royal cobra.

Ramesses II is portrayed with youthful features. The prominent, narrow eyes are set off by an outline in relief and slightly arched eyebrows. The fullness of the face contrasts with the small mouth, set in an austere, slight smile. The nose is missing.

A broad collar consisting of five rows of beads covers the sovereign's chest and is superimposed over a pleated robe, the complicated and fine pleats of which are knotted beneath his left breast.

The surviving right arm is folded across his chest with the hand resting at the centre of the figure and gripping a *beqa* sceptre, the tip of which is now missing but once rested on the right collarbone. The wrist is adorned

radiate out from the centre of the sculpture and completely enfold the left arm.

The richness of the clothing and the figure's pose (which lacks the boldness of the Turin statue), with the sceptre projecting well above the statue's right shoulder, contrast well with the austerity, clarity, classicism and absolute immobility of the face. This face reveals a ruler certain of his own power, an image common also in the royal propaganda literature of the Ramesside Period. (F.T.)

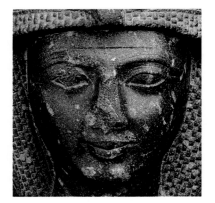

with a bracelet featuring an *wedjat* eye in relief.

The composition as a whole includes elements, such as the pleated robe and the short wig, that began to appear during the Eighteenth Dynasty. There is a strong play of light and shadow that, descending from the curls of the wig, moves through the rows of necklace beads until it reaches the sharp contrasts of the pleats of the robe. These pleats appear to

COLOSSAL STATUE OF RAMESSES II AS A BOY, WITH A FALCON

GREY GRANITE AND LIMESTONE (FALCON'S BEAK); HEIGHT 231 CM
TANIS; P. MONTET'S EXCAVATIONS (1934)
NINETEENTH DYNASTY, REIGN OF RAMESSES II (1290–1224 BC)

This granite statue was found in the ruins of a mud-brick building at Tanis which was part of a cluster of structures not far from the enclosure wall of the Great Temple of Amun. The falcon's beak, carved from a separate piece of limestone, was discovered in an adjacent room. In all probability, therefore, the building was a craftsman's workshop. The sculpture had been taken there to be repaired, although the operation was never completed. It is difficult to establish when the statue was damaged.

Many of the sculptures found at Tanis, the Delta city that was the capital of the Twenty-first and Twenty-second dynasties, had been brought there from other sites in Egypt. It is possible that the loss of the falcon's beak occurred while the work was being transported. Or, more likely, it was decided to reuse the statue for the decoration of the Great Temple despite previous damage. In this case the missing part

was to be replaced once the statue was in the Delta city.

The piece probably originated in the cemeteries at Giza where, during the New Kingdom, colonies of Asiatic people had settled. In spite of a gradual process of assimilation into Egyptian culture, these peoples continued to worship their own deities, some of whom were then accepted and integrated into the Egyptian religion. Among these deities is Horun, the tutelary god of the dead who was assimilated with Harmarchis, the 'Horus of the Horizon' who, according to the Egyptian religious beliefs had his most spectacular manifestation in the Great Sphinx of Giza.

This colossal statue represents Ramesses II with the features of a young boy. He is naked and seated. He holds one finger of his left hand up to his mouth and a large side lock of hair descends to his shoulder. Both these features are characteristic of representations of adolescents in

ancient Egypt. The king wears a cap decorated on the forehead with a cobra, the symbol of kingship. On his head is a solar disc, and in his left hand he holds a reed. This last detail is not found in the typical images of the king. It indicates that, as in many other representations of Ramesses II, the image is to be read as a graphic puzzle in the form of a rebus. In hieroglyphic writing, the solar disc on the head signifies *re*, the child *mes* and the plant *su*. Reading the three symbols from top to bottom gives the word *Ramessu*, the name of the pharaoh.

Behind Ramesses II looms the figure of the god Horun in the form of a falcon. As in earlier statues the falcon is symbolically protecting the king. The bird is shown in a highly stylized manner, with details of the plumage and the talons shown by incised lines that produce a geometric decorative effect, rather than a faithful reproduction of reality.

While this is a workshop piece of no great artistic merit, it is an interesting demonstration of the skilful political policy of the pharaoh. In choosing to place himself under the protection of Horun, Ramesses II satisfied the Syrian peoples of whom Horun was a god, while at the same time reasserting the legitimacy of his own sovereignty, given that according to New Kingdom traditions it was the Sphinx who designated the heir to the throne. (F.T.)

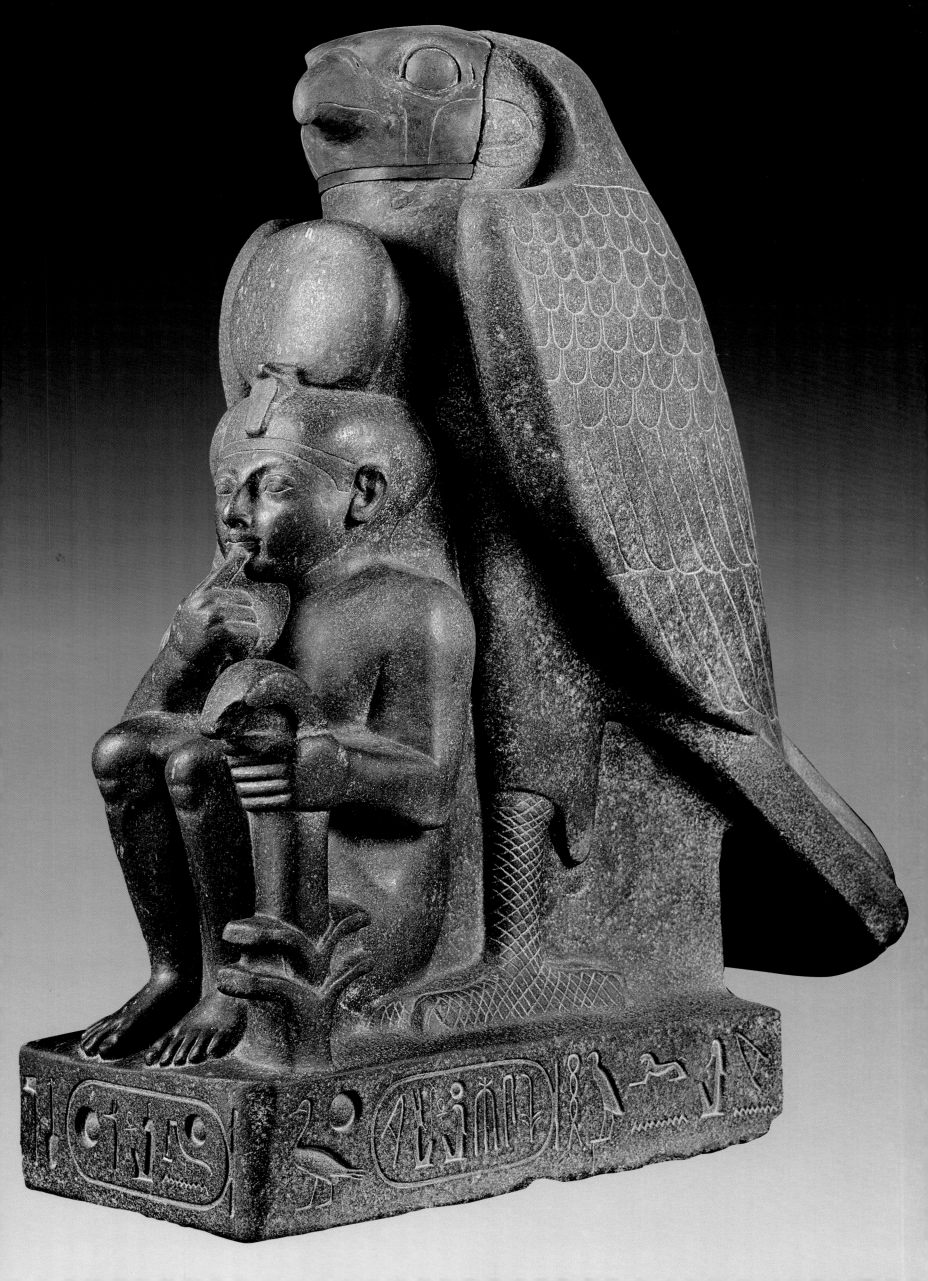

PAIR OF BRACELETS OF RAMESSES II

GOLD AND LAPIS LAZULI; MAXIMUM DIAMETER 7.2 CM
TELL BASTA (BUBASTIS); TREASURE DISCOVERED IN 1906
NINETEENTH DYNASTY, REIGN OF RAMESSES II (1290–1224 BC)

FRAGMENT OF A STATUE OF MERITAMUN

LIMESTONE; HEIGHT 75 CM; RAMESSEUM, TEMPLE OF THE QUEEN, NORTH OF THE
MAIN SANCTUARY; W.M.F. PETRIE'S EXCAVATIONS (1896); NINETEENTH DYNASTY,
REIGN OF RAMESSES II (1290–1224 BC)

These bracelets were discovered together with other jewels and a number of gold and silver vases during construction work on a railway line passing over the site of Tell Basta, the ancient Bubastis. Only a few of the items reached the museum in Cairo; others were sold and today can be seen in the Metropolitan Museum of Art of New York and the Berlin Museum. They would once have been part of a votive deposit or perhaps the treasure from one of the temples of Bubastis. Another find of precious objects had been made in the vicinity only a few months earlier.

The fact that the cartouches of Ramesses II are inscribed alongside the clasp of these bracelets suggests that they were an offering made by the king (they are large enough for a man's wrist) to the local deity, the cat goddess Bastet.

Each of the rigid gold bracelets is composed of two parts linked by a hinge. The fine decoration is executed in the granulation technique and consists mostly of geometric motifs. The upper part is decorated with a duck (or a goose), which has two heads turned backwards over the body. The body of the bird is formed of a carved piece of lapis lazuli while the tail is in gold, again with geometric decoration in granulation.

The lower section of the bracelets is composed of seventeen parallel bars, alternately smooth and ribbed, all fastened to a strip of gold.

These two bracelets are products of a very sophisticated gold-working tradition that also produced the jewels of Tutankhamun, with which close parallels can be traced. The unity of the overall composition is given a degree of vitality by the two necks of the ducks, which cleanly and gracefully break away from the surface of the jewel.

The combination of gold and lapis lazuli (a stone obtained along trade routes from Afghanistan) was widely used in Egyptian jewelry and here again successfully confers a great degree of elegance upon the composition. (F.T.)

Even though only the titles and not the name of the queen are preserved on the rear pilaster, this piece has been identified as a statue of Meritamun, one of the daughters of Ramesses II. On the death of Nefertari (some time after the twenty-first year of the king's reign) she took on the role of the Great Royal Wife. This identification was made possible by the discovery at Akhmim in recent years of a colossal statue of Meritamun, identical to this Cairo example found in the ruins of the Ramesseum.

The painted decoration of the statue is still well preserved. The yellow of some of the facial features and decorative elements combines well with the blue of the wig, both of which are enhanced by the brightness of the extremely fine limestone used for the sculpture.

The face has a serene expression. The eyes are almond-shaped, elongated by a line of cosmetic (shown by two thin incisions), and set below heavy eyebrows. The full mouth is set in a slight smile, similar to those seen on a number of statues of Ramesses II. Thin lines are incised on the neck. The lobes of the ears are covered by large hemispherical earrings.

The delicate face is framed by a three-part wig, from which the natural hair emerges, and is held in place by a diadem featuring two cobras wearing the White and Red Crowns, the symbols of Upper and Lower Egypt.

On top of her head the queen wears a circular diadem, its base decorated all the way round with a frieze of uraei with solar discs. From this base would once have risen a double plume with a solar disc at the centre, a prerogative of the Great Royal Brides.

Meritamun wears a tightly fitting tunic. Around her shoulders is a broad-collar necklace consisting of six rows of beads, five of which are in the form of small amulets of the hieroglyph nefer ('beautiful'). The last row consists of drop-shaped beads. A rosette decorates her left breast while the right breast is covered by the counterweight of the menat necklace which she is holding in her right hand. On her wrist is a bracelet composed of two rows of beads.

The menat necklace was used as a musical instrument and was shaken to produce a loud noise on the occasion of the feasts held in honour of Hathor or other female divinities. The necklace was composed of numerous strands of beads, balanced with a large counterweight, in this case in the form of a female head and ending in a circular element with a rosette.

In ancient Egypt taking part in processions, singing, dancing and playing musical instruments was a typically female prerogative. Priestesses were frequently indicated with their specific functions within the train of the divinity and it was only natural that the queen herself performed a number of these priestly functions. The fragmentary hieroglyphic inscription on the dorsal pillar of the statue reads '...player of the sistrum of Mut and the menat necklace [of Hathor] ... dancer of Hathor....' (F.T.)

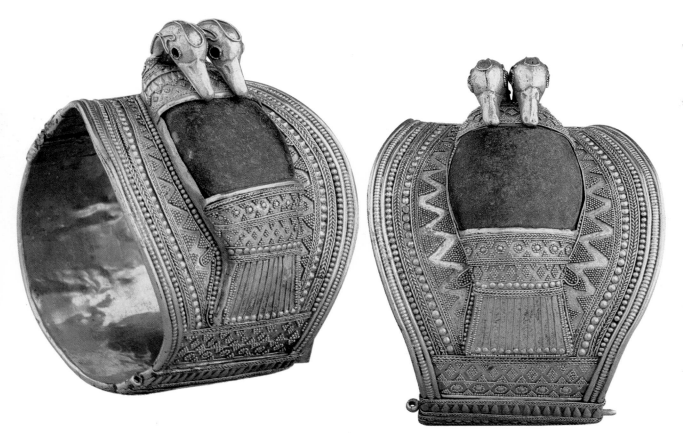

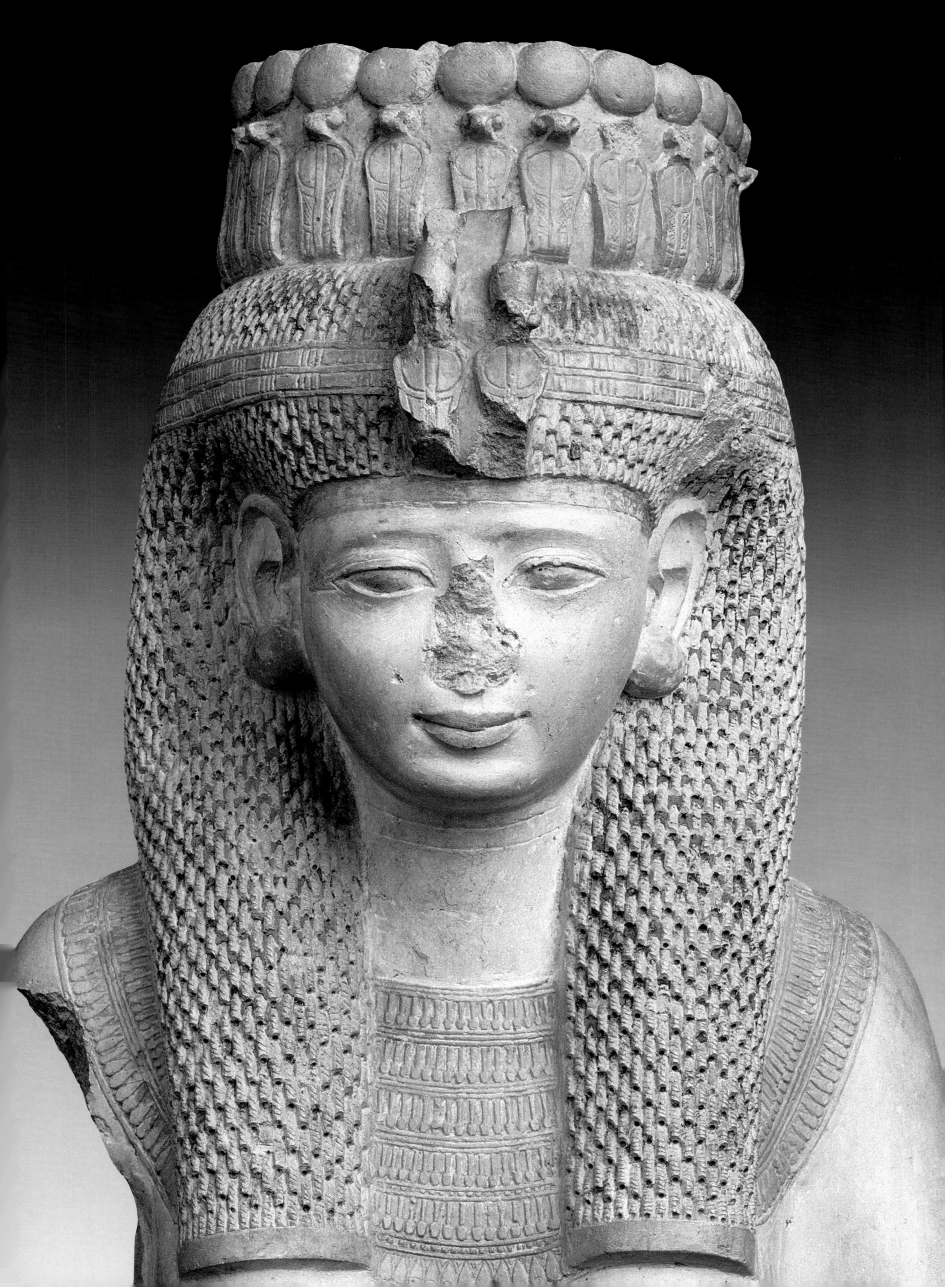

THE 'ISRAEL STELA'

GREY GRANITE; HEIGHT 318 CM; WIDTH 163 CM; DEPTH 31 CM
WEST THEBES, FUNERARY TEMPLE OF MERNEPTAH
W.M.F. PETRIE'S EXCAVATIONS (1896)
EIGHTEENTH DYNASTY, REIGN OF AMENHOTEP III (1391–1353 BC)
NINETEENTH DYNASTY, REIGN OF MERNEPTAH (1224–1214 BC)

This stela with a curved top once stood in the first courtyard of the funerary temple of Merneptah. In order to ensure that his great feats were remembered, the king reused a monument of Amenhotep III, whose vast funerary temple (of which only the colossi flanking the monumental entrance, the so-called Colossi of Memnon, remain) rose close by. Merneptah used his predecessor's temple as a source of building material, thus ensuring its almost complete destruction. For his monument he used only the reverse side of this stela, leaving intact the text of Amenhotep III that survives to this day.

Amenhotep III's inscription, however, was almost completely obliterated during the Amarna Period, when religious fanaticism led to the elimination of all images and mentions of Amun-Re from pictorial scenes and inscriptions in which the god appeared. Following the Amarna Period there was a counter-reformation, and Seti I ordered the restoration of all those parts of the document (most of the text and the images) that had been lost, as recorded in the column of hieroglyphs dividing the scene into two symmetrical parts.

On the side used by Amenhotep III, the king appears on the right and left wearing a *nemes* and the double crown. He is depicted in the act of offering *nu* vases to Amun-Re. The entire composition is surmounted by a winged solar disc from which two cobras emerge. The hieroglyphic text is thirty-one lines long and in it Amenhotep III describes his funerary temple and all the ornaments that made it superior to those of all his predecessors. The king also mentions the three building projects he commissioned at Karnak, Luxor and Soleb. The inscription ends with a discourse by Amun-Re, who, delighted by the feats of his son, concedes dominion over the entire world to him and his heirs.

The side of the stela used by Merneptah also features a scene divided into two parts, but it has a more complex composition in which the symmetry is constantly offset by the addition and variation of certain details. The king is dressed in a long ceremonial robe and wears the Blue Crown on his head. In one hand he hold the *heqa* sceptre while with the other he accepts the *khepesh* sword that Amun-Re, standing in front of him, is holding out to him. In the right-hand scene the sovereign is followed by Khonsu and in the left by Mut.

The text is composed of twenty-eight lines and dates from the fifth year of the pharaoh's reign. The inscription is based on the account of Merneptah's victory over the Libyans encamped along the western borders of Egypt. The enemy is described as cowardly and flees. The Egyptian king captures the enemy's wives, and his sons sack and burn the enemy troops' camp. The account concludes with a list of the defeated enemies. This list includes a number of peoples and places on the Syrian-Palestinian coast, among which is the earliest mention of the nation of Israel, reported as having been completely destroyed – 'its seed no longer exists'. In the years immediately following the discovery of the stela, it was virtually the sole evidence for the identification of Merneptah as the pharaoh during whose reign the Exodus of the people of Israel from Egypt took place. Today it is thought that Israel emerged from a gradual settlement by nomadic tribes in the Philistine region, which had already taken place before the reign of Merneptah. (F.T.)

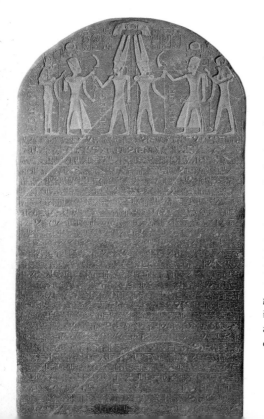

UPPER PART OF A STATUE OF MERNEPTAH

PAINTED GRANITE; HEIGHT 91 CM
WEST THEBES, FUNERARY TEMPLE OF MERNEPTAH
W.M.F. PETRIE'S EXCAVATIONS (1896)
NINETEENTH DYNASTY
REIGN OF MERNEPTAH (1224–1214 BC)

This statue fragment was found in the second courtyard of the king's funerary temple, not far from its base and the plinth of a second, very similar statue. The two portraits of the king must have been set symmetrically along the axis of the sacred building.

Merneptah was the thirteenth son of Ramesses II and the eldest still alive at the end of the long-lived pharaoh's sixty-seven-year reign. When he came to the throne Merneptah must have been about fifty years old; but the face of this

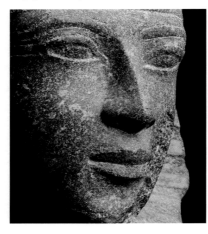

statue portrays him as man in the full flower of youth. It is, in fact, an idealized portrait designed to emphasize his ability to govern the country rather than a true likeness of the king.

The expression is serene but austere and echoes some of the portraits of Ramesses II, who wished to promote the image of a benign yet severe sovereign. This was an ideal model of a ruler who lived up to the expectations of his subjects, protecting them from enemies.

Merneptah is wearing a *nemes* headdress with a cobra over the forehead, the typical regalia worn by Egyptian kings from the Old Kingdom onwards. His eyes are narrow and framed by heavy lids, a remnant of the Amarna style. The line of eye-paint and the eyebrows further emphasize the narrowness of the eyes. The nose is thin and slightly curved while the mouth is straight and wide. The ears are fairly large and are a reference the royal statuary of the Twelfth Dynasty, in which this particular physical characteristic symbolized the willingness of the sovereign to listen to the pleas of his subjects.

The lobes are pierced. The false beard, today missing, was fastened by a cloth chin-strap. Below the stripes of the *nemes*, which descends to the shoulders, can be seen a broad necklace, the outermost row of which is composed of petal-shaped beads.

A number of elements of the statue show traces of polychrome decoration. The eyes were white and black, the cobra, lips and the torso red and the *nemes* yellow. The necklace was painted in yellow, green and blue. (F.T.)

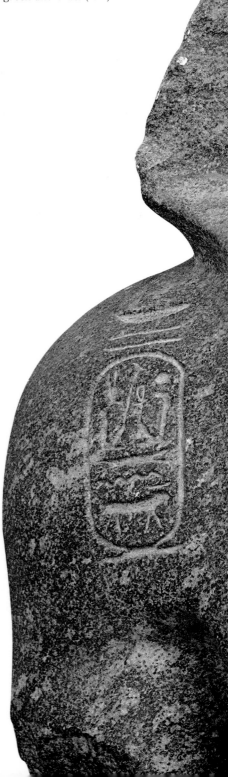

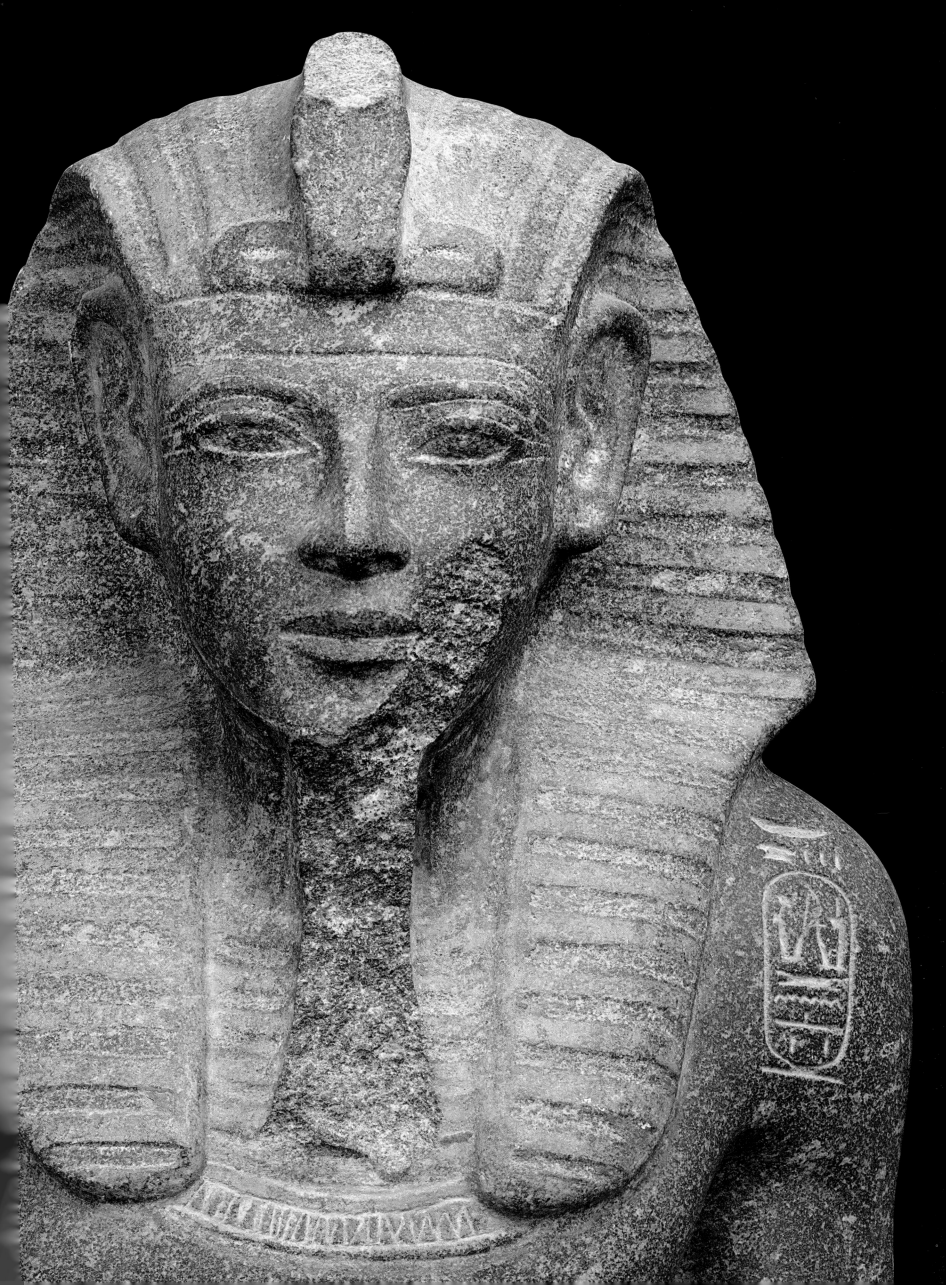

VASE WITH A HANDLE IN THE FORM OF A GOAT

GOLD AND SILVER; HEIGHT 16.5 CM
TELL BASTA (BUBASTIS); TREASURE DISCOVERED IN 1906
NINETEENTH DYNASTY (1307–1196 BC)

This magnificent vase was part of the first cache of treasure that was discovered during the construction of a railway at Tell Basta, where the temple dedicated to the goddess Bastet, the tutelary goddess of Bubastis, once stood. Other jewels and furnishings in precious metals were found in the vicinity a few months later

The body of the vessel has a rounded form and is decorated with a motif of superimposed droplets in vertical columns very similar to cords. On the side opposite to the handle is a vignette in which a richly dressed male figure extends his arms in adoration towards a female deity with attributes not otherwise known in pharaonic

Egypt. The goddess is wearing a tight robe and a headdress from the top of which emerges what may be a tuft of feathers. In her left hand she holds the hieroglyphic symbol of the *ankh* while her right hand grips a sceptre topped with a papyrus flower on which an unidentifiable bird is perched. From this scene two symmetrical hieroglyphic inscriptions run around the shoulder of the vessel and meet below the handle. They contain propitious phrases directed to the king's cup bearer Atumemtaneb.

Around the tall cylindrical neck of the vase is a double band of naturalistic decoration. The upper register draws inspiration from oriental models. Real and fantastic

animals are divided by floral compositions that resemble the oriental tree of life. To the right of the handle there is a remarkable figure of a winged griffin. Another griffin is shown attacking a cat close by. Alongside are two gazelles mating. Other scenes involve fights between various animals set in poses that placed the demands of an interesting compositional form over naturalistic detail.

The lower register contains scenes of hunting and fishing in the swamps, taken from the classical Egyptian repertory. A man is sailing a papyrus boat on which is a small box with a nesting bird, a basket

dangle two fish; a basket and a creel are hanging from the other end. A papyrus thicket separates this scene from the next. A number of men are closing a net in which some birds have been trapped after settling on a pool. Others, having escaped the net, rise in flight all around.

The handle of the vase is in the form of a goat. The animal is rearing on its hind legs and resting its folded front legs on the neck of the vase. Its nose touches the upper rim and a silver ring is inserted in the animal's nostrils. A triangular hole on the forehead would originally have held an inlay.

The skilful combination of

~ and a creel. A lotus flower rests on the roof. Further on another man emerges from a reed bed having captured a duck. Other disturbed ducks rise in flight, abandoning their nests and eggs along the edges of a pool in which three fish are swimming. An angler is also moving away from the pool with a long rod over his shoulder, from which

oriental decorative motifs with others that are typically Egyptian sits well with the cultural upheavals of the Ramesside Period. This was a time when the encounter between Egypt and neighbouring cultures led to the introduction of new styles and an enrichment of the figurative repertory of Egyptian artists. (F.T.)

VASE WITH A HANDLE IN THE FORM OF A COW

GOLD; HEIGHT 11.2 CM
TELL BASTA (BUBASTIS); TREASURE DISCOVERED IN 1906
NINETEENTH DYNASTY (1307–1196 BC)

EARRINGS OF SETI II

GOLD; LENGTH 13.5 CM
VALLEY OF THE KINGS, THE 'GOLD TOMB' (KV 56)
T. DAVIS' EXCAVATIONS (1908)
NINETEENTH DYNASTY, REIGN OF SETI II (1214–1204 BC)

This vase was part of the second of two caches of treasures that perhaps once belonged to the temple of the goddess Bastet and that were brought to light within months of each other during work on a railway line that cut through the ancient city of Bubastis.

The body of this fine vessel resembles a pomegranate in shape and its embossed surface is decorated with a motif that resembles the seeds of the fruit. From the New Kingdom onwards the pomegranate appears very frequently on Egyptian objects and jewelry. It is presumed that the fruit was introduced to the Nile Valley from the East in the aftermath of the successful campaigns of conquest in the Syrian-Palestinian region – it appears among the exotic fruits reproduced in the so-called 'Botanical Garden' of Thutmose III at Karnak.

In spite of a lack of textual evidence, it is reasonable to suppose that the fruit was attributed an apotropaic value, given that it appears so frequently on later amulets. Pomegranates have been found among the objects and foodstuffs in New Kingdom funerary assemblages. A silver vase reproducing the form of the fruit was also found among the funerary treasures of Tutankhamun.

The Bubastis vase has a tall cylindrical neck on which are incised four bands of decorative motifs. The upper band contains a frieze of lanceolate leaves very similar to those painted in bright colours on ceramic vessels of the New Kingdom. The band below features lotus flowers alternating with bunches of grapes and other flowers. Below this runs a frieze of small circles with central dots that can be interpreted as highly stylized rosettes. The final decorative frieze is a festoon of flowers (also highly stylized) with their petals pointing downwards.

The vase has a ring handle which is threaded through an attachment in the form of a reclining cow with its muzzle turned upwards; at each end is a palmette. Both the modelling of the animal and the palmette motif are clear evidence of Middle Eastern influences that had been fully assimilated by the craftsmen of the Ramesside Period. (F.T.)

These two earrings were found together with other objects with the names of Seti II and his wife Tawosret in an anonymous tomb in the Valley of the Kings. It was once thought that they had been hidden there by the raiders of the tomb of the king or the queen (most probably the latter) while awaiting an opportunity to recover them; it seems more likely, however, that this was a burial of one of their children.

Earrings only began to be common in Egypt from the New Kingdom onwards. This is perhaps one of the results of the increasingly frequent contacts made with the oriental peoples during this period. It was a form of jewelry that was not differentiated on the basis of either sex or age. It does appear, however, that earrings were worn

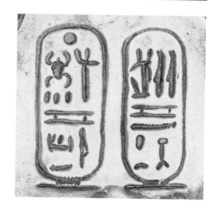

above all by women and children and there are no known representations of adult men wearing them. An examination of the mummies of the kings of the New Kingdom has none the less demonstrated that some of them had pierced lobes with holes large enough for ear ornaments of considerable size.

The two earrings of Seti II are identical: each is composed of three sections. They were attached to the ear by means of two narrow tubes that fitted one inside the other. The slightly larger external tube ends in a hemispherical cap on which the names of Seti II are incised. The smaller internal tube is soldered to a rosette of eight petals, on four of which the king's cartouche is engraved. A second element, suspended by two rings, is again inscribed with the names of Seti II. Seven identical pendants, four small and three large, hang from the lower edge. Each pendant is composed of a ribbed tube from which a flower-head, perhaps a poppy, hangs. (F.T.)

STATUE OF RAMESSES III AS A STANDARD-BEARER OF AMUN-RE

GREY GRANITE; HEIGHT 140 CM
KARNAK, TEMPLE OF AMUN-RE, COURTYARD OF THE CACHETTE
G. LEGRAIN'S EXCAVATIONS (1905)
TWENTIETH DYNASTY, REIGN OF RAMESSES III (1194–1163 BC)

In ancient Egypt the pharaoh also served as the pre-eminent high priest, and was symbolically present at every ritual. Clearly the king could not physically preside over every religious ceremony in every temple at the same time. He therefore delegated this duty to other individuals, who administered religious matters on his behalf.

The pharaoh's presence was ensured magically through his image depicted on the walls of the temple in the act of conducting various ceremonies, or was embodied in the stone statues that, according to the beliefs of the ancient Egyptians, was a substitute for the individual in his absence.

Sculptures of the king carrying a standard were placed at temple entrances and represented him participating in ceremonies associated with processions bearing the emblems of the divinity. On these occasions the simulacrum of the god was placed on a barque and carried on the shoulders of the kingdom's highest officials so that the people could contemplate his majesty.

Ramesses III is depicted here in a striding pose, with his hands held to his sides. He has a youthful appearance and his idealized facial features are very similar to those of Ramesses II, whom he chose as a model to imitate. The face is framed by a graceful wig cut obliquely at the shoulders and adorned on the forehead with a large cobra. The braids are rendered geometrically. The youthful torso is naked and the musculature is stylized.

The king wears a short kilt, as frequently found in Ramesside statuary. The narrow pleats of the cloth converge towards the front where they are covered by a kind of panel or apron with elaborate decoration. In the centre, just below the belt, is a leopard's head from which four bands resembling the markings of bird's plumage descend. At the bottom of the panel are five cobras with solar discs above their heads.

In his left arm the king is holding a staff, at the top of which is a ram-headed shield. This is the emblem of the god Amun-Re, as confirmed by the column of hieroglyphs inscribed on the staff, accompanied by four of the pharaoh's five names. Cartouches with the names of Ramesses III are also incised on his shoulders and the belt buckle.

On the left-hand side of the statue, in the space between the legs, there is an image of the crown prince dressed in a ceremonial robe and holding a fan in his hand . (F.T.)

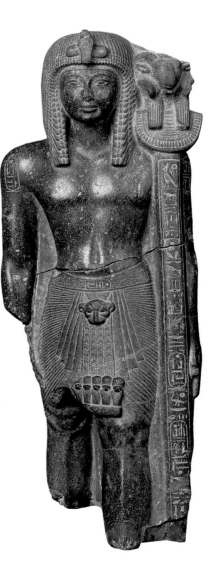

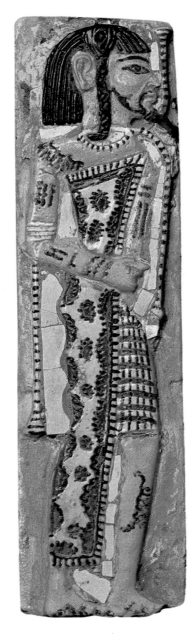

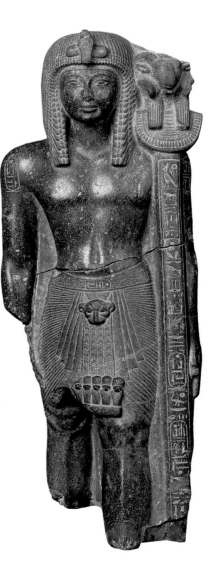

TILE WITH ASIATIC FIGURE
TILE WITH LIBYAN FIGURE

COLOURED FAIENCE; HEIGHT C. 26 CM; WIDTH C. 7 CM
MEDINET HABU, PALACE OF RAMESSES III
ANTIQUITIES SERVICE EXCAVATIONS (1910)
TWENTIETH DYNASTY, REIGN OF RAMESSES III (1194–1163 BC)

Very little has survived of the royal palaces in which the rulers of ancient Egypt lived except for some ruined walls of unfired brick with traces of brightly painted plaster. Given the ephemeral nature of earthly life, the Egyptians did not use durable materials in the construction of their homes. Instead they concentrated their architectural efforts on the tombs and temples in which the dead and the gods resided. The eternal afterlife required sites that would endure and survive the ravages of time. The magnificence and luxury of the pharaonic courts can therefore only be deduced from the remains of their decorations recovered during archaeological excavations.

Among these remains are faience titles that were used to pave floors in the public areas of the palace. As well as testifying to the luxury of royal decor, they also demonstrate the mastery of Egyptian craftsmen of the techniques of working with faience, given that the polychrome effects seen here can only be obtained through a repeated and delicate firing process.

Various enemies of Egypt are depicted on the tiles. The different races are rendered in careful detail so that the ethnic origins of each figure are immediately identifiable. Their costumes and ornaments are colourful and also very specific.

The two tiles illustrated here portray an Asiatic, identifiable by his long, pointed beard, and a Libyan, recognizable by his central braid and the tattoos on his body. Asiatics were one of the traditional enemies of Egypt, but Ramesses III was personally involved in lengthy struggles with the Libyans.

The tiles were laid near to the 'Window of Appearances' of the royal palace at Medinet Habu, where the king showed himself to his people. Treading on the tiles was symbolic of the king's defeat of the enemies of Egypt. (F.T.)

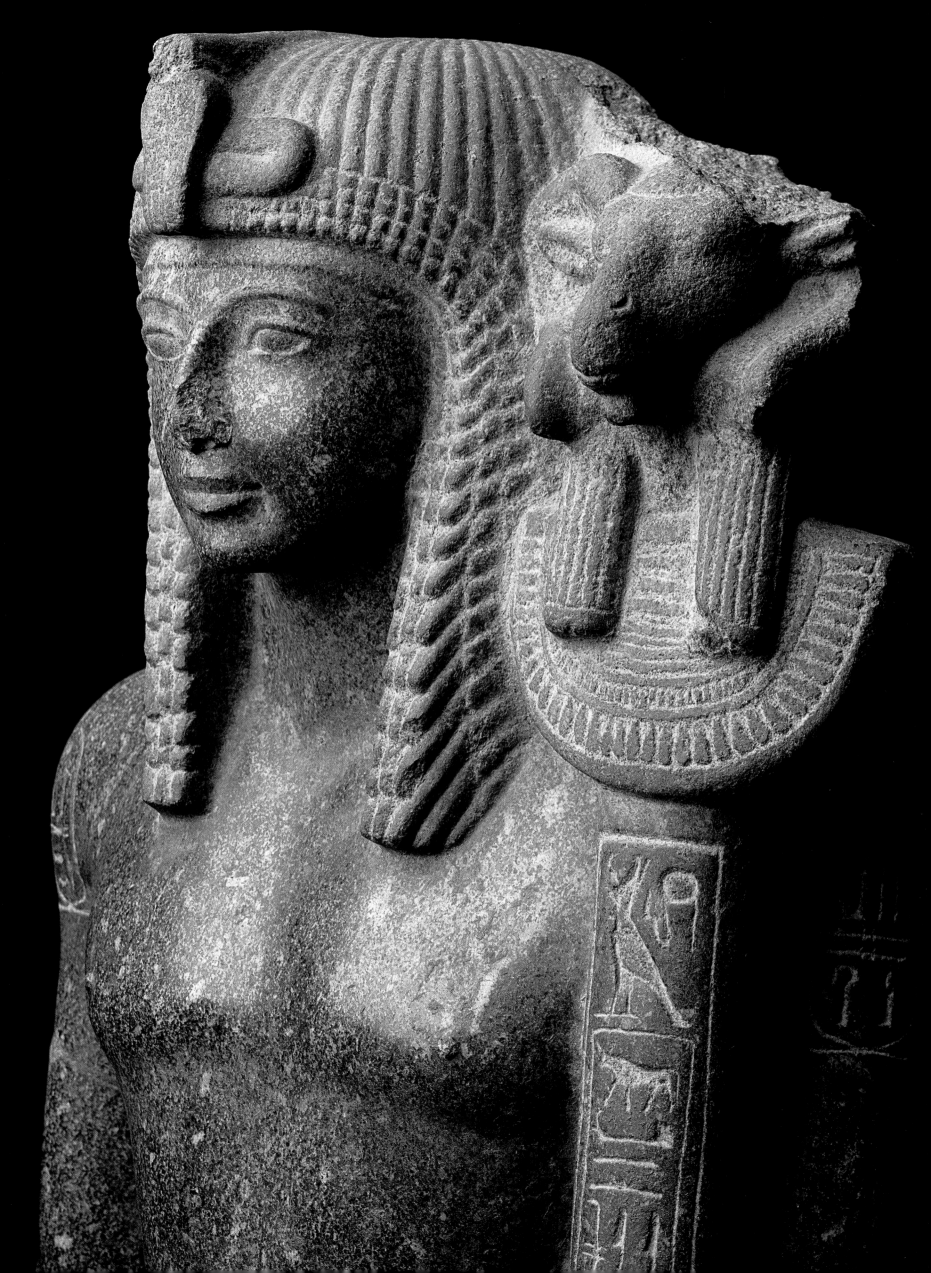

OSTRACON WITH A PLAN OF A ROYAL TOMB

PAINTED LIMESTONE; LENGTH 83.5 CM
VALLEY OF THE KINGS, TOMB OF RAMESSES IX (KV 6)
G. DARESSY'S EXCAVATIONS (1888)
LATE TWENTIETH DYNASTY (11TH CENTURY BC)

This long limestone flake was discovered broken into four pieces during the clearance of the tomb of Ramesses IX. Luckily, the pieces could be fitted back together perfectly. The plan painted on its surface is almost certainly of this particular tomb, although it is only an extremely rough sketch. It would hardly have been sufficient as a working drawing but may either have been a rough draft to which the builders referred as the work progressed, or a record of the tomb once it was completed.

The walls of the tomb are indicated with parallel red lines; the space between was filled with white. The doors are shown as if viewed frontally, with the architrave emphasized in white and the empty space of the passage in yellow. Each section of the tomb was described with a brief caption. The only one of these that can now be read clearly is the one that corresponds with the access stairway.

Access to the tomb was by a flight of steps with a central ramp that assisted with bringing in the sarcophagus and other large items of funerary equipment into the tomb. The caption tell us that this was the 'passage of God', a reference to the sun god Re. It was believed that after his death, the king sailed on the boat that transported the sun through the heavens, and that his destiny was thus linked with the cycle of rebirth associated with the alternation of day and night.

Leading on from the stairway was a first passage, on to which four small annexes opened. These were the chapels of the eastern (to the right) and the western (to the left) gods. A papyrus with a plan of the tomb of Ramesses IV, now in the Egyptian Museum of Turin, provides us with an explanation of their significance. Doorways led into a second and then a third corridor that extends to the antechamber or vestibule where the sarcophagus was placed while the priests performed the ritual purification of the body.

The plan shows the next room with four pillars and a white stripe at the centre. This was the 'chariot room' in which the king's chariot was deposited. The white stripe along the main axis of the tomb represents the slope of the floor descending from the entrance to a lower level and to the burial chamber.

The sarcophagus was placed at the centre of the chamber in the position indicated on the plan by a white rectangle. This site, intended to house the remains of the king for all eternity, was named the 'house of gold in which one rests'. (F.T.)

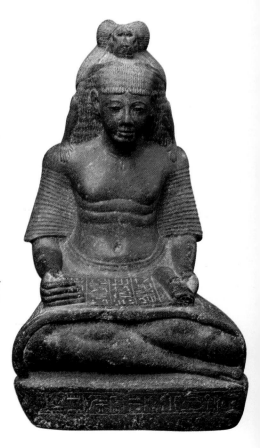

STATUE OF RAMESSUNAKHT, HIGH PRIEST OF AMUN-RE

GREY GRANITE; HEIGHT 75 CM
KARNAK, COURTYARD OF THE CACHETTE; G. LEGRAIN'S EXCAVATIONS (1904)
SECOND HALF OF THE TWENTIETH DYNASTY (END 12TH–11TH CENTURY BC)

The career of Ramessunakht is well documented: the most important position he held was that of high priest to Amun-Re during the successive reigns of Ramesses IV, V and VI. During this period the highest position in the Theban clergy guaranteed immense power in Upper Egypt, to the extent that the holder of this title enjoyed prerogatives that would normally belong only to the king.

We know that Ramessunakht led an expedition to Wadi Hammamat during the reign of Ramesses IV in order to obtain blocks of building stone. His power was such that he was allowed build his own funerary temple, a construction recently brought to light in the hills of Dra Abu el-Naga.

In this statue Ramessunakht is portrayed in the classic pose of the seated scribe. Sculptures of this kind have been found dating to all periods of pharaonic history. What is unusual here, however, is the baboon sitting on the figure's shoulders. The baboon was sacred to Thoth, the tutelary god of scribes and inventor of writing, and this representation showing the creature with his hands resting on the head of Ramessunakht symbolically places the subject under the protection of Thoth. The statue was dedicated to Ramessunakht by his son Nesamun who was also high priest of Amun-Re at Thebes.

Ramessunakht's facial features are typical of the Ramesside Period. The eyes are narrow and elongated, the nose slim, the mouth broad and thin, with the two corners further emphasized by two folds. The high priest wears a three-part wig, with the locks shown as thin waves, which leaves the ears exposed. Ramessunakht's gaze is directed downwards, in the typical pose of a scribe concentrating on his work.

His costume consists of a tunic with pleated sleeves and a kilt that is also pleated at the bottom. The clothing is tight-fitting and transparent on the torso, revealing the pectoral muscles and a prominent stomach that was an unequivocal sign of the high social standing and well-being enjoyed by Ramessunakht. His arms rest on his thighs. The kilt is carved with a hieroglyphic inscription with the titles and name of Ramessunakht. His right hand is represented as if he was holding a stylus, while the left hand grips a papyrus scroll. (F.T.)

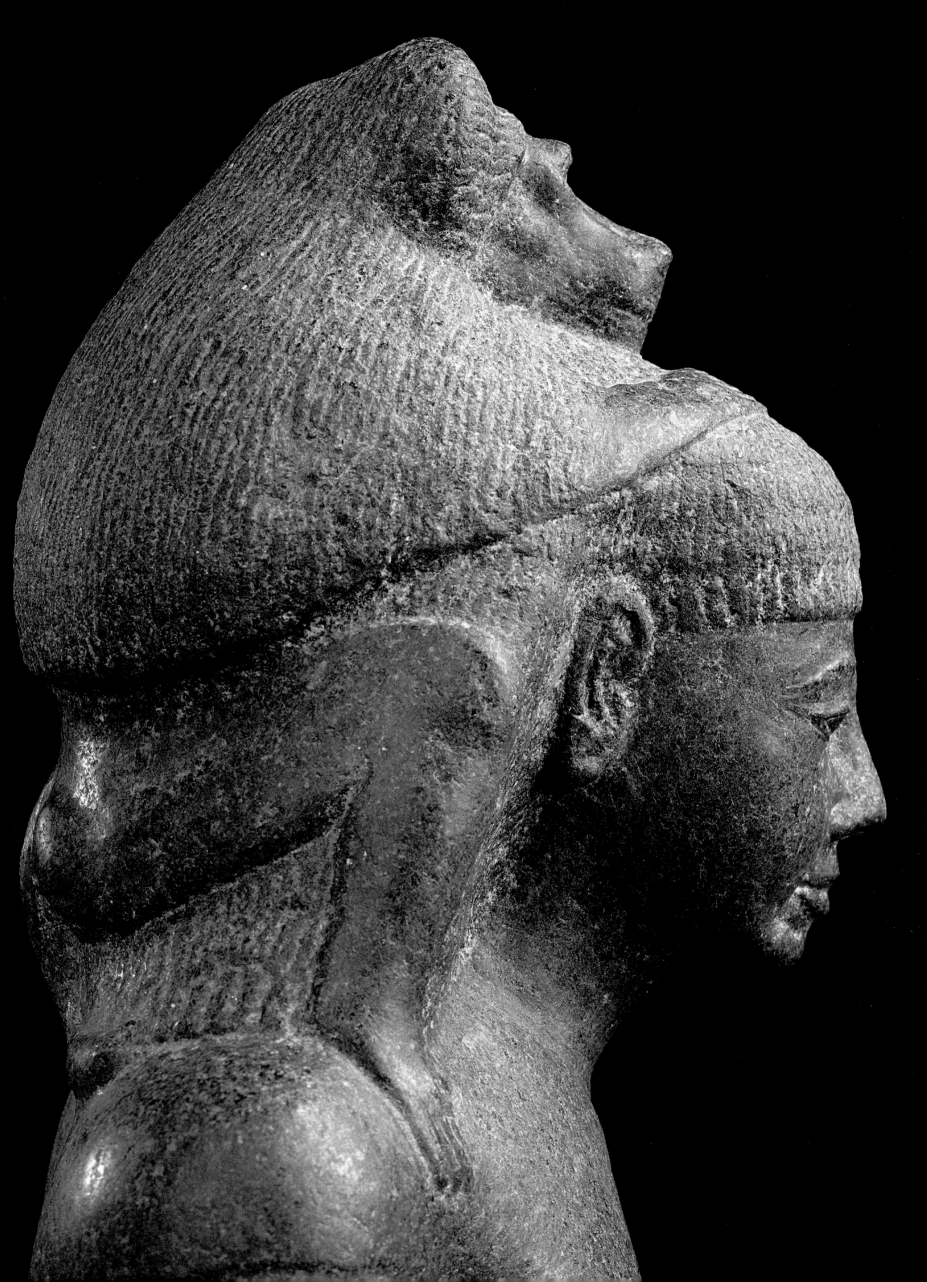

JE 43566

STELA OF BAI

·······························

PAINTED LIMESTONE; HEIGHT 24.5 CM; WIDTH 14 CM
DEIR EL-MEDINA, *TEMENOS* OF THE TEMPLE OF HATHOR
E. BARAIZE'S EXCAVATIONS (1912)
NINETEENTH–TWENTIETH DYNASTY (1307–1070 BC)

This round-topped stela is carved in low relief and painted in bright colours. The pictorial plane is divided into two registers, the upper one containing two rams facing each other. The animals, with cobras rising on their foreheads, wear tall headdresses composed of two tall plumes with a solar disc at the centre. Between them is a small table on which a ewer-shaped vessel stands.

The base line of the scene is represented by a straw mat, and this, if taken together with the stand and the vessel, could be interpreted as the hieroglyph *hetep*, meaning 'offering'. Above this scene are two mirror-image hieroglyphic inscriptions referring to the rams and revealing their divine nature: 'Amun-Re, the beautiful ram'.

The register below, forming the main part of the stela, is divided vertically into two parts. On the left is a portrait of the deceased, Bai, whose title 'Servant in the Place of Truth', identifies him as one of the workers who were employed during the New Kingdom in the construction of the tombs of kings and queens. As well as revealing his name and function, the hieroglyphic text above his head also refers to the figure's pose – kneeling with his hands raised, offering adoration to Amun-Re. Bai is wearing a loose, pleated kilt, a short curly wig, and a broad necklace.

On the right-hand side of the stela are three pairs of ears, each of a different colour: dark blue, yellow and light green. Depictions of ears on stelae were common in New Kingdom Egypt. They related to a new religious concept in which the relationship between the individual and a god was closer and did not necessarily have to rely on the mediation of a priest. The ears are a reference to the divinity listening to the prayers of the faithful, who turn

to the god in search of favours such as the curing of diseases. In almost all cases these are secondary manifestations of local patron gods. At Thebes there were numerous manifestations of Amun-Re, and at Memphis we find a particular version of the god Ptah 'who listens to the supplicant'.

Here, the different colours of the ears are probably a reference to three different aspects of Amun-Re who is thus identified as a god associated with the air and moisture (blue), the sun (yellow), and vegetation (and therefore the earth) and water (green). Bai would thus have described the universal aspect of the deity who, throughout the New Kingdom and successive eras, was considered the supreme god. Prayers to Amun-Re, whatever their motivation, were guaranteed to be the most efficacious. (F.T.)

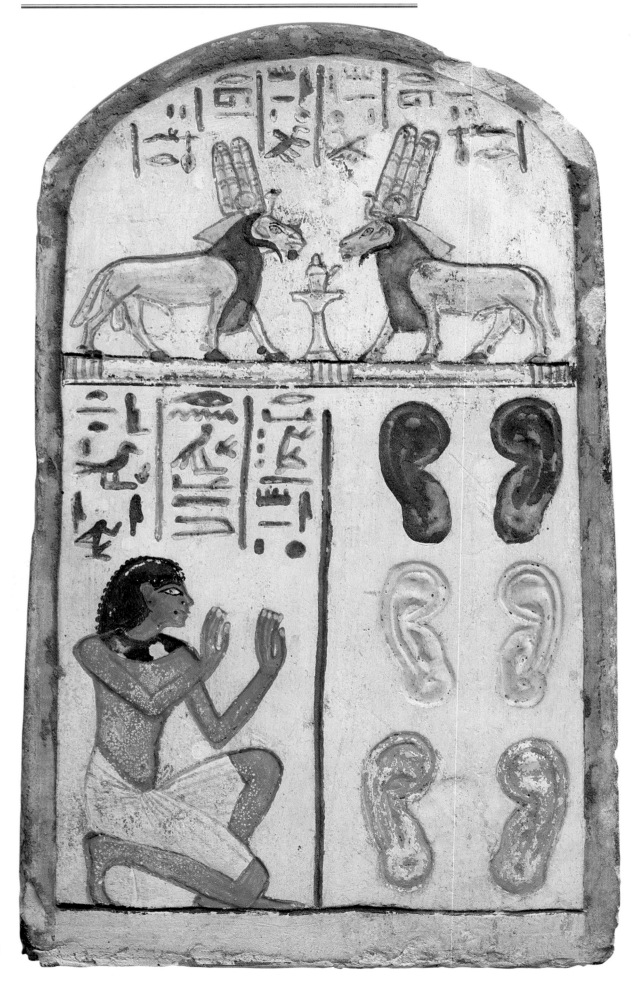

FIGURED *OSTRACON*

LIMESTONE; HEIGHT 11 CM; WIDTH 11 CM
DEIR EL-MEDINA
FRENCH INSTITUTE OF EASTERN ARCHAEOLOGY EXCAVATIONS (1934)
NINETEENTH–TWENTIETH DYNASTY (1307–1070 BC)

CG 25139

FIGURED *OSTRACON*

LIMESTONE; HEIGHT 28.5 CM; WIDTH 23.5 CM
VALLEY OF THE KINGS, TOMB OF RAMESSES VI (KV 9)
FOUND IN 1890
TWENTIETH DYNASTY (1196–1070 BC)

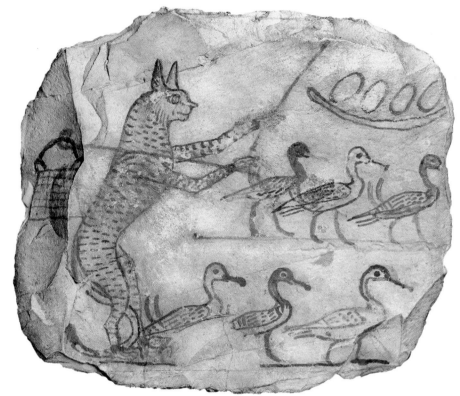

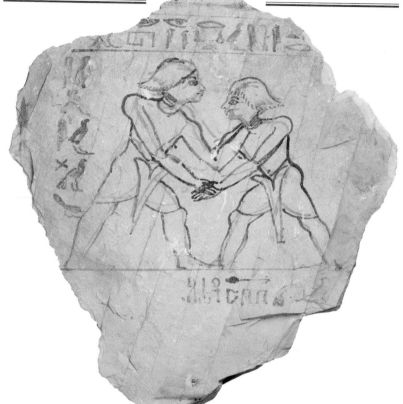

This flake of limestone features a scene painted in a number of colours. A cat standing on its hind legs holds a long pole over its shoulder; a basket hangs from its hooked tip. The cat's left 'arm' is raised and it is brandishing a stick in its paw. In front of the animal are six geese arranged in two registers. Above the upper row is a nest with four eggs.

This vividly depicted scene is drawn from an iconographical repertoire that envisions a world in which normality and the rules of everyday life are turned upside down. In this topsy-turvy universe, seen more frequently in painting than in literature, there is nothing strange about a cat herding geese to pasture rather than hungrily pouncing upon them. The equipment carried by the graceful feline is in fact that of a shepherd who, in following his flock, has to carry with him everything he might need to survive for brief periods.

These scenes are both caricature and satire. Through the subversion of the natural order of things a criticism of behaviour and customs is implied. The artist frees himself from the conventions and restrictions imposed by official artistic canons and expresses himself in less familiar, but more inventive, forms. However, since we are separated from these forms of artistic expression by millennia, it is difficult for us to appreciate and fully understand what it was that this small scene was censuring. Taken out of context, it is impossible to interpret the satire.

Even though it is little more than a sketch, the scene is actually fairly sophisticated. The cat is depicted with grace and care, while the geese were achieved with a swiftness and sureness of line. The birds are repeated from one register to the next in an alternation of light and dark colours.

The six birds can also be interpreted as hieroglyphs. Their arrangement in two groups of three also refers to the way of rendering plurals in hieroglyphic writing. In the writing of the Old Kingdom and later periods, multiples were indicated by repeating the same symbol three times. (F.T.)

This *ostracon* is decorated on both sides. On the side illustrated here is a scene of wrestling between two soldiers. The design was first sketched with red ink and then corrected and completed in black. This process reveals the artist's changes of mind, above all in relation to how to depict the arms of the two wrestlers. Although the two figures are rendered by simple lines they are very vivid and well defined. There is an obvious difference in height between the two: the one on the right is shorter than the one on the left. Both wear short wigs and kilts with penis sheaths. With one hand they grip each other's neck while their other hands are locked together. Their facial features are somewhat cartoon-like. A number of hieroglyphs rapidly traced in black ink act as captions describing the scene.

On the reverse side are two rats depicted with extraordinary realism. They occupy only the upper part of the flake of stone. The upper animal is stretched out and gnawing a fruit held between its front paws. The second, set slightly lower and to the left, is curled up. Its fur is ruffled almost as if it were wet.

The scenes on both sides of the *ostracon* can be considered as the exercises of a painter and in all probability were the result of direct examination of the subjects depicted. This is particularly true in the case of the rats, which are portrayed with great verisimilitude and vividness. The position of the rear paw slightly detached from the body of the upper animal certainly results from careful observation of nature.

In spite of the fact that the wrestling scene is very descriptive and is a direct transposition of an image from real life typical of the methods and techniques of an Egyptian artist, it also contains an aspect of caricature. This is demonstrated by the faces of the two wrestlers, and also by their stocky, heavy musculature, which, rather than being an identifying feature, can be read as a descriptive shorthand reference to the rough life of the soldier, so caustically pilloried in contemporary scholastic texts. (F.T.)

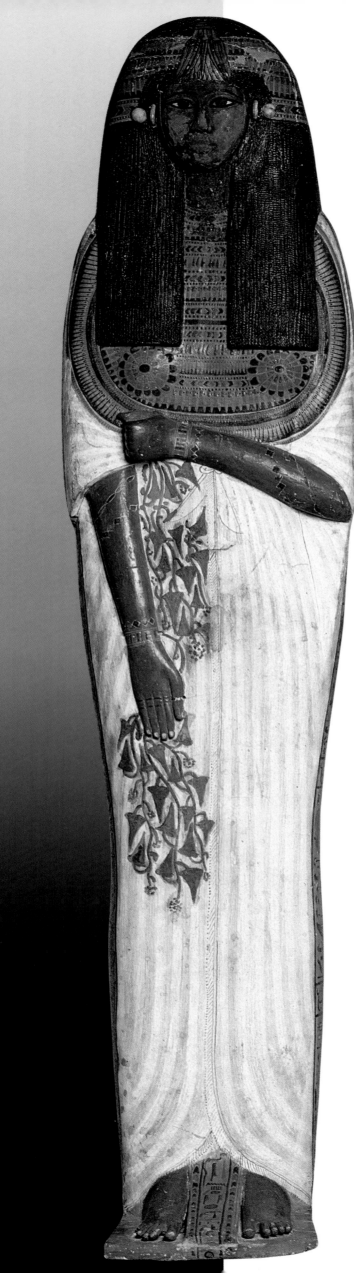

COFFIN OF ISIS

WOOD, WITH PLASTERED AND PAINTED FABRIC
HEIGHT 193.5 CM
DEIR EL-MEDINA, TOMB OF SENNEDJEM (TT 1)
ANTIQUITIES SERVICE EXCAVATIONS (1886)
NINETEENTH DYNASTY, REIGN OF RAMESSES II (1290–1224 BC)

Isis was the wife of a craftsman from Deir el-Medina called Kabekhnet and the daughter-in-law of Sennedjem. Her beautiful coffin was discovered intact in the tomb of the latter by the personnel of the Antiquities Service working under the direction of Gaston Maspero. This is in fact the second coffin in which the mummy of Isis was enclosed. She also had a mummiform external coffin, as well as a pectoral placed directly over the bandages of her mummy. This pectoral was identical to the cover of the internal coffin and provided further protection against damage to the body.

On the cover Isis is depicted richly dressed and as if she were still alive. This representational style had been introduced into Egypt following the religious reformation under Akhenaten and was retained throughout the Ramesside Period. The appearance of this type of coffin is evidence of the changes in thinking that took place during the Amarna Period, which also to some extent affected funerary rituals. A change in attitude would seem to be demonstrated, for example, by the mourning scenes reproduced in the tombs of Tell el-Amarna in which the suffering of the royal family is rendered explicit.

Isis' face is framed by a heavy, braided wig held by an elaborate multicoloured band decorated with geometric and floral motifs. Lotus blossoms, open and in bud, are represented in low relief on the figure's forehead. The lotus flower was a symbol of rebirth. The eyes are narrow while the mouth and the face itself are treated simply. The ears are not shown but are marked by the presence of large earrings consisting of a ring and a hemisphere of bone or ivory. The braids of the wig partially cover a pectoral with brightly coloured and elaborate decoration. The breasts are sculpted in relief and emphasized by rosettes.

Isis is shown wearing a full-length pleated robe that reaches her ankles and has a slit at the front. It is closed with a knot that is just visible below the left arm. The sleeves leave the forearms exposed, which are encircled by two rows of beads and also bracelets at the wrists. She has a ring on the thumb of her right hand. The right arm hangs along the body while the left is folded across the lower chest, clasping a fold of her garment.

Isis is also holding garlands of flowering ivy in each hand, arranged in an elaborate composition and providing a splash

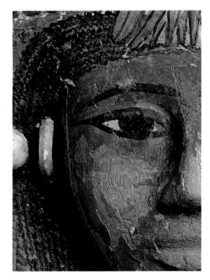

of colour to enliven the whiteness of the robe. Ivy, like the lotus , was associated with the promise of an afterlife.

Although Isis is represented as if still alive, the coffin is mummiform in shape. The lower part of the coffin is decorated with representations of the divine figures who inhabited the Egyptian Underworld. Corresponding to the position of the head of the deceased are the genii of the North, with those of the South reproduced at her feet. The two groups are separated by columns of text containing references to the Four Sons of Horus. (F.T.)

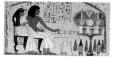

DOOR OF THE TOMB OF SENNEDJEM

..

WOOD, PLASTERED AND PAINTED
HEIGHT 135 CM; WIDTH 117 CM
DEIR EL-MEDINA, TOMB OF SENNEDJEM (TT 1)
ANTIQUITIES SERVICE EXCAVATIONS (1886)
NINETEENTH DYNASTY, REIGN OF RAMESSES II (1290–1224 BC)

The tomb of Sennedjem was discovered intact by group of officials from the Antiquities Service in 1886. The entrance to the burial chamber was discovered still barred by this small wooden door, which provided only symbolic protection. It was sealed with clay bearing the impression of the seal of Theban cemetery, with the image of Anubis.

Sennedjem had the title of *sedjem-ash*, a very common epithet among the workers who constructed the royal tombs and who lived in the village of Deir el-Medina, located amidst the desert hills at the foot of the Theban mountains, far from prying eyes.

The door consists of a single panel, hinged at one side. It is made from a number of planks held together with a system of mortise and tenon joints. It is decorated on both sides. On the external face on a yellow background is a scene in two registers, with a hieroglyph representing the sky at the top. In the upper register Sennedjem, his wife Iyneferty and his daughter Irunefer are standing before Osiris and the goddess of justice Maat, to whom they are paying respectful homage. In the lower register the sons of Sennedjem are portrayed in the same pose before Ptah-Sokaris-Osiris and Isis. Sennedjem and his eldest son have their hands raised in an act of adoration. The two women hold a vase with a long neck, while the other six sons each hold a lotus flower with a long stem.

The scene on the internal face depicts Sennedjem and his wife Iyneferty sitting inside a pavilion in front of a *senet* board on which

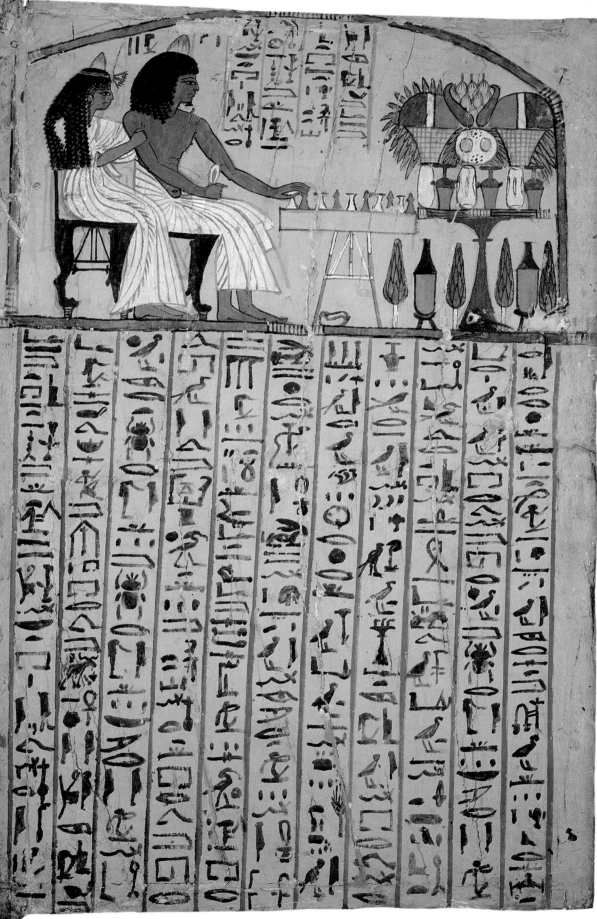

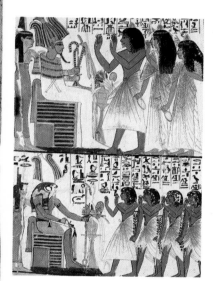

a number of red and white pieces are set. To the right is a table crowded with offerings, and a number of jars and plants are arranged underneath. Below this scene are eleven columns of hieroglyphic text recording Chapters 72 and 17 of the Book of the Dead.

These two chapters deal with the freedom of movement permitted to the dead. The first records a magic formula that allows the deceased to pass through the door of the tomb, and to leave or enter without encountering any danger. The second describes a series of actions that the deceased is permitted to perform, including the possibility of playing *senet*. The game was indeed associated with the promise of eternal life. (F.T.)

COFFIN
OF DJEDHORIUFANKH

Painted wood
Length 203 cm; width 61 cm
Western Thebes, Qurna; T. Davis' excavations (1916)
Early Twenty-second Dynasty
Reign of Sheshonq I or Osorkon I (c. 945–909 bc)

Only the lower part of the coffin of the priest Djedhoriufankh, superintendent of the altars of the temple of Amun-Re at Karnak, survives; its lid is lost. It dates from the early Twenty-second Dynasty when Upper Egypt was an independent theocratic state under the dominion of the powerful Theban clergy. In that period, the priests of Amun-Re were buried in brightly coloured mummiform coffins in well-hidden tombs in an attempt to protect them from the depredations of robbers.

The surfaces of the casket are covered with an iconographic repertory similar to that which in previous ages decorated the walls of the tombs, while the walls in this period were always left undecorated.

The interior of the coffin of Djedhoriufankh presents a decorative scheme subdivided into registers, within which coloured scenes are set against a yellow ground. The part of the walls around the head is painted in imitation of a tent, as were the ceilings of Theban tombs, and the lunette on the base

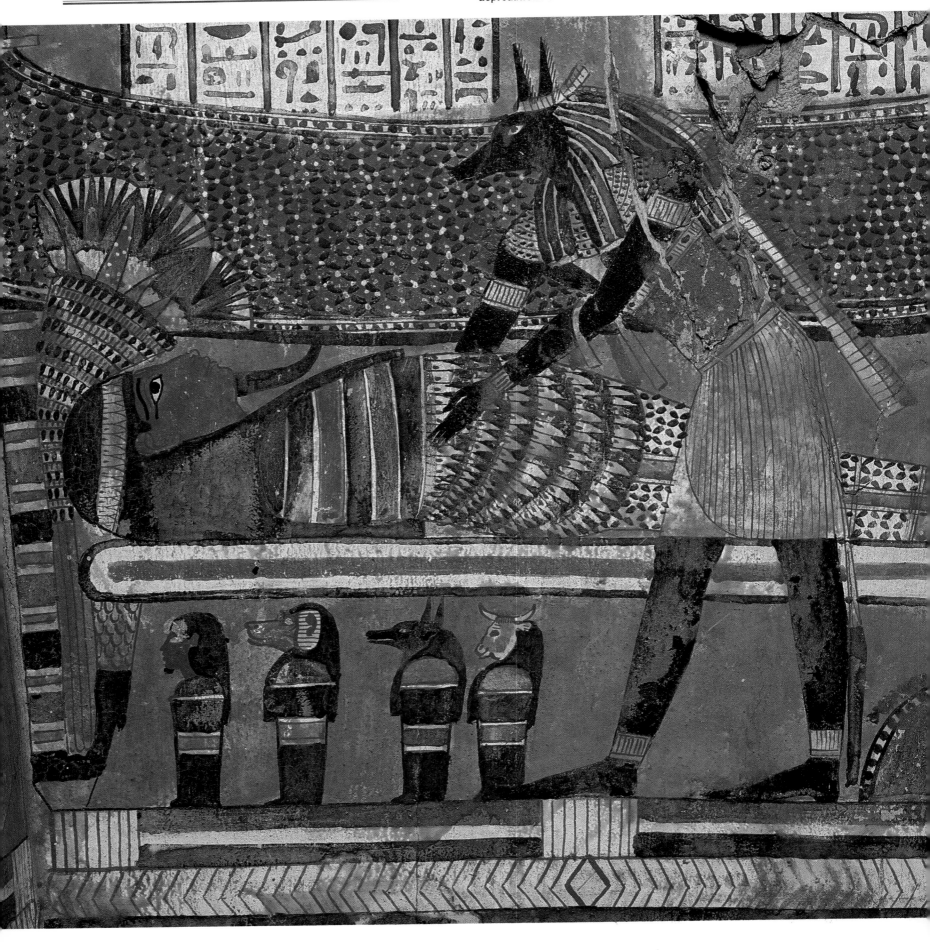

just beneath this has an image of the solar barque, with stem and stern decorated with papyrus flowers. On the barque the solar disc rises above the horizon, placed between two cobras. At the centre of the register below is a personification of the *tyt* amulet (the knot of Isis), with a female head and two upraised arms supporting the water course on which the solar barque is sailing. On either side of the *tyt* amulet two jackals are lying on top of a shrine.

The next register features two cartouches surmounted by a solar

disc. The left-hand one reads 'the great god, lord of the heavens, governor of eternity', while the second carries the symbols *men* (stable), *kheper* (appear) and *re* (the god Re). The interpretation of this sequence is somewhat problematical. *Menkheperre* corresponds to the coronation name of Thutmose III, or the name of a great Theban priest who governed Upper Egypt at the end of the 11th century BC, or alternatively it is a way of writing the name of Amun-Re as a rebus.

On the basis of stylistic criteria, the coffin can be dated to a short period in the Twenty-second Dynasty. This means that we can exclude the first two hypotheses and suggests that *Menkheperre* is indeed used here as a cryptographic reference to the name of Amun-Re in whose cult Djedhoriufankh was a priest. The left-hand cartouche indirectly cites the name of Osiris. Between the two cartouches is a *khaker*, a decorative element from which two serpents emerge with the *tyt* amulet around their necks.

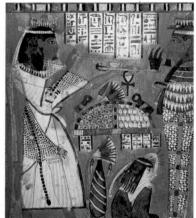

At either end, in front of baskets with offerings, are two birds with human female heads holding their hands in front of their faces in the typical gesture of sorrow.

The register beneath is divided into two almost identical scenes. On the left a priestess is making offerings of incense and papyrus to Ptah; on the right is a priest named Djedkhonsu. The next scene takes place in a tent. Anubis is completing the mummification of the dead man, who is laid on a bed. Four canopic vessels, with lids reproducing the heads of the sons of Horus, stand on the floor beneath the bed. The last scene, surmounted by a frieze of *uraei*, is the largest in the interior. It features the upright mummy of the deceased adorned with garlands, in front of which stands a *sem* priest, identified by the leopard-skin covering his white tunic, who is performing a ceremony of burning incense. The role of this priest was to restore life to the mummified body of the deceased by the 'Ceremony of the Opening of the Mouth'. Between the two figures is an offering table topped by a lotus flower, with a second lotus flower

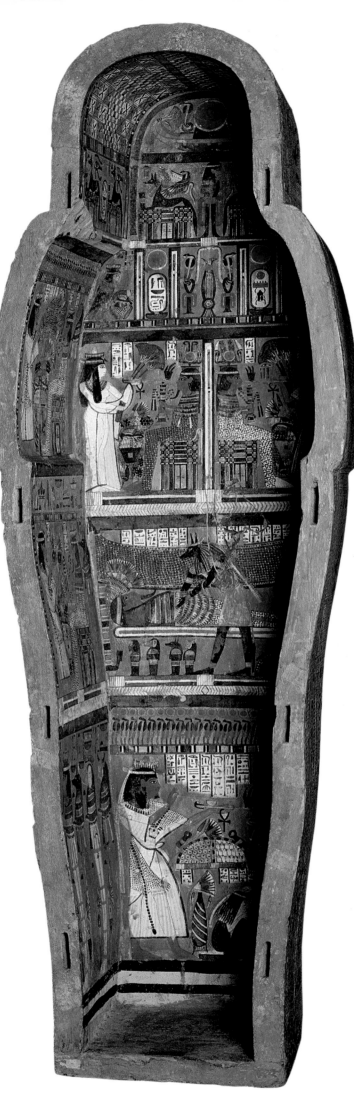

below. Next to it a kneeling woman is tearing her hair with grief.

The side walls of the casket are also divided into registers. At the top is a cartouche flanked by two jackals on shrines and protected by *wedjat* eyes. The two scenes below,

separated by a band of hieroglyphs, feature a priest holding out flowers and two cups to a figure clasping the symbols of royal power. Anubis is behind the throne. In the last register are the Four Sons of Horus, represented in mummy form. (S.E.)

275

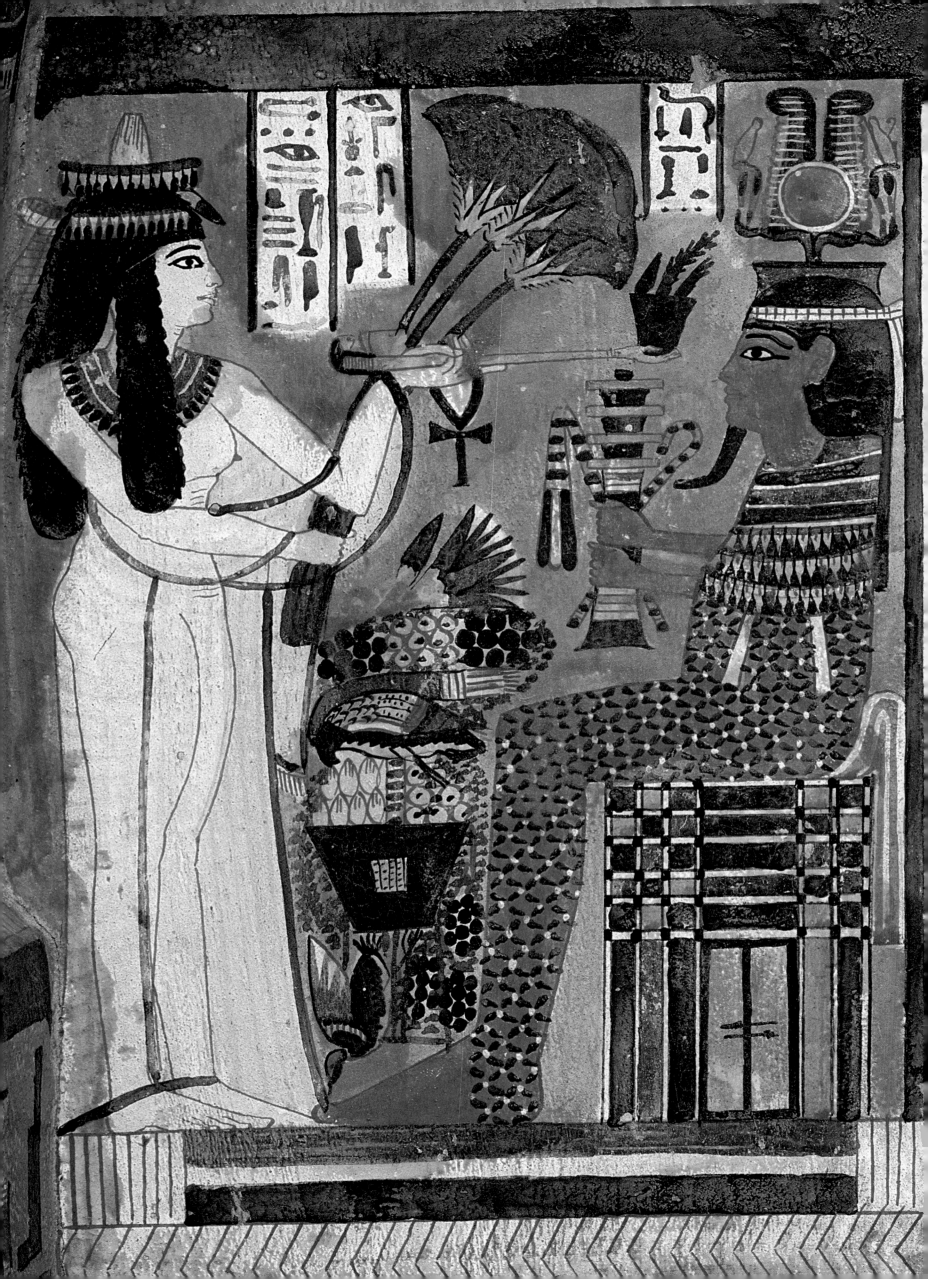

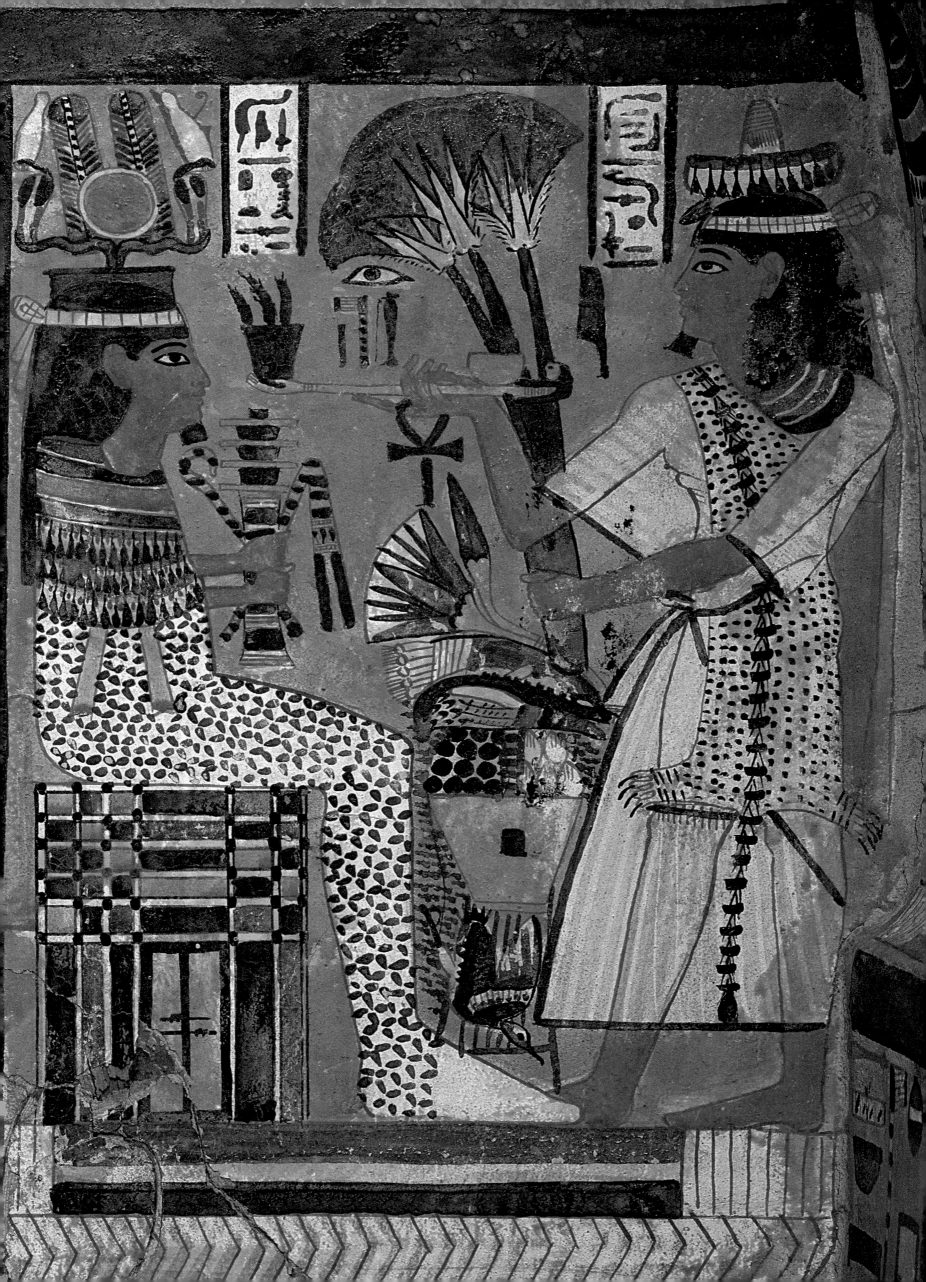

STATUE OF THE DIVINE WORSHIPPER AMENIRDIS

ALABASTER; HEIGHT 170 CM
KARNAK, TEMPLE OF MONTU
EARLY TWENTY-FIFTH DYNASTY (LATE 8TH CENTURY BC)

Princess Amenirdis I, the daughter of Kashta and sister of Piankhi, held the titles of 'Divine Adoratrice' and 'God's Wife' of Amun at Thebes in the last two decades of the 8th century BC, succeeding Princess Shepenupet I, the daughter of Osorkon III.

This was an important priestly office and, during the Late Period and in particular between the Twenty-fifth and Twenty-sixth dynasties, it had a significant political function in maintaining the balance of power between the religious capital Thebes and the administrative capital, the home of the king and the court. During this period the role was performed by a female relation of the reigning pharaoh (a daughter or sister), who probably served as the Upper Egyptian check and counterbalance to the great power exerted by the Theban clergy and their strong tendency towards autonomy. The princesses, who succeeded one another by adoption, thus enjoyed great prestige in the Theban region. There are numerous architectural and sculptural monuments that carry their names.

Around a dozen statues are dedicated to Amenirdis I (some in very poor condition), of which this alabaster sculpture is perhaps the best known. The princess is portrayed in a striding pose, an iconography that was originally reserved for male statues; her right arm is held to her side, with the hand holding a *menat* counterweight, while her left arm is folded across her waist with the hand gripping a kind of fan in the form of a lily, a symbol of femininity and a constant element in the iconography of the 'Divine Adoratrice'.

Amenirdis is wearing a three-part wig that leaves her ears uncovered and is decorated with the plumage of a vulture, the head of which is flanked by a double cobra, as was frequently the case in the Twenty-fifth Dynasty. The vulture, a symbol of Mut, is in turn surmounted by a corona of cobras; a central hole would have allowed another emblem to be inserted, either the double plume of Amun or the horns and solar disc of Hathor. The rest of the softly modelled body with its accentuated curves is only partially concealed by a long, clinging tunic that reaches the ankles, which are adorned, as are the wrists, with jewels. No jewelry is visible around the neck, however, a characteristic common to all the statues of Amenirdis discovered up to now.

The fairly broad face is framed by large ears and has features that are very similar to those of other portraits of the princess: narrow eyes framed with cosmetic lines, lips emphasized with precise incisions tracing their outlines, and the typical 'Kushite line' – the furrow between the nose and the mouth that was made particularly evident in this period.

The style of this sculpture respects the aesthetic canons of the Twenty-fifth Dynasty in representing the human figure, in which the pursuit of classicism is associated with a strong characterization of the faces. This particular sculpture is undoubtedly one of the most successful examples; its sophistication is further enhanced by the luminosity the alabaster lends to its surface. (R.P.)

SHABTI FIGURE OF TAHARQA

FAIENCE; HEIGHT 27.5 CM
NURI, PYRAMID OF TAHARQA (NU 1)
G. REISNER'S EXCAVATIONS (1916–1917); THIRD INTERMEDIATE PERIOD
TWENTY-FIFTH DYNASTY, REIGN OF TAHARQA (690–664 BC)

Shabti figures are funerary statuettes that were included in funerary assemblages in Egyptian tombs from the Middle Kingdom onwards. Their role was to replace the deceased in the gruelling and usually agricultural labours of the Underworld and for this reason they are generally represented as mummiform human figures equipped with a series of tools for work in the fields. The name derives from the original '*shabti*' or '*shawabty*' (referring to their form or the wood from which they were made), and came to signify 'he who responds (in the place of his master)'.

This mummiform statuette portrays the king Taharqa with his arms folded. His hands emerge from

the shroud and in one he holds a hoe and in the other a cord that passes over his shoulder. A rectangular basket hangs from the cord and is represented in relief on his back.

The king is wearing a sack-like headcloth that leaves his ears exposed and terminates in a pigtail on his shoulders. In the centre of his forehead is a cobra. Taharqa's somewhat rounded face has fairly regular features, particularly when compared with the other *shabti* figures of the same ruler. The eyebrows are in slight relief, the eyes are deeply incised, the mouth is fairly small and fleshy, and a long, heavy false beard is attached to the chin. As with other funerary statuettes of the kings of the Twenty-fifth Dynasty, the *shabti* figures of Taharqa feature an extremely powerful torso. The

lower part of the statuette is occupied by ten columns of hieroglyphs containing an original version of the characteristic *shabti* verses.

George Reisner discovered the 1,070 *shabti* figures of Taharqa in the king's pyramid at Nuri during his 1916–1917 excavations at the site. The statuettes were arranged in three rows along the walls of the burial chamber. Although they are fairly similar in terms of overall iconography, the *shabti* figures of Taharqa differ in material (faience, calcite, green ankerite or black granite) and dimensions, which varied from 25 to 60 centimetres.

The face bears a close resemblance to that of a number of larger sculptures of the same ruler, including a granite sphinx from Kawa which is now in the British Museum. (R.P.)

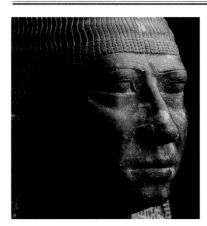

JE 36933 = CG 42236

STATUE OF MONTUEMHET

GREY GRANITE; HEIGHT 137 CM
KARNAK, TEMPLE OF AMUN-RE, COURTYARD OF THE CACHETTE
G. LEGRAIN'S EXCAVATIONS (1904)
LATE TWENTY-FIFTH–EARLY TWENTY-SIXTH DYNASTY (MID-7TH CENTURY BC)

Montuemhet was one of the most famous officials of the Late Period. This statue portrays him standing in the traditional pose for male figures, with his left leg advanced and his arms held to his sides with his fists closed.

He is wearing a flaring wig, which was fairly common in the New Kingdom and reappeared in the Late Period during the transition between the Twenty-fifth and Twenty-sixth Dynasties. The panels of the wig extend on either side of his face, allowing the underlying curls to be glimpsed. The simple costume is composed of a pleated *shendyt* kilt, fastened with a

belt carrying an inscription listing the titles and name of the functionary.

Montuemhet's face is particularly expressive: heavy eyebrows protect deep, but rather narrow eyes underlined by large pouches and prominent cheekbones. His nose is fairly large, as is his mouth, which is straight and tight-lipped. These features compose the hard face of a confident man, with a gaze focused in the distance. The modelling of the powerful body, with its broad shoulders and robust limbs, is wholly conventional, with polished surfaces and a vague suggestion of musculature; it contrasts sharply with the highly individual face.

The base of the sculpture and the dorsal pillar are covered with inscriptions. These contain offering verses dedicated to various divinities and the traditional 'Saitic verse' dedicated to the 'citizen god' that was particularly common during the Twenty-sixth Dynasty. Lastly there is the list of the titles of Montuemhet: 'the Fourth Priest of Amun, the Mayor of the city of Thebes, and the Governor of Upper Egypt'. (R.P.)

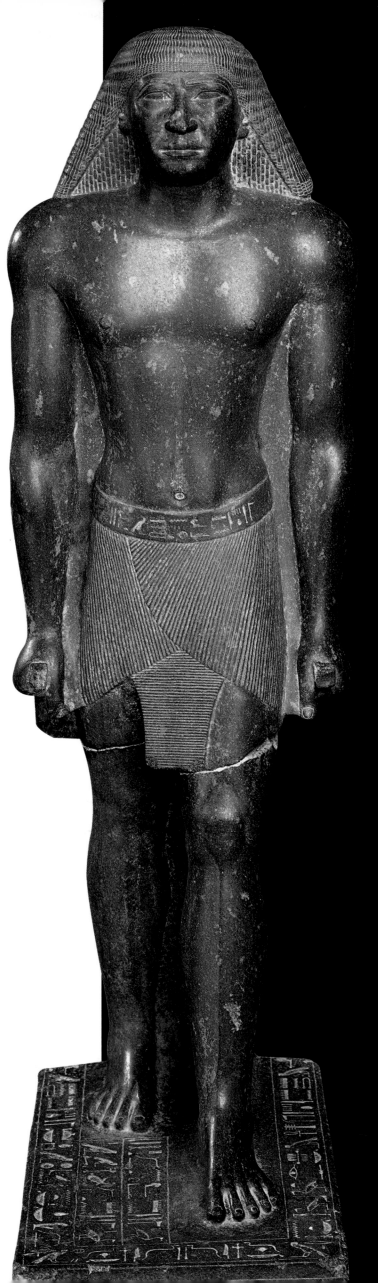

'The falcon has flown into the sky … and the king his son is seated on the throne of Re in his Place.' Thus did the chief of the Medjay (police) announce 'to the people of the Tomb' the death of the pharaoh and the ascension to the throne of his successor, in a papyrus conserved in Turin. This was followed by a sequence of funeral ceremonies culminating in the mummy's interment in a tomb equipped with all that was considered necessary for the last resting-place of the Son of Re and to magically ensure his regeneration.

From the earliest times, the tombs of royalty were distinguished from those of their subjects, just as the king's spiritual destiny was different. The 'palace façade' mastabas of the Early Dynastic period and subsequently the step pyramids and the true pyramids (and not only the best-known examples of Khufu, Khafre and Menkaure) appear, in their solid and impenetrable structure, to symbolize the 'Eternal Seats' of the men who had

A N N A M A R I A D O N A D O N I R O V E R I

THE VALLEY OF THE KINGS AND THE ROYAL CACHES OF DEIR EL-BAHRI

personified the god Horus and who had been the rulers of the world. This was a world that was also thought to be secure and immutable.

Events, however, demonstrated the intrinsic fragility of both the political structure, rocked by the revolutions of the First Intermediate Period, and the presumed invulnerability of the pyramids, as was bitterly noted in a famous text: 'Thus, he who was buried as a falcon is torn from his sarcophagus. The secret of the pyramids is violate…. Thus, he who was unable to make a casket now has a tomb. Thus, the masters of the sacred places are thrown into the desert' (from The Lamentations of Ipu-ur).

With the revival of centralized power at the beginning of the New Kingdom, the royal cemeteries moved to the vicinity of wherever the capital of the kingdom was

at the time. The tombs of the Theban rulers of the Eleventh Dynasty were located on the west bank of the Nile at Thebes in the el-Tarif area and at Deir el-Bahri (such as the monumental tomb of Mentuhotep I), while they returned to the north with the Twelfth Dynasty.

During the Second Intermediate Period, marked by the traumatic experience of the Hyksos invasion, Thebes saw the construction of the tombs of the kings of the Thirteenth Dynasty and subsequently those of the Seventeenth Dynasty, who were responsible for the counter-attack that culminated in the repulsion of the invaders. These tombs too, like those of the Eleventh Dynasty, were located in areas that were contiguous with the inhabited zones, at Dra Abu el-Naga on the slopes of the hills that closed the Nile Valley to the west. The mummy

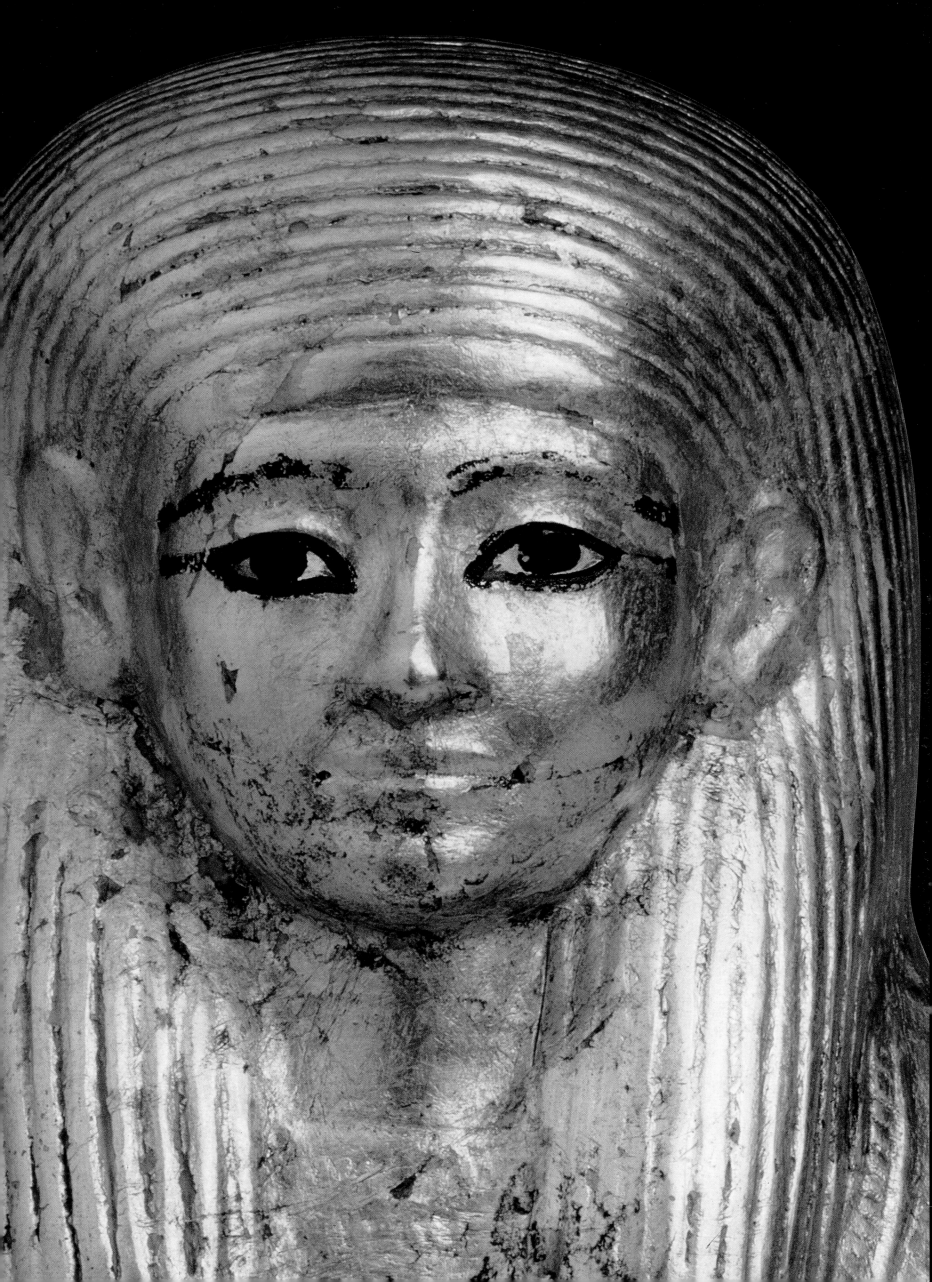

282 BELOW
SHABTI FIGURE
OF RAMESSES VI
JE 96857 = CG 48415
PAINTED WOOD
HEIGHT 26 CM
VALLEY OF THE KINGS
TWENTIETH DYNASTY
REIGN OF RAMESSES VI
(1151–1143 BC)

282 RIGHT
SARCOPHAGUS OF
THUTMOSE I
JE 52344
YELLOW QUARTZITE
LENGTH 248.5 CM
WIDTH 90.5 CM
HEIGHT 100.5 CM
VALLEY OF THE KINGS
TOMB OF THUTMOSE I
(KV 38)
EIGHTEENTH DYNASTY
REIGN OF THUTMOSE I
(1504–1492 BC)

of Seqenenre Tao II, whose head injuries are evidence of a bloody struggle that ended with the victories of his successors Kamose and Ahmose, came from one of these unidentified tombs.

The rulers of the Eighteenth Dynasty, after becoming the undisputed masters of the country, chose a valley behind Deir el-Bahri as their 'Seat of Eternity'. The valley was isolated and invisible to those inhabiting the banks of the river, and the traditionally integrated funerary complex consisting of tomb and temple was thus divided. The funerary temple, 'the House of the Millions of Years', remained near the Nile to ensure the perpetuation of the cult due to the king for all eternity. The burial place was isolated in a site made inaccessible by the mountains around it, breached only by a single narrow entrance passage, used by the funeral processions.

This site, which we call the Valley of the Kings is known in Arabic as Biban el-Muluk (Doors of the Kings). To the ancient Egyptians it was *Ta-set-aat*, 'the Great Place', or more simply *Ta-int*, 'the Valley'. A pyramidal peak, 'the summit', dominated the valley; its symbolic shape may have been a factor in the selection of this site. The main valley divides into the Eastern Valley, which contains the majority of the tombs, and the Western Valley, of extraordinary, wild beauty with its sheer rock cliffs. Only the tombs of Amenhotep III and Ay are located here. The earliest tomb we know of is that of

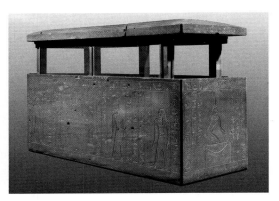

Thutmose I, which is also associated with the name Ineni, the architect who designed and built it. The biographical inscription in his tomb at Qurna in fact reads, 'I directed the excavation of the rock tomb of the pharaoh, alone, without any one else seeing or hearing. I was careful to search out that which is excellent… I have made fields of clay so as to plaster the tombs of the necropolis. It is a work such as the ancestors never did that I have been obliged to do there… I also search for those who will come after me.' Apart from certain expressions typical of this type of inscription (for example, claiming innovation with respects to his predecessors) what is particularly interesting here is the accent placed on the secrecy of the enterprise.

Once the burial rituals were completed, the valley remained deserted except for the teams of workers preparing the current king's tomb, and the police (the Medjay) who patrolled the area. The workers came to the valley along a footpath from a village, the present-day Deir el-Medina, that was isolated and enclosed between rock walls. The inhabitants of the village were those who were involved in building the tombs: masons, scribes, painters, sculptors, wood- and metal-workers.

The isolation probably acted to assure the secrecy of the work in the Valley of the Kings and the Valley of the Queens. Located to the south of the village, this valley housed the children, wives and relatives of the rulers. The village, which had a temple and its own cemetery, has provided us with a great quantity of evidence, some of it in written form, which illustrates the most intimate details of the daily life of the small community.

The tombs of the kings themselves were excavated deep into the cliffs and were composed of a series of steps, ramps and corridors, with occasional deep shafts interrupting the passages. These shafts served to make access difficult for thieves and to collect rainwater and prevent flooding, but they also represented Nun and the cavern of Sokaris. The burial chamber was larger than the other rooms and its ceiling was frequently supported by pillars carved from the rock. The succession of rooms varied over the course of time and while the tombs of the Eighteenth Dynasty (with the exception of the tomb of Ay) were based on a right-angled plan with a sharp change of direction halfway along, those of the Nineteenth were arranged in an almost straight line with a slight angle, again from about halfway along. The latest tombs followed a simple straight line.

We have fairly precise information about the organization of the work of the craftsmen engaged in the excavation and decoration of the tombs. Work probably began when the new pharaoh acceded to the throne, following the completion of the long and complex funerary ceremonies for the deceased king. Mummification alone took around seventy days. The interval between death and burial was taken up with the completion of the tomb, especially if the reign had come to a premature end. In certain cases it even appears that tombs constructed for others were hurriedly adapted.

First, a site was chosen. The selection process involved taking into account the quality of the rock, which was not always suitable, and the proximity of earlier tombs. The workers were then divided into two teams who worked in parallel. The masons and labourers excavated the tomb, removing huge quantities of limestone rubble; and then it was the decorators' turn. Sculptors and painters covered the walls and ceilings of rooms and corridors with scenes and texts designed to ensure life after death for the pharaoh. The texts, which are always accompanied by complex figurative scenes, concern the journey of the sun and the king through the Underworld, the tests that had to be endured and the obstacles that had to be overcome. These texts, named by Egyptologists, include the Book of the Amduat (the oldest and the most frequently included), the Litany of Re, the Book of Gates, and the Book of the Dead (this being far more frequent in non-royal tombs). Some only came into use in the Twentieth Dynasty, such as the Book of Caverns, the Books of Day and Night, the Book of the Celestial Cow, and the Book of the Earth.

To date, sixty-two tombs have been discovered, along with a number of shafts and hiding-places and many materials used during funerary ceremonies. John Gardner Wilkinson was the first to apply the system of tomb numbering in 1827. Later discoveries were assigned successive numbers, the last, number sixty-two, being the tomb of Tutankhamun, discovered in 1922. Of these tombs, only twenty-four are royal; the others belong to the children or other relatives of the pharaohs, or to high-ranking officials. All the rulers of the Eighteenth to the Twentieth dynasties were buried here, with the exceptions of Amenhotep IV-Akhenaten, who had a tomb built at Tell el-Amarna, and Ramesses XI, whose tomb was unfinished. But not all the tombs have been identified. We have yet to discover

the original burial place of the pharaoh considered to be the founder of the royal necropolis, Amenhotep I, who was venerated as such together with his mother Ahmose Nefertari. Yet his mummy was discovered along with others in the Cache of Deir el-Bahri.

Even though these valley tombs were concealed and protected by the Medjay teams, they soon began to suffer from the attentions of robbers, in some cases almost immediately after the burial. The immense treasures buried with the kings, of which we have the perhaps unrepresentative evidence of the relatively small tomb of Tutankhamun, inevitably stimulated the greed of many.

From as early as the Eighteenth Dynasty there is precise testimony of the violation of the royal tombs. For example, in the tomb of Thutmose IV, a text in beautiful hieratic calligraphy written on the south wall of the antechamber commemorates the restoration of the tomb

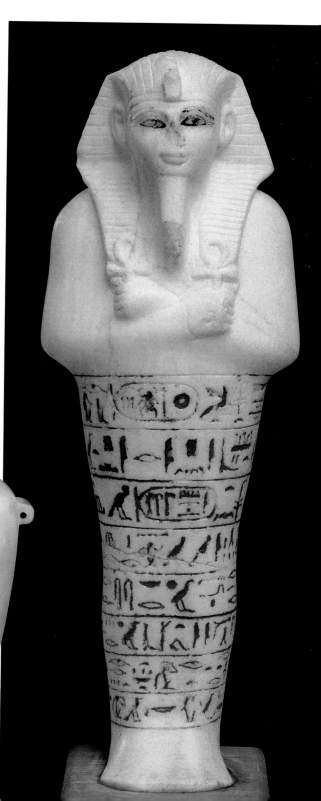

283 LEFT
VASE OF HATSHEPSUT
JE 57203
CALCITE
HEIGHT 33.5 CM
VALLEY OF THE KINGS
EIGHTEENTH DYNASTY
REIGN OF HATSHEPSUT
(1473–1458 BC)

283 RIGHT
SHABTI OF AMENHOTEP II
CG 24230
ALABASTER
HEIGHT 22.5 CM
VALLEY OF THE KINGS,
TOMB OF AMENHOTEP II
(KV 35)
EIGHTEENTH DYNASTY
REIGN OF AMENHOTEP II
(1427–1401 BC)

during the eighth year of Horemheb by the head treasurer Maya and his assistant Djehutymes. It was perhaps Maya, whom we know to have been active during the reign of Tutankhamun, who restored the tomb of this young pharaoh and secured it with the seal of the cemetery (a jackal and nine bound prisoners). It is probable that an initial series of thefts from the royal cemetery took place during the unsettled period following the Amarna heresy and the successive restoration of stability, as the depredation of the tomb of Yuya and Tuyu, parents of Queen Tiye, would appear to prove. The tomb was discovered in 1905, apparently intact, but in reality there are clear traces of vandalism and subsequent restoration.

The thefts continued during later dynasties. A papyrus in the Turin museum, the so-called Strike Papyrus, records acts of vandalism committed by workers in the twenty-ninth year of Ramesses III's reign against the tombs of Ramesses II and his children. It is significant that this plunder took place in a period in which strikes were proving to be a serious social problem. The destructions culminated towards the end of the Twentieth Dynasty and the beginning of the Twenty-first. Uprisings and the increasing influence of the high priests of Thebes overcame the Ramesside Dynasty, already weakened by disastrous economic conditions.

We have been left evocative reports of a number of these acts in a series of papyri describing the trials of grave robbers that provide a contemporary account of the events. The Papyrus Abbott, in the British Museum, is the most detailed of these documents and refers to an inspection ordered in year sixteen of the pharaoh Ramesses IX by the vizier Khaemwaset, at the behest of Paser, the mayor of Eastern Thebes. The inspection committee led by Paur, the Medjay chief at Western Thebes, visited ten royal tombs in the Dra Abu el-Naga region (dating to the Eleventh, Thirteenth, Seventeenth and early Eighteenth dynasties), as well as the tombs of various noblemen and chantresses of Amun. The following day tombs of the Valley of the Queens were visited, but no mention was made of the Valley of the Kings. Perhaps the documents relating to the latter have not survived or, perhaps, Paur was not entirely honest and managed on that occasion to steer clear what may have been dangerous waters.

The confession of one of the thieves, recorded in the fortuitously reunited parts of the Leopold-Amherst Papyrus, provides us with a vivid description of the anxious torchlight search in the suffocating atmosphere of the underground chambers:

'We went to rob tombs in accordance with our regular habit, we found the pyramid of the king … Sobekemsaef, this being not at all like the pyramids and tombs of the nobles which we habitually went to rob. We took our copper tools and we broke into the pyramid of this king through its innermost part. We found its underground chambers and we took lighted candles in our hands and we went down. Then we broke through the rubble that we found at the mouth of his recess and found this god lying at the back of his burial chamber. And we found the burial place of the Queen Nubkhaas, his queen, situated beside him, it being protected by plaster and covered with rubble. This we also broke through and found her [lying] there in a similar fashion. We opened their sarcophagi and their coffins in which they were, and found the noble mummy of this king equipped with [the figure of a falcon]; a large number of amulets and jewels of gold were upon his neck, and his headpiece of gold was upon him. The noble mummy of this king was completely bedecked with gold, and his coffins were adorned with gold and silver inside and out and inlaid with all sorts of precious stones…. We took their furniture which we found with them consisting of articles of gold, silver and bronze, and divided them among ourselves. And we made into eight parts the gold which we found on these two gods coming from their mummies, amulets, jewels and coffins. And twenty deben of gold fell to each of the eight of us, making one hundred and sixty deben of gold, the fragments of furniture not being included. Then we crossed over to Thebes.' (A.J. Spencer, *Death in Ancient Egypt*, 1982). The papyrus then goes on to recount how, after a few days, the superintendents of the district of Thebes heard about the robberies, imprisoned the offender and took away his share of the booty. He was released, however, and continued in his career of tomb robbing, along with many of the inhabitants of this region who followed the same profession.

The accounts need no further comment and provides us with a graphic picture of the violations of the tombs in the Valley of the Kings. Further evidence of these

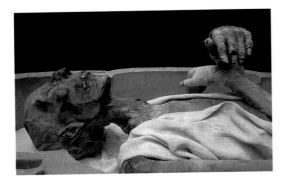

raids comes from of the Papyri Mayer A and B that describe thefts from the tombs of Seti I, Ramesses II and Ramesses VI. It seems the thefts took place many years earlier, given that two of the witnesses are the wife and son of two deceased defendants. The testimony of the widow makes pathetic reading as she speaks of how her husband took away a little copper belonging to the tomb: 'We sold and devoured it'. The confession of one of the thieves is explicit: 'The foreigner Nesamun took us up and showed us the tomb of the king Nebmaatre-Meryamun [Ramesses IV], life, prosperity, health, the great god. We said to him, "Where is the tomb

284 BELOW
WINGED COBRA
CG 24629
WOOD
HEIGHT 44 CM
LENGTH 65 CM
WIDTH 16 CM
VALLEY OF THE KINGS
TOMB OF AMENHOTEP II
(KV 35)
EIGHTEENTH DYNASTY
REIGN OF AMENHOTEP II
(1428–1401 BC)

284 RIGHT
MUMMY OF RAMESSES II
CG 61078
LENGTH 173 CM
WESTERN THEBES
DEIR EL-BAHRI CACHE
(TT 320)
CLEARED IN 1881 BY THE
ANTIQUITIES SERVICE
NINETEENTH DYNASTY
REIGN OF RAMESSES II
(1290–1224 BC)

worker who was with you?" He said, "the tomb worker with the little servant who was with us has been killed so he will not give us problems." So he told us." Clearly there was little honour among thieves. The confession proceeds with a list of the booty that in this case consisted of cauldrons, ewers and vessels in bronze and copper, and clothes and textiles of good quality. After it had been weighed, the booty was divided among the five accomplices, each receiving one hundred deben of copper. Evidently the thefts involved not only objects in precious materials, but also metal vessels, cloths and occasionally the perfumed unguents that were a highly prized and possibly more easily disposed of form of booty.

The situation worsened to the point where, early in the Twenty-first Dynasty, it was no longer possible to defend the Valley. It was therefore decided to recover all the mummies, restore them, provide them with new coffins if the originals had been destroyed, and place them in more inaccessible tombs. There must have been more than one such transfer, as testified by the records inscribed on the coffins and bandages of the mummies themselves. And yet these poor mummies, bereft of their most precious jewels, were still capable of arousing greed, as the complicated story of their rediscovery proves.

Towards the end of the nineteenth century, during the last years of Auguste Mariette's life, papyri and objects belonging to kings, the locations of whose tombs were still unknown, began to appear on the antiquities market. With Gaston Maspero's appointment to the Egyptian Antiquities Service, investigations commenced that led to the incrimination of two brothers of the Abd el-Rassul family. They were arrested and interrogated at length, but only confessed when they realized that they would no longer be able to sell their booty. Maspero had meanwhile returned to France. So, on 6 July, 1881, his assistant Émile Brugsch was led to the hiding-place: a long, straight corridor at the bottom of a shaft, hidden in a mountain ravine to the left of the temple of Deir el-Bahri. Stacked up in the restricted space were around forty mummies, including some of the greatest pharaohs: Seqenenre Tao II, Amenhotep I, Thutmose I, II and III, Seti I, and Ramesses

I, II, III and IX. In a chamber at the end of the corridor were the mummies of Pinudjem II and his wife, and Djedptahiufankh and his wife, the original occupants of the tomb (TT 320).

For security, the cache was hurriedly transferred to the Egyptian Museum in Cairo where the mummies were first deposited in a mausoleum and then exhibited in a mournful first-floor hall. They have now been appropriately housed in a recently refurbished room, equipped with all the necessary technology to ensure their conservation.

Victor Loret discovered a second cache some years later, in 1898, in the tomb of Amenhotep II (KV 35). Here too, alongside the original occupant of the tomb, were found stacks of bodies, including those of Amenhotep III,

Thutmose IV, Seti II, Merneptah, Siptah, Ramesses IV, V and VI, and an unknown woman. Another three bodies lacking coffins were discovered in a side chamber, among them the 'Old Lady' identified as Tiye. Of the other tombs, such as the one known as KV 55, the original occupants are still uncertain, though in this particular case Amenhotep IV-Akhenaten has been suggested.

A number of royal mummies are still missing. There might well be another cache or communal grave, such as the one discovered in 1908 in the tomb of Horemheb (KV 57), yet to be correctly interpreted. The current revival of archaeological activity in the valley by the Egyptian authorities and numerous foreign missions suggests that the future may hold further surprises.

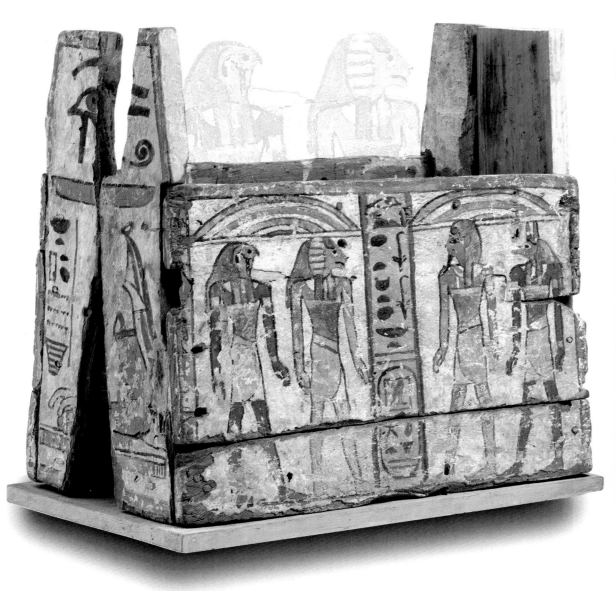

285
CONTAINER FOR SHABTI
FIGURE OF HENUTTAWY
JE 26272 B
WOOD
HEIGHT 58 CM
WIDTH 34 CM
DEIR EL-BAHRI
TWENTY-FIRST DYNASTY
(1070–945 BC)

BIOGRAPHY

Anna Maria Donadoni Roveri *was born in Rome and graduated and specialized in Oriental Archaeology at the University of Rome. She began her career at the Egyptian Museum of Turin in 1965 and returned in 1984 as superintendent, after having spent a five-year period as Director of the Archaeological Heritage Service of the Central Institute of Restoration at Rome.*

As superintendent she has initiated the renovation and expansion of the museum, curated numerous exhibitions and edited both academic and popular publications.

She is also responsible for the revival of excavations, in the Gebelein area, previously explored by Schiaparelli and Farina in the first half of the century.

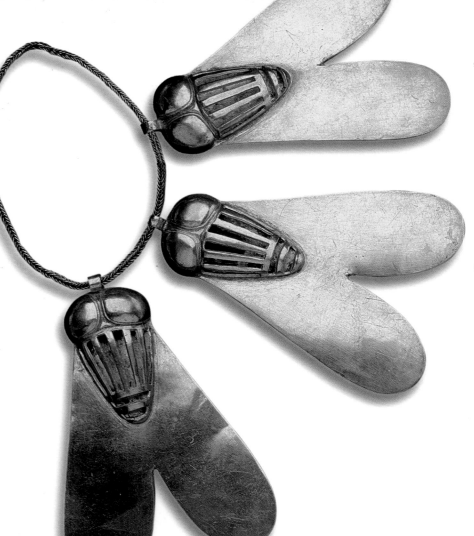

COFFIN OF AHHOTEP

WOOD, GOLD LEAF, ALABASTER, OBSIDIAN
HEIGHT 212 CM
DRA ABU EL-NAGA, BURIAL OF QUEEN AHHOTEP
ANTIQUITIES SERVICE EXCAVATIONS (1859)
EIGHTEENTH DYNASTY, REIGN OF AHMOSE (1550–1525 BC)

There were possibly two Ahhoteps connected with the Seventeenth Dynasty. One was a daughter of King Seqenenre Tao I and Queen Tetisheri, and in turn was the mother of Ahmose I, and possibly also Kamose. But it may have been another queen of the same name, perhaps the wife of Kamose, who was buried with a rich funerary cache in a deep underground chamber at Dra Abu el-Naga.

Only the lid of her large wooden coffin survives as the bottom half was destroyed during the recovery and dispersal of the contents of her intact tomb. Contemporary descriptions record that is was painted black. After having been stripped of its various precious objects, the mummy of the queen also deteriorated and was discarded.

The coffin lid, carved from a single piece of wood (sycamore or cedar) is mummiform and depicts the deceased with her body covered in birds' feathers. This style, common at Thebes during the Seventeenth and early Eighteenth Dynasty, is known as *rishi*, an Arabic word meaning 'feathered'. The wood of the coffin was covered with a thin layer of plaster, into which the decoration was incised. This was then in turn covered with gold leaf.

The face is framed by a massive wig decorated with thin undulating parallel lines imitating hair. The wig extends to the chest where it terminates with two large curls, each with a blue circle in the centre. The rounded forms of the hair are the boldest shapes of the lid, as the rest of the body is only vaguely represented. A cobra, perhaps of gold, would once have sat on the forehead but is now missing. The sinuous tail of the snake is depicted in relief above the wig and is covered with gold leaf.

The face and the neck of the queen are surrounded by a thick blue line, which thus delimited the only naked areas of the body. With its fine, idealized features the face is enlivened by a very slight smile which lends the deceased a serene expression. The large, almond-shaped eyes are inlaid with semiprecious stones fixed with gesso to the eyelids. The eyeball is in white alabaster while the iris is obsidian. The eyebrows and the cosmetic line from the eyes are painted blue.

A necklace composed of concentric bands incised with vertical lines intimating cylindrical beads is represented on the breast of the figure. The necklace ends with small droplet pendants and features two falcons' heads at the shoulders. A cobra and a vulture, side by side with a single pair of outspread wings, are superimposed on the necklace.

The rest of the surface of the coffin lid from the abdomen to the feet is decorated with the feather motif, possibly symbolizing the wings of Isis that enfold and protect the body of the queen.

A column of hieroglyphs is incised in the centre and contains an offering verse in which the name of Ahhotep enclosed within a cartouche can be read.

The legs of the deceased are indicated by means of two unusual tapering and vertical swellings from the knees to the feet, a feature that also appears on the coffin of the pharaoh Seqenenre Tao II. The two coffins are also similar in terms of their bulky appearance and may have been made in the same workshop.

Below the feet of the deceased are rough representations of the goddesses Isis and Nephthys kneeling before an altar. The internal surface of the lid is covered with black paint. (S.E.)

CHAIN WITH FLY-SHAPED PENDANTS

GOLD; LENGTH OF CHAIN 59 CM; LENGTH OF PENDANT 9 CM
DRA ABU EL-NAGA, BURIAL OF QUEEN AHHOTEP
ANTIQUITIES SERVICE EXCAVATIONS (1859)
EIGHTEENTH DYNASTY, REIGN OF AHMOSE (1550–1525 BC)

The funerary cache of Queen Ahhotep contained a group of ceremonial weapons and other objects that were rare in the tombs of women. It has been suggested that this Seventeenth Dynasty queen was perhaps the wife of Kamose, who began the fight for independence against the Hyksos. The expulsion of the foreign invaders was completed by Ahmose, who ruled a unified country under the Eighteenth Dynasty. Ahhotep's apparently high status even though a woman is a characteristic that was maintained throughout the Eighteenth Dynasty.

This type of necklace is a military decoration, known as the 'order of the golden fly' presented by the king to soldiers who had distinguished themselves in battle.

It is composed of a fine chain that is fastened by means of a hook passed through an eyelet. Suspended from the chain are three pendants in the form of flies of large size. Each insect is depicted as if it were resting on the ground. The wings are smooth while the body is chased. The head terminates in two large protruding eyes. In spite of the stylization of the forms, the fundamental features of the insect are easily recognizable. Fine rings attached between the eyes allow the three pendants to be threaded on to the chain. (R.P.)

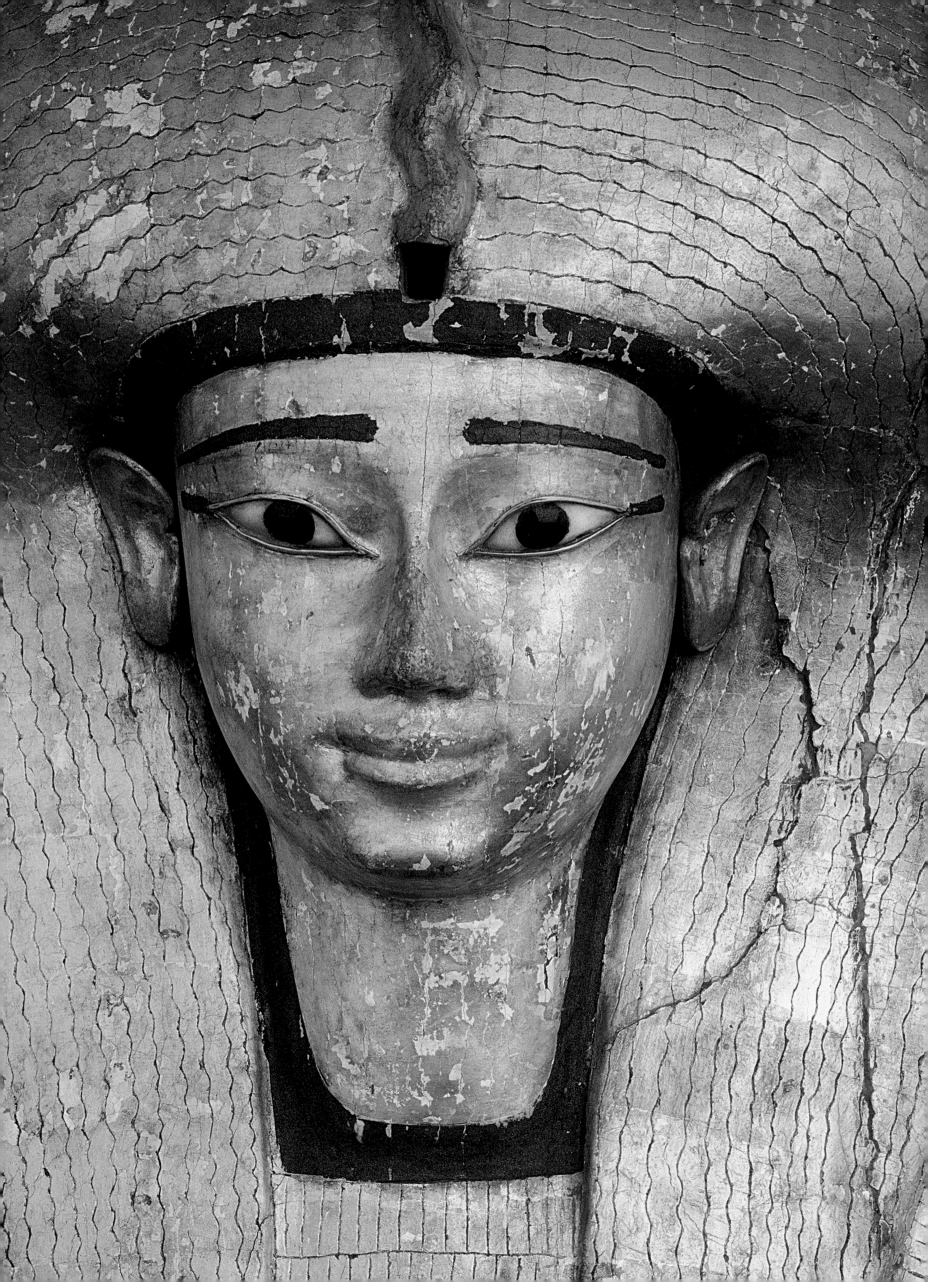

MODEL OF A BOAT
ON A WOODEN WAGON

BOAT (*JE 4681*): GOLD AND SILVER; LENGTH 43.3 CM
WAGON (*JE 4669*): WOOD AND BRONZE; LENGTH 20 CM
DRA ABU EL-NAGA, BURIAL OF QUEEN AHHOTEP; ANTIQUITIES SERVICE
EXCAVATIONS (1859); EIGHTEENTH DYNASTY, REIGN OF AHMOSE (1550–1525 BC)

JE 4681 = CG 52666
JE 4669 = CG 52668

This boat was also part of the funerary cache of Queen Ahhotep. The model represents a boat made of bundles of reeds tied with cords and ending at the prow and stern in two posts in the form of open papyrus flowers. Four gold rings project from the sides of the boat. At either end of the deck are two boxes that served as seats for the helmsman and the captain. Three figures stand out from the rest by their size and material. The captain is standing facing the stern with his hand held to his mouth, evidently shouting orders to the crew. His seat is decorated with repeated Knot of Isis motifs in a series of panels.

The helmsman at the opposite end is standing facing the prow and grips the rudder in his hands. Behind him is another seat decorated with a lion and the cartouche of Kamose, the brother and predecessor of Ahmose. A third, removable figure is seated in the centre of the boat with an axe in his left hand and a staff in his right. These three figures are in gold and are larger than the others.

The crew, much smaller in scale, is composed of twelve oarsmen made from silver. All of them are seated with their backs to the prow and are holding their oars (two of which are missing) over the sides of the boat.

The vessel rests on a wooden carriage with four bronze wheels.

This carriage carried a second model boat in silver, which was also part of the funerary cache of Queen Ahhotep.

Models of boats have been found as grave goods from the earliest times and among remains of settlements of the Predynastic Period. They were generally made of clay or terracotta and later also in wood. The presence of such means of transport in the scenes depicted on vases and walls is undoubtedly a sign of the great importance of the Nile as a major communications route. (R.P.)

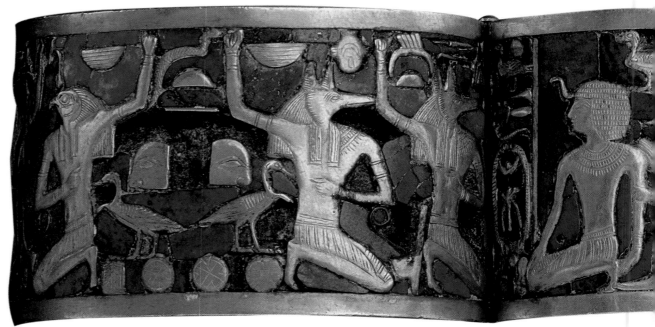

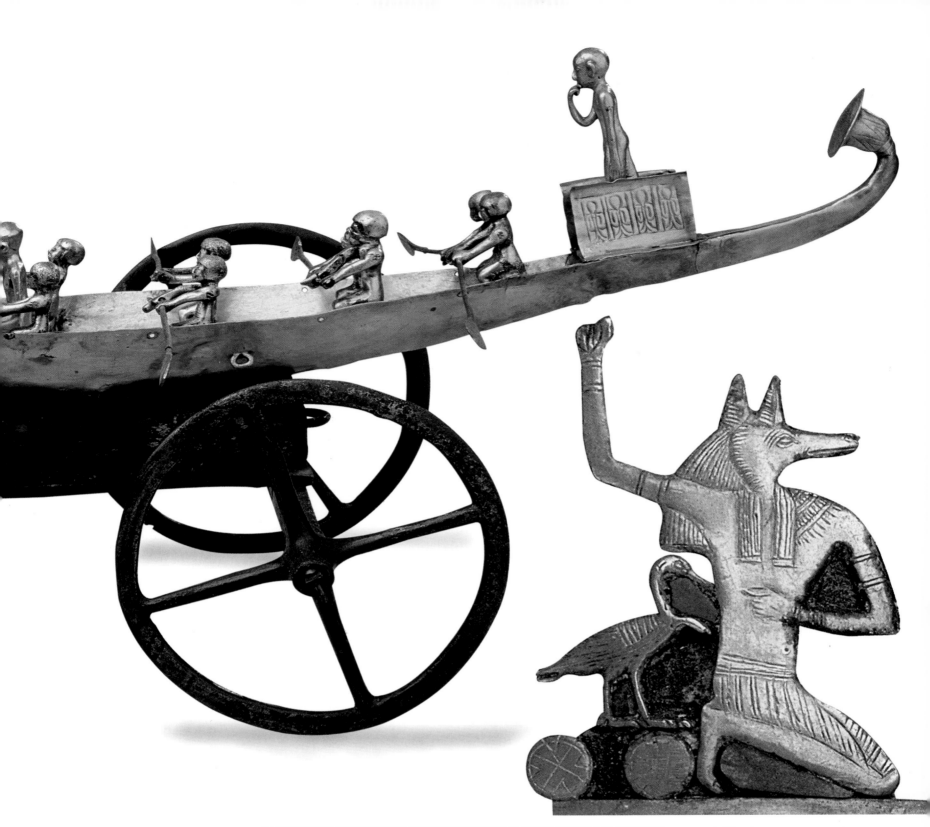

JE 4684 = CG 52069

BRACELET OF AHHOTEP

GOLD AND LAPIS LAZULI; DIAMETER 5.5 CM; HEIGHT 3.4 CM; WEIGHT 96 G
DRA ABU EL-NAGA, BURIAL OF QUEEN AHHOTEP; ANTIQUITIES SERVICE
EXCAVATIONS (1859); EIGHTEENTH DYNASTY, REIGN OF AHMOSE (1550–1525 BC)

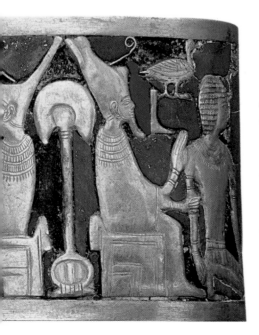

The mummy of Ahhotep was accompanied by a rich assemblage of weapons, insignia and jewels, almost all bearing the name of Ahmose. After many vicissitudes, the treasure came under the control of Mariette, who consigned it to the *Khedive*.

The richness and value of the cache and the fact that it was composed almost exclusively of gifts from the king demonstrates the recognition at the beginning of the New Kingdom of the importance of the role played by the women of the dynasty. This importance may, however, have derived more from the new ideology that identified them as the vehicles of the royal blood rather than from any of their personal capacities.

This bracelet is one of the most elaborate of the jewels that adorned the mummy of the queen. It consists of two semicylindrical pieces of beaten gold linked by two hinges, one of which is equipped with a hook allowing the jewel to be opened. The decoration is composed of pictorial scenes and hieroglyphs. On the right-hand side the decoration is divided into two symmetrical and mirrored scenes separated by a fan placed on a *shen* hieroglyph. At either side is the throned god Geb, who is protecting the pharaoh Ahmose kneeling in front of him. In the left-hand scene the god wears the Red Crown and on the right the Double Crown. At the centre of the two scenes, at the top, is the name of the god. The king's name is written at either end.

The spirits of Pe (Lower Egypt) and Nekhen (Upper Egypt), ancestors of the king before the unification of the two lands, are depicted on the other half, with the head of a falcon and a jackal respectively. They raise their arms as a sign of jubilation, acknowledging the king as the legitimate successor to the pharaohs. (R.P.)

SHABTI FIGURE
OF AMENHOTEP II

GREY-GREEN SCHIST; HEIGHT 31 CM
VALLEY OF THE KINGS, TOMB OF AMENHOTEP II (KV 35)
V. LORET'S EXCAVATIONS (1898)
EIGHTEENTH DYNASTY, REIGN OF AMENHOTEP II (1428–1397 BC)

This fine funerary statuette of Amenhotep II was discovered in March 1898, together with many other objects in the pharaoh's grave goods. The numerous *shabti* figures are made of various materials. Of these, a considerable number are schist and are very similar to one another. They measure between seventeen and thirty-one centimetres high and represent a mummiform pharaoh with his arms crossed over his chest. Hands emerging from the bindings each grip an *ankh* hieroglyph symbolizing life. Amenhotep II wears a striped *nemes* with a royal cobra at the centre of the forehead and a long, narrow false beard that, in the examples that survive intact, ends in a sort of curl. In the case of the statuette illustrated here, the king's face is characterized by soft lines and refined features: eyebrows in relief surmount large almond-shaped eyes, the nose is small, and the mouth is smiling.

The lower part of the body below the arms is covered by eight horizontal lines of text containing the usual *shabti* offering verse, Chapter 6 of the Book of the Dead. This is present with few variations on the various schist examples and is also found on another *shabti* figure of the same sovereign in alabaster. The hieroglyphs and other incised parts are filled with a pale yellow pigment.

The text begins with the king's birth name: 'Perfect god *Aakheperure*, beloved of Osiris, great god,' and proceeds with the verse which asks the *shabti* figure to take the place of the king whenever he is called upon to perform any task in the Underworld. (R.P.)

COFFIN OF
AHMOSE MERITAMUN

CEDAR WOOD; HEIGHT 313.5 CM; WIDTH 87 CM
DEIR EL-BAHRI, ROCK TOMB (TT 358); EGYPTIAN ANTIQUITIES SERVICE
AND METROPOLITAN MUSEUM OF ART EXCAVATIONS (1929)
EIGHTEENTH DYNASTY, REIGN OF AMENHOTEP I (1525–1504 BC)

This imposing coffin was discovered in a small rock tomb excavated in a deep valley to the north of the temple of Queen Hatshepsut at Deir el-Bahri.

The identity of the occupant is still in doubt. On the basis of the inscriptions, its discoverer Herbert Winlock, attributed it to the daughter of Thutmose III, Ahmose Meritamun, the wife of her own brother, the future king Amenhotep II. However, this hypothesis is not universally accepted and according to others the coffin instead belonged to another queen of the same name, the daughter of the pharaoh Ahmose, who again married her own brother, Amenhotep I the founder of the Eighteenth Dynasty.

This huge anthropomorphic coffin was originally enclosed within a vast external sarcophagus that was found in pieces and itself enclosed a smaller coffin, in which the mummy of the deceased was placed. It is made of cedar panels that originally were partially covered with gold leaf and inlaid with precious stones, but these elements were removed by thieves. In the course of the restoration carried out during the Twenty-first Dynasty, the gilding was replaced with yellow paint and the inlays were substituted by a layer of blue.

The decoration follows the classic *rishi* coffin model that was used in Thebes from the Seventeenth Dynasty. The Arabic word *rishi* means 'feathered' and refers to the external decoration of the coffin, which imitates the wings with which it was believed the goddess Isis protected the deceased.

The lid depicts the deceased with her arms crossed on her chest. The face has severe features and displays an extraordinary degree of expressiveness and a sophisticated beauty. Its surface was designed to retain the natural colour of the wood, smoothly polished to evoke the delicate skin of the deceased. The eyes, their outlines and the eyebrows were originally inlaid with obsidian, alabaster and lapis lazuli, but are now composed of inlays of

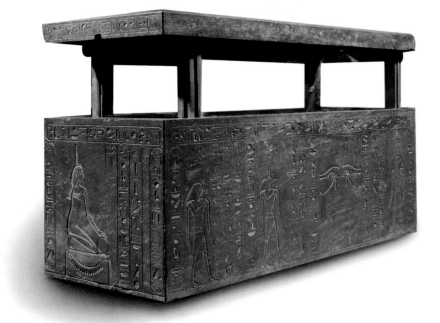

glass paste. The face is framed by a massive wig incised with small cells painted blue, again replacing the missing inlays. The wig falls to the back of the head in imitation of a mass of long hair, while at the front it is parted into two large locks that descend to the breasts, partially concealing a necklace of concentric bands. The breasts and the arms are covered with a motif of incised cells, painted blue during the Twenty-first Dynasty restoration.

Areas emerging from amid the multiple incisions of the wig and torso still carry traces of the small scales of gold leaf with which these parts of the coffin were originally covered. Both hands grip a papyrus sceptre, a symbol of youth and life, and the figure is wearing bracelets represented with incised parallel lines on the wrists.

The rest of the lid is decorated with long parallel feathers, the outlines of which were first traced with black ink and then incised on the surface of the wood before it received its now missing gold leaf covering. At the centre is a vertical inscription painted in blue that descends from the abdomen to the ankles and contains the usual offering verse. Traces of gesso found in the incised hieroglyphs indicated that they were once inlaid, probably with blue glass paste.

The casket, which was left in natural unpainted wood, is also decorated with the incised feather motif and the back is carefully modelled.

The coffin as a whole represents a veritable monument in carved wood, emblematic of the art of the Eighteenth Dynasty. (S.E.)

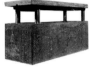

JE 37678 - 52459

SARCOPHAGUS OF QUEEN HATSHEPSUT

RED QUARTZITE; HEIGHT 100 CM; LENGTH 245 CM; WIDTH 87.5 CM
VALLEY OF THE KINGS, TOMB OF QUEEN HATSHEPSUT (KV 20)
EIGHTEENTH DYNASTY, REIGN OF THE QUEEN HATSHEPSUT (1473–1458 BC)

This rectangular sarcophagus has rounded corners at the end corresponding to the position of the head, thus partially reproducing the shape of a cartouche, the oval element that enclosed and protected the names of the pharaohs. It was found in the Valley of the Kings in the tomb excavated for Hatshepsut after she had been proclaimed pharaoh. The sarcophagus is perfectly polished on all sides and decorated with finely carved scenes in one of the hardest stones used by Egyptian artists, the red quartzite associated with the solar cult. The figures of the deities represented are in keeping with the style and sophistication of the other monuments of the queen. A number of columns of hieroglyphs divide the figurative space into different areas, with depictions of the divinities and the genii who were to protect the queen during her journey through the Underworld.

At the foot end is Isis, kneeling on the *nub* hieroglyph (a necklace with pendants symbolizing 'gold'). The goddess's hands rest on the *shen* hieroglyph (symbolizing protection). On her forehead is the cobra. The hieroglyph meaning 'throne', inscribed with her name, rests on her head. Her body is draped in a long, tight tunic with a broad strap partially covering her breast.

Three columns of hieroglyphs are incised in front of Isis, in which the goddess is defined as the daughter of Geb and which record her words: 'Your arms surround the king *Maatkare*, right of voice, you have illuminated his face and opened his eyes'. The whole scene is framed by three long cartouches, two vertical and a higher horizontal one in which the queen associates herself with Isis, declaring their sisterhood. A similar scene is found on the opposite short end of the sarcophagus, where the goddess Nephthys is represented. She too has her name written above her head.

Along the right-hand side of the sarcophagus are depicted two of the sons of Horus (Imseti and Duamutef), between whom is placed Anubis Khentisehnetjer ('he who stands before the tent of the god'), while the other two sons of Horus (Hapy and Qebehsenuef) are represented on the left-hand side with Anubis Imyut ('the embalmer') between them. On both sides of the sarcophagus the texts are composed of tutelary verses for the body of the queen. On the left-hand side there is also a pair of *wedjat* eyes that allowed the deceased to look out of the sarcophagus. In the interior of the sarcophagus are further representations of Isis and Nephthys. (R.P.)

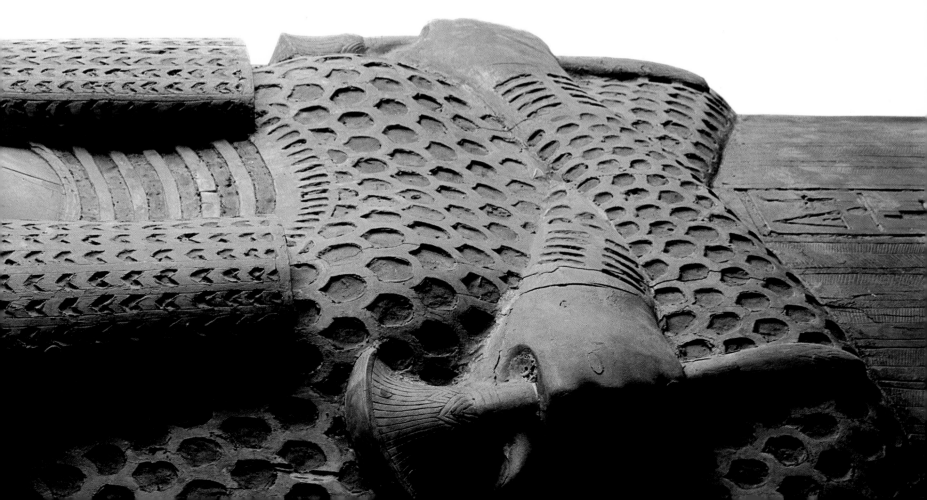

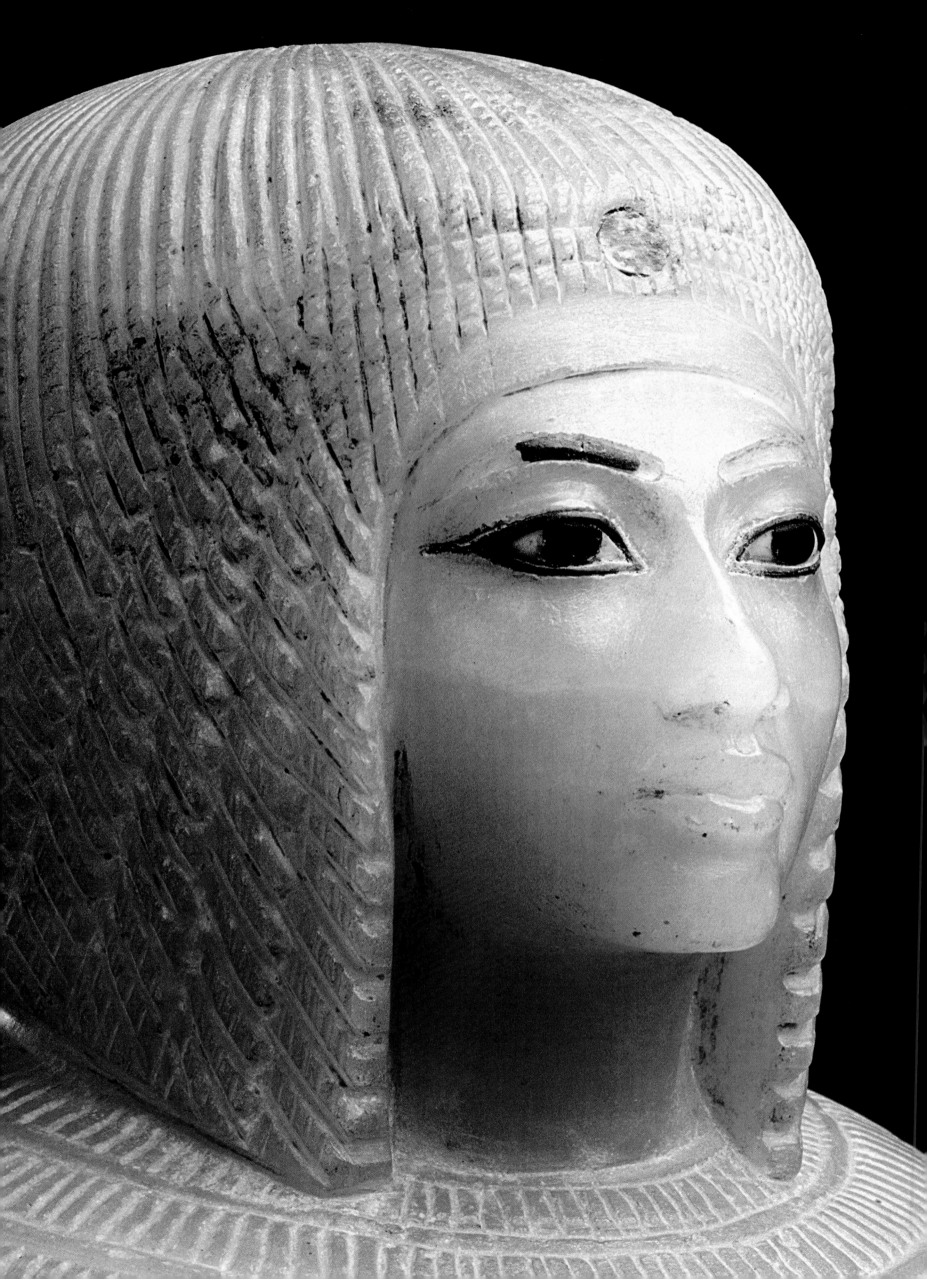

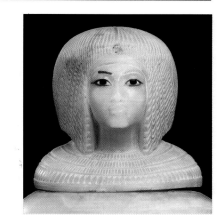

CANOPIC JAR

CALCITE, GLASS PASTE, QUARTZ, OBSIDIAN
HEIGHT 38.5 CM
VALLEY OF THE KINGS (KV 55); DISCOVERED BY E.R. AYRTON AND T. DAVIS (1907)
EIGHTEENTH DYNASTY, REIGN OF AKHENATEN (1353–1335 BC)

Tomb KV 55 was discovered in a state of complete disorder. Together with a coffin with its names deliberately obliterated and a number of furnishings of clear Amarna origin, a group of fine canopic jars was also found. One of these was taken to the New York Metropolitan Museum of Art, while the other three remained in Cairo.

A characteristic common to all the jars is that the inscriptions and the figurative decoration inscribed on the bodies have been carefully chiselled away so that the neither the name of the deceased nor the tutelary verse are legible. This was part of a deliberate *damnatio memoriae* perpetrated against the deceased buried in this unfinished tomb. The identity of the original occupant has long been the subject of speculation.

In accordance with New Kingdom practice, the canopic jars all have lids in the form of a human head portraying the deceased. The face is female and is framed by a short wig with the sides cut diagonally. On the forehead there was originally a cobra, a clear sign that the deceased was a member of the royal family. The eyes are narrow and surmounted by heavy lids. The eyebrows and the outlines of the eyes themselves are created in blue glass paste, while the whites and the pupils are in quartz and obsidian. The nose is small and narrow and the mouth is fleshy with

slightly down-turned corners. This characteristic, together with the fact that a gilded shrine bearing the name of Queen Tiye was also found in the tomb, led the first discoverers to suppose that they had found the burial chamber of this wife of Amenhotep III and mother of Akhenaten and that it had subsequently been reused. The style is of the later Amarna Period by which time the traits of the early part of Akhenaten's reign had been abandoned.

The harmony and balance of the forms mean that these beautiful canopic jars of KV 55 can be included among the most splendid examples of Amarna royal portraiture. Possible identifications of the enigmatic face that appears on each of them include either one of princesses, daughters of Akhenaten, or his wife Kiya. (F.T.)

of the secondary wives of Akhenaten might be recognized). Their inscriptions had been obliterated and the royal cobra on the foreheads had been removed.

Amid the detritus in the tomb, objects with the names of Tiye and a number of seals with the cartouche of Tutankhamun were also found. Unfortunately, the excavations were not carefully documented, an omission that has always created considerable difficulty in subsequent attempts to interpret the discovery.

An initial examination of the mummy contained in the coffin led to its identification as that of a woman. Further and more in-depth analyses proved on the contrary that the corpse was that of a young man of between twenty and twenty-five years of age.

Since the discovery of the tomb there have been a number of suggestions as to the true identity of the occupant of the coffin. Theodore Davis identified the tomb as that of Queen Tiye. And in spite of the fact that the mummy has been universally recognized as that of a man, it appears certain that the tomb was originally occupied by the corpse and the funerary equipment of Tiye, wife of Amenhotep III, who died during the reign of her son Akhenaten. The tomb would then have been re-opened two or three times: when the coffin of Tiye was removed (and perhaps transferred to the tomb of her husband Amenhotep III) and the one bereft

of names was put in its place, and then when the deliberate defacement of the objects was performed. It is difficult to establish the order in which these events took place, and it is even more difficult to put a name to the mummy enclosed in the coffin. The names of Akhenaten and his successor Smenkhkare have been proposed on a number of occasions, but no definite solution has been reached to this enduring mystery.

The coffin was found in very poor condition and was subsequently restored. It was clearly prepared to house the mummy of a monarch, as demonstrated above all by the false beard, the cobra on the forehead and the remains of a flail. One anomalous detail is that the head is covered with a heavy wig rather than the more usual *nemes*.

The sheet of gold that covered the face and carried the inlaid eyes and eyebrows has been ripped off and the names in cartouches in all the inscriptions have been carefully erased. This deliberate damage was performed according to a precise ritual of *damnatio memoriae*. The false beard of lapis lazuli and gold survives. The shoulders are covered by a decorative motif reproducing a broad-collar necklace placed over a shawl from which the hands emerge, covered with gold leaf. The hands are gripping the royal insignia. The lower part of the coffin is decorated with a feather motif similar to *rishi* coffins. (F.T.)

COFFIN LID WITH NAMES ERASED

WOOD, GOLD LEAF, LAPIS LAZULI, GLASS PASTE
LENGTH 185 CM
VALLEY OF THE KINGS (KV 55); DISCOVERED BY E.R. AYRTON AND T. DAVIS (1907)
EIGHTEENTH DYNASTY, REIGN OF AKHENATEN (1353–1335 BC)

In KV 55 a mysterious coffin was found with the names erased and the face completely disfigured. From the moment of the discovery of this small tomb, excavated below the burial chamber of Ramesses IX, it has been one of the most intriguing enigmas of the world of Egyptology.

Together with the coffin, a number of other objects were also discovered, all associated in one way or another with the Amarna Period.

Fragments of a wooden shrine belonging to Tiye, the wife of Amenhotep III, were also found, which carried the carefully obliterated symbols and names of Akhenaten. The name of Akhenaten does survive on the magical sun-dried clay bricks placed as protection for the tomb. In a recess there was a complete set of fine canopic vases (in which the features of an Amarna princess or Kiya, one

293

COFFIN OF AMENHOTEP I

PAINTED CEDAR WOOD; LENGTH 203 CM
WESTERN THEBES, DEIR EL-BAHRI CACHE (TT 320)
ANTIQUITIES SERVICE EXCAVATIONS (1881)
REIGN OF AMENHOTEP I (1525–1504 BC)
REUSED DURING TWENTY-FIRST DYNASTY
REIGN OF SIAMUN (978–959 BC)

The coffin bearing the name of Amenhotep I was not actually made for this pharaoh but was used to contain his mummy when, during the course of the Twenty-first Dynasty, the high priests of Amun had decided to place the remains of Theban rulers and priests in the security of another tomb, which has now been shown to have originally belonged to Pinudjem II. A double hieratic inscription that can be dated to the era of Pinudjem II was traced in black ink on the coffin lid in a position corresponding to the mummy's chest.

This find is one of the rare testimonies to the last great sackings of the Theban cemeteries, which induced the priests of Amun to reinter the mummies of pharaohs and priests in the so-called of Deir al-Bahri Cache.

This particular coffin is mummiform and was subjected to a number of modifications to render it worthy of containing the body of the king. The lid is made of a number of parts joined by wooden elements and strips of leather. The wig was originally decorated with yellow and black stripes, but was subsequently painted a uniform black. The image of a yellow vulture was added on top and a royal cobra with a three-part body in blue, red and black was created to adorn the forehead.

The face is painted yellow, with large eyes and prominent eyebrows. The lips are set in a slight smile and are emphasized with a red line, also used to underline the small dimples on the chin, from which the false beard hangs. The surface of the lid was at one time completely painted white, but the paint was stripped at a later date, leaving the natural colour of the wood. A polychrome circular necklace was once painted on the chest, but this was also eliminated when it was decided to use the coffin to contain the body of Amenhotep I. Instead, an image of the goddess Nekhbet in the form of a vulture with outspread wings was painted on the breast. Below the bird of prey is a column of hieroglyphs containing an offering verse dedicated to Amenhotep I, whose coronation name, *Djeserkare* (Holy is the *ka* of

Re), was also recorded. The inscription is intersected on either side by three bands of hieroglyphs that record the names of Anubis, Osiris and the Four Sons of Horus. The goddess Nephthys is depicted kneeling with raised arms, from which *ankh* symbols hang.

Originally the surfaces of the lower casket would also have been painted, but the paint was removed when the coffin was usurped. On both sides, corresponding with the shoulders, is a *wedjat* eye above a small shrine with a red door. The rest of the side panel is subdivided into four sections by means of inscriptions that are now almost illegible. Within each of them is the image of a divinity. The interior of the coffin is completely covered with black paint.

The original colour and traces of the other details that were obliterated when the coffin was reused suggest that it can be dated to the early Eighteenth Dynasty. Amenhotep I's own coffin had perhaps been destroyed by tomb robbers when they attempted to remove the gold with which it was undoubtedly covered. As was the case with the coffins of the other kings, a replacement was sought that roughly corresponded to the era in which the ruler lived. (S.E.)

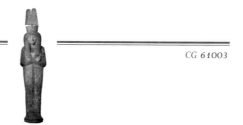

CG 61003

COFFIN OF AHMOSE NEFERTARI

WOOD AND LINEN; HEIGHT 378 CM
WESTERN THEBES, DEIR EL-BAHRI CACHE (TT 320)
ANTIQUITIES SERVICE EXCAVATIONS (1881)
EIGHTEENTH DYNASTY, REIGN OF AHMOSE (1550–1525 BC)
RESTORED DURING TWENTY-FIRST DYNASTY (1070–945 BC)

Ahmose Nefertari, wife of Ahmose and mother of Amenhotep I, was one of the most important figures of her age. She was the first queen to hold the priestly position of Divine Bride and on the death of her husband she acceded to the throne as regent to her son who was still too young to rule. Because of her numerous contributions to the development of the Theban cemeteries and temples, and thanks to her dedication to the reorganization of Egyptian religion, Ahmose Nefertari was the object of devotions from the beginning of the first millennium BC in the Theban region, above all in the workers' village of Deir el-Medina. Her effigy appears in numerous tombs at the site, while her own tomb was probably located in the hills of Dra Abu el-Naga.

The queen's coffin is mummiform and of particularly impressive dimensions. It was transferred to the tomb of Pinnudjem II, with many other royal coffins during the Twenty-first Dynasty.

The deceased is depicted on the lid of the coffin with her arms crossed over her breast. She is wearing a wig decorated with small hollows set in parallel bands, surmounted by a slightly flared cylindrical crown from which two plumes rise. The surfaces of the crown and feathers are also decorated with small hollows.

The eyes are painted in black and white. The strongly arched eyebrows confer a melancholy expression on the face, partially offset by the lips set in a slight smile. A necklace composed of five strands of beads is set around the neck, ending with a row of drop-shaped beads. The shoulders and breast are covered with a tight shawl, which is slightly open at the front and decorated with a series of hollows. The shawl is also wrapped around the arms. The hands are closed to form fists and grip the symbol of life, the *ankh*. The wrists are decorated with bracelets.

A column of hieroglyphs incised down the middle of the lid runs from below the folded arms. It is an offering verse and among other things it asks for 'the sweet breath of the North wind' for the deceased.

The hollows of the lid are filled with blue stucco and the remaining surfaces were originally covered with gold leaf but this was completely stripped by thieves in antiquity. During the restoration of the coffin in the Twenty-first Dynasty, the missing gold was replaced by a coat of ochre paint to evoke the ancient gilding.

The poorly preserved mummy of a woman was found within the coffin (but cannot be identified as Ahmose Nefertari with absolute certainty) as well as the mummy of Ramesses III placed in a red-painted cartonnage container. (S.E.)

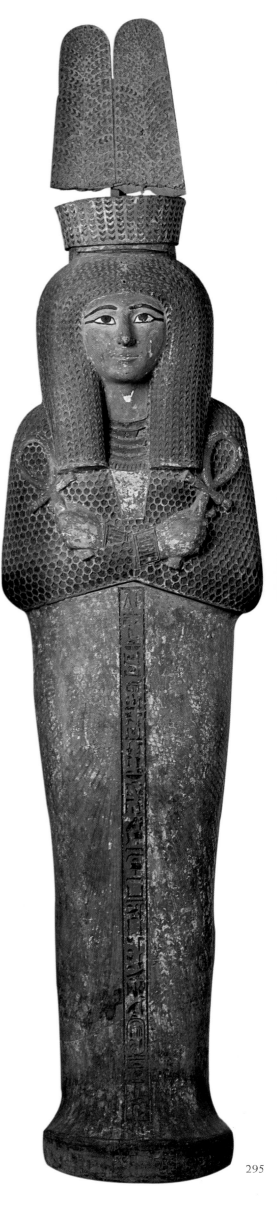

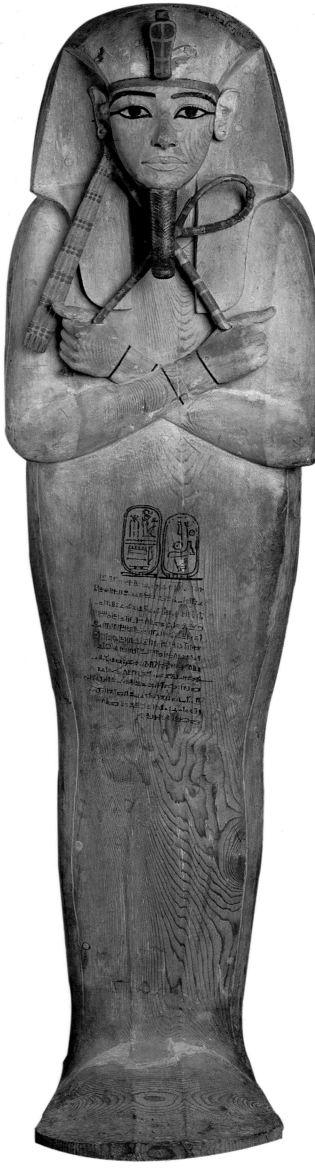

JE 26214 = CG 61020

LID OF THE COFFIN OF RAMESSES II

......................................

PAINTED WOOD; HEIGHT 206 CM
WESTERN THEBES, DEIR EL-BAHRI CACHE (TT 320)
ANTIQUITIES SERVICE EXCAVATIONS (1881)
NINETEENTH DYNASTY, REIGN OF RAMESSES II (1290–1224 BC)

The Deir el-Bahri Cache was discovered amid the cliffs to the south of Queen Hatshepsut's temple. It consists of a simple gallery excavated in the rock and accessed via a shaft with no particular superstructure. It has now been shown that it originally was the tomb of Pinnudjem II. It was chosen by the priests of Amun to serve as a hiding place for the remains of all the most celebrated New Kingdom rulers. They perhaps believed that by using an externally anonymous tomb, the royal mummies would be safe from the continuous and systematic raiding to which the Theban cemeteries had been subjected ever since the end of the New Kingdom.

Prior to being transported to their final resting place, Ramesses II's remains were hidden in the tomb of his father Seti I, considered to be more secure. Their definitive transfer was decided on once this tomb too was raided. The vicissitudes and travels of the mortal remains of Ramesses II can be read in the hieratic inscription traced on the lid of the coffin that finally contained them. The text with the accounts of the various movements is set below two cartouches with the names of the celebrated king, probably inscribed to identify the mummy contained in the coffin.

The question of whether this coffin was in fact originally made for Ramesses II has yet to be resolved. For a sovereign who had reigned over Egypt for sixty-seven years, building more than any other pharaoh before or after him, it would be reasonable to expect a solid gold coffin such as that found in the tomb of Tutankhamun. Instead, the one containing the mummy of Ramesses II is made of pieces of fine wood held together with a system of mortise and tenon joints. In the past it was presumed that the coffin would originally have been covered with a layer of gesso and beaten gold-leaf, subsequently removed by the violators of the king's tomb. This, however, appears improbable given that the current condition of the coffin suggests that it is an

unfinished piece rather than one stripped as the result of a robbery. There are in fact none of the classic signs of damage one would expect had the gold covering been removed by force.

The simple, painted facial features, realized in a style that can be ascribed to the artistic period immediately following the reign of Akhenaten, also serve to increase the doubts over a primary attribution of the coffin to Ramesses II, and some have suggested Ramesses I as the original owner. On the basis of the limited information available, the question cannot be satisfactorily answered.

What is possible is that during one of the transfers the mummy of Ramesses II could have been placed in the coffin of another individual, probably also a king, as shown by the presence of the cobra, false beard, and the flail and sceptre. (F.T.)

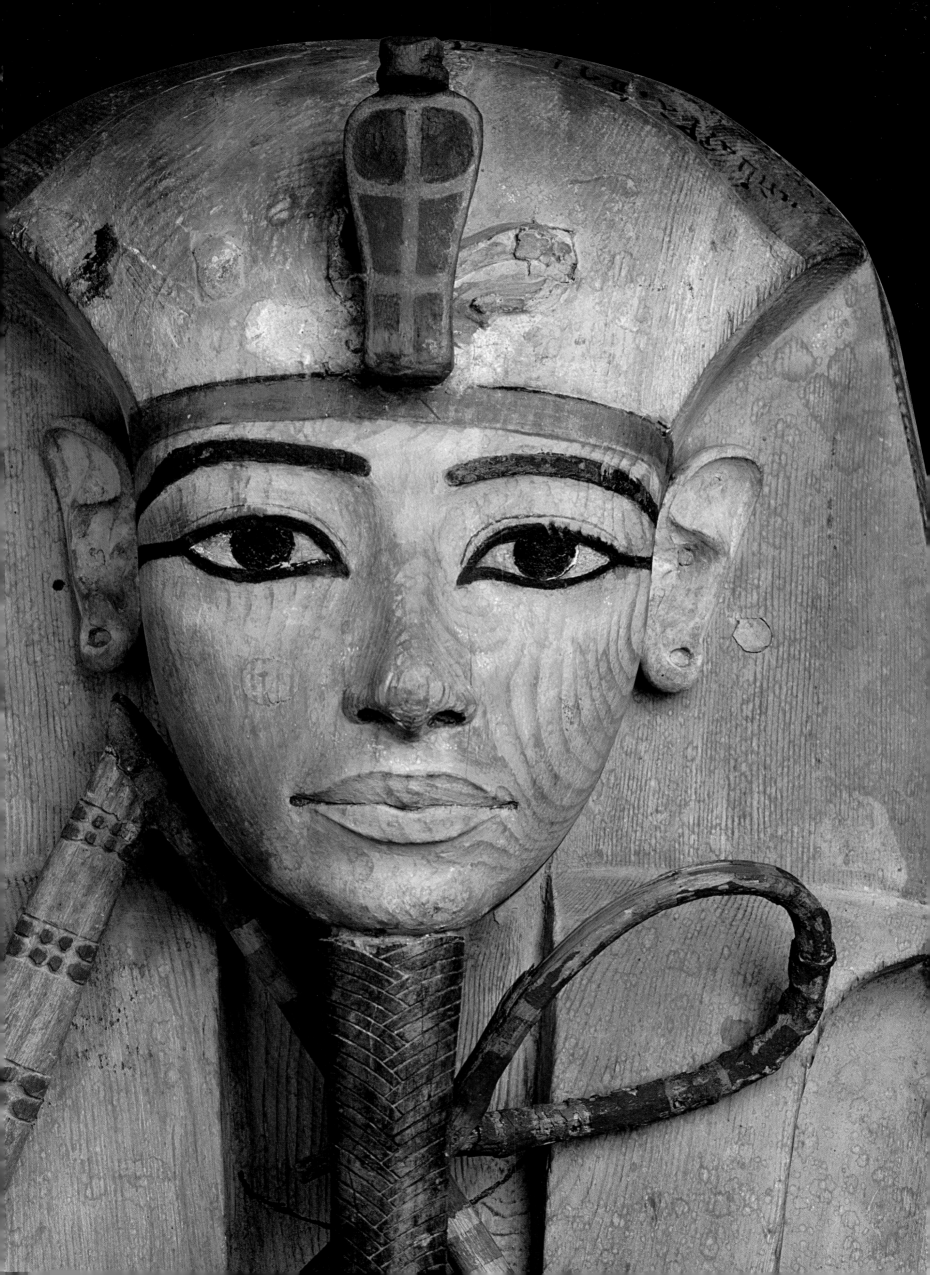

MIRROR WITH CASE

CASE: SYCAMORE WOOD AND IVORY; LENGTH 28 CM
MIRROR: BRONZE; LENGTH 12.5 CM; WIDTH 11 CM
WESTERN THEBES, DEIR EL-BAHRI CACHE (TT 320)
ANTIQUITIES SERVICE EXCAVATIONS (1881)
EIGHTEENTH DYNASTY (1391–1353 BC) AND TWENTY-FIRST DYNASTY
REIGN OF PINUDJEM I (C. 1065–1045 BC)

According to the *Journal d'Entrée* of the Egyptian Museum, this case and mirror were found lying on the breast of the mummy of Queen Henuttawy, wife of the high priest of Amun and pharaoh Pinudjem I, who had been buried along with the most celebrated rulers of the New Kingdom in the Deir el-Bahri Cache.

In Egypt, as in most of the ancient world, mirrors were made of metal with wooden handles. The carefully polished reflecting surfaces were very delicate and thus needed to be protected with special pouches, usually made of leather or vegetable fibres. From the New Kingdom onwards, richly decorated cases in wood began to be used.

The inside of the example belonging to Queen Henuttawy is covered with bitumen and the outside of the lid is inlaid with ivory. It features elegant decoration enclosed within a geometric motif running around the edges. The central section is occupied by the standing figure of a young girl. In her left hand she is holding a festoon of flowers that appears to sprout in front of her feet. Her right arm is raised and a papyrus plant rests on the open palm of her hand. The girl wears a short wig, held by a broad band from which a braid emerges at the side. A number of lotus flowers rest on her head. Apart from her jewels, the girl is naked.

Below the girl's feet is a frame with a stylized reed bed: on either side of a thin vertical strip in the centre, which may be interpreted as a watercourse, two ducks face each other, beating their wings in a play of symmetry suggesting reflections on water. At either end of this strip are bunches of papyri. The decoration on the circular part of the lid also features a stylized swamp scene. A papyrus plant occupies the centre while two nests and two ducks are symmetrically arranged either side. Two lotus flowers sprout from the lunettes on either side of the head of the girl.

A knob on the cover allows it to be opened horizontally around a pivot. Inside the case was a mirror lacking its handle.

The girl's delicate facial features and her jewelry closely resemble many works from the reign of Amenhotep III and this attractive case can perhaps be dated to this period. It would then have come into the possession of Henuttawy at a later date and accompanied the queen to her final resting place. (F.T.)

COFFIN OF MAATKARE

PAINTED CEDAR WOOD AND ACACIA WOOD AND GOLD LEAF
LENGTH 223 CM
WESTERN THEBES, DEIR EL-BAHRI CACHE (TT 320)
ANTIQUITIES SERVICE EXCAVATIONS (1881)
TWENTY-FIRST DYNASTY, REIGN OF PINUDJEM I (C. 1065–1045 BC)

Among the dozens of coffins found within the first Deir al-Bahri Cache was this example belonging to Maatkare, who was possibly the daughter of the high priest of Amun, Pinudjem I, and Queen Henuttawy, and held the title of Divine Adoratrice of the god Amun; she was also God's Wife of Amun.

The coffin is of the mummiform type and is particularly large and massive as it was designed to contain a second coffin, within which the mummy of the deceased was placed, covered with a mummiform wooden panel, in accordance with a custom known from the Ramesside period onwards.

The face has rather refined features and is framed by a rich blue wig furrowed by thin undulating incisions imitating hair, with its tips covered in gold leaf. Much of the wig is covered by the image of a vulture whose wings, extending on either side of the face, end on at the level of the neck with cobras wearing the White Crown of Upper Egypt.

The feathers of the bird are outlined by gold lines and are coloured blue, red or gold. The head of the vulture is now missing but would originally have been executed in gold or gilded wood, fixed to the forehead, and flanked by two cobras. The wig is held in place by a broad band decorated with a cobra painted red and blue. The face and the neck are covered with gold leaf; the almond-shaped eyes have eyebrows and outlines painted in blue while the iris is black.

A twin necklace is placed on the breast. The first part, depicted between the braids of the wig, alternates red and light blue bands and terminates with a row of drop-beads, below which there is a winged scarab. The second necklace is wider and is composed of strands of stylized floral garlands.

The arms are sculpted in relief and are folded. The hands, of which only the left remains, were gilded and perhaps gripped *ankh* symbols, of which the lower section remains in the left fist. The wrists are embellished by two wide bracelets while the elbows are decorated with lotus flowers. On each forearm is another winged scarab with the solar disc between its front legs, while the upper arms carry the image of a falcon with outspread wings on the symbol of gold.

A pectoral in the form of a shrine, with a scarab gripping the solar disc between its front legs set between two seated falcon-headed divinities, is painted below the arms, as if emerging from below the two necklaces. On either side of the pectoral is the god Re, seated on a throne and wearing the *atef* crown. Maatkare is represented with a cobra on her forehead in the act of paying homage to the god, protected by the open wings of the goddess Isis.

A large vulture with outspread wings is depicted on the abdomen. Below is a double column of hieroglyphs containing the names and titles of the deceased. These columns are intersected by three bands of inscriptions on either side that continue on to the sides of the lower casket.

In the panels delimited by the inscriptions are various scenes showing Maatkare in the act of presenting offerings to various deities. Above the feet, the coffin lid is covered with images of two falcons in flight, flanked by two

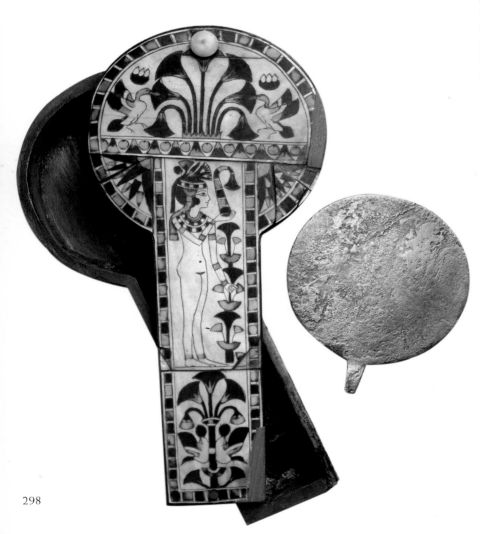

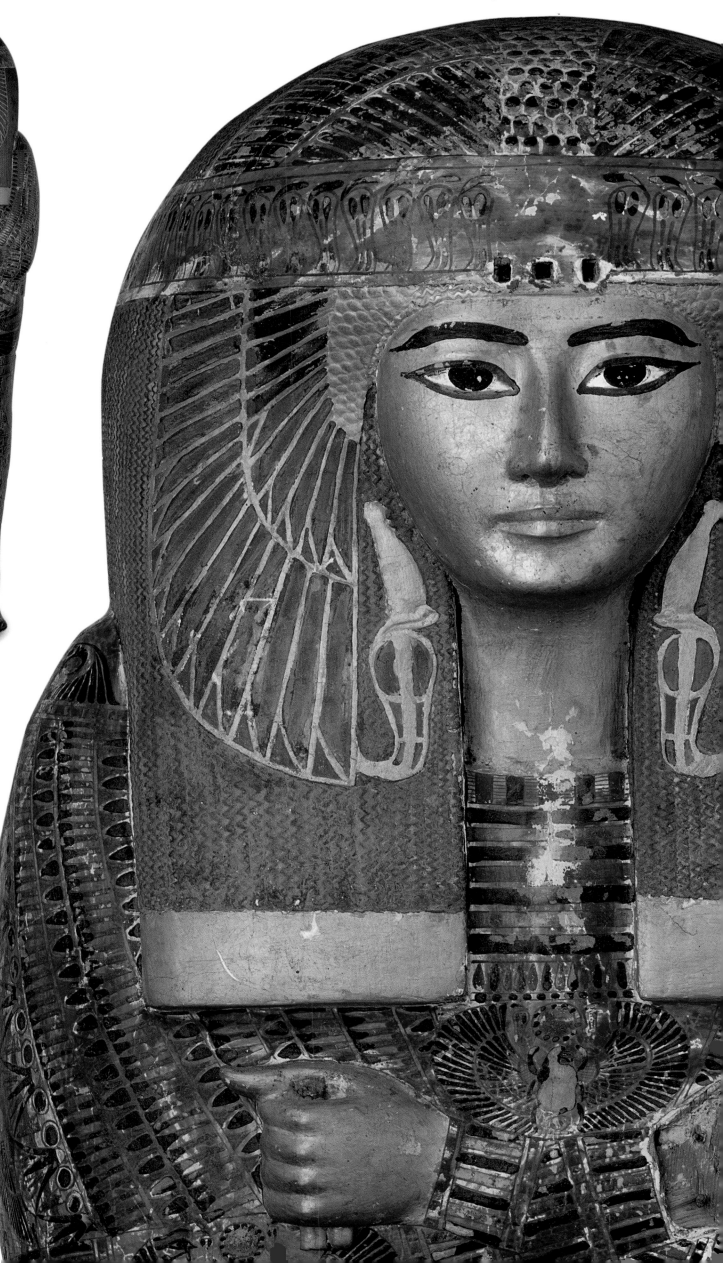

jackals symbolizing the god Anubis resting on a small shrine. On the lower edge of the lid, corresponding to the position of the feet, there is a dual inscription containing the usual offering verse.

Like the lid, the underlying casket is richly decorated. Behind the head is an image of the winged goddess Isis kneeling on the symbol for gold with her arms raised. Images of the jackal god Anubis are depicted below the wings of the goddess. Along the upper edges of the sides runs a long line of hieroglyphs, above scenes depicting the Four Sons of Horus, Thoth and the *djed* pillar, a symbol of duration and stability, separated from one another by double columns of text. The *djed* pillar is again depicted below the feet, flanked by the Knot of Isis, which had an apotropaic value.

The internal floor of the casket is occupied by a large image of the *djed* pillar which has human arms gripping two flails and set above a shrine surmounted by a frame and equipped with a door. The internal walls are not decorated but covered with a uniform coat of brick-red paint.(S.E.)

CATAFALQUE COVER OF ASETEMAKHBYT

PAINTED LEATHER; HEIGHT 195 CM; LENGTH 272 CM; WIDTH 240 CM
WESTERN THEBES, DEIR EL-BAHRI CACHE (TT 320)
ANTIQUITIES SERVICE EXCAVATIONS (1881)
TWENTY-FIRST DYNASTY, REIGN OF PINUDJEM I (C. 1065–1045 BC)

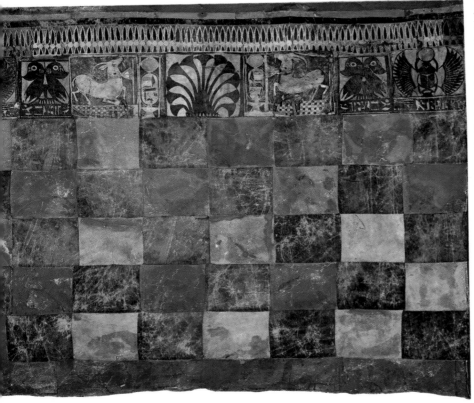

The Deir el-Bahri Cache, hiding place for the coffins and mummies of kings, high priests and members of their families who lived between the Seventeenth and Twenty-first Dynasties, was discovered and secretly robbed by the inhabitants of the local village in 1875. Only in 1881, following lengthy investigations, did the Antiquities Service succeed in locating the tomb and salvaging the important heritage contained within it. During the emptying of the tomb a roughly rolled leather bundle was found at the beginning of a corridor, apparently thrown there shortly before the entrance was finally sealed.

When the roll was opened it was found to be the drapery that covered the catafalque below which the coffin of Asetemakhbyt was placed during the funeral ceremony. Its use is documented in tomb paintings and wooden models depicting funeral processions, in which the coffin is surmounted by a light wooden superstructure covered with a cloth while it is being transported to the tomb.

The central part of the drapery that acts as the roof of the catafalque is decorated to represent the night sky, overlooked by images of the vulture goddess with outspread wings. This part of the drapery is attached to four curtains composed of pieces of leather sewn together to form the sides of the canopy. The top of each curtain is decorated with a characteristic motif of *khekeru* symbols. Immediately below this motif is a frieze of square panels within which are depicted in succession (in pierced and painted leather) a winged scarab gripping the solar disc in its front legs, two papyri, and an antelope kneeling on a *neb* symbol. The lower part of each curtain features a green and red chequer-board motif.

The hieroglyphic inscriptions record the titles of the high priest of Amun Masaharte, the cartouche of his father, Pinudjem I, and the name and titles of the proprietor of the catafalque, Asetemakhbyt. The latter was the superintendent of the harem of Min, Horus and Isis at Ipu (Akhmin) and is said to have been the daughter of a high priest of Amun. The name Asetemakhbyt was fairly common in the Twenty-first Dynasty. According to a number of recent theories based on the similarity of the title, the owner of the catafalque can be identified as a daughter of the high priest of Amun Menkheperre. Pinudjem I, during whose reign Asetemakhbyt would have lived, would therefore have been her grandfather and Masaharte her uncle.

The names of the two important figures would have appeared as evidence of the elevated position of the woman's family. The texts also contain propitiatory phrases requesting that the deceased laid below the drapery be allowed to rest in peace after her death. (S.E.)

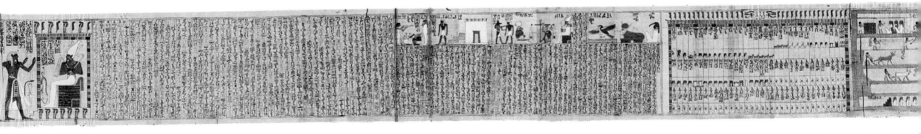

THE BOOK OF THE DEAD OF PINUDJEM I

PAPYRUS; HEIGHT 37 CM; LENGTH 450 CM
WESTERN THEBES, DEIR EL-BAHRI CACHE (TT 320)
ANTIQUITIES SERVICE EXCAVATIONS (1881)
TWENTY-FIRST DYNASTY, REIGN OF PINUDJEM I (C. 1065–1045 BC)

Among the bodies found in the Deir el-Bahri Cache was that of Pinudjem I, high priest of Amun, who had assumed the titles and privileges of a true pharaoh during the second half of his pontificate. His partially bandaged mummy was placed in a coffin usurped from Thutmose I. Between his legs was placed a papyrus scroll on which a number of chapters of the Book of the Dead were painted in the attractive cursive hieroglyphs used for the drafting of funerary texts.

In a period as difficult as the Twenty-first Dynasty, even those figures with great financial resources such as Pinudjem I found it impossible to prepare decorated tombs for their burial. The

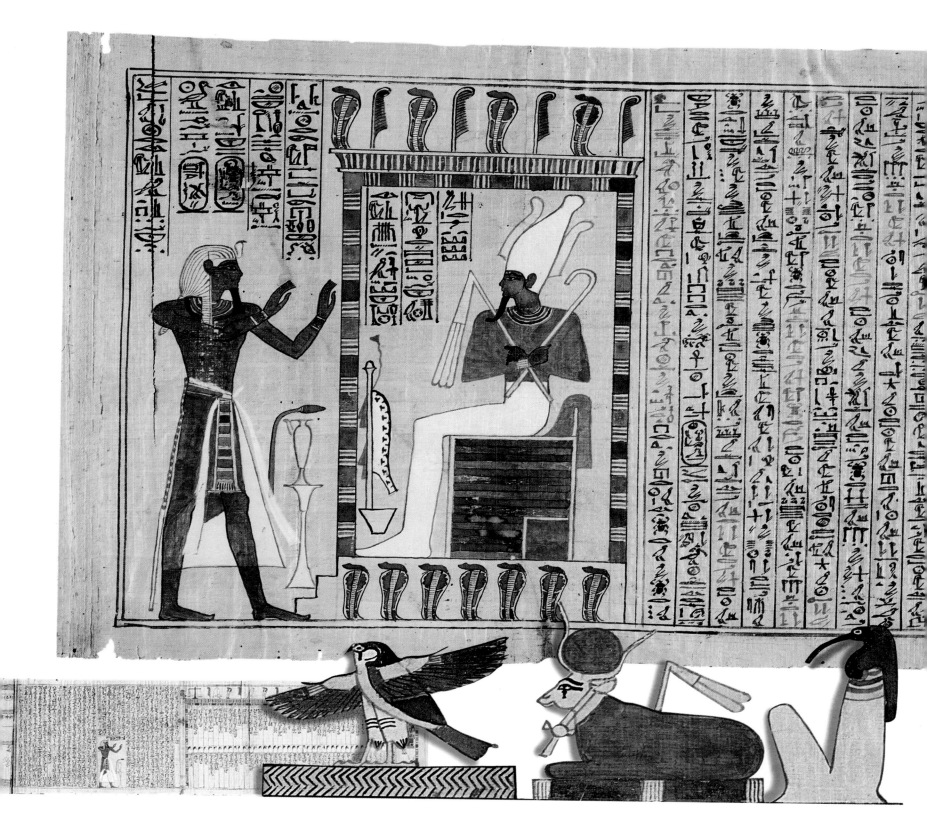

illustrations that once enriched the walls of the complex underground chambers of the New Kingdom were therefore transferred to the funerary papyri which accompanied the deceased on their journey to the spirit world. The most frequent were the Book of Amduat, which described the Underworld and derived from royal funerary traditions, and the Book of the Dead, which instead contained an extremely varied repertory of texts that in some cases were compiled during the Old Kingdom.

Between the end of the Twenty-first and the beginning of the Twenty-second dynasties, the Book of the Amduat and the Book of the Dead were condensed into a single funerary compilation with hybrid contents.

The Book of the Dead of Pinudjem I is closer to the New Kingdom tradition than subsequent ones. This is demonstrated by the use of cursive rather than hieratic hieroglyphs. The text is decorated with magnificent illustrations painted in a sober, delicate style that recalls the wall paintings of the tombs of the kings who ruled between the Eighteenth and Nineteenth Dynasties.

The papyrus opens with an introductory scene in which the deceased, with his hands raised in front of his face, is presenting himself before the King of the Dead, Osiris, seated within a shrine. Behind the deity begins the sequence of chapters taken from the Book of the Dead. The opening passage is Chapter 23, followed by Chapters 72, 27, 30, 71 and 141 (or 143).

There follows the illustration relating to Chapter 110, in which are depicted the Fields of Iaru, reached by the deceased once he or she had entered the Underworld. The landscape is very close to how Egypt must once have appeared: a series of canals defines plots of land where the deceased is portrayed in various agricultural activities.

The papyrus concludes with Chapter 125 of the Book of the Dead in which the judgment of the soul is described. In this text the deceased, after having invoked Osiris and the forty-two gods of the divine court, declares that he or she has committed no sin and thus succeeds in obtaining eternal life. The accompanying illustration displays the most significant aspects of the Divine Judgment. Inside a hall, overarched by a roof decorated with a cavetto cornice, are seated the forty-two judges facing two seated female deities: Maat (Justice) at the top and Maaty (Double Justice) below. At either end above the roof are depicted scales with a baboon (the god Thoth) seated alongside. Placed almost centrally, between two *wedjat* eyes, is a kneeling male figure extending his hands towards the outside. The remaining space is occupied by a series of alternating symbols: the cobra, the feather of justice and the hieroglyph signifying fire. This last is a reminder of the sad fate which awaits those who fail to achieve eternal life: they are condemned to burn in the Lake of Flames. (F.T.)

The Egyptian Museum in Cairo created a special section for the conservation and display of the collection of precious jewels and gold known as the Treasure of Tanis. The splendour of the Tanis masterpieces inspires comparison with the treasures of Tutankhamun. In both cases the caches came from the almost inviolate tombs of pharaohs, and thus allow us to compare the ways in which the Egyptians of two different eras – the 'golden age' of the New Kingdom and the Twenty-first Dynasty – provided for the eternal rest of their divine kings. In terms of technical and sculptural quality, the gold and silver vessels and jewelry from the burials of Psusennes I, Amenemope, and the general Undjebauendjed (Tomb II) are the equal of the funerary furnishings of Tutankhamun. In terms of quantity, however, the contents of these Tanis tombs from the Twenty-first Dynasty are meagre, even if we add together the caches of King Sheshonq and two other mummies housed in the antechamber of Psusennes – of kings Takelot I and Osorkon II – along with the cache of prince Hornakht, which escaped the sacking of the tomb of Osorkon III (Tomb I) in antiquity.

302 ABOVE
BOWL OF PSUSENNES I
JE 85897
GOLD; HEIGHT 3 CM
DIAMETER 16 CM
TANIS, TOMB OF PSUSENNES I; PIERRE MONTET'S EXCAVATIONS (1940)
TWENTY-FIRST DYNASTY
REIGN OF PSUSENNES I (1040–992 BC)

302 BELOW
BASIN OF PSUSENNES I
JE 85893
GOLD
HEIGHT 17 CM
DIAMETER OF RIM 20.9 CM
TANIS, TOMB OF PSUSENNES I; PIERRE MONTET'S EXCAVATIONS (1940)
TWENTY-FIRST DYNASTY
REIGN OF PSUSENNES I (1040–992 BC)

303 OPPOSITE LEFT
ISIS PENDANT
JE 87716
GOLD; STATUETTE: HEIGHT 11 CM; WIDTH 2.2 CM
CHAIN: LENGTH 82 CM
TANIS, TOMB OF PSUSENNES I; PIERRE MONTET'S EXCAVATIONS (1946)
TWENTY-FIRST DYNASTY
REIGN OF PSUSENNES I (1040–992 BC)

303
SARCOPHAGUS OF PSUSENNES I
JE 85911
BLACK GRANITE
LENGTH 220 CM, WIDTH 65 CM; HEIGHT 80 CM
TANIS, TOMB OF PSUSENNES I; PIERRE MONTET'S EXCAVATIONS (1940)
TWENTY-FIRST DYNASTY
REIGN OF PSUSENNES I (1040–992 BC)

JEAN YOYOTTE

THE TREASURE OF TANIS

302 ABOVE
OBELISK OF RAMESSES II
JE 37474 = CG 17021
PINK GRANITE
CURRENT HEIGHT 325 CM
TANIS; AUGUSTE MARIETTE'S EXCAVATIONS (1860)
NINETEENTH DYNASTY
REIGN OF RAMESSES II (1290–1224 BC)

The Egypt of the Third Intermediate Period, withdrawn inside its natural frontiers, no longer possessed the wealth it had enjoyed during the New Kingdom, when the Eighteenth Dynasty pharaohs dominated an empire that extended from Syria in the northeast to the Nile's fourth cataract in the south. Tutankhamun's funerary assemblage included a wealth of large, luxurious ritual objects as well as tools associated with the everyday lives of the living. By contrast, during the Twenty-first Dynasty, the tendency was to eliminate everyday objects of this kind from the grave goods of the deceased and to restrict the funerary trappings to the magical amulets that transformed the dead into Osiris. Nevertheless, the unexpected discovery at Tanis of a small cemetery that contained the tombs of a number of pharaohs – some relocated, many inviolate – was still an extraordinary event.

The mummies of the pharaohs of the glorious New Kingdom period, with the exception of that of Tutankhamun, had suffered badly from robbers, and were

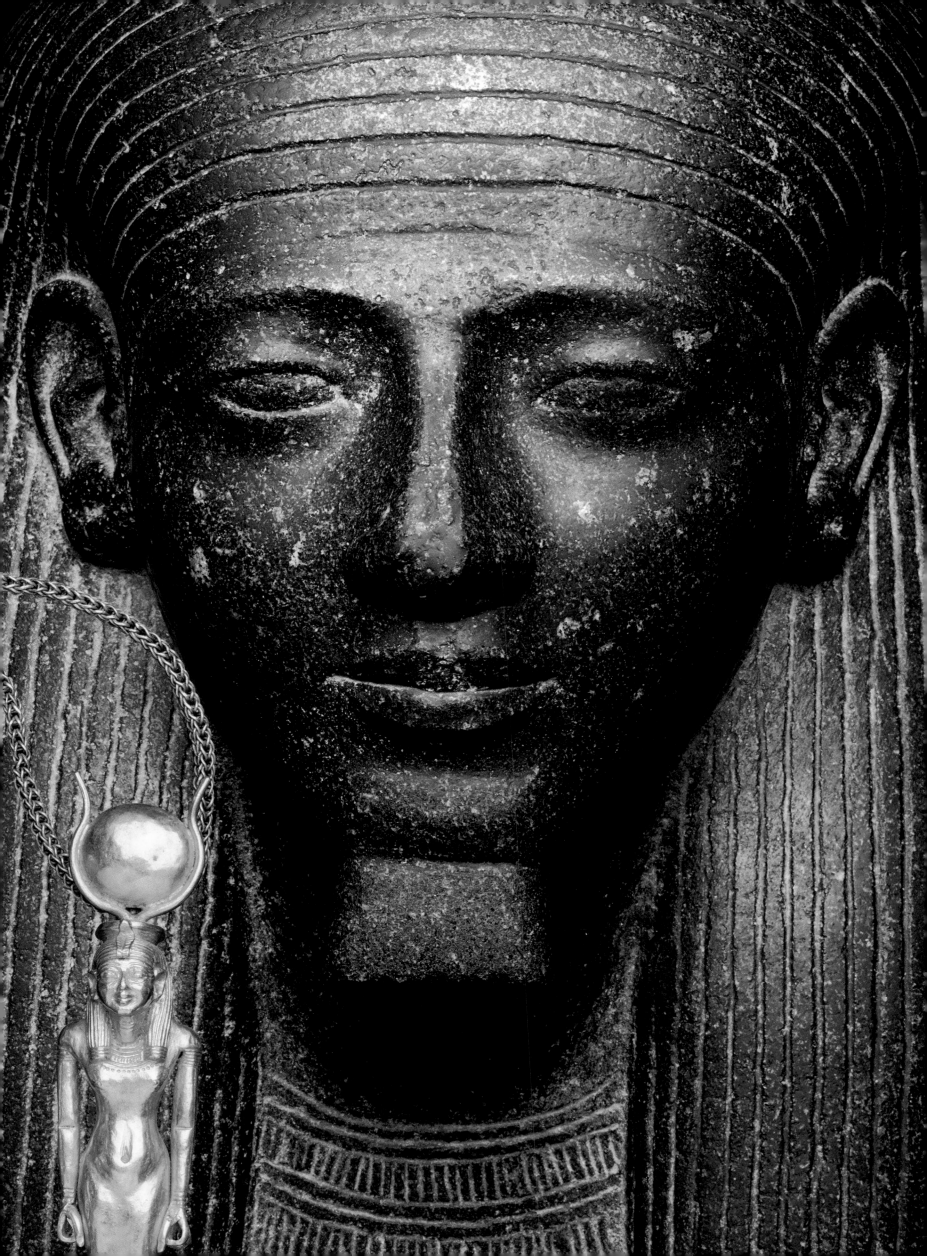

stripped of their treasures. After such pillage, the great priestly families of Thebes moved them to new resting places for safekeeping at Deir al-Bahri. The priests and relocated mummies had very meagre funerary caches. In contrast, the gold and silver treasures of the Tanis kings, the priests' contemporaries, have been handed down to us intact.

The jewelry and vessels of Psusennes have survived the passage of three millennia, escaping discovery that would certainly have resulted in the pieces being melted down, or in more recent times, being dispersed to antiquities dealers. The excavation of Tanis is an all but miraculous example of salvage and conservation, helping provide an answer to the question most frequently posed by the general public: can we still hope to discover rich and intact royal tombs in Egypt? It has to be said that this hope is faint and difficult to quantify, such has been the devastation perpetrated during and since antiquity. Yet the chambers of the tomb of Psusennes I fortunately escaped both destruction and sacking. The neighbouring tomb of Osorkon II also escaped destruction although it was raided by thieves.

Psusennes founded a temple dedicated to the god Amun-Re within a huge mud-brick enclosure wall. At the southwest corner of this temple, he constructed his tomb. Many of his successors had their own tombs built close to his. The temple of Amun, built and furnished with stone and statues brought from Pi-Rameses, the abandoned residence constructed by Ramesses II, was extended and remodelled on a number of occasions by successive dynasties. The result was that nothing remained at ground level of the original Twenty-first Dynasty buildings. Only the underground royal tombs survived. However, not even the tombs themselves were left unscathed.

The history of the construction and destruction of the royal funerary quarter is extremely complicated, as the painstaking excavations and analysis conducted by

Philippe Brissaud have demonstrated. The sandy soil of this area, that covers about 60 x 40 metres, was dug up on more than one occasion to construct new underground chambers, to enlarge and revise the existing tombs, or to dismantle some of them. The access shafts to at least two tombs were covered to create hiding places for further mummies. Small underground chambers (VI and VII) built after the Twenty-first Dynasty were found to have been violated and destroyed. Tomb IV, initially built for Amenemope,

contained nothing but a beautiful sarcophagus with an inscription recording the name of the king. The body and the funerary cache were actually found in chamber 2 of Tomb III, belonging to Psusennes I.

This tomb is a large limestone structure containing two twin chambers (1 and 2) built of granite and destined for the king and his queen Mutnodjmet. There is also an antechamber in limestone, to which a chamber (3) had been added to house the body of a prince, although it apparently

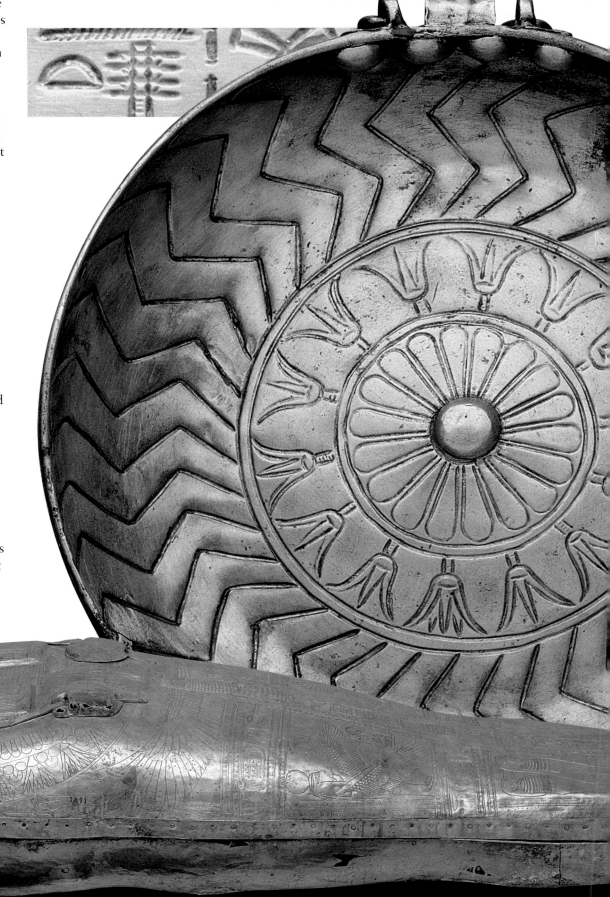

304 CENTRE
CUP OF UNDJEBAUENDJED
JE 87743
SILVER
DIAMETER 16.5 CM
TANIS, TOMB OF PSUSENNES
I; BURIAL CHAMBER OF
UNDJEBAUENDJED
PIERRE MONTET'S
EXCAVATIONS (1946)
TWENTY-FIRST DYNASTY
REIGN OF PSUSENNES I
(1040–992 BC)

304 OPPOSITE BELOW
COFFIN OF SHESHONQ II
JE 72154
SILVER
LENGTH 190 CM
TANIS, TOMB OF PSUSENNES
I; BURIAL CHAMBER OF
SHESHONQ II
PIERRE MONTET'S
EXCAVATIONS (1940)
TWENTY-SECOND DYNASTY
REIGN OF SHESHONQ II
(C. 883 BC)

305
CONTAINER FOR
INTERNAL ORGANS
JE 72159
SILVER
HEIGHT 25 CM
TANIS, TOMB OF PSUSENNES
I; BURIAL CHAMBER OF
SHESHONQ II
PIERRE MONTET'S
EXCAVATIONS (1940)
TWENTY-SECOND DYNASTY
REIGN OF SHESHONQ II
(C. 883 BC)

remained unoccupied. A fourth blind chamber contained the sarcophagus of the general Undjebauendjed. Early in the Twenty-first Dynasty, a similar tomb (I) was prepared parallel and to the south of that of Psusennes I and comprised a large underground chamber in granite with a vestibule created in limestone casing. The name of the founder and owner of this tomb is not known and only tentative suggestions can be put forward.

On the other hand, we are sure that Osorkon II, a king from the middle of the Twenty-second Dynasty, usurped Tomb I for himself, revising the vestibule in such a way that it could house the remains of his father, Takelot I, and creating a new entrance to the underground chambers. Subsequently the granite chamber occupied by Osorkon II was enlarged to accept the sarcophagus of his son, the high priest of Amun, Hornakht. At an undefined date, a large complementary and roughly built tomb (Tomb II) was built alongside the south wall of the tomb of Osorkon.

Pharaoh Sheshonq III built his own tomb (V) in the southwest corner of the necropolis, but also made changes to the interior of the limestone structure of Osorkon II. It was during his reign that the funerary complex was covered with a superstructure in brick. It is thus difficult to know what the chapels of the Twenty-first Dynasty king actually looked like as all we have left are a few sculpted fragments, reused or discarded in this sector of the site.

Similarly, it is also difficult to judge when during the course of the Twenty-second Dynasty the tombs were opened in order to change the resting places of kings and princes. The silver coffin and canopic jars of a hitherto unknown Twenty-second Dynasty ruler *Hekakheperre* (probably Sheshonq II) were moved into the antechamber of the tomb of Psusennes I,

306 LEFT AND RIGHT
BRACELETS OF PSUSENNES I
JE 86027 - 86028
GOLD, LAPIS LAZULI,
CARNELIAN, GREEN
FELDSPAR
HEIGHT 7 CM
MAXIMUM DIAMETER 8 CM
TANIS, TOMB OF PSUSENNES
I; PIERRE MONTET'S
EXCAVATIONS (1940)
TWENTY-FIRST DYNASTY
REIGN OF PSUSENNES I
(1040–992 BC)

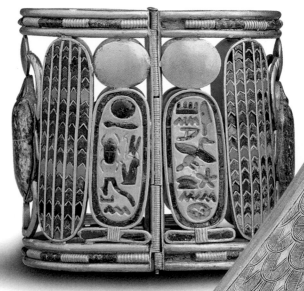

as were the bodies of two kings virtually stripped of their funerary equipment who have been identified as Siamun and Psusennes II of the Twenty-first Dynasty. Perhaps during the era of Sheshonq III an enormous sarcophagus was inserted in the central chamber in the tomb of Osorkon II. The royal casket in the granite chamber had once contained three mummies, including Prince Hornakht. As far as the anonymous Tomb II is concerned, it is probable that it eventually housed the remains of the pharaoh Pami, successor to Sheshonq III.

With all these mummy relocations and tomb appropriations, the royal burial sites of Tanis, with the exception of the tomb of Psusennes I, presented the archaeologists with a daunting spectacle of disorder that was difficult to interpret. A confused mass of objects from diverse

and clearly incomplete caches presented themselves. Some of the tombs had been usurped. For example, the remains of Psusennes' wife Mutnodjmet were replaced by those of Amenemope. Other hurried relocations were completed for reasons of security, like the transfers made in the cemeteries of Thebes during periods of uncertainty and violence towards the end of the Twentieth and Twenty-first dynasties. The coffins, if not the mummies, of the deceased dignitaries were grouped together in a few hiding places rather than left dispersed in individual tombs, even if this meant bringing only a small part of the funerary assemblage with the body.

Another cause of disorder and the gaps in the treasures of the Tanis kings and princes was the sacking of the tombs by thieves. Tombs II (Pami) and IV

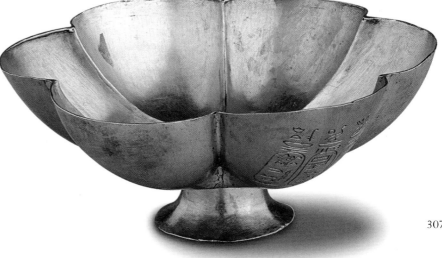

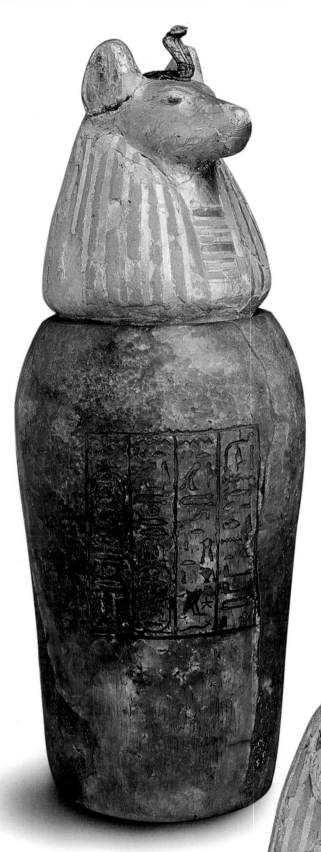

(Sheshonq III) were opened and stripped of their precious contents, with only the heaviest objects (sarcophagi, canopic shrines) being left in place. The tomb of Osorkon II appears to have been attacked at two points of its stone slab ceiling. After having recovered a gold amulet and canopic jars from ground in the area, Pierre Montet entered the tomb from the northeast corner (chamber 2) through the aperture made by the tomb raiders long before. Subsequently he was to discover the thieves' other point of entry in the southwest corner of the granite tomb (chamber 4). Here a large block of stone from the base wall that had been reconstructed following the interment of Hornakht had collapsed on the sarcophagus, making it impossible to lift the lid. The thieves therefore pierced the stone casket in the position of the deceased's chest and blindly removed all the jewels they could reach. The treasure of Hornakht thus survived almost intact.

The clues that allow the violations of the tomb to be dated are very tenuous. Until more information is available we are unable to say whether the raids took place shortly before the rebuilding work of Sheshonq III, during his long reign or after his death. Ground-level shrines in the area of this necropolis have disappeared and brick constructions of Sheshonq II have been razed and subsequently covered over

by the debris of later occupations: ruined buildings constructed in mud-brick and layers of domestic refuse accumulated from the Thirtieth Dynasty up to the Roman period.

After the almost total abandonment of the site in the eighth century AD, the mud-bricks used to build the neighbouring enclosure wall and the buildings around the necropolis decayed and were eroded, accumulating to form a thick covering of black earth. When Auguste Mariette had the temple of Tanis excavated in 1860–1861, his workers dumped a mountain of this same black mud on to the site of the tombs. To reach the royal tombs, the excavators had to remove a formidable quantity of earth, up to eight metres deep. The mysteries of Tanis were certainly well concealed.

On 27 February, 1939, during routine excavations of a group of later buildings along the south side of Psusennes' inner enclosure wall, Pierre Montet found the hole made by the tomb raiders. Struggling to explore the chambers of Tomb I with a small torch, he ordered the mountain of earth covering the area to be removed as quickly as possible. Subsequently, on 19 March, he was able to penetrate the granite tomb of Osorkon II and entered the antechamber of the tomb of Psusennes I on 20 March. Returning in 1940, Pierre Montet reached the sarcophagus of Hornakht. On 15 February he entered the intact burial chamber of Psusennes I and in April the chamber of Amenemope. The treasure of Sheshonq II was transported to the Egyptian Museum in Cairo in March 1939. Psusennes I's and Amenemope's were transferred in March and April of 1940.

The first discoveries were made in the winter of 1939, a time of international crisis that inevitably had an affect on the world of Egyptology and lessened the impact of the finds. The subsequent recovery of the treasure of Psusennes I passed almost unnoticed due to the war. In Cairo, the objects were stored in the cellars for safekeeping and were not exhibited to the public in a special hall until 1944. Returning to France at the same time as the Germans were crossing the Ardennes border, Professor Montet was separated from his discoveries but none the less began publishing his findings, thus making a considerable contribution to our knowledge of the Third Intermediate Period.

The discovery of these royal tombs in the north, a surprise for excavators searching at Tanis for the remains of

308
CANOPIC JARS
JE 85915 - 85914
CALCITE
JE 85915: HEIGHT 41 CM
JE 85914: HEIGHT 43 CM
TANIS, TOMB OF PSUSENNES I; PIERRE MONTET'S EXCAVATIONS (1940)
TWENTY-FIRST DYNASTY
REIGN OF PSUSENNES I
(1040–992 BC)

309 OPPOSITE LEFT
ANKLET OF PSUSENNES I
JE 85781
GOLD, LAPIS LAZULI, CARNELIAN
HEIGHT 5.5 CM
MAXIMUM EXTERNAL DIAMETER 6.6 CM
TANIS, TOMB OF PSUSENNES I; PIERRE MONTET'S EXCAVATIONS (1940)
TWENTY-FIRST DYNASTY
REIGN OF PSUSENNES I
(1040–992 BC)

309 RIGHT
PENDANT IN THE FORM OF SEKHMET
JE 87718
GOLD
HEIGHT 7.2 CM

TANIS, TOMB OF PSUSENNES I; PIERRE MONTET'S EXCAVATIONS (1946)
TWENTY-FIRST DYNASTY
REIGN OF PSUSENNES I
(1040–992 BC)

the Hyksos Avaris and the residence of kings of the Nineteenth and Twentieth Dynasties, Pi-Rameses, suddenly provided information on a complex, confused period that until then had only been known through the temples and cemeteries of Thebes. Inscriptions on gold vessels allowed the genealogy of the kings of the Twenty-first Dynasty to be established. The family and political relationships between the pharaohs of Tanis and the high priests who dominated Upper Egypt were also clarified.

The cache in the antechamber of Psusennes has a parallel in the famous royal cache of Deir el-Bahri, where earlier kings and the relatives of high priests had been placed for safekeeping during a long period of danger to both the living and the dead. It also revealed the relative poverty of the northern monarchy, which had brought the great sarcophagus of Merneptah from Thebes for the body of Psusennes I and reused canopic jars taken from the tombs of Qurna. On the other hand, significant wealth is evident in terms of the dynasty's gold and, above all, silver.

Valuable resources for historians, the treasures of Tanis are equally precious to those who appreciate beauty and fine craftsmanship. The quality of the vessels, necklaces, pectorals and amulets speaks for itself. It testifies to the endurance of the skills of the goldsmiths and jewelers beyond the great Ramesside Period and throughout a politically unstable period. To glorify the kings of Tanis, skilled craftsmen worked their trades, preserving and passing on the best traditions of sacred pharaonic art.

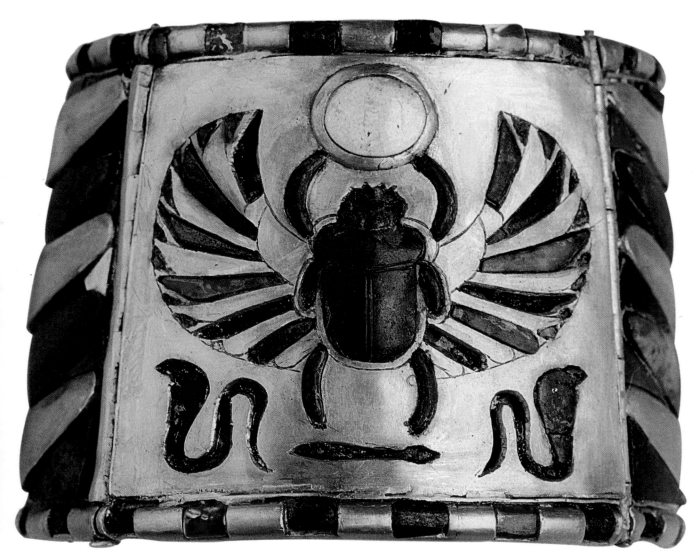

BIOGRAPHY

Jean Yoyotte, *a researcher at the Centre National de la Recherche Scientifique from 1948 to 1963 and then director of the École Pratique des Hautes Études from 1964 to 1992, long held the chair of Egyptology at the Collège de France of which he is now an Honorary Professor. An expert in the historical geography of Lower Egypt, he has conducted in-depth research into the most recent periods of pharaonic history. Between 1965 and 1985 he directed the French mission excavating at Tanis.*

SARCOPHAGUS OF MERNEPTAH
REUSED BY PSUSENNES I

PINK GRANITE
LENGTH 240 CM; WIDTH 120 CM; HEIGHT 89 CM; TANIS, TOMB OF PSUSENNES I
BURIAL CHAMBER OF PSUSENNES I; P. MONTET'S EXCAVATIONS (1940)
NINETEENTH DYNASTY, REIGN OF MERNEPTAH (1214–1204 BC)
AND TWENTY-FIRST DYNASTY, REIGN OF PSUSENNES I (1040–992 BC)

This impressive sarcophagus was found in the burial chamber of the tomb of Psusennes I, constructed within the enclosure walls of the Great Temple of Tanis. The presence on the lid of a cartouche containing the name of Merneptah, the Nineteenth Dynasty pharaoh who was the son and successor of Ramesses II, shows that it was originally made for that king and subsequently reused for the burial of Psusennes I.

The cartouches of the old owner were chiselled away and replaced with those of the new occupant, but, by error or oversight, one was left intact. This fortunate accident means that we are able to identify the original owner of this sarcophagus before, like all the others found at Tanis, it was reused centuries later.

Within the external stone sarcophagus were two mummiform coffins, one in black basalt and the other made of silver. On the top of the lid of the sarcophagus is a large recumbent figure in high relief, representing the pharaoh in the guise of Osiris with the symbols of royalty: a sceptre and flail in his hands and a false beard. The interior carries a superb relief sculpture of the goddess Nut with her arms held upwards, dressed in a tight robe dotted with stars.

Around its upper rim the casket of the sarcophagus features a band with two lines of hieroglyphs. Below these inscriptions, on each side, appear figurative scenes populated with deities and demons and topped by brief captions containing their names.

On both of the short sides are two groups of three figures separated by the central depiction of a palace. At the foot end, from left to right, are a falcon-headed god, an ibis-headed god, a jackal, a human-form god armed with a knife, a jackal-headed god, and the god Horus in the form of a falcon. At the head end the figures, from left to right, are a falcon above a rectangular building, a figure with a human head armed with a knife, the god Horus with a falcon's head, a monkey carrying a bow, a

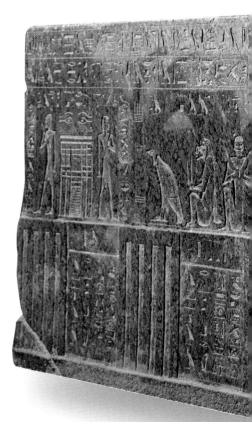

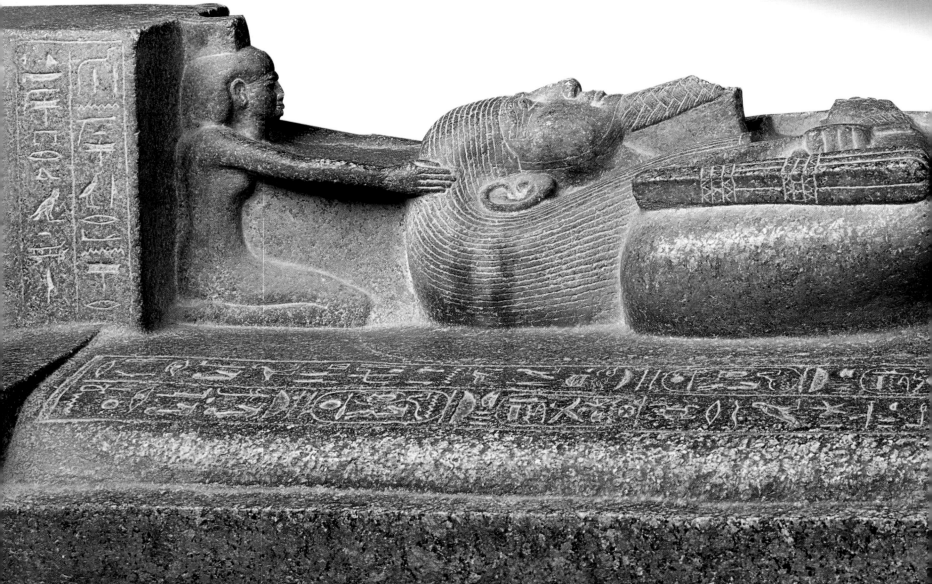

hippopotamus, and a second falcon above a rectangular building.

At one end of the right-hand side is a pair of eyes above the decorated façade of a building flanked by two guardian figures. An inscription refers to the privilege of seeing through them that was granted to the king. The rest of this side has ten figures with human or animal heads, punctuated by stylized depictions of three palaces.

On the left-hand side appear fifteen seated figures facing towards the right, with either human or animal heads. The figures are preceded by a palace and followed by a fish.

The lower section of all four sides of the casket is decorated with a panelling motif that recalls the ancient royal tombs. Within each of fifteen niches is engraved the name of a door followed by a four-column inscription.

The interior of the sarcophagus is also richly decorated. On both the long sides, below a horizontal line of hieroglyphs, appears a long and uninterrupted procession of divinities that continues on to the short sides. At the centre is an altar flanked by two columns of hieroglyphs. Jewels, arms, clothes and sandals are reproduced on the base of the casket. (S.E.)

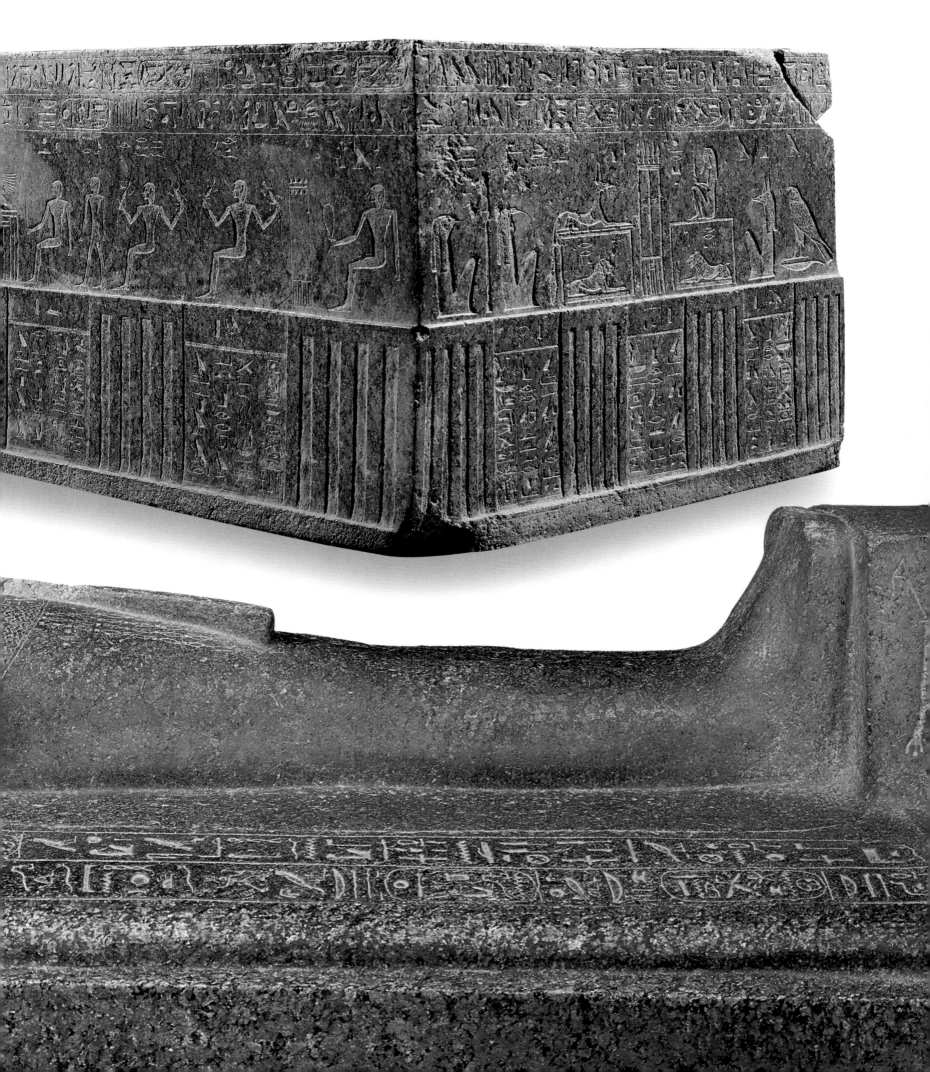

MUMMIFORM COFFIN OF PSUSENNES I

BLACK BASALT; LENGTH 220 CM; WIDTH 65 CM; HEIGHT 80 CM
TANIS, TOMB OF PSUSENNES I, BURIAL CHAMBER OF PSUSENNES I; P. MONTET'S
EXCAVATIONS (1940); NINETEENTH DYNASTY (1307–1196 BC) AND TWENTY-FIRST
DYNASTY, REIGN OF PSUSENNES I (1040–992 BC)

Within the pink granite sarcophagus that Montet discovered in the funerary chamber of Psusennes I, there was another, perfectly conserved mummiform casket in black basalt of extraordinary craftsmanship.

The lid is carved in the form of of the mummy of the deceased, who is shown with his arms folded. The face is framed by a massive striped wig that descends to the shoulders, revealing the ears. The facial features are elegant and rendered with extreme delicacy. The eyes are narrow and the eyelids are heavy. The nose is straight and the fleshy mouth is set in a slight smile. A short beard descends from the chin. Around the neck is a large pectoral, incised in imitation of multiple strands of beads. Bracelets are shown around the wrists and the hands are closed.

Over the abdomen is a delicate depiction of the goddess Nut, kneeling with her arms and wings outspread. From this point, a double column of hieroglyphs runs down the centre, reaching to the tips of the toes. Running parallel with the central inscription are two more columns of text, one on each side. These are crossed by three transverse columns of hieroglyphs that continue on to the walls of the casket, with a fourth is added in line with the arms. Around the base of the lid is a long horizontal inscription that also continues on the back of the head. These texts, arranged in imitation of the external bandages used to wrap mummies, feature frequent cartouches with the name of Psusennes I.

The walls of the casket are densely decorated externally with the figures of a number of deities (the Four Sons of Horus, Thoth and Anubis), flanked by their utterances directed to the deceased. On the left-hand side, at the level of the shoulders, is a decorative motif composed of a pair of eyes above the façade of a palace.

At the foot end of the lid and the head end of the casket are depictions respectively of the goddesses Isis and Nephthys who protect the deceased, now identified with Osiris.

The style and decoration of this finely carved coffin immediately bring to mind examples from the Nineteenth Dynasty. Mummiform coffins in stone became very common in that period, above all for the burial of wealthy private individuals.

The fact that a number of hieroglyphic symbols have been chiselled away and replaced with the name of Psusennes I confirms the supposition that this coffin was indeed commandeered for the funeral of the king, a common practice among the rulers of the Tanis dynasties. Although there is now no possibility of identifying the original occupant, whose name has been so carefully erased, it is probable that, prior to the addition of the royal cartouches, this coffin belonged to a high-ranking dignitary who lived in the late Eighteenth or early Nineteenth Dynasty. (S.E.)

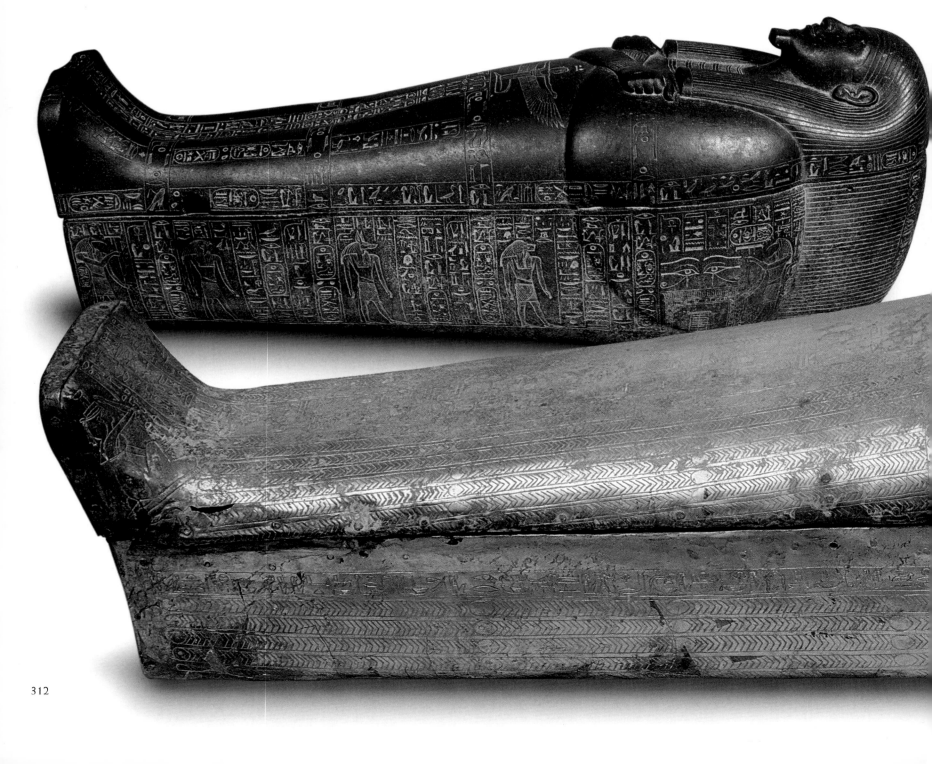

COFFIN OF PSUSENNES I

SILVER AND GOLD
LENGTH 185 CM
TANIS, TOMB OF PSUSENNES I, BURIAL CHAMBER OF PSUSENNES I
P. MONTET'S EXCAVATIONS (1940)
TWENTY-FIRST DYNASTY, REIGN OF PSUSENNES I (1040–992 BC)

The burial of Psusennes I, a ruler of the Twenty-first Dynasty, was discovered intact among the small group of tombs inside the enclosure wall of the Great Temple of Amun at Tanis. The pharaoh's mummy was preserved within three magnificent containers: an external rectangular sarcophagus of pink granite, a central mummiform coffin of black basalt, and a third, internal mummiform coffin made of silver. The first two had been usurped from their original owners and both date to the Ramesside Period, while the third was made by the metalworkers of Tanis specifically to house the remains of Psusennes I.

The lid of the silver coffin portrays the deceased as a mummy with his arms crossed over his chest, displaying the typical emblems of royal power – the *nemes* headdress, the cobra of solid gold on the forehead, the false beard, and the sceptre and flail held in the hands.

The face, with its fine features and serene expression, is embellished with a band of gold across the forehead; the eyes are inlaid with coloured glass paste and a line in relief around the cheeks imitates the strap used to attach the false beard.

Incised around the sovereign's neck is a necklace with multiple strands of beads ending in an upturned lotus flower motif. On the deceased's chest and abdomen are depicted three birds with outspread wings that continue on the sides of the casket. The three birds – with the heads of a vulture, a ram and a falcon respectively – are gripping *shen* rings in their talons as symbols of eternity and are surrounded by a motif of small feathers engraved in the metal. The rest of the coffin lid is covered with long feathers.

Two columns of hieroglyphs in the centre each contain the same text, the prayer of Psusennes I to the sky goddess, Nut. Images of Isis and Nephthys, the tutelary goddesses of the deceased, appear on the lid at the level of the feet, and are flanked by a brief text stating their names. The casket is also completely covered with decoration: the stripes of the *nemes* are reproduced below the head, while the remaining area is entirely covered with the same feather motif present on the lid.

On the bottom of the interior is a magnificent image of the winged goddess Nut, standing on the symbol for gold. Her head is flanked by four columns of hieroglyphs while below her there are images of the goddesses Isis and Nephthys gripping a large sceptre, the symbol of the god Anubis, in their hands. Two symmetrical inscriptions are carved around the sides of the casket containing the words of Nut and those of Psusennes I.

On the inside walls, covered with the same feather motif, extend the wingtips of the three birds present on the lid. The decoration of the coffin is executed with a fine engraving technique, providing another example of the work of skilled craftsmen who were capable of producing wonderful objects in precious metal, typical of the funerary caches found at Tanis.

The mummy of Psusennes I was found within the silver coffin, its face protected by a funerary mask and the body covered with a gold mummy-board. (S.E.)

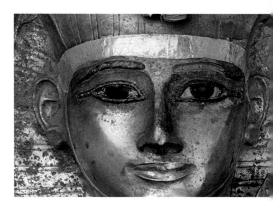

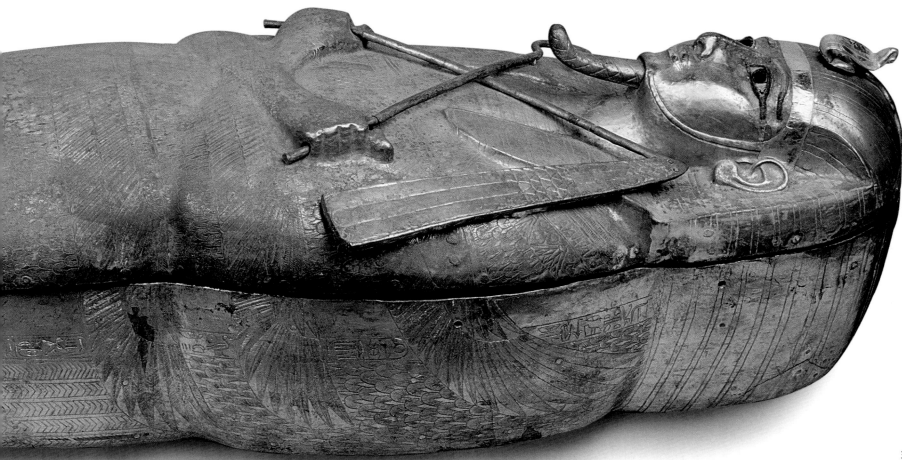

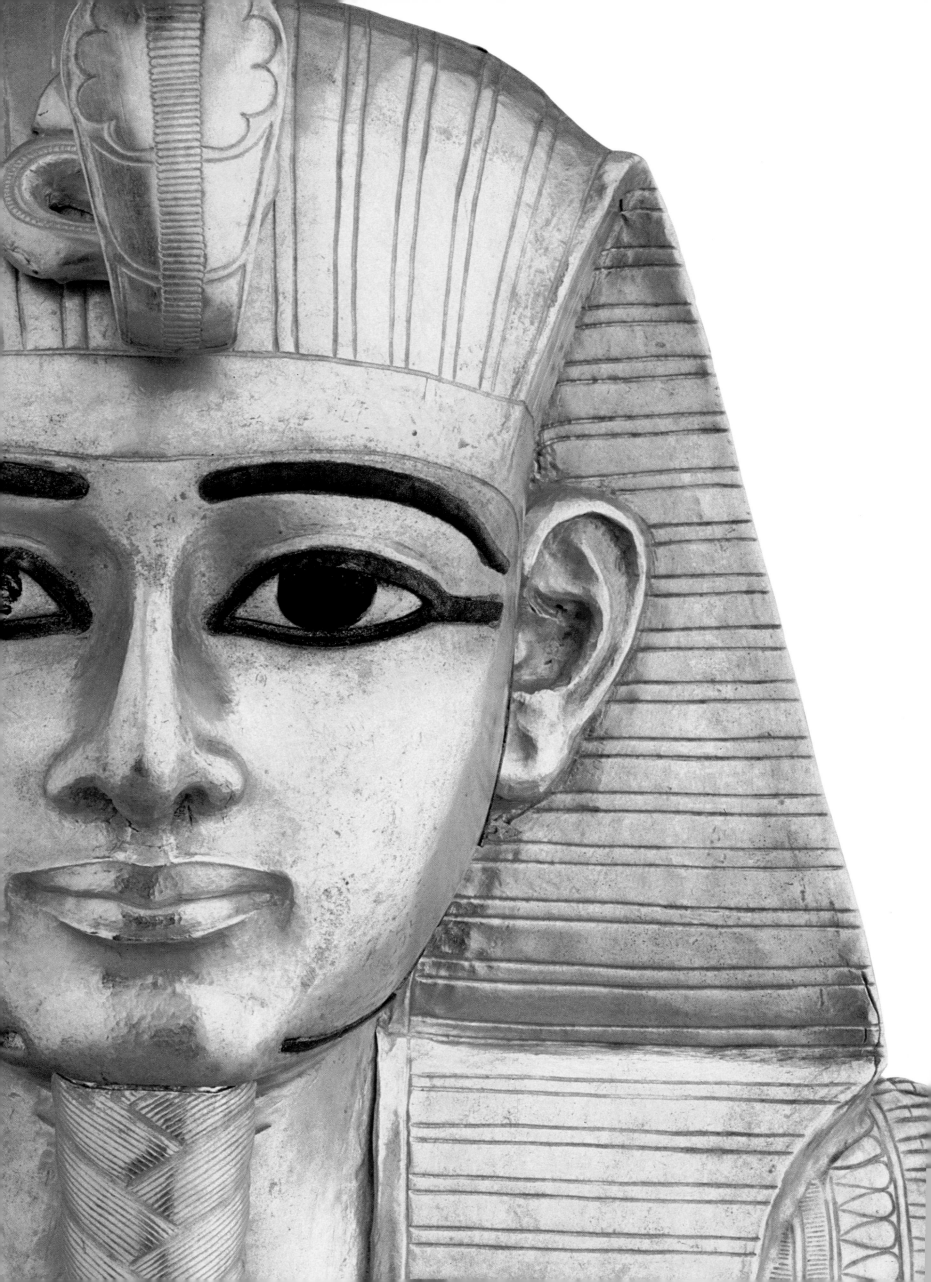

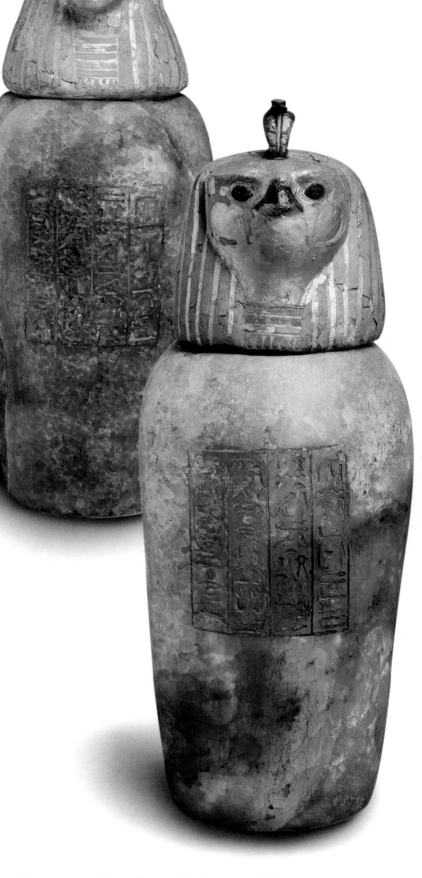

MASK OF PSUSENNES I

GOLD, LAPIS LAZULI, GLASS PASTE; HEIGHT 48 CM; WIDTH 38 CM
TANIS, TOMB OF PSUSENNES I, BURIAL CHAMBER OF PSUSENNES I
P. MONTET'S EXCAVATIONS (1940)
TWENTY-FIRST DYNASTY, REIGN OF PSUSENNES I (1040–992 BC)

The splendid funerary mask of Psusennes I was placed over the mummy's bindings in order to preserve for all eternity the features of the king and thus also his identity. The sober elegance that distinguishes the piece is typical of the work of the skilled craftsmen of Tanis, who produced numerous objects marked by technical perfection and well-balanced forms. The youthful face is suffused with an austere majesty accentuated by the warm light that emanates from the sheet of gold, less than one millimetre thick, from which it is shaped.

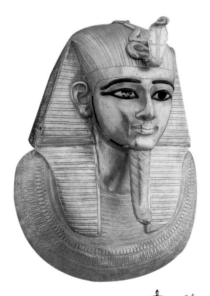

The ancient Egyptians believed that the bodies of the gods were composed of gold, and this metal therefore guaranteed immortality for the king and access to the Underworld alongside the gods.

The pharaoh is wearing a *nemes* headdress with the stripes finely chased in the metal. An impressive royal *uraeus* rises on the forehead. The serpent's sinuous body is coiled at the top of the mask. The soft, smoothly modelled face has an intense gaze, animated by a number of inlays of black glass paste that emphasize the eyebrows, the outlines of the eyes and the pupils, while the eyeballs are rendered in white glass paste. A thin line around the cheeks, inlaid with lapis lazuli, imitates the strap used to attach the false beard worn by kings and the gods. Fixed to the chin by a small gold nail, the beard is intricately braided and its tip curves gently upwards.

On the chest, between the flaps of the headdress covering the shoulders, is a broad *usekh* necklace, composed of twelve stripes imitating rows of beads and three wider external bands decorated with droplet and floral motifs.

The mask is made up of two parts fixed to one another by means of five gold nails folded over the inner surface. (S.E.)

JE 85916 - 85915
- 85914 - 85917

CANOPIC VASES OF PSUSENNES I

CALCITE AND GOLD LEAF; JE 85916: HEIGHT 38 CM; JE 85915: HEIGHT 41 CM
JE 85914: HEIGHT 43 CM; JE 85917: HEIGHT 39 CM; TANIS, TOMB OF PSUSENNES I,
BURIAL CHAMBER OF PSUSENNES I; P. MONTET'S EXCAVATIONS (1940)
TWENTY-FIRST DYNASTY, REIGN OF PSUSENNES I (1040–992 BC)

Canopic jars contained the liver, lungs, stomach and intestines extracted from the corpse during the process of mummification. Each jar was placed under the protection of one of the Four Sons of Horus, Imseti (human-headed), Hapy (baboon-headed), Duamutef (jackal-headed), or Qebehusenuef (falcon-headed), and a goddess (Isis, Nephthys, Neith or Selkis).

Psusennes I's canopic jars are embellished with a thin gold leaf and blue glass paste. Each head is topped by a gilded bronze cobra. A four-column hieroglyphic inscription on the body of the jars contains an invocation to one of the four goddesses and to the Son of Horus whose head is depicted on the lid. The deities are asked to protect the deceased.

These jars were part of a royal funerary assemblage comparable in quality and importance, though certainly not in quantity, with that discovered in the tomb of Tutankhamun. Unlike Tutankhamun's tomb, however, the burial chamber of Psusennes I was intact.

The most precious objects of the pharaoh's burial equipment were enclosed within the silver coffin, which contained the king's mummy, while others, including the four canopic jars, were arranged in front of the external sarcophagus in pink granite.

Psusennes I's canopic jars are among the rare examples of stone vessels found in the royal tombs of Tanis, where, in contrast, there was an abundance of vessels made from precious metals. (S.E.)

PLAQUE OF PSUSENNES I

......................................

GOLD; HEIGHT 16.6 CM; WIDTH 9.9 CM; THICKNESS 0.07 CM
TANIS, TOMB OF PSUSENNES I, BURIAL CHAMBER OF PSUSENNES I
P. MONTET'S EXCAVATIONS (1940)
TWENTY-FIRST DYNASTY, REIGN OF PSUSENNES I (1040–992 BC)

This thin gold plaque belonging to the pharaoh Psusennes I was placed on his mummy over the incision made in the lower abdomen to allow the internal organs to be removed during the initial phases of the embalming process. The ancient Egyptians attached a powerful magical value to this amulet, which was intended to guarantee the physical integrity of the mummy by protecting the wound, thought to be the most vulnerable part of the body. The plaque served to heal and form a scar over the incision made by the embalmer, thus preventing negative or evil elements from entering the body of the deceased.

The apotropaic significance of the plaque is underlined by the engraved decoration on its surface, with painstaking attention being paid to the smallest details. In the centre of the gold rectangle is a

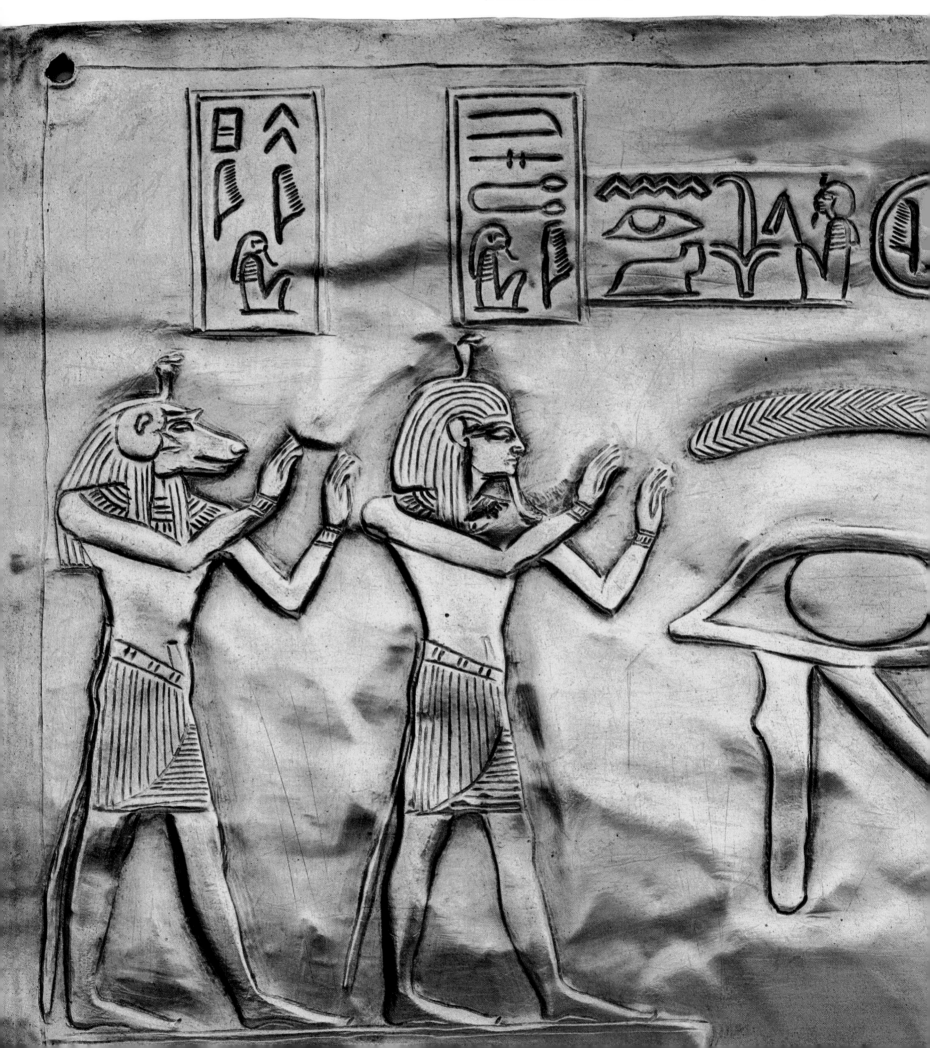

wedjat eye, an emblem of protection in ancient Egyptian beliefs. The term *wedjat* means 'the whole one' and refers to the legend in which the left eye of the falcon god Horus was healed by the god Thoth after it had been torn out during Horus' long struggle against the evil deity Seth. The lines below the *wedjat* eye represent the tears of pain and sorrow of the god, and correspond to the plumage patterns of the

falcon. This eye was also seen as a symbol of the moon, while the right eye of the god Horus was an image of the sun.

On this plaque the image of the *wedjat* eye is flanked by two deities on either side, depicted in standing poses with their arms raised in a sign of devotion. These figures represent the Four Sons of Horus, who served to protect the deceased's internal organs, contained in canopic jars.

The figurative scene is surmounted by hieroglyphic

The heads of the four gods, each topped by the royal cobra, are distinguished according to a tradition that was established during the New Kingdom. Hapy is represented as a baboon, Imseti as a man, Duamutef as a jackal and Qebehusenuef as a falcon. The four deities are wearing pleated kilts and a *usekh* or broad-collar necklace.

inscriptions incised in the metal with the names of the Four Sons of Horus alongside the cartouche containing the coronation name of the king, 'Psusennes, beloved of Amun'.

A thin incised line frames the entire composition. At the corners are the four holes that allowed the plaque to be attached to the mummy's bindings. Though small, this gold plaque is finely crafted, with a great sense of balance. (S.E.)

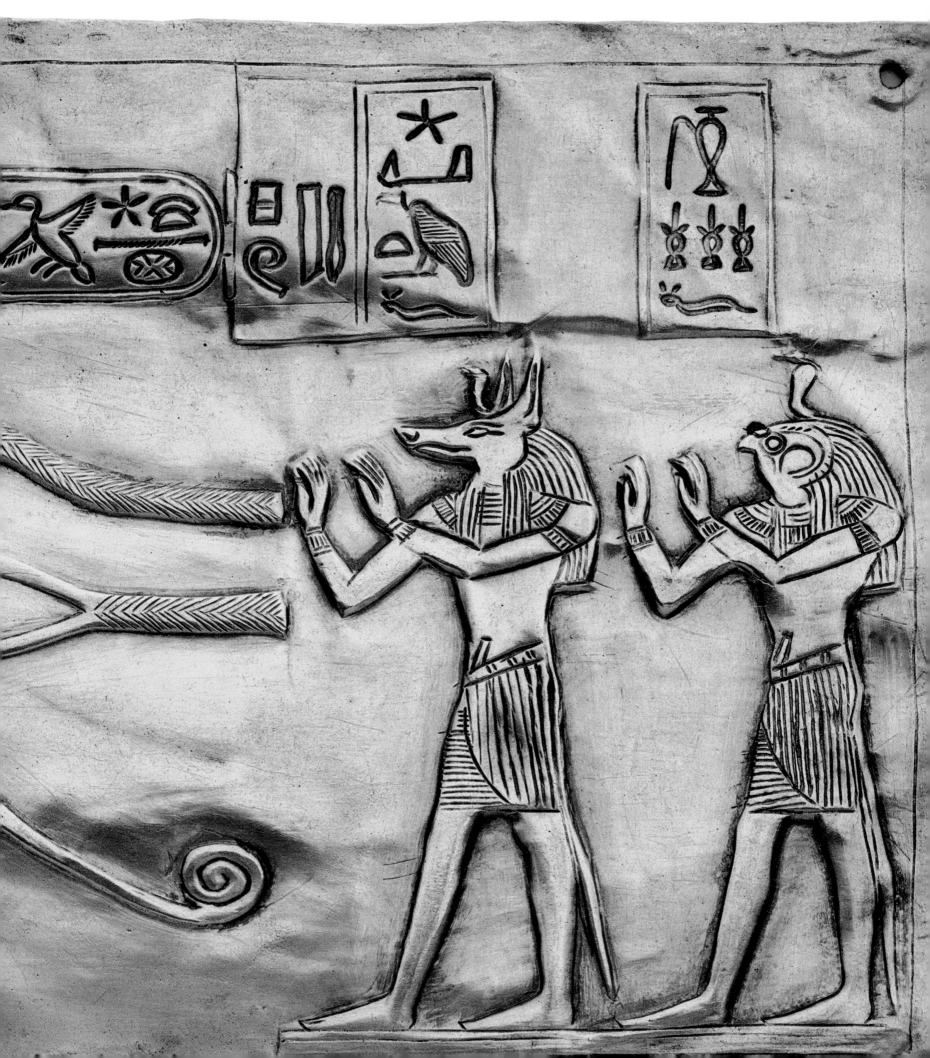

BASIN OF PSUSENNES I

GOLD
HEIGHT 17 CM ; DIAMETER OF RIM 20.9 CM
TANIS, TOMB OF PSUSENNES I, BURIAL CHAMBER OF PSUSENNES I
P. MONTET'S EXCAVATIONS (1940)
TWENTY-FIRST DYNASTY, REIGN OF PSUSENNES I (1040–992 BC)

In addition to their high artistic merit, the gold, silver and bronze vessels found in the tombs of Tanis have great archaeological importance. Before the discovery of these examples from Tanis, vessels such as these, which had both sacred and mundane functions, were known only through mural decorations.

Numerous examples of vessels in precious metals with both domestic and religious uses were deposited in the burial chamber of Psusennes I. This flat-bottomed basin with flaring sides recalls the form of a lotus flower, a motif that frequently inspired the decoration of the metalwork and jewelry produced at Tanis.

The simple, spare shape of the basin contrasts with the elaborate handle composed of a stem made of of three wires. At the base of the handle the wires end in a small palm and at the attachment to the mouth of the vessel they form an elegant openwork lotus flower. This decorative motif had already been used in Egyptian art in preceding periods and is also found on certain

objects dating from the Eighteenth Dynasty. The handle is attached to the basin by three gold rivets.

On the exterior of the basin, opposite to the handle, the cartouches of Psusennes I are inscribed with great skill: 'The King of Upper and Lower Egypt, the Lord of the Two Lands, *Aakheperre Setepenamun*, the Son of Re, the Lord of the Crowns, *Psusennes Meryamun.*'

The basin was found with a gold ewer, also discussed here. The two objects were discovered next to each other in the funerary chamber of Psusennes I. The basin probably served to collect water poured over the hands of the king from the ewer. In a number of paintings a ewer is depicted inside its basin below a table of offerings. (S.E.)

EWER OF PSUSENNES I

GOLD; HEIGHT 39 CM
TANIS, TOMB OF PSUSENNES I, BURIAL CHAMBER OF PSUSENNES I
P. MONTET'S EXCAVATIONS (1940)
TWENTY-FIRST DYNASTY, REIGN OF PSUSENNES I (1040–992 BC)

This ewer was perhaps used for the king's personal toilet and formed a pair with the gold basin also shown here. They were deposited together in the burial chamber of Psusennes I. This is an object characterized by purity of form and decorative sophistication and is one of the finest pieces of tableware in precious metal belonging to the pharaoh.

The body of the ewer swells slightly at the shoulders before narrowing sharply to form a long slim neck that is slightly flared at the top. The neck resembles a column topped by a capital similar to a stylized lotus flower. Five incised rings underline the attachment of the stem to the capital. The profile of the mouth echoes the form of the basin which

JE 85910

RITUAL BRAZIER OF RAMESSES II

BRONZE; HEIGHT 24 CM; LENGTH 33.5 CM; WIDTH 26.5 CM
TANIS, TOMB OF PSUSENNES I, BURIAL CHAMBER OF PSUSENNES I
P. MONTET'S EXCAVATIONS (1940)
NINETEENTH DYNASTY, REIGN OF RAMESSES II (1290–1224 BC)

A number of ritual objects were found in the burial chamber of Psusennes that until their discovery had been known only from painted reliefs on the walls of tombs and temples. As well as numerous liturgical vessels was a brazier in bronze. It rests on four feet and features a narrow cavetto cornice around the top. The heating surface has four holes arranged in a line and twin rows of circular depressions.

At the front of the object, in a rectangular panel edged by a thin frame, is an inscription with two cartouches containing the name of Ramesses II. The text refers to one of the jubilees celebrated by this long-lived pharaoh, and it was perhaps on this occasion that the ritual object was made and dedicated. It would originally have been part of the equipment of a specially built temple in the city of Pi-Rameses. This brazier may have been used in the presentation of offerings to the god or perhaps for the burning of perfumed resins. In the tomb of Psusennes it was used as the base for the tall silver support that acted as an altar for libations.

The appropriation of an object belonging to a distant and renowned predecessor was a fairly common practice among the pharaohs of the Twenty-first Dynasty. It is very probable that in the age of Psusennes I, the brazier was already thought of as a venerable antique. (S.E.)

is also modelled in the form of a lotus flower.

Two cartouches with the coronation and birth names of the pharaoh are incised on the body of the ewer: 'The King of Upper and Lower Egypt, the Lord of the Two Lands, *Aakheperre Setepenamun*, the Son of Re, the Lord of the Crowns, *Psusennes Meryamun*'. The inscription is identical to the one on the basin that complemented the ewer.

The plain lines of the vessel are counterbalanced by the rich decoration around the mouth. The style of this decoration is based on similar vessels from the New Kingdom: a comparable bottle in bronze was found in the tomb of the architect Kha (Eighteenth Dynasty). This ewer was perhaps used to hold water that was poured over the king's hands and collected in the matching basin. (S.E.)

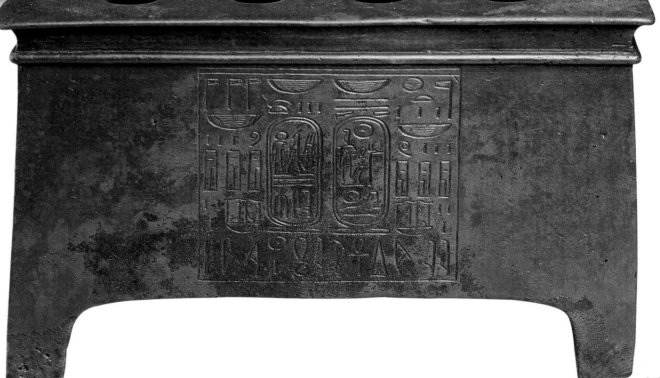

JE 85751

SHEBYU COLLAR OF PSUSENNES I

GOLD AND LAPIS LAZULI; TOTAL LENGTH 64.5 CM; DIAMETER 30 CM
HEIGHT OF THE CLASP 6.2 CM; TANIS, TOMB OF PSUSENNES I,
BURIAL CHAMBER OF PSUSENNES I; P. MONTET'S EXCAVATIONS (1940)
TWENTY-FIRST DYNASTY, REIGN OF PSUSENNES I (1040–992 BC)

At the time of its discovery, the mummy of Psusennes I was wearing three *shebyu* collars similar to those reproduced on the walls of the temples. This particular form of necklace was awarded by the pharaohs to their most faithfully serving officials during the ceremony of the 'gold of honour'.

Psusennes I's sumptuous, heavy necklace is a piece of jewelry unique in its richness and technical perfection, the result of painstaking craftsmanship. It is composed of over five thousand thin gold discs arranged in seven concentric rows, creating a dazzling mass of gold to be worn on the chest.

The front panel is decorated with thin lines incised in the metal and partially inlaid with lapis lazuli. At the top is a winged solar disc that protects the cartouches containing the birth and coronation names of Psusennes I, preceded by his royal titles and followed by propitious utterances for the king. The cartouches are flanked by images of two seated divinities supporting an *ankh*, the symbol of life combined with the *was* sceptre, the emblem of power.

The figure on the left is wearing the Double Crown of a unified Egypt, while the one on the right is crowned by the two tall plumes of the god Amun and has a false beard attached to its chin.

A broad, ornate cascade of linked gold chains of different lengths hangs from the clasp, ending in over one hundred small bells like small upturned flowers. These chains, which are hung in a fan-like arrangement that broadens towards the bottom, would have ensured that the sovereign's torso flashed and shimmered with every movement of his body. (S.E.)

NECKLACE OF PSUSENNES I

GOLD AND LAPIS LAZULI
NECKLACE (JE 85755): LENGTH 56 CM
INSCRIBED BEAD (JE 85756): DIAMETER 1.8–2.5 CM
TANIS, TOMB OF PSUSENNES I, BURIAL CHAMBER OF PSUSENNES I; P. MONTET'S
EXCAVATIONS (1940); TWENTY-FIRST DYNASTY, REIGN OF PSUSENNES I (1040–992 BC)

Numerous jewels were found on the mummy of Psusennes I: bracelets, rings and finger covers, as well as six pectorals, over thirty pendants and six strings of beads.

This necklace, like other similar examples, is quite simple. It consists of two strings of lapis lazuli beads of gradually decreasing diameter, divided by a central gold bead. The outer string of the necklace has thirty beads, the inner one twenty-six. The clasp is made of a double spherical bead that attaches to a flat base on which the cartouche with the name of the pharaoh is inscribed: 'The King, the First Priest of Amun, Psusennes.'. One side of both elements of the clasp is pierced to allow the strings holding the beads to be threaded through.

The lapis lazuli beads are all of a grey-blue colour, veined with white, except one, which is of an intense blue and has no veining. Three lines in cuneiform characters are inscribed on this bead and reveal that it had been dedicated to a god of Assur by an Assyrian vizier to protect his beloved daughter.

The presence of this cuneiform text has given rise to various suggestions as to the original

provenance of the necklace. According to one theory, it could have reached Egypt in the ninth century BC with an Assyrian princess whose hand had been given in marriage to Psusennes I. She would then have dedicated the jewel, a gift from her father prior to her marriage, on the mummy of her deceased husband.

Another theory suggests that the necklace instead dates back to the fourteenth century BC and was a gift to Akhenaten from an Assyrian king. However, the most probable date for this necklace remains the ninth century, but it has so far proved impossible to establish how it came to form part of the funerary cache of Psusennes I. (S.E.)

JE 85788 - 85799

PECTORAL OF PSUSENNES I IN THE FORM OF A WINGED SCARAB

GOLD, RED AND GREEN JASPER, BLACK, RED AND BLUE GLASS, GREEN FELDSPAR
PENDANT: HEIGHT 10.5 CM; WIDTH 12.5 CM; *SCARAB:* HEIGHT 6.5 CM; WIDTH 4.5 CM
COUNTERWEIGHT: HEIGHT 4 CM; WIDTH 2.5 CM; *CHAIN:* LENGTH 42 CM
TANIS, TOMB OF PSUSENNES I, BURIAL CHAMBER OF PSUSENNES I
P. MONTET'S EXCAVATIONS (1940)
TWENTY-FIRST DYNASTY, REIGN OF PSUSENNES I (1040–992 BC)

This magnificent and sophisticated pectoral was placed directly on the mummy of Psusennes I, within the silver coffin that also contained other examples of fine goldworking.

The theme depicted here is the rebirth of the sun, represented in the form of a winged scarab on its never-ending journey, pushing before it the cartouche of the pharaoh and dragging behind it the *shen* symbol of eternity.

The scarab itself constitutes the central element of the pectoral and is carved from green jasper. On either side of its body extend two large wings decorated with lines of red, black and blue glass paste in the form of stylized feathers set in gold. The gold cartouche above the head of the beetle contains the birth name of the pharaoh Psusennes I, *'Pasebakhaenniut Meryamun'* (literally 'The star that appeared in the city, beloved of Amun'). The craftsman used great skill and care in the rendering of all the details of the hieroglyphs in variously coloured semiprecious stones using the cloisonné technique, which consists of inserting coloured stones or glass paste into small cells of gold.

The reverse of the pectoral is entirely gold, with the exception of the central section where the green jasper body of the scarab is exposed, inscribed with Chapter 30 of the Book of the Dead. In this verse, hopes are expressed that the heart of the deceased will not testify against its owner during the final judgement before the forty-two deities that preside over the tribunal of the Underworld.

The backs of the scarab's wings are chased with the same motif of horizontal lines present on the front. The hieroglyphs composing the name of the pharaoh are also visible on the back of the cartouche, again chased into the gold.

The pendant was hung from a double string attached to two rings on the tops of the scarab's wings. The strings consist of oblong beads in gold and coloured stones, ending with a flower-shaped counterweight that is also composed of rows of coloured glass paste set in gold.

Psusennes I possessed no fewer than four pendants featuring a winged scarab. This was a particularly important amulet in tombs due to the protective and apotropaic value that was attributed to it. (S.E.)

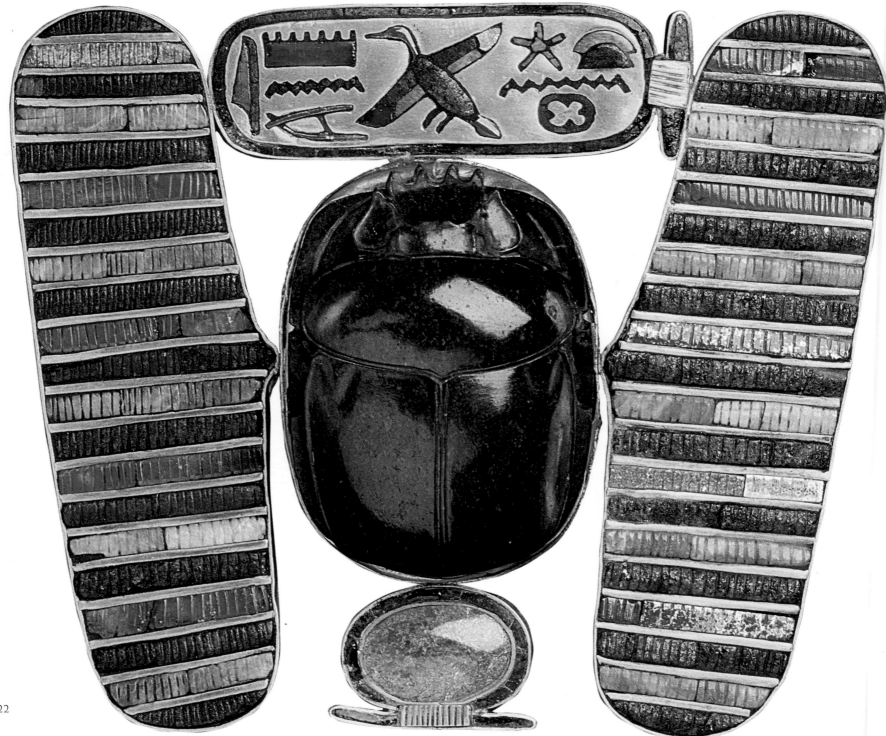

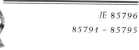

JE 85796
85791 - 85795

NECKLACE OF PSUSENNES I

GOLD, CARNELIAN, LAPIS LAZULI, FELDSPAR, RED JASPER
PECTORAL: HEIGHT 13.8 CM; WIDTH 13.5 CM; THICKNESS 0.7 CM
CHAIN: LENGTH 41 CM (EACH SIDE); TANIS, TOMB OF PSUSENNES I
BURIAL CHAMBER OF PSUSENNES I; P. MONTET'S EXCAVATIONS (1940)
TWENTY-FIRST DYNASTY, REIGN OF PSUSENNES I (1040–992 BC)

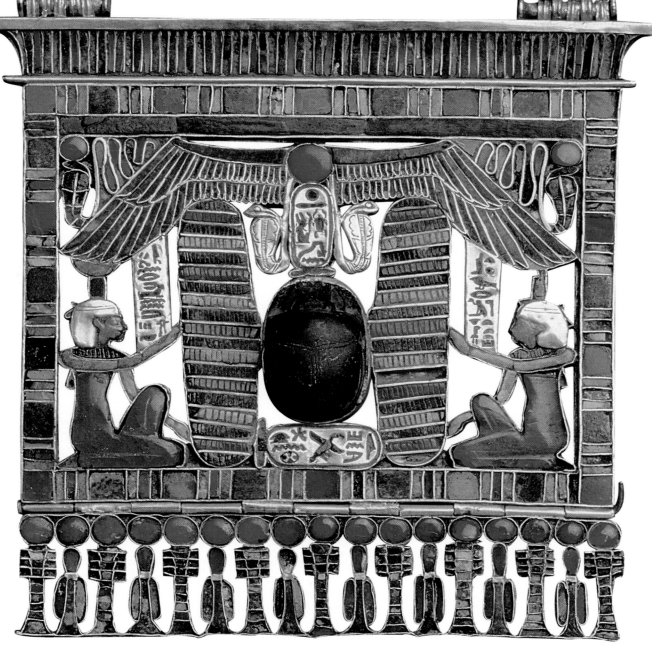

and crowned with solar discs which are fitted into the corners of the composition.

The goddesses Isis and Nephthys, identifiable by the symbols depicted above their heads, are represented kneeling either side of the winged scarab. Both goddesses are holding out their arms and touching the wings of the scarab in a gesture that guarantees protection and eternal life for the pharaoh, who is identified with Osiris.

Above the raised arms of the figures of the goddesses are two brief inscriptions containing their short prayers in favour of Psusennes I. The entire elaborate composition, full of symbolism, is set in a frame reproducing the stylized outline of a temple pylon. The rectangular border is decorated with a frieze of alternating squares and strips. At the bottom, fixed to the base by means of a mobile hinge, is a frieze consisting of a series of seventeen *djed* and *tyt* symbols, the emblems of Osiris and Isis, inlaid in coloured semiprecious stones and each surmounted by a solar disc.

Above the frame of the pectoral is a an overhanging cavetto cornice, again decorated with vertical polychrome inlays. Three rings are soldered on the top of this cornice at each end. Two further rings are interlinked with these and are attached to either end of the double chain from which the pectoral was suspended. The chain was restored by the excavators who pieced together two strings of nineteen oval gold, red jasper, feldspar and lapis lazuli beads found scattered at the bottom of the coffin. At the end of the necklace a counterweight is decorated with a floral motif in inlaid semiprecious stones, ending with a droplet motif.

The reverse side of the pectoral is made of gold finely engraved to reproduce the decoration of the front. At the centre is an oval hole through which appears the only note of colour, the underside of the lapis lazuli scarab inscribed with two columns of hieroglyphs containing the titles and cartouches of the pharaoh. (S.E.)

The mummy of Psusennes, placed in its silver mummiform coffin, was adorned with numerous jewels including several marvellous pectorals dominated by images of winged scarabs symbolizing the sun and the rebirth of the pharaoh after his death.

This pectoral is executed using a sophisticated cloisonné technique that involves setting small inlays of variously coloured semiprecious stones within small cells fixed to a gold base.

The result is a very fine example of the ability of the Tanis goldsmiths to balance form and colour, producing a harmonious and elegant composition. The centre of the jewel is dominated by the image of a scarab, carved from lapis lazuli. Its extended wings are inlaid with polychrome semiprecious stones that have been incised in imitation of rows of beads. The beetle is dragging behind it a gold cartouche containing the birth name of the pharaoh, *'Pasebakhaenniut Meryamun'*,

composed of inlaid hieroglyphs. A second cartouche attached in the same way and containing the sovereign's coronation name, *'Aakheperre*, elected by Amun'*, is being pushed by the scarab and is flanked by two gold cobras hanging from a winged solar disc above.

The feathered wings of the disc, extended as if to protect the entire composition, have tips that appear to be folded forwards to leave room for the apotropaic figures of two royal cobras with sinuous bodies

THREE *SHABTI* FIGURES OF UNDJEBAUENDJED

BRONZE; JE 88501: HEIGHT 9.5 CM; JE 89810: HEIGHT 7.5 CM; JE 89800: HEIGHT 8 CM
TANIS, TOMB OF PSUSENNES I; BURIAL CHAMBER OF UNDJEBAUENDJED; P. MONTET'S
EXCAVATIONS (1946); TWENTY-FIRST DYNASTY, REIGN OF PSUSENNES I (1040–992 BC)

Psusennes I revived a practice seen previously in the funerary assemblages of Ramesses II and III of including a number of *shabti* figures made of bronze in his tomb. This was an uncommon luxury in Egypt at this period as bronze was highly valued. The same honour was also extended to the sister and wife of Psusennes I, Mutnodjmet, and to the general Undjebauendjed, the high-ranking official buried in the same tomb prepared for the royal couple.

The body of Undjebauendjed was buried in a narrow chamber within the walls surrounding the tomb of Psusennes I and, due to lack of space, his *shabti* figures had been deposited in the antechamber of the same tomb where subsequently other members of the royal family were buried.

Along with typical *shabti* figures in faience, the official's funerary equipment included two types in bronze: servants and foremen. In his excavation report, Montet stated that he had found a single foreman figure and around twenty servants in bronze.

Other *shabti* figures had, in fact, already found their way on to the antiquities markets. Sixteen of those today conserved in the Museum of Cairo were acquired in this way. Currently around forty bronze *shabti* figures of Undjebauendjed are known to exist, dispersed in collections around the world.

The servants are all mummiform figures with three-part wigs and folded arms. Below the arms runs a column of hieroglyphs with the name and one of the titles of Undjebauendjed. There are two types of text: one refers to the most important civil position, that of 'general', while the other records the religious title of greatest prestige held by Undjebauendjed: 'Chief Steward of Khonsu'. (F.T.)

FUNERARY MASK OF UNDJEBAUENDJED

GOLD AND GLASS PASTE
HEIGHT 22 CM
TANIS, TOMB OF PSUSENNES I, BURIAL CHAMBER OF UNDJEBAUENDJED
P. MONTET'S EXCAVATIONS (1946)
TWENTY-FIRST DYNASTY, REIGN OF PSUSENNES I (1040–992 BC)

The mummy of Undjebauendjed wore gold finger covers and its face was covered with this precious funerary mask made from a thick gold sheet decorated with inlays of coloured glass paste. The mask covered the mummy's face, neck and ears, ending at the forehead where six small perforated tongues allowed it to be fixed to the head of the mummy.

The eyes, miraculously intact, are made of glass paste of different colours inserted into cavities in the metal: white for the eyeballs and black for the pupils. The eyebrows and the outlines of the eyes are rendered with the same technique. The nose is virtually perfect in form. The lips are narrow and fleshy. The ears are not symmetrical as the left-hand one projects further than the right.

The mask is an idealized portrait of Undjebauendjed as a young man with a serene, tranquil expression lightened by a barely traced smile.

Once again the craftsmen of Tanis have demonstrated their great skill in the working of a thick sheet of gold, achieving remarkable results. The traces of hammering visible on the mask should not be regarded as defects, but rather the result of a definite decision. The goldsmiths preferred an unusual, slightly dull surface rather than one that was highly polished, perhaps considering it more in keeping with the sobriety and elegance typical of the gold working of Tanis.

All the objects in metal found at Tanis are of a very high standard in both qualitative and aesthetic terms and demonstrate the distinctiveness of the art of the city favoured by the pharaohs of the Twenty-first and Twenty-second Dynasties. (S.E.)

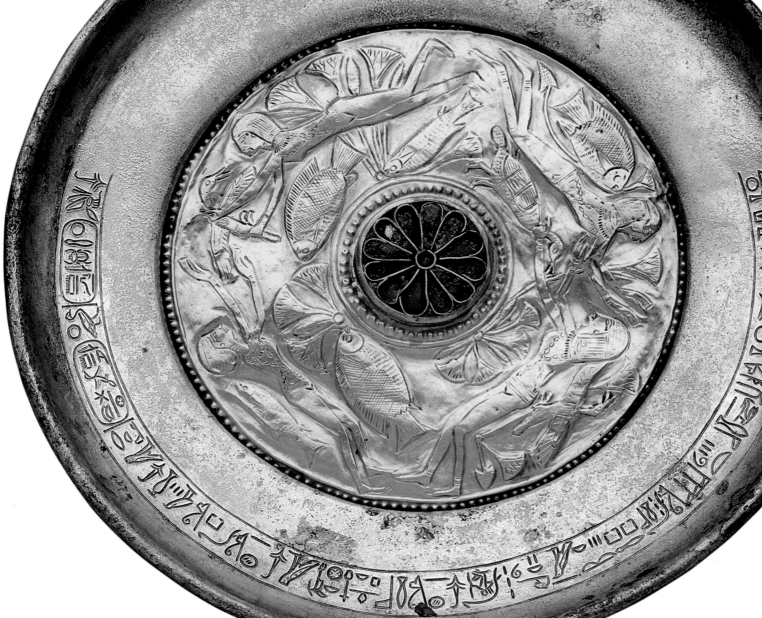

JE 87742

THE PATERA OF THE SWIMMERS

GOLD AND SILVER
DIAMETER 18.2 CM; HEIGHT 2.5 CM
TANIS, TOMB OF PSUSENNES I, BURIAL CHAMBER OF UNDJEBAUENDJED
P. MONTET'S EXCAVATIONS (1946)
TWENTY-FIRST DYNASTY, REIGN OF PSUSENNES I (1040–992 BC)

Various vessels made of precious metal were found on the gilded wood coffin of Undjebauendjed, the most celebrated of which is undoubtedly this piece, which the pharaoh Psusennes I had presented to his faithful official.

The patera is made of silver, a material that was used with more frequency in the Tanis period , when it reached Egypt from Libya, the Near East and via trade with the peoples of the Palestinian coast.

During the Twenty-first and Twenty-second dynasties the techniques of working this metal reached extremely high levels of accomplishment. Artists frequently used it in combination with gold to produce new and original items.

In the centre of the patera is a decorative motif composed of a rosette with twelve petals, originally inlaid with coloured glass paste using the cloisonné technique. A large disc surrounds the central element, edged on the inside and outside by rows of gold beads. The gold disc is embossed with a charming aquatic scene. Four young girls wearing belts and necklaces around their necks and crossing over their torsos are swimming in a pool amidst fish, ducks and lotus flowers. Facing each other in two pairs, they are attempting to capture a number of ducks – two of them have succeeded.

The internal surface of the rest of the patera is made of silver which is undecorated except for a hieroglyphic inscription that reads:

The King of Upper and Lower Egypt *Aakheperre Setepenamun*, the Son of Re *Psusennes Meryamun*. Presented by the favour of the king to the chief steward of Khonsu at Thebes Neferhotep, priest of Khonsu, general, commander of the pharaoh's archers, superintendent of the priests of all the gods, priest Undjebauendjed, justified by Perusirnebdjed [the Egyptian name for Busiris, capital of the Ninth Nome of Lower Egypt].'

At one side is an attachment consisting of a gold handle and a plate decorated with two palmettes. It is fixed to the rim of the patera by four rivets.

Decorative themes associated with the aquatic world are found frequently in Egyptian art, and in this case were probably linked with the everyday function of this object as a container for liquids. (S.E.)

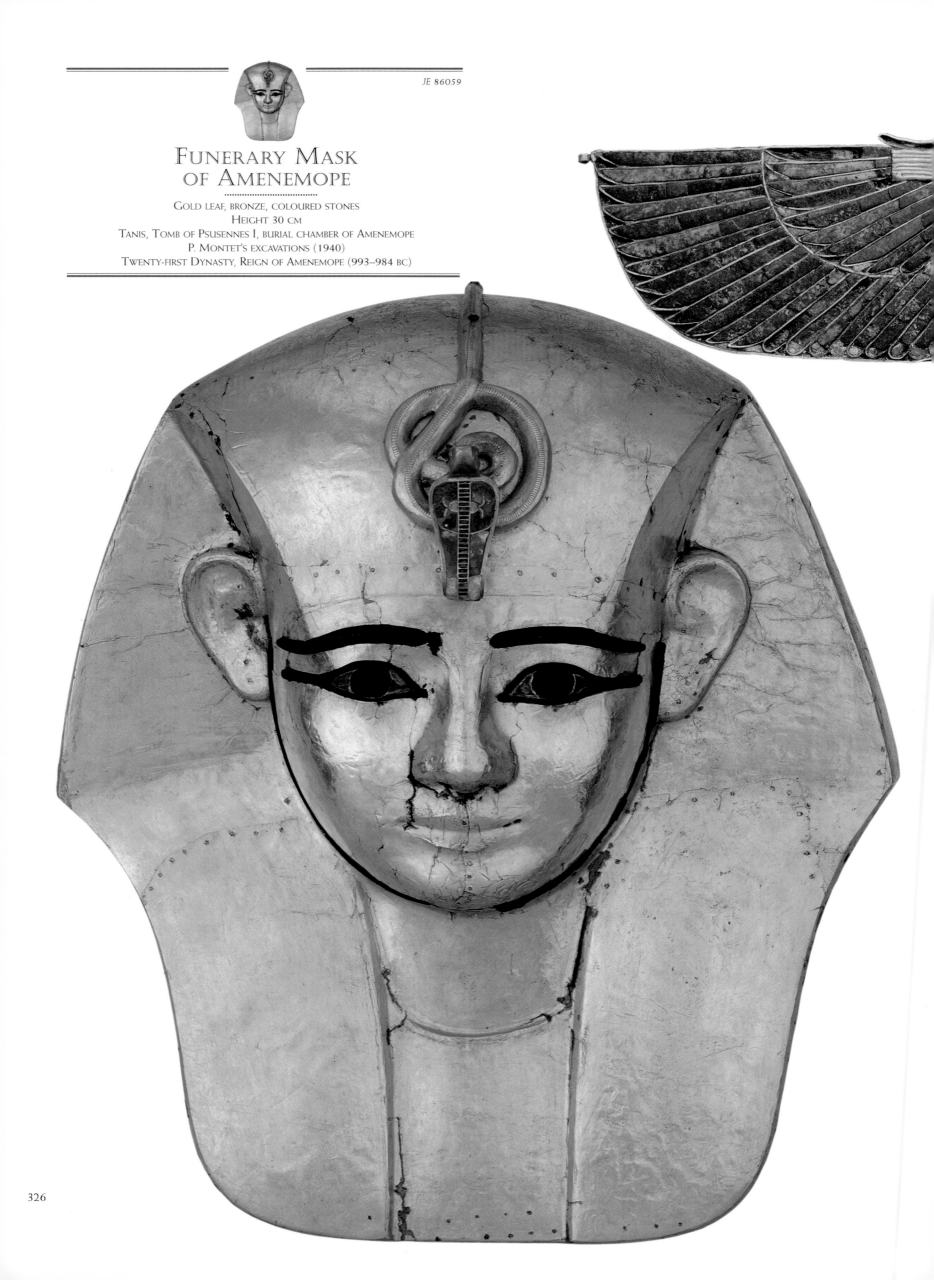

FUNERARY MASK
OF AMENEMOPE

Gold leaf, bronze, coloured stones
Height 30 cm
Tanis, Tomb of Psusennes I, burial chamber of Amenemope
P. Montet's excavations (1940)
Twenty-first Dynasty, Reign of Amenemope (993–984 BC)

JE 86059

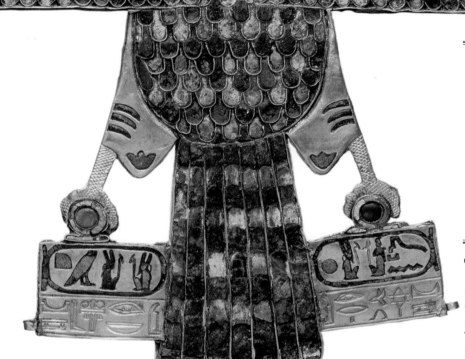

JE 86036

PENDANT IN THE FORM OF A FALCON

..

GOLD AND COLOURED GLASS PASTE
WIDTH 37.5 CM
TANIS, TOMB OF PSUSENNES I, BURIAL CHAMBER OF AMENEMOPE
P. MONTET'S EXCAVATIONS (1940)
TWENTY-FIRST DYNASTY, REIGN OF AMENEMOPE (993–984 BC)

This pendant was placed on the breast of the mummy of the pharaoh Amenemope. His funerary treasure was not large, though it did include a few other items in gold. The relative scarcity of objects found in this tomb can be put down to the fact that many were probably stolen either before or during the transfer of Amenemope's gilded wooden coffin from its original burial site to the funerary chamber of Mutnodjmet, the wife of Psusennes I. This move probably became necessary following a series of robberies within the royal necropolis of Tanis.

The granite sarcophagus intended for Mutnodjmet was also reused for Amenemope: the name of the queen was chiselled off and replaced with that of the new occupant.

The falcon is represented in flight with its wings open. The head, turned to the left, is in solid gold, while other parts such as the beak, the eye, the back of the neck and the decorative motifs on the cheeks are in dark glass paste.

The wings, the body and the tail of the bird of prey were executed in the cloisonné technique. Inlays of pale pink and green glass paste were set into the gold framework, producing a delicate polychromatic effect. The wing feathers spread outwards and are arranged in two rows. The body is decorated with

a droplet motif that also extends to the tail. The feet, again in solid gold, are gripping *shen* symbols of eternity to which two plaques bearing the cartouches of the king are attached. The hieroglyphs within the cartouches are executed in coloured glass paste set in the gold.

On the right-hand plaque can be read the pharaoh's coronation name 'Usermaatre Setepenamun beloved of Osiris of Ro-Setau [necropolis of Memphis]'; on the left-hand plaque is written the birth name 'Amenemope *Meryamun*, beloved of Osiris lord of Abydos'.

Pendants such as this had an apotropaic, protective value and were restricted to royal funerary furnishings. In the iconography of ancient Egypt the falcon was a symbol of the god Horus, of whom the pharaoh was the terrestrial incarnation. (S.E.)

This comparatively simple but still striking mask was an integral part of the mummiform coffin of gilded wood belonging to Amenemope, the successor to Psusennes I, who was buried in the tomb of the latter.

Curiously, Amenemope was buried in the granite-lined burial chamber originally intended for Mutnodjmet, the wife and sister of Psusennes I. Amenemope's mummiform coffin was placed inside a granite sarcophagus that had also been usurped from Mutnodjmet. The wooden parts of the coffin, as well as most of the mummy itself, had been destroyed by damp; the parts made of gold that covered the face and the hands survived, however.

The mask is composed of a thick sheet of gold modelled with the idealized features of the king. The rounded face with its almost infantile expression is framed by the *nemes*, from which the ears emerge. These are positioned rather too high in relation to the position of

the eyes. A beautiful cobra, the symbol of pharaonic regality, rises on the forehead. The snake's long, sinuous body descends from the sovereign's headdress and coils round itself before raising its head. It is made of solid gold with inlays of blue, red and turquoise stones that are in fact the only touches of colour on a mask otherwise characterized by simplicity and purity of form. The pupils, the eyebrows and the outlines of the eyes are made of bronze, as is the line that surrounds the cheeks around the oval of the face. The lips are barely hinted at and their outlines are unmarked. During restoration work the sheet of gold forming this mask was fixed to a head specially modelled in plaster which acts as its new support.

The mask of Amenemope is a compendium of all the distinctive features of the art of Tanis. It is characterized by a spareness of form in contrast with the ostentatious opulence of the funerary treasures of the pharaoh Tutankhamun. (S.E.)

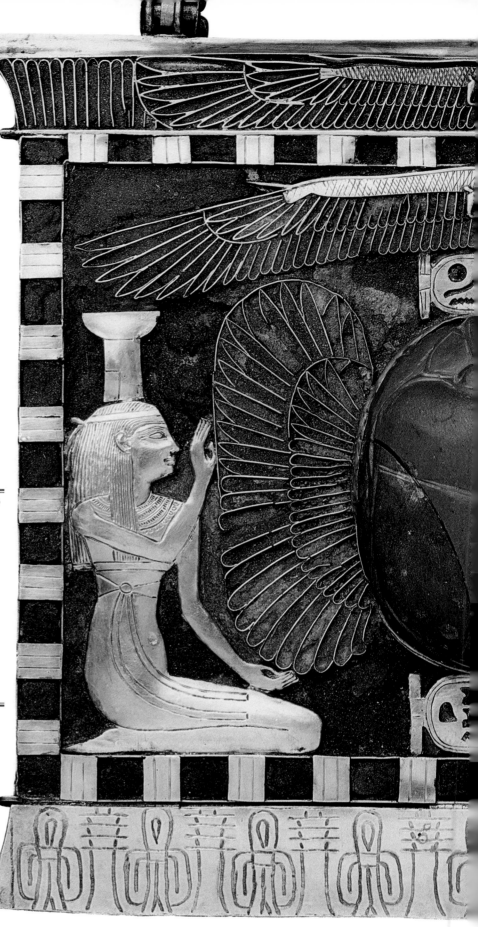

JE 72170

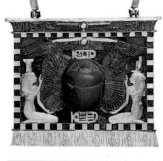

PECTORAL OF SHESHONQ II
WITH WINGED SCARAB

GOLD, SEMIPRECIOUS STONES, GLASS PASTE
HEIGHT 15.6 CM; LENGTH OF THE CHAIN 75 CM
TANIS, TOMB OF PSUSENNES I, BURIAL CHAMBER OF SHESHONQ II
P. MONTET'S EXCAVATIONS (1940)
TWENTY-SECOND DYNASTY, REIGN OF SHESHONQ II (C. 883 BC)

The tomb of Psusennes I was also used for the burial of other members of the royal family. Montet in fact discovered that a second chamber, two annexes and the antechamber of the tomb had been used to accommodate various burials. The remains of Mutnodjmet, the wife of Psusennes, had been replaced by those of pharaoh Amenemope, the successor to Psusennes I. Also found in the tomb was the empty coffin of Ankhefenmut and the burials of Undjebauendjed, a high-ranking dignitary and army general, and of Sheshonq II, a Twenty-second Dynasty king who reigned for a year and in whose burial chamber were also interred a man and a woman whom it has not yet been possible to identify.

This gold pectoral with inlays of glass paste and multicoloured stones was found around the neck of the mummy of the previously unknown pharaoh, Sheshonq II. The gold plate forming the pectoral has an oval hole in the centre, which holds a large scarab in a green stone, the colour symbolizing rebirth. The scarab is winged and holds a cartouche of the king in front of itself and grips another with its hind legs. Inscribed on the base is Chapter 30 of the Book of the Dead in which the deceased hopes that his heart will not testify against him during the final judgment in the presence of Osiris. The feathered wings of the scarab are supported by the kneeling figures of Isis and Nephthys, respectively to the right and left of the scarab, wearing the hieroglyphs signifying their names on their heads.

This central scene, surmounted by a winged solar disc with *uraei*, is inserted within a frame formed from alternating squares of gold and dark glass paste. Above is a cavetto cornice with the figure of a second winged disc similar to the first.

From the base of the panel is hung a separate gold panel, attached by a hinge. This is decorated with an incised frieze in which nine Osiris pillars alternate with nine Knots of Isis, both symbols of protection for the deceased. The rear of the plaque is completely of gold and is incised with the same decoration visible on the front of the amulet.

The pectoral is attached to a gold necklace by means of two rings fixed to the back of the upper frame. A small and very light gold plaque is hung at the end of the necklace by means of a ring. This forms a symbolic counterweight for the pectoral.

The gold figures of the two goddesses Isis and Nephthys, the solar discs and the cartouches were made separately and soldered to the backplate. The decoration of the rest of the pendant is executed in the cloisonné technique, with thin gold wires forming small cells to create the feathered wings of the scarab and the two solar discs. These cells, like the other hollow parts, were filled with a dark green-blue glass paste. (S.E.)

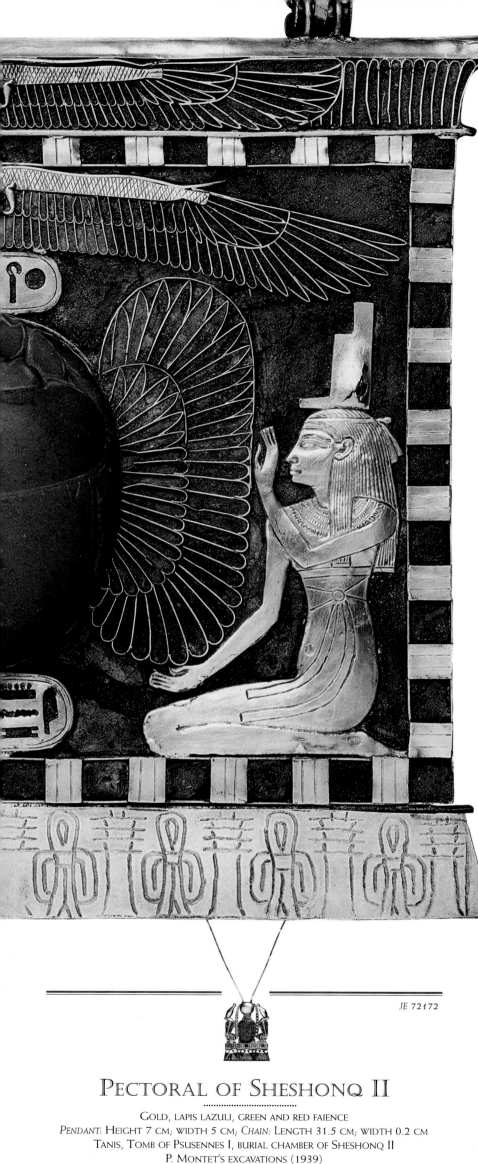

Three pectorals were laid over the mummy of Sheshonq II including this light, attractive example, the symbolism of which refers to the solar cycle. The rebirth of the dead king is identified with the rising sun, symbolized by a scarab. This is a theme that recurs frequently in the jewelry found in the royal tombs of Tanis, but here it is treated in an unusual and original way.

The goldsmith has used the cloisonné technique, setting variously coloured semiprecious stones into a framework of gold. At the centre of the pectoral is a scarab made from lapis lazuli. Above the head of the beetle is a solar disc in gold.

These elements are flanked by two royal cobras emerge, the solar eye. Their bodies, segmented and inlaid with coloured semiprecious stones, some of which are now lost, descend either side of the scarab and pass through two *shen* rings. They are wearing the White Crown of Upper Egypt, created in gleaming gold.

The composition rests on a base decorated with vertical bands. A trapezoidal frieze is attached to the base of this, and is also decorated in gold and cloisonné. Six small gold discs alternate with lotus flowers – three open blossoms and two buds – all made of coloured stones.

The decorative motifs on the front of the piece are faithfully reproduced on the reverse side, chased in the gold. Great care was taken by the artist to highlight the abdominal segments of the underside of the scarab.

This well balanced and graceful composition can also be read as the hieroglyphs forming the name of the King of Upper and Lower Egypt Sheshonq I: *Hedjet* (the White Crown), *kheper* (the scarab), *re* (the solar disc). The pectoral may have therefore been a family treasure inherited by Sheshonq II and included in his funerary cache. (S.E.)

JE 72172

PECTORAL OF SHESHONQ II

GOLD, LAPIS LAZULI, GREEN AND RED FAIENCE
PENDANT: HEIGHT 7 CM; WIDTH 5 CM; *CHAIN:* LENGTH 31.5 CM; WIDTH 0.2 CM
TANIS, TOMB OF PSUSENNES I, BURIAL CHAMBER OF SHESHONQ II
P. MONTET'S EXCAVATIONS (1939)
TWENTY-SECOND DYNASTY, REIGN OF SHESHONQ I (945–924 B.C.)
AND REIGN OF SHESHONQ II (C. 883 BC)

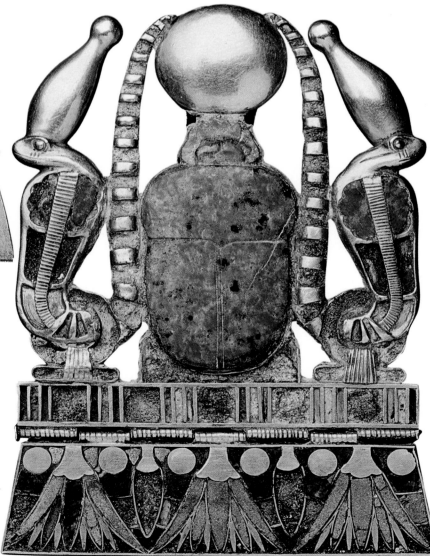

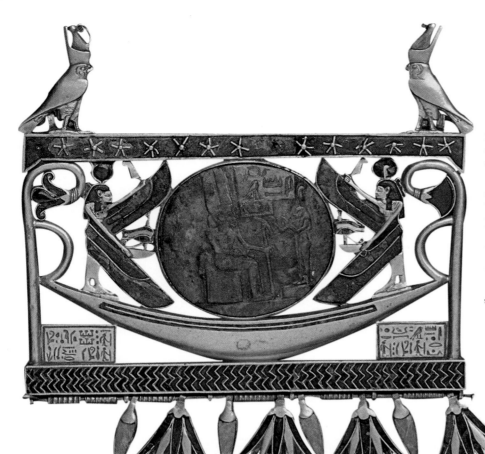

falcons shaped from thick gold sheet and wearing the Double Crown of the unified Egypt.

The waters on which the boat sails are represented by thin zig-zag lines of gold and blue glass paste. From this are suspended lotus flowers, alternately open and in bud. The ends of the solar boat rest on two gold plaques containing a

hieroglyphic inscription written in two lines.

The text on the left continues and completes that on the right: 'Amun-Re-Horakhty travels the heavens every day to protect the great chief of the Me(shwesh), the greatest of the greats, Sheshonq, justified, son of the great chief of the Me(shwesh) Nimlot.' (S.E.)

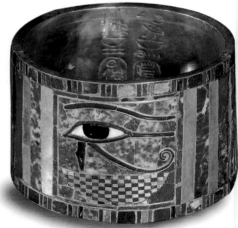

BRACELET OF SHESHONQ II

GOLD, LAPIS LAZULI, CARNELIAN, WHITE FAIENCE
HEIGHT 4.6 CM; MAXIMUM INTERNAL DIAMETER 6.1 CM
MAXIMUM EXTERNAL DIAMETER 7 CM
TANIS, TOMB OF PSUSENNES I, BURIAL CHAMBER OF SHESHONQ II
P. MONTET'S EXCAVATIONS (1939)
TWENTY-SECOND DYNASTY, REIGN OF SHESHONQ I (945–924 BC)

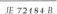

PECTORAL OF SHESHONQ II WITH SOLAR BARQUE

GOLD, LAPIS LAZULI, GLASS PASTE
LENGTH 7.8 CM
TANIS, TOMB OF PSUSENNES I, BURIAL CHAMBER OF SHESHONQ II
P. MONTET'S EXCAVATIONS (1939)
EARLY TWENTY-SECOND DYNASTY (10TH CENTURY BC)

This gold pendant inlaid with lapis lazuli and glass paste was placed on the mummy of Sheshonq II, which was contained in two mummiform coffins with falcon's heads.

This elegant piece of jewelry belonged, as indicated by the inscription, to a figure by the name of Sheshonq, the son of Nimlot. This could be Sheshonq I, the founder of the Twenty-second Dynasty, for whom the pectoral would have been made before he acceded to the throne, but the inscription could also refer to the Sheshonq who was the grandfather of Sheshonq I and also a son of Nimlot. In any case the jewel was produced during the Twenty-second Dynasty and was handed down as a family jewel until it reached Sheshonq II, in whose tomb it was eventually placed.

The main composition of the pectoral is created in gold. Its elaborate decoration features the solar barque sailing beneath a star-studded celestial vault. At the centre of the slender vessel is a large lapis

lazuli solar disc. The disc is engraved with a scene in which the goddess Maat stands before Amun-Re-Horakhty, who is seated on the celestial throne. At the bow and stern of the vessel are Hathor (recognizable by the solar disc in red glass paste enclosed within bovine horns) and Maat (surmounted by the solar disc and ostrich plume). The two goddesses have their winged arms open and extended towards the solar disc in a protective gesture. Their hair and wings are inlaid with lapis lazuli. Both are gripping an ostrich plume in one hand while in the other they hold a hieroglyphic composition formed from the symbol nefer, the wedjat eye and the basket neb.

The celestial vault below which the barque is set is represented by a line of gold stars in a band of lapis lazuli. This band is supported at the sides by the two symbolic plants of Upper and Lower Egypt, the papyrus and the lotus flower, with stems in gold and blossoms in coloured glass paste.

Above the celestial vault are two

Sheshonq II, the high priest of Amun at the beginning of the Twenty-second Dynasty, was chosen by his father Osorkon I as his successor and became co-ruler for a brief period, but died before assuming full power. His mummy was adorned with jewels of extraordinary craftsmanship, some of which must have been part of the rich family treasure Sheshonq inherited from his ancestors.

Seven bracelets were found placed around the pharaoh's wrists, three on the right arm and four on the left, mostly forming identical pairs. The rigid bracelet illustrated here, like its twin, is composed of two gold semicircles linked by hinges, one of which can be opened to allow the jewel to be placed around or taken off the wrist.

The fine decoration is dominated by a large inlaid square containing a striking image of a wedjat eye. The outlines of the eye and eyebrow, and the lines below the eye, are inlaid in blue, the eyeball in white and the pupil in black. This symbol is placed above a neb hieroglyph decorated with a very precise chequer-board motif in which diagonal rows of lapis lazuli and carnelian rectangles are separated by rows of gold rectangles.

The symbolism of this composition is designed to ensure eternal protection for the pharaoh. It stands out against a background of lapis lazuli presumably chosen deliberately for its mottled, streaked appearance which resembles a sky with white clouds.

The rest of the exterior surface of the bracelet features alternating vertical bands of lapis lazuli and gold. This pattern is an imitation of of more ancient Egyptian bracelets which were made from rows of coloured beads separated by solid spacer bars of gold.

The upper and lower edges of the bracelet are decorated with a band consisting of rectangles inlaid with lapis lazuli separated by three bands of of carnelian, all framed by gold.

The decoration of the twin bracelets is identical, with the exception that one of them features a left eye and the other a right, in line with the typical Egyptian predilection for symmetry and mirror images.

The two cartouches of Sheshonq I, the founder of the Twenty-second Dynasty, are incised on the internal surfaces of the bracelets. Sheshonq II must have inherited this amulet, together with his other precious pieces of jewelry, from his predecessor. (S.E.)

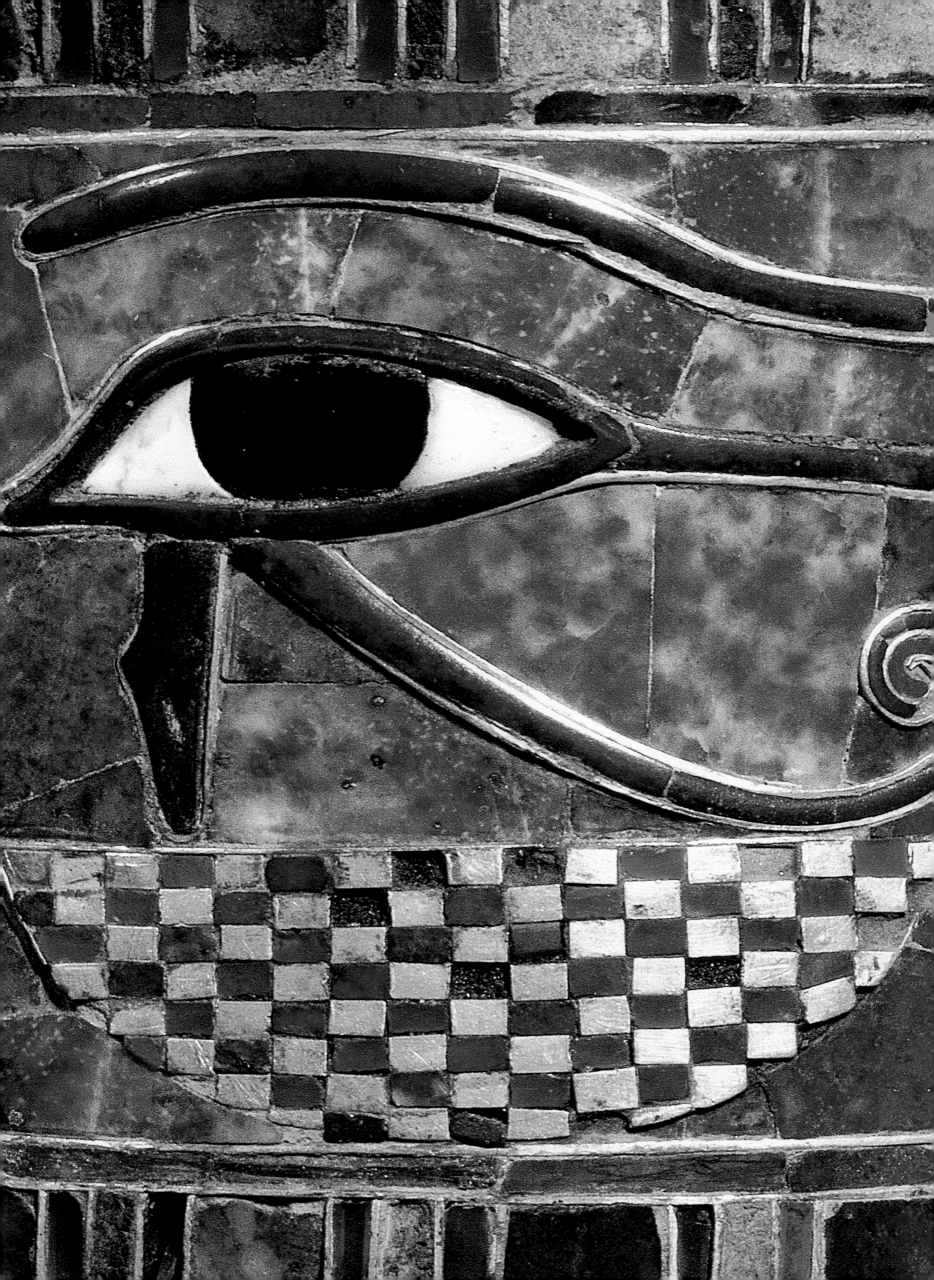

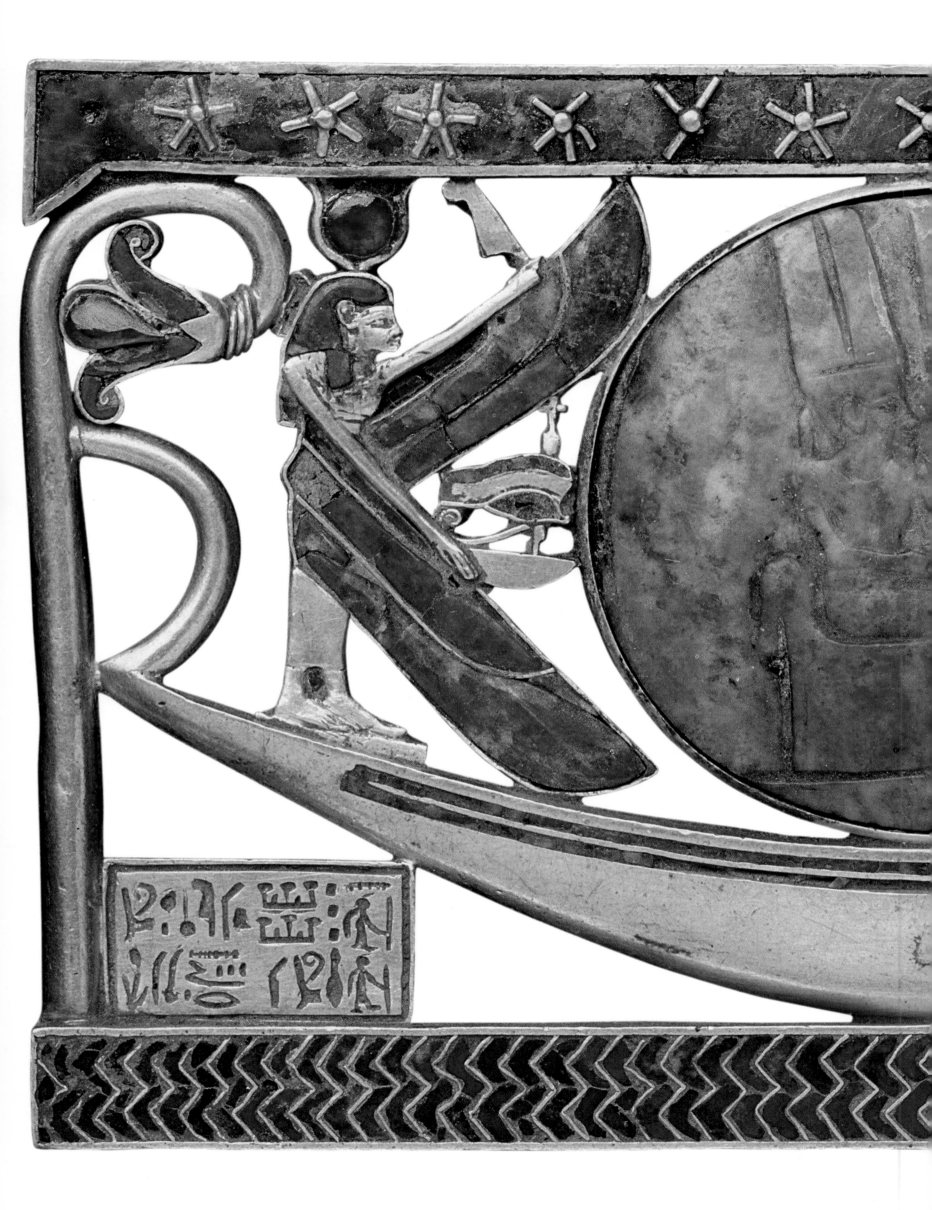

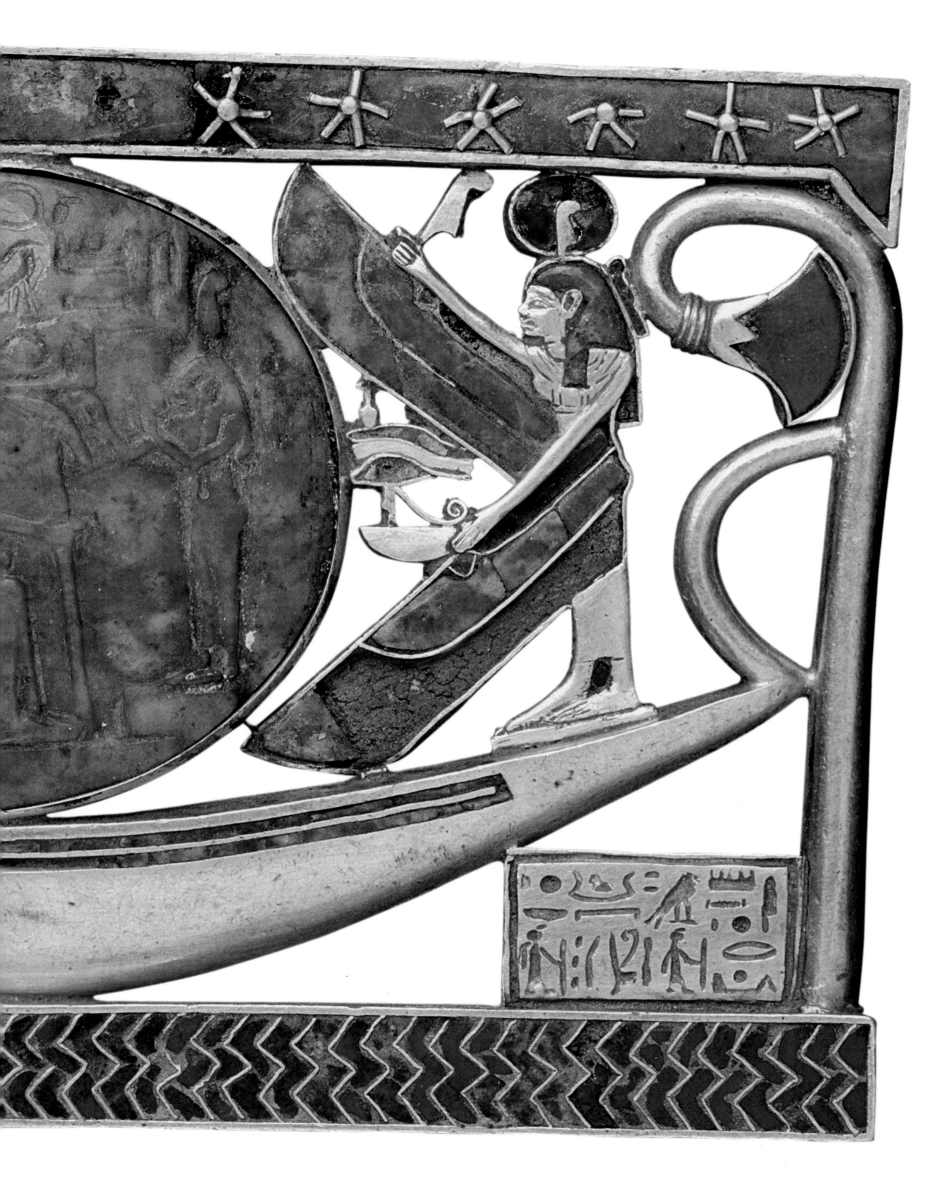

In the course of the nineteenth and twentieth centuries, great discoveries were made in the archaeological exploration of Egypt that attracted worldwide attention to the splendours of pharaonic civilization. Because of its fabulous artistic treasures, the almost intact tomb of Tutankhamun, found by Howard Carter in 1922, has overshadowed all the others by far. But if these treasures convey a vivid image of a royal burial in the heyday of the New Kingdom, it must be admitted that they remain exasperatingly mute about the events that marked the life of this young pharaoh and the circumstances under which he reigned. This is not the case with a number of other discoveries which may have been less spectacular as far as the number of masterpieces they revealed to the world is concerned, but which eventually made more useful contributions to the reconstruction of ancient Egyptian history. Consider, for example, the vast number of texts that Auguste Mariette gathered in the vaults of the Serapeum in 1850–1851, thus saving for science a

HERMAN DE MEULENAERE

THE KARNAK CACHETTE

334 LEFT
A GROUP OF WORKERS
EXTRACTING STATUES
FROM THE KARNAK
CACHETTE (1904).

334 BACKGROUND AND
335
STATUE OF THE SCRIBE
NESPAQASHUTY
JE 36665

SCHIST
HEIGHT 78 CM
KARNAK, TEMPLE OF
AMUN-RE
COURTYARD OF
THE CACHETTE
GEORGES LEGRAIN'S
EXCAVATIONS (1904)
TWENTY-SIXTH DYNASTY
REIGN OF APRIES
(589–570 BC)

unique collection that to the present day has not yet been fully exploited. Other examples are the royal cache of Deir el-Bahri, pillaged and then explored between 1875 and 1881, and the second discovery at Deir al-Bahri in 1891 that produced an astounding number of priests' coffins from the Twenty-first Dynasty. And finally there are Pierre Montet's spectacular excavations, between 1939 to 1945, at Tanis, which brought to light a royal necropolis from the Twenty-first and Twenty-second dynasties that was largely untouched. These findings have helped to illuminate entire periods of Egyptian history, while adding priceless treasures to

the cultural legacy of Egypt. And the discovery of the Karnak Cachette by Georges Legrain between 1903 and 1905 can certainly be included in this list of great achievements.

In 1895, Legrain was summoned to supervise work at Karnak by Jacques de Morgan, who at that time was serving as director of the Antiquities Service. Legrain had already made some remarkable discoveries when Gaston Maspero, who by this time had succeeded Jacques de Morgan, invited him in 1901 to conduct excavations in a spot that was carefully selected for its archaeological potential – together they decided on the courtyard of

the Seventh Pylon in the great temple of Karnak. In the course of this work, the month of December 1903 proved to be particularly lucky. Having excavated some blocks belonging to the jubilee chapel of Amenhotep I, Georges Legrain extended the scope of his search. On 26 December, 1903, he found a large alabaster slab that proved to be a stela of Seti I. Some centimetres beneath, three magnificent statues of considerable size appeared, among which was a figure of Amenemhet, carved from an intensely green stone, that particularly excited the excavators' admiration. These were only the first of a series of discoveries that was to continue

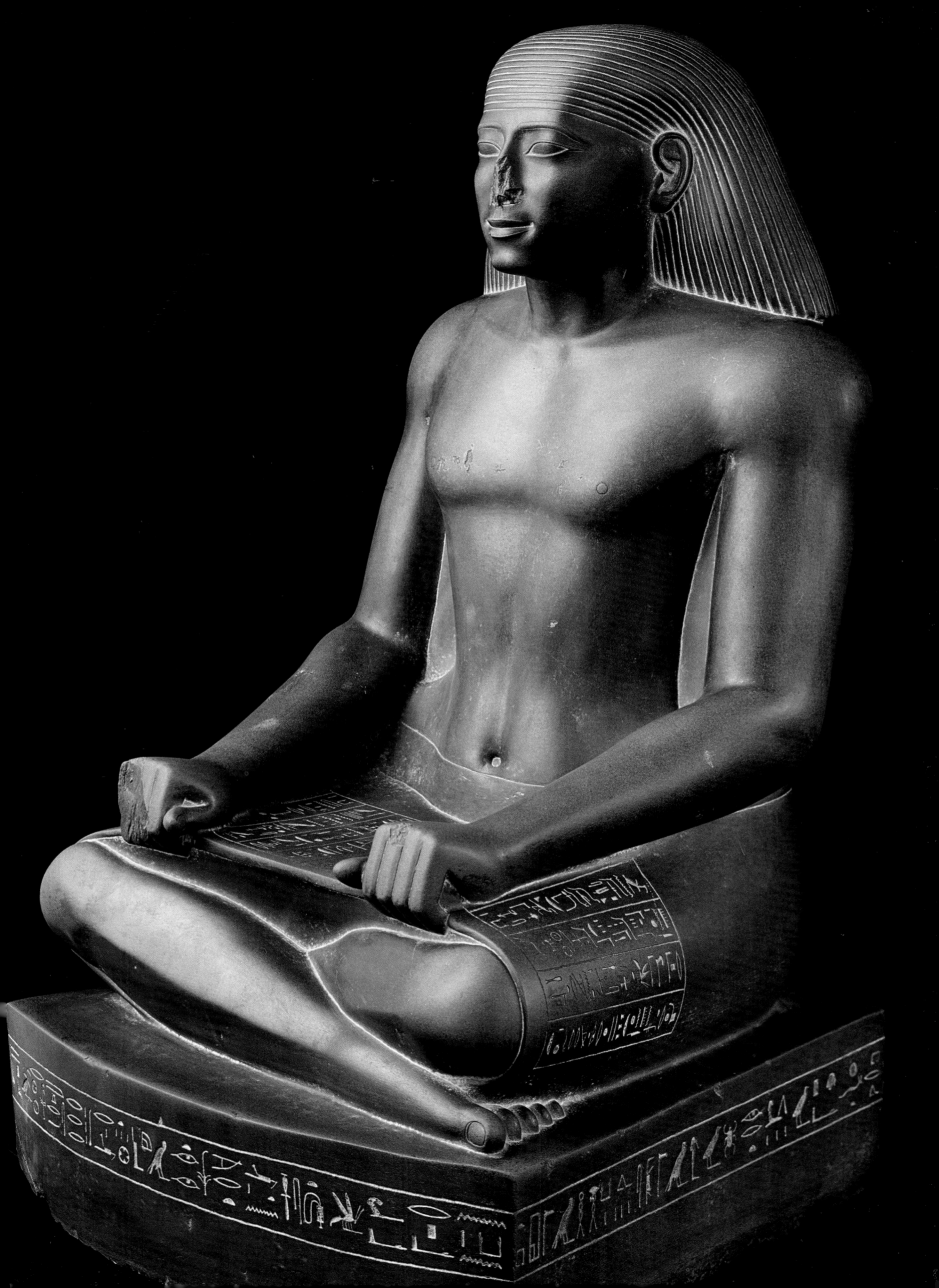

uninterrupted for two years. As soon as they had been removed, the three statues were immediately followed by more and more discoveries. One of the first, a sculpture from the Late Period, was of a certain Ahmes, son of Pakharkhonsu. Already Legrain's discoveries formed a very rich collection of sculpture.

Working under extremely difficult conditions, the team painstakingly recovered over seven hundred statues, sixteen thousand bronzes and numerous other ancient objects by the time the digging was suspended on 25 July, 1905. To excavate this astonishing quantity, the half-naked workers had to toil submerged sand and mud many feet below ground level; at times they were completely stuck and had to wait for their fellow workers to haul them up on to solid ground again.

It is unfortunate that Georges Legrain, no doubt overwhelmed by the huge volume of objects he was uncovering, has left us no more than preliminary accounts of the progress and results of his work. If he kept a daily record of his finds, as presumably he did, his notes have not been preserved. As a result, to gather information on the dates of his discoveries and the circumstances under which they were made it is necessary to search his published accounts in various books and journals and occasionally fall back on secondary sources. This silence is perhaps all the more surprising considering the

interest which the objects, the majority of which bore hieroglyphic inscriptions, must have generated. Such was Legrain's own excitement that he wrote, perhaps exaggerating somewhat: 'I have studied each single one of them, I have copied and translated the inscriptions covering it, prepared its file, its genealogy, and photographed it as soon as it was discovered.' If this documentation really did exist, its loss would have to be regretted as one of the greatest calamities to have befallen Egyptology.

When Legrain was forced to interrupt his work in July 1905 due to water-seepage that threatened the life of his workers, he was certainly aware that the cachette had not yet surrendered all its secrets. The statues he had retrieved were generally intact, although some had been broken during the excavation work. Sometimes he succeeded in putting the pieces back together, but there were several of which there were only fragments. Where he had

not yet recovered the missing part, he was convinced that it would one day emerge from some deeper layer. The interruption of his work put an end to such hopes. The situation has not changed since, and the cachette is still awaiting a determined attempt to complete the task.

Legrain had to take serious measures to avoid being overwhelmed by the continuous stream of objects emerging daily. First, a safe place had to be found to prevent thefts. In fact, once news of his miraculous finds had spread, dubious characters crowded in from all directions waiting for the moment when they could appropriate some part of the booty. Great caution was needed and as soon as they were retrieved, the statues were speedily put under guard in storehouses. Despite all precautions, however, Legrain could not prevent thieves carrying off from the Antiquities Service House two of the beautiful statues he had discovered at the beginning of his excavations. But

following a thorough inquiry, the missing objects were fortunately soon recovered. The guards themselves were found guilty, and four of them were promptly sentenced to three years' forced labour.

As far as possible, the statues were sent regularly to the Cairo Museum. Thus in 1905 ten railway carriages left Luxor station at five o'clock in the afternoon to reach Cairo the next morning. In addition, two boats of the Antiquities Service made two or three trips each.

The extreme care taken by Legrain and his assistants was not always rewarded, however. The enormous publicity surrounding the discovery had aroused the interest of antiquities dealers far too much to hope that they would not try to profit from it by whatever means possible. It is certain that some statues, especially those of medium size, mysteriously disappeared, either while work was still under way, while they were being transported, or even after their arrival at the Egyptian Museum. There is practically no Egyptian collection of any importance in Europe or the United States that does not possess some object from the cachette. Theft was no doubt the primary cause for this dispersal, in whatever way it occurred. How else are we to explain the fact that in some cases one part of the same statue is in the Egyptian Museum and another in a different museum somewhere else?

On their arrival at the Museum in Cairo, the objects were duly registered in the *Journal d'Entrée* (Entry Journal), though sometimes only after considerable delay. In the pages dedicated to these objects, inventory numbers are frequently followed by the capital letter 'D' which signifies that the object, in most cases a statue, had disappeared. Patient research has made it possible to retrace some of these, of which we append a list here that has not previously been published:

JE 36666 London, Sotheby's, 14 July 1986, no. 140
JE 36667 Baltimore, Walters Art Gallery, 170
JE 36972 New York, Metropolitan Museum of Art, 25.184.15
JE 36976 Memphis (USA), private collection
JE 36999 Germany, private collection (CG 42187)
JE 37003 New York, Metropolitan Museum of Art, 35.9.1
JE 37008 New York, Queen's College
JE 37126 Baltimore, Walters Art Gallery, 180
JE 37127 Baltimore, Walters Art Gallery, 167
JE 37158 Baltimore, Walters Art Gallery, 179
JE 37164 Baltimore, Walters Art Gallery, 168
JE 37165 Baltimore, Walters Art Gallery, 163

JE 37329 Baltimore, Walters Art Gallery, 146
JE 37411 Baltimore, Walters Art Gallery, 161
JE 37412 Baltimore, Walters Art Gallery, 162
JE 37846 Baltimore, Walters Art Gallery, 173
JE 37865 Porter-Moss II2, *Topographical Bibliography*, p.162 (CG 42174)
JE 37868 Glasgow, Burrell Collection, 13.233
JE 37870 San Bernardino, Harer Collection, 27
JE 37890 Baltimore, Walters Art Gallery, 174
JE 37984 Paris, antique trade (about 1960)
JE 38010 Bruxelles, Musées Royaux d'Art et d'Histoire, E.7654
JE 38583 New York, Metropolitan Museum of Art, 17.120.145

It should immediately be noted, however, that it is by no means certain that all these statues were stolen. Some must have passed through the Sales Hall of the Cairo Museum, where at one time the authorities offered for sale to visitors examples of objects that it was felt that the Museum already had in sufficient numbers. Other statues annotated as having disappeared reappeared later and were newly registered under another inventory number.

The questions Egyptologists most frequently debate are why the Karnak priesthood deposited so many objects in a vast pit that apparently were not meant to be recovered; and when did this clearance,

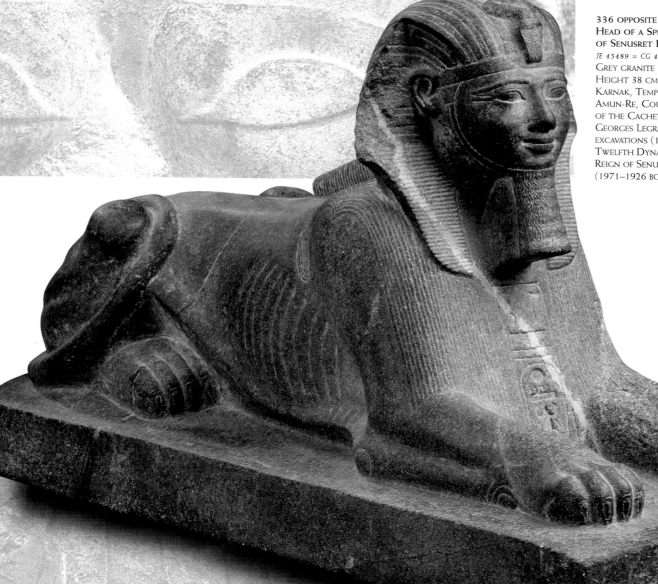

336 OPPOSITE
HEAD OF A SPHINX
OF SENUSRET I
JE 45489 = CG 42007
GREY GRANITE
HEIGHT 38 CM
KARNAK, TEMPLE OF
AMUN-RE, COURTYARD
OF THE CACHETTE
GEORGES LEGRAIN'S
EXCAVATIONS (1904)
TWELFTH DYNASTY
REIGN OF SENUSRET I
(1971–1926 BC)

337 LEFT
SPHINX OF THUTMOSE III
JE 37981 = CG 42069
GREY GRANITE
HEIGHT 32 CM; WIDTH 21
CM; LENGTH 61 CM
KARNAK, TEMPLE OF
AMUN-RE, COURTYARD
OF THE CACHETTE
GEORGES LEGRAIN'S
EXCAVATIONS (1905)
EIGHTEENTH DYNASTY
REIGN OF THUTMOSE III
(1479–1425 BC)

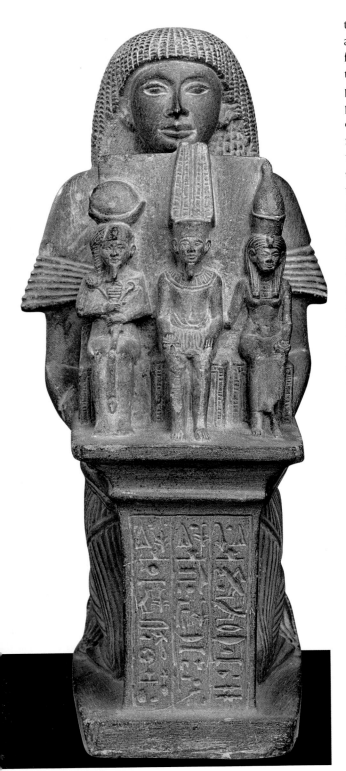

that removed from the Temples of Karnak an enormous number of statues that had filled its halls and galleries, take place? The theory that it was to protect them during a period of war was soon rejected. Other possibilities are that an environmental disaster forced the Egyptians to save what remained of the sacred objects in the temple, or simply that it was necessary to store them safely away while restoration work was under way. Whatever the reason, and despite the fact that not all Egyptologists agree, it is quite evident from Legrain's accounts that the Karnak Cachette was formed on one single occasion, and that the objects were deposited in a rather haphazard manner and in no chronological order. Having found no sculpture he felt to be later than the first century BC, Legrain estimated, no doubt accurately, that the deposit dated to 'the end of the Greek period or, at the latest, the beginning of Roman rule'.

From this remark it is clear that Legrain had studied the archaeological and epigraphic details of the statues very carefully. Almost a century after his discovery, there is nothing that contradicts his analysis. It is still a pity, however, that we can base our opinion on no more than a relatively small part of the collection of statues from his excavations. Legrain himself published, between 1906 and 1925, in three volumes of the *Catalogue Général du Musée du Caire*, a list of about two hundred and fifty statues, mostly from the cachette, and arranged in chronological order up to the end of the Twenty-fifth Dynasty. Since then, this number has increased by about fifty sculptures, added by various Egyptologists in specialist journals. All in all, however, the balance remains unsatisfactory as more than half the statues recovered by the French archaeologist at the beginning of this century have still not been fully published.

The statues of the Karnak Cachette form a remarkable compendium of Egyptian statuary. The material covers almost all the periods of Egyptian history, from the Old Kingdom to the late Ptolemaic Period, with numbers increasing in more recent periods. The less prominent role of Thebes during the Old and Middle Kingdom explains why these periods are represented by fewer statues than the New Kingdom, the Third Intermediate Period, or the Twenty-fifth Dynasty, when the city was the capital of Egypt. Kings of the Twenty-sixth Dynasty transferred central power to the north and this is reflected in a noticeable decline in numbers of statues from this period. Numbers increase again until the Thirtieth Dynasty and during the entire Ptolemaic Period. Generally, most of the epigraphic evidence that Legrain collected in the cachette relates to the last four centuries BC.

It is interesting to note how this abundant material reflects the splendour and decline of Thebes during its long history so closely. Until the beginning of the Twenty-sixth Dynasty, it was not only high-ranking priests, but also kings and civil and military officials who set up their statues in the Temple of Karnak, testifying to their devotion to Amun. When the country's centre of power switched back to the north and the star of Thebes began to wane, this assembly dwindled to include no more than the temple's staff of servants.

The discovery of the Karnak Cachette is both one of the great moments of archaeological exploration in Egypt and

Georges Legrain's claim to lasting fame. Today, his considerable contribution to the science of Egyptology is clear. The rich body of works of art that he saved from oblivion has profoundly changed our conception of Theban sculpture, particularly as far as the study of royal portraits is concerned.

It might be expected that the Old Kingdom would be poorly represented at Karnak, but Legrain found the lower part of a statue of the Fifth Dynasty king Niuserre in a striding position, the upper part of which is in the National Museum of Beirut. Royal figures of the Middle Kingdom are more numerous, though limited to Senusret I, Senusret III and Amenemhet III, the most significant figures of the Twelfth Dynasty. The majority of their statues are true masterpieces, illustrating the realistic vigour that is characteristic of royal sculpture during this period. Senusret I commands attention

338 ABOVE AND 339 LEFT
STATUE OF THE FIRST
PRIEST OF AMUN,
RAMESSUNAKHT, WITH THE
THEBAN TRIAD
JE 37186 = CG 42163
SCHIST (STATUE) AND
SANDSTONE (BASE)
HEIGHT 40 CM
KARNAK, TEMPLE OF
AMUN-RE, COURTYARD OF
THE CACHETTE
GEORGES LEGRAIN'S
EXCAVATIONS (1905)
TWENTIETH DYNASTY,
BEGINNING OF THE REIGN
OF RAMESSES IV (SECOND
HALF OF THE 12TH
CENTURY BC)

338 BOTTOM
STATUE OF OSORKON IV
JE 37426 = CG 42197
LIMESTONE WITH
TRACES OF PAINT
HEIGHT 18 CM
KARNAK, TEMPLE OF
AMUN-RE, COURTYARD
OF THE CACHETTE
GEORGES LEGRAIN'S
EXCAVATIONS
(1904–1905)
TWENTY-THIRD DYNASTY
REIGN OF OSORKON IV
(777–749 BC)

with an almost complete sphinx-head, a fragmentary group representing him before the seated goddess Hathor, and two statues he dedicated to his Fifth Dynasty predecessor, Sahure, and to the nomarch Intef of the Eleventh Dynasty. Two colossal statues of Senusret III, one of them wearing the White Crown, the other the double crown, express the force and power of this great conqueror better than any other of his portraits. The same expression, scarcely moderated, is represented in the seven statues of Amenemhet III. All show the king erect, his left leg advanced and his hands laid flat against his loincloth.

Examples of statuary from the obscure period separating the Middle and New Kingdoms are not absent from the cachette, though the pieces generally lack originality. It is not until the Eighteenth Dynasty that royal sculpture flourishes again and reaches a level rarely achieved before. The reign of Thutmose III was a particular peak in Egyptian history, and the cachette yielded nineteen statues of this king, some of which are distinguished by such stylistic refinement and technical perfection that they have been justly placed among the great masterpieces of Egyptian art. This king, who carried Egyptian imperialism to its height, appears with barely individualized and delicately softened features. It is largely due to Legrain's discoveries that the iconography of Thutmose III is known better than that of his successors. For obvious reasons, the reformer – or heretic – Akhenaten left only relatively few traces at Karnak, unlike his

successors Tutankhamun, Ay and Horemheb, whose names appear on several sculptures of very fine quality. Two splendid statues of Tutankhamun deserve mention, both executed in the same pink granite and revealing the influence of the art of Amarna.

Compared to the Eighteenth Dynasty, the Ramesside Period is represented by a relatively small number of true works of art. Seti I usurped a colossal statue that had probably belonged to Amenhotep IV. Of the eight statues of Ramesses II, three represent the king prostrate, with his right leg stretched back and his arms extended out in front. Ramesses III has two upright statues, one of colossal size, representing him as a standard bearer. Among Ramesses III's successors, only Ramesses VI is conspicuous by two stylized and rather conventional sculptures.

We could end our brief overview of the royal statuary from the cachette here, were

it not for a prostrate statue of Osorkon IV (Twenty-third Dynasty) and a colossal head of King Shabaka (Twenty-fifth Dynasty), today in the Aswan Museum. These are the only testimonies to these periods of foreign rule. The kings of the last indigenous dynasties and of the Greco-Roman Period do not seem to have dedicated their sculpted images at the Temples of Karnak.

The kings of all these periods were emulated by members of their families and their subjects, who dedicated statues to Amun-Re. Not until the New Kingdom do these occur in greater numbers, although relatively little is known about the private sculpture of the Eighteenth Dynasty before

the reign of Queen Hatshepsut. While the queen herself is conspicuously absent from the cachette, her favourite, the architect Senenmut, is splendidly represented by three statues of exceptional beauty. The sculptures of Thutmose III, the greatest pharaoh of ancient Egypt, reveal the delicacy of their sculptor's touch, as do the statues of his mother Isis and of some of his high dignitaries.

Statues from periods later than the Eighteenth Dynasty are often executed in a rather cold manner, devoid of sensibility, and cannot match the level attained by earlier sculptors. There are some notable exceptions, however, such as the two statues of high priest Ramessunakht from

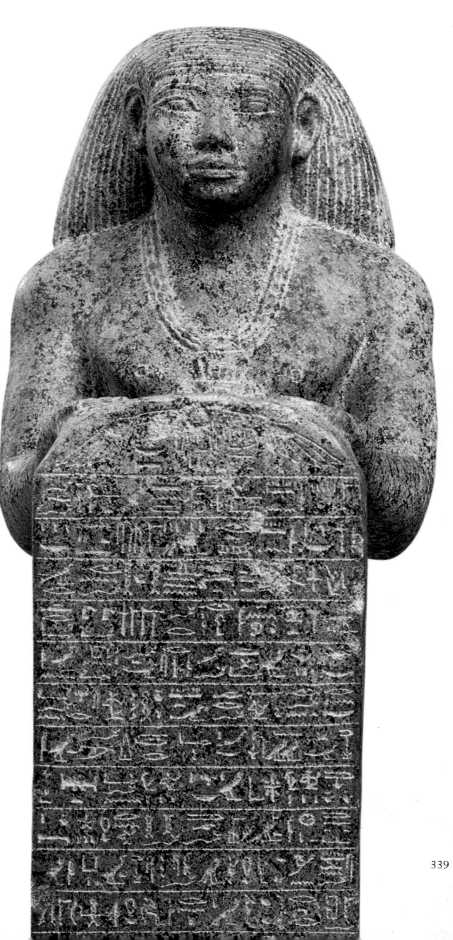

339 RIGHT
STATUE WITH STELA
JE 37852 = CG 42237
GREEN-GREY VOLCANIC ROCK
HEIGHT 40 CM
KARNAK, TEMPLE OF AMUN-RE, COURTYARD OF THE CACHETTE
GEORGES LEGRAIN'S EXCAVATIONS (1904–1905)
TWENTY-FIFTH OR TWENTY-SIXTH DYNASTY (7TH–6TH CENTURY B.C.)

339

the reign of Ramesses IV, which are among the most elegant and original sculptures the Theban school has left us. The increasing power of the Theban priesthood of Amun throughout this period explains why the high priests have left us the most impressive number of testimonies of their artistic ambition.

During the Third Intermediate Period the output of statues rose at an extraordinary rate. Sculptors created a great quantity of portraits of private individuals, generally block statues, often seeking inspiration from the Ramesside style, which was only gradually displaced by the Saite renaissance (Twenty-sixth Dynasty). If certain pieces from this period can justly be considered as examples of a highly accomplished art, the major interest of most of them lies in their long inscriptions, which have made it possible patiently to reconstruct the history of the great priestly families of Thebes under Libyan occupation. From this point of view, the discoveries of George Legrain constitute an inestimable source of information that remains unsurpassed.

After their conquest of Egypt, the Nubian kings of the Twenty-fifth Dynasty installed themselves firmly at Thebes and remained there until Psamtek I, the first king of the Twenty-sixth Dynasty, forced them to retreat. During their rule, the

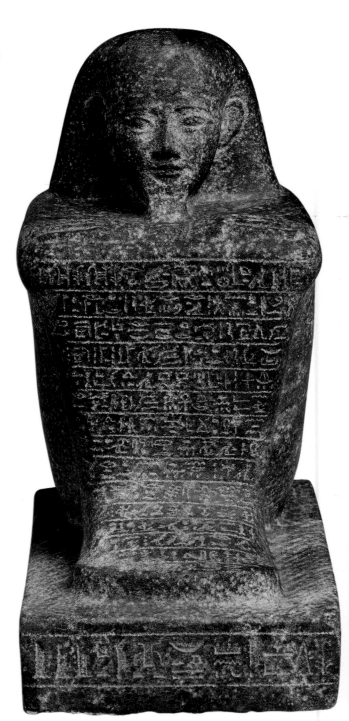

founder of a large family, the last members of which ended their career under the rule of King Necho in the Twenty-sixth Dynasty. The civil and legal administration was managed by the vizier Nespamedu, whom the annals of the Assyrian King Assurbanipal single out as 'king of [the city of] This' and who was succeeded by his son Nespaqashuty. The latter displayed, in the style of one of his most beautiful statues, his submission to his new masters without resistance after the Saite entry into Thebes. Unlike all these royal figures, Petamenhotep, of whom the cachette contains four statues, seems to have held no more than the relatively modest position of lector-priest. Nevertheless, he constructed Egypt's largest subterranean tomb in the Theban necropolis.

In the period of Saite rule, these illustrious characters disappeared one after the other, and their offices remained for the most part empty. While remaining an extremely lively metropolis well into Roman times, Thebes experienced a slow decline from which it never recovered. Dedicated partly by royal emissaries who made brief visits from the north, the Saite statues in the cachette are not numerous. Although the numbers of sculptures increase noticeably from the Thirtieth Dynasty onwards and continue

Kushites maintained a highly hierarchical administration discreetly supervised, in their absence, by the 'God's Wife' of Amun, a celibate princess offered in a symbolic marriage to the god. If certain important positions were entrusted to their own people, such as the first prophet of Amun, Horemakhet, son of King Shabaka, or the king's 'confidant' Irigadiganen, the Kushite kings did not hesitate to appoint Egyptian subjects who had joined their cause. We find the entire nobility of that period represented in the cachette, to such a degree that it is possible to reconstruct their family ties through several generations.

At their head is 'God's Wife' Shepenwepet II, a daughter of King Piye, followed by her great stewards Harwa and Akhimenru. Among the priesthood of Amun, the governor Montuemhat, even if no more than Fourth Priest, played an almost royal part, ruling the principality like a sovereign. His colleagues were the Second Priest Nesshutefnut, a son of King Taharqa, and, particularly, the Third Priest Petamunnebnesuttawy, who was the

to do so through all the Ptolemaic Period, they represent only the priestly personnel of the temple of Amun, who maintained no ties with the royal family and kept aloof from political events. The rather limited interest which this copious material, for the most part unpublished, offers from an artistic point of view is largely made up for by the inscriptions covering the great majority of the statues. Apart from some autobiographical sequences in the traditional style, these texts offer essentially genealogical information: proper names abound, accompanied by various titles conveying an idea of the great variety of cults practised in the celebrated sanctuary of Amun. Dynastic lists, sometimes rather elaborate, bring entire families to life before our eyes. On more than one occasion links can be made between such documents so as to create a multi-generational family tree. Finally, there are passages of religious or funerary content, consisting of prayers addressed to Amun and his ancestors, as well as appeals to the living in which the statue's owner exhorts

the passer-by to pronounce some pious prayer in his favour.

The chronological information yielded by this mass of sources is limited by the absence of royal names. Lacking relatively secure criteria to establish dates, almost all the statues are unable to contribute to the study of the political, institutional and religious history of Thebes between the Thirtieth Dynasty and the Roman conquest.

For this material to be useful in such studies it will be necessary to search all dated contemporary sources, above all the demotic papyri, in the hope of finding a mention of one or other of the figures who dedicated the statues. Some encouraging results are already beginning to emerge. The rather ordinary block statue of a certain Irethorru is suddenly transformed into an important historical document as it appears to have been donated by his son who, according to a dated graffito from the third year of Philip Arrhidaeus (323–316 BC), supervised important architectural work in the Temple of Luxor. Likewise, thanks to a

demotic papyrus of 212 BC in which its owner is named, another similarly unspectacular block statue becomes significant evidence of the decline of Theban art under Ptolemy IV.

There is still a long way to go before the material which Georges Legrain extracted from the Karnak Cachette has yielded its entire contribution to the progress of Egyptological studies. But in the light of what it has already contributed, we can do no better than end with the enthusiastic assessment pronounced by Gaston Maspero when he viewed the excavations:

'Since the discovery of the Serapeum by Mariette, nobody has brought to light so much material of such importance in one single stroke.'

BIOGRAPHY

Herman De Meulenaere *was born in Bruges in 1923. He began his long career at the Musées Royaux d'Art et d'Histoire in Brussels in 1963, gaining increasing responsibility and eventually being appointed to the important position of Chief Conservator in 1984, until his retirement in 1988.*

His teaching career proceeded in parallel, from his early days as an assistant in 1963 through to his appointment to the chair of Egyptology at the University of Ghent in 1973 and eventually to an Honorary Professorship at the same institution in 1988.

Director of the Comité des Fouilles Belges en Égypte from 1966 to 1988, he has contributed to the principal specialist periodicals in the field. He has been the director of the Fondation Égyptologique Reine Elisabeth in Brussels since 1965.

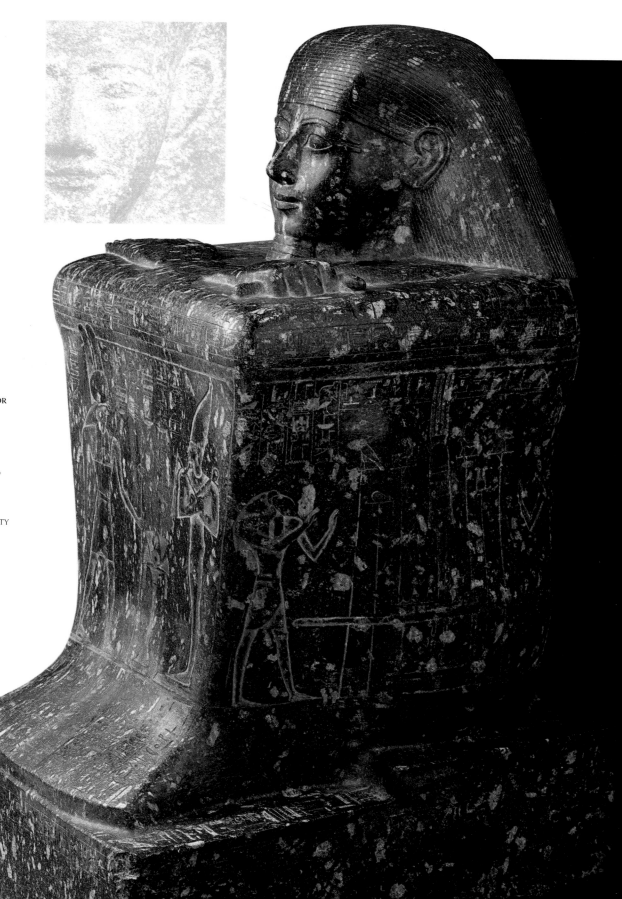

340 AND 341 LEFT
BLOCK STATUE
OF IRETHORRU,
SON OF NESINEHERET
JE 37989
BLACK GRANITE
HEIGHT 26 CM
KARNAK, TEMPLE OF
AMUN-RE, COURTYARD
OF THE CACHETTE
GEORGES LEGRAIN'S
EXCAVATIONS (1904)
LATE PERIOD
(6TH–4TH CENTURY BC)

341 RIGHT
BLOCK STATUE OF HOR
JE 36575 = CG 42226
BLACK GRANITE
WITH INLAYS
HEIGHT 109 CM
KARNAK, TEMPLE OF
AMUN-RE, COURTYARD
OF THE CACHETTE
GEORGES LEGRAIN'S
EXCAVATIONS (1904)
TWENTY-THIRD DYNASTY
REIGN OF PEDUBASTE
(828–803 BC)

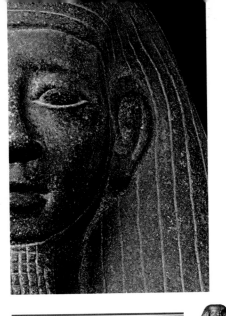

STATUE OF THE FATHER OF THE VIZIER ANKHU

GREY GRANITE; HEIGHT 115 CM
KARNAK, TEMPLE OF AMUN-RE, COURTYARD OF THE CACHETTE
G. LEGRAIN'S EXCAVATIONS (1904)
END OF TWELFTH–EARLY THIRTEENTH DYNASTY (18TH CENTURY BC)

This stately figure is represented sitting on a chair with a low back and resting his feet on a projecting base. The pose belongs to the classic Middle Kingdom tradition, with both hands placed on the knees, the left flat and palm down, the right closed and placed horizontally, holding a piece of cloth. A striated wig with no parting covers his head and widens as it descends to cover the width of the shoulders. The figure wears a long kilt made of a sheet of cloth wrapped round the body and covering it to just under the breast. It has a flap crossing over the front. This type of costume was generally worn by viziers.

We do know that the son of this figure was the Vizier Ankhu, who probably lived early in the Thirteenth Dynasty. His father, named as such in the inscription incised on the seat, may have held the same position between the end of the Twelfth and the beginning of the Thirteenth Dynasty.

His regular, oval face has narrow eyes surmounted by eyebrows in slight relief and his eyelids are slightly lowered. His nose is straight and his small mouth is framed by shallow lines. A broad and ornate false beard completes the face. Only traces of the tendency towards realistic reproduction of facial features that characterized much of the statuary of the Twelfth Dynasty are found here. A traditional offering verse is inscribed on the seat either side of the legs.

As was frequently the case in portrayals of high-ranking Middle Kingdom figures, this statue was not found in the tomb of its owner, but must have been an offering dedicated in the temple of Amun-Re at Karnak, where it was found by Legrain at the turn of the century as part of the Karnak Cachette. (R.P.)

BLOCK STATUE OF SENENMUT WITH NEFERURE

GREY GRANITE; HEIGHT 130 CM
KARNAK, TEMPLE OF AMUN-RE, COURTYARD OF THE CACHETTE
G. LEGRAIN'S EXCAVATIONS (1904)
EIGHTEENTH DYNASTY, REIGN OF QUEEN HATSHEPSUT (1473–1458 BC)

One of most original sculptural types produced in ancient Egypt, the block statue is found in extremely varied forms over the course of Egyptian history.

This statue is of Senenmut, the high-ranking dignitary of Queen Hatshepsut, who is holding the princess Neferure in his arms. Only the head of the child, with the cap and braid of infancy, is visible.

One of the numerous titles held by Senenmut was 'Tutor of Neferure'; he was also the architect of Hatshepsut's most important buildings, both at Deir el-Bahri and Karnak. In exchange for his services Senenmut was rewarded with prestigious monuments and privileges, and numerous statues of him have survived. According to the long inscription on this example, his statues had the honour of being placed in the temples following those of the queen.

It is probable that Senenmut abused his power and that at a particular point in the reign of Hatshepsut he fell into disgrace, as demonstrated by the damage done to most of his monuments. It is likely that the nose of this statue is missing as a result of a deliberate act that aimed to prevent the 'living image' of the official continuing to breathe.

Senenmut's face is carved according to the same stylistic and aesthetic canons used for the statues of the queen, with delicate features, large almond-shaped eyes, a slim nose and a small mouth with a slight smile. In ancient Egypt it was normal for the style of private statuary to follow closely that of royal sculptures. The official is wearing a large wig that spreads over his shoulders but leaves the ears exposed.

The statue is covered with inscriptions. A vertical column of text is carved on the large dorsal pillar created in the form of the backrest of a low throne. It contains the ritual phrase relating to figures honoured in the presence of the gods, in this case Ptah and Sokaris. Four vertical columns are inscribed on either side of the head of Neferure. The internal columns contain the title and name of the princess, 'Divine Bride, Neferure, right of voice, beloved of Amun', and the title of Senenmut in relation to the princess, 'Father and great tutor of the royal daughter, beloved of Amun'. The external columns contain two cryptograms of the names of the queen that Senenmut claims to have composed himself. Finally, fourteen horizontal lines are inscribed on the front of the statue (the first of which is horizontal, following the line of the folded arms), containing the long list of Senenmut's titles, his activities and most important royal concessions. (R.P.)

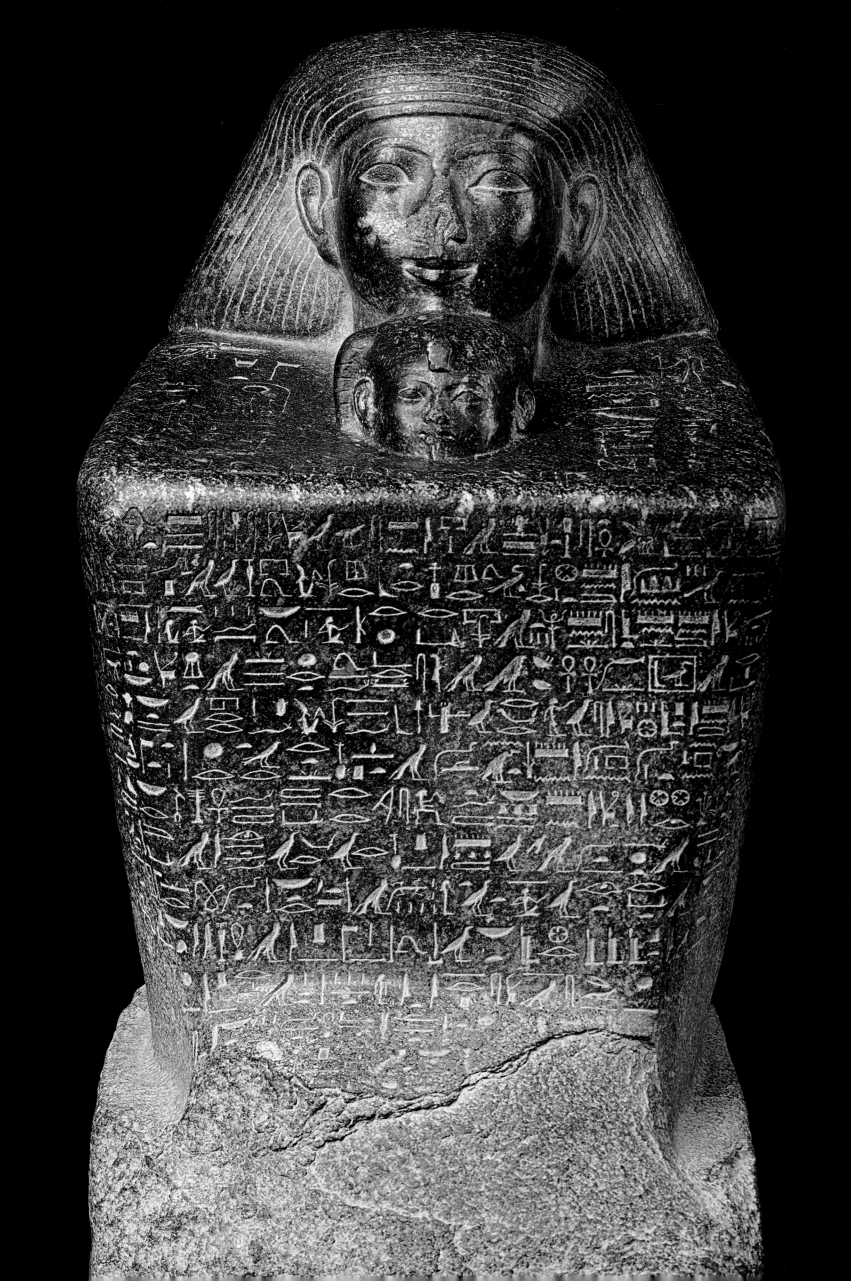

JE 36574 = CG 42126

STATUE OF SENNEFER
AND SENAY

GREY GRANITE; HEIGHT 120 CM
KARNAK, TEMPLE OF AMUN-RE, COURTYARD OF THE CACHETTE
G. LEGRAIN'S EXCAVATIONS (1903); EIGHTEENTH DYNASTY
REIGNS OF AMENHOTEP II (1427–1401 BC) AND THUTMOSE IV (1401–1391 BC)

This sculpture depicts a married couple seated beside each other on a broad seat that has a high backrest and a base projecting at the front. Sennefer is sitting to the right of his wife. He is wearing a neat wig with flaring sides that leaves his ears exposed and around his neck are four collars consisting of ring-beads that in reality would have been made of gold. These are honorary decorations – the *shebyu* or 'gold of honour' awarded to those who had particularly distinguished themselves in their duties. In this case the reward was given to Sennefer as mayor of Thebes, a title that appears in the statue's inscriptions.

Sennefer is also wearing a necklace with a double amulet in the form of a heart which had an apotropaic value. His wrists and ankles are decorated with bracelets. His long kilt reaches to his ankles and is knotted at the waist where a loop of cloth emerges. His chest is sunken and the torso is furrowed with folds of fat, a sign of well-being and the sedentary lifestyle of someone unaccustomed to manual labour. Two cartouches of the pharaoh Amenhotep II are incised on Sennefer's right shoulder.

Sennefer's wife, the royal wet-nurse Senay, has a long three-part wig with thin braids that leaves her ears exposed. She is wearing a necklace composed of multiple strands and a tight tunic that reaches her ankles and has two broad shoulder straps that cover her breasts.

The faces of the two figures have almost identical features (although the oval shape of Senay's is slightly narrower than her husband's): well-defined almond-shaped eyes and eyebrows in relief, a straight nose with a rather wide base, and a small, full mouth. A column of texts down the front of their clothes contains the names and titles of the two figures.

One of the couple's children, Mutnofret, is shown on a much smaller scale standing on a small base between the pair. Her face is damaged. Mutnofret has a three-part wig with braids reaching her chest. Her robe too has an inscribed column of hieroglyphs recording her name. She is also represented in relief on the right-hand side of the chair, kneeling before a table of offerings. Her sister Nefertari is shown in the same pose on the opposite side of the chair. The location the statue was found in is a mark of the great prestige of the couple, who had the honour of placing a statue of themselves in the temple of Amun-Re, alongside those of their rulers. (R.P.)

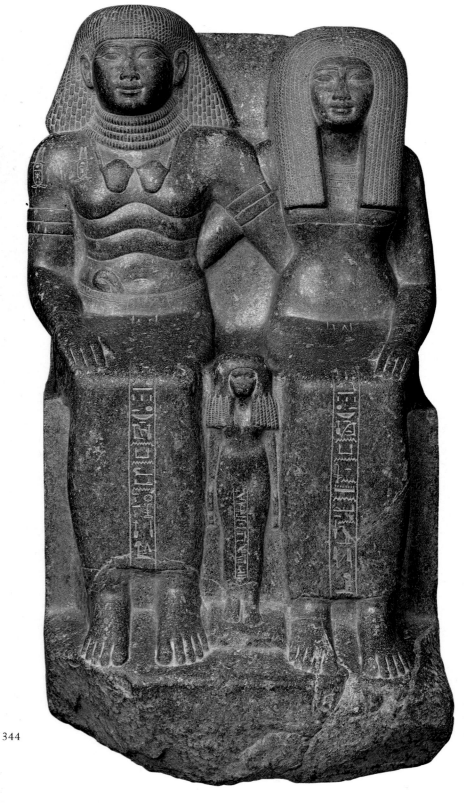

JE 38234 bis = CG 42053

STRIDING STATUE OF
THUTMOSE III

GREYWACKE; HEIGHT 200 CM
KARNAK, TEMPLE OF AMUN-RE, COURTYARD OF THE CACHETTE
G. LEGRAIN'S EXCAVATIONS (1904)
EIGHTEENTH DYNASTY, REIGN OF THUTMOSE III (1479–1425 BC)

The king is depicted pacing with his arms held at his sides. At the rear, the uninscribed dorsal pillar supports the figure and tapers upwards from the base to the top of the headdress. The king is wearing the White Crown of Upper Egypt with a cobra on the forehead and the *shendyt* kilt held by a belt, the buckle of which carries the coronation name of the pharaoh: 'Menkheperre, perfect god, lord of the rituals, blessed with eternal life'.

The king's face in part recalls the solemn style of Hatshepsut, but to some extent also breaks away from it, with greater emphasis placed on the physiognomy. The eyes, decorated with the usual cosmetic lines, are narrower, the nose more hooked, the mouth more rigid. The body is slim, with the musculature emanating a sense of great physical strength even though it is not accentuated and deliberately rigid.

Below the feet of the king, to emphasize his great military successes against foreign enemies, are inscribed the Nine Bows, four below the right foot, five below the left. The bow symbolizes foreigners, the number nine represents the plural of the plural, that is to say three times three (the number two for the ancient Egyptians was dual and not plural). In this way the Egyptians expressed the victory of the pharaoh over all the enemies of Egypt.

The statue seen here was undoubtedly part of a group of extremely fine sculptures that decorated the rooms of the 'Akh Menu', the festival hall that Thutmose had built at Karnak. An inscription on the base alongside the left foot of the king reads: 'The perfect god, lord of the rituals, Menkheperre, beloved of Amun-Re who presides at Akh Menu'. (R.P.)

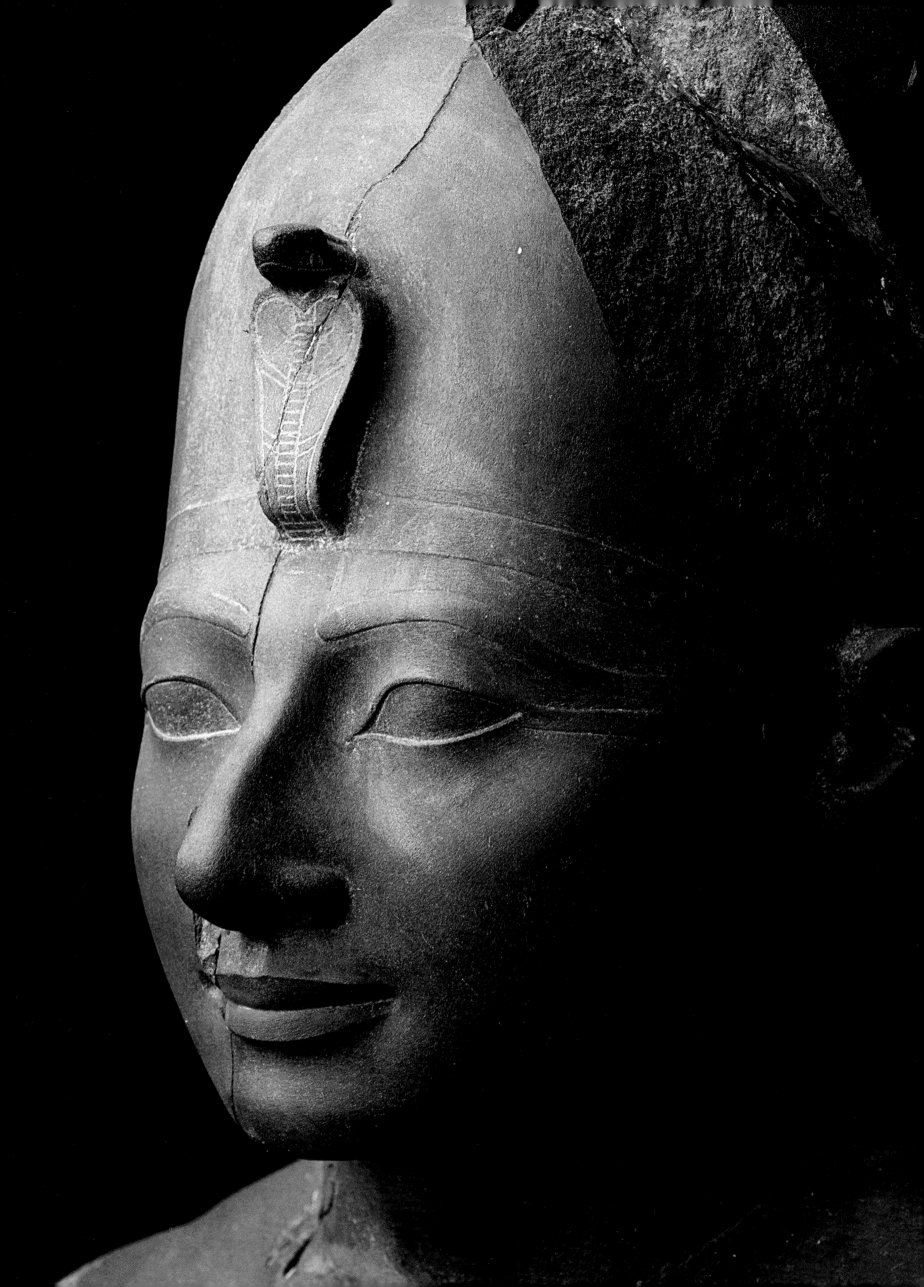

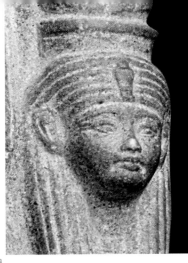

JE 36988 = CG 42194

STANDARD-BEARER STATUE
USURPED BY SHESHONQ

GREEN BRECCIA; HEIGHT 48 CM
KARNAK, TEMPLE OF AMUN-RE, COURTYARD OF THE CACHETTE
G. LEGRAIN'S EXCAVATIONS (1903–1904)
LATE EIGHTEENTH DYNASTY (14TH CENTURY BC)
AND TWENTY-SECOND DYNASTY, REIGN OF OSORKON II (924–909 BC)

This statue, of which the lower part of the legs is missing, represents a walking male figure holding a staff in his left hand which is topped with the head of a female deity. The goddess wears a three-part wig with a cobra on the forehead, surmounted by a headdress from which rises a pair of cow's horns with a solar disc. The goddess could be identified either as Hathor or Isis, who, from the middle of the Eighteenth Dynasty, had begun to assume aspects of the iconography of Hathor.

The male figure wearing a two-part wig. His face is full with elongated eyes enclosed within heavy eyelids and emphasized by strongly arched eyebrows. The nose is thin and straight and the mouth is full with down-turned corners and dimples at the ends. Around his neck are two necklaces in the form of collars known as the 'gold of honour', an award bestowed on those who had particularly distinguished themselves in actions to the benefit of the state. His clothing consists of a tunic with ample pleated sleeves and a loose pleated skirt knotted at the waist and decorated at the front with a triangular panel. The arms and wrists are adorned with bracelets. The right hand is gripping a piece of cloth.

The style, facial features and clothing suggest a date in the late Eighteenth Dynasty, but the dorsal pillar carries an inscription identifying the figure as 'The First Priest of Amun-Re, King of Kings, the supreme commander of the army, the prince Sheshonq, justified, son of the Lord of the Two Lands, Osorkon *Meryamun*'. The inscription thus reveals that the sculpture was reused at a later date, probably for the cult of Sheshonq after his death, given that the epithet 'justified' is placed after his name.

A series of modifications can be dated to the time the statue was reused. The figures of Amun-Re and Osiris were inscribed on the torso and on the triangular panel of the kilt, from which the fine pleats were erased. The damaged right sleeve of the tunic was repaired at the same time, a new piece of stone being attached with a dovetail joint. The left hand must also have been damaged as it was remodelled and is today shorter than it was originally. This second piece of restoration was executed with less care than the first.

No modifications to the facial features were necessary in order to appropriate the statue to Sheshonq. The simple fact that the original inscription on the dorsal pillar had been erased and a new name inscribed was all that was needed to provide the sculpture with a new identity. (F.T.)

BLOCK STATUE OF NAKHTEFMUT

LIMESTONE; HEIGHT 42 CM
KARNAK, TEMPLE OF AMUN-RE, COURTYARD OF THE CACHETTE
G. LEGRAIN'S EXCAVATIONS (1904)
TWENTY-SECOND DYNASTY (945–712 BC)

This sculpture portrays Nakhtefmut, the son of Djedkhonsufankh, seated on a low step with his legs brought up to his chest in the traditional block statue pose. The position of the arms is, however, unusual. Instead of being crossed on the knees, they are placed to the sides of the legs. The hands, which are carved free of the rest of the figure, are holding the shoulders of the god Ptah who stands in front of the figure.

Nakhtefmut is wearing a long, striped wig that falls low over his forehead but leaves his ears exposed. The wig descends obliquely to cover the full width of the shoulders. The smiling face has almond-shaped eyes which are extended to the temples by cosmetic lines. These eyes and the small, delicate nose are reminiscent of the portraiture of the time of Hatshepsut, and in particular certain statues of Senenmut. A short beard links Nakhtefmut's chin with the horizontal block that constitutes a kind of extension backwards from the dorsal pillar of the god.

The mummiform figure of Ptah shows him holding a *djed* pillar in his hands, which emerge from his bandages. He wears the usual cap on his head and a long ritual beard. The block statue with a divine figure resting on the feet of the subject of the sculpture appeared in Egypt during the Ramesside era, although no examples of particular note belong to this period. Following the Twenty-second Dynasty, another example of the genre is provided by the statue of Harwa, the great chief steward of the Divine Adoratrice Amenirdis I, daughter of Kashta and sister of Piankhi. (R.P.)

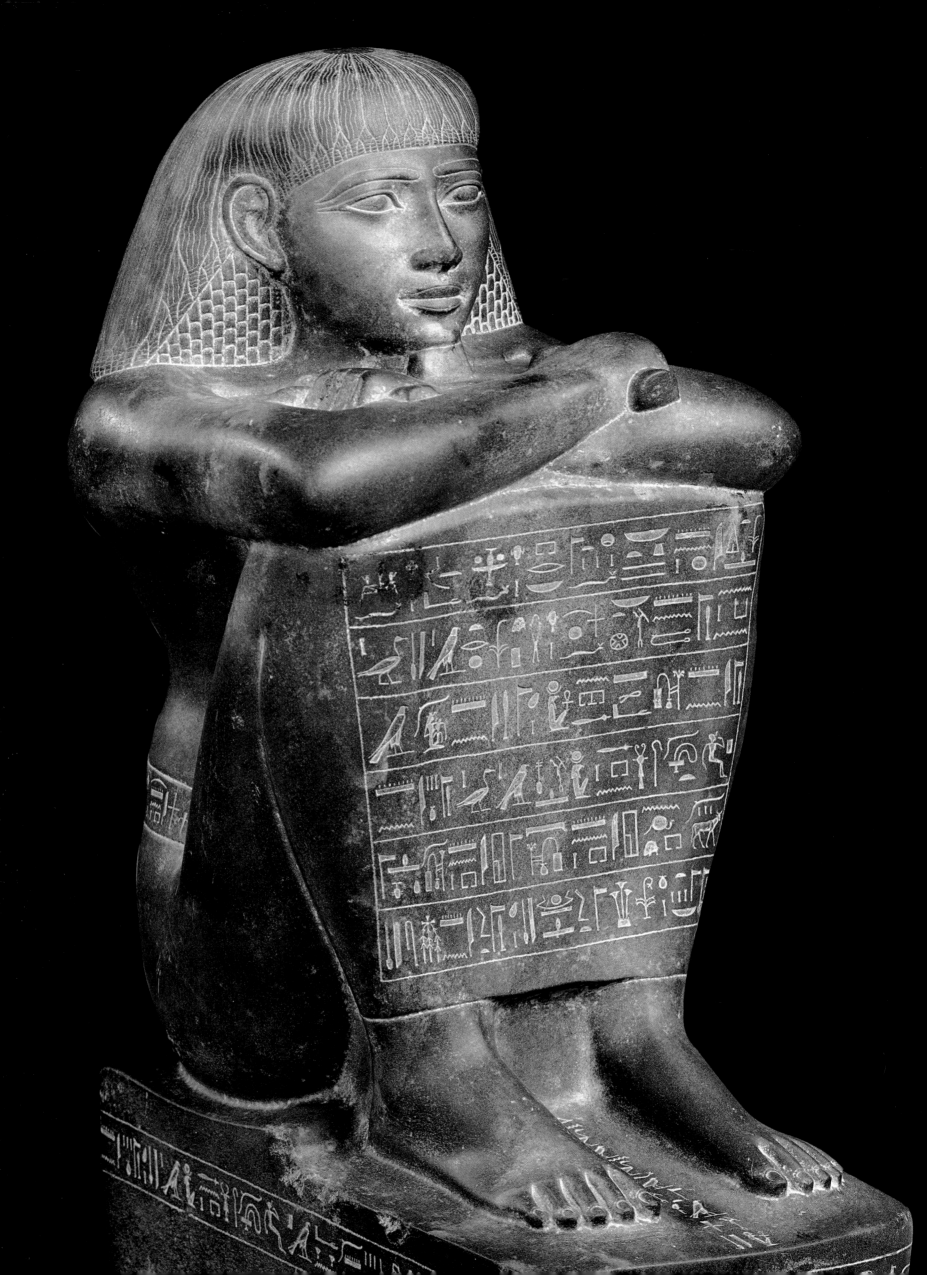

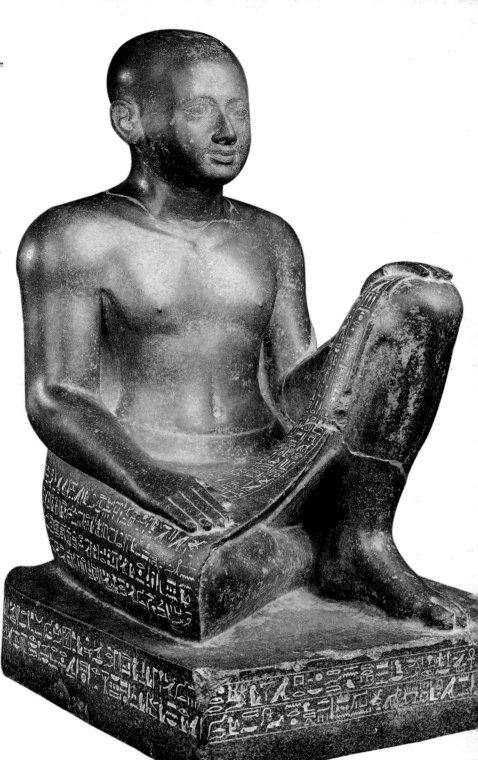

STATUE OF THE VIZIER HOR

BASALT
HEIGHT 96 CM
KARNAK, TEMPLE OF AMUN-RE, COURTYARD OF THE CACHETTE
G. LEGRAIN'S EXCAVATIONS (1904)
TWENTY-SECOND DYNASTY (945–712 BC)

The vizier is seated on a rectangular base with rounded rear corners. The asymmetrical position of the legs, the left folded to the chest and the right resting on the ground at right angles to the other, is rather unusual. This form appeared sporadically in the Old Kingdom and was sometimes revived during the New Kingdom – this statue can be compared with the one portraying Senenmut holding the infant Neferure. The pose is also documented in a number of later sculptures, such as two statues of the steward of Amenirdis I, Harwa (Twenty-fifth Dynasty), and one of the courtier Bes (Twenty-sixth Dynasty).

Hor is wearing a short kilt that is completely covered with inscriptions containing the name and titles of the high-ranking dignitary and his father, the priest Iuatjek. His head is shaved and his rather protruding ears frame a regular face with delicate features and a serene gaze. The eyebrows are shown in very low relief and continue the line of the straight nose. Two shallow lines on either side of the small, smiling mouth delimit the rounded cheeks. The slim neck rests on broad and carefully modelled shoulders with the rather long collarbones traced in relief.

The rest of the torso is more stylized and narrows considerably to the waist, where a broad belt holds up the kilt. Less attention seems to have been paid to the arms and legs, which appear rather large and poorly proportioned. There is no dorsal pillar.

The position of Hor, his shaved head and the absence of a dorsal pillar reveal the artist's clear intention to revive archaic models dating back to the Old Kingdom, to which the sculpture of the Late Period frequently referred. (R.P.)

BLOCK STATUE OF HOR, SON OF ANKHKHONSU

SCHIST; HEIGHT 51 CM
KARNAK, TEMPLE OF AMUN-RE, COURTYARD OF THE CACHETTE
G. LEGRAIN'S EXCAVATIONS (1904)
TWENTY-FIFTH DYNASTY (770–712 BC)

This superb sculpture was discovered intact in the enormous deposit which contained literally thousands of statues and bronzes that had once decorated the temple of Amun-Re at Karnak. They had probably been placed in this pit during the Ptolemaic period. The figure portrayed here is called Hor. He was a priest of Montu, the falcon-headed god of Armant, who,

prior to being replaced by Amun-Re, had been the principal god of Thebes. Although his importance had diminished considerably, Montu continued to be known as the 'Lord of Thebes', as testified by the inscription incised on the front of this statue. The genealogy of Hor himself is also carved on the statue. From this we learn that his family had been indissolubly

associated with priestly functions at Thebes for at least five generations.

Hor is portrayed in the classic block statue format, a type of sculpture that first appeared during the Middle Kingdom and reappeared at intervals throughout subsequent pharaonic history. The very choice of this type of statuary is indicative of a tendency towards archaism that is one of the most characteristic elements of art in general during the Twenty-fifth Dynasty.

This revival of forms and styles from previous ages was part of the attempt by the dynasty of Nubian kings (who ruled Egypt at this time) to affirm the legitimacy of their claim to the throne through the use of a formal language inspired by the purest Egyptian traditions.

Apart from the classic Middle Kingdom pose, another reference to the past in this statue of Hor is the use of the double wig, which recalls models in vogue during the New

Kingdom. But rather than being simply slavish imitations we can also discern in these multiple references a kind of learned reworking of archaic models. This is demonstrated by the fact that the block statue is not composed as a compact geometric unit as the classical conventions would demand, but is a more naturalistic representation of the body of the individual. This constitutes an overt declaration that the artist was not only aware of the historical prototype from which he drew his inspiration, but also the origins of this model itself; that is to say, a seated figure with the knees drawn tightly to the chest. Thus, in contrast with other works of the genre, rather than enclosing the body of the individual within a compact composition, the figure of Hor emerges in this block statue in a series of curved planes that render the sculpture vibrant and full of tension. (F.T.)

STATUE GROUP OF MONTUEMHAT AND HIS SON NESPTAH

BLACK GRANITE; HEIGHT 34 CM
KARNAK, TEMPLE OF AMUN-RE, COURTYARD OF THE CACHETTE
G. LEGRAIN'S EXCAVATIONS (1904)
LATE TWENTY-FIFTH–EARLY TWENTY-SIXTH DYNASTY (MIDDLE OF 7TH CENTURY BC)

This sculpture, of which only the upper half survives, portrays the well known functionary Montuemhat with his son Nesptah, seated on a chair with a high rounded back which is in the form of a stela. That the two men were seated is demonstrated by the position of the partially visible forearm of the right-hand statue.

The two figures are differentiated by a few details. Montuemhat, seated on the viewer's right, is slightly taller than his son and his face is a little wider. His robe also has a more accentuated fold on the chest. Otherwise the two figures are identical. They both wear long wigs striped with narrow parallel incisions. The wig has no parting and leaves their ears exposed. They are also both wearing a leopard-skin garment, a priestly vestment that crosses the torso diagonally from the left shoulder to the right side. The leopard skin is decorated across the chest with a diagonal band containing the titles and names of the two figures. Around their necks each wears a chain from which hangs a Hathor-head amulet.

At the top of the back of the dorsal slab a winged solar disc hovers above two offering scenes. Depicted on the right is Montuemhat, standing with his arms raised in a gesture of prayer and making offerings to Amun, Horakhty and Atum. On the left is Nesptah, portrayed in the same pose making offerings to Osiris, Isis and his father Montuemhat. The lower part was occupied by hieroglyphic texts.

Statuary groups portraying two males are relatively rare in Egyptian art, except during the Old Kingdom. In that period, however, the two human figures represented the same person, portrayed twice, while from the New Kingdom there is the example of the vizier Hor and the First Priest of Ptah, Pahemnetjer.

This particular sculpture, dating from the period between the Twenty-fifth and Twenty-sixth dynasties, can be compared with others representing male statuary groups within a stela-naos, of which a number of examples are known dating from the Twenty-sixth and Twenty-seventh dynasties. An interesting parallel can be drawn with the group composed of the governor of the Saite nome, Wahibre, and his father Padihorresnet, depicted in high relief within a naos, the rear surface of which is inscribed with texts and scenes of offerings to the ancestors.

The same feature is also found on many sculptures from the Persian Period onwards, with long and on occasion fake genealogies inscribed on the statues and stelae of private individuals. The sculptural group of Montuemhat and Nesptah may perhaps even represent the prototype of this genre of statuary. (R.P.)

STATUE OF THE SCRIBE NESPAQASHUTY

SCHIST; HEIGHT 78 CM
KARNAK, TEMPLE OF AMUN-RE, COURTYARD OF THE CACHETTE
G. LEGRAIN'S EXCAVATIONS (1904)
TWENTY-SIXTH DYNASTY, REIGN OF APRIES (589–570 BC)

This statue portrays the vizier Nespaqashuty sitting cross-legged, with his fingers curled round the upper edge of a papyrus open on his legs. This is one of the variations on the scribal pose, according to Jacques Vandier's classification. It differs from the true scribe statue, which shows the subject with a stylus held in the right hand.

The vizier wears a geometrically striped wig with no parting that leaves the ears uncovered and falls to his shoulders. He is wearing a short kilt with a broad belt around his waist. A line of hieroglyphs runs around the base of the statue with the name and titles of the figure.

The face is extraordinarily sophisticated. The slim oval is lightly modelled into depressions that create delicate shadows on the polished surface. The relief eyebrows are elongated towards the temples and the lines of the thin nose and the barely protruding cheekbones create a kind of frame around the long, narrow eyes. The rather large mouth is set in a delicate smile.

While the broad shoulders, the prominence of the collarbones and the well-defined pectorals clearly reproduce the style of the Old Kingdom, the curve of the torso towards the slim waist and the unnatural breadth of the hips set this sculpture well apart from older models.

This statue is immediately identifiable as the product of the Saite period, through the choice of stone, the surface treatment, and the rendering of the details (note, for example, the precision of the vertical columns of text incised on the papyrus). This work exemplifies the tendency of Twenty-sixth Dynasty art to reappropriate the cultural and artistic traditions of previous ages but then to render them in its own distinctive style. (R.P.)

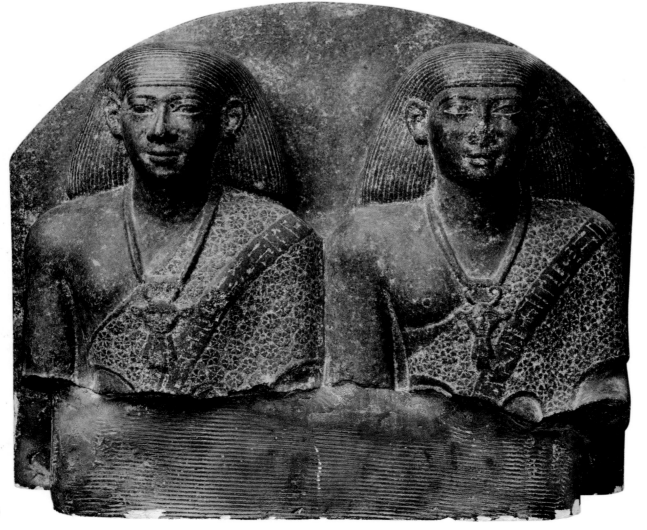

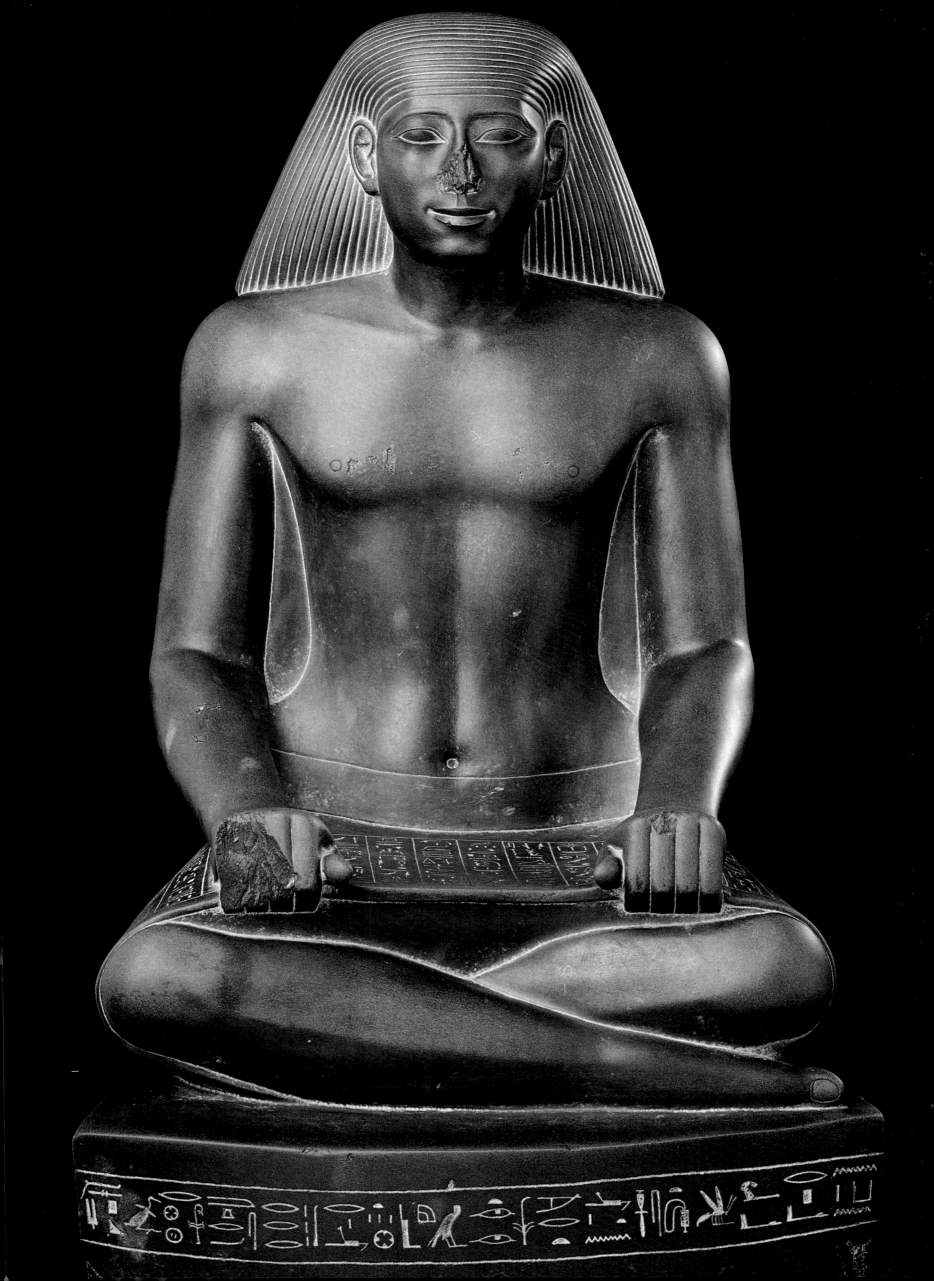

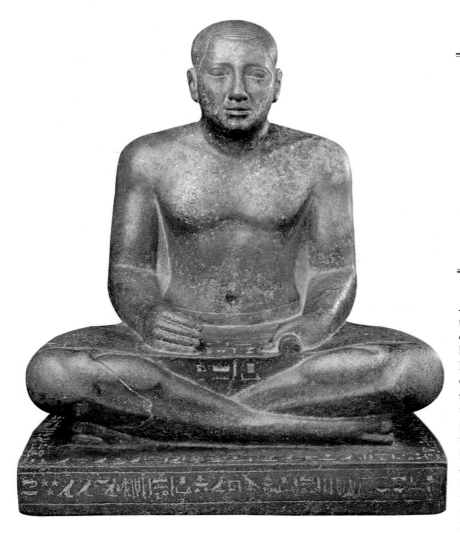

JE 37341

STATUE OF PETAMENHOTEP
AS A SCRIBE

QUARTZITE
HEIGHT 74 CM
KARNAK, TEMPLE OF AMUN-RE, COURTYARD OF THE CACHETTE
G. LEGRAIN'S EXCAVATIONS (1904)
EARLY TWENTY-SIXTH DYNASTY (SECOND HALF OF 7TH CENTURY BC)

This sculpture portrays the High Priest Petamenhotep as a scribe, in the traditional pose dating back to the Fourth Dynasty. He is seated on the ground with his legs crossed. In his right hand he would once have held a stylus while his left supports the papyrus scroll. It is not only the pose, but the overall impression of this sculpture that suggests a deliberate revival of ancient prototypes and their reworking to suit the demands of the time. This was a tendency found in all forms of art between the end of the Third Intermediate Period and the beginning of the Late Period.

Petamenhotep has a short, neat hairstyle, very similar to that of many private sculptures of the Old Kingdom. His hair is rendered in very low relief on the surface of the head and carved with incised lines. While the oldest scribal statues

usually wear a flaring wig with a central parting, an interesting statue of a scribe from the Fifth Dynasty has a hairstyle very similar to that of Petamenhotep. The modelling of the torso reveals the characteristic precision and cleanness of Saite sculptures: a slim physique, shallow depressions dividing the torso, and polished surfaces.

Petamenhotep is wearing a short kilt with a belt at the waist. The legs are carefully sculpted, with the musculature clearly delineated and detailed. The feet are not entirely concealed and are depicted with greater accuracy than in other statues of the same type.

The scribe is set on a low base incised with texts. Petamenhotep, the owner of the largest tomb at Assasif (TT 33), is also known for his numerous stone *shabti* figures, dispersed in Egyptian collections throughout the world. (R.P.)

BLOCK STATUE OF AHMES,
SON OF PAKHARKHONSU

BASALT
HEIGHT 70 CM; WIDTH 30 CM; DEPTH 41 CM
KARNAK, TEMPLE OF AMUN-RE, COURTYARD OF THE CACHETTE
G. LEGRAIN'S EXCAVATIONS (1904)
TWENTY-SIXTH DYNASTY (664–525 BC)

Among the hundreds of statues discovered by Legrain during the excavation of the deep pit in the courtyard in front of the Seventh Pylon of the Temple of Amun-Re at Karnak, many portrayed a seated or crouching figure. The choice of a static pose was directly related to the function these sculptures were intended to perform within the temple. They were placed along the passages accessible to the faithful and represented the statue's owner in the act of awaiting the charity of those passing before him. As the inscriptions show, the reading of the hieroglyphic texts incised on the statue acted as a form of prayer for the deceased person represented. The pilgrim capable of reading would have performed a charitable act simply by pausing in front of the statue and pronouncing what was written. By invoking the name of the figure, his memory was thus perpetuated in the realm of the gods, allowing him to make conceptual use of any offerings, which were his nourishment in the eternal afterlife.

Many of these statues carry texts aimed directly at those passing before them, while others have simple offering verses or record an idealized version of the life of the person portrayed, emphasizing his greatest virtues.

Placing a statue of oneself within the temple was naturally a privilege reserved above all for those who performed some service directly for the god. This was the case with Ahmes, son of Pakharkhonsu, who held various priestly posts in the priesthood of Amun-Re.

This sculpture of him is a classic block statue. The geometrical qualities of the composition and the polishing of the surfaces are characteristic of the Twenty-sixth Dynasty, the period during which the work was produced.

Ahmes is seated on a cushion and is wrapped in a robe that covers even his feet. His arms are resting on his knees and project slightly from the upper surface of the cube. His right hand is gripping an object

that is very similar to the hieroglyph signifying his role as a priest (which in Egyptian is equivalent to the term 'servant' of a god). Seen from the front, the shape formed by the legs is balanced by the smaller shape of the head, enclosed within a headcloth that falls behind the ears. The facial features are highly stylized. The mouth is set in a slight smile while the chin is adorned with a short beard. (F.T.)

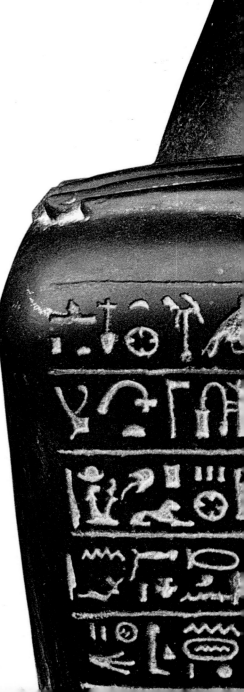

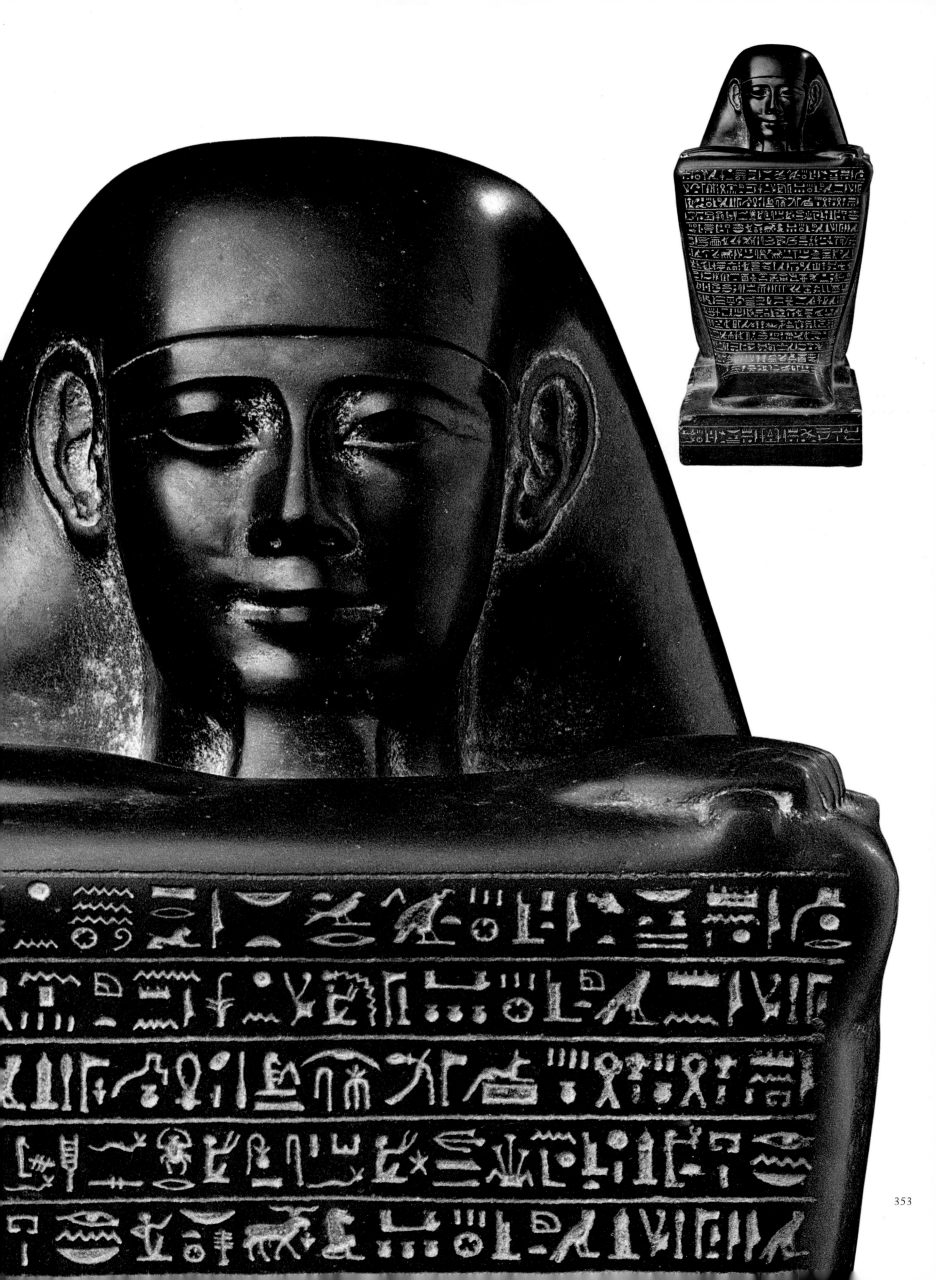

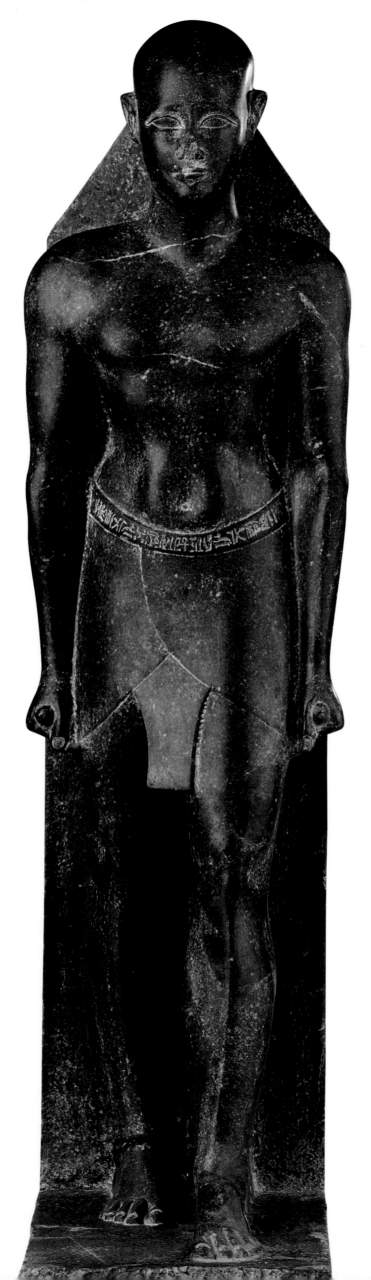

STATUE OF AHMES, SON OF NESBANEBDJED

SCHIST; HEIGHT 95 CM
KARNAK, TEMPLE OF AMUN-RE, COURTYARD OF THE CACHETTE
G. LEGRAIN'S EXCAVATIONS (1904); LATE THIRTIETH DYNASTY–
EARLY PTOLEMAIC PERIOD (SECOND HALF OF 4TH CENTURY BC)

This statue, designated with the excavation number 197, is one of the most interesting of the sculptures discovered by Legrain in the Karnak Cachette. It portrays the 'Divine Father and Priest' Ahmes in the traditional male pose, striding with his arms held at his sides and his fists closed around cylindrical objects. The figure stands on a rectangular base with no inscriptions and is supported at the rear by a broad slab ending in a triangular top. This slab replaces the more common dorsal pillar and harmoniously frames the figure.

Ahmes has a shaved head that highlights his high forehead and the elongated rear of his skull. The well-proportioned and fairly flat ears are very high up on the head, and the lobes are on the same level as the eyes. This detail is very noticeable when the statue is seen in profile, but is almost imperceptible when observed from any other angle because the high forehead compensates for the anomaly.

The almost perfect oval of the face has large eyes traced with a thin cosmetic line and set in hollows delimited by eyebrows in low relief with slightly down-turned tips and shallow but visible cheekbones. The nose is unfortunately damaged but seems to have been regular in shape, while the small, fleshy mouth projects slightly. The slim neck is set on very broad shoulders with rounded musculature. The torso features a distinct three-part division (chest, stomach and abdomen) rendered by depressions delineating the pectoral muscles, the ribcage and the area around the navel.

The fairly rigid pose of the figure is further emphasized by the straight lines traced by the arms and legs. Ahmes is wearing a short, smooth *shendyt* kilt fastened with a belt. The belt is completely covered with an inscription recording the figure's name and titles. Further inscriptions occupy the dorsal slab and are accompanied by incised vignettes. On the back of the dorsal slab, the triangular surface at the top is occupied by two mirror-image scenes in which Ahmes is depicted in a kneeling pose, on the left before Osiris, and on the right before Amun. The scene is protected by a winged solar disc from which are suspended nine *ankh* symbols, hung in three rows. The text below is divided into seven columns and contains the titles of the figure, 'Priest of Amun, of Amaunet, Sokar-Osiris, Amunipet and Khonsu Amunipet', as well as 'Divine Father, embalmer, divine purifier and governor of the nome of Memphis'.

The text also includes a series of biographical notes. The inscriptions on the sides of the dorsal slab contain the usual offering verses. Two further scenes with captions are incised in the area between the legs. Ahmes' eldest son is depicted on the right in a standing pose: 'His eldest son, beloved by him, priest of Osiris, Nesbanebdjed [the same name as the father of Ahmes], born of the lady of the house and sistrum player Tasheritmin'. On the left, Ahmes himself is depicted in a kneeling pose, above a fairly long text of sixteen lines containing the 'appeal to the living'.

This particular verse can be found incised on both funerary statuary and the sculptures that were dedicated to temple deities. The person who dedicated the monument expressed with this verse the desire that his colleagues and all the visitors to the temple, should recite the offering verse and therefore remember his name, receiving in return the intercession of the god to whom the statue was dedicated.

This statue is particularly significant because the biographical information it carries appears to suggest that the duties of its owner were in some way associated with the city of Armant and the bull Buchis, of whom Ahmes may have been one of the high priests. (R.P.)

STATUE OF PAKHNUM

SCHIST
HEIGHT 22 CM
KARNAK, TEMPLE OF AMUN-RE, COURTYARD OF THE CACHETTE
G. LEGRAIN'S EXCAVATIONS (1904)
PTOLEMAIC PERIOD (3RD–2ND CENTURY BC)

This statuette, of which the lower part of the legs is missing, portrays Pakhnum in a striding pose. The completely shaved head and the highly stylized facial features allow the small sculpture to be dated to the early Ptolemaic Period. The dorsal pillar with its triangular top confirms this dating and carries the name of the owner of the statue.

Pakhnum is wearing a long robe, with a strap over the left shoulder, fastened below the chest. The kilt, which would originally have reached to just below the knees, is loose and reminiscent of those in vogue during the Middle Kingdom.

The shaved head and the robe tied just below the armpits are typical features of Egyptian priestly dress. When, shortly after this period, Egyptian cults spread throughout the Mediterranean, these features continued to form part of the costume of priests. Remains connected with the cult of Isis found in Europe include a number of images of priests and initiates of the cult of the goddess that are comparable to this statue.

Pakhnum is holding his arms downwards and to the front; in his hands is a roughly square base on which a figure of Osiris stands. The god is shown in his customary style, mummiform and with an *atef* crown on his head and a false beard.

This type of statue showing a king or private individual holding an image of a god in front of himself is common in Egyptian art and several variations exist. The god is sometimes enclosed within a shrine and in other examples does not actually appear at all, being represented by an emblem (for example, Hathoric sistrums are very common). Normally the chosen god is also the deity of the shrine in which the statue of the private individual was dedicated. It is not surprising, however, that in this case Osiris rather than Amun-Re is represented. The temple of Karnak was principally dedicated to the Theban god, but also housed the cults of the other most important gods of Egypt. Among these was a small shrine dedicated to Osiris the 'Lord of Eternity' whom Pakhnum must have held in particular reverence. (F.T.)

From the time the Twenty-fifth Dynasty pharaohs ruled all of Egypt to the conquest of Egypt by Alexander the Great, the Late Period spans almost four centuries. If the period up to the arrival of the Romans in 30 BC is also included, it is the longest of the four major phases of pharaonic history and, in many ways, the most complex, as Egypt was confronted with the realities of the rapidly changing outside world. By the Twenty-sixth Dynasty, the pharaohs were already involved in trade with the Greek cities of Asia Minor, and they hired Greeks as mercenary soldiers.

In 525 BC the Twenty-sixth Dynasty was overthrown by the Achaemenid ruler of Persia. The Persians ruled Egypt, as the Twenty-seventh Dynasty, for more than a century, withdrawing in 404 BC. They were succeeded by two weak, short-lived native dynasties, the Twenty-eighth and the Twenty-ninth. Finally, in 380 BC, a strong Egyptian ruling family arose as the Thirtieth Dynasty. These were the last native pharaohs to rule Egypt. But, like their Twenty-sixth Dynasty predecessors,

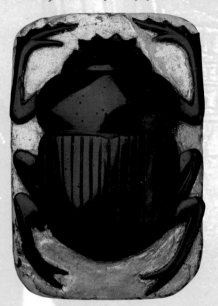

they were unable once more to withstand the Achaemenid Persians, who in 343 BC returned and drove the last king of the dynasty, Nectanebo II, out of Egypt and again seized control of the land. This time, however, their rule was short, for in 332 BC they were themselves expelled by Alexander the Great, whose takeover of Egypt may have been eased by the inhabitants' detestation of the Persians.

Alexander did not stay long in Egypt. But Egypt left its mark on him, especially by reinforcing his belief in his divine destiny, since he considered himself the heir to the Egyptian tradition of divine kingship and the son of the god Amun, to whose temple in the Siwa oasis he made a famous pilgrimage. In turn, Alexander shaped the course of Egyptian history for the next three centuries, by founding the Greek city of Alexandria on Egypt's

356 BACKGROUND
STATUE OF A FEMALE
GODDESS WITH COW'S
HEAD
CG 39134
BRONZE
HEIGHT 27.7 CM
SAQQARA, SERAPEUM
LATE PERIOD (712–332 BC)

356 LEFT
SCARAB
TR 15.1.25.44
GLASS PASTE, WOOD,
GOLD LEAF
LENGTH 11 CM
WIDTH 6.5 CM
PROVENANCE UNKNOWN
GRECO-ROMAN PERIOD
(332 BC–AD 311)

356 BELOW
STATUE OF WINGED ISIS
JE 38891
BRONZE
LENGTH 15 CM
PROVENANCE UNKNOWN
LATE PERIOD
(712–332 BC)

357 OPPOSITE
HEAD OF A KING
JE 28512
BLACK GRANITE
HEIGHT 46 CM
MENDES
(TELL EL-RUBA)
ACQUIRED IN 1888
PTOLEMAIC DYNASTY
(304–30 BC)

EDNA R. RUSSMANN

THE ART OF EGYPT DURING THE LATE PERIOD

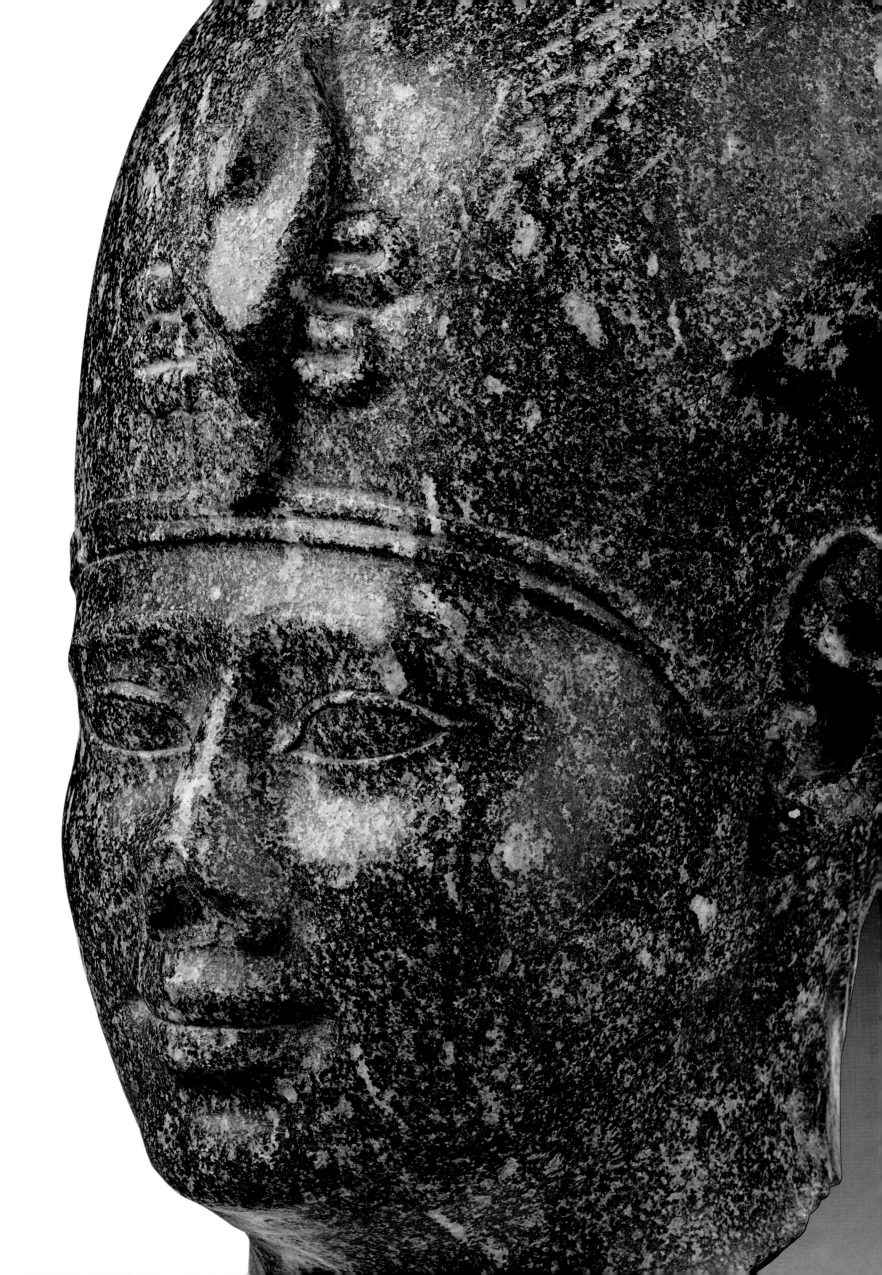

COFFIN OF PETOSIRIS
JE 46592
WOOD AND
GLASS PASTE
LENGTH 195 CM
HERMOPOLIS
(TUNA EL-GEBEL)
TOMB OF PETOSIRIS
GUSTAVE LEFEBVRE'S
EXCAVATIONS
(1919–1920)
PTOLEMAIC DYNASTY
(304–30 BC)

Mediterranean coast and, when he headed east for further conquests, by entrusting the rule of Egypt to a general and childhood friend named Ptolemy. Within thirty years, Alexander and his heirs were dead. In 305 BC, Ptolemy proclaimed himself king. Macedonian by origin and Greek by language, the Ptolemies were to rule Egypt for almost three centuries, until Cleopatra VII and her consort Mark Antony were defeated by Octavian (Augustus) in 30 BC.

It is frequently, but wrongly, assumed that Egypt's political weakness during the Late Period was reflected in an increasingly impoverished and sterile culture. In fact, there is a great deal of evidence that Egyptian culture remained strong and vital. It was during this period that Egyptian culture greatly impressed and influenced foreign visitors and immigrants, especially the Greeks. The Greeks were awed by Egypt's antiquity and, although they found certain beliefs and customs strange and even bizarre, they were perfectly willing to worship many of the Egyptian gods and to adopt specifically Egyptian practices, including the mummification of the dead.

The strength and vitality of Egyptian culture during the Late Period are reflected in its art. Late Period artists maintained the high standards of quality and workmanship achieved in earlier

periods. But they put their own stamp on the artistic traditions they had inherited, and they brought a new level of sophistication to Egyptian sculpture and reliefs. They valued elegance of form and beauty of surfaces, and they were capable of subtly understated effects.

These are not qualities that we usually associate with Egyptian art. Not surprisingly, they are often overlooked by modern viewers and, when noticed, are sometimes ascribed to Greek influence. But such qualities are purely Egyptian. They arose in the formative period of the Twenty-sixth Dynasty, at a time when Greek art was entering its Archaic stage.

The home of the Twenty-sixth Dynasty kings was the Delta city of Sais. The period of their rule, therefore, is often called the Saite Period, and the term 'Saite

renaissance' is sometimes applied to the art of this time. In several important respects, the Saite renaissance is the continuation of an artistic revival that had begun under earlier kings. From these predecessors, Saite artists inherited a strong interest in archaism – the emulation or imitation of art from earlier periods. But unlike Twenty-fifth Dynasty archaism, which emphasizes the sober strength of Old and Middle Kingdom art, the archaizing statues and reliefs of the Saite Period also reflect the delicacy and elegance found in the early works. They also reveal the influence of the highly idealized style of the early New Kingdom. Sculpture made for the Eighteenth Dynasty rulers Hatshepsut and Thutmose III and their followers probably inspired the distinctive sickle-shaped 'Saite smile', a feature that some scholars believe was the source of the 'archaic smile' on early Greek statues.

Egyptian sculptors had always been masters of the art of carving stone. Sculptors of the Twenty-sixth Dynasty matched their predecessors' skill, but they also had their own preferences. They favoured dark, fine-grained stones, such as greywacke, and they paid great attention to surfaces, finishing them in a manner designed to enhance the beauty of their colour and texture. This treatment gives many Saite statues a subtle, almost sensuous beauty, even when a subject is anything but beautiful, such as the apotropaic goddess Taweret.

Most Egyptian sculptures and reliefs of the Twenty-sixth Dynasty express an ideal, characterized by beauty of surfaces, elegance of form, and stylized, smiling faces. Towards the end of the dynasty, however, some statues were carved with portrait features. Portraits and portrait-like representations appear sporadically throughout the history of Egyptian art; they are one of the most striking aspects of Twenty-fifth Dynasty art. But Twenty-fifth Dynasty portraits have stern, even harsh expressions. Those made towards the end of the Saite Period combine a 'Saite smile' with the downward folds and furrows of advancing age, to produce an expression that often, as on the face of an official named Psamtek, seems curiously ambivalent.

The statue of Psamtek shows him under the protection of the goddess Hathor, in her nurturing manifestation as a cow. This symbolic representation was invented in the New Kingdom to express the special relationship between Hathor and the king; consequently, it was reserved for royal use. It is therefore interesting to find the symbolism extended, in the Late Period, to an official with no royal pretensions.

Psamtek's statue is unusual in other ways. It was part of a trio of statues, the other two being seated figures of Osiris and Isis. And, most remarkably, this set of statues was made for Psamtek's tomb. Throughout ancient Egypt's history, the tombs of royalty and of private people had been equipped with statues of the deceased. But in the Late Period, in Psamtek's time, this practice had been almost abandoned. Why this happened is not at all clear. Late Period tombs continued to be decorated with reliefs and hieroglyphic inscriptions, though these, like the reliefs of Horhotep and Neferseshem-Psamtek, were often confined to the doorway of a small chapel.

One consequence of these changes in funerary art is that almost all Late Period statues, whether they depict gods, kings or private people, were made to be placed in temples. The demise of tomb sculpture meant a greater emphasis on temple sculpture, and this must have affected such

359
STATUE OF A KNEELING
KING HOLDING A WEDJAT
EYE
JE 91436
BRONZE
HEIGHT 26 CM
SAQQARA
LATE PERIOD
(712–332 BC)

unclear, but a few isolated examples suggest that this was the case. The statue of a man named Psamteksaneith, which was apparently made during the Twenty-seventh Dynasty, has a portrait-like face with an enigmatic smile similar to those of such late Saite figures as the official Psamtek. And what appears to be a slightly later version of the idealized Saite face is found on a royal head. The head is anonymous, but it was found at Mendes, the Delta home and burial place of the Twenty-ninth Dynasty, and it is likely that it represents one of these obscure kings.

Art in the Thirtieth Dynasty continued to be based on Saite style, and it seems that the kings of this dynasty consciously tried to emulate in their monuments the achievements of the Twenty-sixth Dynasty. But theirs was not a slavish imitation, for Egyptian art was still a living tradition, and it continued to evolve. Thirtieth Dynasty statues and reliefs differ from their Saite prototypes in having somewhat fleshier faces and bodies, and a

statues in ways that are now difficult to perceive. For example, temples, though not really public areas, were obviously less secure environments than tombs. Fear of accidental damage may explain, in part, the Late Period preference for compact, relatively invulnerable statue forms, such as the block statue, and the fact that most Late Period statues were carved in hard stones rather than soft limestone or wood.

The predominance of temple sculpture also explains the scarcity in the Late Period of statues of women. The majority of ancient Egyptian statues of women come from tombs. Goddesses were of course represented in temples, and a relatively small number of temple statues of women show that such images were not banned. But it seems that high-born women did not ordinarily expose themselves to public view, even through their images and even when the public consisted mostly of passing priests. The only women who were regularly represented in temples were queens and other royal women with high religious offices, such as Ankhesneferibre who, in addition to being a royal princess, was the mortal consort of the god Amun. Her statue stood in her divine husband's temple, Karnak.

The style established during the Saite Period was to dominate Egyptian art for the rest of the Late Period. Whether the Saite style continued to develop without interruption during the obscure period of the Persian Twenty-seventh Dynasty and the even dimmer reigns of the Twenty-eighth and Twenty-ninth Dynasties is

360 LEFT
BRONZE MIRROR
CG 27902
BRONZE
DIAMETER 14 CM
ALEXANDRIA
PROBABLY ACQUIRED
PROBABLY 5TH–4TH
CENTURY BC

360 BELOW AND 361 LEFT
**CIPPUS WITH HORUS
ON THE CROCODILES**
CG 9401
GREY SCHIST
HEIGHT 44 CM
WIDTH 26 CM
THICKNESS 11 CM
ALEXANDRIA
DISCOVERED PRIOR TO
1880
PTOLEMAIC DYNASTY
(304–30 BC)

361 OPPOSITE
ISIS
JE 53671
BRONZE
HEIGHT 31 CM
ACQUIRED
(5TH–3RD CENTURY BC)

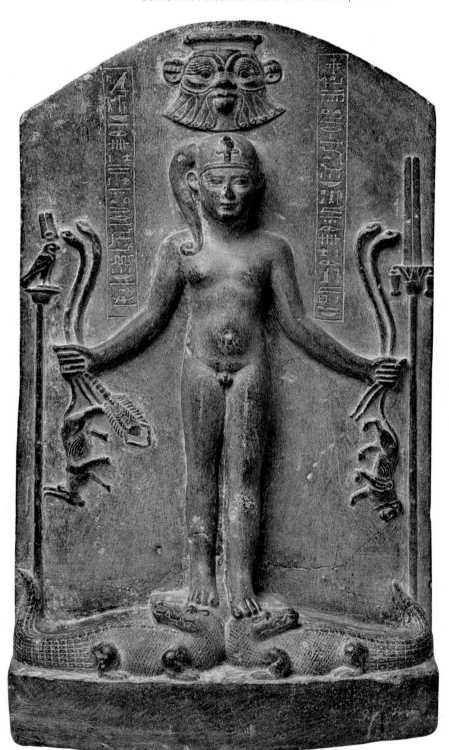

more formal, mannered quality to such features as eyes and brows. The few examples of portrait representations that can be dated to the Thirtieth Dynasty suggest that portraiture was developing more freely. One of the most startling images in all Egyptian art is the nude portrait of the achondroplastic dwarf Teos, carved on the lid of his sarcophagus.

Although tomb sculpture died out and tomb reliefs were very limited, traditional Egyptian funerary practices, including mummification, continued throughout the Late Period, and were even adopted by many of the Greeks and other foreigners who settled in Egypt during these centuries. Sarcophagi and coffins were often massive and elaborate. Some, like that of Teos, were huge stone boxes covered with magical images and hieroglyphic spells. Other stone sarcophagi were carved to represent the mummiform shape of the deceased. Inside these large receptacles, the mummy lay in a wooden mummiform coffin, and similar coffins were used for those who could not afford the most lavish burials. Most wooden coffins were covered with painted images and spells, but a few were even more elaborately decorated.

The wooden coffin of Petosiris, who was buried at the beginning of the Ptolemaic Period, was beautifully

decorated with an inscription made of inlaid glass hieroglyphs. The tiny, brightly coloured details represent one of the earliest examples of mosaic glass.

When the Ptolemies came to power, the Thirtieth Dynasty version of Late Period art was still current. The Ptolemies did not pretend to be Egyptian, but they did claim to rule as legitimate pharaohs. They adopted pharaonic titles and they promoted Egyptian religion, encouraging the construction of temples in which they were represented in traditional royal costumes and poses, worshipping Egyptian gods. Most of the temples that still stand in Egypt were built under the Ptolemies.

The Ptolemaic acceptance of Egyptian traditions helps to explain the fact that under the first rulers of this dynasty, the artists (who were, of course, Egyptian) produced relief and sculpture so faithful to the style of the Thirtieth Dynasty that it can still be very difficult to determine whether a specific work, such as the colossal statue of Amenhotep son of Hapu, was made during the Thirtieth Dynasty or under one of the early Ptolemies.

Alexandria, however, remained Greek and, under Ptolemaic patronage, became a centre of Hellenistic learning and art. As the centuries passed, Ptolemaic Egypt developed complex layers of Egyptian and Greek cultural traits, in which the two traditions both intermingled and kept their distance. Even early in the Ptolemaic Period, some Egyptian art revealed

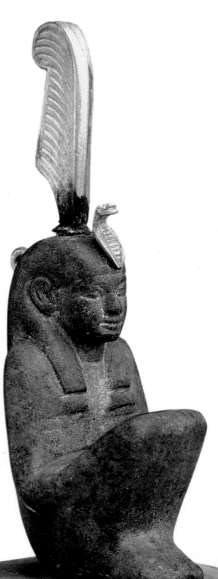

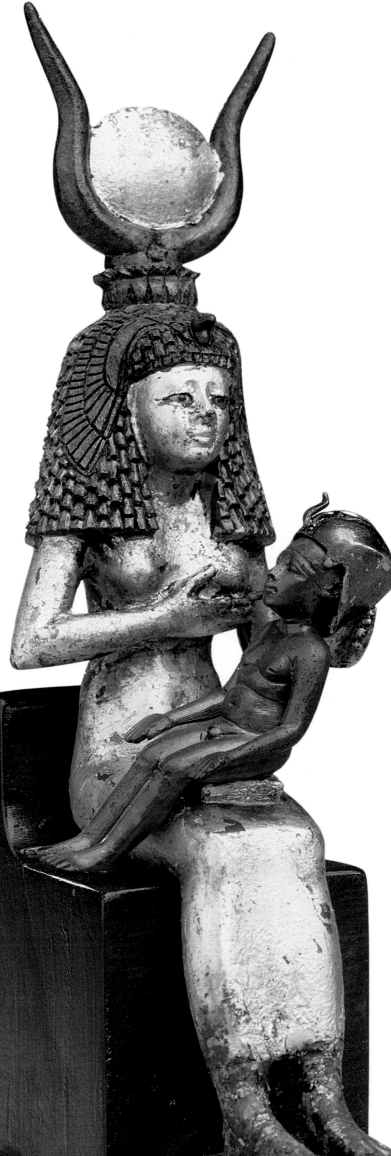

Hellenistic influence; but this influence seems superficial for the most part, perhaps motivated by a desire to be up-to-date and fashionable. For example, a number of statues made during this period depict Egyptian men in an entirely traditional manner – except for their unruly mops of Greek-style curls.

The Ptolemies themselves were represented sometimes in Egyptian style, sometimes in Hellenistic style, and sometimes in a mixture of the two. In all probability, the choice of royal style was determined by the context: on the walls of Egyptian temples, for example, Ptolemaic kings and queens are almost always shown in a traditionally Egyptian manner. But Hellenistic art had gained a foothold, and some Egyptian artists learned to work in this style. Late in the Ptolemaic Period, some statues of private people were Hellenistic in style as well as costume and hairstyle. Such statues are relatively rare, and we have no way of knowing whether they represent people of Egyptian or Greek descent. But they presage the much greater dominance of the Greco-Roman style in Egypt after the Roman conquest.

BIOGRAPHY

Edna R. Russmann, *museum curator and Professor of the history of ancient Egyptian art, specializes in the art of the Late Period.*

She is the author of Egyptian Sculpture: Cairo and Luxor, *and of numerous other scholarly publications. She has taught at several major American universities, most recently at the University of California at Berkeley. She is currently an Associate Curator of Egyptian Art at the Brooklyn Museum of Art in New York.*

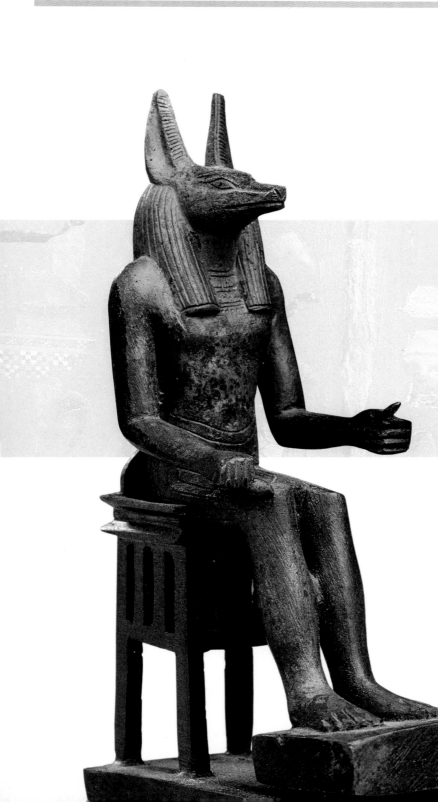

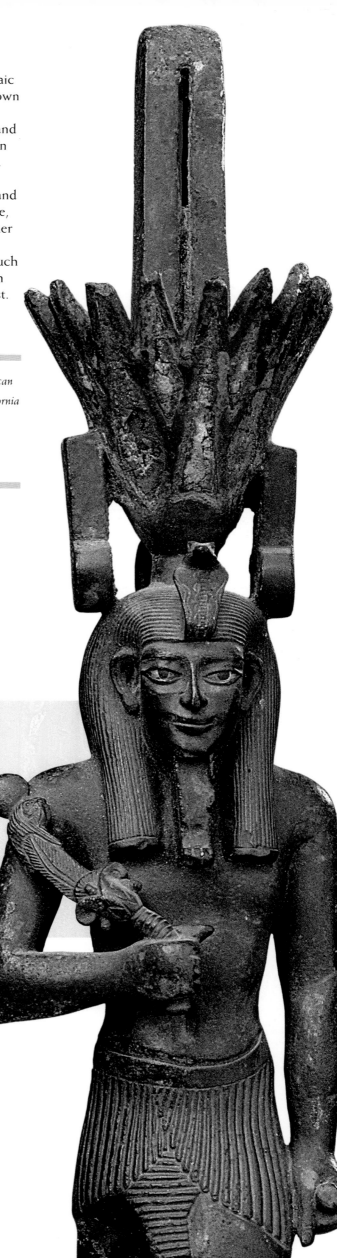

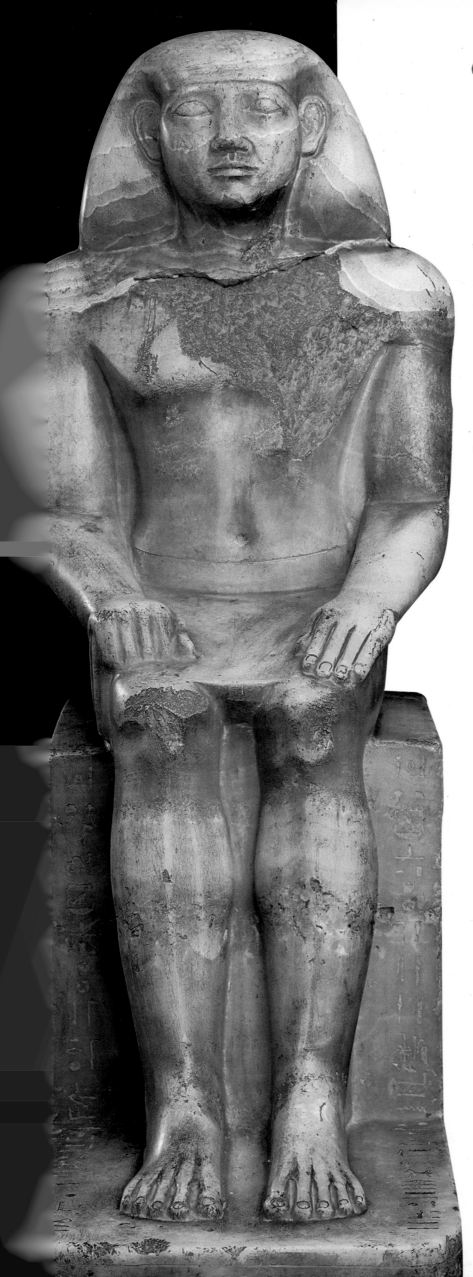

JE 36578

SEATED STATUE OF PETAMENHOTEP

..

ALABASTER
HEIGHT 98 CM; WIDTH 30 CM
KARNAK
LATE TWENTY-FIFTH–EARLY TWENTY-SIXTH DYNASTY (7TH CENTURY BC)

The art of the Late Period, and in particular the time between the Twenty-fifth and Twenty-sixth dynasties, displays a distinct tendency to revive themes and models from the past. This trend is embodied in statuary of the era.

Archaic poses such as that of the scribe, along with wig types and clothing styles dating from the Old, Middle and New Kingdoms, distinguish the fine statuary belonging to the higher social classes. This interesting alabaster statue of Petamenhotep in the Egyptian Museum's collection, which also includes a scribal statue of the same man, represents the official sitting on a cube-shaped seat with a projecting base, in a style displaying close links with the royal statuary of the Old Kingdom. Petamenhotep is seated with his hands on his knees, the left palm down and the right closed in a fist and placed horizontally.

The figure is wearing a wig that leaves his ears exposed and a short kilt with a belt at the waist. The face is very similar to that of the scribal statue – rounded and with regular features. The gaze is

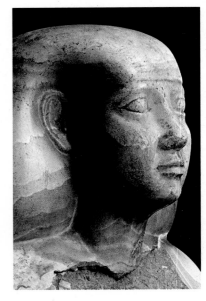

turned upwards, a characteristic shared by sculptures from various periods of Egyptian art, but one that was particularly common in the Old Kingdom. The modelling of the body, with broad shoulders, muscular arms and legs, and well-defined pectorals also reveals a respect for the statuary of the classical period of Egypt's past.

Hieroglyphic texts are incised on the front of the seat and around the base, but they are now in rather poor condition. (R.P.)

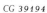
STATUE OF THE GODDESS TAWERET

GREEN SCHIST; HEIGHT 96 CM
KARNAK, NORTHERN AREA OF THE TEMPLE
A. MARIETTE'S EXCAVATIONS (1860)
TWENTY-SIXTH DYNASTY (664–525 BC)

This statue is a highly unusual image of the hippopotamus goddess Taweret, 'The Great Goddess'. The deity is portrayed in a human pose, standing on two legs with the left slightly advanced. The lower limbs and the claws of the upper ones are those of a lion, while the upper limbs are depicted as human arms. At the rear, below the wig and partially covered by the dorsal pillar, is a ridged band that covers the whole of the back and ends at the feet in a kind of tail. This is probably a stylized representation of a crocodile skin. The figure is standing with its upper limbs resting on two hieroglyphs symbolizing protection.

The rest of the figure reproduces the traditional features of the hippopotamus goddess: a large head with an elongated muzzle, small ears emerging from a long, three-part, striped wig, and accentuated and drooping breasts resting on a prominent belly. A cylindrical element on the top of the head would once have held the crown of Hathor, with cow's horns and a solar disc.

An inscription of three horizontal lines on the upper surface of the high base contains a dedication by Pabasa, the steward of the Divine Adoratrice Nitocris, the daughter of Psamtek I, to the goddess Taweret and another female deity, Reret, frequently represented with similar features. Pasaba requests the goddesses' protection for the possessions of the king's daughter.

The sculpture was discovered within a limestone *naos*, or small shrine. The only opening in the shrine was a window in front of the goddess's face. Nitocris was represented on the *naos* in the act of offering sistrums to Taweret. Sistrums were the musical instruments usually associated with the cult of female deities. Further female deities holding tambourines are depicted in the same scene. These are the seven Hathors, the celestial cows, dispensers of life and fertility. (R.P.)

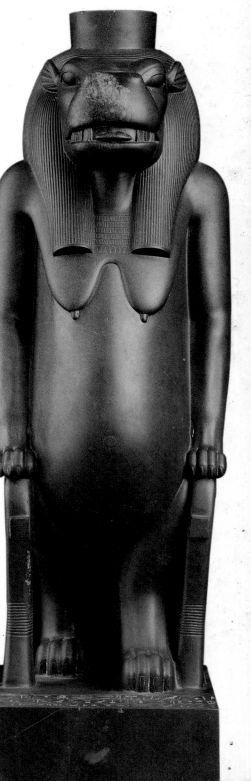

STATUE OF ISIS FROM THE TOMB OF PSAMTEK

SCHIST; HEIGHT 90 CM; SAQQARA
TOMB OF PSAMTEK
LATE TWENTY-SIXTH DYNASTY
(FIRST HALF OF 6TH CENTURY BC)

This sculpture of the goddess Isis was discovered in the tomb of the chief scribe Psamtek, together with other statues of divinities that, like this example, were of extremely high quality.

Isis is portrayed seated on a throne with a low backrest and a base that is rounded at the front. The goddess is resting her hands on her knees, with an *ankh* symbol of life held in the right hand. She is wearing a smooth three-part wig, the front bands of which pass behind the ears and reach her breasts. On her head is a crown in the form of the emblem of the goddess Hathor, consisting of a solar disc between two cow's horns. Isis was frequently associated with Hathor. She is also wearing a close-fitting tunic that reaches her ankles.

The goddess's oval face is serene and has delicate features. The eyes, surrounded by rims in relief, are narrow, with brows in very low relief. The nose is small and the mouth is set in a slight smile. There is a horizontal inscription around the base containing an offering verse dedicated by Psamtek to Isis who is defined, among other things, as the mother of the god Horus.

Isis is one of the deities of the Osirian triad. As the wife of Osiris and mother of Horus, she is symbolically represented as the throne (her traditional emblem) and as the guarantor of the progression of the royal line from father to son. Following the death of her husband, killed by his brother Seth, Isis recomposed the dismembered body and brought Osiris back to life by means of her magical powers. She then conceived with him an heir, Horus, who would avenge his father and take his rightful place on the throne of Egypt. (R.P.)

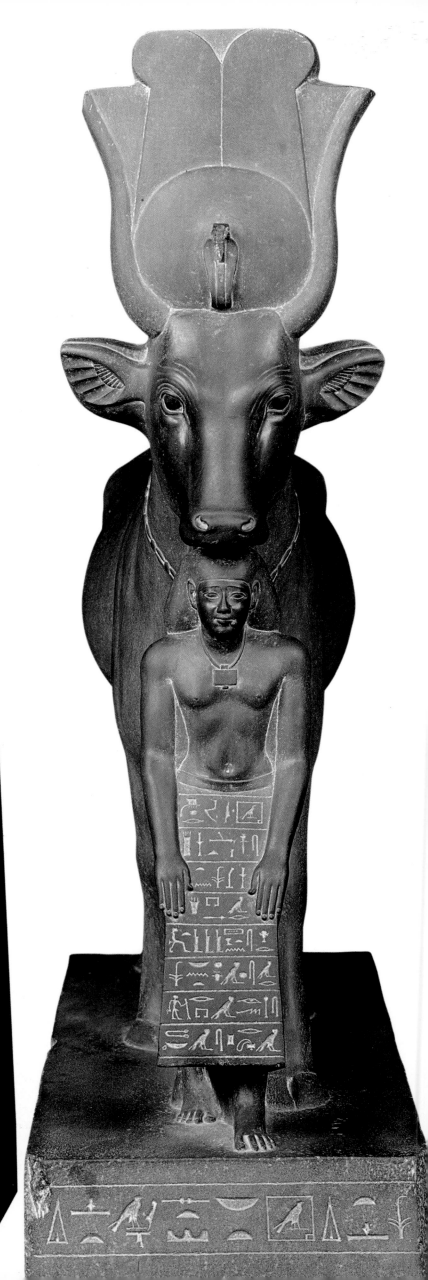

STATUE OF HATHOR WITH PSAMTEK

SCHIST; HEIGHT 96 CM
SAQQARA, TOMB OF PSAMTEK
LATE TWENTY-SIXTH DYNASTY (FIRST HALF OF 6TH CENTURY BC)

CG 784

This sculpture portrays the chief scribe Psamtek with the cow goddess Hathor, in a composition that is well documented in royal statuary. The goddess, in the appearance of a cow, is protecting the diminutive human figure standing before her.

The pair of statues stands on a rectangular base. The statue of the goddess is typical of the sculpture of the Saite period, with polished surfaces and smooth planes that reveal bare hints of the musculature, and a rather rigid pose. An elaborate necklace is hung around the cow's neck, sculpted in relief and equipped with a *menat* counterweight, one of the symbols of Hathor. From the top of the almost human face rises a pair of tall cow's horns with a solar disc, a cobra and two feathers.

Psamtek is standing in front of the goddess with his head protected by the cow's muzzle. He wears a bag-like wig, a necklace with a rectangular undecorated pendant, and a long kilt with a rigid front panel completely covered with a hieroglyphic text containing the titles and name of the figure. He is described as 'Venerable with Hathor'.

The man's hands are resting palm-down on his kilt. His oval face has delicate features and the broad-shouldered torso is accurately sculpted. The text incised around the base contains verses dedicated to the goddess Hathor, defined as the 'Mistress of the desert.' (R.P.)

STATUE OF OSIRIS FROM THE TOMB OF PSAMTEK

SCHIST; HEIGHT 89.5 CM
SAQQARA, TOMB OF PSAMTEK
LATE TWENTY-SIXTH DYNASTY (FIRST HALF OF 6TH CENTURY BC)

CG 38358

This statue was discovered in a shaft in the tomb of Psamtek, together with the other two sculptures seen here, representing Isis and the cow goddess Hathor with the owner of the monument. This one portrays the god Osiris seated on a throne with a low back and a rectangular base with a rounded front.

The god is represented in his usual mummiform aspect, with his hands emerging from his wrappings. The hands are held to his chest, with a flail and a *heqa* sceptre gripped in the right and the left respectively. Osiris wears an *atef* crown consisting of the tiara of Upper Egypt with two plumes at the sides and a cobra at the front, the body of which rises up the high central element of the headdress.

The god's face is almost identical to that of the goddess Isis, with the same narrow eyes surmounted by the line of the eyebrows extended towards the temples, the same nose and the same smile. Only the slightly broader oval shape and the chin complete with a false beard are different.

A formula dedicated by the chief scribe Psamtek to the god is inscribed around the base and contains some of the most frequent epithets. Osiris was worshipped throughout Egypt in all periods and in various forms, at times also in association with other deities. At Busiris, he soon replaced Andjety and at Memphis he was at one point venerated as Ptah-Sokaris-Osiris. But the principal site of the cult of the god of the dead, of the pharaoh who dies and is reborn as the new ruling Horus, remained Abydos, where shrines, stelae and cenotaphs were dedicated to him throughout ancient Egyptian history. (R.P.)

367

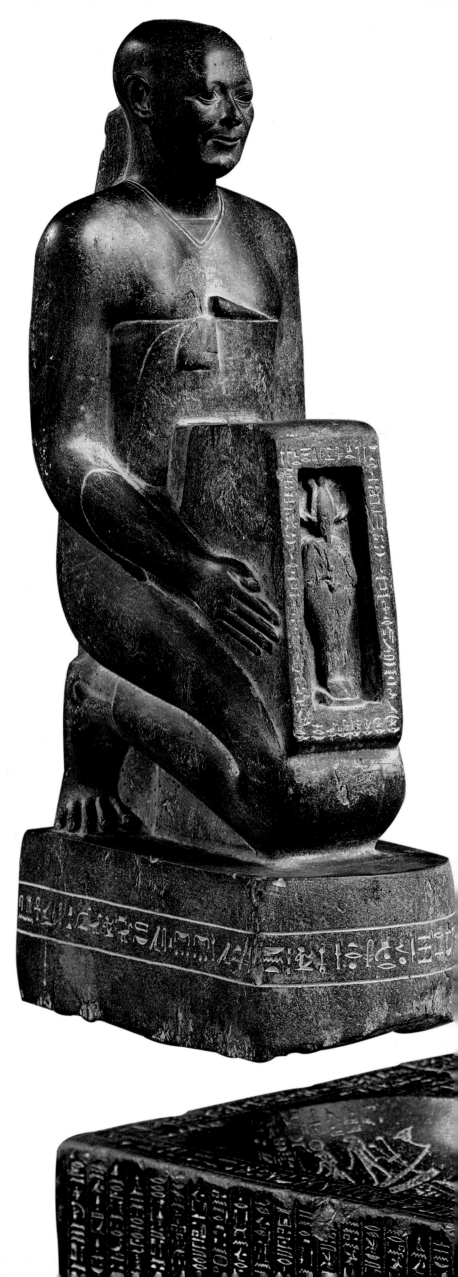

STATUE OF PSAMTEKSANEITH
HOLDING A SHRINE

GREY-GREEN SCHIST
HEIGHT 44.5 CM
MIT RAHINA (MEMPHIS)
LATE PERIOD (6TH–4TH CENTURY BC)

Statues depicting a figure holding a small shrine, or *naos*, developed in Egypt during the Nineteenth Dynasty, although prototypes can be found in the preceding period. It was not until the Twenty-first Dynasty and throughout the Late Period, however, that this sculptural type became widespread.

Generally such statues portrayed an official or a priest kneeling (later also standing) and holding a divine (or royal in the oldest examples) figure, or a small tabernacle (*naos*) within which is a divinity.

This statue portrays the Royal Superintendent of Works in Silver and Gold, Psamteksaneith, kneeling on a high base. The man is holding a *naos* containing a mummiform effigy of Osiris with an *atef* crown. The official has a shaved head and is wearing a thin, almost transparent tunic with a v-neck and a long cloak wrapped around and knotted at his chest. Psamteksaneith's square face is particularly interesting: the rather small eyes, surrounded by fairly distinct rims, are underlined by pouches and low cheekbones. Two deep lines spread from the base of the regular nose and define the cheeks. The mouth with its thin lips is almost open in a smile that creates two lines at the ends. The rounded chin projects slightly. This is one of the most fascinating examples of the so-called realistic statuary that generally dates from between the Twenty-sixth and the Twenty-seventh Dynasties and of which there are examples in Egyptian museums throughout the world.

There has been much debate as to whether such 'realistic' statues influenced the birth of Greek portraiture or whether, on the contrary, they may have been the result of the increasingly frequent contacts between the Greeks and Egyptians from the Twenty-sixth Dynasty onwards. Recent studies tend to bring forward the dating of a number of these sculptures, including this one, from the 6th to the 4th century BC. (R.P.)

MAGICAL STATUE OF DJED HOR

BLACK BASALT
STATUE: HEIGHT 78 CM; DEPTH 43 CM; WIDTH 35 CM
BASE: HEIGHT 38 CM; DEPTH 93 CM; WIDTH 56 CM
TELL ATRIB; CHANCE FIND, 1918
PTOLEMAIC DYNASTY (304–30 BC)

This piece combines two elements characteristic of Late Period religion: a Harpocrates stela held by a figure, and a basin for the collection of holy water, carved in front of the stela in the deep rectangular base. Almost the entire surface area is inscribed with magical texts.

The figure itself is carved in the form of a typical block statue, with legs brought up to the chest and arms folded across the knees. He is wearing a bag-like wig-cloth that leaves his ears uncovered. A smooth beard links the chin to the plane of the arms. The oval face has regular features: small eyes surmounted by arching eyebrows that extend the line of the straight nose, and a small mouth. Even the body and the wig are completely covered with hieroglyphic texts.

In front of the figure and resting on its own feet is a Harpocrates stela, also known as a 'stela of Horus on the crocodiles,' or 'Horus Cippus'. This type of object is found most commonly in the Late Period, its dimensions varying from just a few centimetres to almost a metre high.

Harpocrates (or 'Horus Child') is depicted on these stelae, usually

frontally, but occasionally with the legs in profile, standing on a pair of crocodiles, while holding venomous animals in his hands, generally serpents, scorpions, oryx and lions.

Above the figure of the Horus Child is the head of the god Bes. Both the pictorial elements and texts refer to the mythical episode in which the goddess Isis (mother of Horus and the wife of Osiris) attempted to protect her son Horus from Seth (the brother and murderer of Osiris), who wanted to eliminate his brother's legitimate heir by means of evil and noxious animals. Thanks to her magical powers and the help of certain other gods, above all Re and Thoth, Isis succeeded in averting Seth's threats. She fled and raised Horus concealed in the marshes until he was ready to set out to avenge his father and take his rightful place.

The myth formed the basis of the Egyptian monarchy, establishing

the notions of succession, the victorious destiny of the pharaoh (Horus) over chaos, and the king's association with the divine. But in the Late Period the legend also came to symbolize a spell for personal protection.

Having negotiated the snares laid by Seth, Harpocrates became the protector of all those threatened by the animals that had endangered his own life. Generally the reverse side of such stelae is occupied by texts recounting the myth and containing spells for warding off and defeating evil. While the stelae were used privately as amulets, the magical or 'healing' statues,

representing figures who substituted for the god Harpocrates in his role as a healer, were located in public places and could be turned to by anyone in need of help or protection. They were therefore seen as intercessors with the gods and invested with a role that in the past was the sole prerogative of the pharaoh. The basin placed before the feet of the figure collected water that had been poured over the stela. Having thus absorbed the protective powers of the spells it was used for prophylactic or therapeutic purposes. (R.P.)

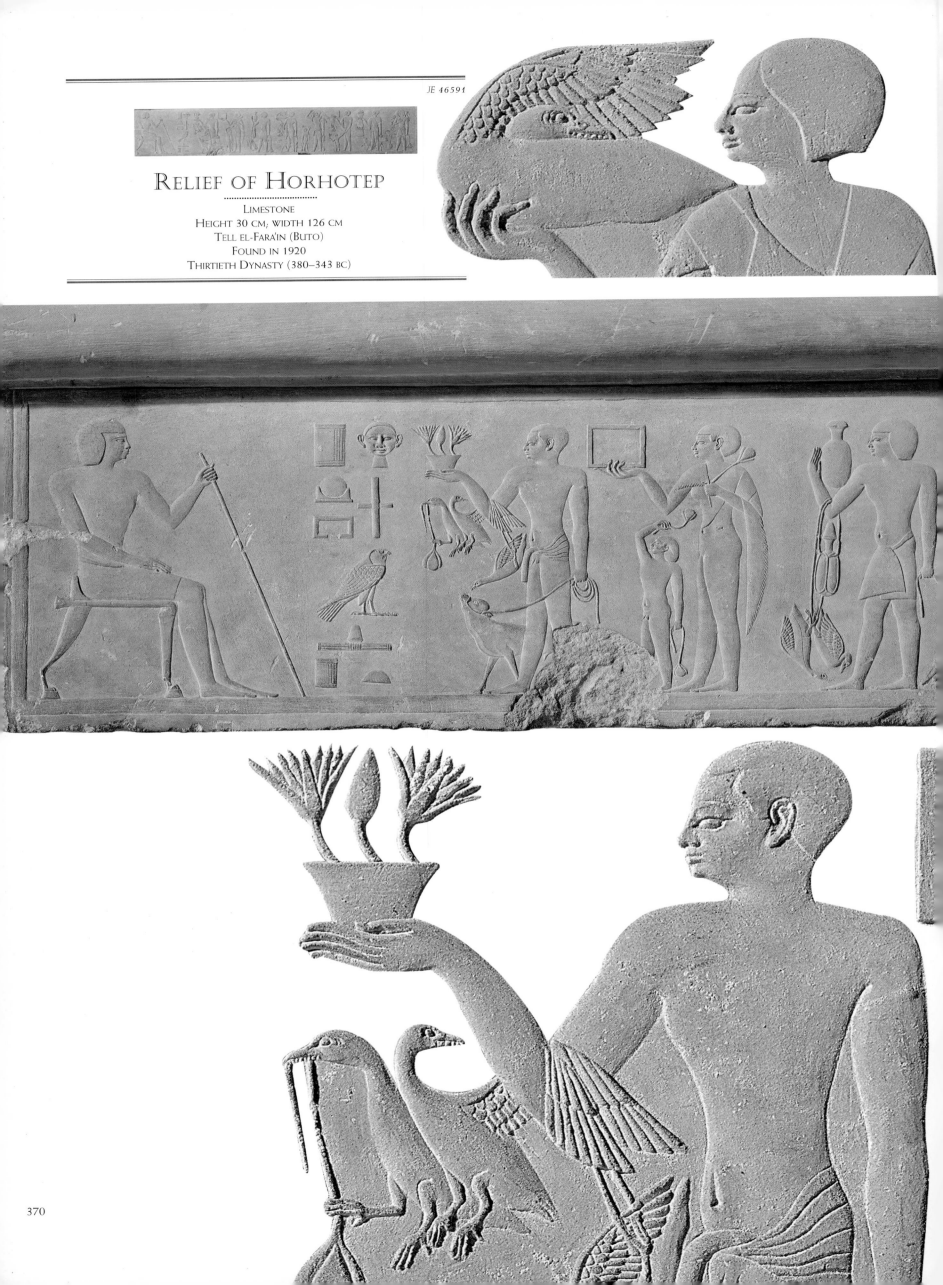

JE 46591

RELIEF OF HORHOTEP

LIMESTONE
HEIGHT 30 CM; WIDTH 126 CM
TELL EL-FARA'IN (BUTO)
FOUND IN 1920
THIRTIETH DYNASTY (380–343 BC)

On the left of this relief is the principal figure, seated on a throne with lion's feet, facing a procession of offering bearers. This is a theme found in Egyptian art from the earliest times. The dignified man, identified as a high priest of Buto named Horhotep, is wearing a short, smooth wig and a kilt that reaches to just above his knees. In his left hand he holds a long staff that is resting on the ground. In front of him a column of finely carved hieroglyphs records his name and title.

Eight adult figures (five men and three women) are placed in front of Horhotep, accompanied by a number of children, various objects and foodstuffs. Two of the women and a man are only partially clothed with cloaks; two of the men wear short kilts with aprons at the front while another two are wearing only brief loincloths. The figures are rendered very differently from those in older bas-reliefs, for instance the bodies are generally more substantial with more accentuated curves. The positioning of the figures in space creates a series of voids that are partially filled by the depictions of the children who, in freer poses than the adults, participate in and break up the formality of the procession. Further movement is provided by the plants held by the figures, as well as the animals they are carrying – birds,

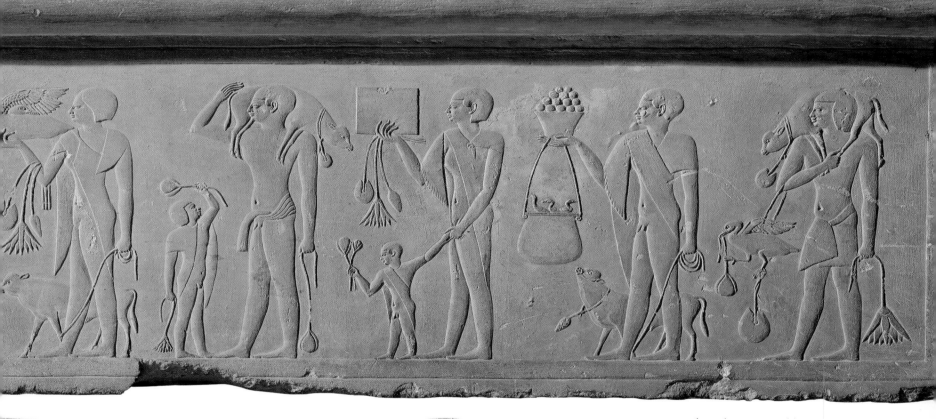

cattle and pigs – in addition to the chests, jars and baskets of fruit.

In spite of the highly finished, precise and detailed nature of this relief, which once more reveals the mastery of Egyptian artists, the image as a whole unequivocally reflects the profound changes that had taken place in a country that had by now been opened to new influences and contacts. These inevitably had a significant impact on the age-old art of the land of the pharaohs. (R.P.)

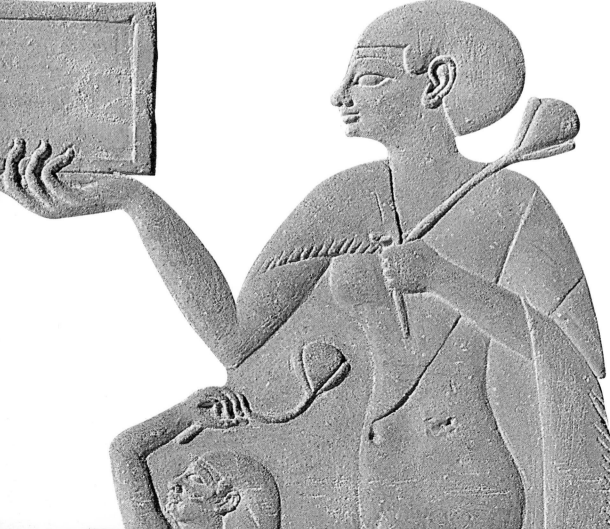

371

PORTRAIT OF ALEXANDER THE GREAT

WHITE MARBLE; HEIGHT 20 CM
TELL TIMAI (THMUIS)
PTOLEMAIC PERIOD (C. 150 BC)

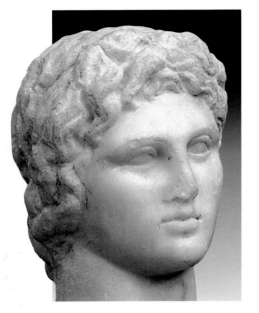

This portrait head belongs to the highly evolved iconographical tradition associated with the figure of Alexander the Great, whose features were frequently depicted and developed throughout the Hellenistic age.

In this portrait, it is clear that particular attention was paid to the face, in contrast with the partial and summary depiction of the hair. The facial features are regular and very soft. The deeply inset eyes lend a certain abstraction to the expression.

The hair is rendered with long wavy curls in the typical 'lion's mane' of Alexander. There is a pronounced asymmetry: on the right-hand side the hairline reaches above the ear while on the left the hair curls down to the neck. At the top of the head is a hole that probably once housed a metal emblem.

Portraits of Alexander always include several typical features and can be identified by the general composition of the work. It was this artistic programme that was responsible for the loose details and the concentration on the rendering of the face rather than the creation of a homogeneous work.

This figure has been identified as a deified Alexander and it has been suggested that it was originally depicted wearing an Egyptian crown, a motif appropriated from the royal descendants of Amun, or a star, in accordance with another frequently found association. However, the lack of detailed information prevents us from reaching a conclusive judgment. On the other hand, even the sketchy and almost impressionistic style allows us to identify with certainty a number of the elements of the traditional iconography of portraits of of Alexander. (A.L.)

HEAD OF ALEXANDER THE GREAT

WHITE ALABASTER; HEIGHT 10 CM
EL-YAUTA, WEST OF BIRKET QARUN
PTOLEMAIC DYNASTY (304–30 BC)

This head once belonged to an alabaster statuette, but the rest of the work has been lost. Given the dimensions of this surviving fragment, it must have been a miniature work. It is still possible to deduce that the head was probably turned slightly to the left. The hair is rendered with long, disordered, and rather wavy curls. At the back of the head is a band.

The overall standard of workmanship is not particularly high, but effects of movement and a play of light and shadow in the composition are created by the transparency of the alabaster. At the top of the head is again a hole that probably housed an emblem, possibly in metal.

The general iconography of this work allows the figure to be identified with certainty as Alexander the Great. The highly idealized features suggest that, as always with representations of Alexander, it was not a true portrait but the result of an artistic process of developing a fixed iconography of the Macedonian general. The head-band or *taenia* is a traditional attribute of the Hellenistic ruler. This symbol of kingship was to be incorporated in the iconography of all successive Hellenistic princes and was also very common in the Egyptian representations of the Roman emperors.

As the composition uses such traditional stylistic motifs it is difficult to date this work with precision. The rendering of the hair and the overall appearance could link it to the Hellenistic period, but there are no elements to permit a more precise dating. (A.L.)

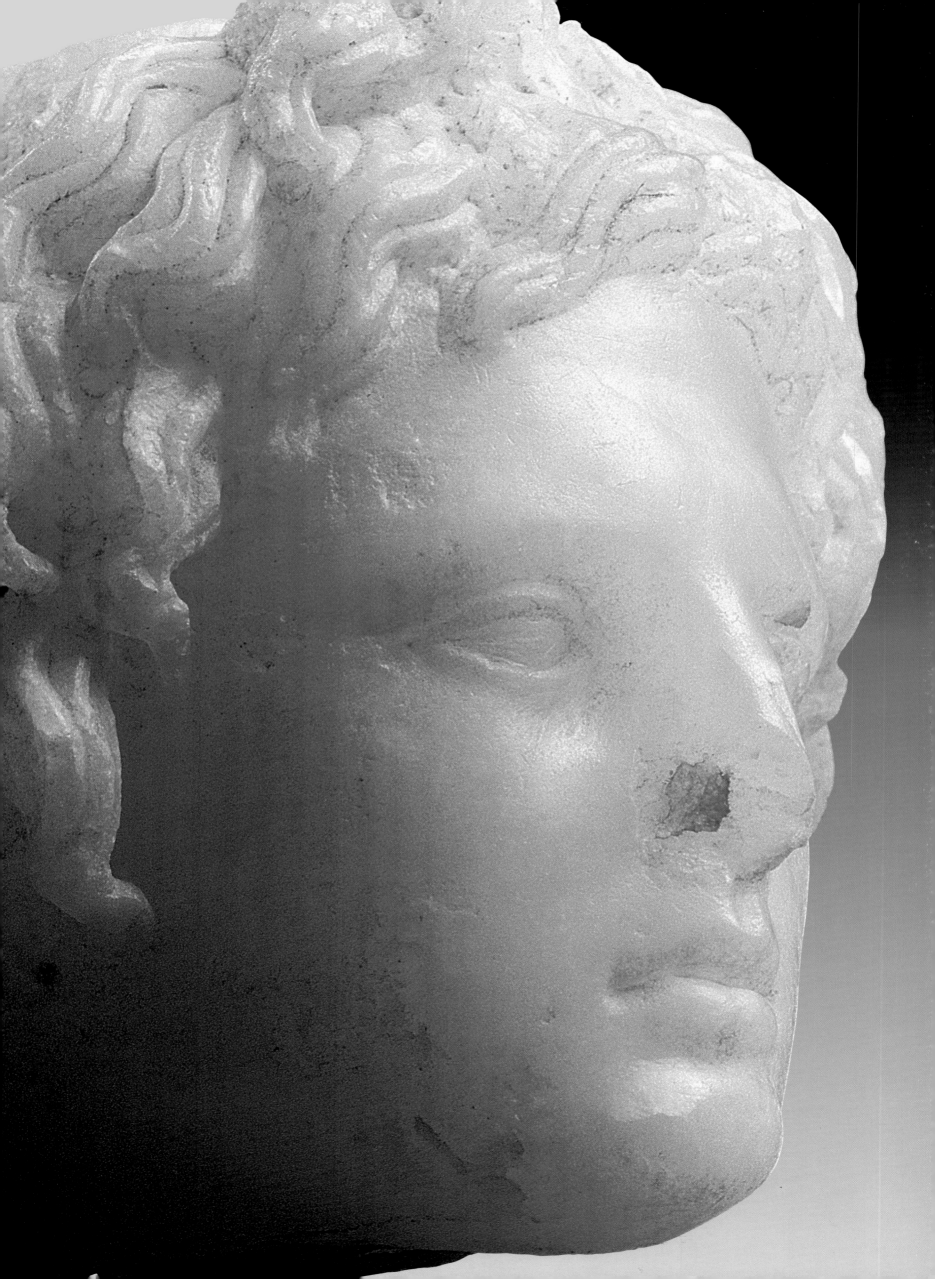

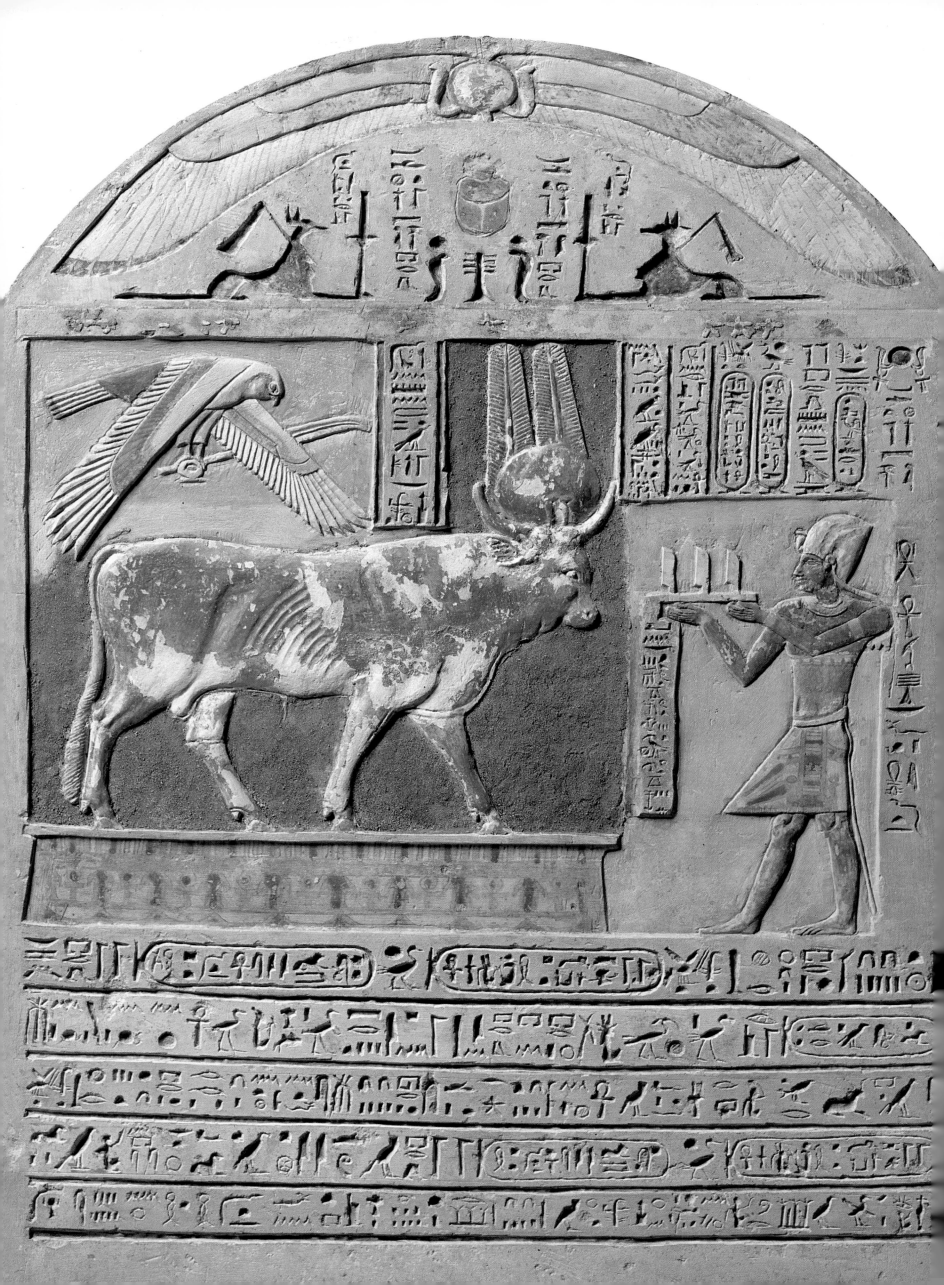

Stela of Ptolemy V

PAINTED AND GILDED LIMESTONE
HEIGHT 72 CM; WIDTH 50 CM
ARMANT, BUCHEUM; EGYPT EXPLORATION SOCIETY EXCAVATIONS (1929–1930)
REIGN OF PTOLEMY V EPIPHANES (205–180 BC)

This stela, which retains much of its original colour, is divided into three registers: the rounded top; the central body with the offering scene; and a text set on five horizontal lines at the base. The top register is framed by the curving wings of a solar disc adorned with two cobras. At the centre of the scene immediately below is a scarab supported by a *djed* pillar placed between two facing cobras with solar discs on their heads. At either side of these are vertical inscriptions mentioning the 'great god Behedet, of the variously coloured feathers'. Two images of the jackal god Anubis supporting a *kherep* sceptre frame the scene at either end.

The middle register, divided from the one above by the symbol of the sky, is largely occupied by an image of the Buchis bull in low relief against an intense blue background. The bull is facing towards the right and stands on a multicoloured base. Its body is covered with gold leaf and it carries the emblems of the god Montu on its head – a solar disc with two tall plumes. A falcon, an image of Montu in animal form, is depicted with its wings outspread above the bull's back. In its talons it grips a *shen* hieroglyph and a feather. A vertical text in front of the falcon

identifies it as 'Montu Horakhty, great god, lord of the Heliopolis of the South [Thebes]'.

Standing in front of the altar, in the act of offering the *sekhet*, the symbol of the fields, is the ruler Ptolemy V. He is wearing the Blue Crown and a ceremonial kilt with a rigid triangular front panel and a form of bodice. Around his arms, wrists and neck are bracelets and a gold necklace. Above the king's head are seven vertical columns of hieroglyphs containing the names of the god Buchis, the pharaoh Ptolemy, his wife Cleopatra, and again that of the sun god, the lord of Behedet. Behind the king is a protective verse and in front of him the offering verse. The text in the panel at the base of the stela contains a dedication by Ptolemy and Cleopatra to the divine bull in the twenty-fifth year of the their reign in order to celebrate its death.

The cult of the Buchis bull, sacred to Montu, is documented in the Theban region from the Thirtieth Dynasty to the period of Diocletian. After its death the bull was mummified and buried in the Bucheum of Armant in ceremonies similar to those held at Saqqara for the Apis bull, and in Heliopolis for the Mnevis bull. (R.P.)

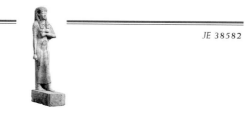

Statue of a Ptolemaic Queen

LIMESTONE WITH TRACES OF PAINT AND GILDING; HEIGHT 47.5 CM
KARNAK, TEMPLE OF AMUN-RE, COURTYARD OF THE CACHETTE
G. LEGRAIN'S EXCAVATIONS (1904)
PTOLEMAIC DYNASTY (304–30 BC)

This statue portrays a woman wearing a long, closely fitting pleated robe, decorated with a red band knotted above the navel that resembles a Knot of Isis. The woman is also wearing a three-part wig that still retains traces of its original black paint. The wig is tied with a red band. The face is squarish and full, and the features are stylized to a high degree. The perfectly almond-shaped eyes, the almost total absence of eyebrows,

and the small, slightly prominent mouth are all characteristics that allow the statue to be dated to the early Ptolemaic Period. At this time, art in Egypt still displayed a noticeable dependency on the Egyptian styles of earlier periods.

The figure is represented in a striding pose, with the left leg advanced. The right arm is held to her side (with the fist closed), while the left is folded below the breast on which a floral sceptre, the

emblem of queens, rests. Around the woman's neck is a broad-collar necklace covered with gold leaf; gold bracelets are placed around her wrists, and gold rings decorate her fingers.

A male figure wearing sandals and a robe fastened at the level of his chest is incised on the dorsal pillar. This is probably the donor who commissioned the work. A number of columns are traced in red on the base; and had the statue been

completed they would no doubt have contained a hieroglyphic inscription containing the name of the donor and the female figure who is represented by the statue.

On the basis of her attributes such as the band around the wig, the sceptre, and the band on her robe, the figure may be identified with some certainty as a deified Ptolemaic queen. The donor was probably a priest dedicated to the cult of the queen. (F.T.)

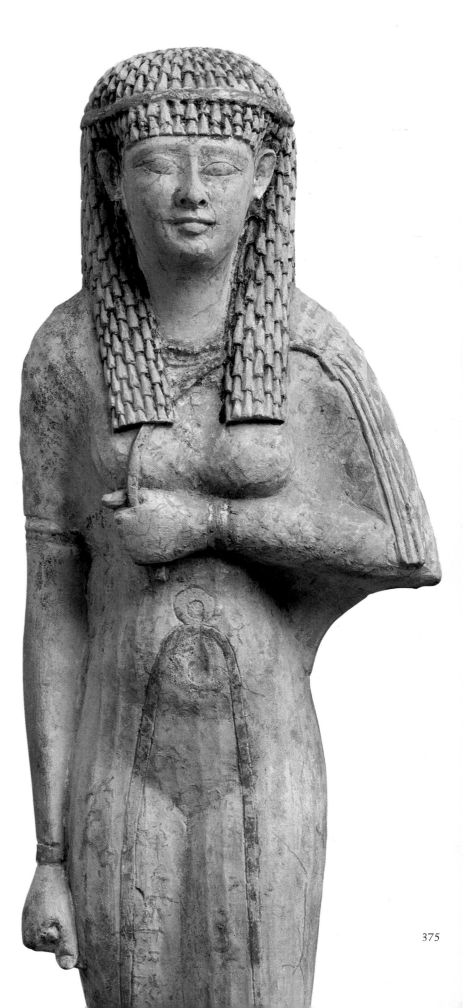

WINGED SCARAB

LAPIS LAZULI, GOLD, SILVER, SEMIPRECIOUS STONES
HEIGHT 77 CM
DENDERA, TREASURE
PTOLEMAIC DYNASTY (304–30 BC)

From the meaning of the ancient Egyptian verb *kheper*, which also forms the word 'scarab', the sacred beetle became closely associated with the concept of 'coming into existence, becoming, and transforming oneself'. The scarab came to symbolize the continual life cycle of nature, including the annual Nile floods, and the death and rebirth of plants, humans, animals and gods. The word *kheper* expresses one of the most fundamental concepts in Egyptian thought and is one of the symbols most frequently used in religious texts relating, in particular, to the creation and the coming into being of the sun god, of whom 'Khepri' is the morning manifestation.

Likewise, the word for scarab is frequently mentioned in funerary texts relating to rebirth and a new life after death. The image of the scarab was also used in Egypt as an amulet that ensured protection and an eternal return. In this guise it is found in funerary and religious contexts throughout the ancient Mediterranean world, and as a 'lucky charm' up to the present day.

Scarabs were made of green or blue faience, or in semiprecious stones – usually green or black. These were the colours associated with the birth of nature and the black silt that brought fertility to the earth. Winged scarabs are generally funerary amulets and are known as 'heart scarabs'. Often of large size, they were placed within the mummy's bindings in a position corresponding to the heart or were the centrepieces of pectorals, of which many examples have been found in royal treasures. They are usually inscribed on their undersides with Chapter 30 of the Book of the Dead.

These scarabs performed a dual role. On the one hand, the magic spell helped the heart of the deceased to respond to the divine judgment; on the other, its presence illustrated the association between the deceased and the sun god that brought about resurrection. Verse 366 of the Pyramid Texts reads: 'The dead person flies like Khepri and alights on the empty throne on your barque, oh Re!' In the Late and Ptolemaic Periods the scarab or the winged solar disc also represented Apis, a sun god identified as Re, Horus of Edfu, or Osiris.

A magnificent example of the jewelry of the period and a testimony to the art of Ptolemaic Egypt, this scarab combines the most important iconographical elements of sun worship: the disc, the symbol of the fiery heavenly body; and the wings of the falcon, its animal manifestation. The *shen* symbol, gripped between the insect's rear legs, symbolizes protection and relates to the object's function as an amulet. The stones and the colours used in the design reflect the religious and magical symbolism of the piece and the concept of rebirth. The scarab itself is carved from very high quality lapis lazuli and is set in gold. The minute and detailed feathers of the wings are inlaid with lapis lazuli, turquoise and red carnelian using the cloisonné technique. Red carnelian was traditionally the colour associated with the sun. The *shen* symbol is also in lapis lazuli and carnelian, while the solar disc is covered with gold leaf. (R.P.)

FALCON COFFIN

GOLD, SILVER
HEIGHT 60 CM; LENGTH 88 CM
DENDERA, TREASURE
PTOLEMAIC DYNASTY (304–30 BC)

The cult of a sky god in the form of a falcon is without doubt one of the oldest in Egypt. During the course of Egyptian history the falcon was first associated with the god Horus and successively with various manifestations of the sun god, undoubtedly due to its ability to fly high in the sky.

In pharaonic iconography, the falcon's wings represent the sky, its eyes the sun and the moon. From the Predynastic Period onwards the pharaoh himself was associated with the god Horus, who also became the first symbol in his complex nomenclature.

Religious sites dedicated to the various gods in the form of a falcon are found in many parts of Egypt from the earliest times: Horus at Kom Ombo, Montu at Hermonthis, Behedet at Edfu, Sokaris at Memphis, and Horakhty at Heliopolis. From the Late Period, and especially during the Ptolemaic Period, the cult of the falcon was unified throughout Egypt.

Numerous cemeteries were reserved for the burial of the animals sacred to the god Horus. Mummies of falcons have been found at Kom Ombo, Thebes, Dendera, Abydos, Hermopolis,

Saqqara and Giza. After death, the falcons were mummified and buried in coffins, usually made of wood, stone or bronze, and also in vessels.

This splendid example from the so-called 'Treasure of Dendera' is made of gold and silver and underlines once again the great prestige enjoyed by these birds. The coffin is itself in the form a falcon and is made up of three elements: body, legs and headdress.

The body is divided into two parts, both fashioned from beaten gold, so that the upper half could

be lifted to allow the mummified bird to be inserted. The legs are crafted in silver, with finely incised decoration depicting the individual feathers and the details of the bird's talons. A solar disc rests on the bird's head.

Like the precious winged scarab, also illustrated here, this casket bears witness to the high quality of Egyptian art during the Ptolemaic Period and the desire of the Greek rulers to honour the powerful and venerable Egyptian gods with works of great value and artistry. (R.P.)

JE 35923 = CG 53668

BEAD-NET AND GOLD MASK OF HEKAEMSAF

GOLD, SEMIPRECIOUS STONES, FAIENCE
LENGTH 145 CM; MAXIMUM WIDTH 46 CM
SAQQARA, TOMB OF HEKAEMSAF
ANTIQUITIES SERVICE EXCAVATIONS LED BY A. BARSANTI (1903)
TWENTY-SIXTH DYNASTY, REIGN OF AMASIS (570–526 BC)

The intact tomb of Hekaemsaf, the superintendent of the royal boats, was discovered in the cemetery of Saqqara, close to the pyramid of Unas. Its rich funerary assemblage comprised model boats, tableware, canopic jars, 401 faience *shabti* figures, numerous jewels, and a limestone sarcophagus containing a coffin in painted wood, in which the mummy was placed.

Hekaemsaf's mummy was adorned with a fine bead net with a a gold mask attached and was covered with a linen sheet. The bead net was found in fragments and was pieced back together by Georges Daressy.

The face of the mask is framed by a wig with black and green stripes achieved by inlays of glass paste. The eyes are also inlaid, with the iris in feldspar, the pupils in obsidian and the eyelids and eyebrows in lapis lazuli. A beard descends from the chin to the same level as the ends of the striped braids of the wig.

The net attached to the mask covers the entire body and is composed of strings of beads in gold, lapis lazuli and amazonite creating a continuous and regular alternation of coloured bands. At every point of connection between the beads are discs of gilded copper. Around the edge of the net is a long row of gold, lapis lazuli and amazonite rectangles arranged in a precise pattern, although the damaged lower section is missing.

A large *usekh* necklace is attached to the net, over the chest of the mummy, and ends at the shoulders with two large falcons' heads in embossed gold. The necklace is composed of eighteen strands of beads of different shapes and colours. There are seven rows of cylindrical lapis lazuli and amazonite beads separated by eight rows of small gold beads, a row of round gold and amazonite beads, a row of gilded drop-shaped beads, and a final row of round beads in lapis lazuli alternating with gold beads. Below the necklace, over the abdomen, an image of the goddess Nut is created from a thin sheet of gold attached to the net. The goddess of the sky, surmounted by the solar disc, has her arms and wings spread open in a gesture of protection. She is kneeling on a long band of gold that carries an embossed inscription. This inscription contains a prayer to her by the superintendent of the royal boats, Hekaemsaf. The final part of the invocation has not survived.

On each side of the column of hieroglyphs are the figures of two of the Four Sons of Horus, the protectors of the deceased's internal organs. The two pairs of figures face each other across the inscription. The four divinities have mummiform bodies and the heads of animals. On the right of the deceased are Imseti and Duamutef, while on the left are Hapy and Qebehusenuef. (S.E.)

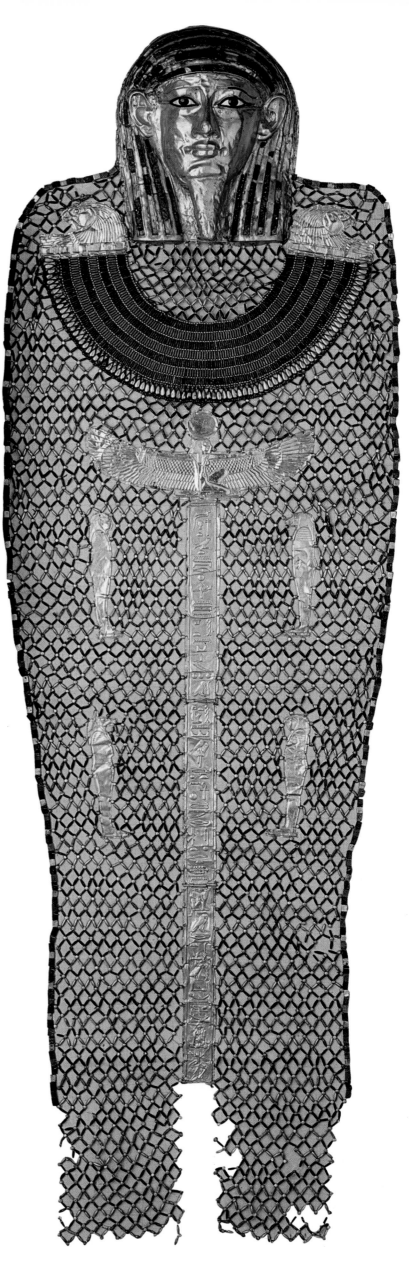

377

Thirty years before the Christian era, Cleopatra VII, the last Ptolemaic ruler, was dead. Augustus had brought Egypt under the rule of the Roman People or, more accurately, his own prefecture. A land capable of producing prodigious quantities of foodstuffs and one that was easily defendable was not allowed to become a base for ambitious Roman nobles: it was governed by a prefect of the equestrian class, not a senator, on short-term appointment. The prefect ruled with the aid of the army, much of which was scattered in small units throughout the land. He had to ensure that taxes were collected and grain was shipped to feed the people of Rome. Alexandria remained the principal seat of government and the old divisions of the nomes (provinces) with their metropolitan cities were retained. Latin was the language of the army, but most bureaucratic details were recorded in Greek. Throughout Egypt

D O N A L D M . B A I L E Y

ROMAN EGYPT PROVINCE OF AN EMPIRE

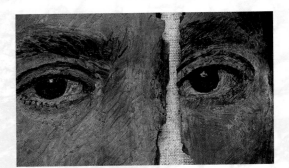

during Ptolemaic times the dividing line between Greeks and Egyptians had become more hazy as time went on, the criterion for being a Greek apparently simply being the ability to speak Greek and then calling yourself Greek. This was a circumstance that the Roman conquerors found incomprehensible and intolerable. Greeks were Greeks and Egyptians were not, and they hardened the rules to make sure that this was so. The Greeks had to prove their Greekness by showing Greek ancestors, male and female, and membership in the Gymnasium, as far back as possible.

Egyptians were regarded as an inferior class, and written regulations, known as the *Gnomon* of the *Idios Logos*, were compiled to enable the Roman authorities to enforce this, often laying down set penalties. A large part of these rules has survived as a papyrus document. Taxes were applied inequitably, the richest paying least. Citizens of Alexandria were highly privileged and paid little tax. The citizens of the provincial towns paid rather more, and the Egyptian inhabitants of the countryside, many very poor, paid much more. And the different taxes that they paid were innumerable. One that was a great burden was the poll tax, introduced by the Romans and continuing for the first three centuries of their rule.

Only citizens of Alexandria could pursue the great prize of the early centuries of Roman rule – citizenship of Rome. But this changed about AD 200 when Septimius Severus allowed Alexandria to have a senate and the nome capitals town councils. Subsequently, the emperor Caracalla issued the *Constitutio Antoniniana*, in AD 212–213, granting almost universal Roman citizenship throughout the Empire, except of course for slaves. But the taxes were not eased. The emperor insisted on his taxes, whatever the state of agricultural prosperity. Years of bad yields were not taken into consideration. Men fled their homes and farms because they could not pay, but their fellow villagers had to find the missing money, and were forced to work the abandoned land. Where whole villages were deserted, neighbouring communities were required to take over the tax burden. Members of the magisterial class, who in earlier centuries very willingly paid for the construction of public buildings and public services, such as the supply of oil for the baths, were forced into performing tasks compulsorily and were often ruined financially by extra burdens. Tax-farmers, unable to obtain their allotted amounts, resorted to violence and to imprisoning family members of the reluctant taxpayer.

There were many periods during Roman rule when life became intolerable, but the fifth and sixth centuries were probably the most prosperous for the generality of the people. The poll tax seems to have been abolished by the emperor Diocletian towards the end of the third century. But many other taxes remained in place and new ones were

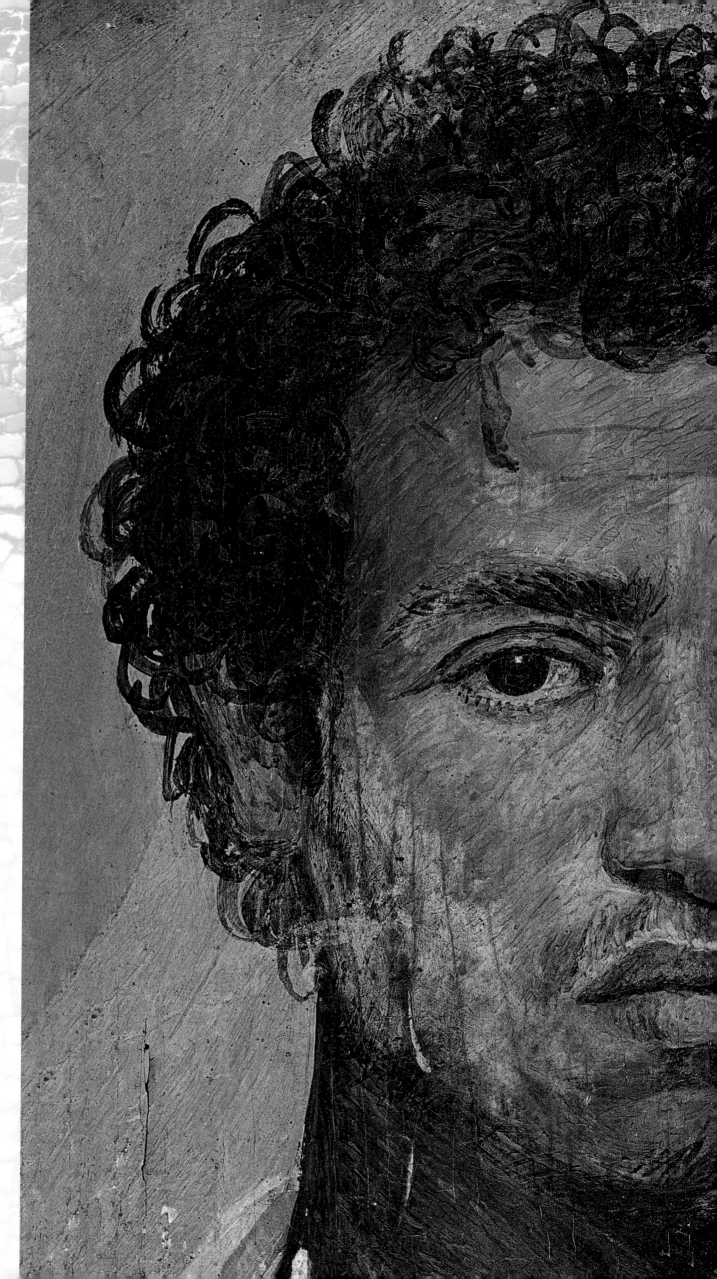

378 LEFT AND **379** RIGHT
DETAILS OF A PORTRAIT
OF TWO BROTHERS
CG 33267
ENCAUSTIC WAX ON WOOD
DIAMETER 61 CM
ANTINOOPOLIS
ALBERT GAYET'S
EXCAVATIONS (1899)
(2ND CENTURY AD)

378 BACKGROUND
JE 67913
MOSAIC
HEIGHT 26.5 CM
WIDTH 33 CM
PROVENANCE UNKNOWN
SECOND HALF 3RD–SECOND
HALF 4TH CENTURY AD

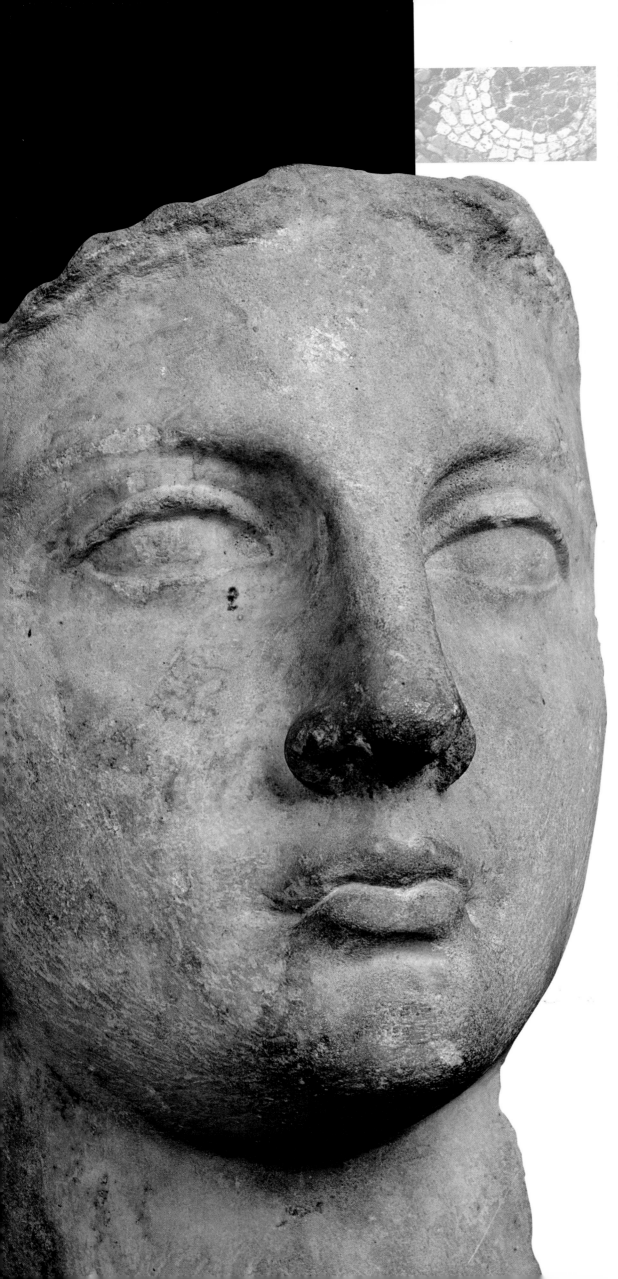

introduced, like the *annona militaris*, a tax in kind for the benefit of the army, and the crown-tax, paid in gold to the emperor by cities and their dependencies. Whereas the Ptolemies had retained their grain and gold in Egypt, the Roman emperors took most of it away. There was slow inflation for centuries, but prices increased dramatically from the end of the third century onwards.

Unlike the rest of the empire, Egypt was not greatly affected by the political anarchy of much of the third century, when emperors put up by armies lasted a few months or a few years, with an inevitable violent death awaiting them. This ended with the success of one of the greatest of Roman emperors, Diocletian. He enacted the most far-reaching changes to the organization of Roman Egypt since its original arrangement under Augustus. Towards the end of the third century, Diocletian divided it into three provinces for administration purposes: *Aegyptus Jovia*, together with Alexandria, was ruled by the prefect of Egypt, and *Aegyptus Herculia* and the *Thebaid* were each under separate governors. These were civil appointments. The military was separated off and the whole country was placed under a single commander, the duke of Egypt. Latin became more and more the language of bureaucracy. Diocletian also revised the tax structure by introducing cycles of indictions, set periods for fiscal exactions, so that people understood more of what

was expected from them. Arbitrary and unexpected demands became less frequent.

Further divisions and amalgamations of the country followed throughout the late Roman period. Despite the presence of a considerable military presence, there were various rebellions against Roman rule. Indeed the Jewish Revolt of AD 115–117 caused immense damage in many of the cities of Egypt until it was finally put down; and the Bucolic Revolt in the Delta in the 170s caused the authorities much trouble. The tribe of the Blemmyes invaded from the south and the east, posing a constant threat. And the Bedouin desert peoples had also to be guarded against. Zenobia's Palmyrenes occupied Alexandria and some of the country in the 270s and Diocletian had to deal with the usurper Domitius Domitianus in the 290s. Towards the end of Roman rule the Persians gained control of the country for a decade, and were expelled in 627; less

than fifteen years later the Arabs came for good. They laid siege to the fort of Babylon near where Cairo later rose and then went on to capture Alexandria in 642, bringing Roman rule to an end after nearly seven hundred years.

Augustus had viewed the Egyptian priesthood as a focus for patriotism, unrest and rebellion, and had severely restricted their power and privilege. With the triumph of Christianity, religious officials, particularly the patriarch of Alexandria, became immensely powerful and were able to thwart the intentions of governors of Egypt and even the emperor. Theophilus, who destroyed the great Serapeum at Alexandria, and Athanasius were but two of these forceful and dominant bishops, for decades a thorn in the side of Constantinople. Because of a difference of opinion concerning the bodily and spiritual nature of Christ, the Egyptian Monophysite Church eventually split from the Melkite, Catholic Church of Constantinople and Rome, and the two were never reconciled.

Monasticism was first developed in Egypt. A community of monks gathered around the desert retreat of the holy Anthony, and Shenute and Pachomius had separately organized forms of monastic establishments nearer to the Nile. Christianity united the Greeks of Egypt and the Egyptian population. As there were more Egyptians than Greek-speakers, the Bible and Christian sacred writings were set down in what came to be called Coptic, the Egyptian language written with Greek letters and a few additional characters from the demotic script. As time went on Coptic was used in secular documents, although Greek continued to be written well into the Arab period.

The country of Egypt to which the Romans came was much as it had been

from early pharaonic times, that is, defined by the Nile. The great north–south river cut through the desert, with a few cultivated kilometres of land, at the most, extending on each bank. The river divided north of the great and once royal city of Memphis into two main branches, with others in between, forming the intensively cultivated Delta. Also of importance agriculturally was the low-lying area of the Fayum, fed by a channel of the Nile and much improved under the early Ptolemies. In the Western Desert were the oases, well-watered areas reached by perilous desert routes: Baharia, Farafra, Dakhla, and Kharga. Farthest west and best reached from the coast, was the oasis of Siwa, where Alexander was confirmed in his divinity by the god Amun. In Egypt and the Fayum, agriculture relied on the annual inundation, which in a good year took water to the farthest reaches of the cultivated areas and covered the ground

with rich Nile silt. Water-lifting devices such as the *shaduf*, the Archimedes screw, and the *sakiya*, were essential for irrigation at other times, or if there was a low Nile. There was abundant fish in the Nile for eating fresh, for salting, and for the production of fish sauce. The main crops were wheat (much of which was shipped to Rome and later to Constantinople), grapes for wine, made in huge quantities, especially in late Roman times, and animal fodder. In the Delta marshes, papyrus grew. Vast quantities were transformed into a writing medium, not only for the bureaucracy of Egypt and its books, but also for the rest of the empire. The land and the river were rich and fruitful, but work was hard and the products were taxed both in themselves and in the money they realized.

Most people lived in villages in the countryside, and many in the chief cities of each nome, which were like overgrown

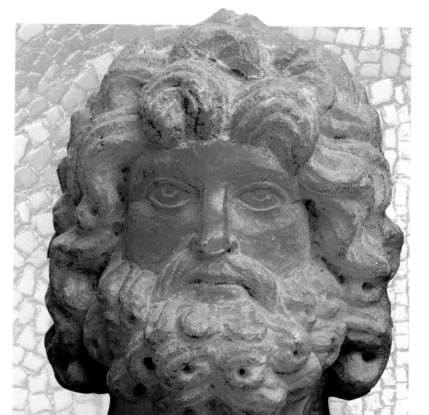

380
HEAD OF A FEMALE COLOSSUS
CG 27468
MARBLE
HEIGHT 73 CM
PROVENANCE UNKNOWN
(332 BC–AD 311)

381
SMALL BUST OF ZEUS
CG 27439
YELLOW ALABASTER
HEIGHT 17.5 CM
PROVENANCE UNKNOWN
(30 BC–AD 311)

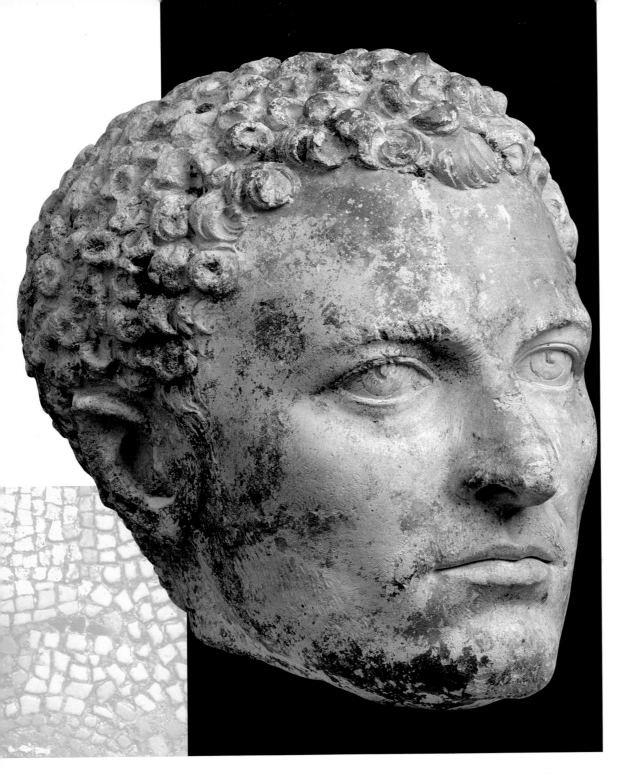

third century AD a majority of the Egyptians were Christian, and there was a progressive decline in pagan religions. Temples in many places were abandoned before the fourth century, although paganism did not easily die away. The earliest surviving churches are of the mid-fifth century, built in the classical basilica form and often employing architectural elements removed from earlier buildings: the great transept cathedral at Hermopolis Magna was built mainly of material taken from public buildings of the second century. Churches were often built on the sites of pagan temples, and are mentioned in abundance in papyri well into the Arab period. Traces of many survive.

In addition to grain and papyrus, a third Egyptian material was also much desired by the Romans and they went to extraordinary lengths to obtain it – stone. The hardstones of the Eastern Desert, the gray granodiorite of Mons Claudianus and of Barud, the diorite of Umm Balad, a variety of stones from the Wadi Hammamat, and the imperial porphyry of Mons Porphyrites were extracted in quarries far from the Nile valley. The infrastructure necessary for its transport and export was complex and organized by the army. Practically all the Mons Claudianus stone was sent to Rome for

villages, with narrow twisting lanes and only occasionally straight main streets, usually flanked by public buildings and punctuated by temples. Both villages and cities relied on agriculture and manufactured goods, particularly textiles, for their prosperity. Alexandria, the main Greek city in Egypt, was supported by the rest of the country and by trade. It was a great entrepôt, manufacturing little of importance itself, but receiving and exporting the produce of Egypt and exotic materials from India and the Far East brought by monsoon winds to ports on the Red Sea and transported across the desert to the Nile. Two other Greek cities, with attendant privileges given to them by the Ptolemies, were Naukratis in the Delta and Ptolemais in Upper Egypt. A third, Antinoopolis, was added by Hadrian in AD 130 and populated by people attracted by tax concessions and other rights.

Many of the temples of the towns were in traditional Egyptian style; but classical buildings introduced by the Ptolemies (and earlier at Naukratis) and in Roman

times became more and more evident throughout the land. The new Greek city of Antinoopolis was particularly well endowed, with architecture matching that of the eastern part of the empire, although its main temple was built by Ramesses II. Hermopolis Magna was not to be left behind and built magnificent structures in the second half of the second century. Not only temples were built but also other public buildings of classical form: theatres, hippodromes, gymnasia, baths, nymphaea, colonnaded streets, triumphal arches and honorific columns. It is probable that the temples built using the classical orders were mainly Capitolia, for the worship of Serapis and Isis, and of the Imperial Cult. Some of the pharaonic-type temples in the cities and villages were immensely old, but many of the most complete that survive today were raised by the Ptolemies and the Romans: Philae, Dendera, Edfu, Esna and Kom Ombo, for example. Others had Roman-period structures added.

In due course, splendid churches were built. It is possible that by the end of the

imperial building projects. Mons Porphyrites porphyry, used as much for sculpture as for architecture, was much more widely distributed, and was employed in Egypt as well as the rest of the empire. The more easily obtained red granite of Aswan, unlike in pharaonic times, was seldom used for statuary, but column-shafts reached distant places in the Roman world. In Egypt it was normal to use locally quarried material, limestones or sandstones, for public buildings, both as ashlar blocks and for decorative architectural elements, such as column capitals and bases, and string-courses, but often combined with Aswan granite shafts.

The arts and crafts of Roman Egypt saw both continuity with and change from what had gone before. Mosaic floors were not as popular in Roman Egypt as in the rest of the empire, but some are found in large private houses and also in bath-houses. Wall-paintings, however, often depicting deities – Isis, Athena, Harpocrates, the rider-god Heron, for example – decorated many of the houses

in the villages and cities. A fine example from the funerary village of Hermopolis-West shows aspects of the myth of Oedipus.

During the early years of Roman rule some sculpture in the round followed traditional styles, but this was already changing under the later Ptolemies. Fine and realistic statues in stone and bronze became indistinguishable from those produced elsewhere in classical lands. A few images of emperors in Egyptian dress and wearing the *nemes* headdress are found, up to the reign of Caracalla in the beginning of the third century AD. But official portraits of standard classical style were made as emperor followed emperor, and were copied, for the most part very well, in Egypt. An extraordinarily incompetent bronze head of Hadrian – if it is he – in the Alexandria Museum is one exception. Although a little white marble occurs geologically in Egypt it does not seem to have been exploited in pharaonic times and it is very likely that all the marble used during both the Ptolemaic and Roman periods was imported. Many of the portraits of emperors and their consorts are in this material, as are private portraits and many of the figures and heads of deities that have survived. Statues of Serapis, Isis and Aphrodite in marble are particularly prevalent, in a great range of sizes. Some of the black and green stone private portraits that were carved in late Ptolemaic times, often of priests, may have continued to be made in the early Roman period. Portrait statues and busts of emperors in imperial porphyry were sculpted in the fourth century in Egypt.

The earlier portraits and figures in this material found in Italy were very probably carved there from the imported stone, and were not Egyptian products. Relief sculpture in marble is occasionally found, such as the fine Mithraic bull-slaying slab from Hermopolis Magna. But most reliefs are executed in limestone and are of a funerary nature, like the many grave stelae from Terenuthis in the Delta, showing the deceased reclining on a couch, or standing with arms raised, and also the fine stela of Isidorus in the Egyptian Museum. Hardstone commemorative stelae in Egyptian style are known: a particularly important one in black porphyry was found in 1995 at Mons Porphyrites and is now at Qena. It is dedicated in the fourth year of the emperor Tiberius (AD 18) to Pan-Min, god of the Eastern Desert, by Caius Cominius Leugas, and celebrates the discovery of porphyry at the site.

Bronze casting had long been known in Egypt and large-sized hollow figures produced by the lost-wax process were developed as early as the Third Intermediate Period. During the Late Period and in Ptolemaic times small bronze votives of gods and sacred animals were made in enormous quantities. This

massive production appears to have slackened off in the Roman period, due perhaps to a reduction of the practice of dedicating animals and figures at sacred animal cemeteries. Small figures continued to be made, possibly for domestic shrines (again statuettes of Isis and of Aphrodite are found in some number). And large figures are also produced, such as portrait heads and statues, and decorative features for the home: a splendid archaic figure of Apollo in the Cairo Museum is probably a large lampstand. Miniature bronze altars, and lamps, ornamental and functional, were made in large numbers, particularly during the first two centuries of Roman rule and also in late Roman times.

During Ptolemaic times a huge variety of terracotta figures were developed in the villages and cities of Egypt, most of which

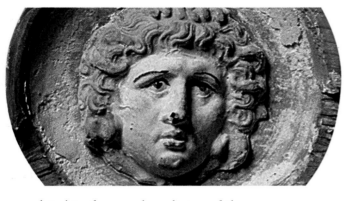

related to the popular religion of the people, their protection from the supernatural and their well-being in all the natural disasters that could befall them. Harpocrates, Isis and Hathor guarded them; Bes protected women in childbirth. In the Roman period the diversity of terracotta types lessened considerably, and the Olympian gods became more popular. Ritual and processional figures decreased in number, and there was an introduction of beneficent spirits, seated women with their hands raised in protection. The Sothic dog of Isis, ensuring the coming of the inundation, is found in some numbers. The majority of these disappear with the adoption by most of the population of Christianity. But the protective spirits remain, from the fourth to the seventh century women with their hands raised benignly guard the house and its occupants, but in a standing posture.

Except in the Old Kingdom, and for a short period in the New Kingdom when blue-painted vessels were produced, the pottery of Egypt tended to be plain and functional and often poorly made. Presumably because of the import of fine wares from other parts of the empire, Egyptian pottery of the Roman period became much more decorative and often skilfully manufactured. From the first century AD until medieval times the pottery workshops of Aswan had a vast output, sent all over Egypt and beyond,

of barbotine wares, red slip wares and painted vessels. Red slip wares were produced locally all over Egypt. Painted bowls and jars, decorated with animals and human figures and often of huge size, are a feature of late Roman potteries. Unlike their pots, the pharaonic Egyptians did decorate their faience vessels, and this was continued into the first two centuries of Roman rule, when kilns like those at Kom Helul at Memphis made a large variety of blue and green mould-decorated vessels and plain wares. The glass manufactured in Roman Egypt was adequate and interesting, but mainly functional. There is no evidence, for example, that the clear facet-cut glass of the second century found on military sites in the Eastern Desert was an Egyptian product.

Some of the gold jewelry of Roman Egypt was directly descended from that of the Ptolemaic Period, particularly in the case of snake bracelets and snake rings, which were very popular from the third century BC until the second century AD. These are known in great numbers, both as actual examples and also shown on coffins, either modelled in cartonnage or painted on mummy-boards. Otherwise, much of the jewelry is close to that found throughout the empire: loop-in-loop chains with wheel and crescent ornaments, known from as far away as Britain (even snake bracelets were made in Britain). And many of the earrings shown on mummy-portraits, the ball-type and the bar-type,

for example, survive in many provinces and Italy itself. Local goldsmiths, however, often made jewelry that was very Egyptian in character, like that found hoarded in a fourth-century jar in a temple at Dush in the Kharga Oasis. A crown showing Serapis and two bracelets were products of the late first or early second century AD, but were accompanied by an elaborate pectoral made a hundred years later. This jewelry was made for priestly ritual use, and other, less elaborate examples have been found in Egypt.

We cannot leave the crafts of Egypt without a mention of the elaborate textiles that have been recovered in huge quantity in the graves and city-mounds of Egypt.

384
TYMPANUM OF WOODEN
SARCOPHAGUS
CG 33102
WOOD WITH POLYCHROME
DECORATION IN
TERRACOTTA AND STUCCO
HEIGHT 36 CM
WIDTH 41 CM
SAQQARA, SERAPEUM
(30 BC–AD 311)

tempera or encaustic (a wax-based medium). A variety of woods were used, some imported. The portraits, of bust length, show the deceased dressed in their finest clothes, some military, mostly civilian. The women and girls wear splendid jewelry, the men occasionally have diadems, the boys amulets. A few are the work of fine artists, but most are the products of good or mediocre painters. They all bring us poignantly close to the Roman inhabitants of the Nile valley. Many come from the Fayum, at Hawara and el-Rubayat; some of the finest were found at Antinoopolis. At the same time, particularly in Middle Egypt, mummies were furnished with plaster heads, painted and often gilded, the women with very elaborate hairstyles. These are much more stylized than the paintings and cannot be regarded as portraits.

The Roman province of Egypt, with its innumerable small mud-brick villages and hamlets, and larger nome capitals, all necessarily situated close to the greatest

river of antiquity, was unlike other provinces of the empire. A civilization of intermittent quality, with splendid highs and desperate lows, persisting over two thousand years in language and tradition, marked the land like nowhere else. The Macedonian Ptolemies, and their Greek immigrants, put a classical gloss upon it, which the Romans continued, accepting those aspects of Ptolemaic bureaucracy that were useful to them and rejecting others. It was a markedly hierarchical society, but that was common throughout the Empire. Because documents survive in the dry climate of Egypt, much more is known about the way the country was run than is the case for other provinces. It is very likely that its bureaucracy was not greatly different from elsewhere, except where its role as a granary of the City of Rome was concerned.

From the time that the Egyptian Museum was founded, material from the Roman period was collected. In 1858 Auguste Mariette was appointed Director of Antiquities and the results of his huge programmes of excavation, Pharaonic, Ptolemaic and Roman, were deposited in warehouses at Bulaq, which he established as the first museum of ancient Egyptian art and artifacts. A new building to house the ever-increasing material was built there but again it proved too small and the museum was moved across the Nile. The present, purposely designed, Egyptian Museum in Tahrir Square was inaugurated in 1902. Galleries, both on the ground and the upper floors, were given over to artifacts of the Roman period in Egypt.

385
NAOS WITH FALCON
TR 18.11.24.46
STUCCOED AND PAINTED
WOOD
LENGTH 27 CM
WIDTH 26.5 CM
PROVENANCE UNKNOWN
(1ST–2ND CENTURY AD)

Without a break, until medieval times, the weavers of Egypt made garments woven in one piece and decorated them lavishly with plant, animal and human motifs. Huge hangings with mythological scenes and funerary shrouds with portraits of the deceased accompanied by Anubis and Osiris were among the finest products.

Unique to Egypt is the mummification of the dead, and the elaborate painted and gilded cartonnage coffins developed in the Late Period and Ptolemaic times continued to be made in Roman Egypt. From the first century AD until the middle of the third century, the stylized human face of the mummy was often replaced by a realistic portrait painted on a flat board, either in

Excavators of sites in Egypt long enjoyed a very generous division of objects to be taken away to their own countries; only the unique and the most important discoveries were retained by the authorities for incorporation into the collections of the Egyptian Museum. This applied equally to material of the Dynastic period and dating to Roman times. In addition to excavations, agriculture, government-sanctioned digging of nitrogen-rich *sebakh* for fertiliser from ancient mounds, and chance finds all served as sources of fine antiquities for the museum in Cairo. Objects newly acquired by these means, both deliberate and chance, adorned the Roman galleries. The museum was thus able to build up a splendid collection of portrait heads and busts, of emperors and important private people, in marble and other hardstones such as porphyry. Full-length sculptured figures, colossal, life-size and smaller, of gods and goddesses, both classical and Egyptian, were obtained, as were reliefs of a funerary and a religious nature, like the bull-slaying slabs from temples of Mithras at Memphis and Hermopolis Magna. Stone stelae, inscribed in Greek or hieroglyphs, and important historical inscriptions were added to the collections in some number.

Smaller antiquities, including bronze statuettes of deities and animals,

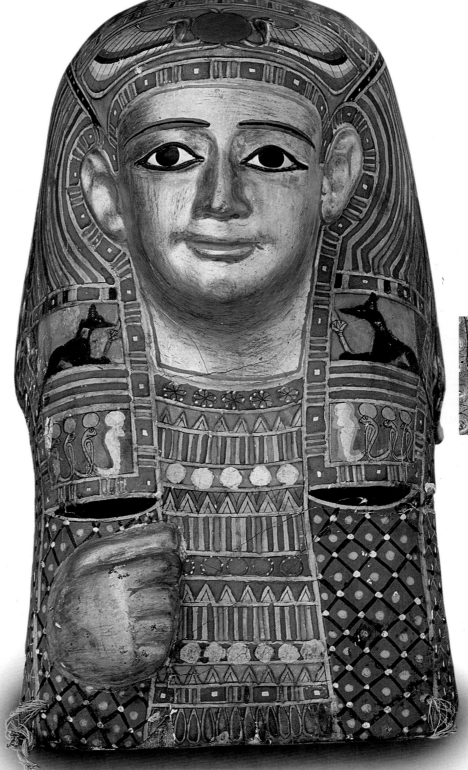

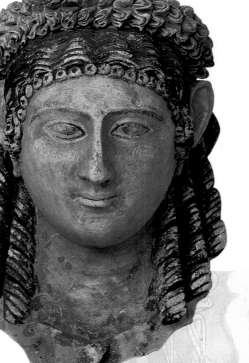

386 RIGHT
FUNERARY MASK
TR 18.8.19.1
CARTONNAGE
HEIGHT 42 CM
WIDTH 26 CM
LENGTH 40 CM
PROVENANCE UNKNOWN
(30 BC–AD 311)

386 ABOVE
FEMALE FUNERARY MASK
CG 33187
PLASTER
HEIGHT 29.5 CM
WIDTH 18 CM
TUNA (1895)
(30 BC–AD 311)

387 OPPOSITE
**MUMMY PORTRAIT
OF FEMALE FIGURE**
CG 33281
LINEN AND STUCCO WITH
POLYCHROME DECORATION
PORTRAIT HEIGHT 27 CM
MUMMY HEIGHT 158 CM
SAQQARA
(AD 325–350)

terracotta figures from the Fayum and elsewhere, pottery lamps and glassware, were acquired and attract great interest today. Papyrus documents in the collections, including letters, receipts for taxes paid or goods received, petitions to officials concerning wrongdoing, and many other subjects, written mainly in Greek, provide many details of life as it was lived during Roman times.

Mummification was carried on into the first three centuries of Roman rule, and many finely wrapped or gilded mummies date from this period. These include examples, mostly from the Fayum and Antinoopolis, with realistic mummy portraits of men, women and children. An important series of these portraits, removed from their mummies, has been exhibited from the time that they were first found in the 1880s.

Although the Egyptian Museum retains and displays a comprehensive array of Roman objects, since the establishment by Giuseppe Botti in 1895 of the Greco-Roman Museum in Alexandria, many objects that would have gone to Cairo were sent there. Numerous objects that had been in Bulaq and at Giza were also transferred directly to Alexandria rather than to Cairo when the new Egyptian Museum opened. The policy of the Egyptian Museum concerning Roman artifacts cannot be consistent, governed as situations so often are by outside influences and demands. For example, major items from el-Ashmunein, like a marble priestess of Isis and a silver treasure, went to Alexandria. Whereas, from the same site and from nearby Tuna el-Gebel, a portrait of Antoninus Pius and a wall-painting depicting scenes from the myth of Oedipus were sent to Cairo. Other provincial museums have opened at various times, each collecting locally found antiquities, both pharaonic and classical, as at Ismailia, Minya, Mallawi, Luxor and Aswan. The Cairo Museum once exhibited late Roman material, the so-called Coptic art, often of a Christian nature, but some was sent to Alexandria before 1899. Much of the remainder, including decorated architectural stonework from Bawit and the Monastery of Apa Jeremias at Saqqara, was transferred to Old Cairo after the Coptic Museum was founded there in 1908 by Marcus Simaika Pasha. Non-Christian Roman-period artifacts, such as the grave reliefs from Terenouthis, are also displayed there. Thus it is that several museums in Egypt exhibit objects from throughout the seven centuries of Roman rule, but the major items are in the collections of the Greco-Roman Museum at Alexandria, the Coptic Museum, and the Egyptian Museum in Cairo, each with strengths of its own.

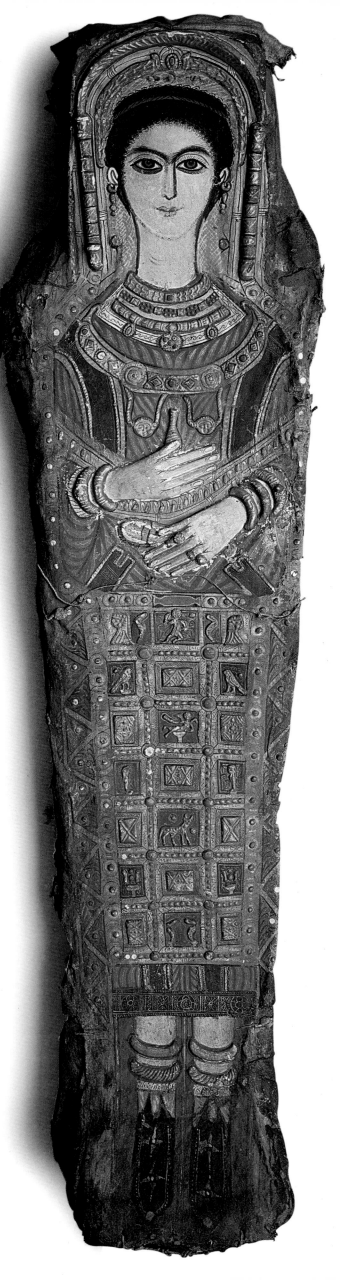

BIOGRAPHY

Born in 1931, **Donald Bailey** joined the Department of Greek and Roman Antiquites of the British Museum in 1955 and retired from the Museum in 1996. One of his main concerns was to publish the ancient lamps in the Museum's collections, and the last of his four volumes dealing with these objects was published in 1996. Since 1980 he has been much occupied with the archaeology of Roman Egypt, working until 1991 at Hermopolis Magna in Middle Egypt and publishing two of the five Final Reports on the site, on the Roman buildings and on the Roman and Arab-period pottery.

He has worked in Egypt at Marsa Matruh and Diospolis Inferior, and, up to 1998, spent five seasons at the Roman quarry site of Mons Porphyrites and four seasons of survey on deserted Ptolemaic and Roman villages in the Polemon district of the Fayum. At present he expects to continue his work at the Red Sea harbour site of Myos Hormos.

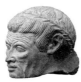

PORTRAIT OF AN OLD MAN

LIMESTONE
HEIGHT 8.5 CM
UMM AL-BREYGAT (TEBTYNIS)
LATE PTOLEMAIC DYNASTY (50–30 BC)

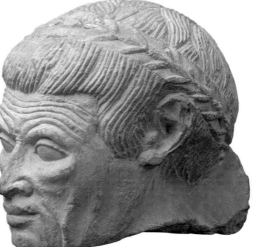

This portrait belongs to a strand of verism in the Egyptian sculptural tradition. The overall style is rather abstract and decorative. Its strong geometry underlines the attention paid by the artist to the almost exaggerated rendering of the signs of old age on the man's face. Its corrugated surface is rich in effects of light and shadow. The cheekbones are especially pronounced and emphasized by the deep hollows below the eyes and the thick, arching wrinkles on the forehead. The deeply set eyes are themselves emphasized by the raising of the eyebrows at the centre, furrowing the forehead. This liveliness of movement contrasts with the immobility of the hair, rendered with a series of thin, inscribed parallel lines, straight and regular around the neck, and slightly curved on the top of the head to indicate the individual locks. The two sections of the hair are interrupted by a laurel wreath fitted close around the head. The presence of this element suggests that the person depicted was a priest.

At the back of the head is the cavity that probably once held a support. This element, which may well have been inscribed with the identity of the subject, suggests that statuette would have been a standing figure with its arms to its sides, perhaps in the act of striding forwards.

Comparisons between the composition of this work with other pieces allows it to be dated to around the middle of the first century BC. This dating receives support from the discovery at the same site of a statue perhaps depicting Ptolemy XII and an inscription relating to the same ruler. (A.L.)

HEAD OF A MALE FIGURE IN BASALT

BASALT
WIDTH 30 CM
TANIS; A. MARIETTE'S EXCAVATIONS (1861)
LATE PTOLEMAIC DYNASTY (80–50 BC)

This head originally belonged to a larger statue that is now lost. The figure depicted is an old man, probably of high social standing. The face is furrowed by three deep lines on the lower part, giving it a severe expression; two of these run from the nose along the cheeks while the third delineates the chin. The thin lips are closed and stiff. The nose is fairly regular in shape but has a small bump at the top close to the eyes.

The gaze is accentuated by the deep-set eye sockets. The eyes themselves are fairly narrow and the eyebrows are slightly raised. Two thin lines can be seen on the forehead. The short, sparse hair is rendered with small parallel lines that are rather stiff.

At the back of the head is the cavity for a rear support. On the basis of this evidence it is probable that the statue was originally of a standing figure, with the arms held along the sides.

This work can be ascribed to the Greco-Egyptian artistic milieu. Three different strands of Egyptian are have been identified during the Greco-Roman period. The first is based on indigenous Egyptian traditions, the second is heavily influenced by Greece, and the third is composed of a blend of the two. This example combines artistic features characteristic of Greco-Roman art with typical Egyptian forms.

This blending of elements from different sources frequently makes it very difficult to attribute a precise date to a work, but in this case the rendering of the hair suggests that it might have been produced in the first half of the first century BC. (A.L.)

STATUE OF HORSAHOR

BLACK BASALT
HEIGHT 83 CM
ALEXANDRIA
LATE PTOLEMAIC DYNASTY (C. 40 BC)

This statue has at some point been severed by a clean cut below the hips. The legs are missing and a little over half of the total height of the sculpture now survives. The statue is of a striding man, in the traditional pose for male figures. The right arm is held to the side, while the left introduces a new gesture as it is folded across the stomach with the hand holding a flap of the robe. The proportions of the statue are somewhat odd, the head being rather large for the slim body.

The figure is dressed in a costume unusual for pharaonic statues but typical of Ptolemaic sculpture. It consists of a thin, round-necked tunic with short sleeves, over this is a cloak that covers the left shoulder and arm but leaves the right exposed. The cloak is wrapped around the body with edges crossed over the right side. The weight of the folded cloth produces an effect of drapery on the left side. It is impossible to say how long the entire costume was, but the pleated hem of the cloak can be seen just below the figure's hand. On the basis of a comparison with other statues it can be suggested that the tunic reached the ankles.

The dorsal pillar identifies the subject of the statue as Horsahor. His face is also highly unusual and is stylistically close to Roman portraiture. His hair is short and receding, with the precisely carved outlines exposing a broad forehead and small ears. The eyes are noticeably asymmetrical, with the right one larger than the left. The deeply carved sockets are delimited by arching and sharply modelled eyebrows, and by high, well-defined cheekbones. The eyes are underlined by pouches, while a series of furrows traces the hollow cheeks, creating a distinct frame around the mouth. The nose is straight and slim and the chin is pronounced.

In spite of the presence of the dorsal pillar with a hieroglyphic inscription, a typical feature of Egyptian statuary, and the pose which echoes that of traditional male sculptures, the portrait of Horsahor has little in common with the style and iconography of human representation in pharaonic art and would already appear to be the fruit of a culture that, while still strongly influenced by the Egyptian tradition, had embarked on a new trajectory. This was the moment of transition into the modern era, characterized in Egypt and throughout the Mediterranean by the development of those schools of thought that were to lead to the birth of Christianity. (R.P.)

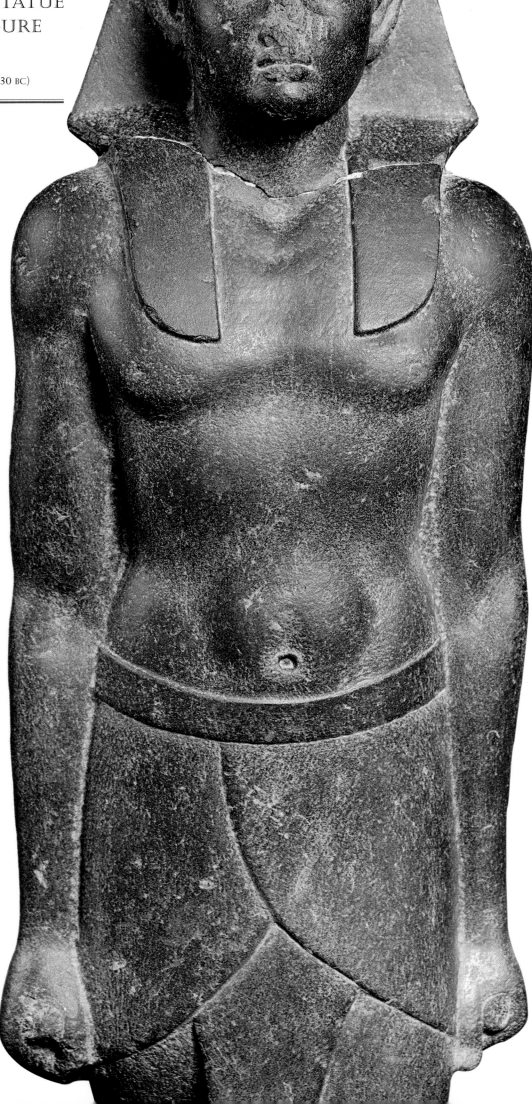

EGYPTIANIZING STATUE OF A MALE FIGURE

GRANITE; HEIGHT 95 CM
PROVENANCE UNKNOWN
LATE PTOLEMAIC DYNASTY (40–30 BC)

This statue is very similar to works produced in the Egyptian sculptural tradition but also displays elements that can be attributed to Greco-Roman influence. The figure's position, as if frozen in the act of taking a step forwards, with the arms held to the sides, and the costume, consisting of a simple kilt wrapped around the hips, clearly places the statue in pharaonic Egypt. Great vitality is visible in the rendering of the torso, with its well-defined pectoral muscles.

The face of the statue is somewhat lifeless and inexpressive. The hair is rendered through small parallel incisions to produce locks arranged in a fairly regular manner. The geometrical and angular headdress provides an image of absolute immobility. The face is bland and its features frozen, though some movement is achieved by the rendering of the slightly pronounced orbital arch.

Works of this kind are generally

very difficult to date. The stylistic canons are identical to those of the Egyptian traditions and only a very few elements, such as the locks of hair, allow it to be attributed to the Roman period. The lack of distinctive facial features also makes it difficult to identify the figure portrayed. It has been suggested that this is a portrait of Mark Antony and for this reason the sculpture has been dated to the decade 40–30 BC. (A.L.)

PORTRAIT OF SEVERUS ALEXANDER

WHITE MARBLE; HEIGHT 23 CM; LUXOR
ROMAN PERIOD, REIGN OF ALEXANDER SEVERUS (AD 222–235)

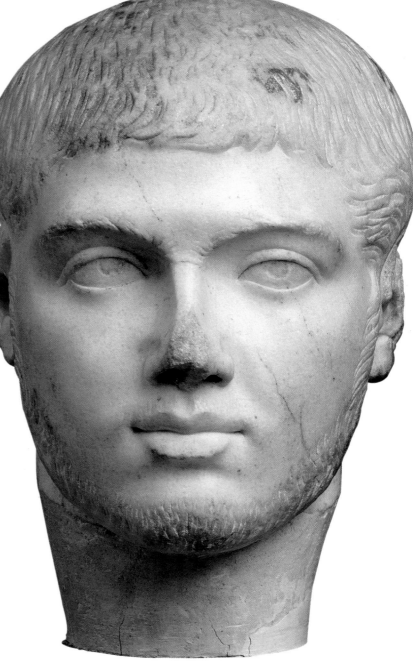

Alongside local production of statues in a continuing Egyptian tradition, a particular style developed that was directly influenced by Rome and which spread through the entire empire. This was a form of 'imperial propaganda' that facilitated the diffusion of the image of the emperor throughout the empire, even to the provinces. There were two principal means of transmitting images of the emperor: coins and sculpted portraits. Today, the coins are used for comparative purposes to identify the sculptural portraits.

The statues were often extremely realistic, and the figure represented here can be identified as Severus Alexander.

His short hair is rendered by irregular incised lines, set vertically. The same technique is used for the beard. The eyes are set in deep sockets, producing a marked shadow. The pupils are shown by an incised circular line. The fleshy mouth is set in a slight smile.

The generally fine appearance of the work is compromised by the oversized restored neck made of stucco, which was probably added in modern times. Because the figure can be identified as Severus Alexander we can date it precisely to between AD 222 and 235. (A.L.)

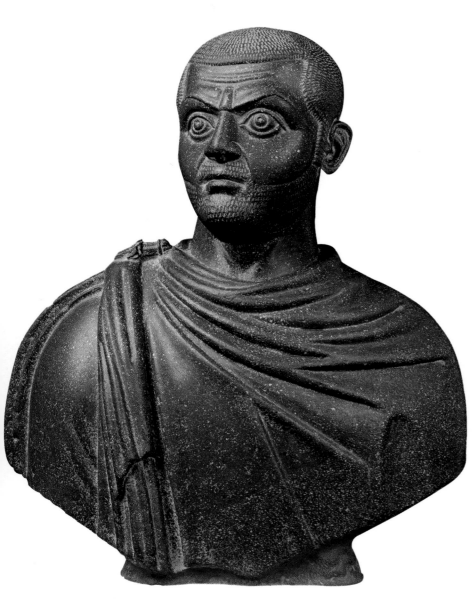

PORTRAIT OF AN EMPEROR

RED PORPHYRY; HEIGHT 57.6 CM
BENHA (ATHRIBIS)
LATE ROMAN PERIOD (LATE 3RD–EARLY 4TH CENTURY AD)

This bust probably portrays an emperor of the late Roman empire. The material used for the work – porphyry – was much favoured by the emperors and is found in Egypt. The sculpture can be compared with the famous tetrarchs of Venice and the portrait of Galerius found in Antioch.

The total abandonment of carefully modelled plastic forms and the old decorative tastes is typical of the art of the early fourth century AD, which stiffened into an increasing abstraction. In official portraiture in particular the inert immobility of the face tends to denote the impersonal and autocratic conception of imperial power.

The heads were larger and more block-like, with depersonalized features. Forms were reduced to strongly delineated geometrical shapes, the details being repeated without variation. Such changes are evident in this bust. The hair and beard, are rendered by short lines arranged very regularly, framing a square face with heavy wrinkles on the forehead. The gaze is made more expressive by the arching of the eyebrows. This has been identified as a portrait of Galerius, but the lack of precise features means this is not certain. (A.L.)

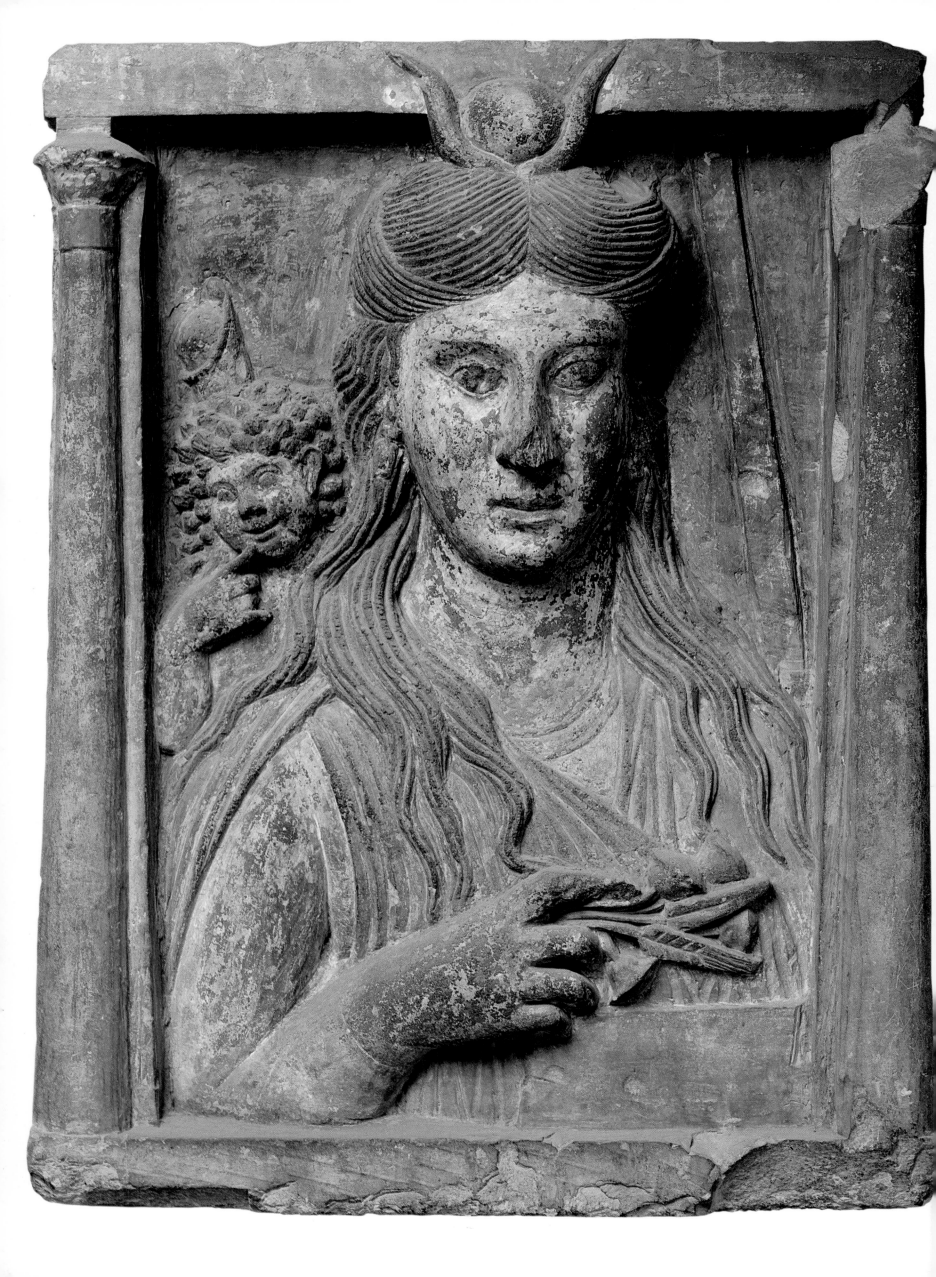

PORTRAIT-BUST OF A FEMALE FIGURE

MARBLE; HEIGHT 61 CM
KOM ABU BILLO (TERENUTHIS)
ROMAN PERIOD (AD 140–150)

This bust is a rather touching portrait of a mature woman of high social standing. The work is distinguished by an elaborate hairstyle, its complicated construction rendered through simple incised geometric lines which make it appear rather flat. The upper part is divided into three regular parallel bands formed of a braid wound round the head and depicted through a series of opposing triangles.

The rather elongated arch of the eyebrows and the chin emphasized by a deep, almost semicircular dimple, provide some depth and shadow to the face, which is turned in a three-quarters pose. The eyes have half-lowered lids and the pupils and irises are rendered with two concentric circular lines. The nose is rather long and the lips are thin and closed.

The neck is framed by the robe which quite high at the rear and crossed at the front with folds of various sizes and depths, the only element of movement in the entire composition.

In the past, the figure has been identified as the mother of Marcus Aurelius, a suggestion not accepted by later scholars. The iconography of the figure and in particular the rendering of the hairstyle, however, do allow the work to be quite closely dated to between AD 140 and 150. (A.L.)

RELIEF OF ISIS AND HARPOCRATES

LIMESTONE; HEIGHT 75 CM; WIDTH 56 CM
BATN IHRIT (THEADELPHIA)
ROMAN PERIOD (1ST–2ND CENTURY AD)

This relief depicts Isis and Harpocrates framed by two small pillars. The presence of these architectural elements gives the composition the appearance of a small temple. In this case the female figure appears almost to project beyond the decorative plane due to her disproportionate scale in relation to the available space. Her body is fairly bulky and somewhat out of proportion with the dimensions of the arm. Her dress is simply rendered by a series of parallel lines crossing at the centre of the torso. Two engraved lines around her neck suggest the presence of a necklace. The hair, with a central parting, is rendered with wavy parallel lines. These lines contrast with two triangles on the sides of the head composed of similar oblique lines. Three serpentine locks frame each side of the neck.

This female figure can be identified as the goddess Isis by the presence of her attributes: a lunar disc set between two cow's horns on her head, and the lotus flowers and the ears of corn held in her right hand.

Behind the right shoulder of the goddess is the fairly sketchy figure of Harpocrates. His left ear is prominent and somewhat out of proportion with the rest of the head, and the face is inexpressive although the artist intended to portray the figure smiling. The hair is rendered with small circular designs in slight relief, and on his head is the crown of Lower and Upper Egypt.

While Isis was a deity of ancient Egyptian origin, she was completely integrated and assimilated within the Roman pantheon. Temples to the goddess were built throughout the empire, including in Rome itself. She was the goddess of fertility, prosperity and navigation. She is often depicted together with the young Harpocrates, who was also associated with abundance and fertility.

The standards of execution of this piece are fairly crude and it is reasonable to suggest that the work was based on compositions from the Roman sculptural tradition but produced by a local artist of average talent. This is demonstrated by the absolute inexpressiveness of the faces and the lack of volume and movement in the sculpture. As is frequently the case with works of this kind, these fairly anonymous features make dating particularly difficult. In general the decorative motifs suggest that the work dates from the first or second century AD, but it is not possible to be more precise than this. (A.L.)

RELIEF OF A FAMILY

WHITE MARBLE
HEIGHT 85 CM; WIDTH 111 CM
PROVENANCE UNKNOWN
ROMAN PERIOD (C. AD 150)

This relief depicts a group of three men and two women. The principal figure, set in the centre, is a bearded man who seems to stand more in the foreground than the others, the artist clearly intending to draw attention to him. This figure's head is turned slightly to the left and he is wearing a chiton (tunic) and a cloak. In his right hand he holds a scroll while his left hand grips the cloak that is wrapped around his waist and hangs over his shoulder. A ring can be seen on the third finger of the left hand.

On this figure's right is a young man with short, curly hair and a band around his head. He is wearing exactly the same clothing as the central figure and is set in the same pose. In his right hand he holds a wreath or a piece of cloth, while the other hand secures his cloak. The pose and dress of these two figures differ from those of the other male, which suggests that the artist used these elements to emphasize differences in status or position between the figures.

On either side of the group are two female figures dressed similarly. The head of the older woman, on the left-hand side of the relief, is covered by a veil. The other woman

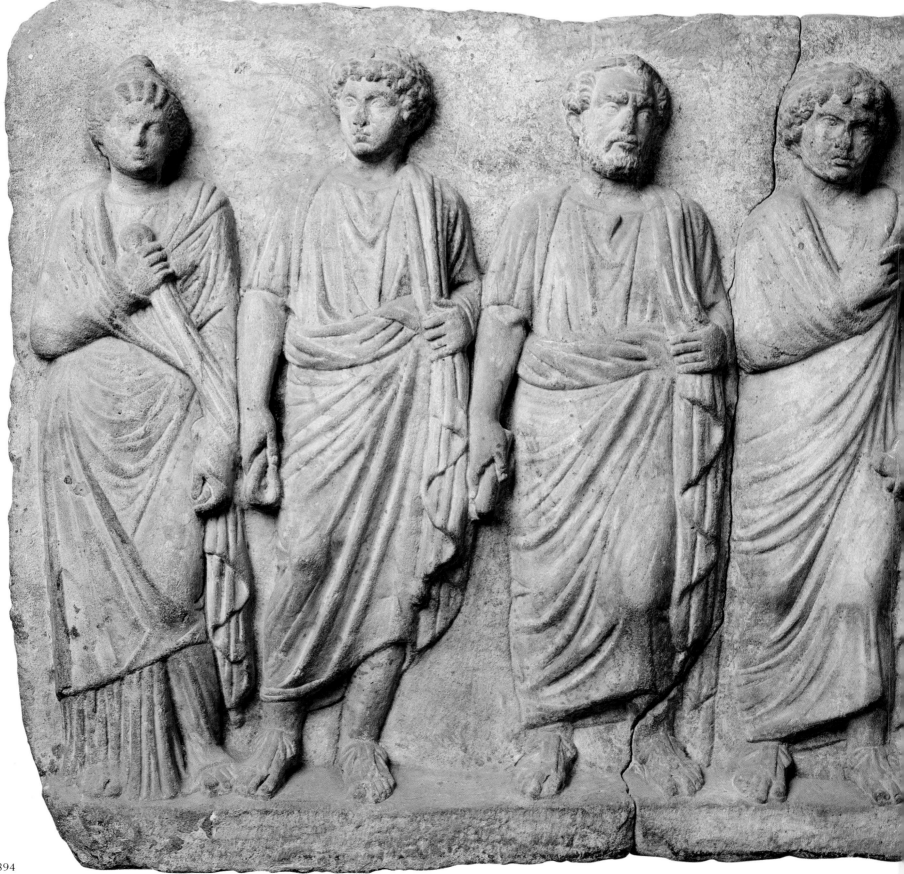

has her left arm along her side, and her right arm grips her robe.

The composition suggests a general hierarchical structure, with the central figure occupying the most important position.

In the past the group represented in the relief has been interpreted as an imperial family, with the central figure being identified as the emperor Antoninus Pius, with Marcus Aurelius to his right and Lucius Verus on his left. The two women would then be Faustina the Elder and Faustina the Younger. In particular, the fact that the older woman has her head

veiled has led to the suggestion that she was deceased and deified. This iconography is common on coins, where she appears as 'Diva Faustina', after having been deified. If this hypothesis is correct then the panel must have been carved after the year 141, the year of the Faustina's death. It has also been suggested that the work may date to the marriage of Marcus Aurelius and Faustina the Younger in 146 or slightly later.

The relief was probably intended to celebrate the imperial family, with a composition based on its hierarchical structure. (A.L.)

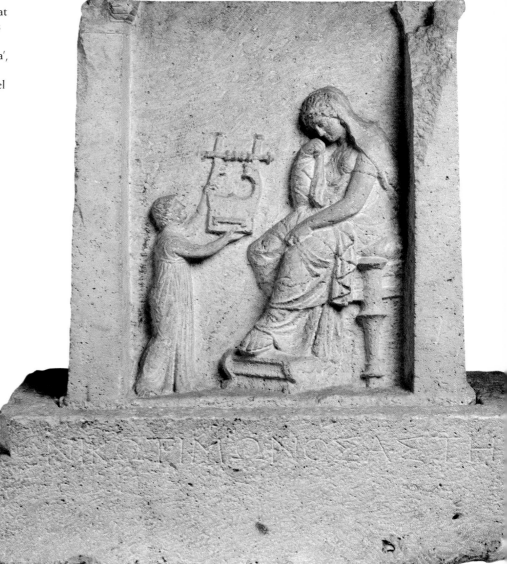

CG 9259

FUNERARY STELA OF NIKO

LIMESTONE
HEIGHT 69 CM; WIDTH 53 CM
ALEXANDRIA
PTOLEMAIC DYNASTY (FIRST HALF OF THE 3RD CENTURY BC)

This funerary stela is composed of two parts: the upper section decorated with a relief; and the base with a Greek inscription. The principal scene is set within two square columns and these two architectural elements give the stela the form of a small *naiskos* or temple shrine.

On the right-hand side of the stela the deceased woman is depicted with her head bowed, seated on a stool, of which a carved leg is visible. The woman is wearing a chiton, over which is a peplum wrapped around the right arm and the head. In her right hand she is holding a handkerchief while the left hand is holding her

cloak. Only the left foot is visible, wearing a sandal and resting on a low footrest. In front of the woman a young girl is depicted to a much smaller scale. She is probably a maid in the service of the woman and is holding out a lyre to the seated figure. The disproportion between the two figures is the result of a compositional decision designed to highlight the central image of the deceased woman. This also explains the contrast between the elaborate pleated robe worn by the deceased and the simplicity of the girl's chiton, rendered with parallel lines. The short step taken by the girl towards the dominant figure

occupying much of the available space is also her only movement.

The small *naiskos* is placed above a square base on which the following inscription in Greek characters can be read:
ΝΙΚΩΤΙΜΩΝΟΣΑΣΤΗ,
(Νικω Τιμωνος, αστη).
This text informs us that the name of the woman was 'Niko, the daughter of Timone', who must have been a woman of high social standing.

The Greek text precisely reflects the style of the decoration: even though the stela was discovered in Egypt it has none of the characteristics that would otherwise allow us to place it in the Egyptian context.

The decoration and the rendering of the figures reflect compositional features typical of Greco-Hellenistic art, while the female figure entirely draped in a swirling cloak recalls the 'Tanagra' figurines which were common in Greece and southern Italy from the third century BC. The general composition of the work thus allows us to date it to around the first half of the third century BC. (A.L.)

SATYR WITH A WINESKIN

TERRACOTTA; HEIGHT 8.5 CM
DELTA REGION
PTOLEMAIC DYNASTY (304–30 BC)

Terracotta statuettes were typical products of all periods of Egyptian history and continued into the Greco-Roman Age, with the addition of models drawn particularly from the Greek artistic tradition. The example illustrated certainly belongs to this context.

It portrays a naked male figure crouching on the ground, covered only with a cloak fastened around his neck. The rendering of the geometrical shapes of the musculature, particularly the legs, is striking. There is a great contrast between the body of the figure, stretching to restrain the wineskin, and the cloak billowing in the wind and streaming in the opposite direction – the two volumes thus balancing one another. The upturned head and the movement of the hair blown by the wind follow the swelling lines of the cloak.

There is some debate as to the identity of the figure. In the past it has been suggested that it might be Aeolus, on the basis of his close association with the wind, or more simply a genie. A passage by Nonnos of Panopolis (early fifth century AD) in his *Dionysiacs* suggests a possible identification with Dionysus. The author relates how the god crossed the River Idaspe on an improvised boat using

an inflated wineskin as an aid. However, the detail of the figure's pointed ears, a characteristic typical of the satyrs, suggests another possible identification. In this interpretation, the bag would be a full wineskin. The available information does not allow us to exclude any of these possibilities. However, the particular emphasis paid to depicting the presence of the wind (highlighted above all by the cloak and the position of the figure straining against it) suggests that this should be a strong element in the identification of the figure.

The production of this type of statuette was fairly constant for long periods and for this reason it is difficult to date the piece precisely. The typically Greek features, however, allow a general dating to the Ptolemaic Dynasty. (A.L.)

ISIS APHRODITE IN TERRACOTTA

TERRACOTTA; HEIGHT 29.5 CM
ABYDOS
ROMAN PERIOD (30 BC–AD 311)

This statuette is of a naked female figure, standing with her arms held close to her sides. On top of her head is a vessels, a *kalathos*, containing flowers. Her body is covered with just two bands crossing below her breasts and she has long hair that descends to her shoulders.

The nudity suggests that the figure is a portrait of Aphrodite, assimilated with Isis due to the close similarities between the two goddesses. Both were goddesses of love and protective deities of women, especially those approaching marriage. Egyptian marriage contracts have been found in which Isis and Aphrodite are mentioned and they are the most frequent subject for the Egyptian terracotta statuettes.

Surviving surface colours allow the original brightly painted appearance of these statuettes to be appreciated. The continuity of production of such works over a long period makes precise dating impossible. (A.L.)

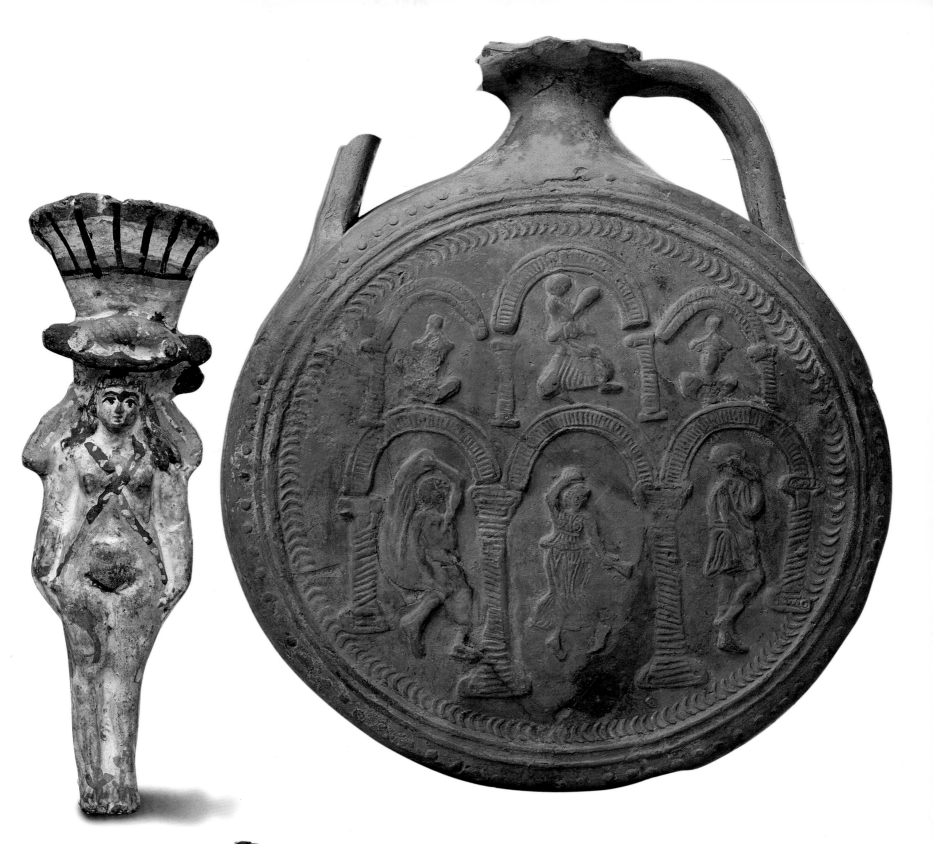

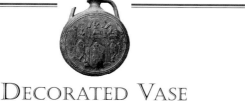

JE 54502

DECORATED VASE

TERRACOTTA
HEIGHT 30.5 CM
PROVENANCE UNKNOWN
ROMAN PERIOD (4TH CENTURY AD)

Terracotta ware was widely produced in Egypt throughout pharaonic history – a tradition that continued to flourish during the Roman period also. Large numbers of statuettes, generally associated with religious cults, and vases have been found from this period. The repertoire of terracotta tableware production was expanded in particular during the Roman period, with the introduction of new shapes. New types of objects and products of high quality were exported to various parts of the Roman Empire.

Numerous examples of circular vessels with mould-made decoration are known from the period of Late Antiquity (fourth century AD), and the piece illustrated here is part of that production.

One face of the vase has a decorative scene positioned on two superimposed planes, all framed within a circle of two relief lines which echo the shape of the vessel. Within these is a concentric line of a small crescent-shaped motif.

The figurative composition has been cleverly adapted to the available surface area. Two rows of figures are arranged within an architectural setting of continuous arches supported by columns. In the upper row, the two side arches are smaller than the central one. In the lower row, an attempt has been made to provide an element of perspective, with the inner columns higher than the external ones. Both rows have been adapted to the limited space available. The arches and columns are decorated with a series of thin parallel lines.

Within each of the architectural elements are set the dancing figures. However, the restricted space, especially in the upper part, has compromised the rendering of the two figures at the sides, whose representation is rather poor and summary.

In the lower row, on the other hand, the available surface area has allowed a more developed depiction, with the central figure of a dancing female being particularly successful. The shape of the vessel and the style of its decoration allow it to be dated to the fourth century AD. (A.L)

DIADEM WITH SERAPIS

BEATEN GOLD
DIADEM: DIAMETER 22 CM; HEIGHT AT FRONT 3.3 CM
PLAQUE: HEIGHT 12.5 CM, WIDTH 8.5 CM
DUSH
ROMAN PERIOD, REIGN OF HADRIAN (AD 117–138)

JE 98535

This diadem is made from a circle of beaten gold which is higher at the front than at the rear. The circlet is closed with a serpent-headed hook. Various decorative elements are attached, including a central plaque featuring Serapis seated on a throne within a *naos* or shrine. The *naos* is itself made of six separate parts. At the bottom there is a plinth in the form of a rectangular base, and at either side stand two fluted columns made of sheets of rolled and riveted metal.

The corinthian capitals of these columns are surmounted by a representation of Isis. The one on the right, which was badly damaged and partially remodelled during restoration, shows the goddess wearing a cloak fastened at the front with a typical Knot of Isis. The figure on the left is represented with a veiled head and has a veiled disc with two horns.

Above the figures rises the pediment, in the tympanum of which is a solar disc framed between two cobras. At the centre of the shrine is the enthroned figure of Serapis with his feet on a pedestal. The figure presents the typical iconography of the deity. He is bearded, with a *kalathos* on his head and is dressed in a chiton with a cloak draped over his knees.

From either side of the *naos* a series of attached leaves runs round the diadem, seven of which remain on the right and nine on the left. The leaves are ribbed and arranged in fan-like groups of three. There are also circular beads on filaments, which represent poppy heads.

The jewel is probably derived from Alexandrine models, though it has been suggested that this piece, together with other objects found with it, was imported. It may have been worn by a priest. (A.L.)

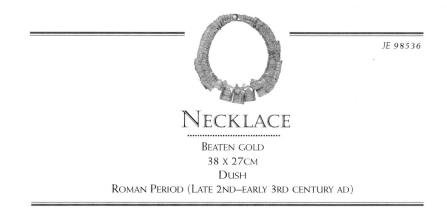

NECKLACE

....................................

BEATEN GOLD
38 X 27CM
DUSH
ROMAN PERIOD (LATE 2ND–EARLY 3RD CENTURY AD)

This necklace with pendants was part of the treasure discovered in 1989 at Dush, the ancient Kysis, at the extreme southern tip of the Kharga Oasis, together with the bracelet and diadem seen here. The three pieces were found in a room within the boundary wall of a temple probably dedicated to Isis and Serapis. This area of the sacred enclosure had been transformed during the fourth century AD into a fortified structure defending the settlement below. On their discovery the jewels were enclosed in a terracotta jar sealed with a lid and placed in a niche. Even though the treasure was found in an area outside the actual temple, it is probable that it once belonged to the temple and was hidden, perhaps following the spread of Christianity and the decline of pagan cults in the fourth and fifth centuries AD.

The necklace is made of a gold wire to which seventy-seven plaques are attached. At the rear is a clasp in the form of a snake's head. The plaques were probably beaten over wooden formers to the same basic pattern: a votive chapel with spiral or fluted columns and the Apis bull in the centre turning to either the left or the right.

This is a common motif for objects of this type and it has been suggested that the plaques were mass-produced and sold outside the temple. It is possible that they were bought by those who consulted the oracle. The necklace might therefore have been a collection of votive offerings, arranged in a casual fashion on a gold wire.

The cult practised in this shrine is revealed by the bust of Serapis, depicted on a sheet of beaten metal, with the traditional iconography of long hair and a headdress. A number of Greek letters are inscribed on the back of the plaque. Their meaning is obscure but they perhaps had a magical function. At the centre of the necklace are three plaques of larger size, each featuring the Apis bull at the centre of a shrine, framed by a *naos* or small temple with fluted columns and decorated capitals.

Also attached to the necklace is a small medallion made from a gold coin with the inscription 'Faustina Augusta', again associated with the cult practised here. On the back of the coin is the goddess Cybele (assimilated during the Roman Period with the Egyptian goddess Isis), with two lions at her feet, a shield in her right hand, and the dedication 'Matri Magnae'. (A.L.)

BRACELET WITH AGATE

....................................

BEATEN SHEET GOLD AND AGATE
DIAMETER 9 CM
DUSH
ROMAN PERIOD, REIGN OF HADRIAN (117–138 AD)

This fine bracelet is made from a sheet of beaten gold decorated with attachments in the form of plant motifs. At the centre is an oval setting enclosing an elliptical black, white and red zoned agate (3.6 cm long and 3.1 cm wide).

The circular band is around forming the frame of the bracelet is 2 cm wide and closes at the central collet. At either side of the agate runs the decorative motif consisting of three-lobed leaves, almost certainly vine leaves, with thick veins. These alternate with groups of three tendrils made from twisted wire. The leaves are all pointed in the direction of the collet.

This jewel, like the diadem with Serapis and another bracelet, belong to the same Hellenistic cache and formed part of the Treasure of Dush. The type and style of the decoration allow the piece to be dated to the Hadrianic period. (A.L.)

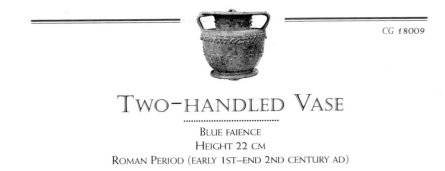

TWO-HANDLED VASE

..
BLUE FAIENCE
HEIGHT 22 CM
ROMAN PERIOD (EARLY 1ST–END 2ND CENTURY AD)

Faience production was a major craft industry in Egypt in all ages and continued unabated into the Roman period. A multitude of different objects was created in this glass-like material in many different colours. These delightful objects, including vessels of various shapes, were exported in the Roman Period to all parts of the empire, where they decorated wealthy patrician houses or were perhaps placed in tombs as part of rich funerary assemblages.

The piece illustrated here is a vase with two handles, a projecting, flat rim and a lid. The applied handles are attached horizontally at the rim and meet the shoulders of the vessel where the body widens sharply.

The decoration of the vase is arranged in three different lines that emphasize the neck, the shoulder and the central part of the body. The first and third bands are the same, consisting of a motif of four leaves arranged in a uniform pattern and placed at regular intervals in a continuous line. The central band is wider and features a succession of three leaves, again arranged in a regular pattern. The general style of the piece makes precise dating impossible, but it certainly can be placed within the context of the faience production in Egypt of the Roman period between the end of the first and the end of the second century AD. (A.L.)

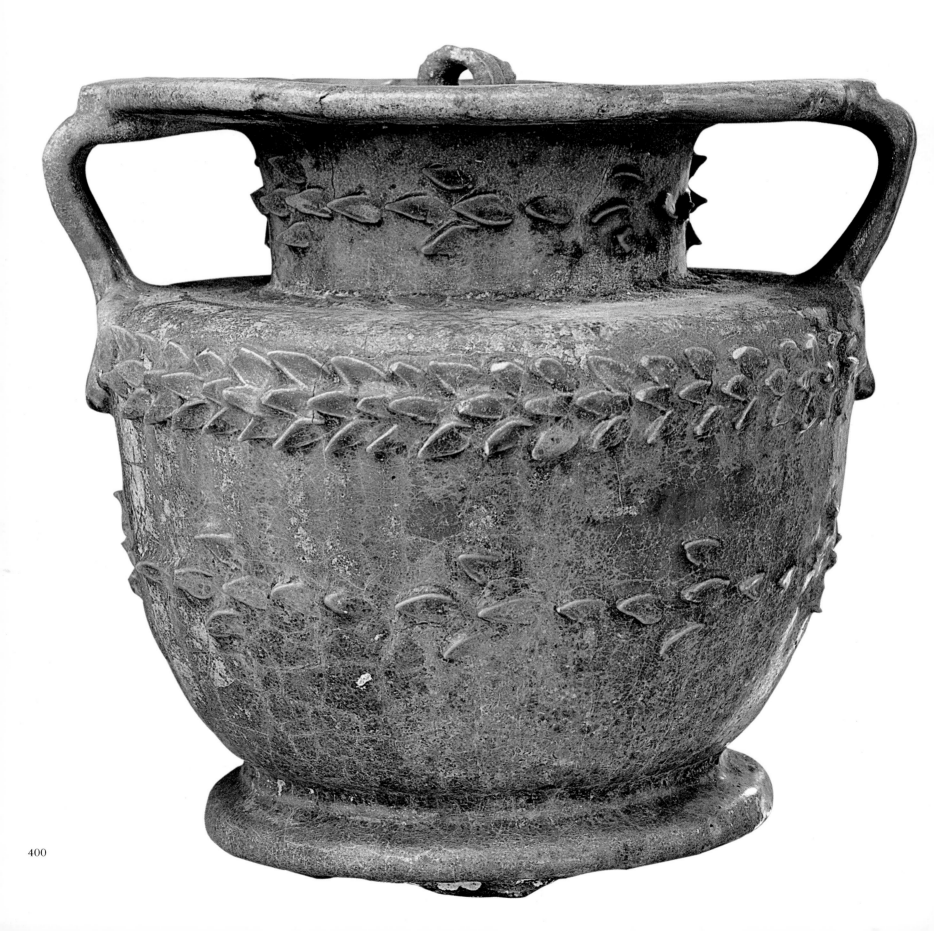

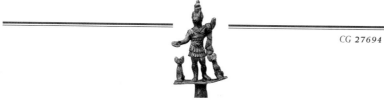

STATUETTE OF ANUBIS

BRONZE; HEIGHT 14.8 CM; WIDTH 6.5 CM
PROVENANCE UNKNOWN; ACQUIRED WITH THE HUBER COLLECTION
ROMAN PERIOD (2ND CENTURY AD)

This statuette represents the god Anubis with a canine head on a human body. Anubis was a funerary deity from the Egyptian pantheon who was responsible for guarding cemeteries and presiding over the mummification process. He is usually portrayed as a jackal. During the Roman period, the fusion of different artistic and iconographical traditions brought about the development of the 'Anubis legionary', as seen in this example.

The god wears a traditional Egyptian headdress and has a human body. While the upper part of the figure can be attributed to the purely local iconographical tradition, the lower part is closely linked to the culture of the Roman world. The figure is wearing a cuirasse. The right arm is held out and holds a dish, while the left is lifted and partially covered by the cloak. The position of the legs, one straight and the other bent, suggests that the broken raised hand may have held a spear. The lower part of the body is rather ill-proportioned. On either side of the figure is a dog.

The modest artistic quality of the statue shows that it was produced locally, the result of the fusion of Roman influences with Egyptian traditions. The type of decoration and representation are compatible with a date in the second century AD. (A.L.)

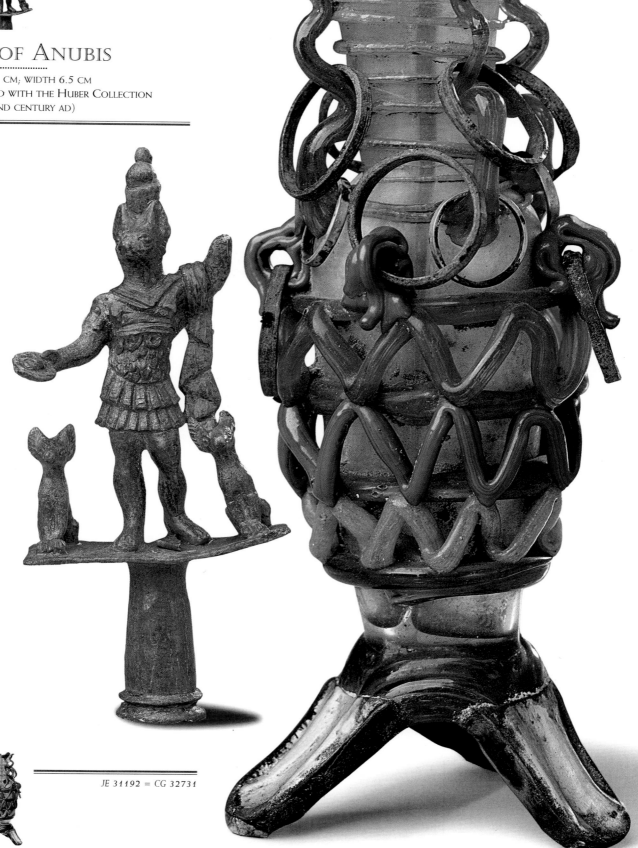

ORNAMENTAL GLASS VASE

GLASS, BRONZE, GOLD; HEIGHT 13 CM
ACQUIRED; PROBABLE PROVENANCE FAYUM
ROMAN PERIOD (2ND–3RD CENTURY AD)

The production of glassware was already a part of the Egyptian craft tradition prior to the Greco-Roman period. Techniques of glass-working had, in fact, been known in Mesopotamia and Egypt since the third millennium BC and were used to produce amulets and scarabs. The first vessels were produced from around 1500 BC. Early glassware was produced with a sand core that was subsequently removed. The core-forming technique disappeared towards the third century BC and was replaced by moulding and grinding. It was not until the first century BC, however, that the glass-blowing techniques used to produce this piece were introduced. This elaborate-looking vessel was in fact produced using a simple technique, with coloured filaments of glass applied to the basic vessel.

The general form of the vase makes it rather difficult to date accurately. However, complicated appliqué pieces became most common during the second and third centuries AD.

The amphora was blown and the decoration applied in separate operations. The first element to be added was the tripod base which was soldered to the vessel, while the other decorative elements were added in successive stages.

A light blue filament has been applied around the neck of vase. Darker blue serpentine motifs were then overlaid. The latter then had bronze rings inserted. The section where the neck widens is emphasized with a series of red circles in which bronze rings have again been added. The lower part of the vessel is decorated with three bands of a zig-zag filaments of different colours: dark and light blue, and red. The foot of the vessel is a tripod in blue and yellow. The rim is enriched with more rings of red glass. (A.L.)

PORTRAIT OF
A MIDDLE-AGED MAN

ENCAUSTIC WAX PAINTING ON WOOD
HEIGHT 34 CM; WIDTH 18.5 CM
PROVENANCE UNKNOWN
ROMAN PERIOD (FIRST HALF OF THE 2ND CENTURY AD)

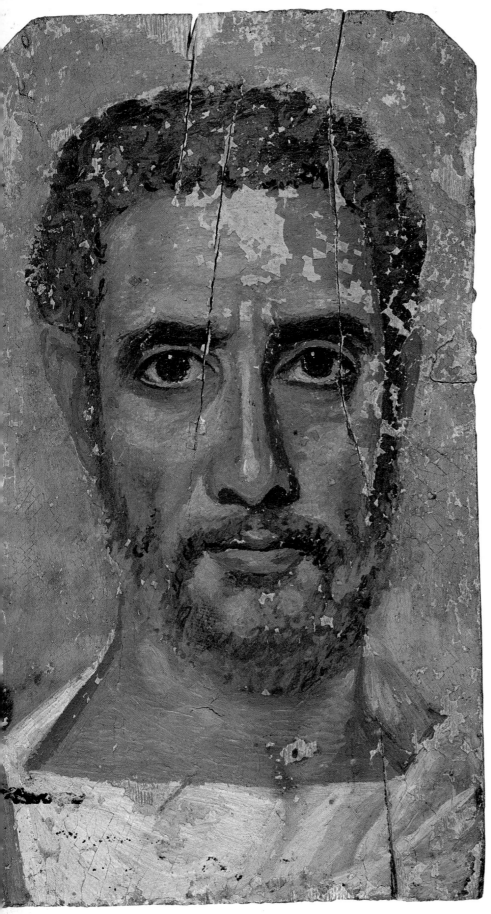

This portrait is painted on a wooden panel. The bust is represented in three-quarters view, with the torsion of the head denoted by the two darker lines at the bottom of the neck. The figure is wearing a white cloak gathered on the left shoulder, where three pleats are drawn in light grey. On the right-hand side there is a thick line of carmine red. The figure has an elongated face, the most distinctive feature of which is the long nose emphasized with a white highlight.

The brown eyes are very lifelike and realistic and are emphasized by darker outlines. The dark red mouth is irregularly shaped with the lower lip being more pronounced. The face is completely framed by the beard and hair, both rendered with small grey curls, a distinctive feature that allows the figure to be identified as a middle-aged man. On the basis of comparison with other portraiture of the period, these decorative elements allow the work to be dated to the first half of the second century AD. (A.L.)

PORTRAIT OF A YOUNG WOMAN

ENCAUSTIC WAX PAINTING ON WOOD
HEIGHT 42 CM; WIDTH 23 CM
HAWARA; W.M.F. PETRIE'S EXCAVATIONS (1888)
ROMAN PERIOD (2ND CENTURY AD)

This panel is one of the series of marvellous portraits painted on wood that were placed over the faces of mummies in Egypt during the Roman Period. The richness of the clothing and the jewels often worn by these figures allows them to identified as members of a high social class.

This woman is depicted with an elongated face and olive-coloured skin. Her most characteristic facial features are the rather long nose and the close-set eyes. The mouth is regularly shaped with fairly thin lips. The eyes are large and emphasized with arched eyebrows. The dark hair is gathered and tied on the top of the head.

Around her neck is a necklace made of a strand of purple stones of a rectangular shape. The same stone is used in the double pendant earrings, with one circular element and one square. Her robe is of a dark tone and the pleats around the neck are highlighted with traces of contrasting light and dark purple.

The portrait is unusual not only because of the rendering of the facial features, but also in the representation of the distinctive jewels and the robe. This suggests that sketches were probably not used in this case and that the portrait was an original work from life. This further supports the suggestion that the woman belonged to a particularly rich family. The general characteristics of the portrait allow it to be roughly dated to the second century AD. (A.L.)

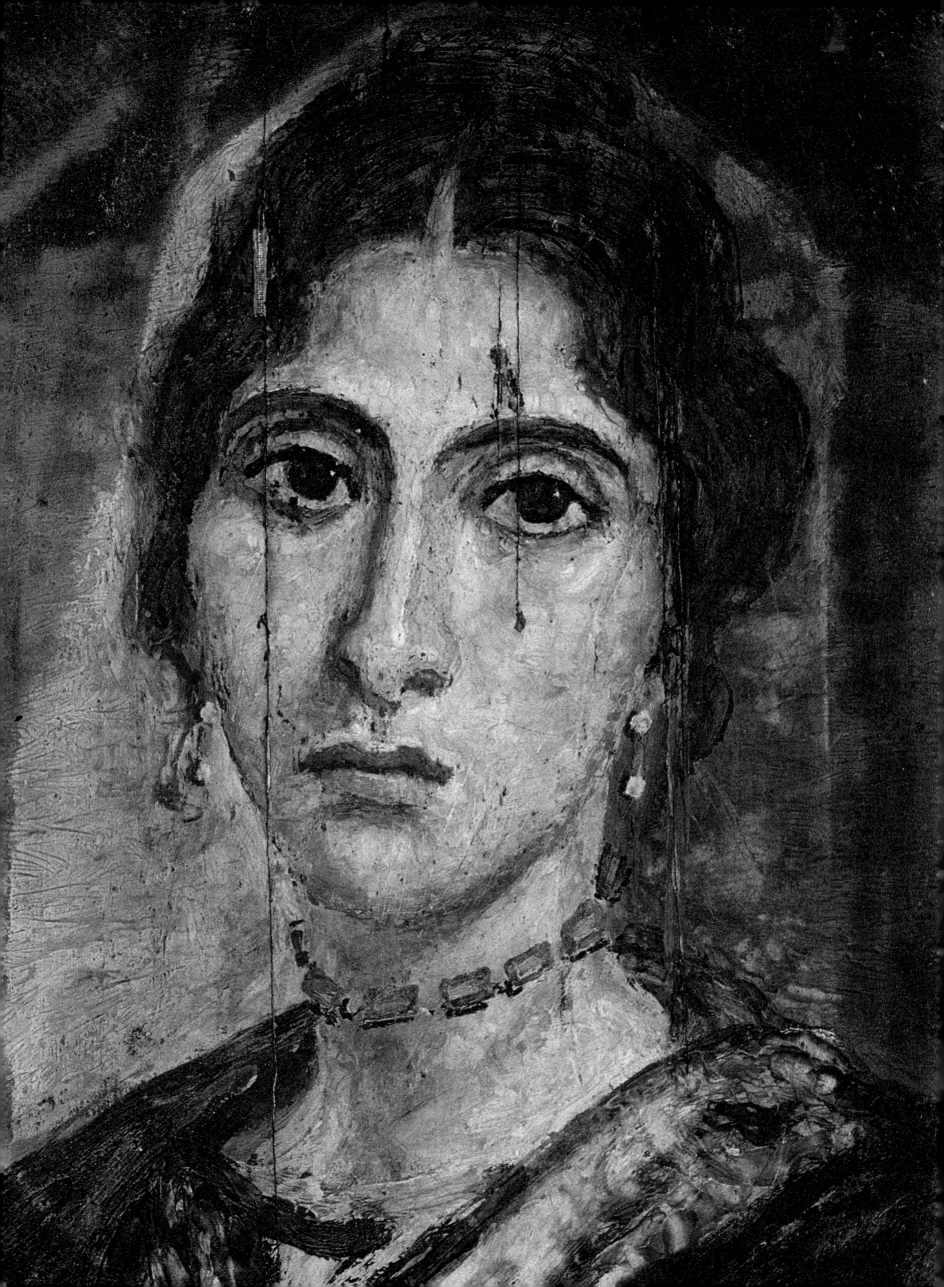

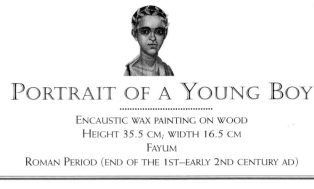

PORTRAIT OF A YOUNG BOY

ENCAUSTIC WAX PAINTING ON WOOD
HEIGHT 35.5 CM; WIDTH 16.5 CM
FAYUM
ROMAN PERIOD (END OF THE 1ST—EARLY 2ND CENTURY AD)

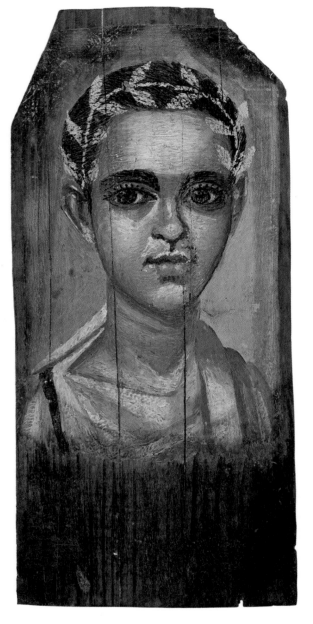

This portrait of a young boy wearing a laurel wreath is painted on a white ground. The skin is olive coloured and the facial features are highlighted with white on the cheeks, chin and forehead. The mouth is regularly shaped and light pink in colour. The nose is small and broad at the bottom. The boy's hair is rendered with dark lines and is partially covered with the laurel wreath. The leaves of the wreath are fairly broad and regularly shaped, and are flattened on the surface of the head. The thick eyebrows frame large, expressive eyes. The upper eyelashes are roughly rendered with thick lines. The head is turned slightly, with the movement being emphasized by dark lines on the neck. The torso is small in proportion to the upper body. The young boy is wearing a white chiton with a carmine red *clavus* or stripe on the right shoulder. A cloak can be seen on the other side.

The iconography and decorative features that have been identified in the Fayum portraits are fairly repetitive and there are few variations to the basic repertory. The presence of wreaths and crowns has a precise meaning in the pictorial tradition of Fayum, where they are symbols of athleticism and youth. This iconography is thus a prerogative of young males from families of a high social standing.

The general composition of this work and the decoration allow it to be dated to between the end of the first and the beginning of the second century AD. (A.L.)

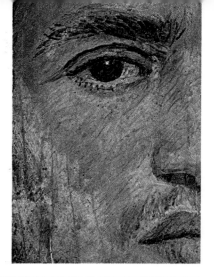

CG 33267

PORTRAIT OF TWO BROTHERS

......................................

ENCAUSTIC WAX PAINTING ON WOOD
DIAMETER 61 CM
ANTINOOPOLIS
A. GAYET'S EXCAVATIONS (1899)
ROMAN PERIOD (2ND CENTURY AD)

This circular panel is painted with the touching portraits of two figures identified as brothers due to their similarity. They are depicted slightly smaller than lifesize, a practice typical of the area around Antinoopolis. The figure on the right is the elder and has fairly dark skin, with the facial features highlighted with yellow lines. The mouth is regularly shaped and very full. As is usual in such portraits, the figure has a moustache rendered by short parallel lines. The same technique is used to depict the rather sparse beard. The cheekbones are very pronounced. The nose appears to be regularly shaped, but there is damage to the portrait in this area. The eyes are enlivened by the depiction of the slightly lowered eyelids, surmounted by thick dark eyebrows. The hair is represented with disordered wavy curls. The man wears a white chiton, the folds of which are picked out in yellow. Above the chiton, he is wearing a white cloak with a carmine red lining. Above his shoulder hovers the figure of Hermes wearing his customary winged sandals and cloak, and holding a caduceus, the staff entwined by snakes, in his right hand.

The youth of the younger figure on the left is emphasized by his lighter skin and his still fairly rounded facial features. The light-coloured lips are regularly shaped and highlighted by a thin moustache. The nose is also regular and slightly flaring at the bottom. The eyes are set off by rather thick eyebrows rendered with dark vertical lines. The hair is depicted with the same disordered curls as his brother. This figure is wearing a white tunic decorated with a continuous red stripe and a line of spots of the same colour; on the left shoulder of the robe is a swastika. Over the tunic the young man wears a red cloak fastened at the right shoulder with a green stone. Above this shoulder is a statuette, the colour of which suggests that it is made of gold or perhaps bronze. The statuette is of a young standing god, with the right leg tensed and the left flexed. The left arm of the statuette is extended along the body while the right is bent to support a staff. On the head is an Egyptian crown. This statuette has been identified as a king, possibly Alexander.

The apparent quality of their clothes and the presence of the two possibly gold statuettes above the shoulders of the men suggest that the brothers were members of a patrician family. (A.L.)

405

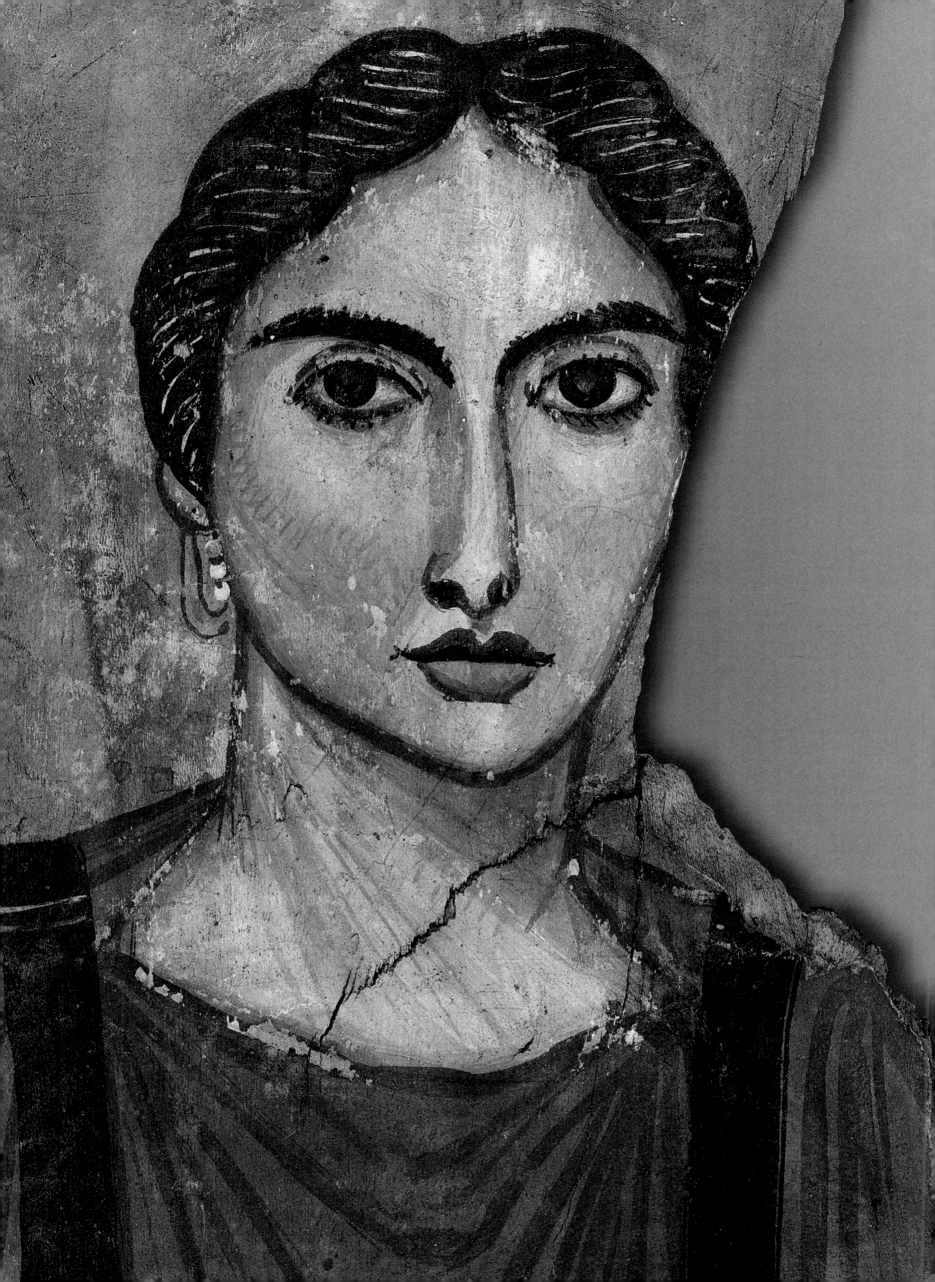

PORTRAIT OF A YOUNG WOMAN

ENCAUSTIC WAX PAINTING ON WOOD
HEIGHT 31 CM; WIDTH 22 CM
FAYUM; ROMAN PERIOD (LATE 1ST CENTURY AD)

The subject of this portrait was obviously a woman of high social standing. She is portrayed on a black ground looking straight out at the viewer. The face is painted in a pink tone with the features picked out with white highlights. The dark red mouth is regular in form and the nose is slightly elongated. The eyes are large and rather luminous, emphasized by arching eyebrows drawn with short black parallel lines. The hair frames the face and is rendered with extremely tight but fairly disordered curls. Two pendant earrings with two beads decorate the ears and the woman is wearing a gold necklace. The clothing is not visible but comparison with other contemporary portraits leads us to presume that the woman was depicted with a purple chiton with one or two broad stripes.

The hairstyle dates the work to the second half of the first century AD. (A.L.)

PORTRAIT OF A FEMALE FIGURE

TEMPERA ON WOOD
HEIGHT 35 CM; WIDTH 19.5 CM
EL-RUBAYAT (PART OF THE COLLECTION SINCE 1893)
ROMAN PERIOD (FIRST QUARTER OF THE 4TH CENTURY AD)

Although this portrait of a young woman is well painted and the rendering of the features is extremely realistic, the decorative elements are very plain. The woman is not wearing costly jewels and her hairstyle is relatively simple.

The figure is painted on a grey ground, with the body facing forwards and the head turned slightly to one side. The face is oval in shape and rather elongated. Her skin is olive in colour, with the features picked out with pink highlights. The mouth is regular, but with a rather full bottom lip. The eyebrows are rendered with very fine parallel lines and reach the bridge of the rather long and prominent nose. The shape and size of the nose are rendered in white and pink lines. The woman's dark hair is divided with a centre parting and is painted with fine, parallel and regularly spaced white lines. The right ear has a pendant earring with a stem and three white pearls.

The slight twist of the neck is shown with long, light brown lines that stand out against the olive skin. The dark brown robe is fairly simple, with folds of the drapery depicted by a series of lines of a slightly darker colour, lending a degree of movement to the composition. Vertical broad dark bands (clavii) are represented on both shoulders.

The dating of this portrait is a rather complex matter. In the past it has been placed in the first quarter of the fourth century AD, but more recently it has been suggested that it was painted between AD 161 and 180. The problem lies above all with the simplicity of the decoration, which has no distinctive elements. However, the general composition of the piece is closer to the works of Late Antiquity and Byzantium and favours a later dating to the fourth century AD. (A.L.)

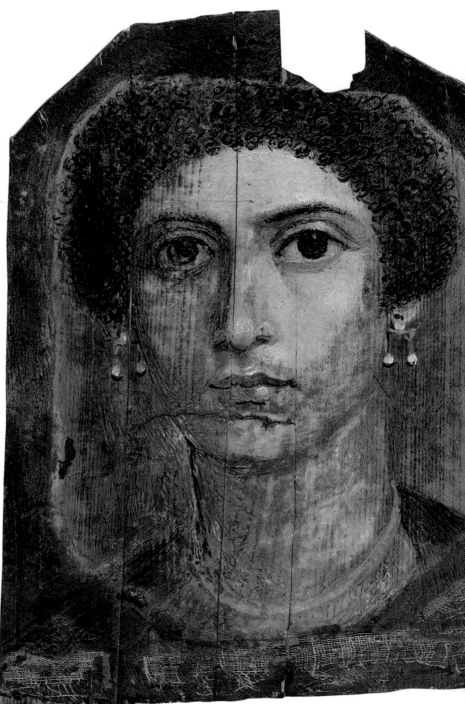

PAINTING WITH A SCENE FROM THE STORY OF OEDIPUS

PAINTED PLASTER
HEIGHT 98 CM; WIDTH 239 CM
TUNA EL-GEBEL
ROMAN PERIOD (30 BC–AD 311)

This painting depicts a scene from one of the most deeply rooted myths in Hellenistic culture, that of Oedipus. He was the son of the King of Thebes, and it was prophesied that he would kill his father and marry his mother.

This scene reproduces, not in chronological order, crucial moments in this mythological tradition: his journey towards Thebes and the killing of the father, and the solving of the riddle of the Sphinx. The myth, which retained its powerful symbolic meaning during the Roman period, recounted how Oedipus had been abandoned at birth by his father, Laius, King of Thebes, who feared the fulfillment of the sphinx's prophecy that he would be killed by his own son. Oedipus, also suffering under a prophecy that he would marry his own mother, fled from the family that had then raised him, believing that Polybus and his wife, the rulers of Corinth, were his natural parents. This scene shows what followed immediately after his decision to abandon his adoptive home.

Oedipus (the first figure from the left) flees from Corinth in the direction of Thebes, encounters the Sphinx and successfully solves its riddle (What is that has a voice, moves on four legs in the morning, two at midday and three in the evening? The answer: man) and finally becomes the King of Thebes. In this representation he then meets Laius, seen here kneeling and already mortally wounded by the knife brandished by his son, the last figure on the right, and kills him. Ignorance, personified by a female dancer, witnesses the scene: Oedipus has committed the crime without realizing that the victim is his true father.

The organization of the painting reverses the logical chronological development of the story. In the myth, Oedipus meets Laius on the road to Thebes and it is only after he has killed him that solves the riddle of the Sphinx.

All the figures can be identified by their Greek names, painted next to them as captions.

The story is also made more comprehensible by the presence of figures embodying states of mind, events or cities. The third figure from the left, who is seated after Oedipus and the Sphinx, personifies the riddle; the fourth can be identified as the city of Thebes; and the fifth is the dancing figure symbolizing the ignorance of Oedipus, who is an unwitting parricide.

As a whole, the composition reveals a rather modest artistic talent, evident above all in the rough sketching of the raised arm of the dancing woman, which fails to render the perspective of the movement and the correct bodily proportions.

The work can be considered as a Roman copy of a work borrowed from the Greek tradition. (A.L.)

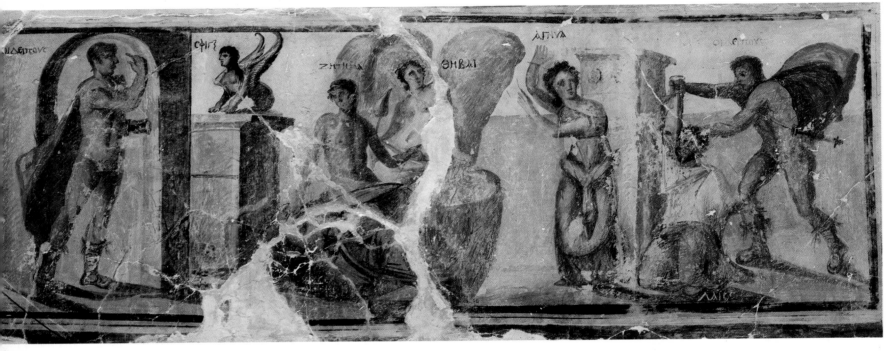

MOSAIC WITH HEAD OF MEDUSA

POLYCHROME STONES
HEIGHT 26.5 CM; WIDTH 33 CM
PROVENANCE UNKNOWN
ROMAN PERIOD (SECOND HALF OF THE 3RD–SECOND HALF OF THE 4TH CENTURY AD)

This head of a female figure is a fragment from a mosaic. The artist was very skilful, achieving rich colour variations and fine details through the use of very small tesserae of different stones. Darker outlines around the nose and eyes produce a sense of depth.

In accordance with the traditional iconography relating to Medusa, the hair is in fact a nest of serpents. The myth tells how Medusa, one of the three Gorgons and the only one who was mortal, dared to compete in a contest with the beauty of Minerva, who, annoyed by her presumption, turned her hair into snakes. The large, fixed eyes are typical of the art of this period, and again recall the myth in which Medusa was condemned to turn any living thing to stone with her gaze. Perseus, with the aid of various gods and clever stratagems, managed cut off her head with which he then turned all his enemies to stone. Out of Medusa's blood were born Pegasus and Chrysaor.

Characteristics of the artistic tradition of this period can be seen above all in the fixed, expressionless gaze that itself appears petrified. The face is broad and flattened and the cheeks appear large in relation to the rest of the face. The half-closed mouth is fairly small.

The style and form of the composition can be compared with other examples from the mosaic tradition of late antiquity. Faces like this one were frequently used to decorate a frame surrounding a central motif, usually featuring a complex scene that in this case may have been linked to the myth of Medusa and Perseus.

Alternatively, this fragment may itself have been the framed section – an emblem at the centre of a floor surrounded by a variety of other decorative motifs. (A.L.)

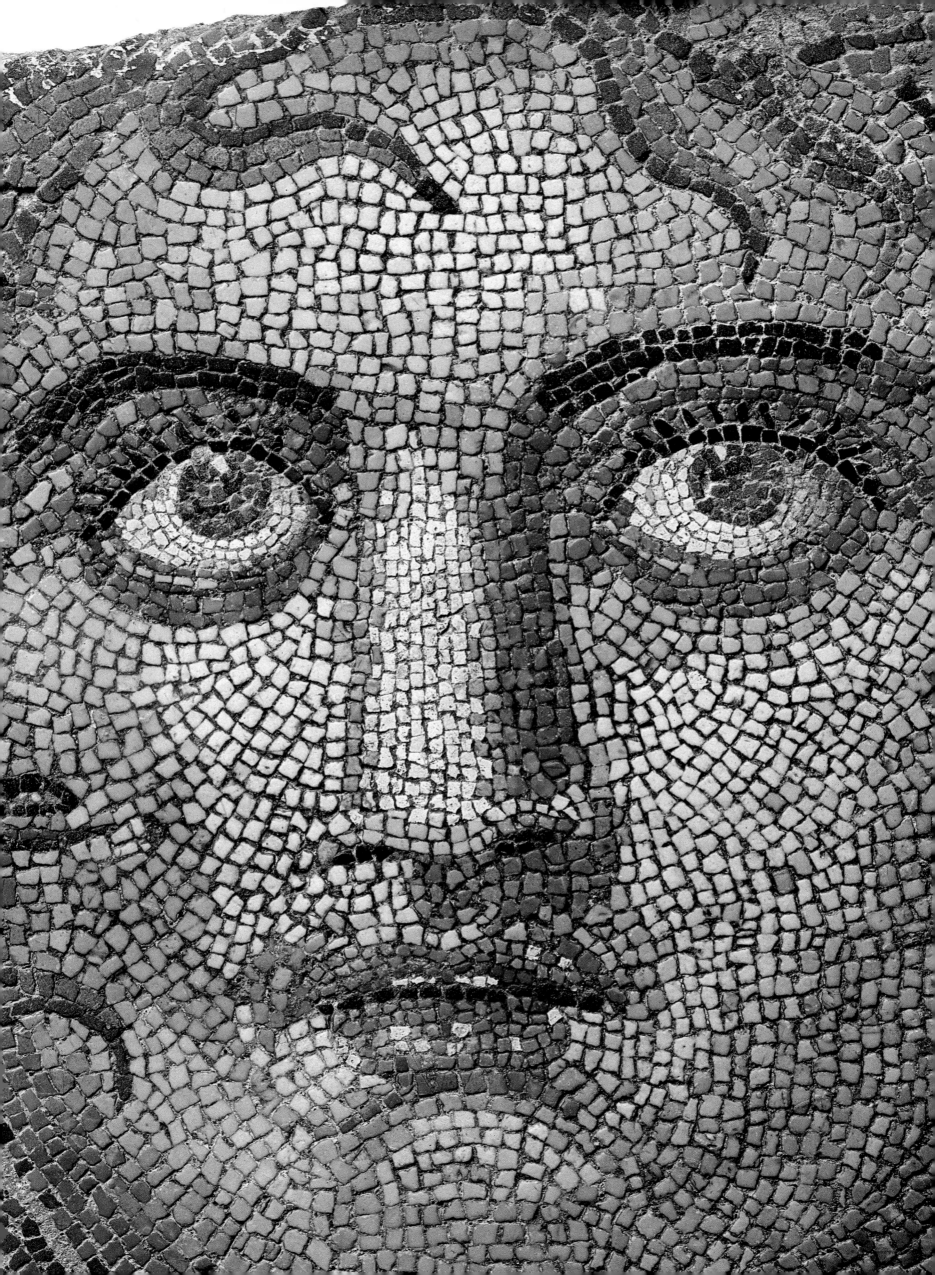

LIST OF OBJECTS

THE NUMBERING OF THE OBJECTS AND ANNOTATED BIBLIOGRAPHY

THE NUMBERING OF OBJECTS
The numbering of objects as they enter the Museum is today a continuation of the system initiated by Mariette in his personal *Inventaire du Musée de Boulaq*, the original manuscript of which is kept in the Bibliothèque Nationale in Paris.

The *Inventaire* was subsequently copied and used as the museum's official Register of Acceptance (*Journal d'Entrée*). There are currently twenty-four volumes of the *Journal d'Entrée*, in which around ninety-nine thousand

entries are recorded (more than one object may correspond to a single entry number). The *Journal d'Entrée* numbers are usually painted in black on the objects and may in certain cases be preceded by the abbreviation JE.

The numbers corresponding to the publication of the objects in the general catalogue (*Catalogue Général*) of the Museum (see below) are generally painted in red on the objects and in certain cases are preceded by the abbreviation CG.

It was customary that whenever the author of a volume of the catalogue assigned a number it was immediately applied to the object. As certain volumes of the catalogue, even though they were ready for publication, have never been issued, it may be that a CG number does not actually correspond to the actual publication of the object to which it has been applied. The list of CG volumes of which unpublished manuscripts exist is as follows:
CG 1809–2000, 16001–16330

L. Borchardt, *Catalogue Général des Antiquités Égyptiennes du Musée du Caire. Nos 1809–2000: Foundation Deposits, Models and Tools.*
CG 4741–4797
G.A. Reisner, *Catalogue Général des Antiquités Égyptiennes du Musée du Caire. Nos 4741–4797: Tel el-Amarna Tablets.*
CG 6030–6294
E. Chassinat, *Catalogue Général des Antiquités Égyptiennes du Musée du Caire. Nos 6030–6294: La seconde trouvaille de Deir el-Bahari II.*
CG 16001–16330 = CG 1809–2000

CG 17101–17120
Ch. Kuentz, *Catalogue Général des Antiquités Égyptiennes du Musée du Caire. Nos 17101–17120: Pyramidions.*

CG 18794–18815
F. W. von Bissing, *Catalogue Général des Antiquités Égyptiennes du Musée du Caire. Nos 18794–18815: Tongefässe II.*

CG 20781–20830
J.J. Clère, *Catalogue Général des Antiquités Égyptiennes du Musée du Caire. Nos 20781–20830: Stèles funéraires et votives du Moyen Empire.*

CG 26350–26665
C.C. Edgar, *Catalogue Général des Antiquités Égyptiennes du Musée du Caire. Nos 26350–26665: Terracotta Lamps.*

CG 26666–27424, 32801–32970
C.C. Edgar, *Catalogue Général des Antiquités Égyptiennes du Musée du Caire. Nos 26666–27424, 32801–32970: Terracotta Statuettes.*

CG 28127–28300
P. Lacau, *Catalogue Général des Antiquités Égyptiennes du Musée du Caire. Nos 28001–28126: Sarcophages antérieurs au Nouvel Empire III.*

CG 29324–29365
H. Gauthier, *Catalogue Général des Antiquités Égyptiennes du Musée du Caire. Nos 29324–29365: Sarcophages anthropomorphiques des Époques persane et ptolémaïque.*

CG 32801–32970 = CG 26666–27424

CG 32971–33000, 43228–44000
Pedrizet, *Catalogue Général des Antiquités Égyptiennes du Musée du Caire. Nos 32971–33000, 43228–44000: Terres cuites.*

CG 34190–35000
P. Lacau, *Catalogue Général des Antiquités Égyptiennes du Musée du Caire. Nos 34190–35000: Stèles du Nouvel Empire. IV.*

CG 43228–44000 = CG 32971–33000

CG 42251–43226
G. Legrain (then Ch. Kuentz), *Catalogue Général des Antiquités Égyptiennes du Musée du Caire. Nos 42251–43226: Statues et statuettes des rois et des particuliers. Tomes V–VI.*

CG 44701–45252
G. Bénédite, *Catalogue Général des Antiquités Égyptiennes du Musée du Caire. Nos 44301–44638: Objets de toilette. Tome II.*

CG 50201–50299
Kaplony-Heckel, *Catalogue Général des Antiquités Égyptiennes du Musée du Caire. Nos 50201–50299: Demotische Ostraka und Holztäfeln.*

CG 54001–54310
A. Moret (then Ch. Kuentz), *Catalogue Général des Antiquités Égyptiennes du Musée du Caire. Nos 54001–54310: Linteaux de portes et montants.*

CG 57050–58000
Dia Abou-Ghazi, *Catalogue Général des Antiquités Égyptiennes du Musée du Caire. Nos 57050–58000: Denkmäler des Alten Reiches III.3.*

CG 58037–58091
W. Golenischeff, *Catalogue Général des Antiquités Égyptiennes du Musée du Caire. Nos 58037–58091: Papyrus hiératiques. Tome II.*

CG 68001–68197
G. Bénédite, *Catalogue Général des Antiquités Égyptiennes du Musée du Caire. Nos 68001–68197: Jeux.*

CG 69001–69099
G. Bénédite, *Catalogue Général des Antiquités Égyptiennes du Musée du Caire. Nos 69001–69099: Matériel du scribe et du peintre.*

The rapid transfer of the monuments from the site at Giza to the present location at Midan el-Tahrir was not without its problems, and many objects lost their JE number. This situation convinced the museum staff that there was a need to provide a new numbering system for the objects that lacked any information that could be identified through the sketchy descriptions in the *Journal d'Entrée*. A provisional system was thus devised, abbreviated as 'TR' (from the English, Temporary Register) or 'RT' (from the French, Registre Temporaire), which indicated the day, month and year (of the new cataloguing), followed by a progressive number used to differentiate the various objects registered on the same day. Where the JE or CG number of an object was identified, the TR was automatically eliminated.

The provisional numbering is painted in a cross on the objects and is to be read from left to right and from top to bottom. For typographical reasons, a TR number is generally transcribed in publications by separating data with a full stop.

There are twelve volumes in the Temporary Register. The first object inventoried is dated 3 May, 1914.

In the 1960s the organization of the museum was completely revised, following which all the objects were subdivided into seven sections:
I) Treasure of Tutankhamun, jewels, and royal mummies.
II) Old Kingdom
III) Middle Kingdom
IV) New Kingdom and written material
V) Late Period
VI) Coins and papyri
VII) Scarabs, sarcophaghi and *ostraca*

Each section has an autonomous system of registration involving the attribution of a progressive number to each object, according to its position within the museum halls. Nowadays, rather than being recorded in the Temporary Register, an object lacking any form of numbering will on occasion be assigned a number in the Special Register (abbreviated as 'SR') of the section concerned.

The SR numbers are painted in white on black cards placed alongside the objects. When these numbers are cited in a publication the object's progressive number is always preceded by that of the section in Roman numerals.

Given that the statues found in the Karnak Cachette and the objects forming part of the funerary assemblage of Tutankhamun have received only partial publication in the volumes of the *Catalogue Général*, they are still cited in some publications through the numbers attributed to them at the moment of their discovery. The white tags with black lettering placed by Carter when he photographed the objects in situ can still be seen in the museum display cases. The number attributed by Legrain, preceded by the initial 'K' is traced on many of the sculptural works found in the Karnak Cachette.

THE CATALOGUE GÉNÉRAL

At the time of the construction of the new museum building it was decided to publish details of the entire collection of Egyptian Antiquities in Cairo in the form of formal catalogues. Each batch of objects was attributed a sequence of numbers and was assigned to an expert, generally a member of the Museum or the Antiquities Service staff.

The first volumes of the *Catalogue Général* (abbreviated as 'CG') were published shortly after the opening of the new museum premises. The regularity of their publication decreased with the outbreak of the First World War, further diminished following the Second World War, and came to a virtual standstill in the late 1950s. Of this publishing venture, unique in the extent and accuracy of the documentation, around eighty of the hundred or so volumes originally planned have been published. Some of them are still stored in manuscript form, just as they were left by the experts who were working on them, while others have never been completed.

Only in recent years have attempts been made to revive the systematic publication of the vast collections of the Egyptian Museum.

CG 1–1294
L. Borchardt, *Catalogue Général des Antiquités Égyptiennes du Musée du Caire. Nos 1–1294: Statuen und Statuetten von Königen und Privatleuten im Museum von Kairo. I–V*, Berlin 1911–1936.

CG 1295–1808
L. Borchardt, *Catalogue Général des Antiquités Égyptiennes du Musée du Caire. Nos 1295–1808: Denkmäler des Alten Reiches (ausser den Statuen) im Museum von Kairo. I–II*, Berlin 1937–1964.

CG 1308–1315, 17001–17036
Ch. Kuentz, *Catalogue Général des Antiquités Égyptiennes du Musée du Caire. Nos 1308–1315 & 17001–17036: Obélisques*, Cairo 1932.

CG 2001–2152
F.W. von Bissing, *Catalogue Général des Antiquités Égyptiennes du Musée du Caire. Nos 2001–2152: Tongefässe. Bis zum Beginn des alten Reiches*, Wien 1913.

CG 3426–3587
F.W. von Bissing, *Catalogue Général des Antiquités Égyptiennes du Musée du Caire. Nos 3426–3587: Metallgefässe*, Wien 1901.

CG 3618–4000, 18001–18037, 18600, 18603
F.W. von Bissing, *Catalogue Général des Antiquités Égyptiennes du Musée du Caire. Nos 3618–4000, 18001–18037, 18600, 18603: Fayencegefässe*, Wien 1902.

CG 4798–4976, 5034–5200
G.A. Reisner, *Catalogue Général des Antiquités Égyptiennes du Musée du Caire. Nos 4798–4976, 5034–5200: Models of Ships and Boats*, Cairo 1913.

CG 5218–6000, 12001–13595
G.A. Reisner, *Catalogue Général des Antiquités Égyptiennes du Musée du Caire. Nos 5218–6000, 12001–13595: Amulets I–II*, Cairo 1907–1958.

CG 6001–6029
E. Chassinat, *Catalogue Général des Antiquités Égyptiennes du Musée du Caire. Nos 6001–6029: La seconde trouvaille de Deir el-Bahri (sarcophages)*, Leipzig 1909.

CG 7001–7394, 8742–9200
J. Strzygowski, *Catalogue Général des Antiquités Égyptiennes du Musée du Caire. Nos 7001–7394, 8742–9200: Koptische Kunst*, Wien 1904.

CG 8001–8741
W.E. Crum, *Catalogue Général des Antiquités Égyptiennes du Musée du Caire. Nos 8001–8741: Coptic Monuments*, Cairo 1902.

CG 8742–9200 = CG 7001–7394

CG 9201–9304
H. Munier, *Catalogue Général des Antiquités Égyptiennes du Musée du Caire. Nos 9201–9304: Manuscrits coptes*, Cairo 1916.

CG 9401–9449
E. Chassinat, *Catalogue Général des Antiquités Égyptiennes du Musée du Caire. Nos 9401–9449: Textes et dessins magiques*, Cairo 1903.

CG 9501–9711
U. Wilcken (published by von C. Gallazzi), *Catalogue Général des Antiquités Égyptiennes du Musée du Caire. Nos 9501–9711: Griechische Ostraka*, Cairo 1983.

CG 10001–10869
B.P. Grenfell and A.S. Hunt, *Catalogue Général des Antiquités Égyptiennes du Musée du Caire. Nos 10001–10869: Greek Papyri*, Oxford 1903.

CG 11001–12000, 14001–14754
M. Quibell, *Catalogue Général des Antiquités Égyptiennes du Musée du Caire. Nos 11001–12000, 14001–14754: Archaic Objects*, Cairo 1905.

CG 12001–13595 = CG 5218–6000

CG 17001–17036 = CG 1308–1315

CG 18001–18037, 18600, 18603 = CG 3618–4000

CG 18065–18793
F.W. von Bissing, *Catalogue Général des Antiquités Égyptiennes du Musée du Caire. Nos 18065–18793: Steingefässe*, Wien 1904–1907.

CG 18600, 18603 = CG 3618–4000

CG 20001–20780
H.O. Lange and H. Schäfer, *Catalogue Général des Antiquités Égyptiennes du Musée du Caire. Nos 20001–20780: Grab- und Denksteine des Mittleren Reichs. Teil I–IV*, Berlin 1902–1925.

CG 22001–22208
Ahmed-bey Kamal, *Catalogue Général des Antiquités Égyptiennes du Musée du Caire. Nos 22001–22208: Stèles ptolémaïques et romaines*, Cairo 1904–1905.

CG 23001–23256
Ahmed-bey Kamal, *Catalogue Général des Antiquités Égyptiennes du Musée du Caire. Nos 23001–23256: Tables d'offrandes. Tomes I–II*, Cairo 1906–1909.

CG 24001–24990
G. Daressy, *Catalogue Général des Antiquités Égyptiennes du Musée du Caire. Nos 24001–24990: Fouilles de la Vallée des Rois 1898–1899*, Cairo 1902.

CG 25001–25385
G. Daressy, *Catalogue Général des Antiquités Égyptiennes du Musée du Caire. Nos 25001–25385: Ostraca*, Cairo 1901.

CG 25501–25832
J. Cerny, *Catalogue Général des Antiquités Égyptiennes du Musée du Caire. Nos 25501–25832: Ostraca hiératiques. Tomes I et II*, Cairo 1935.

CG 26001–26123, 33001–33037
J.G. Milne, *Catalogue Général des Antiquités Égyptiennes du Musée du Caire. Nos 26001–26123, 33001–33037: Greek Inscriptions*, Oxford 1905.

CG 26124–26349, 32377–32394
C.C. Edgar, *Catalogue Général des Antiquités Égyptiennes du Musée du Caire. Nos 26124–26349, 32377–32394: Greek Vases*, Cairo 1911.

CG 27425–27630
C.C. Edgar, *Catalogue Général des Antiquités Égyptiennes du Musée du Caire. Nos 27425–27630: Greek Sculpture*, Cairo 1903.

CG 28001–28126
P. Lacau, *Catalogue Général des Antiquités Égyptiennes du Musée du Caire. Nos 28001–28126: Sarcophages antérieurs au Nouvel Empire*, Cairo 1904–1906.

CG 29301–29323
G. Maspéro, H. Gauthier (in collaboration with d'Abbas Bayoumi), *Catalogue Général des Antiquités Égyptiennes du Musée du Caire. Nos 29307–29323: Sarcophages des époques persanes et ptolémaïque. Tomes I–II*, Cairo 1914–1939.

CG 29501–29733, 29751–29834
C. Caillard, G. Daressy, *Catalogue Général des Antiquités Égyptiennes du Musée*

du Caire. Nos 29501–29733, 29751–29834:
La faune momifié de l'Egypte ancienne, Cairo
1905.

CG 30601–31270, 50001–50165
W. Spiegelberg, Catalogue Général des
Antiquités Égyptiennes du Musée du Caire.
Nos 30601–31270, 50001–50165
Demotische Denkmäler. I–III,
Leipzig/Berlin 1904–1932.

CG 31271–31670
A.E.P. Weigall, Catalogue Général des
Antiquités Égyptiennes du Musée du Caire.
Nos 31271–31670: Weights and Balances,
Cairo 1908.

CG 32001-32367
C.C. Edgar, Catalogue Général des
Antiquités Égyptiennes du Musée du Caire.
Nos 32001–32367: Greek Moulds, Cairo
1903.

CG 32377-32394 =
CG 26124–26349

CG 33001–33037 =
CG 26001–26123

CG 33101–33285
C.C. Edgar, Catalogue Général des
Antiquités Égyptiennes du Musée du Caire.
Nos 33101–33285: Graeco-Egyptian Coffins,
Masks and Portraits, Cairo 1905.

CG 33301–33506
C.C. Edgar, Catalogue Général des
Antiquités Égyptiennes du Musée du Caire.
Nos 33301–33506: Sculptors' Studies and
Unfinished Works, Cairo 1906.

CG 34001–34068
P. Lacau, Catalogue Général des Antiquités
Égyptiennes du Musée du Caire. Nos
34001–34068: Stèles du Nouvel Empire. I–II,
Cairo 1909–1926.

CG 34087–34189
P. Lacau, Catalogue Général des Antiquités
Égyptiennes du Musée du Caire. Nos
34087–34189: Stèles de la XVIIIème
Dynastie, Cairo 1957.

CG 36001–37521
P.E. Newberry, Catalogue Général des
Antiquités Égyptiennes du Musée du Caire.
Nos 36001–37521: Scarab-shaped Seals,
London 1907.

CG 38001–39849
G. Daressy, Catalogue Général des
Antiquités Égyptiennes du Musée du Caire.
Nos 38001–39849: Statues de divinités.
Tomes I et II, Cairo 1905–1906.

CG 41001–41041
A. Moret, Catalogue Général des Antiquités
Égyptiennes du Musée du Caire. Nos
41001–41041: Sarcophages de l'Époque
Bubastite à l'Époque Saïte. Tomes I et II,
Cairo 1913.

CG 41042–41072
H. Gauthier, Catalogue Général des
Antiquités Égyptiennes du Musée du Caire.
Nos 41042–41072: Cercueils anthropoïdes de
prêtres de Montu. Tomes I et II, Cairo 1913.

CG 42001–42250
G. Bénédite, Catalogue Général des
Antiquités Égyptiennes du Musée du Caire.
Nos 42001–42250: Statues et statuettes des
rois et des particuliers. Tomes I–III et index,
Cairo 1906–1925.

CG 44001–44102
G. Bénédite, Catalogue Général des
Antiquités Égyptiennes du Musée du Caire.
Nos 44001–44102: Miroirs, Cairo 1907.

CG 44301–44638
G. Bénédite, Catalogue Général des
Antiquités Égyptiennes du Musée du Caire.
Nos 44301–44638: Objets de toilette. Tome I,
Cairo 1911.

CG 46001–46529
H. Carter, P.E. Newberry, Catalogue
Général des Antiquités Égyptiennes du Musée
du Caire. Nos 46001–46529: Tomb of
Thutmosis IV, London 1904.

CG 46530–48575
P.E. Newberry, Catalogue Général des
Antiquités Égyptiennes du Musée du Caire.
Nos 46530–48575: Funerary statuettes and
Model Sarcophagi. I–III, Cairo
1930–1957.

CG 50001–50165 =
CG 30601–31270

CG 51001–51191
J.E. Quibell, Catalogue Général des
Antiquités Égyptiennes du Musée du Caire.
Nos 51001–51191: The Tomb of Yuaa and
Thuiu, Cairo 1908.

CG 52001–53855
E. Vernier, Catalogue Général des Antiquités
Égyptiennes du Musée du Caire. Nos
52001–53855: Bijoux et orfèvreries, Tomes
I–II, Cairo 1927.

CG 57001–57023
A. Moret (edited by Dia
Abou–Ghazi), Catalogue Général des
Antiquités Égyptiennes du Musée du Caire.
Nos 57001–57023: Monuments de l'Ancien
Empire III.1: Autels, bassins et tables
d'offrandes, Cairo 1978.

CG 57024–57049
Dia Abou-Ghazi, Catalogue Général des
Antiquités Égyptiennes du Musée du Caire.
Nos 57024–57049: Denkmäler des Alten
Reiches III.2: Altars and Offering Tables,
Cairo 1980.

CG 58001–58036
W. Golenischeff, Catalogue Général des
Antiquités Égyptiennes du Musée du Caire.
Nos 58001–58036: Papyrus hiératiques,
Cairo 1927.

CG 59001–59800
C.C. Edgar, Catalogue Général des
Antiquités Égyptiennes du Musée du Caire.
Nos 59001–59800: Zenon Papyri I–IV,
Cairo 1925–1931.

CG 61001–61044
G. Daressy, Catalogue Général des
Antiquités Égyptiennes du Musée du Caire.
Nos 61001–61044: Cercueils des cachettes
royales, Cairo 1909.

CG 61051–61100
G. Elliot Smith, Catalogue Général des
Antiquités Égyptiennes du Musée du Caire.
Nos 61051–61100: The Royal Mummies,
Cairo 1912.

CG 63001–64906
Ch. T. Currelly, Catalogue Général des
Antiquités Égyptiennes du Musée du Caire.
Nos 63001–64906: Stone Implements, Cairo
1913.

CG 67001–67359
G. Maspéro, Catalogue Général des
Antiquités Égyptiennes du Musée du Caire.
Nos 67001–67359: Papyrus grecs d'Époque
byzantine. I–III, Cairo 1911–1916.

CG 69201–69852
H. Hickmann, Catalogue Général des
Antiquités Égyptiennes du Musée du Caire.
Nos 69201–69852: Instruments de musique,
Cairo 1949.

CG 70001–70050
G. Roeder, Catalogue Général des Antiquités
Égyptiennes du Musée du Caire. Nos
70001–70050: Naos. I–II, Leipzig 1914.

CG 70501–70754
F. Bisson de la Roque, Catalogue Général
des Antiquités Égyptiennes du Musée du Caire.
Nos 70501–70754: Le trésor de Tôd, Cairo
1950.

MUSEUM GUIDES

The first descriptions of the objects currently held in the Egyptian Museum in Cairo were written by Mariette in the early years of the Antiquities Service, and refer to the objects displayed in the halls of the museum at Bulaq. The very title of the guide reveals that Mariette considered the Bulaq premises to be no more than provisional (A. Mariette-bey, Notice des principaux monuments exposés dans les galeries provisoires du Musée d'Antiquités Égyptiennes de S. A. le Vice-roi à Boulaq). The first and the second (revised and expanded) editions were published in Alexandria (1864–68); the third and the fourth in Paris (1869–1872); the fifth (completely revised), the sixth and seventh in Cairo (1874, 1876, 1879).

A selection of the most important exhibits from the Bulaq museum forms the basis of another work by Mariette, Album du Musée de Boulaq, published in Cairo in 1871, in which ample space was devoted to views of the halls and the way the objects were displayed in them.

Published posthumously from a manuscript, Auguste Mariette's Monuments, divers recueillis en Égypte et en Nubie (Paris, 1899), in addition to documenting the scope of the Frenchman's excavations in Egypt, also acted as a catalogue of all the objects found and preserved in the Bulaq museum.

The book by Luigi Vassalli, I monumenti istorici egizi. Il Museo e gli scavi d'Antichità eseguiti per ordine di S. A. il Vicerè Ismail Pascià, Milan, 1867, describes the first excavations by the Antiquities Service and the events that led to the creation of the Bulaq museum.

The last guide to the Bulaq museum was written by Mariette's successor, Gaston Maspero (Guide du visiteur du Musée de Boulaq, Cairo, 1883). Gaston Maspero was also responsible for the guide to the museum of Giza (Notice des principaux monuments exposés au Musée de Gizeh), published first in Cairo in 1892 and then reprinted in 1895. The compilation of the first guide to the Egyptian Museum in the new building at Midan el-Tahrir again fell to Maspero: Guide du visiteur au Musée du Caire. This volume, published in Cairo, was revised on a number of occasions between 1902 and 1915. There was also a version in English edited by J.E. and A.A. Quibell (Guide to the Cairo Museum), which was also reprinted on numerous occasions between 1903 and 1915. The German edition dates from 1912 and was translated and revised by G. Roeder(Führer durch dem Ägyptischen Museum zu Kairo), and was also published in Cairo.

Following the example set by his predecessor, G. Daressy published a Notice sommaire des principaux monuments exposés au musée Égyptien du Caire (Cairo, 1922, with an English edition published in the same year) that takes into account the changes within the museum since its inauguration.

The discovery of Tutankhamun's tomb and the subsequent arrival at the Museum of all the objects belonging to his funerary assemblage obliged Daressy to publish a revised and expanded edition of his guide in 1925.

In 1927, without mention of the author, but following the format of Daressy's guide, a guide was published at Cairo in English (Cairo Museum. A Brief Description of the Principal Monuments) and French (Musée du Caire. Notice sommaire des principaux monuments), with numerous modifications determined by the arrival of the objects from the tomb of Tutankhamun that persisted up until the early 1930s.

A German guide to the museum (edited by A. Hermann) dates from 1935. From the end of the Second World War the guide to the museum became available in its definitive format. Between 1946 and 1986 numerous editions were published (with a version in Arabic joining the English and French editions) that attempted to keep up with the changes made within the museum's display areas. The numbering of the objects in the guide is unique and corresponds with white labels with a red line on the lower edge applied to the bases or the frames of the display cases.

PUBLICATIONS RELATING TO SELECTED OBJECTS

Many works, especially by western authors, are dedicated to a discussion of a selection of the museum's most significant exhibits. One such volume intended for the most discerning and interested visitors, and in which each object is described according to the criteria of a scientific catalogue is the book by M. Saleh and H. Sourouzian, The Egyptian Museum Cairo. Official Catalogue, Mainz am Rhein, 1987 (also published in French and German). It contains a selection of almost three hundred objects, to which are attributed a specific number that corresponds with brown self-adhesive labels with white numerals applied to the display case or on the base. This is undoubtedly the work that better than any other allows one, while visiting the museum and viewing the exhibits, to gain an almost complete overview of Pharaonic culture.

Along the same lines but with a more general treatment of the monuments are the multi-author volume Ägyptische Kunst aus den Sammlungen des Museums in Kairo (Prague, 1962) and the works by W. Forman, M. Vilimkova and M. H. Abd al-Rahman (Egyptian Art, London, 1962, published in German in 1972), R.P. Riesterer (Das Ägyptische Museum Kairo. Band I: Augsgewählte Kostbarkeiten and Band II: Grabschatz des Tut-ench-Amun, Berne, 1966), E.L.B. Terrace and H. G. Fisher (Treasures of the Cairo Museum, London, 1970) and R.P. Riesterer and K. Lambelet (Das Ägyptisches Museum Kairo, Berne, 1980).The book by S. Donadoni, Musei del mondo: Museo Egizio, Milan, 1969 (English edition 1969, French edition 1971, German edition 1976) and the one by J.-P. Corteggiani L'Égypte des pharaons au Musée du Caire, Paris, 1979, 1986 (German edition 1979, 1987, English edition 1987) are the result of personal selections made by the authors on the basis of discussions across the whole history of Egyptian culture. Readers therefore have the unique opportunity of being guided through the museum by two of the most authoritative experts in the field.

The collective work co-ordinated by Maspero, Le Musée Égyptien in three volumes published in Cairo between 1890 and 1924 is devoted to particular exhibits and the problems relating to them in an exhaustive treatment.

The book by G. Grimm and D. Johannes (Kunst der Ptolemäer und Römerzeit in Ägyptischen Museum Kairo, Mainz am Rhein, 1975) remains somewhat unusual among the works dedicated to the pharaonic exhibits in that it deals exclusively with the objects belonging to the Greco-Roman period in Egypt that, in spite of the opening of the Greco-Roman Museum in Alexandria, are still housed in the Egyptian Museum in Cairo. This is a detailed annotated catalogue that presents to an academic readership a series of objects that would otherwise be relatively unknown but which document the crucial period of the fusion of Greek civilization with the Mediterranean world.

The recent opening of the hall of the royal mummies on the first floor has led to the publication, in addition to the official guide, of a slim volume by S. Ikram and A. Dodson, Royal

Mummies in the Egyptian Museum, Cairo, 1997, in which not only all the royal mummies found within the Museum are described but also all those from the Cachette of Deir el-Bahri and the excavations conducted in the Valley of the Kings that for one reason or another are preserved elsewhere.

There are various volumes devoted to the Museum in which photography plays a leading role. The most important are: Le Musée du Caire. Photographies inédites d'André Vigneau, Paris, 1944, and E. Drioton, Encylopédie photographique de l'art: le Musée du Caire, Paris, 1949. By this last author there is also a small guide, which, however, is not an official publication, E. Drioton, Le Musée Égyptien, Cairo, 1939.

The Museum is reduced to its essentials in the catalogue-guide by M. Saleh, Cairo. The Egyptian Museum and Pharaonic Sites (Cairo, 1997). In just a few pages all the major masterpieces are described all with incomparable majesty by the man who perhaps knows them best, having been the director of the Museum for over twenty years.

Exhibitions held at the Egyptian Museum
From the 1970s the Museum has also been used as a venue for temporary exhibitions, which have served above all to celebrate the excavations of foreign nations or the work of eminent Egyptologists. Two exhibitions held in 1976 and 1988 (of which there is no catalogue available) were organized to display to the public newly acquired or less well-known exhibits from the museum's collection.

The Egyptian Museum in Cairo
in Ten Years: 1965–1975.
An Exhibition held in the Museum in 1976, Cairo 1976.
Exhibition of the 25th Anniversary of Czech Excavations (1959–1984), Cairo 1985.
Centenaire de l'Institut Française d'Archaéologie Orientale. Musée du Caire, 8

janvier–8 février 1981, Cairo 1981.
Cinquante années à Saqqarah de J.-P. Lauer. Musée du Caire, 13 avril 1980–15 mars 1981, Cairo 1982
Archaic Egypt, Cairo 1982.
The Egypt Exploration Society Centenary Exhibition (1882–1982), Cairo 1982.
L'egittologo Luigi Vassalli-bey 1812–1887, 9 maggio - 9 luglio 1994, Cairo 1994.
Il contributo italiano alla costruzione del Museo Egizio del Cairo, Cairo 1995.

Exhibition on European excavations in Egypt
Isis. The Egyptian Goddess Who Conquered Rome, 16 November–16 December 1998, Cairo 1998.

Foreign exhibitions of objects from the Egyptian Museum
From the early 1960s to the second half of the 1980s a series of major exhibitions took many of the most important of the Museum's exhibits around the world. As well as being opportunities to present the wonders of the pharaonic civilization to those unable to travel to Egypt, they also served to bring to the attention of the specialist public a number of objects published for the first time in the catalogues on the exhibitions.

The most important of these exhibitions, which also served to relaunch Egypt as an attractive tourist destination, was undoubtedly that devoted to Tutankhamun. Beginning in 1961, when the most beautiful objects from his tomb were shipped to the United States (remaining there until 1963), the exhibition moved to Japan (1965–1966), Paris (1967), London (1972), and the Soviet Union (1974). It then returned to the United States, from where it moved to Canada (1976–1979) before completing its trip around the world in Germany (1980–1981).

On the occasion of the completion of the restoration of the mummy of Ramesses II, France and Egypt celebrated by organizing an exhibition of a grandeur appropriate to the pharaoh. The exhibition devoted to Ramesses II was inaugurated in France in 1976 and restaged some years later in Montreal, from where it passed to cities in the United States (1985–1988).

An exhibition dedicated to the figures of Akhenaten and Nefertiti was staged in Belgium (1975) and Germany (1976), in which, alongside the exhibits from the Egyptian Museum in Cairo were the objects discovered by Borchardt's mission at Tel el-Amarna. currently held in the Egyptian Museum of Berlin.

Other exhibitions worthy of note and featuring artifacts from the Egyptian Museum in Cairo include those organized in Germany and devoted to the divine role of Egyptian royalty (Götter Pharaonen, 1978–1979)

and to the role of women. The latter, inaugurated on the occasion of the Fifth International Congress of Egyptology at Munich (1985), was subsequently taken to other European cities.

In Italy, an exhibition devoted exclusively to objects from the Museum was organized in Venice (Tesori dei faraoni, 1985).

In recent years, Austria has dedicated an exhibition to the successful excavations conducted by the University of Vienna at Tel al-Dabha, with objects from the Museum's collection (1993), while Korea has recently displayed a series of monuments that give a general idea of the Egyptian civilization to a people geographically and culturally remote from the Nile Valley (1997).

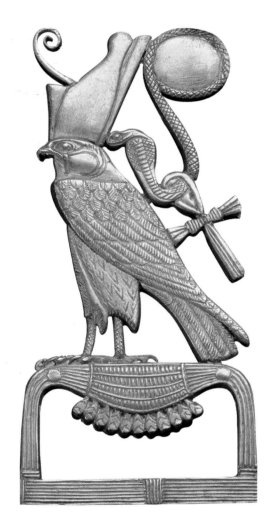

416
NECKLACE WITH PECTORAL DEDICATED TO SENUSRET II, FROM DAHSHUR (DETAIL)
JE 30857

PHOTOGRAPHIC CREDITS